Comics & Media

Comics & Media

Edited by Hillary Chute
and Patrick Jagoda

The University of Chicago Press

Critical Inquiry

Editorial Correspondence
W.J.T. Mitchell, *Critical Inquiry*, The University of Chicago, 202 Wieboldt Hall, 1050 East 59th Street, Chicago, Illinois 60637. Email: jww4@midway.uchicago.edu
World Wide Web URL: **http://criticalinquiry.uchicago.edu**

Critical Inquiry (ISSN 0093-1986) is published four times a year in Autumn, Winter, Spring, and Summer by The University of Chicago Press, 1427 E. 60th Street, Chicago, Illinois 60637.

Critical Inquiry

Spring 2014

Special issue of *Critical Inquiry*
Comics & Media
Edited by Hillary Chute and Patrick Jagoda

Foldout: Chris Ware, conference poster, "Comics: Philosophy and Practice," May 2012

Foldout: Seth, pages from *George Sprott*, 2009

On the cover: R. Crumb, rejected *The New Yorker* cover (2009).

Front and back endpapers: Seth, sketches of conference participants.

Designed by Marieke McClendon.

For Gabriel Mitchell

Many thanks to the following people and institutions at the
University of Chicago for their support:

The Mellon Residential Program for Arts Practice and Scholarship at the Richard
and Mary L. Gray Center for Arts and Inquiry, the deputy provost for the arts,
and the Reva and David Logan Center for the Arts for sponsoring the 2012
conference "Comics: Philosophy and Practice" and supporting this issue.

The Division of the Humanities

The Franke Institute for the Humanities

The Center for the Study of Race, Politics, and Culture

The Center for the Study of Gender and Sexuality

The Department of English

The Karla Scherer Center for the Study of American Culture

Critical Inquiry

Published four times a year in Autumn, Winter, Spring, and Summer.

Subscriptions. Individual subscription rates for 2014: $56 print + electronic, $49 print-only, $48 e-only. Institutional print + electronic and e-only subscriptions are available through JSTOR's Current Scholarship Program and include unlimited online access; rates are tiered according to an institution's type and research output: $219 to $438 (print + electronic), $186 to $372 (e-only). Institutional print-only is $219. Single copy rates: institutions $65, individuals $17. For additional rates, including two-year and three-year rates for individuals and reduced rates for students, please visit **www.journals.uchicago.edu/CI/**. Additional taxes and/or postage for non-U.S. subscriptions may apply. Free or deeply discounted access is available in most developing nations through the Chicago Emerging Nations Initiative (**http://www.journals.uchicago.edu/ceni/**).

Special Issue: Comics & Media

Hillary Chute and Patrick Jagoda

Introduction

Why does it make sense for a professor who specializes in what we might think of as the "old" media form of comics (with its instantiation, in the US, in newsprint) and one who specializes in new media studies (with an emphasis on digital forms) to collaborate on a special issue of *Critical Inquiry*? Although seemingly at opposite ends—at least judging by the different materiality of the objects that generate our research—of a spectrum in literary studies and in the humanities generally, we have found numerous opportunities to collaborate. (We have worked together since we began teaching, each at slightly obverse angles to the English department, at the University of Chicago in 2010.) It is not only that the medium of comics, like new media texts from electronic literature to video games, includes both words and images or that both smack of newfound respectability, at least in the context of academia. It is rather that comics and new media so often enable an intense focus on how complexly woven stories unfold across time and space and, particularly, how these involve the reader (or viewer, or player) to generate meaning through interacting with, or themselves shaping, spatio-temporal form. Across all of the different kinds of work, scholarly and artistic, included in this issue, we see attention to the ludic engagement produced by a range of forms both "old" and "new." The included pieces also attend to embodied activity, not only the work of the hand of the creator, but also the embodied activity of reading, looking, and playing, whether in relation to the printed page, the stage, or the screen—and the spaces among them.

The "Comics & Media" special issue is inspired by the May 2012 "Comics: Philosophy and Practice" conference at the University of Chicago, which here provides a springboard for an exploration of media histories with their numerous continuities—and divergences. Organized by Hillary Chute (under the auspices of the Mellon Residential Program for Arts Practice and Scholarship at the University of Chicago's Richard & Mary L. Gray Center for Arts and Inquiry), the conference offered three days of public conversations, talks, and panels featuring seventeen of today's most acclaimed cartoonists: Lynda Barry, Alison Bechdel, Ivan Brunetti, Charles Burns, Daniel Clowes, Robert Crumb, Phoebe Gloeckner, Justin Green, Ben Katchor, Aline Kominsky-Crumb, Françoise Mouly, Gary Panter, Joe Sacco, Seth, Art Spiegelman, Carol Tyler, and Chris Ware.[1] This special issue archives the events of that historic gathering of cartoonists and also takes them as a starting point to amplify—through critical essays, transcripts, and original artwork from conference participants—issues that the conference highlighted about producing and consuming media as an embodied activity, about time, space, play, print culture, and also what we might think of as the reemergence of the handwritten form of comics in today's media landscape. As its title indicates, the conference aimed to create generative exchange between arts practice and critical and theoretical practice. The original artwork and the critical essays themselves produce a cross-media conversation in this issue. And just as the cartoonists at the conference expressed, again and again, meticulous attention to the materiality comics instantiates, "Comics & Media" expresses its own commitment to the physical object by pub-

1

1. All of the conference's events are archived in this issue, excepting Lynda Barry's writing workshop "Writing the Unthinkable" and Ben Katchor's lecture "Halftone Printing in the Yiddish Press and Other Objects of Idol Worship," which is part of his forthcoming collection of visual essays. Video from the conference can be found at criticalinquiry.uchicago.edu/comics_conference/ and the complete program at graycentercomicscon.uchicago.edu/

lishing at a larger size (7 x 10) and in full color throughout, which distinguishes it from any other issue in the history of *Critical Inquiry*.

"Comics & Media" considers a range of mediascapes: the objects of its critical essays include film, ballet, vernacular Russian print (*lubok*), transmedia games, comics, sculpture, panorama, and hypertext. Examining ballet alongside games alongside comics, the question for us is: how do these forms inform each other and, through their constellation, promote a robust comparative media studies? These forms raise a number of aesthetic and philosophical inquiries into how artistic forms in general generate movement and stillness (on their surfaces and within their audiences), how they enable different forms of play, and how we experience and apprehend media in relation to each other. This issue balances three essays exploring different media forms that make up a transhistorical media triptych (Yuri Tsivian, Daria Khitrova, and Patrick Jagoda, N. Katherine Hayles, and Patrick LeMieux), with three essays that take comics as a central point of inquiry and reveal their commitments by situating the form within various media ecologies (Tom Gunning, Scott Bukatman, and Katalin Orbán). Further, this issue instantiates in its own material form the dynamic view of media its essays index, interspersing the essays with comics art by ten contemporary cartoonists (Barry, Bechdel, Gloeckner, Green, Kominsky-Crumb, Mouly, Seth, Spiegelman, Tyler, Ware), eight illustrated conference transcripts, and a sampling of images from Henry Jackson Lewis (1837–1891), an artist who was born into slavery and has been called the first African American cartoonist—along with, online, an exclusive hub from the transmedia game *Speculation*.[2]

We are less interested in emphasizing multimedia forms than we are in transmedia relations—both historical and currently unfolding—among ostensibly discrete and evidently imbricated or impure forms.[3] By transmedia, we are not gesturing merely to those multiplatform experiences represented by contemporary transmedia novels, alternate reality games, or web series with social media components.[4] We aim to historicize transmedia objects but also to foreground a methodology that moves across media. For us, the term describes a relationship between media that is proliferating and relational rather than additive. It is a way of opening up an analysis by

attending to intersections and differences instead of investing in sharp demarcations among discrete media at the outset. It is a way of beginning in the midst of rich media ecologies instead of separate media. Attention to comics, a popular form that has evolved and has also, at least in part, happily remained what Kominsky-Crumb calls a "dinosaur" medium,[5] makes legible how transmedia implies movement across media, their creators, and their audiences. While we do not always agree with the dichotomous valence of the old media/new media distinction, this formulation draws attention to continuities and discontinuities that are mutually illuminating.[6] We seek to explore past histories of a form and also point to experimentation with emerging hybrid forms. In this way, comics and transmedia games, both of which absorb and reconfigure the potentials of other available forms and media in different ways, serve as historical and formal bookends to this issue.

Evident from the prominent space opened up to practicing artists and original visual work, the intertwining of theory and practice is significant to the shape of this issue and our view of how to practice contemporary media studies. As we began to imagine this issue, we had back-to-back teaching and research collaborations with artists—Chute with cartoonist Bechdel, Jagoda with new media artist Sha Xin Wei—through the Gray Center for Arts and Inquiry, which enabled us to work within forms like comics and transmedia games, thinking through their properties and constraints from the inside-out as well as the outside-in. Collaboration, as our work together on this issue suggests, is a critical component of the transmedia ecologies and approaches that we track. Collaboration has, in recent years, thrived in the emergent digital humanities and new media studies. The benefits of such collaboration should not, however, be limited to digitally oriented fields. Areas such as comics, film, and game studies reward thick comparative analyses that benefit from multiauthor projects and extended dialogues. The comics conference, for instance, was the result of an on-campus collaboration with Bechdel, who taught "Lines of Transmission: Comics and Autobiography" with Chute in Spring 2012; they continue their collaboration here in the short comics piece "Bartheses."[7] Similarly, Sha taught, with Jagoda, a course on "Transmedia Games: Theory and Design" in Fall 2012 that yielded an alternate reality game

2. The conference transcripts have been edited and condensed for inclusion in the journal.

3. We began our conversation about transmedia relations at a 2011 panel (with Henry Jenkins) about "Transmedia, Comics Form, and Contemporary Adaptations" at the Comic Arts conference at the San Diego Comic-Con. For more on the centrality of transmedia flows to popular culture as it has manifested at Comic-Con in recent years, see Patrick Jagoda, "The Transmedia Turn in Popular Culture: The Case of Comic-Con," *Post45* 23 (Aug. 2011).

4. For more, see Henry Jenkins, "Transmedia Storytelling," *Volume* 19 (2009): 56–59.

5. Aline Kominsky-Crumb, "Aline Kominsky-Crumb," *Dangerous Drawings: Interviews with Comix and Graphix Artists*, ed. Andrea Juno (New York, 1997), p. 170.

6. See *New Media, Old Media: A History and Theory Reader*, ed. Wendy Hui Kyong Chun and Thomas Keenan (New York, 2006).

7. For more on the collaboration between Hillary Chute and Alison Bechdel, see "Lines of Transmission: Comics and Autobiography," Gray Center for Arts and Inquiry, graycenter.uchicago.edu/experiments/lines-of-transmission-comics-and-autobiography

much like the *Speculation* project discussed in the Hayles, Jagoda, and LeMieux essay in this volume.[8]

This issue calls attention to the work of conceptualizing form by designing it—in short, to the critical work of making. The subtitle to a recent book on Ware (who created the poster for the conference) is "drawing is a way of thinking."[9] (Richard Dienst's blog Thinkingthroughimages, inspired by Jean-Luc Godard, highlights how this same idea disrupts the monocular tendencies of visual thinking.)[10] Programming and media design, too, are ways of thinking. Comics is a form where we see this kind of work happening in print culture; one needs to design in order to conceptualize the work. As the authors of the book *Digital_Humanities* note, we should move "design—information design, graphics, typography, formal and rhetorical patterning—to the center of the research questions."[11] Art and design, then, are taken up in this issue not as mere decoration but as material ways of thinking about and through media.

Comics and Media

Comics is now, perhaps, in the position that film was in the 1960s and onward, in terms of assimilating into spaces like the museum and the academy; there are currently several academic journals devoted to comics, all from the past ten years, just as journals of film scholarship started emerging approximately five decades ago.[12] (Perhaps this is why the two film theorists featured in the suite of scholarly essays about comics—Gunning and Bukatman—step back so easily from the twinned discourses that so often plague discussion of emergent forms: cheerleading on one hand and the performance of marginality on the other.) Some cartoonists at the conference expressed mixed feelings about what some others might consider the ascension of comics into mainstream cultural spaces even as vaunted institutions court comics, encourage their production, and in some cases provide a platform for innovation (for instance, when Ware introduced sequential narrative to the covers of *The New Yorker*). And some cartoonists noted mixed feelings about the concept of the academic conference itself. When Crumb sent a postcard confirming his attendance (he and Chute arranged his participation entirely through postcards), he wrote, "Hillary, I looked at the schedule of panel discussions you sent for the comics conference. Looks okay to me. My biggest fear about such panels is that the audience will become bored."[13] And it's worth noting that bored here appears in bigger letters than the words in the rest of the sentence (fig. 1). "I try to be entertaining and not too serious or intellectual. This is after all about comic books. It is not, you know, like about the threat to the environment of global warming or something really serious like that. Let us keep in mind again this is about comic books!"[14] Crumb is the creator of the infamous 1969 "Drawing Cartoons Is Fun!," a one-page manifesto concluding with the words "It's only lines on paper, folks!!" that lent his panel its title at the conference.[15] The question of how comics, a form historically so demotic and productively "below critical radar" (to use a phrase of Spiegelman's), sits in diverse spaces constituted one of the most generative and unresolved lines of inquiry at the conference and provided a rich area of actual disagreement. But while in the opening to his essay Gunning notes he observed the participants disavowing comics as art, the conference in our view took place not under the sign of the question "Is it art?" but, moving forward from the assumption, it asked rather "how is it working?" Crumb himself was decidedly not bored—he called out questions throughout about technique and craft from his seat in the audience.

What are the issues comics asks us to encounter in the conversation about histories and philosophies of form and expression? "Everything I call philosophy is rooted in my miseducation in reading comic books," W. J. T Mitchell explains memorably in his conversation with Spiegelman. "Certainly the idea of picturing theory comes to me directly out of comic books."[16] In an original poster created for the conference, Ware dubbed the event "a conference addressing the art of the empathetic doodle."[17] One place to start, then, is with the interaction between text and reader—or, perhaps, author and reader—that the mutualistic term *empathetic* suggests. Comics is a form with a peculiar syntax; among its most basic elements are panels (also called frames), gutters, speech balloons, text boxes. How the gutter, the space in between panels, divides and proliferates time is at the heart of how comics works, as we see in comics criticism and as many of the artists and scholars here discuss. It is a medium that

3

8. For more on the collaboration between Jagoda and Sha Xin Wei, see graycenter.uchicago.edu/experiments/alternate-reality-a-pervasive-play-project. For the *Speculation* digital exclusive hub, see criticalinquiry.uchicago.edu/nexus_x

9. See *The Comics of Chris Ware: Drawing is a Way of Thinking*, ed. David Ball and Martha B. Kuhlman (Jackson, Miss., 2010).

10. See Richard Dienst, *Thinkingthroughimages*, thinkingthroughimages.wordpress.com

11. Anne Burdick et al., *Digital_Humanities* (Cambridge, Mass., 2012). See also Johanna Drucker, "What Is Graphic About Graphic Novels?" *English Language Notes* 46 (Fall–Winter 2008): 39–55.

12. For instance, *Cinema Journal* (1961); *Cineaste* (1967); *Film and History* (1970); and *Camera Obscura* (1976).

13. Robert Crumb, postcard to Hillary Chute, 1 Mar. 2011.

14. Ibid.

15. Crumb, back cover, *Plunge into the Depths of Despair* (Berkeley, 1969).

16. W. J. T Mitchell and Art Spiegelman, "What the %$#! Happened to Comics," *Critical Inquiry* 40 (Spring 2014): 20; hereafter abbreviated "WT%."

17. Chris Ware, conference poster, "Comics: Philosophy and Practice," May 2012.

MARCH 1, 2012

HILLARY: LA POSTE 39631A
 I LOOKED AT THE SCHEDULE OF PANEL
DISCUSSIONS YOU SENT FOR THE COMICS CONFER-
ENCE. LOOKS OKAY TO ME. MY BIGGEST FEAR
ABOUT SUCH PANELS IS THAT THE AUDIENCE WILL
BECOME BORED... I TRY TO BE ENTERTAINING
AND NOT TOO SERIOUS OR INTELLECTUAL... THIS
IS, AFTER ALL, ABOUT COMIC BOOKS... IT'S NOT,
YOU KNOW, LIKE IT'S ABOUT THE THREAT TO
THE ENVIRONMENT OF GLOBAL WARNING, OR SOME-
THING REALLY SERIOUS LIKE THAT... LET US
KEEP IN MIND, THIS IS ABOUT COMIC BOOKS!
 ANYWAY, I'M LOOKING FORWARD TO IT MOSTLY
AS A CHANCE TO VISIT WITH SOME OF THE ART-
ISTS, WHO I CONSIDER OLD FRIENDS AND DON'T
GET TO SEE TOO OFTEN.
 ALINE AND I JUST RETURNED FROM DEHLI, INDIA A
FEW DAYS AGO. THE COMICS FESTIVAL PEOPLE, ALL
QUITE YOUNG, WERE VERY GOOD TO US, TOOK GOOD
CARE OF US, BUT INDIA IS INTENSE. THE FESTIVAL
IS A SMALL ONE, IN FACT. COMICS ARE JUST GETTING
OFF THE GROUND THERE. AFTER IT WAS OVER, THE
FESTIVAL PEOPLE TOLD US THAT NEXT YEAR THEY'RE
GOING TO NEED A BIGGER SPACE.
 WHO DO WE CONTACT ABOUT COMING INTO CHICAGO? IS THERE AN E-MAIL ADDRESS?

H. CHUTE
DEPT. of ENGLISH
WALKER 516
1115 EAST 58TH ST.
CHICAGO, ILLINOIS
U.S.A. 60637

Figure 1. Postcard from R. Crumb (2012).

builds and organizes the space of the page by assembling a series of moments—thus turning, as Spiegelman has often commented, time into space.

Crucially, the gutter spaces of comics are, in a sense, unregulated spaces, interstices that are components of meaning for the reader to fill in (or choose to ignore). For this reason, comics (which Marshall McLuhan dubbed a cool medium—that is to say, one that provokes an active level of participation),[18] is a form that gestures at robust readerly involvement; it actively solicits through its constitutive grammar the participant's role in generating meaning. Further, comics pages do not function as directively as some other forms of media; the correct direction of reading is often unclear, and deliberately so. The relationship between word and image is often disjunct, even within the space of one frame. As Orbán explains, "Discrete… components' narrative, temporal, spatial, verbal, and visual connections almost never coincide in a single mandatory path and rather compete as alternatives."[19] The result is that comics, even apart from the important role of the visual detail, is significantly about the aesthetics of attention—the fullness of the concentration required to

absorb its narrative or discursive procedures. These are often about a kind of slowing down, a "ruminative" kind of attention, to use Bukatman's term, in the act of reading and producing meaning (empathetically?) with the text.[20] Sacco calls his journalism in the medium of comics, for instance, slow journalism—both to indicate, we believe, the amount of time it takes him to draw unfolding conflicts in the Middle East and the Balkans and the rigorous kind of engagement with the surfaces of his pages that his work demands.[21]

We also see this process, the slowing down of decoding, occur in the untranslatable features of comics. The conference attended to comics writing, as we see in the very title of Spiegelman's *Breakdowns: Portrait of the Artist as a Young %@&*!*, a book that everywhere calls attention to the material form of comics, both in its surfaces and across them. Spiegelman's work forces readers to take the full measure of comics writing. The title, for instance, is irreducibly comics—which is to say, it demonstrates a significant feature of how comics communicates what cannot be translated to other forms. To say the title out loud, one must say, for instance, as many do, "Portrait of

4

18. See Marshall McLuhan, *Understanding Media* (Cambridge, Mass., 1994).

19. Katalin Orbán, "A Language of Scratches and Stitches: The Graphic Novel between Hyperreading and Print," *Critical Inquiry* 40 (Spring 2014): 170; hereafter abbreviated "LS."

20. Scott Bukatman, "Sculpture, Stasis, the Comics, and Hellboy," *Critical Inquiry* 40 (Spring 2014): 107; hereafter abbreviated "SS."

21. See Joe Sacco and Mitchell, "Joe Sacco and W. J. T. Mitchell in Conversation," *Critical Inquiry* 40 (Spring 2014): 53–70.

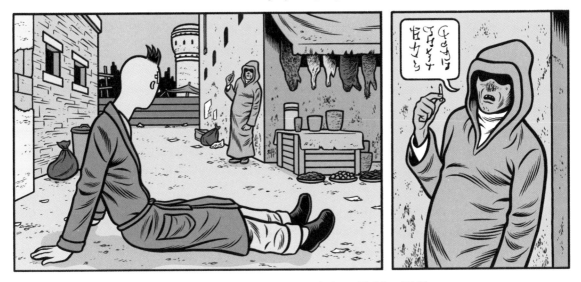

Figure 2. Charles Burns, two panels from *X'ed Out* (2010).

the Artist as a Young Blankety-Blank." To type the title one must either spell out the hand-drawn squiggle—the third character in its last "word"—as the Library of Congress does or use—as Pantheon does in its official press releases—an ampersand. Both involve an act of translation that reminds us of the irreducibility of comics' marks and movements. We see this also in the breathtaking fake language Burns created for his book series *X'ed Out* and its related publishing offshoots, like the self-pirated *Johnny 23*, a cut-up (á la William S. Burroughs) version created entirely in the marks of the alphabet Burns imagined and drew (fig. 2). Comics compel us to encounter writing as visual and also to encounter the visual as writing. Rodolphe Töpffer invented the conventions of modern comics in the 1830s because he was able to use the same implement—and make the same kind of mark—for his writing as he was for his pictures. Gunning's essay in this volume places comics among a history of forms and practices that make up what he calls "a countertradition of writing."[22] André Leroi-Gourhan, cited in Gunning's essay, argues: "Graphic expression restores to language the dimension of the inexpressible—the possibility of multiplying the dimensions of a fact in instantly accessible visual symbols" (quoted in "AS," p. 49).

All three of the critical essays on comics are about the practices of reading that comics provoke. "Comics' dynamic nature eludes formal description unless the action of reading is factored in," Gunning observes ("AS," p. 46). This is about movement on multiple levels: how the form implies movement and how readers themselves create motion. Gunning broadens the history of comics, and also names its possibilities, by putting comics in conversation with the popular visual technology of the panorama, an architectural form of visual display that, like comics, demands a shift in viewpoint and hence introduced temporality into the act of viewing. Also drawing on film and animation, and comics' kinship and difference from these other forms, Gunning articulates the paradox of reading a succession of still frames: "While the art and concept of animation always shadows the comics, the relation between them is hardly one of larva to butterfly, as if comics simply awaited the fullness of time and technology to deliver them from an unwilling immobility. Rather, the power of comics lies in their ability to derive movement from stillness—*not to make the reader observe motion but rather participate imaginatively in its genesis*" ("AS," p. 40; our emphasis). This participation, it is worth noting, is conceptualized as ludic, even, specifically, likened to a game. This issue connects critical accounts of play and reading practices with accounts of the significance of play to creative practices, such as we see in Seth's discussion with Burns, Clowes, and Ware—particularly about his building of model cities that are featured in his comics—and in the work of Barry, who highlights the relation of drawing and play in her original comics piece *Car and Batman*.

Gunning and Bukatman's essays work as a pair even as they connect in key ways with Orbán's and speak to all of the various features of this issue. Gunning and Bukatman are film theorists and historians whose study of motion in film and chronophotography informs their rich analyses of the static yet animate form of comics.[23] Bukatman,

5

22. Gunning, "The Art of Succession: Reading, Writing and Watching Comics," *Critical Inquiry* 40 (Spring 2014): 50; hereafter abbreviated "AS."

23. It is interesting, too, that many of the comics scholars in this volume also write about new media and that many of the new media scholars write about comics. Bukatman, for instance, treats cyberpunk and virtual reality in his earlier book *Terminal Identity: The Virtual Subject in Postmodern Science Fiction* (Durham, N.C., 1993). And Henry Jenkins recently published "Introduction: Should We Discipline the Reading of Comics," *Critical Approaches to Comics: Theories and Methods*, ed. Matthew J. Smith and Randy Duncan (New York, 2012), p. 114. See also Jenkins, *Convergence Culture: Where Old and New Media Collide* (New York, 2006).

writing on Ware and Jerry Moriarty in addition to Mike Mignola and Auguste Rodin, is fascinated by how comics exploits what he calls "the innate stasis of the medium"—a feature we can understand through attention to sculpture ("SS," p. 104). Crucially for Bukatman, the emphasis on stillness speaks to a certain condition of reading, one in which the reading process is slowed down. The stillness of the form makes legible the experience of comics as "static panels in an array"—an experience of jaggedness Bukatman sees the comics embracing. As a result, Bukatman interprets comics as invested in the book as both object and network, a group of nonlinear correspondences "upon the page or across a story" ("SS," p. 116). In both Gunning and Bukatman, the fullness of the activity of reading comics depends on the different perceptual processes of looking at images that comics pages propose; they are a successive series of panels and a single composition at the same time. This Wittgensteinian duck/rabbit state of comics (to use Gunning's formulation) is one of many of comics' simultaneities and is related to its simultaneous temporalities (as is legible in particularly powerful ways in historical narratives by Bechdel, Sacco, and Spiegelman).

Orbán's essay explicitly connects the old-media paper form of comics and the newer digital, virtual practices of reading, both of which she acknowledges configure reading as multisensory experience. In her view, graphic narratives "explore a new sense of materiality"("LS," p. 169); their multimodality, like the so-called hyperreading and hyperattention of digital reading practices, insists on the embodied experience of reading. We see this, she argues, in Spiegelman's large and "emphatically material superbook" *In the Shadow of No Towers* (2004), which forces "haptic visuality" ("LS," pp. 172, 173); in David Small's graphic memoir *Stitches* (2009), the book itself—and the surface of print—stands in for the body, not by metaphoric logic but rather by metonymic logic in which the embodied experience of the cancer-stricken protagonist/author is made contiguous with the reader's experience through the multimodal surface of the book. Crucially, Orbán ties the kind of reading that graphic narratives like Spiegelman's and Small's are offering with digital hyperreading. In her view, print does not have to be the other to hyperreading in computer environments; it too provides an embodied dynamism, in the form of comics.

Materiality, embodied reading, embodied creation—these terms have a currency across all of the essays, as they do also in the conference conversations. For artists, this is tied to the work of the hand that is so much a feature of creating comics. Barry—explaining in a panel with Crumb, Brunetti, and Panter that she believes mak-

ing images "has an absolute biological function"—held up her hands and said, "I think these are the original digital devices." She added, wiggling her fingers, "Check them out. Wireless. Bio-fueled."[24] And the materiality of the object that the individual hand makes is yet one that is by and large divorced from the singularity of fine art (although many of the cartoonists' fine art influences were revealed at the conference, which showed how a huge range of cultural forms make up the visual vocabulary of a form that is hybrid in so many different ways).

Along with the investment in circulation is the focus on the book as object. Comics direct attention to the physical object of the book; Spiegelman puts it this way: "the physicality is part of what it is" ("WT%," p. 30). Seth expressed a view similar to many other cartoonists when he explained on the "Graphic Novel Forms Today" panel: "When you work on a comic it doesn't feel that it truly exists until it is that final physical printed object. It is not the original art."[25] Clowes described—in a phrase evocative of Bukatman—that comics to him, when finished, is like sculpture. It becomes a three-dimensional object (book) out of the space of his imagination (he also seemed to speak for the panel when he said, "it feels very much like a comic on the web is, you know, a website with pictures of a sculpture instead of the sculpture itself").[26] From Burns's two-inch high accordion booklet "Cut Up" (2012) to Ware's eleven-by-seventeen-inch *Building Stories* (2012), a huge box containing fourteen discrete comics narratives, comics emerged as one of the key sites of cultural practice where variegated experiments with print formats today occur. Ware's Building Stories, which he unveiled for the first time at the conference, sold out its first print run; comics, a site-specific form that cannot be reflowed the way typeset prose can and is a boon in book publishing, is, in a sense, saving the concept of the book as object today. Yet, asked about the digital revolution, Spiegelman responded without the pessimism that has come to characterize the response of some print fetishists:

This is really an amazing moment. I keep reading about the death of the book, and the odd thing is that as the book is so called dying, the most beautiful books possible since the middle ages are much easier to make because of the thing that's supposedly killing them: the digital revolution makes beautiful printing possible at a much more reasonable cost than ever before. For me one of the wonders of it has been giving comics a history and a past for the first time.

This is especially telling coming from someone who has also said "the history of comics has up to now been

6

24. Barry et al., "Lines on Paper," *Critical Inquiry* 40 (Spring 2014): 239.

25. Seth et al., "Graphic Novel Forms Today," *Critical Inquiry* 40 (Spring 2014): 153.

26. Ibid.

the history of printing" ("WT%," p. 30). And though *Building Stories* is virtually a manifesto for the book as a material object, it also promotes forms of decision making, spatial navigation, narrative architecture, and interactive play that are common to new media forms such as video games.

Media and Comics

The concept of medium can be understood, as Marie-Laure Ryan observes, either as a "channel of communication or material means of expression."[27] In this special issue, we emphasize both the communicative and material dimensions of media. Media, however, suggest not only a thing or a constellation of technologies but also an archaeological technique for perceiving and making sense of different forms of life. As Mitchell and Mark Hansen put it, "Like the strata of the seeable and sayable that, in . . . Michel Foucault's archaeology of knowledge, make knowledge possible in a given historical moment, media broker the giving of space and time within which concrete experience becomes possible."[28] Though several essays and interviews in this issue refer to comics as a unique medium, these same pieces also suggest that the concept of media is always relational and that comics are always in conversation with other media. Media, we might say, are always transmedia and not simply in our current historical moment. One key goal of this special issue is to better historicize the present through a richer archaeology of forms. Instead of suggesting a neoformalism, the essays collected here emphasize readerly movements across media such as film and comics and digital games.

The digital revolution of the late twentieth century has given rise to a complex media ecology. Henry Jenkins describes this cultural shift in the circulation of media content across systems as "convergence." Jenkins defines "convergence" as "the flow of content across multiple media platforms, the cooperation between multiple media industries, and the migratory behavior of media audiences who will go almost anywhere in search of the kinds of entertainment experiences they want." He offers a compelling example of this cultural transformation in his analysis of *The Matrix* (dir. Andy and Lana Wachowski, 1999). Rather than a film trilogy, Jenkins observes, *The Matrix* was a mythology or a world that stretched across various media, including video games (*Enter the Matrix*), animated shorts (*The Animatrix*), comics (*The Matrix Comics* with pieces by writers and artists such as Neil Gaiman, Bill Sienkiewicz, and Tim Sale), and an online virtual world ("The Matrix Online"). These different products were so interdependent that consumers could not achieve a complete experience of the world of *The Matrix* without exploring extensions of the story in other media. One of the key attributes of convergence culture is that unlike the consumers of stand-alone films or episodic television shows, users are now "encouraged to seek out new information and make connections among dispersed media content."[29]

Digital technologies and their economic imperatives have introduced a number of innovations in a media culture enabled by computation and the popular networking revolution of the world wide web. Over the preceding decade, Web 2.0 has opened up new participatory consumer practices and dissemination methods with the gradual proliferation of social networking sites, user-generated web content, bookmarking, microblogging, and cloud computing. These changes have given rise to new artistic forms such as networked video games and transmedia narratives. However, rather than a complete rupture, we see these important changes as making visible a transmedia ecology that predates the late twentieth century.

Comics, for us, are not simply the exemplary case of how to engage media studies in a transmedia present. Nonetheless, as Mitchell puts it in his conversation with Spiegelman, comics have a capacity "to reflect on their own status as an infinitely flexible medium" that allows us to think carefully about and through our broader contemporary media situation and its longer historical emergence, especially through the twentieth and early twenty-first century ("WT%," p. 20). Though the study of comics certainly benefits from medium-specific analysis, it is historically and materially limiting to amputate comics from their broader context: their artistic, economic, and cultural connections to a host of other media. The contributors to this issue, then, understand comics not as a self-contained medium but as a node within a constellation of media, including sculpture (Bukatman, Clowes, Seth, Ware), the panorama and film (Gunning), digital media (Orbán), self-portraits and advertisements (Taylor), photography (Sacco), painting (Panter), electronic storytelling (Gloeckner), and vaudeville (Spiegelman). Spiegelman's own career bears this out. He probes the intellectual and formal dimensions of comics by working in other forms, such as dance—in his collaboration *Hapless Hooligan in "Still Moving"* with the experimental company Pilobolus—and installation art: an enormous stained-glass mural in New York City's High School for Art and Design, as well as music, in his performance piece *Wordless* created with the composer Phillip Johnston. Other pieces take this methodological imperative to different areas, treating films in relationship to photos and stage plays (Tsivian); ballet in relationship to *lubok*, a relative of chapbooks and comic strips (Khitrova); and transmedia digital games in relationship to English letterboxing, Polish *podchody*, invisible theater, situationist

7

27. Marie-Laure Ryan, "Introduction," in *Narrative across Media: The Languages of Storytelling*, ed. Ryan (Lincoln, Neb., 2004), p. 20. The former sense of "channel of communication" is more often taken up in media studies and communication departments. The latter sense of "material means of expression" is more common in fields such as English and cultural studies.

28. Mitchell and Mark B. N. Hansen, "Introduction," in *Critical Terms for Media Studies*, ed. Mitchell and Hansen (Chicago, 2010), p. vii.

29. Jenkins, *Convergence Culture*, pp. 2, 3.

dérive, scavenger hunts, poetry, and video games (Hayles, Jagoda, and LeMieux).[30]

The essays in this volume make historical claims about what happens in processes of transmediation and interactions among forms. We see that process especially in the transhistorical media triptych of essays by Tsivian; Khitrova; and Hayles, Jagoda, and LeMieux. Tsivian describes "Chaplin's transmedia journey" across national borders and artistic movements. This journey came to produce what he calls the "Soviet Chaplin," a complex effect of a network of work produced by European intellectuals and artists in the early twentieth century.[31] In Tsivian's essay, the medium of film and the figure of the film star are not self-contained. The construction of Chaplin's fame draws from older media and looks forward to a contemporary convergence culture. It is not merely that Chaplin appeared in multiple media, including photos, drawings, essays, stage plays, and films, from the 1910s through the 1940s. A movement across media enables Tsivian to track the metamorphoses of Chaplin as an unstable transnational figure. In this essay, Chaplin's comedic identity and legacy are not merely framed by his great films, from *The Kid* (1921) to *The Great Dictator* (1940) and beyond. Chaplin's complicated fame becomes the result of diverse audiences and the work of avant-garde artist communities in France, Germany, and Russia.

Like Tsivian's, Khitrova's analysis moves across media, but Khitrova does so to make sense not of a figure but of an art form: ballet.[32] As she observes, ballet brings together several media, including classical music, classical dance, fairy tales or mythological stories, and set constructions. As with other forms discussed in this issue, ballet is not simply a composite of multiple forms or mixed media. Through the historical dimension of revolutionary poetics, Khitrova tracks the ways that ballet has changed over time, in Russia and around the world, as a kind of transmedia form. In the Russian context, ballet underwent a significant transformation following the 1917 revolution after which the position of operas and ballets on the Soviet media hierarchy became uncertain. In a broader global context, ballet itself experienced an artistic revolution in the early twentieth century. Through a close reading of *The Steel Step*, a ballet produced by Serge Diaghilev's dance company and staged in Paris and London in 1927, Khitrova explores the role of media not commonly associated with ballet, including political posters and *lubok*, in the transformation of the art form. Though not a new medium, *lubok* (a Russian popular art practice

that stretches back to the eighteenth and nineteenth centuries) enabled *The Steel Step*'s innovations in choreography and its adaptations to a postrevolutionary cultural context. At a formal level, the visual storytelling of the *lubok* also helped to bridge two elements of ballet that exist in tension with one another: narrative and dance.

One dimension of transmedia relations evident in both Tsivian and Khitrova's essays is the ludic interplay among media across time (a feature of motion and play that the form of comics suggests also from a different angle). Khitrova draws from Yuri Lotman to characterize the *lubok* as an occasion for playful improvisation and live enactments based on the still images. Similarly, in the final essay of this triptych, Hayles, Jagoda, and LeMieux explore the relationship between transmedia narrative and live interplay through a form that only became possible in the early twenty-first century: the alternate reality game (ARG). Emerging from the convergence culture that Jenkins describes, this form, like the digital computer itself, absorbs or simulates numerous available media in the course of telling a single and playable narrative.

Hayles, Jagoda, and LeMieux focus on the ARG *Speculation*, a game that they cocreated and that unfolded in both online and offline spaces starting in 2012. Over the course of several months, the *Speculation* transmedia experience became accessible through a network of short web-based prose stories, fictional corporate documents, audio files, videos, computer games, double-encoded slow-scan television transmissions, social media challenges, flash drive dead drops, internet relay chats, and more. As in Tsivian's focus on Chaplin and Khitrova's analysis of *The Steel Step*, *Speculation* is not so much a mixed media composite as a transmedia process that unfolded through time. This ARG's form of play departed from the "fun" associated with most consumer-oriented games and transmedia entertainment products. *Speculation* promoted an active, improvisational, and partially unscripted interplay between the game designers and an emergent collective of players. The game became less of a creator-driven work and more of a collaboration, a type of practice-based research, that mutated the core narrative in ways that the designers could not have initially predicted.

Transmedia technique has grown widespread and visible in the twenty-first century, but as many of the essays in this volume suggest it has a history that long precedes contemporary digital games. This media perspective makes visible forms and histories that might otherwise go unnoticed. To emphasize transmedia in its current and

30. See N. Katherine Hayles, Jagoda, and Patrick LeMieux, "*Speculation*: Financial Games and Derivative Worlding in a Transmedia Era," *Critical Inquiry* 40 (Spring 2014): 220.

31. Yuri Tsivian, "Charlie Chaplin and His Shadows: On Laws of Fortuity in Art," *Critical Inquiry* 40 (Spring 2014): 72, 71.

32. See Daria Khitrova, "'This Is No Longer Dance': Media Boundaries and the Politics of Choreography in *The Steel Step*," *Critical Inquiry* 40 (Spring 2014): 134–49.

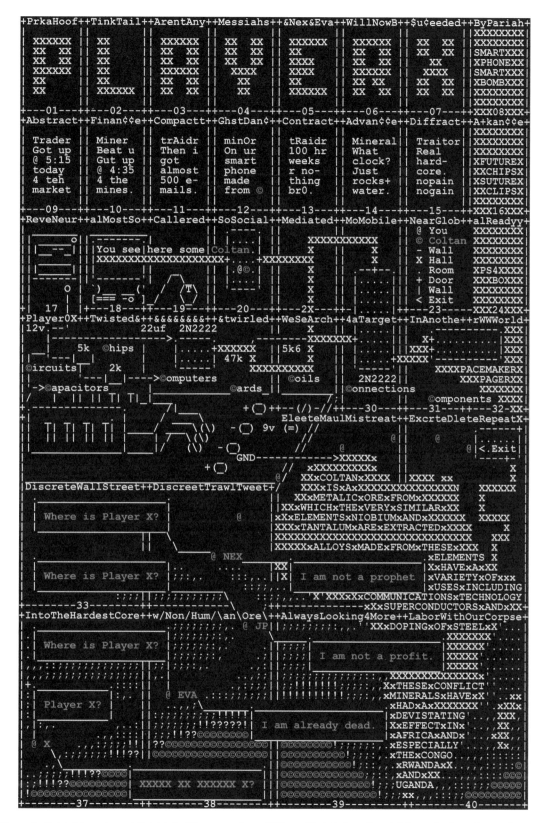

9

Figure 3. Patrick Jagoda and Patrick LeMieux, section of "Player X: A ©oltan ©omic" from the *Speculation* alternate reality game (2013).

historical forms, this volume includes an online feature alongside the print volume: an interactive archive of the *Speculation* game that includes challenges, minigames, narratives, and branching links. We do not see this piece as a supplement to the print issue but as one demo or proof of concept of the communicative and material processes that the scholarly essays analyze. One of the features of this online archive, created specifically for this issue, is a graphic narrative created with ASCII art: a text-based visual design technique that emerged from computing culture (fig. 3). Though it reads like a comic, this piece draws from digital media, including conventions of instant messenger and the roguelike computer game. Though many parts of this story are available on the main hub, the full collection of comic panels only becomes available if the reader actively solves eight challenges, each of which yields one of eight necessary passwords. Building on the concern with materiality evident in all of the essays, though especially the three pieces focused on comics, this ASCII-based online comic (called "Player X: A ©oltan ©omic") explores the materiality of new media through a narrative about coltan: a metallic ore that is critical to the manufacture of electronic consumer goods such as cell phones and video game consoles but has promoted major human rights violations and inhuman labor practices in places like the Democratic Republic of Congo.[33]

The *Speculation* archive feature points toward different possible futures for comics and media. Graphic narratives and digital games, for instance, have mutually influenced each other in a variety of ways, through comics-to-games adaptations (from Atari's 1984 *Spy vs. Spy* to DC Comics's popular 2011 *Batman: Arkham City*) and games-to-comics adaptations (from the 1992 *Super Mario Adventures* to the 2010 *Mass Effect: Redemption* miniseries). Beyond the realm of adaptation, some web comics have started adopting new media aesthetics and mechanics. One noteworthy example is Ryan Woodward's interactive graphic novel *Bottom of the Ninth* (2012), which incorporates not only text and images but also audio, animations, and user agency enabled by the affordances of a touch screen. A very different example is *Homestuck*, Andrew Hussie's web comic made up of over six thousand total panels featured on the MS Paint Adventures website. As a browser-based graphic narrative, *Homestuck* makes use of numerous new media features including simple Flash animations and hyperlinks. This comic also repeatedly frustrates the user's desire for explicit interactivity, inviting and then curbing the type of agency promised by many new media projects. As new media continue to transform and the transmedia ecology expands, the intersections between comics and media promise to change as well. In archiving a summit on the possibilities of comics, exploring new media experiments, and highlighting the work of inquiry as inclusive of criticism and creative artwork, this issue thickens media histories and offers a vocabulary for the way we look, read, and play now.

10

33. For more, see Michael Nest, *Coltan* (Malden, Mass., 2011).

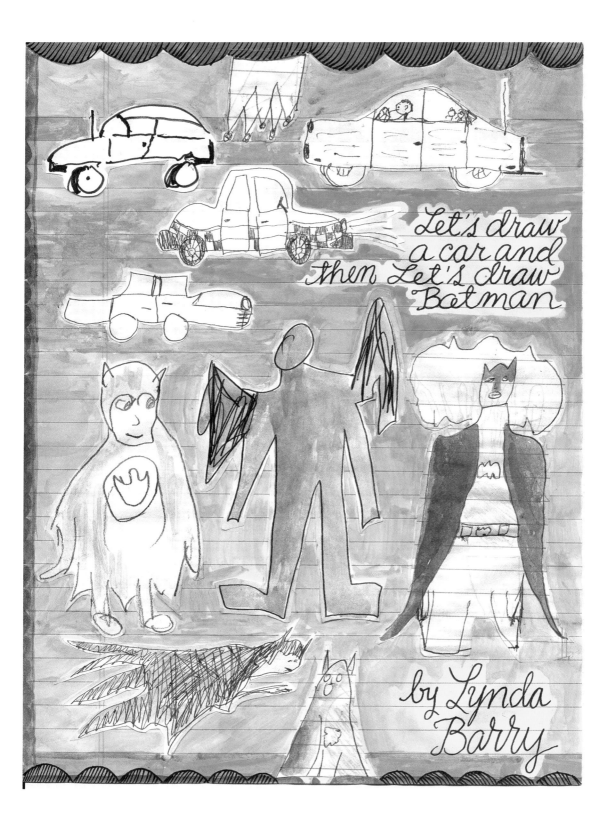

There is something beautiful in the lines made by people who stopped drawing a long time ago.

And there is something curious about how scared they are when I ask them to draw

a car for two minutes or one minute

It's an exercise from 'Cartooning: Philosophy and Practice' by Ivan Brunetti that I sometimes use during the first part of a workshop I teach called, "WRITING THE UNTHINKABLE"

Draw a car, even if you don't know how, to see what happens.

And what usually happens is a kind of involuntary laughing that sounds like the laughing of people who are about to enter a Spookhouse ride---

Just how scary is this ride going to get? Your car begins to take shape and the shape it takes seems out of your control -- there is a thrill there

And a terror too, that becomes especially evident when I ask people to stand up and look at each others' drawings

All we did was draw a car but the room feels like it's on fire. Why?

3

Some of the cars are quite far-out
and some are
barely there,
like phantoms
made of ghost
lines

Others are more
certain –
and some
seem to feel their
way in

The same thing
happens when
I ask them to
draw BATMAN

sometimes someone knows just how to do it---

but mostly they are not sure of the way but

because they only have a very limited amount of time to do it, thinking it over doesn't come into play and a natural kind of picture comes about.

like this

like this

and this

and sometimes we say this kind of picture looks like a kid drew it.

and people are dismayed by this and
even ashamed enough to
destroy
it --- _immediatly_

But
what
if the way kids draw -- that kind
of line that we call 'childish' --
what if that is what
a line looks like
when someone is
having an experience
by hand? _A live_
wire! There is an
aliveness in these
drawings that can't be
faked, and when I
look at them, that
aliveness seems to come
into me. I'm glad to see
and feel them.

Real
aliveness
of line
is hard
to come by

When some one learns
to draw -- to render --
it's the first thing
that goes -- the
aliveness ---
And it's what
some artists
spend their
whole lives
trying to get
back; The
Spookhouse and the MERRY-
GO-ROUND are
two different
rides.
When we
say a kind
of drawing
is good
we may
be talking
about a
certain kind
of ride everyone
can stand and
understand --
though the thrill
is gone, it's nice, a
ride on the merry-go-round...

And then there is that _other_ ride....

THE SPOOK HOUSE the one with all the not-knowing that both scares and delights us to bits---to Little bits of line that are the tracks we traveled on while screaming and laughing because we have no way to control the outcome and we are in motion anyway, creating some kind of energy that still runs through the drawing even after we've lifted our hand away. The pictures you see here were made by 35 adults who were together--

for one afternoon in the Fall of 2012. I asked them to leave behind any drawings they didn't want. I colored them in. You power them on.

Public Conversation: What the %$#! Happened to Comics?
W.J.T. Mitchell and Art Spiegelman
May 19, 2012

ART SPIEGELMAN: This was going to be a talk by me but I was too daunted by the audience of fifteen or sixteen peers who were billed as being here with me. So I couldn't make myself deliver something that's called a keynote address. And it seemed better to me to be interviewed at a university like this by one of its leading scholars, because that way I get to be the wise guy instead of the stuffy scholar in the room.

W.J.T. MITCHELL: Thanks, Art. I see now what my role is going to be.

SPIEGELMAN: Sorry, but you have to play your part.

MITCHELL: So this conversation is in place of a keynote address on the topic of Comics: Philosophy and Practice. We might want to begin by asking this general question throughout: is there a philosophy of and in comics? Can comics engage in philosophical discourse? We know they can tell stories and record events. But can they philosophize? I firmly believe they can, if only in their unrivalled capacity to reflect on their own status as an infinitely flexible medium that combines words and images, stories and bodies, thoughts and actions, subjective and objective experience. In fact everything I call philosophy is rooted in my miseducation in reading comic books. Certainly the idea of picturing theory comes to me directly out of comic books. Where else can you see a thought hovering over the head of a thinker? Where else can you draw an imaginary door on a wall and then walk through it?

Art and I have been talking compulsively on the telephone over the last few days about the topics we would take up here today, and we have come up with a few general thoughts or what in the academy we call "naïve questions." We might think of them as addressed to the entire group of artists assembled here. First, I would like Art to address the downside—let's call it the curse—of comics. We see from Art's first image (fig. 1) that the very being of comics, what a philosopher would call its "ontological status," seems naturally to be uttered as a curse. As if one could not just say, "What is comics?" but was compelled to ask, "WTF is comics?" Is there a curse of some kind hovering over comics? Is it their notoriously low cultural status? Or is there a more profound curse involved in the fact that comics are becoming an academic subject?

My second naïve question is simply a request for Art to reflect on drawing, writing, and lines on paper, and particularly this mysterious process, of making a mark—the interplay of the hand, the instrument, and what appears on the page.

Our third question concerns the relationship between stereotype and caricature…what are they? Are they the same thing? Are they essential to the comics medium, or just one option among others?

It also seemed important as a general question to consider the future of comics. There is of course this enormous past history of comics and its artistic precedents, stretching back through illuminated manuscripts, hieroglyphics, and cave painting. But this conference might be a moment for thinking about the future of this medium. It has evolved into something whose potential nobody knows. What happens when comics become wall art? Stained glass? When comics move into the museum? Or into the movies, where they have been since the beginning, but now seem to have a new relation to cinema? Should we think of the move to the museum as parallel to the question of the curse of comics, in the sense that sometimes getting put up on the wall in a museum is a way of being hung that is not necessarily a blessing.

SPIEGELMAN: The curse of comics as the lowest art is basically why I became a cartoonist. If the world we exist in today is the one I fell into, I would never have gone into this racket. I didn't want to be a writer, and I didn't want to be a painter. And the fact that you could fly below the radar and be left alone was an important aspect of being a cartoonist for me. At least that was the case when I started. Among my many illustrious achievements nobody has yet mentioned the Garbage Pail Kids and the Wacky Packages that I cut my teeth working on. I was working in

the grand old tradition of turning a buck with your pictures, getting people to come into the tent.

MITCHELL: Is that why you made pictures like this (fig. 3)?

SPIEGELMAN: In the 1970s I was reading Marshall McLuhan. He pointed out that when something is no longer a mass medium, it has to become art or it dies. And I was realizing comics even in the 1970s were beginning to wane from their glory years—when they were truly a mass, mass medium. And I thought of it very literally as a Faustian deal that had to be made with the culture, and it was a fraught one and a dangerous one, a danger which a lot of your questions and topics point to: what is this museum thing, what is this academicizing? And I figured it was necessary for comics to find their way into libraries, book stores, universities, and museums, because otherwise there wouldn't be an apparatus that could sustain what had been sustained by Sunday newspapers and pamphlet comics and things like that in the later part of the century. It was a Faustian deal because the medium gets tainted by its aspirations toward legitimacy, and I was part of the taint; I was part of creating the problem at a certain point. This image was made as a lithograph when I finally had gotten a grant to do something. I used to apply for grants in New York City and they would always move me around from pictures to words to finally mixed media where I'd lose out to Nam June Paik because he was also into words and pictures. Since they couldn't put me into either category, I had to be up against video artists.

The first comics were really born as a kind of extension of vaudeville. They were slapstick. These comics were disapproved of almost as soon as they were born because they were for the unwashed mass, the immigrant culture that was being acclimated to America, and reading the funnies wasn't what you should be doing on Sundays. (Were you supposed to be reading R. Crumb's *Genesis* or something? I don't know.) So the medium was born with a kind of unsavoriness. It was originally an unwanted byproduct of a printing process. Joseph Pulitzer wanted to bring art to the masses and he wanted to print the world's great art and spent a lot of money making the color press to make it possible. And fortunately, for the degenerates amongst us here, it didn't work. It couldn't be done. The printing wasn't good enough to print the Mona Lisa. It was fine for art with off-register color, and that meant the Sunday supplements got born the way we know them. It was a perversion of the original intent to uplift. Almost immediately this tug of war began. Some newspapers resisted having comics because they were so vulgar. This tug of war is one of the better things that happens in America: we're an anxiety-ridden culture, feeling we should be more cultured. It creates a tug of war between the vulgar and genteel that leads to fruitful results. The vital whorehouse jazz inspires Gershwin's *Rhapsody in Blue*, and both are worth keeping.

MITCHELL: You said you fell into this. It was a kind of curse. Or at least it was your fate. This reminds me of a line by Alexander Pope, the great eighteenth century poet. He asked the question, "Why did I write? What sin to me

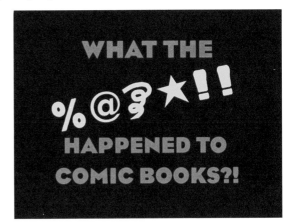

Figure 1. Art Spiegelman, *What the %@&*!! Happened to Comic Books?!* (2012).

unknown dipped me in ink, my parents, or my own?" So here is a classical poet and he also regarded it as a kind of curse. He said it must be original sin that led me into this. Could the curse of comics reveal something about human nature and art itself? Do we have an original sin that requires us to fall into an artform like this?

SPIEGELMAN: Well, Pope was a goy. So this original sin stuff is not for me. *[laughter]* Unoriginal sins. The act of repetition and copying of other cartoonists—that is plenty of sin for us.

The fact is that ultimately the sin is this co-mixing of words and pictures, so of course you get doubly cursed. If Pope was a sinner, presumably Michelangelo was also at least gay and thus probably a sinner. *[laughter]* And here [in comics] you double up on the sinning because you have to work between these two zones—without the distinction of having the Pope as your patron, but having instead basically the unwashed and kids as your audience. But all mass mediums are seen as sins because basically we live in a world where if children like something, adults get very frightened, and try to control it. [Fredric Wertham's 1954] *Seduction of the Innocent* was a book I found in the library, early on; it was responsible for these comic book burnings. I found it a very useful book because I knew what comic books to buy on the basis of the index in the back. *[laughter]* I realized that when we talk about this shifting moment that we've gotten into today, part of it is because when they were burning those comic books they saw comics as the antithesis to literacy.

MITCHELL: Your mention of the index reminds me of the way the Roman Catholic Index of Forbidden Books provided a quick guide to desirable reading when I was a kid. One of the things I always loved about comics, and especially *Mad Magazine*, was that it was a kind of guilty pleasure. I once took my son when he was thirteen years old to the offices of *Mad Magazine*, and the editors there said to him, well, kid, if you are a subscriber to our magazine, either that means you are really, really precocious and smart, or you are really sick and perverted. (I think his response was, "Wow! You guys are really cool.")

21

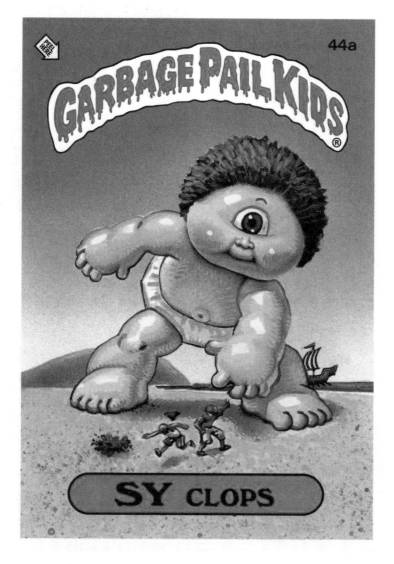

Figure 2. John Pound, Sy Clops, Garbage Pail Kids sticker/trading card (1985).

22

And for us it didn't matter; maybe being smart and being a little perverted felt like one thing. Hiding your comic book inside your textbook gave you the double pleasure of being smart and an outlaw at the same time. What does it mean now when you don't have to hide it anymore and it is not a guilty pleasure? Are we going to have guilt-free comics? Is that a good thing?

SPIEGELMAN: That sounds awful to me. I remember my friend Jay Lynch, an underground cartoonist, used to hide copies of *Playboy* inside his *Mad Magazine. [laughter]* Then he reached an age where he had to flip it around. *[laughter]*

But *Mad* was an important inspiration. I don't know if it was a guilty pleasure. There was an essay by Robert Warshow admitting he was abashed at his interest in *Mad*. For me, *Mad* was the Codex. It was what ruined my life. Gave me that original sin, or whatever you call it. It was where I discovered everything. I discovered the parody

way before I knew what the original was. Had to work my way backwards figuring it out. One of the main things I was thinking about recently is that one of the important things about *Mad* was "the chicken fat" as Will Elder called it.

MITCHELL: What is chicken fat?

SPIEGELMAN: Chicken fat is the guilty pleasure. It is the thing that will cause cardiac arrest eventually. It is that ladling onto an image all those extra images that slow it down. So you have to give the picture a lot of time. Even though we use the word "read comics" more than "look at comics," basically what *Mad* insisted on was that, like a Hogarth picture, you would have to reenter deeply and decode all of the little background stuff. It's a lot of images to decode. When you get really close up, even that border that was part of the original *Mad*—when you look really closely at the border, it was like a month's worth of reading right there. It had a banner that said "literature" and the

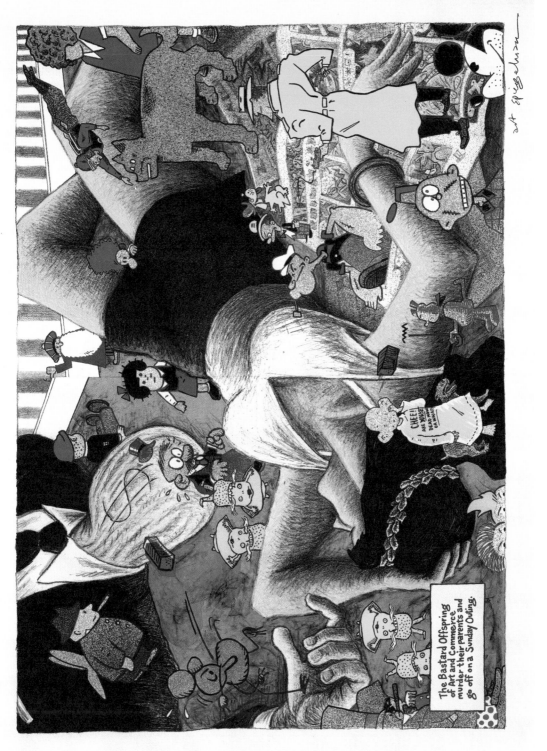

Figure 3. Art Spiegelman, *The Bastard Offspring of Art and Commerce Murder Their Parents and Go off on a Sunday Outing* (1990).

medallion above shows a crossword puzzle—an emblem that explains comics as the essence of literature, moving your eye up and down as well as left to right to search for meaning. "Art" shows calendar pin-up art. Then right below, there's something that said "medicine"—a high stack of coins and dollar bills was the picture. *[laughter]* And the letters themselves had, like, centaurs and maidens cavorting through them. It was a highly dense kind of picture making. Insofar as I'm partially responsible, having been called—God knows why—the father of the graphic novel (I have been demanding the blood test ever since)—I trace it all back to my *Mad* lessons.

MITCHELL: You don't like the phrase "graphic novel"?

SPIEGELMAN: I don't like the phrase. It existed as one of the euphemisms that people have used to say that comics are not a guilty pleasure. Graphics: sort of respectable. Novel: since the nineteenth century, very respectable. So graphic novels are doubly respectable. When I was growing up you couldn't say you were a cartoonist because it is like saying, how do you do? I'm a case of arrested development. And now being a "graphic novelist" has a certain caché.

MITCHELL: So what's not to like?

SPIEGELMAN: The danger is that it gets arid and genteel. The Faustian deal is worth making; it keeps my book in print. But it is important to have work that isn't easy to assimilate on that level.

The nature of *Mad* was to give you a lot to chew on. In *Portrait of the Artist as A Young Blankety-Blank* [I have a panel that says]: "I studied *Mad* the way some kids studied the Talmud..." (*[aside:]* "Goddamn furshlugginer kid.") But look at the *Mad* comic book cover. It is very avant-garde, filled with chicken fat. And capable of mixing drawing and photography in a completely new way, so that a photograph of roof tops and water towers collaged with a gargoyle monster drawn by Basil Wolverton can be called "The Beautiful Girl of the Month." And the whole cover is designed to look like a *Life Magazine* cover—at the time *Life* was the flag of middlebrow respectability. *Mad* allowed you to see that there is something unsavory in the squeaky clean monolithic culture of Disney in the 1950s. [In the Harvey Kurtzman and Will Elder story "Mickey Rodent," the main character is] a rodent. He has rat traps attached to his fingers. He is unshaven. The Disney police are dragging him off because he's not wearing his white gloves. Everything, even the style of drawing, is called into question.

MITCHELL: Since you brought up drawing, let's turn to that question. It has always struck me that especially in this so called digital age, the idea of handmade, hand-drawn lines of paper can seem old-fashioned. And yet the handmade character of comics seems so essential to the many of the most innovative comic artists today, includ-

ing many of those gathered here. And I also wondered if you could reflect on the pun that is built into the word "drawing" itself, a pun that may be relevant to our discussion. And that's the idea of drawing as pulling or being attracted to, being drawn towards something. The ancient myth about the birth of drawing was that its invention was motivated by love and desire. This was a very popular motif for artists in the eighteenth and nineteenth century, and it always involved the same scene. The lover is leaving, so the young woman, the maid of Corinth, sketches the silhouette of her lover on the wall. This is the Greek version of the origin of drawing. It starts with love, or maybe lust. Do you think drawing has anything to do with desire? With lust? With the wish to bring something into the world that doesn't exist?

SPIEGELMAN: Many cartoonists were misguided. We thought our drawings would bring women into our lives. A lot of cartoonists have the experience of drawing sexual pictures. I was feeling guilty enough to always draw the naked woman's torso and then turn it into a dog's head where the tits would become eyes. So if anybody discovered the drawing before it was finished, I could just play innocent and say "Oh, is that what you thought I was drawing?"

MITCHELL: The Greek myth about the birth of drawing reverses the gender roles, as you can see, and makes drawing a feminine invention. The young woman is sketching the silhouette of her young lover, about to leave, probably never to return.[1] And Cupid is holding her arm, guiding her hand. She's using Cupid's arrow to etch out the drawing. With his other hand, Cupid is holding up the torch to make the shadow to be sketched.

SPIEGELMAN: The other thing that's true about this picture is it is done at just about the right time to be part of the physiognomy adventure. [People] would trace silhouettes to study the sitter's character. One used the silhouetted, reduced version of the face. The idea was that the face was the reflection of the soul. So if you had a good sturdy profile, you were a good sturdy person. If you had a swinish profile, you were a swine. And that image looks like exactly what [Johann Kaspar] Lavater was doing in his parlor with people coming by to visit.

MITCHELL: But you start, I think, not with the silhouette or the profile, but with the doodle. Or as Chris Ware puts it—one of the themes of this conference is actually, "the empathetic doodle." A drawing which has something to do with empathy, sympathy, with reaching out to another soul. But it doesn't have, necessarily, an object, except for doodling itself. Here, for instance, is Hogarth's doodle, what he called "the line of beauty."

MITCHELL: Could Hogarth's *Analysis of Beauty* be one of the origins of comics? Doodling for me has always meant drawing at or in the margins—drawing that just draws

1. In a discussion of this image with Slavoj Zizek, he insisted that the departure of the lover is to be seen in a very positive light, because the Maid of Corinth would clearly prefer to masturbate in front of the image of her departed lover rather than have his actual, messy physical presence. Fantasy (and drawing) is always better than the real thing. I wish I had brought this up in my conversation with Spiegelman. –WJTM

Figure 4. Cover of *Mad Magazine* (Dec. 1956).

Figure 5. Anne-Louis Girodet de Roussy-Trioson, *The Origin of Drawing* (1829).

into itself, like an aimless spiral, or that strays off into distraction—the sort of thing we academics do while we are listening to somebody's lecture, a kind of parody of taking notes, and a beautiful excess of invention. I notice that the spiral line, the essential doodle, frequently plays a role in your self-portraits, as in the following image of yourself as a vortex wearing a hat in your sketchbook, *Autophobia*. I especially love the little square voice balloon pretending that this book was made just for me, "with respeck & warm wishes." In your work, I think Hogarth's line of beauty becomes a coiled spring.

SPIEGELMAN: [I like] Andre Breton's notion of beauty: beauty must be convulsive or it must not be. (So what drew me to cartooning was not trying to draw the loved one, but just to hang out with the loved one, which was Mom.)

For me, *Mad* was my window into the world away from my kind of overwrought immigrant refugee household; [I was] learning about American culture through *Mad* basically. And this thing of making lines. (A game I played with my Mom consisted of her making an abstract scribble and me turning it into a representational doodle.) So when I first saw Robert Crumb's manifesto in the form of a parody page […] it had this line on the bottom that has become well known in my set and is now the conference's penultimate panel's title, "It is only lines on paper, folks!!" That seemed really profound to me at a certain moment. Then I realized that was the most pernicious thing I ever heard. It is an interesting thing, and it certainly gives license to allow one to doodle and to make whatever is in one's head visible. But it also can be a dangerous thing to shrug it off with an "only."

Lines on paper include most written things, which would include Martin Luther's dangerous text, *Mein Kampf*, and beyond. The idea of lines on paper is a way of recording [something] and getting it past your aural field. It is built a certain way. Cartooning specifically is built on lines that are visual language, using the visual sign for something people will recognize. That pathetic doodle is not always empathetic. [There is a] cartooning book from the 1920s or 1930s showing you how to draw the various types, the language you have to learn to be a cartoonist. You had to learn to draw the nigger, the wop, the kike, the spic. It built on this notion of physiognomy. It was a way that the first comic strip artist, Rodolphe Töpffer, with his first graphic novel was saying, well, as science, physiognomy is insane. I met too many nice people with high foreheads and they are really stupid. It is not a system. On the other hand everybody knows what you mean so it can be used as a visual language.

I became fascinated by the Mohammad cartoon controversy [in Denmark]; you can see how dangerous those lines on paper can seem to people no matter how many times you tell them they are lines on paper.

MITCHELL: I wanted to ask you about stereotype and its relationship to caricature. A stereotype seems to be a normative image. Stereotypical images are generic. They are schematic. They allow us to recognize types [like the

Figure 6. William Hogarth, *The Analysis of Beauty* (1753).

27

"men" and "women" bathroom icons]. That's a caricature [a drawing of Barack Obama].

SPIEGELMAN: With good cartooning, with good caricature, you are working with stereotypes and giving them the individuation of personality.

MITCHELL: This is what the logical positivists wanted out of imagery. Isotypes are what Otto Neurath called them. He wanted to have a universal language that was in some ways the antithesis of caricature. It was all about recognizable types.

SPIEGELMAN: It is on a spectrum, not even a wide spectrum from A to B to get from normative to abnormal, but it is an interesting thing. I think that cartooning works somewhere between those two zones. It could just work with stereotype without working with caricature. But it can't work without the stereotype. It needs to have that aspect to it. Stereotyping is literally how things got copied and printed and we're talking about a medium that traffics through that and in that. But I would say even here, one of the dangers in caricature is you move from a type toward making a statement about a type when you do it. That's certainly true of the old Italian caricaturists who got started with their doodle drawings, showing a personality type through the individual. One of the problems with our fraught twenty-first century is [how] to move away from this kind of typology. How do you draw a black president and make sure people don't think he's—black? It is an important issue, how to do this.

28

Figure 7. Art Spiegelman, *Auto-phobia: For Tom with Respeck and Warm Wishes* (2012).

The danger comes with the toxic part of caricature. It is why caricature remains dangerous in the world. A guy in Syria had his hands broken because he dared make a caricature of the president.

MITCHELL: If they were just broken, it must have been only a misdemeanor. *[laughter]*

SPIEGELMAN: Exactly. But here, when we talked about lines on paper being fraught with a certain kind of horrible power, it has to do with the power to dehumanize.

MITCHELL: One of the sources of caricature is clearly the figure of the animal. Basically you treat somebody as an animal.

SPIEGELMAN: It is not just Nazis portraying Jews as rodents. We did it as a precondition to dropping a bomb on Hiroshima. Stereotyping certainly exists in the famous "terrorist fist bump" cover of *The New Yorker* [July 21, 2008]. How do you deal with the images hovering around and give them a visual voice—defuse dangerous cultural stereotypes while actually showing the cartoon images underneath them.

MITCHELL: That brings us to to words and pictures. I wanted to set this up with probably the biggest cliché in the world. The great image [by Magritte]: "This is not a pipe." And we know that you could talk about this forever. Michel Foucault had a very perceptive statement about it. He said "we must therefore admit between the figure and the text a whole series of intersections or rather attacks launched by one against the other, arrows shot at the enemy target, enterprises of subversion and destruction, lance blows and sounds, a battle." And then there is [G.E.] Lessing, who also thinks of the relationship of words and images as potentially a war, but one which he wants to prevent by establishing firm, clear boundaries. . He says, "painting and poetry should be like two just and friendly neighbors, neither of whom is allowed to take unseemly liberties in the heart of the other's domain, but who exercise mutual forbearance on the borders and effect a peaceful settlement for all the petty encroachments which circumstances may compel either to make on the rights of the other." So what is it? Peace or war? Stable or shifting borders between words and images? Or both? Or one and then the other?

SPIEGELMAN: I think Lessing lost and we won. Those peaceful neighbors were not supposed to linger. Putting words and pictures together is like breeding a mongrel, a mixed breed. The pictures were to show the monumental distillation of something; the words were the history, the story. The idea of using two different languages, mixed media and comedy, is so much the world we live in now. The world Lessing lived in, with the beginnings of that quest for literacy, was one where the word was primary:

Figure 8. Art Spiegelman, *Portrait of the Artist as a Young Man*, in *Breakdowns: From Maus to Now* (1977).

in the beginning was the word—it was sacrosanct. And the image was fine for the generalized beauty of a very limited sort. I think that's why it is not a problem for us anymore. Because beauty and ugliness are all such a convulsive stew at this point.

MITCHELL: Here are Lessing's words [that] he used to distinguish words and images. You already used some yourself. Images are directed toward the body; language toward the mind. The silent image, the eloquent word, beauty and sublimity, and the eye versus the ear. Gender categories as well. For Lessing, the visual is the feminine mode. Poetry addresses the masculine soul. This was canonical thinking of using media, of keeping them separate, segregated in the eighteenth century. It always struck me that when I started in this business by studying the work of William Blake, I was plunging right into the center of a transformation in the relation of words and images. Blake insisted on violating the segregation of the arts and media. He insisted on a composite art, an art that cuts across these boundaries, confusing them. An art that turns words into images and images into words, that mingles them promiscuously. To have this event—a kind of "comics summit"—fulfills a dream I have had for a long time. Finally, people would see that there is nothing

Figure 9. Art Spiegelman, *Ha! Turn This One into Something!* in *Breakdowns: From Maus to Now* (1977).

wrong with mixed media. That pure painting, pure po-
etry, were doomed, along with their analogous categories
of pure nationalities, pure genders, and races. It makes
me wonder how we ever got into the game of purifying the
arts and media in the first place.

SPIEGELMAN: The Lichtenstein show is about to open in
Chicago. And Dan Clowes's show is opening in California
and will end up in Chicago as well [at the Museum of Con-
temporary Art]. Robert Crumb has a show in Paris, a ret-
rospective of his work. I have one moving out of Paris. At
this point that mingling of words and pictures is allowed.
Way past whatever Barbara Kruger was doing, and also
well past what Lichtenstein was intending. Something
happened where that original Faustian deal I was talking
about has more to it than I thought. Art museums won't
necessarily want to hang the same works that might be
studied in lit departments. It is not the same work that will
live happily on a wall and in a book. Showing something
intended for reproduction on the wall is the equivalent of
showing the carved piece of wood used to make a wood-
cut. If you were a wood carver, you could look at that and
find it interesting, but it doesn't hold the same space on
a wall that something made for the wall might. I guess I
first realized it when I was in a show in LA where I was in
the same room with Gary Panter. His work is made for a
wall. It is a mark best revisited as a mark rather than re-
thinking again and by rereading the content of the work.
His art looked great there. I realized in some ways his im-
ages look better than they can when they are printed in a
book. And for him maybe the original really is an original.
Like an original work for a wall. And the book functions
as almost a catalog for that as opposed to something that's
being made primarily for reproduction—a book you can
look at rather than a canvas where you can pore over the
lines. It made me realize the Faustian deal has a subclause.
In the world we live in now the avant-garde of comics
are moving toward colonizing the visual side of comics.
[These are] Gary Panter's kids, the same way that, to a de-
gree, a lot of people in the room would be Robert Crumb's
kids or younger brothers. And that's a new place. To have

to think about what it is when the pictures aren't as eas-
ily contained by the words. Yes, I'm trying to figure out a
space in between walking the line, still, in my late middle
age. So if we were talking about the verbal part having to
do with sublimity and poetry and moving in time, it's also
true that a lot of visual stuff has to do with the body—the
things that can't be articulated in other ways. And maybe
comics as they move to the future are trying to figure out
ways that [they] won't be happily contained anywhere in
books or walls.

Q&A

AUDIENCE MEMBER: Can you talk about the digital revo-
lution?

SPIEGELMAN: Let me just cut to the chase, which is that
this is really an amazing moment. I keep reading about
the death of the book, and the odd thing is that as the
book is so called dying, the most beautiful books possible
since the middle ages are much easier to make because of
the thing that's supposedly killing them: the digital revo-
lution makes beautiful printing possible at a much more
reasonable cost than ever before. For me one of the won-
ders of it has been giving comics a history and a past for
the first time. Used to be very hard: if you wanted to see a
bunch of Sunday *Gasoline Alley* pages, you had to ferret it
out first, at the flea market, and then eBay. And now it is
really being offered to us. And books are coming in every
possible format. Like the small box of *Peanuts* reprints in
its entirety. And also amazingly large books. A book as
object is part of what it means to be functioning in a world
where we've got that iPad going on. Like that big McCay
book [published by Sunday Press Books] can't be reduced
down. The physicality is part of what it is.

To me this is an important thing as I contemplate the digi-
tal revolution: the history of comics has up to now been
the history of printing. Every time there's been a change in
the technology of printing, there's been a different kind of
comic that's become possible, so that the comic strip, as I
told you, was an outgrowth of this new color printing that
was made available in color papers. There were enough of
them around so that some printing salesman said, let's take
the old Sunday comics and use the spare time on the print-
ing presses to reprint them. That led to a medium related to
comics, Sunday comics, but that was really something else.
It had the added potential that comes with turning pages
and seeing things that would develop and change, so when
you turned the page you could be surprised. It led to that
big fad, Superman. And a new revolution came with the
short run offset presses that allowed underground newspa-
pers to happen in the 1960s and allowed the underground
comics to happen. You didn't have to spend as much to set
up and print. Alternative papers could exist without the
same mass constituency or advertising. It led to Xeroxed
revolutions and mini-comics.

Now this new thing means it will have to find its own
voice. It isn't going to really just be what I use it for. I
use my iPad as a medium for reading Rodolphe Töpffer.
When it actually figures itself out it will be something

Figure 10. R. Crumb, *Drawing Cartoons Is Fun!* In *Despair* (1969).

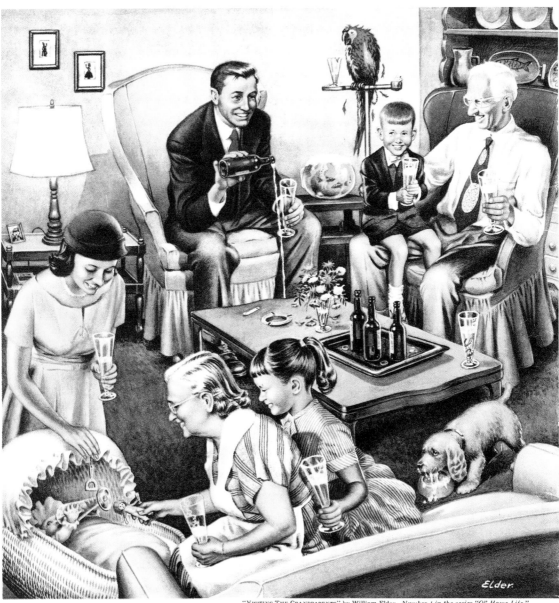

"VISITING THE GRANDPARENTS" by William Elder. *Number 1 in the series "Ol' Home Life."*

While you are visiting—

What makes a glass of beer taste so good?

Malted barley—with important body minerals plus liquid matter. For thing that makes glass of beer taste so good is terrible thirst.

Tangy hops. Yes—visiting can be a series of tangy hops if you play your cards right. And you'd be surprised how good free beer tastes!

The way it "goes with everything"—makes beer this country's Beverage of Moderation—the way it fits into our friendly way of life—the way each glass makes us friendlier and friendlier and friendlier.

Beer Belongs—Enjoy It!

Figure 11. William Elder, *Visiting the Grandparents*, in *Mad Magazine* (Apr. 1956).

else. And what is interesting now is how in order to work in this medium you are doomed to work in something as ephemeral as dance. Like the code, the language that these things are being turned into, pixels, becomes unreadable after a couple of decades. When I worked with Hillary on *MetaMaus*, we took a CD-ROM that had been made about my *Maus* books with hyper-links to audiotapes of my father, to panel sketches, photo references, other documents feeding into the page. It was all cutting edge, state-of-the-art—the CD-ROM that lasted for four years before it was replaced by the Internet. And when we wanted to just put it back in the world, it had to be built from scratch. [People] couldn't read the damn thing and use it. It was written in a code—something more obscure than Aramaic. The result is that anything one is making now is likely to evaporate unless it can be salvaged and rewired to become whatever comes next. I used to think of newspaper as ephemeral; now I think of it as the equivalent of stone carvings. It is still here.

MITCHELL: Is the pace of innovation and obsolescence outrunning our ability to cope with it?

SPIEGELMAN: The thing is, when you are working on something in this new media, it is interesting because there are no filters. You are allowed to get out without climbing past gatekeepers like art directors and editors. You are also working in a world where nobody will pay attention. The nature of all of these electronic gadgets is that you get an adrenaline rush, a shot of dopamine from the click. You are always asked to click and move on to something else. Books are always finite and you move back. That's why the word rereading came out of my mouth several times. It is that rereading, that searching for the chicken fat, that gives substance. It isn't from how many different images and texts can you consume in like forty-five minutes of trolling for porn on the Internet. But how can you actually focus on something in a world that's moving faster and faster? That focus is something that books allow for. And therefore books may have a life that's more interesting than just what vinyl fetishism is for music listeners. There may be something specific to the book that gives it a franchise on a continued existence.

AUDIENCE MEMBER: I see *Mad* as one of the first mass media to comment on itself. That's where self-consciousness appears. And I think people often talk about *Mad* when they should be talking about Will Elder.

SPIEGELMAN: Well, Will Elder and Harvey Kurtzman together. [Separately each had genius, but together they were like Leopold and Loeb—capable of lethal mayhem.]

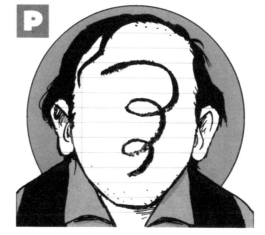

Figure 12. Art Spiegelman, *Doodle Inside Head*, in *Breakdowns: From Maus to Now* (1977).

AUDIENCE MEMBER: *Mad* was a precursor of so much that followed where we do see a kind of self-consciousness. *Mad* elevates a lot of stuff say, starting with *Zap Comix* and many [works] coming up from the graphic novel. Could you say a little more about where you see that early *Mad*?

SPIEGELMAN: It changed the world, Mad did. It is more than a style of humor that Harvey brought out. It was a way of radically questioning what you are looking at that at the time was like the necessary inoculation and how to survive the monolithic 1950s culture. The mass media really didn't have that many loopholes in it. But since we're talking about Elder, I want to find some fantastic image I had somewhere ["What makes a glass of beer taste so good?"]. This showed you how people actually survived the 1950s of Norman Rockwell's America. *[laughter]* It was really a kind of speaking truth literally to power. That early *Mad* was always questioning the style it was working in and using that and also the content of, so what is this dinner at grandma's house, or whatever? How are you going to live through that afternoon? Actually the kind of questioning—it raised I think the generation that protested the Vietnam War because it didn't trust what it was reading in the papers. Forcing the question was an important moment. It was trying to point toward something. What happened in the last couple of decades is this is now the normal form of discourse. So now a news show is called the spin room. The way you are getting the news is you are getting the attitude toward the news while you are getting the news. You are getting it as if we're all talking about how somebody else is being spun when of course it is you that's being spun through this media savvy, "Well, if Obama said this, that really means that he's trying to tell you that Romney is…and that image of…" You are given all of the metadata instead of being given the data. And it meant that a certain kind of irony has now become so normal that it doesn't serve as an inoculation against the mass culture since it has become the mass culture. Even though there are these fantastic accomplishments, like The Simpsons and like The Daily Show that manage to both give you the broad culture and comment on it at the same time, we now have to make a place past irony that I have been calling neo-sincerity. *[laughter]* This involves making use of all the tools of irony that have been developed before and during the *Mad* moment and after, and using them to say things that need saying. This is why I was exempting, for example, The Simpsons and The Daily Show from the standard mere ironic shrug while basically feeding Karl Rove's latest marching orders.

AUDIENCE MEMBER: I don't think professors are taking

33

STONED AGIN!

34

Figure 13. R. Crumb, *Stoned Agin!* in *Your Hytone Comics* (1971).

risks in some senses. I was wondering what would be an unsafe way to handle comic books in the classroom?

SPIEGELMAN: I was terrified when I found out my book was being used as a text in school. Because I remembered that Silas Marner was an inoculation against George Eliot for fifty years. That if it got used in a school, it would be like medicine. [But] the fact that people become more sophisticated being forced to look at it, it is all good. It is outside the classroom where the things that you're now opened up to and can look at should be allowed to flower.

I guess my fear is—now I'm beginning to see things that are not "long comic books that need bookmarks and that want to be reread," but [rather] things that are being made consciously, like "We're making graphic novels." The problem is making them so they can be used in schools. I think that leads to a different kind of work—designing them for an audience of academics. Maybe that has a chance of drying things out that concerns me. The main thing in that Faustian deal was the idea to leave comics alive enough so artists could rebel against the genteel perameters. So there remains room room for a cartoonist to say, "No, comics aren't good unless they are printed on newsprint and show pictures of naked people. No, comics aren't good unless they are as abjectly ridiculous as a bathroom graffiti scrawl." This is an important part of the spectrum and it is why I mentioned that genteel-vulgar tug of war being a good thing. *The Yellow Kid* and *Little Nemo*. And even though I might be self-deprecating, I'm proud that *Maus* is being used as a canonical text. It means that ultimately the work will continue to be read, and it was made to be read. So I have to get past my schoolboy snarl and accept the fact that it is not only bad stuff that happens in classrooms. I think that might have come out in my earlier snarling and I didn't quite mean it that way. I'm just wary of what happens when things get dried out and rarified rather than considered.

AUDIENCE MEMBER: For the longest time comics in terms of their format were really limited to either comic books or comic strips in the newspaper, both of which were still periodical format coming out serially. And now [we are] in an age where we have graphic novels that come out from publishing houses, and web comics, and someone who is the audience for comics may never have gone in their lives to a comic store or picked up a comic from a newsstand. What does it mean for comics as a form that it no longer has a dominant format? At least in the West.

SPIEGELMAN: Well, what is interesting is it does have a dominant format now; it is called the graphic novel. It is the book. The single book that tells a story. And that can function. You mentioned these other things like the web, which can be periodic. It can happen every day, people clicking on the website. I think insofar as we have a culture that can consume things, it can include graphic novels. The problem with graphic novels, maybe, is that to make material in three hundred page chunks, man, talk about original sin, you know? That's an enormous amount of punishing labor. Many of the best graphic novels that are coming out take five years, seven years, nine years. For me it was thirteen years [making *Maus*] trying to figure out what this graphic novel might be. And that has led to people trying to find loopholes in the contract. I see a few of my peers are finding ways to do that. Charles Burns is working in the *Tintin* [album] format—three separate books that make up a cycle—as a way of not having to make some three hundred page book in one gulp. If that's the only format that people can get paid for making comics in, there is a problem, because people who can barely put together a two-page story have to make a six hundred page story to make their mark. It is one of the things that's interesting about the art for walls [issue], which is I think for the short form comic may become one of its strongest possible expressions; because for me at least, comics are an art of compression. And it is a reducing down into very finite number of marks and symbols to make something happen. And one of the masterpieces of comics in my mind would be "Stoned Again" by Robert Crumb. The guy's head bleeding through his hands as he's stoned. Or [Crumb's image of] modern America, the picture of America as it goes from rural to urban blight ["A Short History of America"]. I don't know if you know these pages. But if you see them, you don't forget them; they become an indelible word for you almost. A way of understanding something. It can be done in a very compressed space. It is more likely for that to be able to exist as prints and then as wall art. Maybe the art world can offer a space for that kind of work where one would consider and reconsider the short, one- or two-page project as a significant project. And that involves a relearning to look at the visual side of what comics can be.

35

The Art of Succession:
Reading, Writing,
and Watching Comics

Tom Gunning

At the recent conference on comics at the University of Chicago nearly everyone wanted to avoid declaring that comics were an art.[1] For the most part the people who drew and wrote comics proclaimed that they had no interest in being dragged into this category by academic critics, while most of the academic critics claimed they had no such intentions. As a film historian, well versed in the debates during the last century over whether cinema could be an art, I find such discussions simultaneously pointless and oddly useful: pointless, because so little depends on settling the issue. At least since Walter Benjamin's "The Work of Art in the Age of Mechanical Reproduction" the question whether a new medium fits into the category of art became irrelevant, when we consider that photography, cinema, television—or comics—have already redefined our expectations of what art forms do. These technological and popular forms transformed modes of representation and perception long before critical discourses got around to taking inventory of loss and gain. Nonetheless, such debates can usefully articulate what makes new media tick, especially as they rub against established categories and expectations.

For more than a century comics have portrayed modern experiences through a dynamic interrelation of narrative and pictures—without waiting to be defined. Comic strips and comic books deftly blazed a highway through our childhood and adolescence with images and stories that helped us contest our often unwilling adjustment to adulthood. Speaking personally, even more than television or the movies (or rock and roll, which didn't seize my imagination until I was an adolescent), the comics opened escape routes through a world in which I lived, but to which (to steal a line from Nick Ray's first movie) I had never been properly introduced.

Panoramas of Media Hybridity: Unrolling Images

I am in favor of—no illustration, since all that a book evokes must take place in the reader's mind; but if you use photography why not go straight to the cinematograph [cinématographe], whose unreeling (unfolding) will replace, images and text, many a volume, advantageously.
—Stéphane Mallarmé[2]

It could be—and has been—argued that the era of high modernism defined itself through concepts of media specificity (as in Clement Greenberg) while the era of postmodernity issued in a postmedia condition (as in Rosalind Krauss).[3] I don't intend to debate the theoretical validity of this shift, simply to note the odd way comics fit into this schema. For more than a century comics have prowled around issues that remained on the periphery of modernist concerns. Now issues of representation, temporality, narrative, and writing have moved from the margins to the center of critical discourse, as borders differentiating media collapse. Krauss claimed the centrality

To my brother-out-law Jonathon Rosen, *imagiste* extraordinaire. I would also like to signal my debt in understanding comics to my old friend Scott Bukatman, whose daunting insight when writing on comics kept me from approaching the topic, and to my new friend Hillary Chute, who encouraged me to try nonetheless.

1. I am referring to "Comics: Philosophy and Practice," a conference presented by the Grey Center for Arts and Inquiry and the Mellon Residential Fellowship Program for Arts Practice and Scholarship at the University of Chicago on 18–20 May 2012.

2. Quoted in Christophe Wall-Romana, *Cinepoetry: Imaginary Cinemas in French Poetry* (New York, 2013), pp. 61–62. Mallarmé was responding to a question about the value of illustration. Christophe Wall-Romana, whose analysis of writing in relation to moving images has influenced this essay, comments brilliantly on this neglected quotation. I also want to thank Livio Belloi who first brought this passage to my attention.

3. See, as classic texts, Clement Greenberg, "Modernist Painting," *Modernism with a Vengeance, 1957–1969*, vol. 4 of *Clement Greenberg: The Collected Essays and Criticism*, ed. John O'Brian, 4 vols. (Chicago, 1993), pp. 85–93, and Rosalind Krauss, *"A Voyage on the North Sea": Art in the Age of the Post-Medium Condition* (London, 2000).

of television to the postmedia age, but I would claim that comics provide a longer and richer history, part of a popular modern tradition that interbreeds pictures and writing and introduces new processes of reading through an art of succession. The shift from modernism defined in terms of medium specificity signals a transition from defining the material properties of a medium to describing processes of reception; in the case of comics, acts of reading and viewing, while asserting differences, also move across the borders that separate media from each other.

In 1766 Gotthold Lessing established an axiom of modern aesthetics, claiming in *Laöcoon, an Essay on the Limits of Painting and Poetry* that these arts held contrasting relations to temporality and narrative. Although this complex essay contains nuances and contradictions,[4] its principal legacy lies in the assertion that writing and language best convey temporal succession and narrative due to the linear and successive nature of its signs. Images, in contrast, effectively capture only a single moment. This claim about the proper role of art forms set the stage for later definitions of medium specificity, as Lessing's argument became progressively rarified into a Greenbergian position where not only time and narrative but the space of representation became eliminated from modern visual art.

In the modern era it becomes increasingly difficult to conceive of high art practices independent of critical discourse. On the other hand, the popular arts proceed with little discussion of boundaries and definitions, promiscuously contaminating narrative and images. Reversing the lessons of Lessing, arrangements of images in the popular arts frequently portray succession rather than a single pictorial event, invoking a temporal process similar to reading. These forms fuse writing and imagery, reading and viewing. Comics exemplify this tradition, creating in their hybrid form a new relation to the viewer in which the act of reading embodies a new participation in an act of movement, producing both a modern fascination with the mobile and a deep democratization of literacy as reading becomes a means of amusement.

Intertwined pictures and narrative have a long tradition: from the manuscripts and monuments of the ancient Near East, through the devotional and funeral images of late antiquity, to the lives of saints or chronicles of kings in the Middle Ages. With the rise of the printing press in the modern era, popular prints and broadsides, illustrated books and serial engravings attracted new audiences. Such arrangements of images in succession to tell a story, usually including words, have often been understood as the ancestors of the comics. I will not attempt to survey this lineage, which has a number of fine historians.[5] I

will approach comics not only as the confluence of word, image, and narrative but as an art of succession, founded not only on illustration but on a flow, a guided course of reading in which images and language propel each other. It has been debated whether or not words constitute a necessary aspect of the form.[6] For me the issue lies less in the presence or absence of literal words than in the linear process of reading, the arrangement of signs in successive order, and the dynamics of motion this entails, which, as the wordless stories of Willette and other comics artists show, does not depend on words.

At their origins, both writing and the pictorial arts shared successive arrangement in sequence. Denise Schmandt-Besserat's investigation of the origins of writing claims an intense symbiosis between the appearance of writing and contemporaneous forms of art. After the development of writing, she claims, "consciously or unconsciously, figures in an image were treated according to principles similar to those governing the signs of script."[7] Focused on the ancient Near East, she claims that formal aspects of writing shaped the composition of images found on pottery, seals, and stelae. From an earlier circular orientation found in preliterate artistic practice, new linear configurations conveyed temporally arranged narratives. "Ancient Near Eastern Art adopted horizontal parallel lines as the central principle for organizing its images. Figures were arranged in linear compositions in the same way that signs were disposed on a tablet."[8] Although visual similarities across millennia can be misleading, the parallel lines Schmandt-Besserat finds in Mesopotamian seals and stelae inscriptions perform a similar role to the strip of comics, organizing the arrangement of figures and the course of the reader's attention.

I agree with Scott McCloud that a sequence of juxtaposed images defines the comics, but I am intrigued by the impetus behind this sequence, the motive force for the flow of images. The acts of writing and drawing comics are put into motion by the viewer/reader in a complex act of reading that constitutes perhaps the key contribution of this unique form. Yet, in some respects specific to comics (albeit certainly drawing on long, even ancient, traditions of succession), the appearance of comics in the nineteenth and twentieth century also partakes of a modern fascination with visual motion whether virtual or real. I want to relate comics to this modern cultural fascination with motion, shared with other hybrid popular arts that appeared around the turn of the eighteenth to nineteenth centuries. Putting aside for the moment the more obvious ancestors of comics, such as the depiction of successive stages in the lives of saints, emperors, and generals (not

4. See, for instance, W. J. T. Mitchell's "Space and Time: Lessing's Laöcoon and the Politics of Genre," *Iconology: Image, Text, Ideology* (Chicago, 1986), pp. 95–115.

5. See, for example, David Kunzle, *The Early Comic Strip: Narrative Strips and Picture Stories in the European Broadsheet from c.1450 to 1825*, vol. 1 of *History of the Comic Strip* (Berkeley, 1973) and *The Nineteenth Century*, vol. 2 of *History of the Comic Strip* (Berkeley, 1990); hereafter abbreviated *N*. For a popular version, see Scott McCloud, *Understanding Comics: The Invisible Art* (New York, 1994); hereafter abbreviated *UC*.

6. Scott McCloud does not see words as necessary to the definition of comics but does includes the idea of a deliberate sequence, which I see as defining the process of writing; see *UC*, pp. 8, 21.

7. Denise Schmandt-Besserat, *When Writing Met Art: From Symbol to Story* (Austin, Tex., 2007), p. 25. See as well her discussion of the development of writing from tokens used keep track of stables and goods in Schmandt-Besserat, *How Writing Came About* (Austin, Tex., 1996).

8. Schmandt-Besserat, *When Writing Met Art*, p. 102.

to mention harlots, rakes, and drunkards), I will explore a different popular visual technology: the panorama. The obvious differences between this architectural form of visual display and the intimate and domestic modes of reading comics allow me to focus on the shared impetus that drives succession.[9]

The panorama was once so omnipresent (Stephan Oettermann calls it "the first true visual 'mass medium'")[10] that the term became absorbed into common language. Patented in 1787 by Robert Barker, the panorama revolutionized the image, destroying its previously defining aspect—the frame. As Bernard Comment writes, "abolishing the frame was the only way of transcending the limits of traditional representation."[11] This abolition of the condition of the modern tradition of easel painting, the frame surrounding Alberti's window, exploded the circumscribed logic of perspective, radically transforming the space of painting, but in the opposite manner from the Greenbergian tradition, which stressed the shape and flatness of the canvas as a defining aspect of the medium.

The panorama combined the unusual scale and format of the canvas (massive and shaped in a circular or semicircular configuration) with a uniquely designed building. The effect of the panorama thus depended as much on architecture as painting. As Erkki Huhtamo puts it in his recent study of the form, "it was turned from a representation into an illusory environment."[12] From the moment of the viewer's entrance, the design of the panorama functioned as an apparatus of vision.

To gain access to a panoramic canvas, the spectator had to walk along a darkened corridor so as to forget the reality of the world outside and so that the effect of being plunged into the total illusion of the representation would have more impact. Viewers were confined to an observation platform and could not approach the canvas. A canopy concealed the overhead lighting that entered from behind a glass panel.[13]

The viewer was completely surrounded by the circular painting, while architectural design concealed upper and lower limits of the image, giving the illusion of a boundless view. Concealed skylights filtered the daylight that shone on the painting, leaving the viewers in relative shadow. The space between the viewing area and the canvas frequently contained a three-dimensional environment including life-sized props (and even figures) that merged into the two-dimensional images of the canvas. The effect was immersive.

The panorama liberated the image from the constraint of the frame, delivering a complete view of the encompassing horizon. However, the observer was completely subject to the apparatus of the exhibition schema, a 360-degree space that confined the observer in "a com-

plete prison for the eye" (*P*, p. 21). If the perspective projection of the Renaissance picture frame figures a visual mastery of space from a single point of view (and in a single moment), the panorama poses a perceptual paradox. Has the viewer's vision been extended to an all-encompassing view, that of a god unlimited by perspective, or does the panorama enforce a sense of the complete subjection of a viewer surrounded by the viewpoints of a panopticon? The panorama offers a spectatorial position from which mastery and subjection merge. The Albertian frame had fixed both scene and viewer not only within a single position but, as Lessing would stress, a single moment, freezing space and time within a singular frame or orientation. In contrast, the panorama could never be seen entirely from a single viewpoint—or in a single moment. The possibility (and indeed necessity) of shifting viewpoints introduced a dimension of temporality to the act of viewing.

The panorama offered what Oettermann describes as a "democratic perspective" as "the infinite number of points of view are matched—theoretically—by an infinite number of viewing points from which observers can look at the picture without distortion" (*P*, p. 31). Rather than a single observer regarding the scene in isolated contemplation, the panorama attracted an audience, a commercial mass made up of varied classes, who wandered from viewing point to viewing point to obtain the full effect of the image. The spatial and visual environment of the massive canvas forged new relations with viewers by challenging the idealist pictorial tradition of contemplation, eliciting the often-visceral responses of an audience rather than the absorption of a single viewer withdrawn into him- or herself. Rather than intellectual contemplation, physical sensations and reactions emanated from the panorama, exemplifying a desire to overcome the limits of representation. This highly sensual hyperrealism aggressively violated the domains of aesthetic experience defined by Lessing and others but fascinated a new broader public. When the unified point-of-view frame was abolished, the picture hemorrhaged, transforming the temporal unity of the image as much as the bounded nature of painting.

A panorama of a sublime landscape or a titanic metropolis clung precariously to the convention of a single moment, undermined by the audience's mobile gaze surveying sequentially the different quadrants of vision, presenting an image that viewers could consume only in sections. But panoramas portraying events, primarily battle pieces, often worked into their designs successive incidents, which had not all occurred simultaneously. These complex visual topologies were frequently accompanied by written guides, which suggested a program of viewing for the massive image, sketching a narrative of views. If the

9. I also discussed the panorama in relation to landscapes in Tom Gunning, "Landscape and the Fantasy of Moving Pictures: Early Cinema's Phantom Rides," in *Cinema and Landscape*, ed. Graeme Harper and Jonathan Rayner (Chicago, 2010), pp. 31–70, to which this section is indebted.

10. Stephan Oettermann, *The Panorama: History of a Mass Medium*, trans. Deborah Lucas Schneider (New York, 1997), p. 7; hereafter abbreviated *P*.

11. Bernard Comment, *The Painted Panorama*, trans. Anne-Marie Glasheen (New York, 2000). p. 100.

12. Erkki Huhtamo, *Illusions in Motion: Media Archeology of the Moving Panorama and Related Spectacles* (Cambridge, Mass., 2013), p. 3; hereafter abbreviated *IM*.

13. Comment, *The Painted Panorama*, p. 161.

circular form of the panorama liberated it from a single vanishing point, it also invited a mobile gaze.[14]

In the United States and England, especially, this successive viewing of extensive panoramic images became literalized in another form, as virtual succession became an actual movement in the moving panorama. Although this form of panorama developed many forms, as Huhtamo's recent magisterial study demonstrates, its essential mechanism and effects remained stable. The lengths of these unfurling canvases were measured in miles, and their unrolling sometimes lasted for more than two hours. (John Banvard's panorama of the Mississippi was advertised as three miles in length, while Albert Smith's rival version was claimed to measure four miles; these figures were undoubtedly exaggerated for publicity, but this underscores the attraction of extensive dimensions.) Mounted on twin sets of rollers like a gargantuan version of a Chinese scroll painting, the moving panorama unrolled bit by bit, accompanied by music and a spoken lecture commenting on the views. Eschewing the total immersion of the 360-degree format, the moving panorama offered an ever-expanding image, presenting a literal succession of views for a seated audience. One critic described the spectacle as "how to go 30 miles without moving at all" (quoted in *IM*, p. 66). The introduction of motion to the panorama drew on two models. The flow of images mimed the mobile views offered by a journey, drawing on the convention that Charles Musser calls early cinema's "spectator as passenger" convention.[15] The spectator is situated by the apparatus so as to see (more or less) what a traveler might see during an actual spatial itinerary. Secondly, the conjunction of spoken narrative and successive images recalls traditions of storytelling accompanied by visual illustrations (see *IM*, pp. 32–34). As much as travel, the impetus of narrative, spinning out a story, motivates the movement of images. Huhtamo claims, "In subsequent development, moving panoramas became less concerned with immersion and more occupied with visual storytelling" (*IM*, p. 80).

Wolfgang Schivelbusch cannily described the view from the moving train as "panoramic," and the affinity he suggests between the most modern nineteenth-century technologies of transportation and representation is instructive.[16] They both seem to devour landscapes not only though a logic of succession but from the force of mechanically driven speed. Like the steam engine, the moving panorama converts force into a consistent forward motion that carries the viewer along. Within the panorama the course of the Mississippi was traveled in a matter of hours, collapsing not only miles of riverbank but days of journey into a manageable visual experience; it also relieved the viewer of physical effort and even danger. Huhtamo quotes doggerel composed for one panorama: "to see all the wonders o'er this spacious field, / You have noth-

ing to do just keep your eyes peeled" (quoted in *IM*, p. 175).

If the circular panorama abolished the frame, the moving panorama simultaneously displayed and undermined it. In most cases the panorama itself was displayed within a theatrical proscenium, often within a frame that served to accent the picture while concealing the mechanism that moved it. While such frames could be ornate, they were also permeable; images passed through them rather than being contained. In some cases this movement was continuous, the slipping by of landscape miming ongoing transportation and journey. However, most moving panoramas alternated between images presented as still (paused and commented on by the lecture) and images intended to be viewed in motion. Journeys tend naturally towards continuous motion, while illustrated stories might call for a series of tableaux, motion replacing one image with another. Both forms used a combination of motion and stasis. Journeys paused to relate incidents or comment on remarkable features of the landscape. Likewise many narrative panoramas, such as the surviving *Moving Panorama of Pilgrim's Progress* set their dramas within an unfolding landscape, unified by a consistent horizon.[17]

The hybrid nature of the panorama medium encourages alternation. As Huhtamo puts it, "the tension between continuity and discontinuity was at the heart of the medium" (*IM*, p. 257). Besides the regulation of movement and pauses, the composition of the painted roll expressed continuous discontinuity. Some unfurling panorama used frame lines to separate scenes, but others, such as *The Moving Panorama of Pilgrim's Progress*, avoided sharp geometrical frames and blurred transitions between separate compositions. If the moving panorama appears less radical than the circular panorama in undermining the tradition of the framed tableau, the act of moving images past the viewer undoes the isolating effect of the frame. Instead of defining the limits of the image, the frame becomes permeable, an arbitrary barrier easily passed over or through. As the lecturer verbally accompanied the unrolling spectacle, the descriptive or narrative flow of language seems to drive the image past the frame, inviting the spectator to follow its course with their eyes and imagination if not with physical movement.

Framing Motion on the Page

> Why things happen after each other in this film
> is because there isn't room for everything at once.
> —Robert Breer on his film *Pat's Birthday* (1962)

Panoramas, circular and moving, vividly display the polymorphous nature of movement that transformed the art of succession in the nineteenth century. The panorama does not resemble the comic strip in the literal way a seventeenth century broadside might. Neither circular nor moving

14. Anne Friedberg introduced the concept of the virtual mobile gaze in *Window Shopping: Cinema and the Postmodern* (Berkeley, 1994).

15. Charles Musser, *Before the Nickelodeon: Edwin S. Porter and the Edison Manufacturing Company* (Berkeley, 1991), p. 260.

16. See Wolfgang Schivelbusch, "Panoramic Travel," *The Railway Journey: The Industrialization of Time and Space in the 19th Century* (Berkeley, 1986), p. 52–69.

17. *The Moving Panorama of Pilgrim's Progress* is preserved in the Saco Museum, Saco, Maine and illustrated and discussed in *IM*, pp. 182–84.

panoramas provided models for comics in scale, composition, or mode of consumption. But the panorama radicalized the process of reading/viewing through a new emphasis on the portrayal of time and motion that rendered the succession of images dynamic and the reader/viewer virtually mobile. Verbal narrative employs the linear temporal aspect of language that Lessing described. In the nineteenth century this narrative movement also absorbed the pictorial. Comics became modern through evolving a new mobile address to the spectator as much as by evoking motion in the incidents portrayed.

In the eighteenth and nineteenth century the viewing of pictures and the act of (especially silent) reading served as figures for the interiority of contemplation and reflection. Rather than aspiring to such timeless absorption, panoramas triggered physical involvement (sensations as well as literal or imagined movement) and an awareness of time and duration. The moving panorama endowed succession with an intensified sense of direction, a flow of narrative that carried the audience along. The lecturer provided spoken commentary on the spectacle from a stage or podium placed between the images and the audience. This hybrid verbal/visual form propelled images into motion, fusing the flow of language with the mobile mechanism of the apparatus. The moving panorama aspired less to abolish the frame than to transform it into a vehicle for transporting the audience. Landscape panoramas (such as the numerous voyages up or down the Mississippi; Smith's accompaniment of the "Overland Mail" from Europe to India or his ascent of Mt. Blanc; the panoramas portraying the flight of aeronautical balloons) naturalized the mechanics of movement by representing journeys via varied modes of transportation (see *IM*).

Granting the difference between panoramas and comics, both forms transformed relations between media and the reader/viewer in the nineteenth century by representing movement through pictures. Spatial voyages also naturalized the succession of images in early nineteenth-century comics as in the pictorial chronicles of voyages drawn by Rodolphe Töpffer or Cham (see *N*, pp. 82–85). Such odysseys accustomed readers/viewers to a new mobile manner of viewing successive images. Portraying travel created a visual vocabulary of motion that not only depicted physical movement but constructed a reader/viewer who could follow action through a series of images.

Comics have been defined as narratives conveyed by a sequence of picture and—usually—words. In the media environment of the nineteenth century, there is a force of movement lurking within this definition—the acts of both composition and reading, which propel images through space and time. This movement gives birth to the dynamic experience of reading comics. McCloud uses an image of a measuring device to illustrate the symbiosis between time and space in comics: a tape measure, marked off in inches, merges into the circularly calibrated face of a clock—space assumes the form of time (see *UC*,

p. 100). The image visualizes the alchemy I find in comics, but it rather erroneously identifies time and space with tools of measurement rather than a mobile experience. Whether lateral or circular, measuring devices produce numbers and units rather than images in motion. Although accomplishing McCloud's pedagogical purpose, the icon tends to freeze the actual dynamics of comics. What else can an illustrator do but convey motion through motionless drawings, unless she chooses simply to abandon her craft and go into animated cartoons, that art cognate to the comics that seems to evolve from it naturally? But while the art and concept of animation always shadows the comics, the relation between them is hardly one of larva to butterfly, as if comics simply awaited the fullness of time and technology to deliver them from an unwilling immobility. Rather, the power of comics lies in their ability to derive movement from stillness—not to make the reader observe motion but rather participate imaginatively in its genesis.

We could describe this dilemma of comics as its Bergsonian paradox. Writing around the same time as the emergence of cinema and the commercial triumph of comics (the previous fin de siècle), Henri Bergson located the central fault of Western thought in its lack of consideration of motion and duration. Ever since the time of the ancient Greeks, motion had been thought about in terms of stasis.[18] Movement was misconceived as a divisible series of still spatial points (often absurdly, as in Zeno's paradox of the race in which Achilles can never overtake a tortoise given a head start) rather than a coherent flow of temporal action. Bergson even felt the mechanical nature of cinema remained prisoner to this fallacy, seeking to create motion from a rapid series of still photographs.

In their media hybridity, comics realized the particular power of superimposing, almost stereoscopically, different regimes of viewing and reading. I am aware that not all comics do this to an equal degree and, as my historical contextualization makes clear, comics by no means are the only form that can accomplish this fusion. If comics belong to a broader tradition of bringing movement to images, they also have a specific history. A quick survey of the ancestors of comics makes this clear.[19] The broadsides produced in the centuries after the invention of the printing press used successive images to chronicle the series of events in the lives of saints and sinners, the course of wars, rebellions, and political plots. Up until the end of the eighteenth century, each image in these series occupied a separate space and time. Generally placed within sharply defined frames, each image illustrated a distinct stage of the story. Little continuity of movement exists between these relatively autonomous frames, other than that supplied by the (usually written) logic of narrative. Physical actions rarely bridge frames (in fact, in early forms the image sometimes includes a series of successive events within a single frame, distinguishing them through planar composition, placing an earlier inci-

18. Although this issue recurs in all of Bergson's work the key text for our purposes remains Henri Bergson, *Creative Evolution*, trans. Arthur Mitchell (Lanham, Md., 1983).

19. See Kunzle, *The Early Comic Strip*.

dent in the background while a later event occupied the foreground). Numbers or letters mark separate frames or events, providing a clear order for the reader to follow in order to grasp the sequence.

These early Western sequential visual narratives set a pattern that modern comics followed but also revolutionized. Each image finds its place within a narrative succession, usually clarified by both a written account and by diacritical marks, such as numbers or letters, indicating the order in which they should be read. The form of succession also relies on protocols of reading, generally moving left to right and from top to bottom. The images are separated from each other, most often enclosed in frames, although sometimes they are fused in an overall composition that combines various events, while diacritical marks create an order within them. Generally extended gaps of time and often space appear between images. The written narrative traces connections across these caesuras.

While some later comics follow this pattern, presenting images as relatively autonomous stages of a story, modern comics increase the continuity between images. Kunzle nicely referred to this transformation as a "graphic speedup."[20] Rather than separate stages of a story, the images increasingly present phases of a continuous action. The gaps between individual images become briefer; rather than illustrating a story in a punctual manner, comics portray a flow of action. The reader no longer leaps from one stage to another but rather follows action across a series of images. This flow varies, creating rhythm by making gaps between images sometimes longer, sometimes shorter.[21] This increased flow of both reading and action entailed new attitudes towards drawing and composing: subordinating illustration to physical action and introducing new attitudes between the frames and the page layout.

The pivotal figure in this modern transformation seems to be Rodolphe Töpffer, the Swiss writer and cartoonist whose comic albums delighted the literary elite of Europe in the early nineteenth century.[22] Many of Töpffer's innovations now seem inherent in comic form but emerged clearly only with the new culture of movement in the nineteenth century. Transformations in drawing developed from a new physicality in the portrayal of figures. Kunzle traces the development of a caricature tradition that privileged the physical body, not only exaggerating individual physiognomies, but developing a keen eye for posture and variations. Henry Bunburry's caricature strips from the late eighteenth century posed a series of active figures as they dance or whisper to each other. This emphasis on figures, as Kunzle points out, also liberated images from the heavily detailed background seen in the broadsheets or in Hogarth's etchings, which anchored characters in fixed

settings. Caricature strips introduced an abstract space that served simply as a container for action.[23]

Töpffer used the caricaturist's freedom of figure and space to open up new mobile narrative possibilities. His plots relied on physical action—dances, collisions, chases, escapes, and rescues—conveyed by a nervously sketched line. Innovations in lithography reproduced this new lively drawing, replacing the solidly carved woodcuts or etching processes with the tremulous gestures of the hand. Töpffer's drawings introduced an almost electric sense of the human body that was not only plastic and flexible but nearly vibrating with the urge to action or the surprise of reaction (see *N*, pp. 28–71).[24]

Emphasizing motion and continuity exclusively oversimplifies not only Töpffer's art but the new terrain of the comics. As Huhtamo indicated with the moving panorama, continuity implies the alternative of discontinuity, and motion introduces the possibility of interruption. The power of the art of succession lies in the tension between these two modes and the possibility of their alternation. Thus Töpffer introduces the hero of his first album, Histoire de M. Jabot, in a pose *(en position)* reflecting a vanity that his dress and behavior remain fashionable and proper. The action then takes him through a series of embarrassing collisions, awkward encounters, and falls in the domain of polite society, from which he hopes to extricate himself and regain status by reassuming his position. Motion depends on its contrary for effect. The mobility of the new forms allowed the comic possibilities of stillness; static images became a gag rather than a norm.

Interplay between stillness and motion may be acted out by figures, but a new attitude toward the frame and page layout took it to the structural level. Broadsides often placed their series of sequential frames within an overall composition, as central images or roundels were flanked by columns of frames or surrounded by numbered images. But these designs remained largely independent of narrative functions. In modern comics, design of both frame and page layout fused narrative succession with pictorial strategies of mirroring and repetition. Töpffer's page design extended the comics' symbiosis of reading and picture. He created a gestalt that functioned both successively and simultaneously, configuring an act of reading into a complex pictorial design.

The dynamics of Töpffer's picture narrative migrated into the layout of the page and its frames. The nervous lines that mark the borders of his frames often wiggle or vibrate in sympathy with (or perhaps alarm at) the actions they contain. They are active rather than passive, connecting incidents as much as they separate them, and often forcing the reader to leap from place to place. Some scholars describe Töpffer's frames of alternating actions as anticipating cinema's parallel editing; the juxtaposition

41

20. Kunzle, "The Voices of Silence: Willette, Steinlen and the Introduction of the Silent Strip in Chat Noir, with a German Coda," in *The Language of Comics: Word and Image*, ed. Robin Varnum and Christina T. Gibbons (Jackson, Miss., 2001), p. 4; hereafter abbreviated "V."

21. For a useful typology of transitions see *UC*, pp. 70–81.

22. For the best account of Töpffer, see *N*, pp. 28–71.

23. See Kunzle, *The Early Comic Strip*, pp. 360–63.

24. See also *Rodolphe Töpffer: The Complete Comic Strips*, ed. Kunzle (Jackson, Miss., 2007).

of frames serves a rhythmic function of interrupting, repetition, and alternating. [25]

Thus page thirty-nine in Töpffer's *Histoire de M. Jabot* lays out these successive frames from left to right: M. Jabot wreathed in smoke, arms outstretched as he reacts to his nightshirt being set on fire by a candle / his amorous neighbor next door, the Marquise, wringing her hands as she hears his cries through the partition / M. Jabot's newly purchased hunting dogs baking their heads off (which is all we see of them in this narrow frame as they strain against their leashes to the right) / The Marquise's little dog facing left (so confronting the hunting dogs across the tremulous frame line), also barking / A slightly wider frame as the flames ignite a hunting rifle leaning against a chair, which discharges with another cloud of smoke (fig. 1).

It is somewhat misleading to compare this strip to a cinematic sequence that moves through a series of viewpoints. Instead, we see a page composed of carefully juxtaposed frames that alternate regularly between adjoining apartments with parallel yet conflicting compositions (male human figure in distress / female figure leaning toward him in concern; dogs snarling at each other; climax of an explosion of an animate object). Sound mediates between frames, creating continuity in space and time, while the action from frame to frame follows a linear logic of cause and effect. As powerful as the temporal progression of action and reaction may be, the total effect of the page conveys balance and alternation, a rhythm of differently sized frames, separation and articulation achieved by *decoupage*.

One of greatest of Winsor McCay's *Little Sammy Sneeze* comic strips portrays the usual stages of Sammy's building "awkachow" in a close framing that eliminates the usual surrounding environment and story situation (which Sammy's sneeze always destroys in the penultimate frame).[26] Here, however, disaster is wreaked on the surrounding frame, whose fragments, after the sneeze, lie shattered around our somewhat abashed rheumy hero (fig. 2). Rendered palpable, even material, the frame ends up destroyed. Beyond guiding our course of reading, the frame of nineteenth-century comic strips becomes an active participant in the fun. As Kunzle nicely puts it, "by the 1890s framing in itself represents movement of a kind and begins to compete with the story line" (*N*, p. 368). As in all aesthetic forms, rules and restriction exist to be played with, and in a ludic form like comics the game is nearly always smash and run. Frames become barriers to be crossed, exceeded, bent, and even rendered invisible. But they always appear as structuring limits (even the anarchist fin de siècle cartoonists for *Le Chat Noir*, who tended to eschew square borders, constantly imitate frame lines with diegetic props, such as lamp posts, that divide the action or fuzzy limits to the scene that make

them float as if suspended in some extraterrestrial realm).

If in the modern era the high arts strove to achieve greater purity and separation between media, the popular arts fused them in new ways, utilizing new technologies (the panorama, the cinema, new modes of printing) and directing viewer attention to the flow of time in movement. The hybridity of the comics, what Hillary Chute refers to as "its word and image cross-discursivity,"[27] staged a confrontation between succession and simultaneity. The modern comic reworked this conflict onto another formal level—the relation of frames to page or succession to layout—and thereby discovered new ways to negotiate space and time, movement and pattern, image and story. Upon this field two forms of reading collide. Nearly every commentator on comics discusses this conflict, but Chute describes it most succinctly in terms of the process of reading: "This duality—one's eye may see the whole page even when one decides to commence reading with the first box of the first tier—is a defining feature of comics, which lays out its temporal unfolding in juxtaposed spaces on the page" (*GM*, p. 8). Chute describes this as a spatial strategy, claiming that by "representing time as space, comics situates the reader in space, creating perspective in and through the panels" (*GM*, p. 9). She explains her understanding partly through comments McCloud made in an interview:

> That's the one thing that comics has that no other form has. In every other form of narrative that I know of, past, present, and future are not shown simultaneously—you're always in the now. And the future is something you can anticipate, and the past is something you can remember. And comics is the only form in which past, present, and future are visible simultaneously. . . . You're looking at panels, which, if you're reading panel two on page two, then to its left is the past, and to its right is the future. And your perception of the present moves across it.[28]

McCloud and Chute offer a compelling description of how we read comics. But I question the view of time offered here, which recalls McCloud's tape-measure clock. Chute presents time as linear, irreversible, and outside the control of the viewer, like the running time of a film. Chute contrasts film with comics, claiming, "yet comics is not a form that is experienced in time, as film ultimately is" (*GM*, p. 8). Comics differ from film by "allowing a reader to be in control of when she looks at what and how long she spends on each frame" (*GM*, p. 9). Setting aside a discussion of the temporality of cinema, I find Chute's analysis of our relation to comics very insightful, but I question her claim that this is "not a form

25. See, for instance, Pierre Chemartin and Bernard Perron, "To Switch Back (and Forth): Early Cases of Alternation in Comics and Cinema," in *Cinema e fumetto: XV Convegno internacional di studi sul cinema / Cinema and Comics: XV International Film Studies Conference*, ed. Leonardo Quaresima, Laura Ester Sangalli, and Federico Zecca (Udine, 2009), pp. 115–34.

26. See Winsor McCay, *Little Sammy Sneeze: The Complete Sunday Comics 1904–1905*, ed. Peter Maresca (Palo Alto, Calif., 2007).

27. Hillary Chute, *Graphic Women: Life Narrative and Contemporary Comics* (New York, 2010), p. 5; hereafter abbreviated *GM*.

28. McCloud, interview with Chute, *Believer*, Apr. 2007, www.believermag.com/issues/200704/?read=interview_mccloud

Figure 1. Rodolphe Töpffer, *Histoire de M. Jabot* (1833).

43

Figure 2. Winsor McCay, *Little Sammy Sneeze* (1905).

44

experienced in time," thereby assuming a narrow defini-
tion of our temporal experience as measured by the clock.
She actually acknowledges the temporal dimension of
reading comics in her choice of terms: "when" and "how
long." Rather than ignoring time, comics open up new
modes of representing it.

Comics allows a complex experience of reading images.
As Chute points out, we can switch between different
practices and indulge different pleasures, neither of which
eliminate the other, but which do require an alternation, a
change of perspective and expectation, an escape from an
exclusive linearity. Chute's error, I believe (which does not
lessen the insight of her description, only calls in to ques-
tion her sense of comics as spatial rather than temporal),
assumes time must be literally contained in the medium
as a consistent and measurable quality—as it might seem
to be in a film, which has a measurable running time and
speed. Bergson described such an understanding of time as
spatial, quantifiable, and linear. But the experience of dura-
tion, as Bergson taught us, is based in human experience,
not determined by clocks or timers. The time of reading
that Chute describes so well exemplifies such an authen-
tic human experience (and use!) of time, not as an exte-
rior quantity, but as a lived dimension. Like other modern
popular arts, comics give us a profound experience of time
through a complex portrayal of movement and succession
within a varied practice of reading.

If I am critiquing Chute's description of the way time

and space operate in comics, it is because I think her analy-
sis profoundly reveals the power of comics as an art of suc-
cession and a medium of new processes of reading. Comics
offers simultaneously two alternative regimes of reading:
an overall one that grasps the page as a total design and a
successive one that follows the order of individual frames
one at a time. Her description actually reveals the intricate
and varied negotiation a reader performs through the con-
fluence of images and words within a course of movement.

Let us look at an acknowledged masterpiece of such
design by McCay from his most ambitious comic strip,
Little Nemo in Slumberland. A full-page strip from 10
July 1906 has often been reproduced as an outstanding
example of McCay's art. Scott Bukatman, McCay's most
insightful commentator, has already noted its complex
interweaving of framing, motion, and perspective.[29] The
page contains seven numbered frames in successive order
following a narrative progression. The top frame embla-
zons the title of the comic across the width of the page.
In this lateral frame Nemo and the Princess stand sur-
rounded by a dozen attendants, who rush about making
preparations so that Jumbo can carry the young pair to
the Princess's father, King Morpheus, who has been anx-
iously awaiting them. The following five vertical panels
reverse this lateral orientation; all but the last have identi-
cal narrow shapes stretching to the bottom of the page.
They present the approach of Jumbo the elephant, who
moves from background to foreground, descending broad

29. See Scott Bukatman, *The Poetics of Slumberland: Animated Spirits and the Animating Spirit* (Berkeley, 2012), p. 86; hereafter abbreviated *PS*.

steps towards Nemo and the Princess who wait below. The Princess tries to reassure Nemo, who is frightened by the approach of the huge beast. They mount into a golden seat perched on the end of the elephant's trunk, which lifts in the penultimate frame. The final frame appears in the lower right corner of the page. Following the pattern of all Nemo strips, it interrupts the action and truncates the last horizontal panel (of the precariously settled Nemo and the Princess) with an awakening in another time, another place. Nemo in bedclothes hunches toward the comforting embrace of his mother in the small frame, both secure and restricting, of his domestic bedroom.

As in most of Nemo's early episodes, the narrative action moves through bizarre environments using unusual means of transportation, yet Nemo never seems to get very far in his ever-delayed approach to King Morpheus's palace. Like the curlicue narrative of Laurence Sterne's *The Life and Opinions of Tristram Shandy, Gentleman*, Nemo endures an uncomfortable blend of motion and stasis, as frenzied efforts and energy expended to get somewhere encounter endlessly multiplying delays, detours, and zigzags. Nemo's journeys evoke the familiar dream experience of being unable to move from one place to another in spite of strenuous effort. The very form of the comics, their push/pull between the stasis of the image and the motive force of narrative, provides the perfect medium for this dilemma.

The title frame rehearses issues that will be more dramatically acted out in the rest of the episode. With its lateral shape it serves primarily to unfurl the title itself, which is superimposed across the tableau of the attendants. The composition presents a series of similar figures engaged in contradictory actions. The serial composition of the attendants (most wearing the same uniform and possessing strictly identical faces) arranged linearly across the frame, resemble characters of pictographic writing. Their mirrored and reiterated postures fill the frame with stages of movement within a pattern of repetition, as if all of this commotion were to no avail. Demonstrating Bukatman's claim of the influence of Eadweard Muybridge and Étienne-Jules Marey on McCay, these cookie-cutter figures in varied stances recall a chronophotograph showing a single figure multiplied, frozen in the diverse positions of his motion (see *PS*, pp. 28–32). The rhythm of reversal in direction and orientations of the figures conveys a sense of getting nowhere fast.

The visual core of the episode lies in the central five vertical frames (fig. 3), which line up across the page beneath the title. They each show a stage in the elephant's approach, a carefully parsed-out trajectory showing McCay's awareness of motion chronophotography and cinematography. The identical width of these panels conveys a sense of steady progress as the uniformity of the frames contrasts with the startlingly enlarging elephant. McCay's complex mastery of point of view nearly overwhelms us. In all but the penultimate frame, we see Nemo and the Princess at the bottom of the frame awaiting the elephant's arrival. They remain small figures, particularly in relation to the elephant. In contrast, Jumbo expands dramatically as he nears the children. In the second frame most of the animal is framed within the top of the panel, separated from the children by the expanse of steps (only his extensive ears break the frame). But in each successive frame not only does he descend the stairs, swinging his trunk, but his ever enlarging features overflow the panels. By frame five, the long, strangely flaccid, trunk takes up most of the panel as if determining its shape. The movement becomes disturbingly dreamlike. The elephant's engulfing enlargement reflects Nemo's trepidation. But the beast is not literally seen through Nemo's point of view. Rather the approaching elephant seems to emerge from the page, moving towards—well—us, the reader/viewer, threatening to invade our space.

The optical drama of the looming elephant overwhelms the narrative pretext of supplying transportation to Morpheus. In the penultimate truncated frame, Jumbo not only enlarges a bit more but lifts his trunk to reveal a shocking pink mouth. I hardly need to point out the merging phallic and yonic imagery here, which any child can see and which, in a Freudian reading, supplies the trauma that awakes Nemo in the next frame. But I would stress the threat of literal engulfing the image embodies, swallowing down the viewer/reader (need we add dreamer?) as the final climax of this visual phantasmagoria of movement.

The image of being swallowed obsesses popular visual media.[30] James Williamson's 1901 film *The Big Swallow* offers its locus classicus. In this brief film a man objecting to having his picture taken approaches the camera, moving dramatically into close-up as he invades the foreground of the image, enlarging precipitously as he does so. First the man's face and then his mouth fill the entirety of the frame. The mouth gapes revealing a dark gulf into which we watch a (previously unseen) photographer and camera tip and fall. The mouth closes and the man now withdraws, mollified as he chews contentedly. This masterpiece of early cinema displays the qualities of the new medium, its mastery of motion and the optics of the lens with its variable field of vision. It also acts out an aggressive posture towards the viewer. Its affinity with McCay's comic indicates less a direct influence than a shared delight in playing with imagery in motion and confronting the viewer/reader.

It is tempting to use this strip as an allegory for the comics as an art of succession. Like optical illusions such as the duck/rabbit composite that fascinated Ludwig Wittgenstein, it is almost impossible to see this comic exclusively as either a successive sequence of individual panels or a single composition. It flips constantly between two alternatives, provoking the vertigo that McCay made his signature and the perfect manifestation of Nemo's dreamworld. It is not just that I see the strip as succession and as composite but that I am seized by my awareness of its unending play between different states and of my own position simultaneously outside the image as reader and

30. See Donald Crafton's survey of the theme in animated cartoons in *Shadow of a Mouse: Performance, Belief, and World-Making in Animation* (Berkeley, 2013), pp. 262–68.

the threat of being swallowed by it, immersed in its spatial and temporal logic.

Admittedly this comic page is more extraordinary than the norm, but the possibilities McCay so ingeniously seized and exaggerated here are not unique. They are inherent in the medium, apparent to varying degrees in all comics, and other examples play the game so gloriously displayed here. This page lays out for us the acrobatic skills and vertiginous sensations that the comics call on us to exercise. It transforms the act of reading into a game (Bukatman has sagely observed that "reading comics is easily understood as a form of play") (*PS*, p. 11); it so aligns pictures that they seem to move, and it also yet makes us aware of our role in generating motion from still images. Quoting Bukatman again, "The printed page has indeed become a playground, for the reader as much as [comic characters]" (*PS*, p. 12).

Writing between the Lines

RRReeeaaaddd ttthhhiiisss fffiiiillllmmm
— inscribed on the film surface of Patrick
Clancy's *Peliculas* (1979)

Comics play with the process of reading by crossbreeding the linear succession of written or spoken language with the different (possibly opposed) temporality and perceptual processes of looking at images. Such hybridity extends beyond comics, constituting an alternative popular tradition to the modernist concern with maintaining media specificity, beginning with Lessing's essay defining the different temporality of language and images and the need to stay within their boundaries. By varying the nature of the images, the means of their succession, and the way in which the flow of language functions, this hybrid tradition gave rise to several media (the panorama, comics, the cinema) as well as genres (the comic strip, the graphic novel, the broadside).

Comics' dynamic nature eludes formal description unless the action of reading is factored in—the participatory interaction between reader/viewer and comics. Comics are not inert objects; they must be read to be experienced. The power of comics to make reading playful partly explains its attraction for children, as they master this essential but often fearsome task of delivering themselves over to the regime of written signs. Comics show us that reading can exceed and break its dominant rigid protocol, liberating the imagination, expanding the frames.

In order for comics to liberate reading, they must first liberate the act of writing, reuniting the art of calligraphy with the art of making images. Bukatman has nicely characterized Johann Wolfgang von Goethe's reception of Töpffer's early comics as work that is "something between writing and drawing, a kind of handwriting or calligraphy that combined aspects of the iconic and the symbolic" (*PS*, p. 83). Thus comics transform early childhood's complementary tasks of acculturation (whose often traumatic nature we tend to forget) into a carnival of subversive delight. A fanciful strip by *Le Chat Noir* artist Adolphe Willette says/shows it all. Serving as preface to his 1926 book *Pauvre Pierrot* and dedicated to his school master,

The Origin of Pierrot enacts the birth of comics out of the spirit of writing (see *N*, p. 4).

We see a page from a schoolboy's copybook with seven spaces scored laterally across the page with sharp straight lines (fig. 4). The first of these contains three carefully written capital *A*s, exemplars in the drill of training a child's hand to trace identical shapes and place them carefully upon an undeviating line. The last four of these letters deviate, distort, and begin to lift off the baseline with a will of their own. The next line regains composure, as five perfect small *b*'s line up correctly—but then not only levitate but twist with varied motions. The third line has migrated entirely from scriptural into the figural, as the little *b* (for bébé?) morphs first into an infant, then a crescent moon with a raven (or a black ink splotch?) perched on it, which (as the figural becomes a narrative of succession) frightens the child, now costumed as Pierrot, who runs off to the right (following the direction of writing), stumbling as he reaches the margin.

The following line of writing makes a concentrated effort to restrain this figural play by returning to regularity and repetition. Instead of loops that float off the page and give birth to babies, strictly straight lines are traced, angled slightly to discipline the hand towards the slant of cursive writing. But by the end of the line these strokes become tremulous and uneven. The next line attempts to restore control, with similar results as it nears the margin. The strokes of the sixth line slant precariously until pairs of lines transform into a stick figure, fully endowed with a graphic sense of motion, grabbing a stick. In the final seventh line the stick figure either executes a dance or kicks the ass of another stick figure and then mutates into a Pierrot dressed in tails as his stick becomes successively a fencing foil, a discharging pistol, a clarinet, and finally a slapstick with which he flattens a fleeing black cat whose outstretched paws claw the signature of the artist at the bottom of the page.

If I had to prove the complexity and compression of meaning comics accomplish, I could rest my case with this example. With elegant economy the strip captures civilization and its discontents. The repressive drill of learning to write generates imaginative forms of escape. But this bildungsroman also culminates in the mastery represented by the perfect penmanship of the cursive artist's signature inscribed beneath the cat's paws. The artist has learned to fashion a name for himself through a process both playful and violent—as most games are. Clearly the hybrid reading habits of the reader are exercised here, as we oscillate between reading a line as a differential element within a system of signs or as miming the rhythms of life and the progress of action by becoming an image. The strict left-to-right order of repetitive pedagogical regimes becomes the flow of surprising actions, emotions, violence, and mishaps. We learn to read this narrative by following the linear course of the exercise; in the process we not only transform line into image but convert linear progression into story and metamorphosis.

We could read this strip as yet another allegory, one of the profit that comes from hybridity. Through subjection to the succession of writing, images do not simply contra-

47

Figure 3. Winsor McCay, *Little Nemo in Slumberland* (1906).

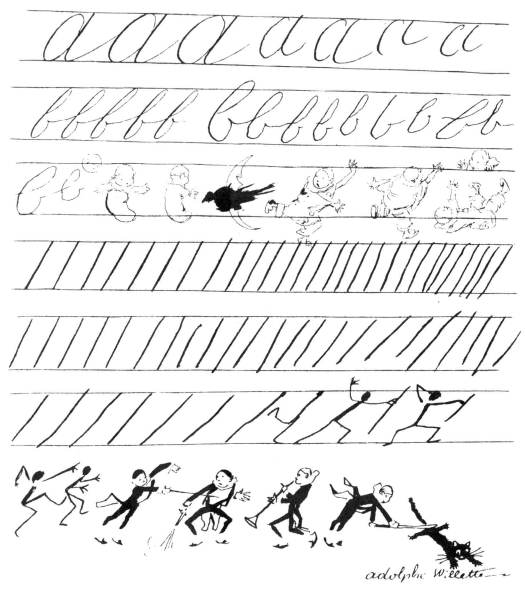

48

Figure 4. Adolphe Willette, *Origin of Pierrot* (1926).

dict their essential nontemporal nature but take on a new role: writing stories through the flow of line and drawing. That which Lessing had separated join together in the comics and give birth to new forms of expression. But I see another story behind this. Willette's strip reaches back to the prehistory of childhood recalling the primal trauma of acculturation to which comics provide a response of resistance and adaptation. But if Willette revives memories of the origins of writing in our earliest education, this strip also reminds us of comics' relation to the earliest stages of writing itself and the revolution it endured as it moved from the pictographic to the phonetic. Willette, like his colleague Steinlen at *Le Chat Noir,* was a proponent of the wordless strip (*Histoire sans paroles*) (see "V"). When asked about the frequent obscurity of his wordless narrative, Willette responded, *"Comprenez-vous l'ecriture Pierrotglyphique?"* (quoted in "V," p. 8). This caprice of defining his graphic style as pictographic writing demonstrates, as does all his work, that a lack of words does not mean a lack of writing. Comics do not simply combine words and images but rather contaminate and transform one by the other. In comics, images, forced into a flow of succession, take on the form of reading, while writing regains the dimension of imagery.

The comparison of comics to pictographic writing is another commonplace that has perhaps been dulled by general acknowledgement but whose implications need to be unrolled. McCloud discusses the relation of picture writing and comics as an essential part of his broad definition of comics. He claims that "the earliest words [presumably he means written words] were, in fact, stylized pictures." However, he adds, "It didn't take long, though—relatively speaking—before ancient writing started to become more abstract," adding, "the written word was becoming more specialized, more abstract, more elaborate—and less and less like pictures" (*UC*, pp. 142, 144). This transformation from pictographic writing to a phonetic alphabet provides an important background for McCloud's understanding of what comics do. However, his admirable pedagogic clarity leads to a simplification. He speaks of pictures and words drifting "as far apart as was possible," obscuring the stakes behind this transformation and naturalizing it as a process of evolution ("It didn't take long, though") (*UC*, p. 145). As with McCloud's tape-measure clock, history seems to accomplish things simply by taking place.

A more considered account of the transformation of writing by paleontologist André Leroi-Gourhan supplies a context, which supports, but also complicates, McCloud's schema. Leroi-Gourhan stresses that the development of writing involved the coordination as well as the differentiation of the graphic and the strictly linear phonetic aspects of writing. His terms return us to Lessing's distinctions: "graphic symbolism enjoys some independence from phonetic language because its content adds further dimensions to what phonetic language can only express in the dimension of time."[31] Thus the relation between writing and image involves an inherent ten-

sion, a tension based in fundamentally different relation to viewers/readers in terms of time, space, and visuality. "Graphic expression restores to language," he claims, "the dimension of the inexpressible—the possibility of multiplying the dimensions of a fact in instantly accessible visual symbols" (*GS*, p. 200).

Language constitutes an essential moment in human evolution, both physical and psychological, the coordination that Leroi-Gourhan traces between speech and gesture, mouth and hand. Language represents another level of human evolution with the introduction of writing or more broadly what he calls "graphism."

> While it can at a pinch be claimed that tools are not unknown to some animal species and that language merely represents the step after the vocal signals of the animal world, nothing comparable to the writing and reading of symbols existed before the dawn of Homo sapiens. [*GS*, p. 188]

Leroi-Gourhan's concept of graphism marks out a space prior to the opposition Lessing describes between picture and language. The interaction of the rhythm of oral speech and the gestural rhythms of inscription determine the original scene of writing and reading. He sums up his claim: "figurative art is inseparable from language and proceeds from the pairing of phonation with graphic expression. Therefore the object of phonation and graphic expression obviously was the same from the outset. A part—perhaps the most important part—of figurative art is accounted for by what, for want of a better word, I propose to call 'picto-ideography'" (*GS*, p. 192).

Graphic symbols maintain a relation between the pictorial and the linguistic, a relation that grew more distant and distinct as language and writing developed:

> Two languages, both springing from the same source, came into existence at the two poles of the operating field—the language of hearing, which is linked with the development of the sound-coordinating areas, and the language of sight, which in turn is connected with the development of the gesture-coordinating areas, the gestures being translated into graphic symbols. [*GS*, p. 195]

The tension between the visual gestural/graphic mode of language and language as a linear phonetic system remains productive throughout history. According to Leroi-Gourhan:

> The invention of writing, through the device of linearity, completely subordinated graphic to phonetic expression, but even today the relationship between language and graphic expression is one of coordination rather than subordination. An image possesses a dimensional freedom which writing must always lack. [*GS*, p. 195]

49

31. André Leroi-Gourhan, *Gesture and Speech*, trans. Randall White (Cambridge, Mass., 1993), p. 195; hereafter abbreviated *GS*.

This transformation does not take place through the gradual morphing of writing towards abstraction or a simple drifting apart of word and image. Rather, cultural transformations determine this revolution in human culture. The subordination of graphism to the purposes of account books, royal lineages, and national chronicles demanded a univocal meaning and a system of signification and regularity for the process of record keeping through writing. Writing as instrumental activity differentiated itself from the child's play of scribbling.

To summarize this schema: coming from a common origin, language develops in two modes: the graphic—or, as Leroi-Gourhan refers to it, the mytho-graphic ideogram—and the linear phoneticized writing that developed with the tasks of bookkeeping and genealogy. The increasingly linear and speech-dependent aspect of written language served as an efficient tool for the conveying of information, as "writing is viewed as an economical method of transcribing narrow but precise concepts—an object achieved most efficiently by linear alignment. The language of science and technology meets such a definition and the alphabet meets its requirements" (*GS*, p. 209). But Leroi-Gourhan questions the entirely positive progression of this definition. While the instrumental view of writing renders tasks of organization and communication more effective, the elimination of the mythographic aspect of writing risks muting vital aspects of human culture. He claims:

> Language was placed on the same level as technics; and the technical efficacy of language today is proportional to the extent to which it has rid itself of the halo of associated images characteristic of archaic forms of writing. . . . Such unification of the process of expression entails the subordination of graphism to spoken language. . . . However, it also entails an impoverishment of the means of nonrational expression. [*GS*, pp. 211–12]

Behind the aesthetic imperative Lessing saw in separating the instantaneous image and the course of writing lies a profound tension between different forms of communication in relation to time and even different modes of thought and expression. Bringing them together opens a vibrant but hybrid space, fusing writing, narrative, linearity, and imagery. While as scholars and critics of comics we must remain wary of both utopian genealogies and Manichean dichotomies, forging a relation to a form of writing that is bound to physical gesture and imagistic communication grounds comics in a discontinuous but rich tradition. Leroi-Gourhan's concept of graphism as being at the root of writing influenced Jacques Derrida's grammatological approach to writing as a trace that precedes the transcription of the voice through phonetic alphabet. But graphism that aspires towards the imagistic opens a somewhat different (if possibly related) approach, one that extends (but also transforms) Lessing's alignment of language with temporal succession. Viewed in this perspective, the flow of writing not only mimes the course of time but also the sweep of motion (the cinematographic [or writing of motion], to invoke the name that the Lumières gave to their invention). Thus more is at stake here than simply seeking out an ancient pedigree for comics; the place of this practice within a countertradition of writing becomes clear, a tradition that runs as alternative current in the recurring fusion of written and visual forms over the centuries. Leroi-Gourhan's contrast of the mythographic ideogram to the phonetic alphabet had in fact been anticipated in Benjamin's analysis of emblems and allegory in the baroque era: "So it is that alphabetical script, as a combination of atoms of writing, is the farthest removed from the script of sacred complexes. These latter take the form of hieroglyphics."[32] According to Benjamin, "at one stroke the profound vision of allegory transforms things and works into stirring writing" (*OG*, p. 176). The emblem books and alchemical diagrams of the seventeenth century related in style (and often in mode of production) to the contemporaneous popular broadsides that provided the direct ancestors of comics. But given the double perspective—superimposing the modernist on the historical—that Benjamin sought in his nonhistoricist vision of the baroque, his phrase "stirring writing" also seems intended to recall modernist experiments in typography. Stéphane Mallarmé's "Un Coup de dés," with its erratic typography invoking the rhythms of a ship in distress, not only inaugurates the tradition of writing that Christoph Wall-Romana describes as cinepoetry (in which writing invokes the moving image yet remains resolutely a form of writing), but exemplifies the phrase John Osborn translated as "stirring writing."[33] The original German is "erregende Schrift."[34] The verb *erregen* means to arouse, excite, even to anger, and the present participle can mean dizzying. Stirring in the sense of both moving in itself and stirring up the reader seems a good equivalent. In other words, according to Benjamin, the writing of the baroque aspired to convey the effect of physical and emotional motion, a language beyond the simple atomism of phonetic verbal transcription that instead, as Benjamin says, "tends towards the visual" (*OG*, p. 176). It is from this hybrid of writing, imagery, reading, and motion that the comics spring. But more than referring back to primal sources, comics keep this tradition vital.

32. Walter Benjamin, *The Origin of German Tragic Drama*, trans. John Osborne (New York, 1998), p.175; hereafter abbreviated *OG*.

33. Besides Wall-Romana's brilliant discussion of cinepoetry, another recent discussion of the blurring of boundaries between the media of writing and pictures within a flow of reading occurs in Pavle Levi's recent book *Cinema by Other Means*, in which the author intriguingly discusses a variety of avant-garde works that invoke the cinema's flow of images "by other means" both pictorial and written. His insightful discussion of comics anticipates some of the claims in this essay, although I personally find his invocation of the Lacanian concept of the suture unnecessarily entails connotations of ideological complicity in the flow of images, and so I avoid it myself; see Pavle Levi, *Cinema by Other Means* (New York, 2012), esp. pp. 139–44.

34. Benjamin, *Ursprung des deutschen Trauerspiels* (Frankfurt, 1963), p. 196.

Epilogue: Cavemen of the Future

In 1916, Vachel Lindsay—American poet, social reformer, advocate for public art, and visionary crackpot—published *The Art of the Moving Picture* (revised in 1922), one of the first books to claim cinema as a modern art form. Lindsay wrote that the movies (barely two decades old when he first published the book) represented a revolution in American culture and writing which he called hieroglyphic:

> American civilization grows more hieroglyphic every day. The cartoons of Darling, the advertisements in the back of the magazines and on the bill-boards and in the street-cars, the acres of photographs in the Sunday newspapers, make us into a hieroglyphic civilization far nearer to Egypt than to England. . . . But there is not a man in America writing advertisements or making cartoons or films but would find delightful the standard books of Hieroglyphics sent out by the British Museum, once he gave them a chance.[35]

Lindsay's millennial dream celebrating a popular culture which married words and images (emulated in his own illustrated poems, inspired by William Blake) seems prophetic. Like many early twentieth century modernists, Lindsay envisioned the new popular arts as a sort of primitivism, a return to primordial sources (he admiringly referred to the new movie fans as "cavemen").[36] It is hard now to take seriously his claims that transformations in language will issue in the broad social, not to mention historical and even cosmic, revolutions that Lindsay predicted for the twentieth century. But the changes in media that followed his predictions are undeniable. It may be naïve to see the pictorial narratives appearing since the end of the eighteenth century, and ever increasing in their omnipresence, invading all areas of cultural endeavors, as healing an ancient breach in the history of human language. But the popularity and hybridity of their play with time certainly responds to aspects of human experience that the isolation of media seemed to close off. Comics reinvent not only a form of visual storytelling but transform the process of writing and reading that mark our first entry into the adult world of signification and linear temporality.

35. Vachel Lindsay, *The Art of the Moving Picture* (1916; New York, 1970), pp. 21–22.
36. Ibid, p. 291. For this primitive motif in film theory, see Rachel O. Moore, *Savage Theory: Cinema as Modern Magic* (Durham, N.C., 1999).

Bartheses
Barthesian Doubt edition

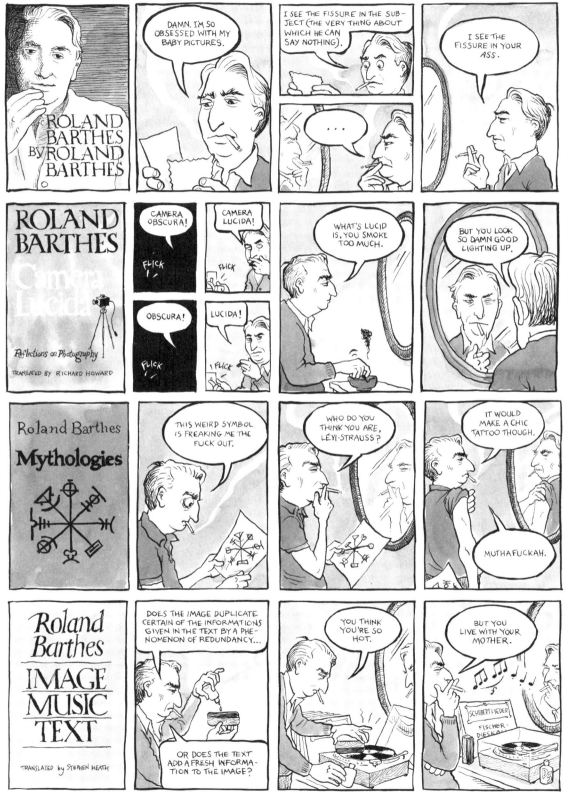

By Hillary Chute and Alison Bechdel, with a tip o' the nib to Noah Feldman and apologies to Kate Beaton.

Public Conversation:
Joe Sacco and W.J.T. Mitchell
May 19, 2012
Introduced by Jim Chandler

JIM CHANDLER (from his introduction): The first time I heard Joe Sacco introduced I knew who he was but I hadn't yet read him. The introducer, Dan Raeburn, made a lot of it—the fact that he was a comics journalist rather than a graphic novelist. I confessed, at the time I wondered about what seemed like the preciousness of this distinction. I later learned from Hillary Chute that Art Spiegelman got *Maus* moved from the fiction to nonfiction [bestseller] list of the *New York Times*. Now that I have read Sacco's work, I learned I was mistaken. These are not books of fiction but of witness and much depends on a sense we are getting a record of the truth, one based in firsthand reporting, extensive research, even archival documents of the sort that are included at the end of *Footnotes in Gaza*. His thoughtfulness about his subject comes through when he talks about his work, as you'll see, but it is evident enough already in his text. As he explained in a recent interview with Hillary Chute, he writes the words first and blocks out the spaces for them on the page before he draws a thing. There is also something to be said about the way he represents himself in these graphic narratives. He always represents himself with no eyes behind his glasses. There are a number of interpretations one could place on this. Is this an act of representing a kind of Homeric blindness that allows him to see things others can't see? Is it the idea that his eyes reflect rather than see the world? Or are these empty spaces peepholes for us ourselves to see the world afresh? I hope this is the sort of topic that will come up in the discussion that follows.

W.J.T. MITCHELL [to the audience]: Is this the best blankety blank conference you've ever been to? *[laughter]* I've been asking all my colleagues, why can't professors learn to talk like this? It really is inspiring. *[applause]* This wonderful medium of comics has its own history, its own kind of specific character, but in our time and in this moment it is going through some amazing mutation that we're all trying to grapple with. But I can give one very short answer to what the blankety blank happened to comic books. Joe Sacco happened. His unique synthesis of journalism, history, and comics has revolutionized the nature

of the medium. But Joe: I want to hear your answer. What do you think? What happened to comic books? And what did you have to do with it?

JOE SACCO: I don't know if I want to answer that. I'll let historians answer that question. Academics. I think what happened to comics is a space sort of opened up for adult comic books. Generally speaking most comic books that I knew when I was growing up were for kids, and I think the undergrounds in the 1960s opened up a space. And then Art Spiegelman opened up a space. And I feel I'm of that generation of comics that went through the doors that were opened up by that group of cartoonists. So I think it had already happened. But it just took time for editors and others to acknowledge it. It was happening before I was there.

MITCHELL: Can I argue a little bit about the adult question? If it were just that comic books became something for grown ups, how is it that to me the really wonderful thing about comics is a certain refusal to grow up in a normal way, or to accept some kind of routine notion of what adulthood amounts to? It seems to me that one of the secrets of the comics medium (and I think the session we just heard on "Comics and Autobiography" bears that out), is that it is a kind of second childhood that has come to comics in our time. Would you agree with that?

SACCO: I look at my life and I don't feel it is a childhood, but I feel really lucky that I'm sitting there drawing, which was a childhood thing. I think all kids draw and some kids just stop drawing—the vast, vast majority—and the ones who just keep drawing end up being cartoonists, or illustrators, or something like that.

To me it is not an extension of my childhood so much. I think the drawing grew up with me in some ways. But I think what I've always liked about comics—and I'm talking about the underground tradition and what has followed—is the subversive nature. If you want to compare that or confuse it, whatever you want to say, with being childish, I don't know, but I think that it is subversive somehow. You can do things with comics; you can sort of

let your hair down in this way, and there was that beautiful moment in the 1980s and early 1990s when I realized no one is really paying attention. You can find your own voice without people barking in your ear.

MITCHELL: I want to get to the journalistic and the historical character of the work that you are doing, and I should mention that I first heard Joe Sacco's name from Edward Said, who said, "Have you read Joe Sacco's *Palestine*?" I had been to Palestine several times and I hadn't.

I want to talk not so much about autobiography but about self-portraiture, how you see yourself, and especially how you draw yourself. You insert your own image into the narrative much more prominently than normal journalism and history would permit. The first time we met, about a year ago, I said, "You are much better looking in person than in your comics!" You said, "Everybody says that!" But why is that? Why do you have the ugliest mug of all the characters in your pictures?

SACCO: If you look at the first issues of *Palestine*, they are what we call in the comics profession the "big foot style," very much influenced by Robert Crumb and other cartoonists, where everything is exaggerated, everything is lanky. That was the way I was drawing myself. But if you look at the first, let's say dozens of pages of the book Palestine, everyone is drawn like that. After I finished the first issue—and in those days they were mainly coming out as comic books in the pamphlet sense of the word—I heard that a Palestinian playwright had seen the cover and before she even looked into it she tore it up because she felt the representations of the people were stereotypical in the worst possible way. And I heard the same thing from Jewish friends saying, oh, you are drawing Jews with big noses. You know, that's just the way you draw when you are influenced by the underground cartoonists. Everything was grotesque to me. I was grotesque. I'm interested in the grotesque somehow. But I thought about it and being an adult I thought, well, if this is aspiring for some sort of journalistic truth, I have to be a bit more accurate in how I portray people and things. And you'll see that [in] my way of drawing people I forced myself to draw representationally, which is not natural to me. It still isn't. But my own character—it wasn't intentional, but I just ignored it. It was only a couple years later when someone said, "Well, you know, everything else looks more real but you don't." And I hadn't really thought about it, frankly. People tell me that I draw myself in a grotesque way, and I kind of nod my head and agree, but it was very unintentional.

The thing is, you can draw yourself the way you look or you can draw yourself the way you feel. I sort of fall in that latter category. I often feel the way I'm drawing myself. There is an accuracy in that drawing. That's what drawing is. It is going to some other form of accuracy sometimes.

MITCHELL: How were you feeling here [in *Palestine*; fig. 2]?

SACCO: I was badly fed up with things and I think this is a scene from where people were trying to get me into their shops in Jerusalem, I put that sort of city face where you walk by beggars.

MITCHELL: The blank eyes here are a refusal to make eye contact?

SACCO: I want to show some part of myself that's true, but not everything. It is a signal to the reader.

MITCHELL: I always thought that *Maus* was the defining moment when the comics medium addressed the greatest catastrophe of the twenty-first century. But you have

Figure 1. Detail from Joe Sacco, *Palestine* (1996).

taken up the catastrophes of the late twentieth and the early twenty-first centuries. I suppose it is just an obvious question, but what drove you to that? Art led the way in taking up these incredibly serious subjects of atrocity, horror, terrible crimes, and you have followed it up in Bosnia and in Israel/Palestine. What led you to do that?

SACCO: Compulsion, I guess. It is weird to talk about it in a way because you want the work to speak for itself. Because you don't want it to sound trivial. A sense of outrage of what is going on in the world. That sounds kind of maybe silly or trite somehow.

MITCHELL: Not to me.

SACCO: Perhaps it sounds silly in our ironic age. But compulsion—that's pretty much it. With *Palestine*, my training in journalism played a big role in my motivation. When I began to read about what was actually going on with the Palestinian issue, I was furious at American journalists, and the American style of journalism in which I had been trained. I realized that you could write "facts" about something and still not tell what is really going on. It is that sort of anger or indignation that drove me toward that subject and others. Anger is to me a constructive force. I was looking for an outlet and that was comics—I was already doing comics and I thought, well, I'm a cartoonist, so how do I put this together? Well, go and do comics about these things.

MITCHELL: Paradoxically this medium which is so often dismissed as childish, trivial, sub-literary and so forth has been the place where a certain kind of justice seemed to be at stake, and where [we see] the ability to penetrate official so called grown-up views of the world, to look freshly at reality—that's another way in which I think of it as a second childhood. I was led by *Mad Magazine* to this perception very early. Suddenly I saw what irony was, and not just irony, but a kind of irony that penetrates, that peels off the surface. This seems absolutely crucial—irony and satire as revelation.

SACCO: That panel that Art showed of "Mickey Rodent" from the EC *Mads* [with] one of the characters being hauled off by the police—that *Mad Magazine* was also really important to me. I used to read *Mad Magazine* when I was a kid, but I didn't understand a lot of the parodies, because they were so specifically about a movie I had never seen. It was only when they started reprinting the EC versions and putting them in the *Mad* special [editions]—where they would reprint the *Mad* comic from the 1950s—that the revelation occurred to me.

Mad stood on its own even when it was not making fun of anything specific. And that really worked for me. Will Elder's work in particular, I didn't think things could be done that way. It just kicks open something in your head. And suddenly I was drawing like Will Elder, filled with attention to detail, which became very important in my work. Go home and read your *Mads*.

MITCHELL: And the very word *Mad* resonated with two meanings: it was the right to go crazy, but also the right

to get angry and to reveal the truth hidden by adult hypocrisy. I think that's why it was so inspiring to a whole generation and still has resources for us.

SACCO: There are periods where you go along and suddenly you encounter something, it can be a book, it can be a movie, that just opens up another door. It is like reading Ferdinand Céline or Samuel Beckett and their wild way of telling things and you think, wow, I wish I had some of that. It is not like you can put it in your work directly, but it just inspires something that makes you try to think in a different way.

MITCHELL: I want to say, one of the things I love most about your work is what I might call the unserious moments when you are on your mission as the agent of truth, justice (but certainly not the American way). Here you are supposed to be going to Palestine to talk to and help their people, to tell the truth and aid in the cause of justice, and they are just harassing the hell out of you. But you show yourself as just a guy on his way to work (there is no cape

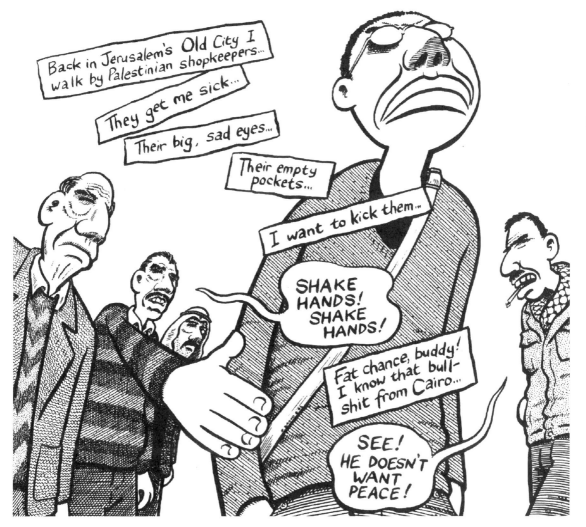

Figure 2. Joe Sacco, *Palestine* (1996).

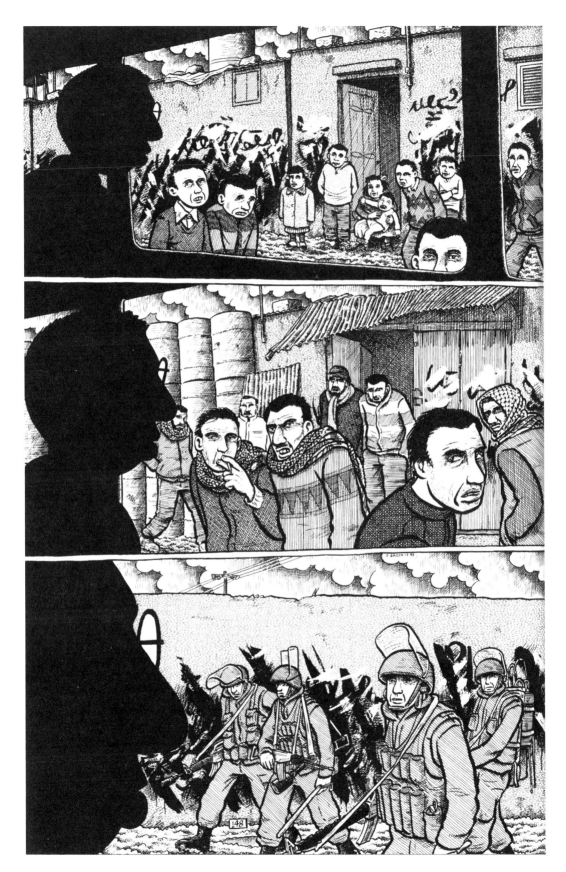

Figure 3. Joe Sacco, *Palestine* (1996).

in sight, just those blank glasses). These are the moments that strike me as really giving a frame to the much more serious moments, the moments when we are confronted with atrocity. How to you do that? Do you think about the need to ease the reader in or transition into what are often really horrible realities that you are coming to?

SACCO: I think I used to be a bit more conscious of trying to transition the reader and trying to balance—put some humor in it—but now I've learned just to stay out of the way. Because even in some of the worst situations there is humor anyway. And the trick is to stay out of the way of the humor and let it be there. I mean, I talk to a lot of journalists and sometimes I'll read something they write and they are so focused on the main issue that they don't allow for those humanizing moments that actually reveal the people they are talking to as human. It is just a question of staying out of the way of those moments. It is not like you have to find them. They are there all the time.

MITCHELL: Let me show you another picture, another self-portrait, with lots of figures in the background. You treated yourself here [in *Palestine*] as a silhouette. A shadow on the scene. What were you thinking about in doing that?

SACCO: There was an unreality. Because this was a tour of Jabalia refugee camp, a real hard place. This was the late 1990s where you could go to the UN and say, yes, I want to take a tour of a refugee camp. They would say, okay, get in the van and we'll drive around. They would say, look at this and look at that and they kept saying, if you want to stop and speak to people, you can. And I couldn't bring myself to stop and speak to anyone because I felt that I was on a safari. And that's what this is getting to in some way.

I didn't want to stop anywhere. I just wanted to go home. We stopped at a clinic where they were teaching deaf kids how to speak. And some guy who was a teacher there just looked at me and said, if you really want to see the camp, just come back. I'll host you. I thought, okay, and that's how I really saw the camp.

MITCHELL: So here is another image of you arriving in Sarajevo, from *The Fixer*. This image haunts me all the time. I think it is partly the sky. The way you render it. It is so intense. And also the figure of the partly bombed out, very modern buildings and then you completely alone. This is a kind of motif—you are not always with crowds, not always in the midst of action. Sometimes you are just there, all by yourself.

SACCO: This is a particular situation where I had just come over Mount Igman with French troops and I transferred to a civilian bus. I didn't know where I was. I told the bus driver I'm going to the Holiday Inn. I know where journalists go. I'll go to the Holiday Inn. I figure that's where journalists go. The bus stopped and I said so where is it? Someone just said, down there. And there were like these sniper walls. You have to pass by the sniper wall and say, oh, man, this is not a good feeling because no one was

there. I mean—that's a clue that it is probably not a good place to be. *[laughter]* So I could have described everything I have told you in words. In fact I think in my script I actually did have words. But then part of the process of doing a comic is saying, okay, what words go out? When does the picture speak for itself? And I realized in this case, no words are necessary at all if you want to create that mood. You don't want to talk about that mood. You want the reader to have that mood.

MITCHELL: But this also strikes me in some way as so antithetical to conventional grown-up journalism, in which the journalist is supposed to be so well informed. He's supposed to have done the research. He's supposed to know where he's going.

SACCO: Right. I've been around a lot of journalists and I would say that a few of them are grown-ups. *[laughter]*

MITCHELL: I'm reminded here that during the first Gulf War, cameraman Mark Biello, who was the "eyes" of CNN's *Live from Baghdad*, described their crew as "first to go, last to know."[1] This picture of you, all alone, going into this war-torn region really does haunt me. Can you talk about the sky? Why were you drawing it that way?

SACCO: I remember once someone asking me in a crowd like this, you know, "That picture—what is that stuff in the sky?" I said, those are the clouds. Of course I hadn't drawn them in any way realistically. But the thing about comics—I'm doing journalism but it is a fluid medium so there is an expressiveness about drawing that I don't want to lose. Essentially the oppression is what I'm trying to get to. It was a very overcast day, and to me this is how it felt. It is not a journalistic attempt to say that there was actually a cumulus cloud there. It was dark. It was oppressive. It is an expressive way of drawing it.

MITCHELL: Kind of psychic clouds? How the sky felt, not how it looked.

SACCO: Perhaps.

MITCHELL: It just occurred to me—I often see you in scenes like this in which the landscape dominates. You don't just draw people, figures, actions, but pay a lot of attention to environments. So the whole space around the characters is as important as the figures themselves.

SACCO: To me the landscape is a character somehow. That's what you often remember about a place. I feel that's what I have to convey—just as much as the people is what it looks like. Why else would I be drawing this stuff?

MITCHELL: In some cases you've done real studies of a place. In *Footnotes in Gaza*, first you begin by narrating a history of Gaza and dwellings, and the whole sequence from basically hovels and caves to primitive clay huts to when the Quakers arrive; they build cabins. So it seems to me that you perhaps are trying to deal with what the Jesuits called "composition of place" in their meditation practices. You want to put the viewer into the place not just for

57

1. See my *Picture Theory* (Chicago, 1994), p. 403, for a critique of CNN's "eyewitness" style. —WJTM

59

Figure 4. Joe Sacco, *The Fixer* (2003).

the action but for the feel of the whole environment.

SACCO: I don't know what other function I would have. If you are depicting something graphically and it has a pretense to journalism, the idea is to get the reader there somehow. So landscape—what it looked like in the past, what it looks like now, all that's important. I want the reader to open up the book and just immediately be there. I think [that is] the power of the image.

ROBERT CRUMB [from the audience]: It works!

SACCO: Thanks.

KOMINSKY-CRUMB [from the audience]: Very menacing sky.

MITCHELL: So let's consider this picture: a street scene in Gaza from your book, *Palestine* (fig. 5). One of the greatest misunderstandings of the comics medium, in my opinion, is that people think that comics are "easy reading," that you can skim through them quickly and take it all in. But when I look at this street scene, it strikes me as being— I'm not trying to flatter you—Brueghelesque. A panorama filled with detail. No central subject, no main action. But lots of little incidents going on here in the tradition of the great realist painters.

SACCO: Brueghel is a big influence. This is also in the tradition of Will Elder to me.

MITCHELL: You want to explain that?

SACCO: In the sense of the detail and paying attention. And in this particular case, I mean being a Westerner growing up and going to high school and all that stuff, when you are in a place like this, it is truly overwhelming. I wanted to give that sense of just being overwhelmed by things going on. It is not one thing in front of you that you can focus on. It is many, many, many moving parts all at once. And something like this is meant to give the reader that feeling.

MITCHELL: The feeling of too much to take in?

SACCO: Too much to take in, but also giving a lot of information if the reader wants to study it. Pages like this have no words, but they are meant to be read slowly. Sometimes, actually, words are meant to carry you very quickly across a page, but an illustration, a sort of splash page, is meant to slow the reader down.

MITCHELL: In the spirit of that, Art Spiegelman says his comics are meant to be read to the sound of a dripping faucet.[2] Could we let the faucet drip for a few minutes—do a slow reading of this?

SACCO: Sure. This is the van I'm in. Kids are getting out of school. They all have their little uniforms on. Often their mothers were bringing them back from school. Then there were the goats or sheep at the open garbage. And everyone was driving Peugeots in those days, so I took a lot photographs of Peugeots. There were the concrete barriers that are meant to cut off avenues of escape if there is a clash

with soldiers. The graffiti everywhere. You'll see it along the walls. There would be political slogans everywhere. In those days everyone had a slogan, every Palestinian faction. Then Israeli soldiers would come by and pull some young men out of their houses and give them paint and say, "Paint over it." That's why you see the slogans were always crossed out. It was very heavy rains when I was there, and I wanted to depict that sense of mud and weather. The four days or five days I was there in Gaza at this point, homes had been flooded out. I wanted to get that across. So there are many elements in this big page that are in individual panels later. Repeated imagery to me is the power of comics because it is different than photography. Photography's strength to me is one image tells the whole story. To me the strength of comics is that many images tell the story and you can repeat certain things. Like the mud or the garbage or the graffiti. You don't have to mention it. The reader is there all the time with those things.

MITCHELL: The blocks on the roofs?

SACCO: That's to keep the roofs from blowing off. It is very stormy, so those are corrugated asbestos roofs. So people would put cinder blocks on top, tires, anything that would hold the roof down during the storm.

MITCHELL: And the point of view?

SACCO: That's the great thing about being a cartoonist. If you know something about drafting or perspective, you can pull yourself up.

MITCHELL: So you didn't base this on an aerial photo or helicopter shot?

SACCO: No. I didn't have the money for a helicopter tour.

MITCHELL: There is also the disposition of the figures, the way you have arranged things. All these little mininarratives.

SACCO: The thing about drawing is you have to think about, "How do people walk in mud?" You begin to think about balance and the way people are avoiding things and how that shifts the body. It makes you kind of inhabit everything you draw.

MITCHELL: I think you could spend a lot time slow looking. But there is also slow listening, and there are many scenes of this sort that you elaborate where you are basically just listening to somebody narrate. You are no longer telling the story. Somebody else does the storytelling for you. Here [from *Safe Area Goražde*] is an eyewitness to the incident when Serbs brought Muslims to a bridge and shot them. Do you know where this man is now?

SACCO: I don't. I remember interviewing him in a refugee camp. The thing about the interview—I didn't want to put it in there because it would break up the way I established how I would depict the interviews. While he was telling me the stories of people getting their throats cut on the

2. As instructed in Spiegelman's 1973 "Don't Get around Much Anymore," collected in *Breakdowns* (New York, 2008). —HLC

60

Drina River, he was watching a football game on TV. Like a soccer game on TV. So he had his eyes half on the TV and he was telling this story watching the TV.

MITCHELL: Amazing. And as he tells the story, you begin to see it, or to draw it, to depict it. I don't know if there is any other medium that can do this quite this way. You are a translator of his words into your images, or are they his images? Are you doing that as you listen? Because a lot of what you are doing is not photographing—and you don't sketch live on the spot I take it.

SACCO: An image might come to my mind, but generally, you know, being trained in the straightforward journalistic way, it is about talking to this guy, keeping him on track. Journalism is cold sort of work. You are trying to get the information out of him. People often digress. They get off-track. So I'm focusing on his words and getting him to tell a story. Sometimes the last part is told first and I say, now, let's back up. You constantly have to sort of help him tell you the story. Later—only then the problem becomes, how am I going to draw this bridge? I am not going to get there because it was the end of the war. The war was still going on and it was impossible for me. I actually found photographs of it. So I was able to draw it accurately.

MITCHELL: So there was a photographic basis of this scene?

SACCO: Of the bridge, certainly. Of the killings, that was based on his description which was confirmed by other accounts, and even read [about] elsewhere, where [others] described the same sorts of things. Obviously I'm a filter. I mean, I do all I can to be as accurate as I can, but there is no getting around the fact that I'm the one who is translating his experiences into drawing, which by nature is a subjective act. But as much as possible I'm trying to use the information I've been given to depict something, to get to the essential truth of what happened.

MITCHELL: When I first encountered these scenes, I was reminded of the debate surrounding *Schindler's List*, Claude Lanzmann's critique of it, and his film *Shoah* which he claims was totally built around oral interviews, with no attempt to go back and see or depict the terrible events of the Holocaust. Lanzmann wanted to impose a kind of prohibition on the visual representation of these scenes of horror. I've always been of two minds about that. Of course there is a kind of pornography of violence and of atrocity. Your work does not do what *Schindler's List* tries to do, to take you inside the gas chambers. It does something else. To me the thing that makes this work is that you are well aware you have an eyewitness who is verbally telling the story, like the interlocutors in Lanzmann's *Shoah*, and the story is being translated into images by you. So it is a double translation, as if the reader is forced to understand all the layers that lie between you and this reality. That's not a question. I just wanted to blurt that out.

SACCO: It is interesting you bring up Lanzmann because I really admire the movie *Shoah*, but I don't admire him saying the only way to do it is my way. I don't agree with that. I think his movie is a work of genius. It is powerful for all the reasons he thinks it is powerful.

My problem with *Schindler's List* and by extension my own work is that in the end you realize you are setting the tone for what people are going to remember about this event. I mean there are a lot of people who are going to think of Schindler's List as that was how the Holocaust was somehow. And maybe [Spielberg has] put a lot of effort into recreating certain things, but I wonder about my own work and I think, oh, is this is the last image of this particular event that people are going to know? You realize this: there is a real, dangerous, powerful thing about representing something, because that becomes kind of a final word in a way.

MITCHELL: I want to go now to the other side of the green line. Into Tel Aviv, looking out from Israel into Palestine. This [in *Palestine*] is another one of those moments where the journalist crosses from what was supposed to be the object of the story into the other side of the story. I'm not going to call it objectivity but there is a kind of even-handedness. Here is your conversation with these two Israeli architects, in which you observe the Palestinian territories from the walls of Jerusalem. Then you go to cafes. It is all about conversation around this. The audience can track what is happening for themselves. But I wonder, why was this in here?

SACCO: In this particular case I thought it was an interesting story. It confronted me with the idea that, as many Israelis would say, you haven't told our side. Because when I told them what I was doing, that was their first question: what about us? It is a very fair question. So I spent a little time with them at that time, and then I visited them in Tel Aviv. What was interesting is that they had a certain amount of sympathy for the Palestinians, these young Israeli women, and they looked at the landscape and they—as architects, the settler landscape was offensive to them. It didn't fit in with the environment, whereas they thought the Palestinian villages fit to the hills and the way the topography [was]. So we talked about that stuff. So there is a certain amount of sympathy they have, but the deeper you get, the more defensive they got, so that it ended with a conversation in Tel Aviv where one of them said something like, you know, we know all about the bad stuff. We're just tired of talking about it. They want to just have their lives. Just like everyone even I—you don't want to be confronted with inconvenient details of homelessness or other things that are in your neighborhood. And this is another case of that. I think it is part of the human condition to get defensive at some point.

MITCHELL: It is certainly part of the Israeli condition. When I read this, I [thought], I have had this same conversation at least seventy-five times. It goes in circles.

SACCO: The liberal that isn't really the liberal. A lot of us are like that.

MITCHELL: Well, we're right here in Chicago, on the South Side, surrounded by our own problems. Some of the design of this building is meant to keep the homeless out—to keep people from using the rest rooms. There isn't one on the first floor, so those of you who need one will have to go downstairs.

61

63

Figure 5. Joe Sacco, *Palestine* (1996).

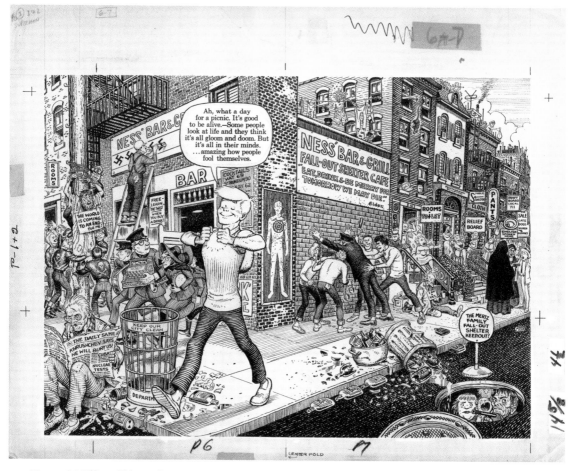

Figure 6. William Elder and Harvey Kurtzman, "Goodman Meets S*perm*n," in *Help! Magazine* (May 1962).

SACCO: I'll remember that when I'm homeless in Chicago. *[laughter]*

MITCHELL: Just by way of trying to push out a thought, I'm going to use an academic word: dialectics. But I actually prefer William Blake's word: contraries. As Blake put it: "Without contraries is no progression." Are contraries what make comics come alive? It seems to me that the vital principle of comics lies in the contraries of word and image interacting and producing third things in between, as if their multiplying effect generates an unpredictable "product." It is also the thematic contraries, in your case, especially of the incredible horror of things that human beings will do to each other. And right along side that is everyday life, the most ordinary scenes. Which is why I think you made notes to yourself [in your *Footnotes in Gaza* journal], don't forget to put in the children. Because the children are very much there in Gaza. They start over the next day. Or they continue playing among the ruins. So that's one set of thematic contraries. I wonder, is this something that you are conscious of? That you think there needs to be a kind of balance or dialectic between these?

SACCO: I'm not drawing the children as a statement of, well, there is a new generation and maybe they'll figure it out. Because actually I don't believe that. Unfortunately I

think they'll grow up to be a bunch of stinkers like the rest of us. *[laughter]* They were just around, so I drew them.

I'm trying to draw what I've seen. I'm actually not trying to editorialize or put out rays of hope. I'm glad kids are playing soccer. I've also seen kids with slingshots shooting donkeys. You see kids doing their thing.

MITCHELL: Many of the comic artists here are very self-conscious and reflexive with the medium. They are always playing with the boundaries of it. Breaking the frame, diving into the gutter—literally or figuratively. But you do it, too. Maybe not as often. This image is one that struck me because your comment on this in your introduction to the Special Edition of *Palestine* was, no, this was too much. This was kind of trying to play a jazz riff that's too much.

SACCO [Looking at slide]: That's an outtake, isn't it? It was overdoing it. I would show the guy getting beaten. I didn't want to overdo this pain. I mean concentrating on the mouths screaming and all that. And then this thing of just going off into the deep. I mean maybe it is a good image in a certain way, but it just overdid it for journalistic purposes. I mean, for journalistic purposes, he was badly beaten.

But you sort of look at it and you think, okay, now I've gone over some line. Background clouds, that's, you know,

that's background clouds. It is not the central focus. Here the central focus is these faces that are drifting off into the abyss. And I think that's just going too far. It is a matter of degree. In my earlier work I experimented more. And the unfortunate thing with doing journalistic work is you have to hold back a lot of experiments. You kind of have to restrain that part of yourself. Just because you need to tell the story.

MITCHELL: Okay.

SACCO: You don't agree?

Figure 7. Detail from Joe Sacco, *Palestine* (1996).

MITCHELL: No. I don't. Because I thought this was an attempt to put the viewer inside the experience of being beaten. Not to show being beaten from outside. Some sense of it from inside as you lose consciousness.

ROBERT CRUMB: Too technique-y.

MITCHELL: I think a verdict has been delivered on this question.

SACCO: There is a scene in the same book, *Palestine*, where there is a guy hooded, being interrogated. What I do is I increase the amount of panels so he's in a smaller and smaller space as time goes on, but I think that works because that's trying to give some feeling of oppression. But again, it is a matter of degree. I think really getting inside someone's pain, that's a matter of fiction. That's where fiction works. And I think that's where fiction can take over.

MITCHELL: Which leads me really to my last question. Which was the choice between fact and fiction. Do you see a graphic novel in your future?

SACCO: A novel novel? I think a good thing about comics is they are always such considered works by the people doing them. But they just take so damn long to do. You do three or four books and suddenly it is twenty years and everyone thinks, oh, you do journalism and that's all you can do. Then I begin to question, is that all I can do? But I would like to break out of that. And try some fiction, try essays, just try other things. I think, creatively, I think I need to now.

Q&A

MITCHELL: Does the audience have questions?

CRUMB: Technical questions. Those Brueghel-like panoramas that you do with all that detail. Do you take a lot of photos? Because you do that artwork when you go home, you can't do that in the middle of the situation. Do you make sketches? Take photos? What do you do?

SACCO: I'm not a sketcher. I only sketch when I have to. I don't carry around a sketchbook. I do carry around a sketchbook when I go, but I often come back from a place after two months and I have three pages in it. I take photo-

graphs because—I just want them for reference. My photographs are not interesting as objects at all, but: here is a car. This is the kind of thing the person is wearing.

CRUMB: I always marvel at the authenticity of the detail in your stuff. It is just marvelous. I wonder how you get that—I'm sure some of it must be from memory.

SACCO: You know, memory lasts for about a year or two. But that's why I write notes to myself in my journal. I often write very visual descriptions in my journal. I keep a very religious journal at night. That's where I'll say, don't forget to draw this, or I will describe something as a writer would describe something visually, so I can transform it later.

AUDIENCE MEMBER: When you are doing your journalistic work, you are hearing the story at least two times. First from your interview subject and then again when you are drawing it. So lots of the stories are really tragic and powerful. I'm wondering if the second time [when] you are drawing it is actually more powerful than the first time when you hear it.

SACCO: That's a good question, because the truth of it is, I mention that journalism is kind of a cold thing, and it is a very cold profession if you are doing it well. You are hearing these awful stories and you are trying to draw the person out. I mean, you are aware of the person's humanity and you don't want them to break down, but you want to get to the next step. So you are just pulling it out, and you learn over time how to do that. Really it is very clinical. It is like being a doctor. You are making an incision, you are taking out something not trying to do any damage, and then you are—well, I guess they have to sew themselves up after you've left.

It is much easier to hear the stories than to draw them. Drawing you actually have to really picture it or try to picture it and, as I said before, inhabit things. So you have to inhabit other peoples' pain or other peoples' aggression. You are thinking in those terms. I mean, it comes down to what does the shoulder do when someone is lifting a club. You are looking at yourself in the mirror trying to think of how that works, you know? So you are there in it. And that's much more difficult.

AUDIENCE MEMBER: Hi, Joe. I actually have a question via Twitter from Athens, Greece.

SACCO: Keep burning that place down! *[laughter]*

AUDIENCE MEMBER: He asks, as a journalist, do you get involved or stay removed? Could you describe your journalism ethics and does it affect your work on the ground? Is there pressure to make a difference with your work?

SACCO: I can't be removed because ultimately—despite

65

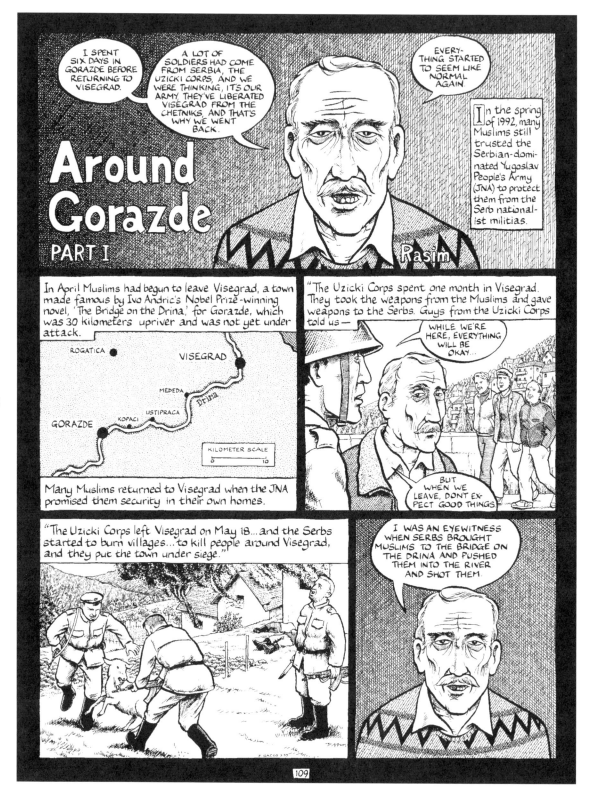

I SPENT SIX DAYS IN GORAZDE BEFORE RETURNING TO VISEGRAD.

A LOT OF SOLDIERS HAD COME FROM SERBIA, THE UZICKI CORPS, AND WE WERE THINKING, IT'S OUR ARMY, THEY'VE LIBERATED VISEGRAD FROM THE CHETNIKS, AND THAT'S WHY WE WENT BACK.

EVERYTHING STARTED TO SEEM LIKE NORMAL AGAIN.

Around Gorazde
PART I

In the spring of 1992, many Muslims still trusted the Serbian-dominated Yugoslav People's Army (JNA) to protect them from the Serb nationalist militias.

Rasim

In April Muslims had begun to leave Visegrad, a town made famous by Ivo Andric's Nobel Prize-winning novel, 'The Bridge on the Drina,' for Gorazde, which was 30 kilometers upriver and was not yet under attack.

ROGATICA
VISEGRAD
MEDEDA
Drina
USTIPRACA
GORAZDE
KOPACI

KILOMETER SCALE
0 10

Many Muslims returned to Visegrad when the JNA promised them security in their own homes.

"The Uzicki Corps spent one month in Visegrad. They took the weapons from the Muslims and gave weapons to the Serbs. Guys from the Uzicki Corps told us—

WHILE WE'RE HERE, EVERYTHING WILL BE OKAY...

BUT WHEN WE LEAVE, DON'T EXPECT GOOD THINGS.

"The Uzicki Corps left Visegrad on May 18...and the Serbs started to burn villages...to kill people around Visegrad, and they put the town under siege."

I WAS AN EYEWITNESS WHEN SERBS BROUGHT MUSLIMS TO THE BRIDGE ON THE DRINA AND PUSHED THEM INTO THE RIVER AND SHOT THEM.

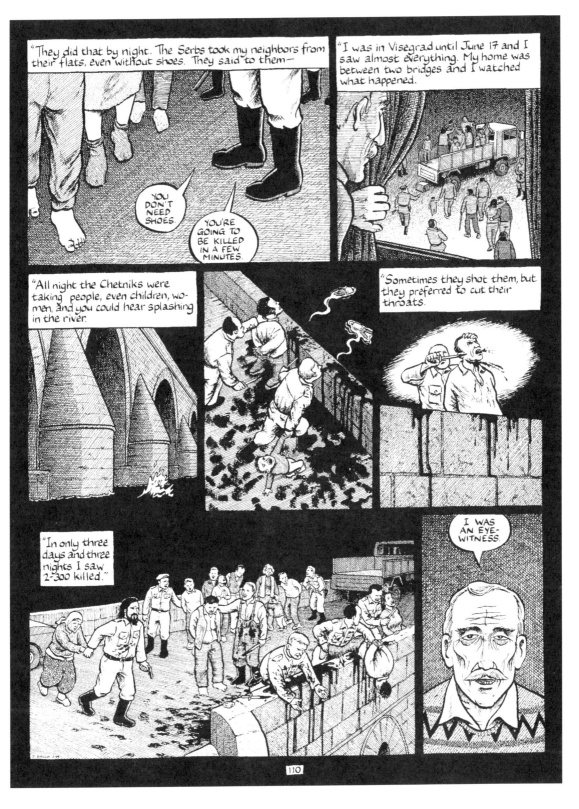

Figure 8. Joe Sacco, *Safe Area Goražde* (2000).

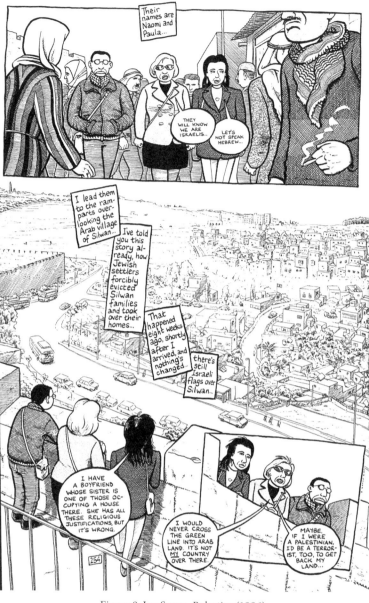

Figure 9. Joe Sacco, *Palestine* (1996).

me, I won't say it is more ethical than the so called objective, but I think it is truer. It is more honest.

AUDIENCE MEMBER: You mentioned the man who was telling you a story while he was watching a football game. I was wondering why you didn't put that in [Safe Area Gorazde].

SACCO: Part of me wishes I had, but I had already established this way of showing people telling their stories where it would just be their face. I think it is something I took from Dan Clowes actually. I remember seeing Eightball [and thinking], yeah, I have to do that sometime! And years later I did. I thought that was effective. It might have been effective individually for that story to tell that part of it or show that. But I felt it would break that continuum in a way.

AUDIENCE MEMBER: What attracts you to particular conflicts? I seem to notice that you depict not just stories but stories that maybe were overlooked, ignored, or the human side was ignored. Is there something from your personal background or personal experience that attracts you to those untold stories? How do you find the stories to create these works?

SACCO: The stories are coming at us from the news all the time. History throws stories at us. I remember being in Sarajevo with other journalists and we would look around and say, why aren't we in Rwanda? You could be there, too. But in the end you invest a certain amount of research time and emotional energy into something and you can only be effective by telling a set amount of things. You can be very ineffective talking about everything and scattering yourself. Especially with comics, which is a slow sort of medium, you have to choose a couple of things. I was interested in the Palestinian issue in particular because of its relationship to American journalism. I thought Palestinians were terrorists without knowing much about the Middle East. American journalism hadn't given me some context to overcome that prejudice and think about it in a different kind of way. With Bosnia, it was just—this sounds trite in a way, but I'm from Europe originally, and this thing was happening in Europe and I remember that phrase, "never again." Yes, you could have been in Rwanda doing a story like this. You could have been in Cambodia, I guess. You make a decision and then you sort of stick with it. But I'm not attracted to conflict for conflict's sake. In fact I don't want to go back to any more conflict zones. Because after a while you realize you've had it. And you realize

68

what I've told you—I actually care about the people I'm meeting. I make friends. I have no problem with making friends. Most journalists make friends. They just don't often show that. I think that detracts from their stories in a way. Sometimes it is the human interactions you can't get across unless you show your relationship with other people. So I do stay in touch with some of the people I've met along the way. I can't help but get involved. I mean, people involve you. When I was in Gorazde, people were giving me notes to take to their loved ones they hadn't seen in years in Sarajevo. Then they asked, can you buy me jeans in... Can you get me this? Suddenly you just get involved. I need to put myself in the story now. It is because it somehow brings something into relief about a certain situation. So to me being truthful about my role as a journalist, the filter that I am, the fact that I'm a Westerner in a foreign situation—all of that is ethical. And to

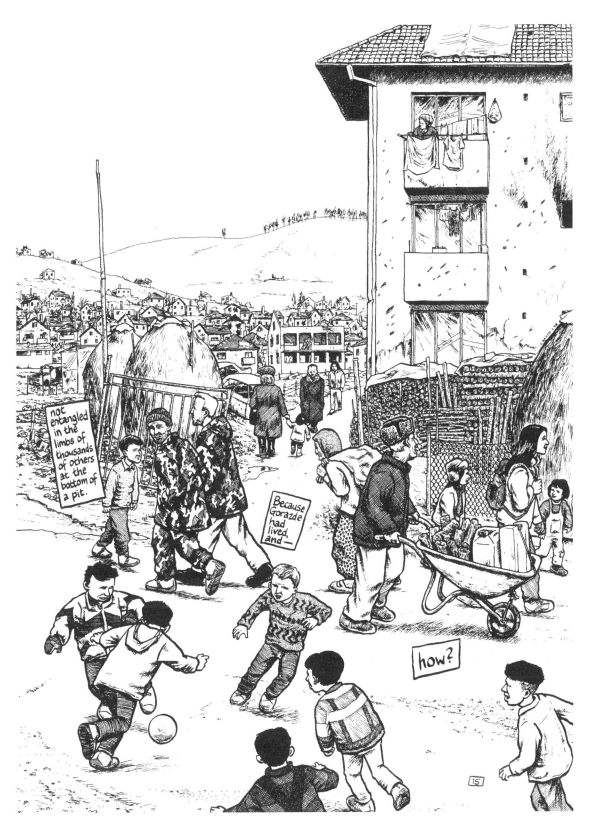

69

Figure 10. Joe Sacco, *Safe Area Goražde* (2000).

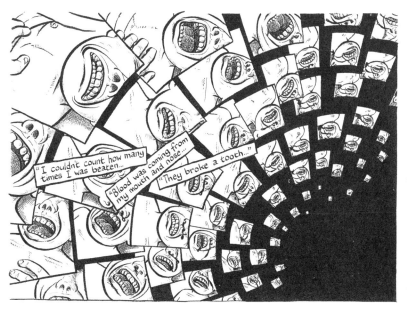

Figure 11. Joe Sacco, *Palestine: The Special Edition* (2001).

[laughter] I have relations with them. If you want to say that's not journalistic, that's not objective, you should be distanced, and judge it—I don't care. I'm trying to present something honest. Objectivity is a different word to me than honesty. If someone whose cause I appreciate or I think I'm sympathetic to says something outrageous, to me as an honest journalist, I report the outrageous thing.

AUDIENCE MEMBER: One of the most powerful things about your work when you are reading it [is] you as the reader find out [something] for the first time, just like your character in the story is investigating it for the first time. But do you think that integrity and that honesty remains for you rereading it? Do you think that that has been reshaped about any of these events? That it has become more complicated?

SACCO: Every now and then I'll sort of prance around with two or three pages I particularly like and reread them for years. But generally speaking, I just have not sat down and read the whole thing all the way through. I know in the early work I'm bumbling around because I was bumbling around. In my later work, I might bumble around every now and then but pretty much I am not. And that's because I no longer did in reality.

AUDIENCE MEMBER: Did you get braver?

SACCO: No. In fact I got more cautious. When I was in Palestine, the thing was: other people are running, I'm running with them. That's the way I looked at things. But later on [I felt], I don't want to go down that road. Those kids are over there but I'm not comfortable going there.

MITCHELL: This is the difference between you and the photojournalist. They say when the shooting starts, the writers run for shelter, the photographers run toward the shooting. Since comic artists use both words and images, perhaps they have to run in both directions at the same time, like some demented cartoon character.

SACCO: I have a scene in *Footnotes in Gaza* of an Israeli armored fighting vehicle coming towards us. Everyone is running except for the one or two—there is one photographer just getting his picture. He's going to stay there and get his picture. Those people are really brave and they are in a different league than the cartoonists, I'll tell you that much. *[laughter]* "Oh, do I have my ink?"

you would not be effective anymore. I'm at that point.

AUDIENCE MEMBER: Modern journalism is really conscious of spin. So with that in mind, you still present your journalism from a very personal sort of perspective. And how do you think people take that?

SACCO: I don't know how people take it. I was doing autobiographical comics, like a lot of people in my generation influenced of course by the underground. When I went to the Middle East I didn't really have some definite notion of what I was going to do. I figured I was going to tell my autobiographical story of being in the Middle East. Journalism got pulled into it; that's how I behaved when I was there. I realized that journalistic switch came on. You just start asking questions in a certain way. So I never really thought about all that. It was just I'm there in the strips, or in the comics, and this is my point of view.

And I would say that the important thing for me isn't so much objectivity. It is: I want the journalists to admit their context, their prejudices, somehow, or to know something about them. There were British journalists I read and the British journalists in papers like *The Guardian* and *Independent* use the pronoun "I" in their work. You begin to get a sense of that journalist and you begin to judge that journalist's work—you begin to know, well, that's how he sees it and now I'm going to extract something from that knowing that that's how he sees it. The problem with spin is, it is generally they are never telling you that they've got a prejudice or they've got an agenda. You know that I care about these people. I'm not going to pretend they are ants or flies (and I shouldn't say that about ants or flies).

Charlie Chaplin and His Shadows: On Laws of Fortuity in Art

Yuri Tsivian

Introduction

"We theorists need to know laws of fortuity in art,"[1] Viktor Shklovsky wrote in 1926; it is from Shklovsky that I borrow the phrase used in the title of this essay. Shklovsky's dictum was programmatic and polemical at once. What it polemicized against were theories that saw art as a manifestation of outer laws: laws of the human psyche with its suppressed drives and displaced desires; societal laws that focused on social thought or class struggle; religious laws that encouraged the quest for the spiritual in art. Shklovsky realized that "laws of fortuity" was an internally contradictory phrase but believed that this contradiction was intrinsic to art. In Shklovsky's view, law and fortuity were at output-input ends of the cognitive processor called art. He never used exactly these words, of course, but did claim that art was a processing device. What this device processed was art's raw material, be it the experiential material of "life" or the semantic material of language. Why people needed art, Shklovsky theorized, was to experience that material anew. That experience involved seeing the lawfulness of the fortuitous and the fortuity of what we take for laws. He called the latter processing defamiliarization; as to the former, the simplest example is rhymes.[2] It is entirely by chance that in a language like Russian the plural for *frost*, *morozy*, rhymes with *roses*; yet poetry treats such fortuities as law. A student of English verse might use *womb* and *tomb* as an example. When Shklovsky called on theorists to study laws of fortuity what he meant were laws indigenous to poetry and art.

One could hardly think of a better anarchist than Charlie Chaplin or of more lawless laws than those legislated by the Soviet avant-garde artists whose images of Chaplin I will examine in this essay. As Ilia Zdanevich, Russian-French futurist-dadaist poet and artist, remembered in 1923,

> Ten years ago when we began, we used to paint [pictures] on our faces, stage debates, print manifestos and publish hand-written books every day. We threatened to turn the world upside down and rebuild the Earth; we glorified the new spirit. We would create masterpieces by a stroke of a pen; issue poems consisting of three words and books of white pages. Soon, we discovered laws in all these fortuities, ink-blots and broken windows, and started constructing.[3]

The Soviet Chaplin, as I intend to show, was constructed exactly this way.

This study is not so much about Chaplin as it is about what other people made of him, that is, about Chaplin's famous fame. One often hears that what made Chaplin's fame really universal was that both the sophisticated and the unsophisticated liked him, and liked him alike. This view is sentimental and wrong. Chaplin was a man of two fames, as we sometimes observe a person casting two shadows, not necessarily similar to each other or to the person that casts them. Fame number one was Chaplin's enormous success with regular filmgoers; this fame came to him instantly, and by 1915 everyone more or less agreed on who was the funni-

I am indebted to Jennifer Bean, Cecilia Cenciarelli, Livio Jacob, Daria Khitrova, Aleksandr Lavrentiev, David Robinson, Eirik Steinhoff, Roman Timenchik, and Jennifer Wild for helping me with different things at different times.

Unless otherwise noted, all translations are my own.

1. Viktor Shklovsky, *Tret'ia fabrika* [The Third Factory] (Moscow, 1926), p. 86.

2. See Shklovsky, "Art as Technique," in *Literary Theory: An Anthology*, ed. Julie Rivkin and Michael Ryan (Malden, Mass., 1998), pp. 17–23. See also the useful volume on Shklovsky's theory of defamiliarization *Ostrannenie: On "Strangeness" and the Moving Image; the History, Reception, and Relevance of a Concept*, ed. Annie van den Oever (Amsterdam, 2010).

3. Quoted in Aleksandr Lavrentiev, *Laboratoriia konstruktivizma: Opyty graficheskogo modelirovaniia* [The Constructivist Laboratory: Experiments in Graphic Design] (Moscow, 2000), p. 36.

est film comedian in the world.[4] This was the kind of fame Chaplin could understand and knew how to handle.[5]

The other fame (the fame I'll be dealing with in this essay) emerged later—between 1916 and 1919. This was when Chaplin became a cult figure among young European intellectuals—playwrights, poets, and artists; launched by Guillaume Apollinaire, this fame originated in France from where it spread to Germany and Russia, changing its shape as it changed these countries. Chaplin was aware of this fame; from time to time someone would show him a strange picture of himself or tell him a weird story told about him, but the more Chaplin learned about this fame the more puzzled he felt—once he even called Sergei Eisenstein for help.

Let me quote a passage from a conversation between the two that took place in California in 1930, the way Eisenstein remembered it some fifteen years later in his essay "Charlie the Kid" published in 1945:

> Charlie and I are in Hollywood and going to Santa Monica. . . . As we are sitting in the car, he pushes over a book to me. It's in German. "Tell me what it's all about," he says. . . . It is a German expressionist booklet and at the end is a play, dealing, of course, with a cosmic cataclysm: Charlie Chaplin pierces through the revived chaos with his stick, and points the way of escape beyond the world's end, politely touching his bowler as he does so. I had to admit I got stuck in interpreting this post-war delirium. "Please tell me what it's all about" is what he might have said about much that is said about him. It is extraordinary how much metaphysical nonsense sticks to Charlie Chaplin.[6]

I will return to Eisenstein's verdict in a moment; but, first, let me ask the factual question: what could have been that German play that Chaplin showed to Eisenstein in Santa Monica? Since the books Chaplin left behind in California in 1952 are now considered lost all we can make are guesses.[7] Let me make two. There are two German stage plays about Chaplin that could pass for an expressionist drama, each with some sort of cosmic cataclysm or another, though neither of them is exactly about the end of the world. One is the tragi-grotesque drama *Chaplin* by Melchior Vischer published in Potsdam in 1924, in the last act of which Chaplin talks to a comet that is approaching the Earth. The comet gets confused and cannot find the Earth anymore. Chaplin tips his bowler hat and the stage darkens.[8]

The other candidate is *Die Chaplinade* (*The Chapliniad: A Film Poem*) published by a better-known author, expres-sionist-turned-dadaist-turned-surrealist Iwan Goll, in 1920.[9] It is a play in verse, a *Buchdrama*: the dramatic genre more suitable for reading than performing. Goll's book became known not only for its text but also for its pictures; it came out with a series of illustrations by Fernand Léger. It was the first time that Léger tried his hand at Chaplin's figure, which would later become a recurrent motif in Léger's art.

There is no doomsday scene in *The Chapliniad* either, yet there is a cosmic-scale cataclysm: in act 4, Chaplin splits the Earth asunder and climbs down into the crack. Goll's "film poem" begins with a mediascape: a thousand movie posters with Chaplin presented as the King of Hearts adorn a city. Chaplin is disquieted; he is too used to motion to feel at home in the arrested medium of bills. The bill-bound Chaplin comes to life, steps off the wall, and deposits his regal attributes—crown, scepter, and orb—in an ashcan. Goll's hero is tired of being the king of movies and gambling cards; what he wants is to explore the outside world (as well as its inside, as we later learn). Thus begins Chaplin's transmedia journey, which, as we will see, does not stop at the end of Goll's book.

In act 4, Chaplin is shown wandering in the desert and pulling a deer on a rope. "He sits down on a dune after spreading his handkerchief and kissing the ground Bedouin style. . . . He begins to dig. The earth opens. Fantastic views of the earth's interior. On reaching its center Chaplin puts a telephone receiver to his ear and listens, as at the center of a telephone system, to the voices of all the world (heard as if from a phonograph)."[10] The voices of the world disappoint Chaplin. These are media trivia, he thinks: "Tumult of lies, telephoned stupidity, craziness of radiograms." Indeed, what runs through the center of the earth and, via the telephone, through Chaplin's head is a mixture of culinary, carnal, and political concerns spiced with sensational news and empty turns of speech; note also the mixture of German and French (Goll was a bilingual poet):

> Ten million butterflies / Elderly baker murdered / Un jour viendra / In the year 800 Charlemagne was / All or nothing, I say / 112-degree fever / Macaroni with red tomatoes / I love the lady from Zanzibar / Bitte schön / Christson & Co., collars and men's wash / Shuttle train to Marathon / The radicals are frightened / Là là là petite femme / No, better yesterday than tomorrow / Charlottenburg 6 / Brains baked in butter… ["C," p.47]

As a piece of poetry, the above passage is more elaborate than Goll's hero appears to admit. There are two puns

4. On the early phase of Chaplin's fate, see Charles J. Maland, *Chaplin and American Culture: The Evolution of a Star Image* (Princeton, N.J., 1989), pp. 9–20. On the first mentions of Chaplin in Russia, see a useful list of sources appended to *Charlie Chaplin o sebe i svoem tvorchestve* [*Charlie Chaplin on Himself and His Films*], ed. A. Kukarkin (Moscow, 1990), pp. 331–39.

5. See Charlie Chaplin, "What People Laugh At" (1918) and "A Rejection of the Talkies" (1931), in *Focus on Chaplin*, ed. Donald W. McCaffrey (Englewood Cliffs, N.J., 1971), pp. 48–54, 63–68.

6. Sergei Eisenstein, *Film Essays and a Lecture*, ed. Jay Leyda (New York, 1970), p. 127.

7. I am indebted to David Robinson for this piece of information. As Cecilia Cenciarelli informs me, the list of papers and documents preserved in the Chaplin archive does not contain a description that might fit the book in question.

8. See Melchior Vischer, *Chaplin: Tragigroteske in Sechs Bildern* (Potsdam, 1924), pp. 89, 96.

9. See Iwan Goll, *Die Chaplinade: Eine Kinodichtung* (Dresden, 1920).

10. Goll, "The Chapliniad: A Film Poem," trans. Frank Jones, *New Directions*, no. 39 (1979): 46–47; hereafter abbreviated "C."

Figures 1–3. Ferdinand Léger, illustrations of Charlie Chaplin, in Iwan Goll, *Die Chaplinade: Eine Kinodichtung* (1920).

on Chaplin's first name. If we fill in the word missing in the first of them we recognize the king motif attached to Goll's Chaplin from the start; as history tells us, in the year 800 Charlemagne was crowned. "What a poor thing is man!" Chaplin concludes. "All literatures melt away at the golden word: pain!" ("C," p. 47).

We may or may not agree with Eisenstein who called Goll's drama "post-war delirium" (if indeed the book that Chaplin showed him in Santa Monica was Goll's), but there is one thing that Eisenstein was right about: Goll's Chaplin has little to do with either Chaplin or Chaplin's art. And it is exactly because any connection between the cinematic world of Chaplin and Goll's poetic world can only be arbitrary or fortuitous that his phantasy and others of that ilk are of special interest to the theory of fortuity in art.

From this perspective it hardly matters whether it was Goll's or some other Chapliniad that Eisenstein dismissed as metaphysical nonsense. Chaplin found the wrong person to ask; he could hardly expect an impartial answer from someone like Eisenstein. Back at home, Eisenstein belonged to a group that called itself LEF, the Left Front of Arts—an association of like-minded artists which combined futurist poets like Vladimir Mayakovski, constructivist artists like Aleksandr Rodchenko and Varvara Stepanova, formalist scholars like Shklovsky, and radical filmmakers like Dziga Vertov. These were different people with different views, but none of them, if asked, was likely to find a better name than nonsense for an expressionist portrayal of Charles Chaplin. On the other hand, plenty of nonsense about Chaplin emerged from their midst: dialectical nonsense, communist nonsense, and other irrelevant stuff that I'll try to get a sense of after we consider two pictures from Paris, where the Chaplin craze among intellectuals began.

2. Two Artists and a Model

What makes Goll's book particularly important for this story is that it harbors two shadows of Chaplin, not one. One dwells in the medium of words, the other in the medium of illustrations supplied for Goll's drama by Léger. Cleverly, Léger coordinates Chaplin's gestures with the place of his pictures in the book—as well as with the events with which

Goll's Chaplin is involved. As we open the book, Chaplin greets us by raising his bowler hat (fig. 1); and so he does before we close it (fig. 4). Another picture illustrates the moment when Chaplin rips himself off the poster on which three of the first and two of the last characters of the CHAR-LOT name are left behind (fig. 2); still another depicts Charlot as he is sitting in the center of the Earth, receiver pressed to his ear, listening to the world's foolish conversations as written words like *Charottenburg*, *petites femmes*, and so on surround and attack him from every side (fig. 3).

Let us compare Léger's illustration from 1920 shown as figure 4 with a drawing by Marc Chagall from 1929 (fig. 5); let me use these two pictures to explain what I'll be looking at. Imagine them as two angles of a comparative triangle, the third angle of which is Charlie Chaplin, whom Chagall and Léger are portraying. I am not going to compare the artists' manners; it would take an art historian to undertake this. What I'll be looking at are two sides of the triangle that converge on Chaplin—not to discuss resemblances and not to speculate how and why Chaplin's figure has been transformed, but to find out about the give and take between the artist and the model.

The dreamy Chaplin in figure 5 who is losing his shoes and his face as he walks and who carries a lost wing tucked under his arm may look like a regular Chagall schlimazel, but here is a question: was it Chagall that gave this wing to his model, or did Chagall borrow this attribute from Chaplin? There were only two films by that date in which Chaplin used wings. In *The Kid* (1921) his Charlie is shown dreaming he is an angel, and in *The Gold Rush* (1924) the latter is turned into a chicken in the cannibalistic imagination of a starving prospector.

Let me now venture another triangular comparison. If we compare two shots from *The Kid* and *The Gold Rush* (figs. 6 and 7) with Chaplin's image as shown in Chagall's drawing (fig. 5) we will see that the latter is fed by two films, not one; while the wing stuck under Chaplin's armpit in Chagall's drawing is as angelic as Chaplin wears in *The Kid*, his chicken feet point to *The Gold Rush*.

Matters become more complicated when we ask, did Chagall simply help himself to Charlie-the-chicken, or did he perhaps also bring something to the table? Con-

Figure 6. *The Kid*
(dir. Charlie Chaplin, 1921).

Figure 4. Ferdinand Léger, illustration of Chaplin, in Goll, *Die Chaplinade*.
Figure 5. Marc Chagall, drawing of Charlie Chaplin (1929).

74

Figure 7. *The Gold Rush*
(dir. Charlie Chaplin, 1924).

Figure 8. Marc Chagall,
La Poule (1928).

Figure 9. Charlie Chaplin.
Publicity still.

sider another picture by Chagall (fig. 8), the gouache painted in 1928, one year before Chagall made the drawing in figure 5, but, yes, after he would have seen *The Gold Rush*. The picture is named *La Poule* (*The Chicken*): the man-chicken it depicts has a cap and a curly beard. The moon, a church, and a cabin are dreamy elements of the surrounding landscape.

Chagall's chicken bears no resemblance to Chaplin; there are no traces from Chaplin's films, and, in fact, no reason to look for them. Chaplin or not, bonding or merging with domestic animals is what humans often do in Chagall's pictures. The family tree must be triangular here; Chagall's drawing of Chaplin (fig. 5) descends from Chagall's bearded chicken (fig. 8) cross-bred with the Chaplin-chicken from *The Gold Rush* (fig. 7). On the other hand, I promised myself not to speak for Chagall but to stick to Chaplin in this study.

Or take Léger, whose Chaplin lifts his hat (figs. 1 and 4) much like the real Chaplin does in his films and publicity stills (fig. 9). It may appear that the rest of it, from the sawteeth haircut to the now jugged, now guitar-shaped lines of Charlot's costume have been given to Chaplin by Léger.

Léger, however, writing in 1926, held Chaplin responsible for his cubist looks; Chaplin, in Léger's eyes, was a unique specimen of a human that successfully metamorphosed into a black-and-white living object (*objet vivant*). As Léger called this object, it was Charlot *cubiste*.[11]

To what extent Léger's statement is relevant to Léger's art is beside the point. What is important for us here is to connect what Léger wrote about Chaplin with Shklovsky's laws of fortuity in art. Consider the fortuity of rhyming. It is only by chance that some words, different in different languages, may sound similar in Russian or in English. Then the poet comes to string such words into a series that suddenly makes sense. The fortuity has assumed the semblance of a law. It was no more than a visual rhyme that Chaplin's efforts to simplify his character's black-and-white silhouette and countenance turned out to chime in with the cubist pursuit of Léger; make-up and costuming was as much a part of the silent comedian's profession as was the skill of using dramatic situations like famine for slapstick visions of walking poultry. This was fortuity. But

11. See René Jeanne and Charles Ford, *Le Cinéma français 1895–1929*, vol. 1 of *Histoire encyclopédique du cinéma* (Paris, 1947), pp. 178–79. See, for a detailed account on Chaplin and Léger, Jennifer Wild, "What Léger Saw: The Cinematic Spectacle and the Meteor of the Machine Age," in *Léger: Modern Art and the Metropolis* (exhibition catalog, Philadelphia Museum of Art, 14 Oct. 2013–5 Jan. 2014), pp. 145–50.

that Léger and Chagall responded to Chaplin's pictures with theirs was their way of treating fortuity as law.

3. Crossing to Soviet Russia

With national borders, some media are more fortunate than others. Unless a miracle happens, poems are lost in translation whereas pictures usually come across unscathed. Bound together between the covers of *Die Chaplinade*, Goll's Chaplin and Léger's Charlot lost each other on the book's way to Russia. Goll's text, translated into bad Russian by Riurik Rok, was buried in the obscure magazine *Sovremennyi zapad* (The Contemporary West) in 1923. Léger's name and work, in turn, were known in Russia as early as 1912, and his puppetlike Chaplin was more than welcome there.[12] In 1922 some of Léger's Charlot drawings were reproduced in three Russian-language constructivist publications: in the art journal *Object* (fig. 10), in the film journal *Kino-fot* (fig. 11), and in a book on new art by Ilia Ehrenburg entitled *And Yet the World Goes Round*.

As a result, even before Chaplin's films reached Russia, the French worship of Chaplin was already there, taken up and adjusted to the tone and the terms then in vogue among the Soviet Left. You almost visually experience this shift when you open Ehrenburg's book on Léger's page-size Charlot drawing and read on the opposite page what Ehrenburg has to say about Chaplin:

Charlot is one of us: he is new, he is left-wing, he is a FUTURIST.... Charlot does not rely on inspiration; he is not an intuitive comedian, but a meticulous CONSTRUCTOR whose movements are based on schemata as rigorous as those of a medieval juggler. Charlot's movements are funny not because they are spontaneous, but owing to the precise FORMULA he is using.[13]

Taken for a cubist in the country of cubism, in constructivist Russia where futurism spelled the future Chaplin became a futurist like Mayakovsky and a constructivist like Vladimir Tatlin or El Lissitzky. Note that in Ehrenburg's book-manifesto quoted above, the words "futurist," "constructor," and "formula" appear in a larger font. These were catchwords of the left-wing studio talk and such was the constructivist practice of making catchwords jump off the page.

4. Chaplin in a Transmedia Triangle

I start my account of Chaplin's further metamorphoses in Russia with another three-angled comparison, this time between (a) a poem by Mayakovsky, (b) a series of pictures drawn by Stepanova, and (c) an enigmatic movie to which both the poem and the pictures seem to be pointing.

Mayakovsky's poem (written in 1923 and entitled "Kinopovetrie" [Film Craze]) is about Chaplin the Tramp and Chaplin the Rebel. A tramp today, Chaplin tickles Europe pink; a rebel tomorrow, he will lead the tramps of the world against her. This poetic prophecy ends in an imaginary gesture: the poet reaches for a movie theatre program to look up the next picture on the bill:

Meanwhile, projectionist, show us more movies;

Usher, hallo!
The latest attraction! This one's his newest!
Charlot the flier,
Airborne Charlot![14]

Let me ask the same question as I did when speaking of Charlie-the-Chicken by Chagall: "Charlot the flier"—is it merely a poetic image or perhaps a reference to a Chaplin movie? The answer is not as simple as the question may suggest. Those who know Chaplin are likely to say it must be an image, for aside from the angel dream in *The Kid* no flying stunts are found in Chaplin's silent films.[15] And those who know Mayakovsky will be moved to agree, adding perhaps that it is a stock image; there are plenty of airborne characters in Mayakovsky's poems between 1922 and 1925 (the take-off years of Soviet civil aviation); one of Mayakovsky's books of poetry was even entitled *Letaiushchii proletarii* (Flying Proletarian).[16]

All this is true; and, yet, evidence exists that the "airborne Charlot" may not, after all, be Mayakovsky's invention. The evidence I will exhibit first will be of pictures. The other piece of evidence is a movie. I will connect the pictures with the movie in an attempt to explain how it happened that the image of Chaplin and the idea of flying became apocryphally connected.

The pictures I am going to discuss are by Stepanova. They come from a series of drawings that she did for the special Chaplin issue of the constructivist magazine *Kino-fot* in September 1922.

Figure 12 shows Stepanova. The man whose bold head she is proudly tapping is her husband Rodchenko, also a constructivist artist; hanging on the wall behind them are the covers of the *Kino-fot* that Stepanova designed. Two of them, 3 and 2, announce the Chaplin issue inside one of which more of Stepanova's portrayals of Chaplin are found (figs. 13–16).

Those familiar with the constructivist doctrine will easily tell why these little figures were called constructions, not depictions; they have texture, they are not enslaved to

75

12. On Léger's reception in Russia, see A. A. Babin, "Kniga Gleza i Metzenzhe 'O kubizme' v vospriiatii russikh khudoznikov i kritikov" [Gleizes and Metzinger's book Du "Cubisme" as viewed by Russian artists and critics], *Russkii kubofuturizm* [Russian Cubo-Futurism] (St Petersburg, 2002), pp. 37–38.

13. Ilya Ehrenburg, *A vse-taki ona vertitsia* [And Yet the World Goes Round] (Moscow, 1922), p. 127.

14. Vladimir Mayakovsky, *Polnoe sobranie sochinenii* [Complete Collection of Works], 13 vols. (Moscow, 1957), 5:100 .

15. Heather Kiernan suggests that the line alludes to *The Kid*. As it follows from her article, Kiernan was familiar with Mayakovsky's, not in the Russian original, but via a French translation; her retranslation of *Film Craze* from French into English self-servingly turns Chaplin into an angel: "'Now he is making his film, / A "sensation" world-wide. / On the screen flies / Charlie furnished with wings, / Charlie the sublime'" (Heather Kiernan, "The Hero of Our Time: Chaplin and the Avant-Garde," *Queen's Quarterly* 101, no. 3 [1994]: 551).

16. On aviation and Russian literature, Mayakovsky included, see Yuri Leving, *Vokzal–Garazh–Angar: V. Nabokov i poetika russkogo urbanizma* [Train Station–Garage–Hangar: Vladimir Nabokov and Poetics of Russian Urbanism] (St. Petersburg, 2004).

Figure 10. Léger's Chaplin in *Veshch* (1922).

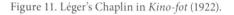

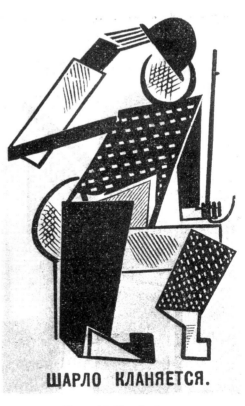

Figure 11. Léger's Chaplin in *Kino-fot* (1922).

Figure 12. Aleksandr Rodchenko and Varvara Stepanova (1922). Photo by Mikhail Kaufman.

Figure 13. *Chaplin Bows.*

Figure 14. *Chaplin Falls.*

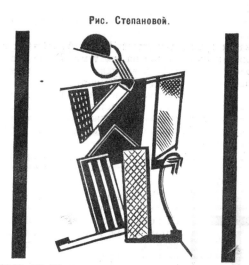

Рис. Степановой.

ШАРЛО НЕ МЕНЯЕТ КОСТЮМА И НЕ ДЕЛАЕТ ГРИМА.

Figure 15. *Chaplin Never Changes His Costume or Uses Make-up.*

Рис. Степановой.

ЧЕЛОВЕК НА ПРОППЕЛЛЕРЕ

Figure 16. *Man on a Propeller.*

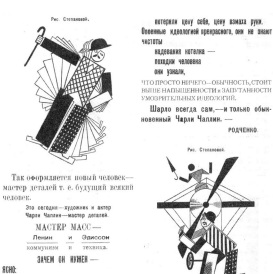

Рис. Степановой.

Так оформляется новый человек—мастер деталей т. е. будущий всякий человек.

Это сегодня—художник и актер Чарли Чаплин—мастер деталей.

МАСТЕР МАСС —

Ленин и Эдиссон
коммунизм и техника.

ЗАЧЕМ ОН НУЖЕН —

ЯСНО:
500.000.000 человек

потеряли цену себе, цену взмаха руки. Опоенные идеологией прекрасного, они не знают чистоты
надевания котелка —
походки человека
они узнали,
ЧТО ПРОСТО НИЧЕГО—ОБЫЧНОСТЬ, СТОИТ ВЫШЕ НАПЫЩЕННОСТИ и ЗАПУТАННОСТИ УМОЗРИТЕЛЬНЫХ ИДЕОЛОГИЙ.

Шарло всегда сам,—и только обыкновенный Чарли Чаплин.
— РОДЧЕНКО.

Рис. Степановой.

Figure 17. *Varvara Stepanova.* From *Kino-fot* (1922).

77

АРКАДІЙ БОЙТЛЕР

Figure 18. Arkadii Boytler, *Boytler contra Chaplin* (before 1922). Publicity still.

Figure 19. Aeroplane—
Conklin comes on.

Figure 20. Close up of Conklin
at propeller.

Figure 21. Conklin swings
propeller—

the page, and they do not "represent" Chaplin's manner-isms but reenact them; and on the whole, they are akin to other geometrical humans that Rodchenko and Stepa-nova used to draw and paint in the very beginning of the twenties. Yet our task here is not to discuss Stepanova's art but to ask about her stake in Chaplin.

There are nine pictures all in all; and three of them show Chaplin as we have never seen him in his films. In figure 16 we see him grasping at a propeller, which is spin-ning (as indicated by the two arrows and the bowler hat blown off from Chaplin's head). The text reads "Man on a Propeller;" it sounds like a movie title, and the whole picture reminds one of a sketch for a film poster.

Evidence presented in figure 17 permits us to recon-struct what happened. This is a page from *Kino-fot* with two pictures that give a good idea of how the man got on the pro-peller. The one at the bottom right shows Chaplin trying to jump-start an aircraft using the method called (in old pilot English) "spin the prop," while a frightened lady is shown waving her umbrella. Evidently, the man succeeds, but fails to jump aside. As the plane takes off Chaplin becomes part of its propeller (fig. 17, upper left). Note the fanlike shapes that indicate that the propeller is spinning; note also that the blades of this fan are shown in foreshortening, which means that this living propeller is flying straight into us.

There are two questions I will now address. The first one, factual, is about the film, the other one (hypothetical) about the interest this film could have held for Stepanova and the constructivist circle. About the film, two things are clear: the film is neither by Chaplin nor was its story born in Stepanova's head. The film existed, was shown in Moscow, and was reviewed in the theater weekly *The Spectacle* by a critic who was not particularly impressed:

> Chaplin makes one expect a good movie, but *Man on a Propeller* deceived our expectations. The movie is shoddy. It claims to be about wonders of technology, but the eye of the camera mercilessly reveals them as crude props. … Chaplin is brilliant, but his part-ners are mere extras – their attempts to be funny pale next to the topmost acting techniques shown by this genuine eccentric, a former acrobat and juggler. The

theme of the script is espionage, the subject charac-teristic of the bourgeois society. Characters' adven-tures arise from desperate attempts on the part of secret agencies of two rival countries to procure the secrets of aviation technology.[17]

So, what is this movie? I first suspected the film was made by one of Chaplin's imitators. Chaplin had many, sued some, and hated all. Some used his name to sell their films; some, jokes and mannerisms; some, like Russian-turned Mexican filmmaker Arkadii Boytler staged and screened one-man contests between Charlie and their own comic mask (fig. 18).

There are enough pseudo-Chaplin movies but not a lot about planes. Looking for look-alikes turned out to be a false lead. The wanted film, as Jennifer Bean kindly pointed out to me, is most likely *Dizzy Heights and Daring Hearts*, the 1916 Keystone comedy in which Chester Conklin plays a foreign spy eager to beat a rival spy "countGoUpSkey" in the compe-tition for the airplane franchise from the United States.

The film survives, as does its continuity typescript.[18] At one point in the intrigues Conklin kidnaps the airplane mogul's daughter (played by Clair Anderson), but she plummets to the ground using her umbrella as a makeshift parachute. He lands to capture her again, but this is how the continuity sheet describes what happens as soon as Conklin forces Clair Anderson into the passenger pit:

> 70 – Aeroplane – Conklin comes on – Let run until Conklin goes up to propeller
> 71 – Insert of Anderson in aeroplane
> 72 – Close up of Conklin at propeller
> 73 – Insert of Anderson
> 74 – Conklin swings propeller and gets on…
> 78 – Aeroplane – with Conklin on propeller – he falls off
> 79 – Exit door – they see this
> 80 – Insert of Conklin spinning thru air – Flying
> 81 – Roof with barrel – Conklin falls in[19]

Let me show how these two segments of the shoot-ing continuity look through the camera lens and on the screen. A frame enlargement (fig. 19) covers action num-

17. Aleksei Gan, "Chelovek na propeller" [Man on a Propeller], *Zrelishcha* [Spectacle] 3 (1922): 17.

18. Title sheet from production file for *Dizzy Heights and Daring Hearts*, file 141, Mack Sennett Papers, Department of Special Collections, Margaret Her-rick Library, Academy of Motion Picture Arts and Sciences, Los Angeles; hereafter abbreviated *MS*.

19. Fragment of continuity from production file for *Dizzy Heights and Daring Hearts*, file 141, *MS*.

Figure 22.—and gets on.

Figure 23. Aeroplane—with Conklion propeller.

Figure 24. Insert of Conklin spinning thru air.

Figure 25. Flying.

Figure 26. Roof with barrel.

Figure 27. Conklin falls in.

ber 70; figures 20–21, actions 72 and 74; and figures 22 through 27 are the insert of Conklin spinning through air and falling into a fire barrel.

As we recall, Conklin's film was advertised and reviewed in Russia as Chaplin's. Conklin was not a Chaplin imitator; conversely, he was Chaplin's partner on a number of films, and even his walrus moustache was a far cry from Chaplin's toothbrush affair. How come *Dizzy Heights* was shown in Russia as Chaplin's movie?

What must have happened is this. Chaplin's name was all the rage, but his films were pricey; besides, in 1922 not many people in Russia knew the real Chaplin's face too well. It was only in 1922 that Lenin's New Economic Policy reopened the country's market for foreign films. It is not hard to imagine a light-fingered importer going through distribution documents and rubbing out the "Conk" part of Conklin's name and replacing it with "Chap."

Apparently, by the end of the summer the secret was out, for this is what we read in the editorial for the *Kino-fot* Chaplin issue signed by its editor-in-chief Aleksei Gan:

> Chaplin's name is so big nowadays that it makes shady profiteers rub their hands. Tens of so-called "Chaplin" films shown recently on the territory of Soviet Russia—like *The Death of a Monster*, or *Man on a Propeller*—are Chaplin films without Chaplin. It is in order to put an end to this profiteering that we dedicate this special issue of *Kino-Fot* to Charlie Chaplin, this first and unique film comedian. Let all our comrades know …[20]

And so on. One can understand Gan's rage; it was he who had earlier praised Chaplin's genuine eccentric act-

ing techniques in *Man on a Propeller*.[21]

We read Gan's philippic on the first page of the Chaplin issue, but no sooner is he kicked out of the door than this pseudo-Chaplin comes back through the window; only a few pages down we see this stubborn little movie again, looking at us from Stepanova's drawings. Stepanova, one must admit, had even improved upon the original movie; not only does she give her hero the benefit of a frontal view (compare figure 17, bottom, with figure 22), she also shows her Charlot triumphantly soaring, whereas in the film the propeller adventure ends in disgrace. Now is the time to ask the second question: what could have been so special about *Man on a Propeller* that made Stepanova make this film her own?

5. Speculation from Evidence

We may rephrase this question in light of what we know about the Chaplin chicken of Chagall and Léger's cubist Charlot. Is there something about *Dizzying Heights* that could have won the heart of a constructivist artist? I know this is a speculative question. One does not need to be either an artist or a constructivist in order to like this or that film. There are ways, however, of answering this question without letting speculations fly too high. All we need is to adduce more evidence.

Stepanova was a constructivist artist. Constructivism was an avant-garde group whose self-given name dovetailed with their clearly articulated platform. We do not create, we construct. In Russian (unlike English) you do not construct houses; there is another word for this. The only things you construct are machines. Love for machines, for things that rotate, was what a conscientious constructivist was expected to vow. The future of the human race is in bonding and merging with machines.

Figures 28 and 29 show two preparatory studies for Stepanova's Chaplin series. Knowing Conklin's film we

79

20. Gan, "Pervoe" [The First], *Kino-fot*, 3 (1922): 1.

21. Gan, "Chelovek na propeller," p. 17.

Figures 28–29. Varvara Stepanova, *Man-Propeller*.

Figure 30. Caproni's hydroplane (300 hp).

Figure 31. Farman's aeroplane Goliath.

80

can tell which moment her brush was doggedly trying to capture. This was the moment of truth, the moment when the man on the propeller turns, physically, into a mechanism; now he still looks like a man, now he is already a propeller.[22]

More than any other machine, constructivists loved planes. Early biplanes with their light uncovered structures were held up as the image of the perfect artwork. Ehrenburg's constructivist manifesto *And Yet the World Goes Round* includes two photographs (figures 30–31) to illustrate this point from his constructivist program: "Our task is: to build an art object that could fly."[23]

Such are two rather obvious points about constructivism one can make to explain the case of Stepanova's *Man on a Propeller*. There is also a third one, more roundabout and less obvious. To make this point I will have to return to the problem of authenticity so indignantly raised by Aleksei Gan, the chief editor of *Kino-fot*, and so lightly dismissed by Stepanova if indeed she knew that who she believed was Charlie Chaplin was in fact an entirely different man.

Every journal and any periodical at times becomes a chaotic affair to run. Some writers are late with their articles, and some artists submit their illustrations at the last moment. We are not sure if Stepanova had a minute to read Gan's editorial or Gan to take a second look at

Stepanova's illustrations. Maybe, the whole incident happened by an oversight. But, then, that's the end of the story. And, to paraphrase Carl Mayer's famous intertitle inserted before the last reel of *The Last Laugh* (1924), the writer of these lines likes this eccentric story so much that he thinks it deserves a more interesting ending.

6.Chaplin and Chaplinism

To do this, let us factor out fortuity and assume, if only for interest's sake, that Gan looks at the drawings and says, did you know the man of the propeller is not Chaplin but some other man? and that Stepanova answers, Who cares? Is there a context we can point to that could be used to justify Stepanova's position?

The quickest way of testing this is to take a closer look at the evidence at hand. The evidence I produce this time is textual. There are various texts in the Chaplin issue of *Kino-fot* between which Stepanova's drawings are embedded. First, there is Gan's angry editorial; then, there are three constructivist essays each devoted to Chaplin: one by Stepanova's husband, artist and designer (not yet a photographer) Rodchenko; another by left-wing film director Lev

22. In a relatively recent English-language edition of Stepanova's works both drawings have the caption "Charlie Chaplin Turning Summersaults"; see Alexander Lavrentiev, *Varvara Stepanova: The Complete Work*, trans. Wendy Salmond, ed. John E. Bowlt (Cambridge, Mass., 1988), p. 105. As Lavrentiev admits in his letter to me, the titles were conjectural: originals are preserved without captions.

23. Ehrenburg, *A vse-taki ona vertitsia*, p. 71.

Kuleshov (then in charge of a workshop of acting students whom Kuleshov trained according to what he declared was a new scientific method); and another one by theatre director Nikolai Foregger, then head of an avant-garde theatre named Foregger Workshop whose most talked-about production, *Dance of Machines*, came out exactly in 1922.

Take Gan's editorial. Even though *Kino-fot* was a constructivist magazine and Gan saw himself as a constructivist theorist, there is little specifically constructivist in saying that Chaplin is inimitable and that people who paid to see Chaplin are entitled to see his genuine films. This is common sense; any journalist would say so. But as we move on to Rodchenko's, Kuleshov's, and Foregger's essays, the intellectual portrait of Chaplin we discover grows increasingly different from Gan's and from anything we know about the real Chaplin.

Their Chaplin is a left-wing intellectual; a theorist, even a scientist, and a dedicated teacher. And I must stress that this image is not fanciful but conjectural; the less these people knew about Chaplin the more they modeled him upon themselves. As was typical for Soviet avant-garde groups, constructivism as a movement was born from theoretical debates held at an educational institution. Here, it was taken for granted that artistic culture is transmittable and teachable; that ideas are as important as artworks; that new forms in art come always as a trend; that the purpose of art is not entertainment but instruction. And so on. Let me repeat, even though the real Chaplin would hardly buy into any of this nonsense, it is to it that we owe the constructivist image of Chaplin.

As one can tell by the way it is typeset, this passage comes from Rodchenko's essay; its text is not printed but designed, and designed like one might a mathematic equation. What the equation says is this:

Charlie Chaplin is the master of details.

MASTER FOR MASSES—

	Lenin	and	Edison
	Communism	and	technique.

WHY WE NEED HIM—

The above trinity—Chaplin, Lenin, and Edison—makes more sense than may at first appear. According to Rodchenko, these three men hold three keys for the better tomorrow. Edison knows about electricity, Lenin knows how to build a better society, and Chaplin knows the secret of perfect physique. "Why we need him," Rodchenko further explains, is to teach us (half a billion of us) the beauty of ordinary gestures: the art of walking, how to wave your hand, how to put on a hat. Rodchenko's are the words of a true constructivist; they deny art and celebrate life: "Misled by the bourgeois notion of beauty people forget the beauty of everyday movements and gestures.[24]

This strange idea—that Chaplin, with his off-beat walk and his idiosyncratic gestures, is in reality an expert in the new plasticity that Chaplin teaches in the enormous classroom of all film theatres in the world—was not Rodchenko's invention. This was a recurrent fancy in the Soviet mythology about Chaplin. I think I am able to trace

Figure 32. Detail of Aleksandr Rodchenko's Chaplin essay.

it all the way back to Belgium where this fancy appears to have been born and also to show its itinerary from Belgium to Russia where it became part of the constructivist mentality. The end of this essay looks like a good place for a foray in intellectual geography. Meanwhile, a few words about Foregger's and Kuleshov's essays about Chaplin.

Foregger's essay is about Chaplin idolizers and Chaplin imitators, and it is from reading Foregger that one can easily imagine why Stepanova may have taken it lightly had she been told that her little propeller man was not Chaplin. Its title is "Charlottenbuergers and Chaplinism."[25] The word *Charlottenbuergers* is a triple pun: on Charlie's French name, on the name of a district in Berlin, and, more importantly, on the word *buerger* which in German and Russian means the same thing as petit bourgeois in English and French. Foregger's *Charlottenbuergers* are idolizers; these are portly European middle-class moviegoers for whom Chaplin is merely en vogue. It is for them that the yellow press concocts incredible anecdotes and stories from Chaplin's life. All these cheesy consumers want to know is what Chaplin eats and with whom he sleeps.

The second term in the title of Foregger's essay, *Chaplinism*, refers to Chaplin imitators. These imitators, Foregger explains, are Chaplin's followers and students. *Charlottenbuergers* may snub and slight them, but we, the Soviets, must realize that Chaplin is not alone; he has created an army of Chaplins. Nowadays Chaplinism is a school. To illustrate this point Foregger quotes a story he came across in the *Paris le Soir*. According to this newspaper one theatre proprietor announced a tournament of Chaplin's doubles; unknown to the judges, Chaplin applied, but was not admitted.

This anecdote had circulated in gossip columns from as early as 1915. It was a myth, but one that Chaplin never denied. The morality tale the myth implied was how the true genius is crowded out by epigones—or something as trite. Whatever the original message of this story there is no doubt that Foregger got it correctly, but, much in the spirit of the Soviet twenties, he decided to turn the tables. Why did Chaplin's imitators succeed in surpassing their teacher? "Clearly," answers Foregger, "it was because they studied Chaplin on the screen. Therefore they have had two teachers—one was Chaplin and the other was cinema itself." And on he goes, mimicking or parodying the terms and the structure of argument characteristic to the Russian formalist school of thought: "Chaplin is an academic; he invents new techniques, creates the canon, and launches a school. From

81

24. Alexandr Rodchenko, "Charlot," *Kino-fot* 3 (1922): 6.

25. See Nikolai Foregger, "Charlottenbuergery i Chaplinism" [Charlottenbuergers and Chaplinism], *Kino-fot* 3 (1922): 2–4.

Figure 33. Labor angles. V. Liutse's drawing in Ippolit Sokolov, "Teilorizovannyi zhest" (1922).

Figure 34. Labor grid. V. Liutse's drawing in Ippolit Sokolov, "Teilorizovannyi zhest" (1922).

82

there, the school takes over. Chaplin provides new formulae, which the school develops and popularizes. American film comedy exists under the badge of Chaplinism."[26] Apparently, in Foregger's eyes Hollywood was not (as it was in reality) an internally competitive community but a collaborative research institution, a huge workshop of sorts. If we assume that Stepanova shared this illusion there is no wonder she did not care who the man was on the propeller—Chaplin himself or a disciple whom Chaplin trained.

We do not know if Stepanova believed in the Chaplin-workshop myth, but we know that Lev Kuleshov did. We know this from his essay in the *Kino-fot* special issue on Chaplin, and we know this from a letter that Kuleshov wrote to Chaplin. Let us look briefly at both.

"Not many people have Chaplin's mastery of their bodies," Kuleshov's essay says, "because Chaplin has studied the mechanism of his body and treats it as a mechanism. The only other actors that treat their bodies this way are a group of young people from the experimental workshop at State Cinema Institute, which I, Lev Kuleshov, happen to teach. We study human body on the basis of exact calculations and scientific experiments. And Charlie Chaplin is our first teacher."[27]

Unbelievable as this may sound, Kuleshov meant what he said. In 1924 he made an attempt to contact Chaplin by mail on behalf of his film acting workshop, *experimentalnyi kinokollectiv.* This is not fan mail. It looks more like a letter a scientist might have written to a colleague abroad, a methodical affair, with sections numbered in Roman and subsections in Arabic: one, who we are; two, what we have achieved, three, what we want from you; and two more points elaborating on their theoretical principles. And, of course, it begins with "Dear sir."[28]

The letter informs Chaplin that Kuleshov and his group have discovered a number of laws that govern screen acting; that to discover these laws, they have carefully studied Chaplin's work; that they have assumed that Chaplin would be as interested in their results as they were in his. What they want from Chaplin is three things: to know more about his method and what he thinks about theirs; "would cultural filmmakers in America be interested in establishing an ideological link with us";[29] and lastly, to send them a bibliography of printed works that he thinks might be relevant to their further research. Imagine Chaplin's face if he had opened Kuleshov's letter.

7. The Belgian Trace

Why was Kuleshov so convinced Chaplin was as much in love with science as he himself was? One possible answer has to do with a Belgian literary myth. But before we get there I need to explain something about Kuleshov's workshop. The ideas, methods, and equipment they used were not exactly their own. Much of this Kuleshov borrowed from another research institution, the State Institute of Labor, built to adapt to Soviet conditions the labor efficiency methods developed by the American Frederick Winslow Taylor.[30]

26. Ibid., p. 4.

27. See Lev Kuleshov, "Esli teper' . . ." [If now . . .], *Kino-fot* 3 (1922): 4–5.

28. Kuleshov, "Pis'mo k Chaplinu" [Letter to Chaplin], *Sobranie sochinenii* [Collected Works], ed. A. S. Khokhlova and E. S. Khokhlova, 2 vols. (Moscow, 1987), 1:418–20.

29. Ibid., 1:419.

30. See Richard Stites, "Man the Machine," *Revolutionary Dreams: Utopian Vision and Experimental Life in the Russian Revolution* (New York, 1989), pp. 145–64.

The Labor Institute was geared to study human locomotion, and this was something Kuleshov's workshop used, too.[31]

What does Taylorism have to do with acting and, specifically, with Charlie Chaplin? To learn more about this we need to examine an essay entitled "The Taylorized Gesture" written by one Ippolit Sokolov, a self-proclaimed art theorist who did not belong to the core of the left-wing theatre movement but rather to its lunatic fringe. This Sokolov used to take up the ideas implicit in the work of people like Kuleshov and Meyerhold and drive them to their logical extreme. This essay is a case in point. As the Taylorist Institute of Labor trains workers to move rationally at their working places, it says, so must the theatre teach ordinary people to move correctly in ordinary life.[32] Illogical, indecisive, curved, and rounded gestures must be banned from the future socialist state; the straight line plus the acute angle (fig. 33) will be the staple of the new style which Sokolov calls "the style of Russian Socialist Federation."[33]

It is in order to transmit this new style from the stage to the street that Taylorist tools must be used in actor training, Sokolov goes on, like the grid covering the walls and the floor in exercise rooms (fig. 34). In Kuleshov's acting workshop grids like this were indeed used.

Sokolov's essay makes an obscure reference to a mysterious foreign professor, Locharlochi, known for his method of teaching everyday movements by making his pupils imitate operations performed by machines constructed specifically for this special purpose.

This professor was not Sokolov's invention. Locharlochi is a literary character invented in 1920 by Belgian author Franz Hellens for his novel *Mélusine*, whose imagery literary historians of our day have labeled presurrealist. In the chapter entitled "Our Teachers, Machines" Hellens makes the reader enter a vast corridor of sorts with various mechanisms aligned along its walls while people grouped in front of them are trying to imitate the motions of their mechanical parts.[34] We also encounter the inventor of this method, professor Locharlochi whose profound philosophy and faultless mastery of his body contrast with his funny looks and enormous boots. It took no trouble for critics to crack the professor's name and find out the name hiding inside Locharlochi: Charlot.

This is how Hellens's Professor Chaplin explains his international teaching project:

My name is Locharlochi. I have spent much time studying people. The universal mistake is in the wrongly understood movement. Nature is a powerful teacher, but nature is erratic and prone to whims. The mechanical disciplines and organizes nature without infringing on it. There were times when people walked slowly, without thinking of just stamped marking time. They idolized water, fire, wind and they invented gods. Gods are dead. Our teachers are our own creations, the machines.[35]

And so on. All this sounds very general and hopelessly academic. Nor does it get any funnier when, two pages down, Hellens's Chaplin explains, in professorial French, that his funny gait and comic routines are a cunning pedagogical device; they make learning fun. What Hellens's novel does succeed in is the contrary; it turns Chaplin into a boring lecturer.

Hellens's novel was never translated into Russian (nor was it into English as far as I can tell).[36] Had it been, Hellens's Chaplin and his lectures might have been easily forgotten. It so happened, however, that Russian readers learned about Professor Locharlochi from a briefer and much livelier source: Hellens's own essay "Literature and Cinema," published in the Russian constructivist magazine *Veshch* (Object) in 1922.

Distinct from his *Mélusine*, Hellens's excellent essay compares Chaplin's work not to some abstract mechanisms built to improve human locomotion but to real (and really exciting) machines that surrounded people in 1922. Chaplin's bond with these machines is not cerebral, as it is in the novel, but somatic and stylistic. As Hellens explains in this essay, the superhuman precision and control that distinguish Chaplin's films, especially the 1921 *The Kid*, inspire the same kind of respect for their maker as one feels towards the constructors of airplanes and cars. The reason for this is that "no artwork of our days comes close to the blinding clarity of this film's internal mechanism."[37]

In my recent novel *Mélusine*, Hellens adds, I turned Chaplin into a scientist, a weird and wonderful genius of dynamics, whose schools for the study and teaching of movement installed in four parts of Europe herald the new ethos of "social movement." One can imagine the kind of resonance a talk like this must have caused in the poor mind of a young proselyte like Ippolit Sokolov. But, of course, as we know some stronger minds too did not remain unaffected.

8. Epilogue

The following couple of points will help round up the story about the relationship between Chaplin and the Soviets. What makes this relationship interesting and worth looking at is that it is not merely about the artist and the model. The relationship between Chaplin and

83

31. See Nicoletta Misler, "The Art of Movement," in *Spheres of Light, Stations of Darkness: The Art of Solomon Nikritin*, ed. John E. Bowlt et al. (exhibition catalog, Thessaloniki, 2004), pp. 362–69. The State Museum of Contemporary Art opened in 31 January 2004 and closed 20 March 2004.

32. See Ippolit Sokolov, "Teilorizovannyi zhest" [The Taylorized Gesture], *Zrelishcha* 2 (1922): 10–11.

33. Sokolov, "Stil' R.S.F.S.R." [The Style of Russian Soviet Socialist Federative Republic], *Zrelishcha* 1 (1922): 3. For more on Taylorized gestures, see Oksana Bulgakowa, "Laboratoriia pravil'nogo dvizheniia" [Laboratory of Correct Movement], *Fabrika zhestov* (Moscow, 2005), pp. 130–36.

34. See Franz Hellens, *Mélusine ou la robe de saphir* (Paris, 1952), pp. 65–66.

35. Ibid., p. 68.

36. See Nora Gall, "La Presence de Franz Hellens en Union Sovietique," *Franz Hellens: Recueil d'études de souvenirs et de témoignages offert à l'écrivain à l'occasion de son 90e anniversaire*, trans. L.Z. Tokarski, ed. Raphaël de Smedt (Brussels, 1971), pp. 173–74.

37. Hellens, "Literatura ikinematograf" [Literature and Cinema], *Veshch'/Gegenstand/Objet* 1–2 (1922): 11–12.

Figure 35. The "globe dance" in *The Great Dictator*
(dir. Chaplin, 1940).

whoever takes a pen and writes about Chaplin or takes a brush and paints his image is not twofold. There is always a triangle, a third force that interferes, be it Leninism, Taylorism, Thomas Edison, or Chester Conklin. This third force is, as a rule, something totally incidental and fortuitous, something that makes Chaplin's journey across media similar to a comedy of errors.

This brings back Viktor Shklovsky's mot that I quoted at the beginning of this essay. Theorists theorize about laws: economic laws, the law of gravity, or laws of society. We art theorists, Shklovsky says, need to know more about laws of fortuity, for our subjects are artists, people that specialize in making use of chance and making sense of nonsense.

If we look back at the story of Chaplin and his avant-garde shadow, we should admit that Shklovsky had a point. Take the connection we discussed earlier on between Chaplin's chicken and that gouache chicken painted by Chagall. Each of these chickens belongs to a separate, autonomous world. Chaplin's chicken stems from the world of British stage buffoonery aided by Hollywood special effects; Chagall's chicken, in its turn, belongs to the Paris school of painting coupled with Russian-Jewish thematic material. A sad Jewish chicken facing a Russian church is a complex cultural image; Chaplin's chicken, however brilliant, is a slapstick gag.[38] Chagall's chicken was born in the head of a French painter; Chaplin's chicken, in the head of a demented poultry lover. Who would venture to find, it would seem, more than a mere coincidence in the encounter we witness?

Today we may realize that this was but a chance encounter, but can we be sure that Chagall realized this? Apparently, he did not. For when in 1923, after several years in Russia, Chagall returned from Paris, this is what he said in his very first interview to the magazine *L'Art Vivant*: "It was pleasant for me to note the triumph of Expressionism in Germany, the birth of the surrealist movement in France, and the appearance of Charlie Chaplin on the screen. Chaplin seeks to do in film what I am trying to do in my painting. He is perhaps the only artist today I could get along with without having to say a single word."[39]

Making law of the fortuity called Chaplin was, we have seen, something Léger did when he inverted his Charlot-the-cubist and even animated this figure in *Ballet Mécanique* (1924). Iwan Goll who, in tandem with Léger, detached Charlot from his home medium in *Die Chaplinade*, turned Chaplin into a cosmopolitan globe-trotter, a figure similar to the one Goll made of himself when he wrote in the same year, 1920, "Yvan Goll has no home; by fate a Jew, born by chance a Frenchman, made by the whim of a rubber stamp a German."[40] As Eisenstein wrote about Chaplin, the latter reminded him of a crystal ball in the hands of a fair-ground Cagliostro; whoever looked into it saw what they imagined they saw.[41]

Epilogues can afford to be a little irresponsible. Let me, therefore, end this essay with an irresponsible hypothesis. The point I began with was that Chaplin had problems understanding what European intellectuals made of him. I quoted Eisenstein's essay "Charlie the Kid" in which the Soviet director recalls how he tried and failed to explain to Chaplin that German play that I believe was *Die Chaplinade* by Goll. In Chaplin's eyes, we assumed all this was pure fortuity. We never asked if he ever tried to convert it into law.

Now imagine a different scenario. Allow for a moment that Eisenstein did give Chaplin a brief idea of some main things about Goll's *Chaplinade*. Chaplin's globalism is the main leitmotif of the latter; Chaplin's fame is global, Chaplin is the citizen of the globe, he trots the globe, and he splits the globe asunder to listen in its womb to multilingual conversations.

In act 1, at the moment Chaplin climbs off his poster and becomes human, the globe image emerges for the first time. Goll's Chaplin is in ecstasy, his face becomes radiant, and he says to himself, in verse:

> To be human is enough to make us great . . .
> The world turns softly:
> And you are balancing the globe on your fingertip
> And will toss it back to infinity![42]

Suppose Eisenstein translates this verse to Chaplin and Chaplin, in turn, translates Goll's metaphor into the language of mime. Would it sound too good to be true to suggest that ten years later Goll's poetic phantasy of a globe turning and bouncing on Chaplin's finger resurfaces in the pantomime that Chaplin's Hitler performs in *The Great Dictator* (1940) after saying to himself, softly: "Aut Caesar aut nullus! I am emperor!" (fig. 35).

If so, Chaplin's journey across media ends in a homecoming with a trophy.

38. Do Chagall's pictures rely on Jewish contexts? See Ziva Amishai-Maizels, "Chagall's Jewish In-Jokes," *Journal of Jewish Art* 5, no. 3 (1978): 84. Was Chaplin Jewish, and if not, where does the legend stem from? See Joseph Halashmi, "And He Is of the Seed of the Jews," *Griffithiana* 73–74 (2004): 164–75.

39. Quoted in Benjamin Harshav, *Marc Chagall and His Times: A Documentary Narrative* (Stanford, Calif., 2004), pp. 323–24.

40. Quoted in Clinton J. Atkinson and Arthur S. Wensinger, "An Introductory Note," *Massachusetts Review* 6 (Spring–Summer 1965): 498.

41. See Eisenstein, "Charlie the Kid," p. 126.

42. Goll, "The Chaplinade," trans. Atkinson and Wensinger, *Massachusetts Review* 6 (Spring–Summer 1965): 503. This translation better renders this place in Goll's text than Frank Jones's.

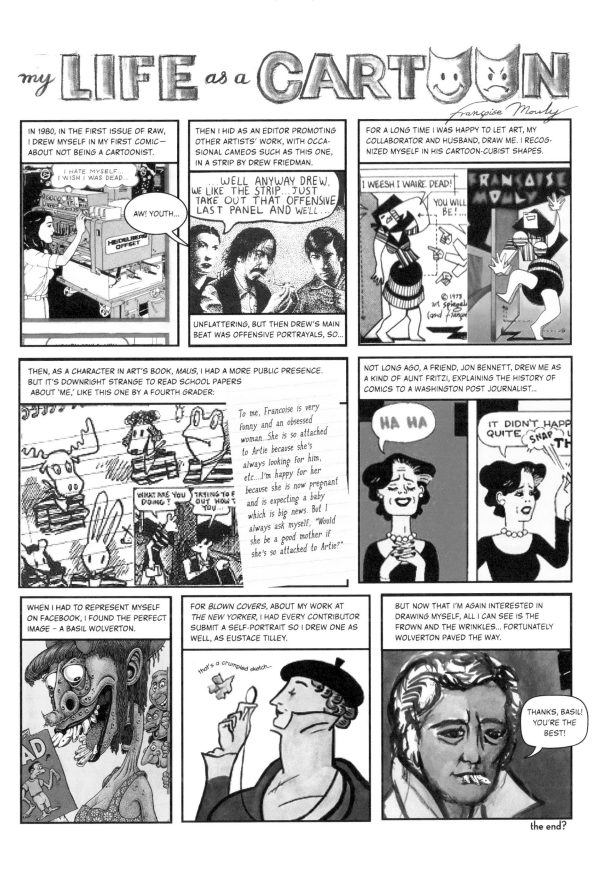

Panel: Comics and Autobiography
Phoebe Gloeckner, Justin Green, Aline Kominsky-Crumb, Carol Tyler
Moderated by Deborah Nelson
May 19, 2012

DEBORAH NELSON: Hi. I'm from the Department of English here at the University of Chicago. Autobiography is probably the most ubiquitous content matter in the American arts scene of the last sixty years. It is one of the most eagerly consumed and bestselling, however much the *New York Times* and other cultural guardians chastise us for our appetites. It is less often recognized as one of the most formally innovative and exciting forms of storytelling across a wide media platform—prose, film, poetry, performance art, drama. I could name any number of other things and you could name more and not least the graphic narrative. The graphic memoir or graphic autobiography has been one of the most innovative, compelling, tortured, hilarious, psychologically astute, historically insightful, sublime, obscene, scatological, and idiotic forms we have encountered. We need to spend some time with its foremost practitioners today.

In what I've read from many of you, if not all of you, when you started doing autobiographical work, you had a strong sense of your own anonymity, in the sense that no one will ever see this.

ALINE KOMINSKY-CRUMB: We were right.

NELSON: That clearly has disappeared if today's event is any proof of that. Can you talk a little bit about the origins of the work? When that anonymity changed, how that might have changed your relationship to your work, what you chose to write about, and what you plan on writing about?

JUSTIN GREEN: Everyone I knew knew at least someone that was killed in Vietnam. And a couple people that were injured. And there was a feeling of a real collision, not quite like the intramural sport going on down by our hotel [over NATO]. I had terrible survivor guilt. I felt that what I was doing was very trivial, and I needed to wage my own war. And so I looked within and I don't know if this means anonymity, but I didn't want to present myself as a hero, but rather as a specimen. So the comic form gives you a multifaceted view of doing that. I don't know if you

noticed, but old Superman comics have little panels at the top that say later, or soon, next day. Well, I turned that into the narrative voice where I would stack several lines of copy. But then I realized, I'm hiding up there. That's my voice, but I can show something below that either contradicts it or amplifies it. And on top of that, not only do I get to put balloons into the character's mouths, but there are thought balloons. So there is a multidimensional way of being anonymous yet at the same time pushing the story forward. But I never thought—I just thought it would, I guess, biodegrade. *[laughter]* It's a newsprint. It's been following me around for decades now.

PHOEBE GLOECKNER: When I was very young, I wanted to write about things that had happened to me, but I felt like I wasn't supposed to. I was just compelled. I had to do it. And I think because I was so afraid of doing it, that I started separating a little and seeing myself as a character. Which actually allowed me to have more empathy for that character because I really, you know, couldn't stand myself, especially as a teenager. So you get this kind of schizophrenic thing, which I actually think is normal. You have to do that because, you know, comics are a narrative form, they have a narrative structure, which is all artifice. Life isn't like that.

So you have to do so much manipulation of any set of facts or experiences to make them interesting or to make sense even to yourself. What you're after is not a set of true facts. You're after some sort of emotional truth, at least I guess I was, or just truth about what it is to be alive at whatever point. But I'm working on this project in Mexico in Juárez at the border, and it was supposed to be something that was done in a matter of months and then I was out of there. And I've been going back there for eight years and getting to know a few people very, very well. I think what I'm doing, although I didn't know it at first, is that I have to be in the story. I'm not an outsider reflecting things because I know it's my eyes. It means nothing to me if I'm just reflecting. I can't reflect something that I know little about. I have to, like, feel it and for me that

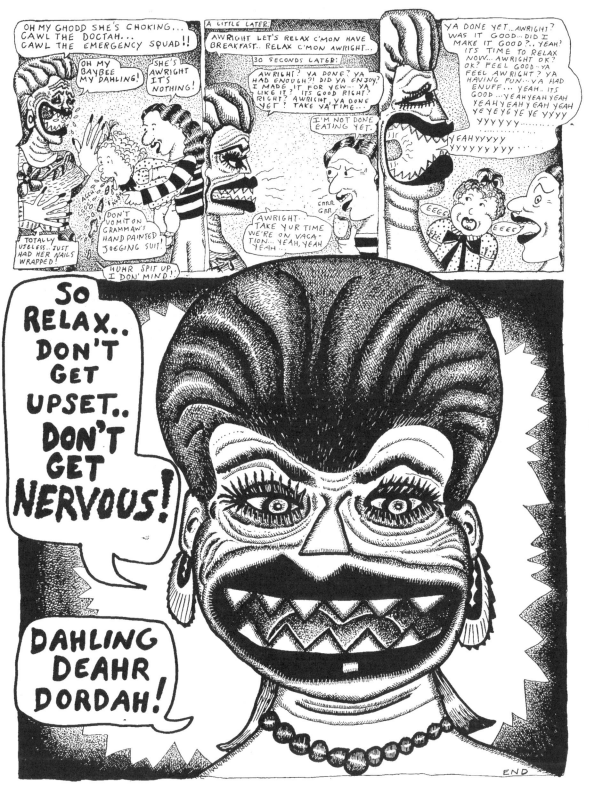

Figure 1. Aline Kominsky-Crumb, "The Bunch Her Baby & Grammaw Blabette," in *Weirdo*, no. 6 (1981).

Figure 2. Justin Green, cover to *Binky Brown Meets the Holy Virgin* (1972).

meant going back repeatedly, suffering in a sense with those people that I was writing about. I had to muddy the mix or it wasn't even real.

GREEN: So you are shifting your viewpoint as you become enveloped in the story.

GLOECKNER: Oh, yes, I'm changing just immensely. The creation is a destructive process in a sense. You kind of destroy yourself and then rebuild it. And it's painful.

KOMINSKY-CRUMB: It's dangerous what you're doing, too. Isn't it?

GLOECKNER: Two of my friends got death threats and they were at my house for nearly six months because I had gotten a lawyer at the University of Michigan to take their case pro bono. We just found out a week and a half ago that they did finally get asylum. It has been such a long process. It is like I'm so involved somehow.

CAROL TYLER: I'm just amazed at what she just said. When I started out as a painter, I just couldn't, like, say it all. And then what it was that I had to say was usually rooted in injustices, or personal slights, or how awkward I always feel. But since I've been doing this, gosh, since forever, especially with [my last project], I'm so sick of talking about myself. Because I've grown into bigger, more important things. But yet I agree, I feel like I only know what I have gone through. And I trust my emotions and my instincts. So to make a fantasy character or something like that just seems…what is that? When in fact the real, emotionally breathing thing that I feel is important.

So it is interesting how you start out telling stories about, oh, something that happened in, you know, in your twenties or thirties, things that mattered then, and now as I'm sixty, I feel like my subject matter is just changing. So much more intense. But at the same time I just want to say, oh, fuck it and do a page for *Weirdo* now and then. *[laughter]*

KOMINSKY-CRUMB: I'm the grandmother or great grandmother of autobiographical comics. Justin is the great grandfather, but I started—

GREEN: We've entered a new generation now?

KOMINSKY-CRUMB: I'm waiting for my grandchildren to announce what they're going to do. When I saw Justin's work it gave me permission to or a way to find my voice to talk about my own life, and I was motivated by rage at my mother. I could only talk about my mother all the time. Everything was in reference to my mother because she was so—such a monster. So seeing Justin's work gave me a way to combine my alienation from art school with the rage at my mother. For years, my motivating factor was to draw the meanest, most grotesque images of my mother. Now I feel really guilty because she's a nice old lady. I'm going to see her tomorrow in Miami. *[laughter]*

I really thought she would never see my work, and I don't think she would have if it wasn't for several factors. One was Terry Zwigoff's film [*Crumb*] in the 1990s. I thought

his film would either never get finished or just show in some arty theaters that my mother would never go to. I was really honest in the film and I hold up these drawings of my mother, saying, yeah, I drew this of her, ha ha look at her, she really is like that, she's even worse than that, she's just a monster. I couldn't ever even capture what a monster she really is but I'm trying. I keep trying different ways to show more aspects of her monsterhood. So Terry said, aren't you scared your mother is going to see this? I said, no, she would only see it if it came to the shopping mall behind her condo. But it did! *[laughter]* And she called me up and said, well, you know, I saw the film and I am very hurt. She didn't talk to me for three months and then we never talked about it again. You know, since then, now that I'm a grandmother and a mother and my daughter has a lot of issues with me, you know, I feel sorry for my mother. I feel completely caught in between all of those things.

I still find that my relation with my family and the people close to me is what constantly feeds me because that's what I know the best and on a daily basis that's what irritates me the most, what moves me the most, what, you know, colors everything, are those immediate relationships. I don't even know how to get beyond that. I wouldn't know how to make a political comic or make any kind of social commentary beyond what I immediately know, what's in front of me and what I experience on the most direct level. And Justin, his comics showed me a way to access that voice and so that's a great gift, you know? I don't know what would have happened to me otherwise.

NELSON: You've all made reference to Justin. Can you talk about influences both within the field of comics but also in art forms outside and around?

TYLER: We have all kind of bounced off and influenced each other.

KOMINSKY-CRUMB: Stand-up Jewish comics. Nature.

TYLER: Plants and stuff. *[laughter]*

KOMINSKY-CRUMB: Don Rickles and Frida Kahlo. *[laughter]*

GLOECKNER: I get really interested in self-published memoirists.

NELSON: Like out of the back of their car, that kind of thing?

GLOECKNER: No, like the vanity presses. Now it is all on the Internet. You can easily do it POD. Like Ira Lunan Ferguson. He was a psychologist who wrote thirty books, some of them as long as like 1500 pages, all published by himself. And one of them was a trilogy of books called *I Dug Graves at Night to go to College by Day*. *[laughter]* And then there was a subtitle, *Autobiography of a Half-Blind West Indian Immigrant*. He was this black man who had been rejected from Howard University, which had been his lifelong goal. And then he had a chip on his shoulder and got ten degrees and started writing about himself.

KOMINSKY-CRUMB: It's like not being allowed in Israel or something.

89

GLOECKNER: Exactly.

When you read his words, it's so hard to get the story because he's just, like, saying anything. He's not doing what these guys do, which is processing it and turning it into something else. So it's a totally different kind of experience to read it. But yet it's fascinating.

GREEN: I remember being very attracted to the Ash Can school of painting and also to social realism. At the Art Institute—it is probably in the basement now, but The Rock by Peter Blume is this luxurious image of a future world of devastation with these distended characters. And I used to stand in front of it, hoping that, by osmosis, the meaning of the painting would come into me. And now it is my—what do you call it? Screen saver? *[laughter]* And it still has a resonance for me. But I remember in 1967, my privileged ass was in Rome. And it was there that I was working on my conscientious objector statement. And I was constantly shuttled off to these museums to see the works of the Renaissance. And I even went to St. Peter's, I saw the Pietà. And then I saw a little fragment of an underground paper with an R. Crumb drawing. I don't even remember which one it was. I just saw the line and it was like a call to action. It brought my own culture back to me in a sea of unfamiliar and oppressive images. And I'm not alone in this. I was talking to a man who must be twenty years my junior last night at dinner. He had the same thing with Mr. Natural. Instant recognition. And so I'd always been a closeted cartoonist. It was looked askance at at RISD, where I went. But it just came out whenever I—odd moments. But then I started to pursue it in earnest, and I saw that my efforts were turgid. They didn't have a zen-like mark.

There was an artist who somehow—he is obscure now, but his name was Ben Shahn. You see his influence in all these record covers from the 1950s, where guys would try to get his chops of that line; it had a scimitar-like application. Andy Warhol found an ingenious way of replicating that by inking something and then slapping something on top of it and then the result would look like he had the chops, but he didn't. *[laughter]* And he was a good artist, too. But he didn't have that, what I saw in Crumb. And then I was in Philadelphia and I was crashing on a pile of coats in a commune. I was laid out like a corpse. This scrawny little guy came in with a sketchbook and he started drawing me. And I was really pissed but I was so tired I couldn't say anything. *[laughter]* When I met Crumb a few years later, I realized he was that guy. *[laughter]*

GLOECKNER: It's so funny you meet the people you need to meet.

NELSON: Can you tell a story about that? How do you meet the people you need to meet?

KOMINSKY-CRUMB: It's a finite group for one thing.

GLOECKNER: I've said this a million times, but—

KOMINSKY-CRUMB: Don't say it.

GLOECKNER: Quickly. I was fourteen or fifteen. My par-

ents read *Zap Comix*. They had them wedged under their mattress and we weren't allowed to read them. But we read them, of course. Same thing, when I saw *Zap*, I think it was the first time I had ever seen a depiction of sex. I was at the point where I didn't really believe that sex was real, or [I believed that] someone made that idea up. *[laughter]* Like it couldn't really happen. Then I saw [Crumb's] Joe Blow. I don't know. It just—it was so beautiful. I mean I'm not even talking about the story. So beautiful, the drawing. And then I was obsessed with Janis Joplin and I saw the album; R. Crumb drew the picture on that. I had this feeling, like, oh, my God!

It almost made me cry. And then I got *Twisted Sisters* because I used to go into head shops and sneak in there and feel weird and buy comics. And when I got *Twisted Sisters*—it was Diane Noomin and Aline Kominsky—I memorized that comic. I mean, I never read any other comics but underground comics.

KOMINSKY-CRUMB: It was deeply disturbing that you were so into that work.

GLOECKNER: You don't know how into it! I read it so many times and every time I would get something more out of it.

KOMINSKY-CRUMB: She wanted to come and, like, Robert and I would be her parents. She had this fantasy that we would be nice parents—she told me that later. Oh my God, you were so twisted! Horrible! What an idea. Ask our daughter about it. Really. *[laughter]* It's not a good idea.

NELSON: So I had a slide up here which was Aline on the cover, sitting on the toilet, for which she was roundly criticized. It was revolutionary. And there is also one of Justin from *Binky Brown* in there. I wanted you to talk a little bit about, you know, just the way that—the sex and the scatology of the work is so important to its charge. It was so controversial. It still retains a certain kind of charge, although obviously it changes over time. Can you talk a little bit about how you deal with that? When you want to do that, what are you thinking about? And also is that a distancing effect? Or a way to create proximity with your own sort of really intense bodily experiences? Or personal experiences? Phoebe, you draw very graphically, you draw very explicitly and very anatomically pristine images of sex, even if what's going on is far from that. So I just wonder if you could talk in general about some of those intensely private bodily components of the work.

GLOECKNER: But don't you feel like, you know, the more—the less you hide certain things, the less personal, in a sense, your work becomes? Because everyone has experienced the same things or felt the same things. Everyone has gone to the bathroom for Christ's sake.

NELSON: Right. Sure.

GLOECKNER: So even if it's autobiographical, the kind of truer it is, the more it becomes everybody.

GREEN: So in a sense it is like the continuation of Kurtzman to reality. I should have said *Mad Magazine* was a

91

Figure 3. Aline Kominsky-Crumb, cover to *Twisted Sisters* (June 1976).

Figure 4. Phoebe Gloeckner, "Minnie's Third Love: Or, Nightmare on Polk Street," in *"A Child's Life" and Other Stories* (2000).

big influence. But what Phoebe was saying reminded me of that—that it's a way of undercutting so called reality.

TYLER: I've never drawn explicit stuff. I am a little after you guys, you know? I didn't really start drawing or get published until the late '80s, so it just wasn't my subject matter. But I've not shied away from other emotionally charged subjects; I wanted to stab my daughter to death and stuff like that. *[laughter]* I had postpartum psychosis and I had this episode where I just, the knives were laying there, and I thought, oh yeah, I could just get her and then get me. It was horrible. What is the most horrible thing you can think of? Killing your kid, right? I thought, now do I draw that? Yes, I do, because the truth is, people have horrible, horrific thoughts and things happen. And I've had so many women come up to me and say, thank you, because you know what? I thought I was at my wit's end with my kid and I thought about how you sort of just ran from that and that's the same thing I did. That's good. So for whatever reason we go to these horrible things, but… people love it. *[laughter]*

KOMINSKY-CRUMB: I have to go back to the image of myself on the toilet. When I drew it I didn't even think anything of it because I think I always did my best thinking on the toilet. So it was obvious to draw myself thinking on the toilet because that's where I was mostly. And also I think I was interested in drawing underground comics because I thought they were things you read in the toilet and I was so sick of fine arts and thinking of putting stuff in galleries and trying to improve yourself and sell yourself and make yourself better than you are. So I was trying to go down into the gutter, and that's where I was. I didn't think anything of drawing myself on the toilet. And then Peter Bagge said to me, oh my God, you drew yourself on the toilet on the cover of a comic. I thought, yeah, that is really disturbing. Especially for a woman. It's so unfeminine, and so disgusting, it's such a turnoff, and I think that, all the sex I always did in my comics is the most unerotic thing that you could ever imagine. I think it's the opposite of erotic art, I think it's like ecch. Who would want to go near her? It's so horrible! And all the disgusting substances and bodily fluids and noises, and hideous

sex organs looking like plucked chickens and things like that. I had to confront that in my work. That's how I see it now. But at the time I had no idea why I did anything. *[laughter]* Completely uncontrollable.

TYLER: [Justin,] will you please talk about the dick rays [in *Binky Brown*]?[1]

GREEN: Well, the rays, sadly, no more veer to Iowa. Or in this case I think Michigan, but no, they only go about half a city block.

KOMINSKY-CRUMB: They're getting weaker with age?

GREEN: Yes, I'm afraid so.

TYLER: There are streets he can go down now in Cincinnati he couldn't go down.

GREEN: It is like having an annoying relative that you want to hit with a ball-peen hammer. You're tired of it. And besides, OCD, one of the few behavioral disorders that makes the world a better place *[laughter]*—has a component of detachment that knows that this can't be right. And so it is recording and it is having an active dialogue that says, stop it, what are you doing? This is ridiculous. But then the more primitive side has to go back and check the story regardless. So perspective is vital to my orientation to drawing and to understanding how a ray can function. But in a way it's such a bombastic view of the universe. And learning Photoshop is a gift. *[laughter]* Because I realized there's no ultimate line. You know, you can draw something in complete control. Your very best work. And you blow it up to four hundred percent and you see this sea of pixels that render your work a tar brush. And so that inexactitude is freeing, in a way. It means you can float anywhere.

ROBERT CRUMB: Are there any medications for OCD?

GREEN: Of course there are.

CRUMB: Do they work? If he took medications maybe he wouldn't have done those great comics.

TYLER: That's what Bill Griffith [of *Zippy the Pinhead*] said. He told me, Carol, never give him drugs.

KOMINSKY-CRUMB: When I met Justin, I asked if drawing comics helped with the rays. I thought maybe that would be therapeutic to write about the stuff. He said, no, it made no difference whatsoever.

GLOECKNER: Art is not therapy. It just makes you feel more connected to the world, perhaps, if you're lucky.

CRUMB: You foist it on the public.

KOMINSKY-CRUMB: Yeah, you foist it on the public but it doesn't take [the OCD] away. It's still there, it maybe even gets stronger the more you focus on it.

TYLER: OCD is an isolating syndrome and it is perfect for a cartoonist. Because you are in your studio and you can control your world.

GREEN: Would you want your traffic controller to have OCD? *[laughter]* The pharmacist?

GLOECKNER: You remember those two frames from Binky Brown? It had the girl's bathing suit and a little hair was peeking out and then the nun's hat. A little strand of hair. That's so beautiful. That's so beautiful.

Q&A:

AUDIENCE MEMBER: One of the things that is most striking about graphic memoirs is that you can tell the world—you can give people a much clearer picture of what life might have been like. And I'm just wondering about people in your life. You [Aline] mentioned your monstrous mother who ultimately saw your work. How have people that you have depicted in your work responded to what you have shown? And how have you dealt with your feelings about depicting other people in your work?

GLOECKNER: I mean you make a character of yourself. It is not really you. People can feel like it is you, but in a sense it is not. And that's just like the characters that represent everyone else. I have people being incredibly angry at me, incredibly angry still, but yet I feel like I've done nothing to harm them. I'm not blaming anybody for anything. Sometimes I've combined characters. You have to abbreviate life.

KOMINSKY-CRUMB: I can't do that. My character is me. I have no detachment and no control and I can't make up anything.

GLOECKNER: Wait. I have to give you the punch line. *[laughter]* So this guy liked me or I liked him, I forget, in high school. He came up to me about thirty years later and he says, wow, I read your book and, yeah, I remember that time we did this and this and this. And I'm just looking at him because you know what? I combined that character with somebody else. It wasn't him. He did not experience that. But somehow because I made it feel so right, well, it could have been him or something.

KOMINSKY-CRUMB: You are probably more skillful than me. I can't make up anything.

GLOECKNER: It is not like I made it up.

KOMINSKY-CRUMB: No but you combined it. I can't even do that. One time I did draw this person I knew and I did a story about her and I asked her and she said it was okay. And I made her look as good as I possibly could, and I really smoothed the edges. And then in the end, when it came out, she never talked to me again. Never.

GLOECKNER: You can't do that! You set her up.

KOMINSKY-CRUMB: And I thought I was really kind in my story. I made myself particularly grotesque in the story, and her way better than me, and she still hated me. So I found that you have to be really careful when you talk about other people. So I try and stick to myself as the main

93

1. In *Binky Brown Meets the Holy Virgin Mary*, the protagonist develops an Obsessive Compulsive Disorder in which he imagines that many phallic objects of all different kinds emit "penis rays" to be avoided. —HLC

grotesqueness and other people just reacting, and I try not to touch anybody else.

TYLER: My mom still says, why do you have to tell everything to all these people? You don't even know who they are.

KOMINSKY-CRUMB: When I was in San Francisco, when the Air Pirates people [of *Air Pirates Funnies*] were taking old characters and trying to make their work—

GLOECKNER: And getting sued—

KOMINSKY-CRUMB: They told me to find an old character and memorize it and then use that to tell my stories so that it would be less grotesque. I tried to do that and it just looked like an old Jewish woman put on with an animal body or something. Even more grotesque like that.

GLOECKNER: Aline, you always describe it as grotesque but it is so charming. You can't help but love that character. It is cute.

KOMINSKY-CRUMB: No, it's not cute. It's barely human.

AUDIENCE MEMBER: I'm curious as to what you guys think considering the digital revolution. In the future, comic artists might move towards using tablets and things like that. And detaching the connection between the body, the paper, lines and things like that, that kind of give personality to the comics. How do you think it is going to affect the future of comics?

GLOECKNER: Did you get pissed off when the Gutenberg press was invented and books weren't one of a kind objects? Did that really piss you off? *[laughter]*

KOMINSKY-CRUMB: It was probably a degeneration, probably made things worse.

GLOECKNER: We're in a transition and it looks ugly right now. But computer is just another tool.

GREEN: I think it is more than a tool. It is a real game changer.

GLOECKNER: I'm simplifying. But it is. Things will get better.

GREEN: I was thinking of why would so many cartoonists get together? And one reason would be for a funeral. *[laughter]* And you think about it, there is no more Rubylith, Zip-A-Tone, re-touch white, rubber cement.

KOMINSKY-CRUMB: Yeah, boo hoo, no more Zip-A-Tone.

TYLER: No Zip. No X-acto knives!

GREEN: You can get beautiful drafting equipment—

TYLER: Yeah, French curves, I love them.

GREEN: The daughters are selling them for twenty-five bucks on eBay. So that's the death. Another reason they would get together is for a wedding. And now your brain is being harnessed to the maniacal power of a computer. It is really a wonderful tool. It has its limitations, but I think every responsible artist who is starting now must reckon with it. And once you do, who knows what the re-

sults will be. It's just astounding what every year brings. I mean I think of the crude ways that I kept notes. Even before *Binky*. Like yakking into a cassette recorder. If I needed to draw a tractor I had to go to the library. I had to spend an hour looking for tractor parts. Everything is now so accessible. And the cross-references are there at your fingertips. Any artist whose work you want to see. It is mind-boggling.

TYLER: But you are seeing this little picture on a screen.

GLOECKNER: Screens will change and they have. Rapidly. It is really awkward now. URLs are some impossible address that someone did out of convenience. But things will simplify.

TYLER: Here is what I tell my students, because I teach comics. I teach them how to dip a pen, do a basic one-pager. I tell them that you got to have a mind behind the mouse. You [have] got to know the comics tradition. So I show them how to use a ruler and ink with a straight edge. Very cornball, but they love it, because there is something very, you know, tactile and they get the ink on their fingers—stuff like that. I teach the basics of pen dipping. The art of that. And then we do computer stuff. And I'm telling you, I just—I feel kind of sad about it. [Justin] is a master sign painter but there are no signs left, and you have to mourn it and move on.

KOMINSKY-CRUMB: Kids that are raised with [the computer], they know it from birth. It will be a different kind of tool to them. It will be an extension of their nervous system in a way that it will never be for me. And as an artist I look for a meditational aspect in drawing. I'm into slow art. As I get older that becomes more important. The process is more important to me than the result. But I can understand that for my two-and-a-half-year-old grandson that machines and the buttons and all of this is an extension of his nervous system that will be very natural. And I think it will be different.

GLOECKNER: Yes, but I think it's not just the way we make marks. I really think we really have to stop and consider how people read. How people absorb information. When you see comics on the web they are generally just like scanned comics that are placed there as if they are printed comics. And that's a mistake because people don't read that well. We have to start designing books or thinking of different ways to communicate what we're saying. It is actually fascinating and—I'm excited. I mean, I'm frustrated because no one can do everything. And I can't do what I want to do because I don't know how to program, but I keep trying to find a way.

NELSON: Justin, you have stuff that's online. Has it changed the way you think about your drawing?

GREEN: It changes the way I look at the sky. I was in Indiana looking up at some crows. I wanted to free transform them and move them to the lower right. *[laughter]* Carol and I were coming in to O'Hare and I saw this beautiful blend of the sky to the lake and I thought of using—Art [Spiegelman] told me about layers.

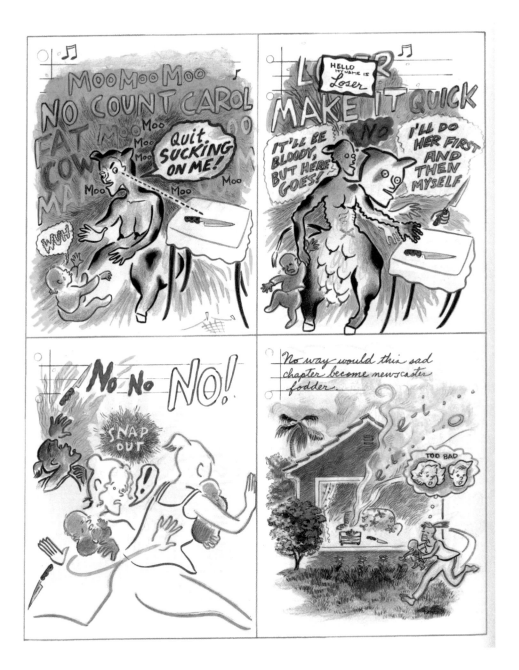

Figure 5. Carol Tyler, "The Outrage," in *Late Bloomer* (2005).

96

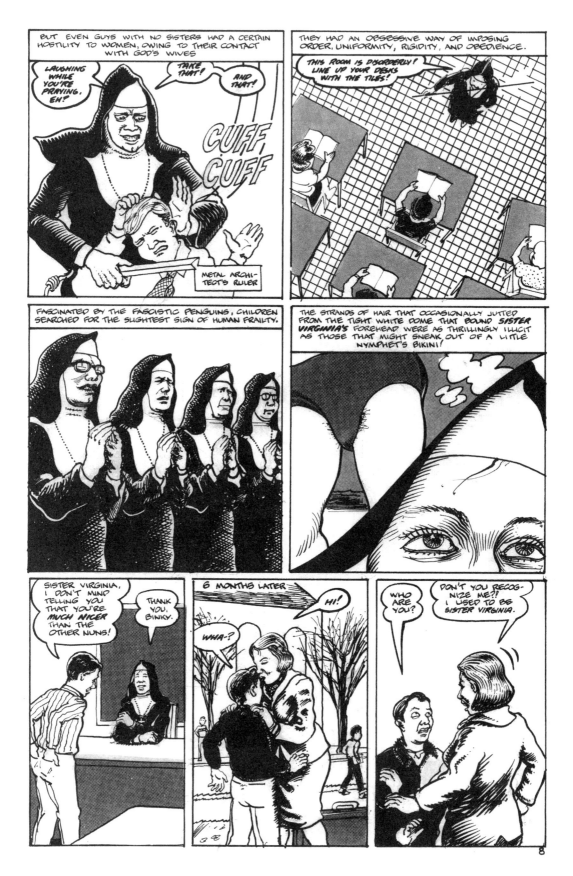

Figure 6. Justin Green, *Binky Brown Sampler* (1995).

TYLER: I can't believe you are in that so much. You come upstairs and go, I did a fascinating thing on Photoshop today. I'm like, so what? He's really, really, he's fascinated.

GLOECKNER: Yeah, but it is not just the programs. It is the idea, a way of thinking. Programs come and go.

GREEN: I'm perfectly willing to accept that this is a lapsed paradigm that we're doing. And that these new tools will lend themselves to a new mode of communication that is somewhat akin to comics, but more available to more people.

KOMINSKY-CRUMB: But we'll be dead, it's okay.

NELSON: Phoebe, are you working with this?

GLOECKNER: I'm working on two versions of a long novel. And one would be an electronic version. But just think about it—

TYLER: Are you creating electronic art? How are you doing that? Are you doing print and scanning?

GLOECKNER: Well, both, really. I'm trying to take advantage of some of the bells and whistles. But subtly. Because I want the people to read a whole three hundred page novel and not stop and get distracted and run away, which is what I do whenever I read anything on a computer tablet. I want to understand how I think what makes me run away, and I mean, I'll have animation in it, but it will be slight. You'll see a character and suddenly notice they are breathing. You'll think it was just a picture, but it is kind of alive. So some things will be like that just reminding you of the viscerality behind it. Or else they'll advance the narrative in some way. They'll function in different ways but I want to keep people reading.

NELSON: So you are not thinking differently about how you narrate. The narration component—

GLOECKNER: People can go backwards and forwards and bookmark this page. You have to start thinking about how those things interconnect. As you said, everything is interconnected and cross-referenced. And people think that way so, you know, but so do I. But how do you do that in a book and still get someone through it? You want to control the experience rather than have people just getting lost.

NELSON: Well, that was an experiment that bombed in the 60s or other decades trying to have people read and insert.

GLOECKNER: Invent endings in hypertext novels…

NELSON: I think it makes it turn into a different form. I'm talking about when it was in a book, in print, people still kind of managed to work their way from beginning to end.

AUDIENCE MEMBER: The autobiographical form is something I really admire. All of you are just fantastic and awesome and I would say in particular Carol Tyler, I have a copy of *The Job Thing*, and thank you for rewriting my resume for me. How do you feel like this has bettered you as a person? Are you better off having done comics or drawings, illustrations as opposed to say, therapy?

GLOECKNER: Some of us might have done both. *[laughter]*

KOMINSKY-CRUMB: We need it all. We need drugs, therapy, and comics.

AUDIENCE MEMBER: But specifically, I guess what I'm trying to say, was it worth it?

GLOECKNER: You just have to do it! Accomplishing anything makes you—gives you a sense of self-worth. We could have been quilters or something.

TYLER: Ten thousand stitches.

KOMINSKY-CRUMB: Just the meditative process of focusing on something every day does something to your brain waves and it helps you in other ways. You create your own reality and you make this come alive, that's something.

GLOECKNER: You get coherent brain waves.

TYLER: I'll tell you, I [just] went through the worst eight months of my life—my mom passed away. She lives four hours from my house, and my sister has cancer, and [there was] all this running back and forth. But there was one moment in all of that horror that I was able to come home and sit down at my drawing table and it was as if everything melted and I was there. And it was so peaceful. It was like, oh, I'm home!

GLOECKNER: And you have complete control, really.

KOMINSKY-CRUMB: You create the reality.

TYLER: You are the boss. Your inks, your pen.

AUDIENCE MEMBER: I was wondering if any of you had thought much about feature-length animation. I'm thinking about what Marjane Satrapi did with *Persepolis*, or, I saw a wonderful animated film recently called *Chico and Rita* [by Fernando Trueba and Javier Mariscal], or I'm thinking back to *Waltz with Bashir* [by Ari Folman]. Animation has now moved into a new realm perhaps comparable to graphic novels. I'm wondering if any of that appeals to you or apropos of what is coming.

KOMINSKY-CRUMB: I'm not allowed to talk about anything to do with any films because of *Fritz the Cat* [directed by Ralph Bakshi in 1972]. It was such a bad experience in our family. I would love to have, like, Robert's and my work animated. I think it would be really funny to have our two characters animated, but he would never let it happen in this lifetime. Off-limits.

CRUMB: It costs money. You need big money guys and they just wreck everything. Make your ideas shit.

AUDIENCE MEMBER: I was really wondering whether you think the medium has emotional potential. For example, *Chico and Rita* had a lot of strong emotion in it, plus great music. Animation wasn't the best, but that was an outlet for Javier [Mariscal].

GLOECKNER: Why adapt things? Look at Hayao Miyazaki. How much more emotional can you get than with *Spirited Away*. It was so beautiful. He's an animator first, I would say.

97

AUDIENCE MEMBER: I was thinking of making something new. Not adapting something you had in the media. I was wondering if the medium is appealing to any of you.

KOMINSKY-CRUMB: It is not you by yourself at drawing table. The thing that Carol is talking about, being by yourself and creating a universe with nobody else around, that incredible feeling of being home.

GLOECKNER: You could do it by yourself. It would take a long time.

GREEN: There is also a power to our medium, our humble medium, that is unique. Because, for example, take writing. Like we all write, right? We could cough up ten thousand words if we had to. But when we look at like a real pro, like Thomas Wolfe or Philip Roth…

GLOECKNER: Or Thomas Jefferson.

GREEN: We're pikers, but we know how to balance images and words in a way that becomes kinetic. That's not animation. It is closer to music than art.

TYLER: Dance. Movement.

KOMINSKY-CRUMB: It's something else. Opera, I think it is like opera.

GREEN: People can recall specific panels.

GLOECKNER: It is inseparable, the words and the images. It's neither nor, it's something else.

GREEN: And there's plenty for us still to learn. You're always going to risk losing a few hours of work because you tried something and it didn't work. It is a humble cobbler's type of medium.

AUDIENCE MEMBER: To go back to the question of digital technology in the field. I don't want to belabor the point if you guys are not that interested in it. You guys spoke generally about how the field will change and more possibilities will become available. How do you feel about how it will affect the ability of people to come into the field and to tell their story? It seems like the digital technology allows people to come in who don't necessarily want to do all the hard work that maybe some of you had to do to learn your craft.

GLOECKNER: Digital art can be difficult.

AUDIENCE MEMBER: Absolutely, it can. Absolutely. But absolutely I can get on Microsoft Paint and draw circles for heads.

GLOECKNER: I bet you could do that with a pen, too.

AUDIENCE MEMBER: I can, I am so lazy.

GLOECKNER: But artists aren't idiot savants. You could draw stick figures.

AUDIENCE MEMBER: My question is, does that idea bother you at all? The potential for just an influx of people into the field who aren't maybe working that hard or aren't that interested in paying their dues. Or is it just that people

98

should tell their story and it doesn't matter if the field is glutted?

KOMINSKY-CRUMB: I have to answer that. In the early 70s when I started drawing comics, there was an opening up to anybody because of the success of *Zap Comix*. Anybody could get published. I met someone on the bus, I saw her drawing, and I asked her to come to this [comics collective] meeting because we needed more pages in the book. There was no quality control. When I look back at that stuff, it is so bad, it is unbelievable. It would never be published now. But that was a period of blossoming because of that openness. And eventually some of the stuff just disappeared and the really good stuff continued to stay good. Like the stuff that was really good holds up and the other stuff is just terrible. So I imagine it is not that different [today].

GLOECKNER: It is like having an audience filled with people, some might be called beautiful and some might be called just people. *[laughter]* And it makes life so much more interesting. If you open a comic book and it is so beautifully drawn and you know you love this author, you get tired. It is stifling.

AUDIENCE MEMBER: To get back a little further to Ms. Gloeckner's comment about abbreviating your life. One thing I discovered is that when you look back at your life, usually the memories aren't in the kind of dramatic scenes we expect in narrative, graphic or otherwise, but all these emotional impressions which can be lovely but they don't always automatically translate into scenes. When you sit down to write, how do you take your emotions and get a narrative out of that?

GREEN: I think that the dirty little secret of comic writing is copyfitting. Copyfitting.

GLOECKNER: You only have so much space to fit the word in.

GREEN: We might really come up with a phrase we want to use and we think it is neat, but it all depends because maybe you need to have an arm that is holding a broken bottle in that place, so you've got to ax an adverb that you like. So we're all like master bullshitters. We can move a story along—that's the important thing—to keep the continuity going, but then every once in a while, like you say, there will be a dramatic moment and that's when we try to find a pictorial motive. That's where our art school chops come into play and we know how to manipulate lights and darks and make something pop out. But you can't do that in every panel, of course. I was speaking to Aline before we started and she mentioned she had done the last panel first. That's a great way to start I think. Because then you can parse your movement more economically going backwards. And of course there is always the splash panel. That's the poster, like the circus poster where you lure the rubes into the room. And you really work out with your lettering and your drawing there. They say, oh, this is well drawn. It looks interesting. And then you can kind of lame out as the story…

KOMINSKY-CRUMB: In my case they usually run when

they see the first page. They say, I'm not going any further, this is too disgusting. You get rid of a lot people that way. Eliminate the riff raff.

GLOECKNER: I have the most horrible work habits because I never sketch more than one panel—I don't plan anything. It is like I don't even know what the story is. But it is almost a reluctance to—I feel like if I sketch anything in advance I'm giving myself an assignment and like I'm hiring myself. And it is so boring.

KOMINSKY-CRUMB: I agree. I never know what is going it happen either. I like to keep suspense. Being nervous and almost sick that I'm not going to be able to finish the story in the right number of pages is part of the dramatic tension that's interesting.

TYLER: I've been working on a book for eight years and I just finished. I was amazed at how I thought I had it down. I got it. Got it. And then some shit would happen. So at the very like last month of wrapping up the book, something incredible happened. So I had to go back in and quick do twenty pages because it had to be added.

GLOECKNER: It is an additive process, and for me it's always subtractive subtract.

KOMINSKY-CRUMB: I think we create a narrative and I think we have this logical story and it is all going to work out like a film. And that's not even the important thing at all. That's just an excuse to vent all this totally neurotic stuff, and it is all the unwitting, interesting things that you put out there that are interesting.

GLOECKNER: The process is not like a job. It is your life. You don't even think of it as "my job."

AUDIENCE MEMBER: It seems to me the questions about the computers and technology misses that moment in the late 1990s when everyone started going online, [and it] really changed autobiographical comics. This has not so much to do with the death of Zip-A-Tone, but Phoebe, when you were bringing up the vanity press, that outpour was on the web. People are writing on their blogs about sitting on the toilet now. It seems it especially affected autobiographical comics where now you have to make these three hundred page memoirs. It seems like autobiographical comics [that are] just two- or three-page stories, or four-page stories, the opportunities to do that today have sort of lost out because it is just easier perhaps to make a blog post or a Facebook update.

GLOECKNER: I always felt people—you know, you can do your art any way you want. You don't even have to tell yourself it is a memoir or autobiographical. You are just doing it. You don't tell yourself—you don't define yourself. That's so limiting. But there are masterpieces possible in any genre, any medium. There are blogs which, you know, are brilliant. So it doesn't really matter how we do it. It doesn't matter if it is three pages or in the form of a memoir.

AUDIENCE MEMBER: I like three page stories. I miss those. It seems like autobiographical cartoonists have to make books. There seem to be less opportunities to publish three page stories or short works.

GREEN: Publish them where?

AUDIENCE MEMBER: They are gone.

NELSON: Can we talk about the anthologies? Where there is a shorter work.

TYLER: One of my old students has a thing called *Kindling Quarterly*. I have my students do a one-to-three-pager. They have to go through the process of submitting to a little magazine. A one-pager is a great thing to learn. Because if you can master the one-pager, you have got a splash panel involved, you have sequence, and you have got to finish it at the end of the page. So it is like a haiku.

KOMINSKY-CRUMB: I'm thinking about that right now because we're going to Miami tomorrow to visit my parents and we have to do a one-page strip for the French magazine. I'm already thinking before I go there I will be influenced by what is happening there. I'm already writing the story before I go. I already have a preconceived idea of what it is going to be. *[laughter]* I have to limit it to nine panels or twelve.

NELSON: I was going to ask a question about that actually. I was wondering about the transition from not life to art, but art to life now that you work as memoirists and in autobiography. Do you ever have these meta-thoughts while you are experiencing something that maybe make the experience impure because you are thinking about it and changing it and thinking of drawing it while you are experiencing it? Versus, Phoebe, how you were saying you kind of naturally became a character.

GLOECKNER: Yes, but just like you said, the very awareness of that turns it back into a real experience. Then you might have to write about that feeling. *[laughter]* It doesn't matter—you can't adulterate your life. It is what it is.

KOMINSKY-CRUMB: Sometimes I do see life, you know, separate, and see it as a comic while it is happening. But that doesn't mean I can change how other people are acting. *[laughter]* They are still being themselves.

HILLARY CHUTE: I was wondering if you could talk about style, because you all have such different drawing styles. And I'm curious, how would you each describe your own style?

KOMINSKY-CRUMB: I have no style. It is like awkward, hideous scratching. No control over it. Hopefully it has like some power of—an expressiveness, that's the best I can hope for. Beyond that there is nothing. I try to make it readable. Hopefully like the crudeness and the lack of skill, you know, helps the expressiveness come through purely. But these other people have actual styles.

GREEN: Going back to the Robert Crumb fragment, I spoke of my initial discovery of his work. The reason that resonated is because it had a tradition about it that went back hundreds of years. It suggested through this pen line, which was obviously a flexible nib, that there had been a gesture about it. And that went back to the wood-

99

100

Figure 7. Phoebe Gloeckner, "An Object Lesson in Bitter Fruit," in *"A Child's Life" and Other Stories* (2000).

cut tradition. It was a graven image that was germane to my culture that was an ideal to live for. And now I see that as assurance and fluidity and simplicity and, like they say, Hokusai on his death bed said, in ten years I'll have it. It is a never ending quest. But it is an ideal. You want clarity.

GLOECKNER: I can't stop doing details. Ever. The wood grain and everything. I wanted to study medical illustration because I was always thinking about things in my head. I wanted to be able to visualize—I wanted to know what was in my body, too. It seemed just as significant. So I could cut people open and look at that. It actually demanded as much attention to detail as comics. But just quickly—I just want to say, in my classes, I have them copy a master. A great master. So they do that—they copy that page of yours, Robert Crumb.

CRUMB: You sent me those. That was unbelievable.

GLOECKNER: They copy it. I tell them they can't trace it. It has to be different size. But then I think, okay, what if I had them copy a page by Aline? You laugh and I laughed, too. I don't know if they're going to understand its greatness. You belittle your work, but you must know that on some level it is beautiful. But will they understand that? I think they can understand the process—that it is so difficult and hard because it is so great. But with Aline's work it is different.

CRUMB: In the beginning most of the people who read comics were boys and they really admired fine pen line and, you know, good drawing. They despised Aline's work.

AUDIENCE MEMBER: This is for the female artists. I wondered, when you started out, was there more scrutiny? Was it harder? Did people discourage you? Because a lot of people think women aren't funny. Did they get the humor? The female artists are sort of accused of being maybe too personal or too emotional.

KOMINSKY-CRUMB: We all started in different eras. Really. I started first, then Phoebe, and then Carol. We were at different—the atmosphere was different for each of us I think. When I started it was early women's comics. That was the first group of women's art collective, we got together to do comics. That was a very divisive group in a lot of ways. There were different conflicting agendas in that group. It wasn't necessarily the most nurturing atmosphere to draw in.

GLOECKNER: It was so unpleasant sometimes. But we stuck with it, didn't we?

KOMINSKY-CRUMB: There was a very big feminist movement at that point. They were censoring other people's ideas. Actually I had more trouble with conflict with other women than I did with the men at that period of time. Men were very encouraging to a lot of the women at that time in the early 1970s. I felt like I got a lot of nurturing from Justin, from Robert, from Spain [Rodriguez], from Art and Bill [Griffith]. I felt actually I didn't have that conflict with the men, but within the women's group it was very conflictual and very heated.

GLOECKNER: It is still kind of going on. I find myself when I'm invited to things, I'm the token female. It pisses me off because I'm like—if I'm going to do anything, call me a cartoonist. Don't add a fucking adjective to it. I don't call Robert a white male cartoonist. Well, actually I do. *[laughter]* But you are that just as I'm a female cartoonist. Right?

BILL BROWN: So we've been talking about this as autobiography which it certainly is but also very seriously self-portraiture. Phoebe you talked a little bit about externalizing one's self. Can you imagine if you—if, Aline, one knows your comics but has never seen you in person, what a shocker it is to see you in person. Right?

KOMINSKY-CRUMB: Why would you say that? *[laughter]*

BILL BROWN: I'm interested in a certain moment of the scene of production where you are producing yourself. Which of course isn't yourself, but it's some version of yourself. Sometimes I mean for—I mean for all of you. Sometimes I'm sure it is really funny. It is like oh, my gosh that's just hysterical. Other times it must be very painful. As though, yes, that's who I am. That's what I look like. That's what I look like. So I just would like to hear all of you talk a little bit more about not the narrative, but about the self-portraiture. About representing yourself. And at the moment where you see yourself made manifest on the page.

GREEN: Well it really is an unforgiving medium if you don't retouch. *[laughter]* And the slightest little flick of the hand like a thirty-second of an inch makes all the difference in an attitude or a gesture. And when you are on, you magically do something that you aspire to.

You keep copying your success. But then you live with the stuff. You look at it day after day and some of it is very unflattering. Like a fun house mirror. You try to hide from it. But there is a truth there that you have to face.

GLOECKNER: But when you draw yourself, though, he's asking. Don't you feel the way you described about drawing anybody?

GREEN: No.

KOMINSKY-CRUMB: Yourself is different.

GREEN: You can be merciless with anyone else.

KOMINSKY-CRUMB: People will say you are ugly when they meet you. If you draw yourself ugly, they say, "Well, you look a lot better than I thought." *[laughter]*

GREEN: It goes back to something Art was saying yesterday. I can't quite remember exactly the words. But it was something about implied irony. You can't make an idealized portrait of yourself because then you are vain. So you are intentionally ironic.

KOMINSKY-CRUMB: In early women's comics that was the dividing point. When some of the women were making themselves into romantic heroines, and others were making ourselves into grotesque monsters. The grotesqueness that I had in my early drawings was a reflection of how

Figure 8. Carol Tyler, cover of *Wimmen's Comix* (1990).

my parents made me feel. It wasn't a choice. I felt that ugly and horrible. I didn't even think I looked human in my early comics. I barely resembled a human being. My parents made me feel that horrible. But gradually as I became more confident as an adult, I at least became a little bit human in my drawings.

GLOECKNER: Maybe it is not even always a question of ugly or beautiful. It is something else. You don't want to make your features so reduced to just bumps that it is not you. You just have to find your essence somehow. And it is beyond any kind of judgment.

TYLER: Well, I lead with the chin.

KOMINSKY-CRUMB: And I lead with the nose.

GLOECKNER: And I have three little balls of putty for the nose.

TYLER: So we've got our spots. But the hard thing for me is I felt self-conscious and bad my whole life, so I try to make that person on the page a little better. You know? She's okay. She looks good.

GLOECKNER: But you want to make that character likable, too.

KOMINSKY-CRUMB: I don't want to make mine likable.

GLOECKNER: But you have.

KOMINSKY-CRUMB: I don't try to.

GLOECKNER: But you did.

TYLER: Do I make myself old and crotchety like I look? In my comics I don't know if I should do all the lines and wrinkles, because I spend so much time trying to smooth it out and not have it be there.

GLOECKNER: It takes so much longer to draw yourself as you get older because there are so many lines. *[laughter]*

KOMINSKY-CRUMB: I just had a Botox injection here so now I can keep my forehead smooth in my drawing.

GLOECKNER: So much easier—it is practical.

KOMINSKY-CRUMB: Used to be a big line here but now it is erased.

GLOECKNER: I cut off both of my ears so I don't have to draw them. *[laughter]* They are too hard to draw.

KOMINSKY-CRUMB *[pulling cheeks back with the palms of her hands]*: Draw yourself looking into the mirror like this. Draw it like that.

TYLER *[holding up her left cheek with her finger]*: Drawing with one finger like this, so this is up. So maybe it won't sag.

KOMINSKY-CRUMB: How I look with that side? That looks pretty good.

TYLER: How about you, Justin? What do you do? We're all cosmetic here. What are you doing?

GREEN: I want my suffering to have the beauty of your flesh.

103

Sculpture, Stasis, the Comics, and Hellboy

Scott Bukatman

It's become common to understand comics as a medium of motion, even as something of a moving image medium. Scott McCloud's champion analysis, *Understanding Comics*, points to the battery of devices that comics artists have used to depict motion—motion lines, blurring of moving objects or backgrounds, multiples of the same figure indicating the progress of movement within a single panel (see Carmine Infantino's rendering of the Flash), the lines of force and seething energies associated with Jack Kirby, and plenty of others.[1] McCloud's very definition of comics hinges upon movement, upon the change that occurs between one panel and the next. Sequence, change, movement: these are the foundation of the medium. Comics emerged as a mass medium nearly contemporaneously with the cinema, and both spoke to the frequently observed sense that modern life was, excitingly and disturbingly, speeding up. The continuing confluence of comics and the cinema aligns them both as dynamically moving media, each a neat complement of the other. My own writing has explored the ways early comics mocked the disciplinary aspirations of chronophotography, and I've celebrated the kineticism of the superhero (whose kinetic and metamorphic being seems almost absurdly appropriate to the digital technologies of the cinematic blockbuster).

But comics and cinema are very different. The cinema tends to speak to an embodied subject; the viewer is immersed in an adventure of perception in which eyes and body are directly engaged, in which perceptual and corporeal limits are both recalled and transcended. Comics do not grab in just this way. They are normally more engrossing than immersive and present instead a complex adventure of reading in which syntheses of word and image, image sequences, and serial narratives are continually performed—as such theorists as McCloud, Thierry Groensteen, and Charles Hatfield have admirably demonstrated.[2] Further, for all the avowed similarities between cinema and comics, they differ entirely on the level of materiality. Comics images neither move nor record things that previously moved, and there is no imprinting of the physical world onto a material substrate (with or without digital intermediation). An artist's hand movements are recorded onto a surface, but this phenomenon is nearly always unrelated to the diegesis. Comics present an arrayed sequence of images more or less hand-drawn by an artist (with or without assistants or software). An individual comics panel has more weight in relation to the whole and contains more narrative information than does a single film frame.

Getting some distance on comics' propensity for movement, change, and metamorphosis reveals ways that comics can exploit the innate stasis of the medium to different purposes: narrative, certainly, but also formal, conceptual, and even theoretical. Here, film might yet provide a useful analogy. The field of film studies has recently witnessed a turn to the theorization of stasis. Laura Mulvey's *Death 24x a Second*, Karen Beckman and Jean Ma's collection *Still/Moving*, and Elvind Røssaak's *Between Stillness and Motion* are all indicative texts.[3]

For the most part, however, film theory proves less helpful than one might want in finding analogous operations in comics. The analyses are, for the most part, deeply

For their questions, comments, and enthusiasm, I would like to thank students and colleagues in my graduate seminar on comics at Stanford University in 2013, the Graphic Narrative Project (also at Stanford), and the 2013 edition of the International Comic Arts Forum, held in Portland, Oregon.

1. See Scott McCloud, *Understanding Comics: The Invisible Art* (New York, 1994).

2. See Thierry Groensteen, *The System of Comics*, trans. Bart Beaty and Nick Nguyen (Jackson, Miss., 2007), hereafter abbreviated *SC*; and Charles Hatfield, *Alternative Comics: An Emerging Literature* (Jackson, Miss., 2005). Note that this doesn't take account of the various experiments in cinema and comics that would complicate this dualism.

3. See Laura Mulvey, *Death 24x a Second: Stillness and the Moving Image* (London, 2006); *Still Moving: Between Cinema and Photography*, ed. Karen Beckman and Jean Ma (Durham, N.C., 2008); and *Between Stillness and Motion: Film, Photography, Algorithms*, ed. Røssaak (Amsterdam, 2012).

connected with the technological bases of the medium: the materiality of the film strip, the automatism of the camera, the illusion of life, the indexicality of the photograph. Stasis in cinema is almost inevitably the cessation of movement. Laura Mulvey has gone so far as to argue that the static image is the repressed content of the cinema: the still image partnering with narrative closure to return cinema to its original, inanimate state of discrete, static, images printed on a strip of flexible celluloid. Borrowing from Peter Brooks's work on Sigmund Freud's *Beyond the Pleasure Principle*, Mulvey writes, "movement, inherent in the death instinct, jostles with its aim to return, to rediscover the stillness from which it originally departed."[4]

Stasis in comics, though, doesn't speak to the same issues or conditions as stasis in cinema. First of all, there is no need to rediscover stillness; static images are fully on display. Nor does the comic image speak to what is no longer there, as in the frozen moment of the photograph. Stasis in the comics is neither the freezing nor the cessation of motion; it is, more simply, the absence of movement. How, then, does stasis in comics become significant, and what are the terms of its significance?[5]

Jerry Moriarty's *Jack Survives*, a series that began appearing in the pages of Art Spiegelman's *RAW* in 1980, uses stasis tellingly.[6] His comics are painted, sometimes more or less monochromatically, other times with full, flat swathes of color. The paint freezes the action, whether it's the smoke rising from Jack's cigarette or the action-packed moment when his shoelaces snap simultaneously, the moment is one that is captured and frozen in place—the ephemeral made epic. Paint also directs attention to the surface of the image and its materiality as an image—there's nothing like painting a word balloon to give it material presence and weight (as Roy Lichtenstein and Andy Warhol demonstrated some decades before) (fig. 1). Other elements direct attention to the picture plane: word balloons arbitrarily distorted and/or hidden behind elements of the scenery, a logo that spills over and behind the panels of his page/canvas, white paint that almost but not quite obscures the palimpsest of text beneath it. In some of his later work, the space between panels is eliminated, and dramatically different perspectives abut one another, undermining the perspectival illusion of any one of them.

Inspired by Moriarty's father, Jack is a middle-aged man of an indistinct past; he wears a hat and tie, seemingly even on weekends, and is, if not a stoic, at least a man who expresses minimal emotion. He is, on a psychological level, somewhat closed to us, and Moriarty entraps him

on the surface of the picture plane—there is no depth, no point of access, no behind. This is not the same as implying that Jack has no inner life, just that we're not privy to it. Greice Schneider, comparing Moriarty to Edward Hopper, refers to the sense of suspended time in each as a "temporal impression of a time that accumulates" rather than passes in the steady drumbeat of resolved events.[7]

Looking at the heavily worked surfaces of Moriarty's earlier works in black, white, and pale blue, I'm reminded of the animated films of William Kentridge as well as Rosalind Krauss's analysis of them. Kentridge works through continual modifications of a single drawing rather than photographing a series of discreet drawings. Each frame of Kentridge's films bears the traces of the drawing that was and perhaps clues to the drawing that will be. For Krauss, this profoundly undermined the plasmatic freedoms that animation traditionally promised. Far from the magical environs governed by the internal laws of "cartoon physics," in Kentridge's work "weight makes its appearance through his sense that this transformative power needs to have a certain drag placed on it, a certain resistance or pressure exerted against its weightless fluidity."[8] Moriarty's technique, with its thickly laid paint, its palimpsests, and its sense of time in suspension, introduces a similar drag, an inertial force that forces us to remain in place before the work, with no possibility of going further.

For Moriarty, painting provides both the material and the rhetoric to work against the movement of comics, while for Moriarty's great admirer, Chris Ware, graphic design works against the linear momentum of the medium. Ware's emphasis on text as a pictorial form arrests the gaze and transfers language from the plane of transparent narration to a constituent element of a world that demands, above all, to be read (a similar effect to that produced by Moriarty's materialization of text). *Acme Novelty Library #16*, part of the ongoing Rusty Brown saga, features Ware's characteristic typographical display and play as well as his characteristic treatment of time. The characters are pinned in place by the geometric precision of Ware's line and the isometric projections of his space. These characters are richly psychologized, but our access to them is not aided by a naturalistic style of illustration that would encourage us to recognize their humanity from the first. Instead, Ware's characters are schematically designed, minimalist machines that the reader must animate. Their precise, flat forms are situated in panels that are often carefully balanced across

4. Mulvey, *Death 24x a Second*, p. 71.

5. This is not the first time I've considered stasis in the comics. In an extended discussion of the relation of comics to the chronophotographic experiments of Eadweard Muybridge and Étienne-Jules Marey, I located a parodic function that systematically mapped movements that led either to chaos or stasis. The neatly stacked cans that are sent flying by the ejaculation of Winsor McCay's Sammy Sneeze (not to mention the carefully ladled soup, the meticulously reconstructed Dinosaurus, and the very panel boundaries themselves, all of which are reduced to shambles of various kinds) stage a resistance to the imposition of order and measurement imposed on the bodies within chronophotographs and the disciplinary societies that they serve. Narrative is characterized by movement, while stasis represents its closure, its termination. See Scott Bukatman, "Comics and the Critique of Chronophotography, Or 'He Never Knew When It Was Coming!'" *Animation* 1 (Summer 2006): 83–103.

6. See Jerry Moriarty, *The Complete Jack Survives* (Oakland, 2009).

7. Greice Schneider, "Jack Survives—Jerry Moriarty," *The Comics Grid* 1 (2011): www.comicsgrid.com/2011/02/jack-survives-jerry-moriarty-2/

8. Rosalind Krauss, "'The Rock': William Kentridge's Drawings for Projection," *October*, no. 92 (Spring 2000): 17.

Figure 1. Jerry Moriarty, *The Complete Jack Survives* (2009).

the double-page; symmetries and even rhythms dominate.[9] Moment-to-moment transitions are indulged to an almost parodic degree. Stasis becomes an existential condition; time seems to expand infinitely, as does the time it takes for every incident to unfold.

This issue has two stories unrolling simultaneously: Most of the page is devoted to Rusty and his father, a teacher at the school where much of the "action" takes place, while a small tier at the bottom relates the overlapping story of Rusty's childhood friend Chalky White and his sister beginning new lives in Omaha. Ware pays homage to the Sunday funnies of another era, which often paired a smaller "topper" strip with the main strip by the same creator, but here it introduces new problems for the reader, who must choose to either juggle two narratives simultaneously, page by page, or read first one and then the other.

In the recently completed *Building Stories*, Ware introduces the trope of a central image around which the double-page spread is organized. Its position in the reading sequence is not clearly marked, but its placement and size are emphatic—these images are emblematic or even allegorical. It is not clear—when faced with a central image of a room, unconnected by lines, arrows, or gutters—how to proceed through the page that flows around it, and indeed it's largely immaterial in what order one proceeds (this strategy, writ large, obviously informs the box o' comics that constitutes the epic *Building Stories* itself). In the massive sequence produced for the oversized *Kramers Ergot 7*, the central spread opens to reveal a life-sized toddler asleep in the center space; other examples in other components include images of money, masks, birth control pills, an old photograph, and the toddler, now a few years older. The image of the child speaks to the central importance the child occupies in her mother's life, but also, and more ambivalently, to the irresistible gravitational pull that she has exerted on the shape of the woman's life.

But my primary text will be Mike Mignola's *Hellboy*, an action and adventure comic that rather unexpectedly emphasizes the stillness of the image and of the page. For the rare *Critical Inquiry* reader unfamiliar with him, Hellboy is a hulking, red-skinned figure with cloven hooves, a sinuous tail, muttonchops, and two bumps where his horns used to be. Swathed in a trench coat and usually packing some serious heat, he is one of the foremost paranormal investigators of his day, serving as a sometime member of the Bureau for Paranormal Research and Defense (he comes down rather more heavily on the defense side of things). A demon summoned by desperate Nazis near the end of World War II to abet their plans of world domination, he first manifested as a small and frightened horned creature. (Part of the joy and curse of comics studies is that you all too often find yourself typing sentences like that one.) A timely raid by Allied forces resulted in the critter's adoption by Professor Trevor Bruttenholm, who raised him as a normal lad. Saddled with the knowledge that he is the demon Anung Un Rama, the Beast of the Apocalypse, Hellboy has lived a life of resistance, refusing his destiny (hence the filed down horns). He has aged more slowly than the humans around him, and his adventures have spanned several decades. The comics vary in structure and tone. Some stories are short, taking no more than ten pages, while others stretch over a six-to-eight issue arc. Some connect to the larger cosmology, others are heavy with atmosphere, still others simply give us Hellboy punching out some sort of occult beastie. The comics combine mysticism and cosmicist science fiction with superheroic action; Hellboy's response to the appearance of an ages-old demon or animated corpse is usually a brief exclamation of "Jeez!" or, more typically, the interrupted locution, "Son of a —!"

Stasis does not immediately suggest itself as an appropriate aesthetic strategy for *Hellboy*. The comic doesn't emphasize the quotidian experiences of child-rearing or aging as works by Ware and Moriarty do; what it emphasizes is adrenaline-pumping, demon-stomping action. Small wonder that *Hellboy* was one of the earliest comics-to-film adaptations in the current superhero genre cycle. Jocular action with epic undertones and unceasing opportunities for all the visual imagination that digital special effects can put forth positions *Hellboy* as seemingly destined for the screen. To date, *Hellboy* has served as the basis of two feature films (both directed by Guillermo del Toro), and a few animated ones produced for the DVD market—and so provides a somewhat direct example of the gulf between film, animation, and comics. Mignola has served in some creative capacity for all of these projects and seems happy enough with them (and indeed, they've got their moments, not least of which being the casting of a pitch-perfect Ron Perlman as Hellboy). Reviews and box office returns attest to the success of both films, and their strong showing undoubtedly helped cement Hollywood's romance with superhero/comics adaptations.

I, on the other hand, was less enchanted. Other than a few lovely hang-out scenes in the first film (*Hellboy*, dir. del Toro, 2004) the adaptations are dominated by bombastic action more informed by del Toro's aesthetic sensibility than Mignola's. What was lost, and what I missed, was Mignola's aesthetic, which epitomizes much that is interesting about comics and which is more proper to the stasis and status of the printed page. Space, figure, and, yes, even demon-stomping are treated differently in the comics and films in ways that speak to the affordances and constraints of both media. Mignola's *Hellboy*, while remaining in all ways an action comic, is steeped in a stasis that seems almost contemplative. That this innovative exploration of page, movement, sequence, and figure takes place in the pages of a monster-adventure-action comic is remarkable. Ultimately, I want to argue that *Hellboy* speaks to the condition of reading by creating something of a ruminative and intertextual space for the reader to occupy. The terms of that creation can begin to be understood, perhaps surprisingly, through a consideration of the medium of sculpture, as we shall see below.[10]

107

9. In *Building Stories* and some later *The New Yorker* covers, Ware has begun to introduce modeling and a greater individuality to his portraits; see Chris Ware, *Building Stories* (New York, 2012).

10. In a subsequent essay, I plan to explore another relevant medium—the illuminated medieval manuscript.

Figure 2. Mike Mignola, *Hellboy: The Island*, in *Dark Horse Comics*. Colors by Dave Stewart (2005).

page), digital coloring with plenty of modeling, heavy photo-referencing (or appropriating) for characters, scenography, and props, abundant Photoshopped effects, and a general tendency towards a kind of photorealism all permit an *Iron Man* film and an *Iron Man* comic book to share attributes. *Hellboy* has little of this. The colors are largely flat, the palette is more expressionist than naturalistic, the art remains tidily framed within panel boundaries, the heavily stylized artwork is far from the realist norm (most of the artists with whom Mignola works have similar cartoony elements), the battery of devices for representing movement in comics, such as motion lines or digital blur, are absent, and dialogue is comparatively minimal.

The *Island* begins decidedly not with a bang. Two panels of pale seagulls against a pale sky, followed by a wide panel of ancient, wrecked ships (fig. 2). Sky and sea are unmarked areas of negative space, and only the darker grays of timbers and hulls assert themselves. The next panel brings us closer to one of the ships, deep violet hues draw the eye, and an inset caption contains one enigmatic word, "Hellboy…" The bottom panels give us Hellboy himself, seemingly adrift beneath the waves, and a close-up of a pendant in the shape of a head, stained a dark blue and set against a black background. The reader may assume spatial contiguity—the darkness seems the darkness of the sea—but it isn't certain. Captions recapitulate a conversation the reader might remember from an earlier tale: "Where are you going?" "Africa." "And after that?" The question is unanswered.

The next page brings us back to one of the shipwrecks—"Hellboy…" is repeated. A narrow panel returns us to Hellboy, yellow eyes visible now and open, looking upward. The last panel on the top tier frames an almost abstract interplay of rocks, debris, sky, and sea. "Wherever the wind blows," seems to be the belated answer to the hanging question of the previous page. Two vertical panels present the submerged portion of the wreck, with the skeletal remains of its crew trapped eternally below. The final panel on the page is roughly two-thirds of the page tall and two-thirds of the page wide: seen from shore, the distant figure Hellboy emerges from the water, his red body and brown coat the only relief from the grays and blacks of this Sargasso (fig. 3).

If there is one thing missing from this opening tableau, it would be movement. Not only is the action about as minimal as could be, but all the myriad cues that comics use to indicate motion are absent. Everything is quite still. Indeterminate time passes, and sequentiality itself is presented in a weakened form; those two vertical panels of the undersea wreck exist in no evident temporal rela-

The Island, a two-part story from 2005, was produced in the wake of the production of the two *Hellboy* films and marked the first story Mignola had both written and drawn in three years. Somber and barren and lush, it's one of Mignola's most striking works. Much of the cosmology that underlay the *Hellboy* comics, elements that had been hinted at in earlier tales, were now explicated. Mignola has written that he was apprehensive about the way the films changed that cosmology and wanted to re-mark his territory by making certain his version was canonical by the time the second film was released. But there may be something more in *The Island* than Mignola acknowledges, and that is an attempt to reclaim Hellboy for the comics, to reestablish his aesthetic upon Hellboy's world, to, in other words, take Hellboy back to the world of the page and the book.

There is nothing evidently cinematic about the aesthetics of the *Hellboy* comics. Contemporary superhero comics have evolved a grammar that derives heavily from action cinema and that has in fact come to be called a cinematic style: "widescreen" panels (often bleeding off the

Figure 3. Mike Mignola, *Hellboy: The Island*, in *Dark Horse Comics*. Colors by Dave Stewart (2005).

tion to the "action" of the scene. They have been there, they continue to be there. That there are two panels would seem to indicate some diachronic movement, but a closer look suggests that this might be a single image, bisected by an arbitrary panel division—a synchrony instead.

This is all a far cry from, say, the finale of the second *Hellboy* movie (*Hellboy and the Golden Army*, dir. del Toro, 2008), as a digital multitude[11] (seventy times seventy) of mechanical demons assault Hellboy & Co. from all directions. Explosions, metallic clanking, assorted thuds, gunfire, and endless crashing define the sequence. The camera flies and glides amidst the action; all is kinetic and sonic overload, a sensory immersion with its own attendant pleasures. Admittedly, I'm comparing the somber start of one story with the exuberant climax of another, but as I'll demonstrate, Mignola's action scenes feature many of the same elements as those I've begun to identify here.

It would be unhelpful, not to mention inaccurate, to simply state that *The Island* is less "cinematic" than the *Hellboy* films. But the style of the comic and the style of the film are not congruent. One is all flash and quickness, the other is measured, perhaps even stately. The viewer is

propelled through the film scene but detached from the comics sequence. There are film styles that would be more appropriate to Mignola's *Hellboy* pages; after all, the story begins with a couple of shots that establish atmosphere before gradually revealing setting, followed by character, followed on the subsequent pages by action. Perhaps, given those two nonsequential panels on the second page, the ideal director to transfer this scene to film would not have been del Toro but rather some alternate world Yasujiro Ozu.[12]

Or perhaps *Hellboy* would lend itself to *Sin City* treatment where directors Frank Miller and Robert Rodriguez (and, in one sequence, Quentin Tarantino) lovingly re-create the aesthetics of Miller's *Sin City* comics. Shots are both longer and more static, movement more measured, physiognomies are exaggerated à la Miller, and, as in the original comics, the palette is restricted to black and white with splashes of color. It's tempting to imagine a lustrously red Hellboy moving through his worlds of darkness, but it must be said that *Sin City* and its imitators evoke stasis and stillness rather than give us the thing itself—an approximation of and homage to the source material that

11. See Kristen Whissel, "The Digital Multitude," *Cinema Journal* 49, no. 4 (2010): 90–110.

12. From quite early in his filmmaking, the Japanese director Yasujiro Ozu eschewed camera movement and reframing in his wondrous family melodramas; his characters undergo the most massive of life changes—aging, marrying, child rearing, dying—within an aesthetic marked by an almost unvarying formal restraint and precision.

Figure 4. Mike Mignola, *Hellboy: The Sleeping and the Dead*, in *Dark Horse Comics*. Colors by Dave Stewart (2011).

figures as zombies, vampires, and the resurrected provide the action. Kinetic battle sequences, often to the death, are followed by stases that are often closures, just as in nearly every action comic book out there.

But stasis figures more idiosyncratically in *Hellboy*, in ways that allow us to reflect upon the medium of comics and its possibilities. Rather than working within or around a cinematic paradigm, Mignola draws more heavily on sculptural principles, and his aesthetics is further informed by German woodcuts, Japanese prints and manga, Renaissance stained glass, and medieval iconostasis.[13]

One finds in Mignola's art, to a degree unusual in comics of all sorts, a deemphasis on line in favor of mass. Jack Kirby is an acknowledged influence on Mignola, and indeed some of this emphasis on mass comes from him, but the battle sequences in Kirby's comics are also riots of force lines pulling the eye in all directions. To take another example from genre comics, the combination of line and expressive brushwork in Gene Colan's art in such titles as *Daredevil* or *Tomb of Dracula* creates a less frantic, more sensuous movement that subtends or structures the whole page; his pages are as fluid as Mignola's are static. Figures in comics from Kirby and Colan to Charles Schulz and Ware are defined by outlines, while in Mignola's work blocks of color do more to define areas and bodies. To be clear, Mignola doesn't eschew the outline, but it does less work than in the art of many of his peers, and this contributes to what we might see as a sculptural sensibility that emerges in the work.

A cursory glance at a pile of *Hellboy* comics quickly reveals Mignola's investment in the sculptural (fig. 4). Funerary sculpture litters his landscapes, and his cover images often favor posed tableau replete with gravestones, sepulchers, and sculpted figures. Small marks pepper the surfaces, be they stone, cloth, or flesh, endowing the whole world with a chiseled quality.[14] One finds in Mignola's pages a sustained attention to the figuration of a powerful body, one that embodies physical force and dynamism in a static pose. And in the action scenes, backgrounds and subsidiary elements vanish, focussing attention on what Alex Potts refers to as an "abstract ideal of formal purity"

nevertheless barrels along at a rate of twenty-four frames a second. The viewer is no more able to take in more than a single image or linger longer on any particular one than in any other film. As an homage and a stylistic experiment, *Sin City* works wonderfully; as a model for cinema or as an equivalent to comics, less so.

In considering stasis in Mignola's comics, one might as well begin with the death drive—he is called Hellboy, after all. If stasis equals death, and if the manifestation of stillness speaks to the desire to return to an inanimate state, we don't have to look very far to find this in *Hellboy*, for Hellboy is steeped in death. He's the spawn of a demon, his destiny is to bring about the end of everything, the mise-en-scène is abundant with corpses, cemeteries, and tombs, and such inappropriately animate

13. Thanks to Eduardo Vivanco and Beth Kessler for the stained glass connection. I discuss Andrei Molotiu's invocation of iconostasis below.

14. Many thanks to Benjamin Woo for reminding me of this characteristic Mignola technique, which was actually what led me to the sculptural connection in the first place.

in which expressivity is entirely focalized through the figure's form and attitude.[15] This claim could be extended to much superhero action art, perhaps, but here the treatment of color, absence of motion lines, deemphasis of line in general, reduction of background detail, and the sense of forms frozen in mid-movement lends itself particularly well to the comparison. The blocky figure of Hellboy seems especially sculptural, carved from some mysterious red stone—more statuelike than statuesque. But sculpture serves as a useful touchstone in ways that move beyond the posture of bodies and their placement among sepulchral forms. Here we must turn our attention to Mignola's construction of the space of the page and the significance of the page in comics before returning to a fuller consideration of the sculptural imagination at work.

Mignola's pages nearly always hew to a grid formation, but almost never to a symmetrical grid of equally sized panels. A randomly selected page in *The Third Wish* is composed of seven panels, all of different sizes. A large vertical panel in the upper left is balanced by three tiers of a total of four panels on the right, and the large panel on the bottom left is not balanced by the much smaller final panel on the right. One could understand this as an elaborate stack of elements balanced within the ultimate bounding unity of the page, or one could go a step further and suggest that the space looks to be carved from the block of space represented by the blank page (fig. 5).

One of the hallmarks of comics, noted by theorist after theorist, is that a page can be encountered in two ways: it can be processed

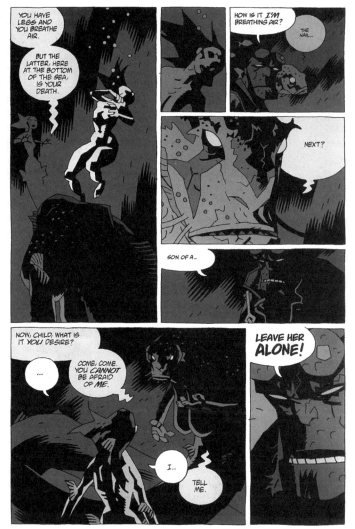

Figure 5. Mike Mignola, *Hellboy: The Third Wish*, in *Dark Horse Comics*. Colors by Dave Stewart (2002).

111

one panel after the other, as a planar, diachronic form, as a totality, and as a tabular, synchronic unity. The reader probably moves back and forth between these modes of apprehension. Mignola's pages lend themselves to the synchronic view more than most; they invite a contemplation of the whole before (and/or after) one has absorbed the narrative content of the scene. Elaborate balancing of such elements as panel shape and size, a unifying palate, minimal use of speech balloons, motion lines or other *emanata*, and a nonrealist flatness all invite an apprehension of the page as surface. Forward movement is thus balanced, if not exceeded, by the stasis of the page as a synchronic unit.

This is furthered through the use of Mignola's most characteristic element. His pages will often be punctuated with small panels that contribute nothing to the action

or forward movement of the narrative. Usually these are small close-up views of elements of the mise-en-scène: a crumbling stone face, a bird on a branch, an array of lilies. These are most often moments of foreboding; the space is not completely known, danger could come from any direction. The stasis they present within the narrative, then, is literally a moment of suspense. What's more interesting, though, is what they do to the process of reading. From the days when Winsor McCay numbered the panels of *Little Nemo in Slumberland*, comics creators have struggled with effectively guiding the reader's eye across the array of panels in the proper sequence.[16] The placement of speech balloons and captions, the protocols of reading directionality, the use of overlapping panels—all these can dictate sequence so that the reading flows easily. When in doubt (or when one is Ware importing

15. Alex Potts, *The Sculptural Imagination: Figurative, Modernist, Minimalist* (New Haven, Conn., 2000), p. 25; hereafter abbreviated *SI*.

16. The practice of numbering panels provides a case study in uneven development—some practitioners of early newspaper comics did, some didn't. McCay numbered the panels in *Little Nemo in Slumberland* from its start in 1905 but didn't on the concurrently running *Dream of the Rarebit Fiend*. Was numbering *Nemo* a courtesy to younger readers? I don't know.

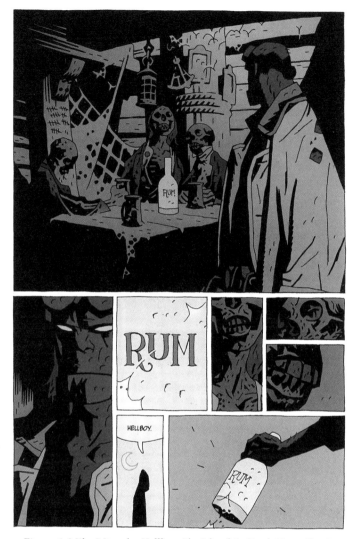

Figure 6. Mike Mignola, *Hellboy: The Island*, in *Dark Horse Comics*. Colors by Dave Stewart (2005).

than narrative. They seem to exist beyond sequence and instead exist simultaneously with the unfolding narrative events. The seventh page of *The Island* serves as a particularly good example (fig. 6). Hellboy has just realized that last night's drinking companions are, er, dead and desiccated. Taking in the scene, he grabs the bottle of rum and seemingly heads out of the room (he is exiting the panel and page in any case). The narrative panels here would involve the large half-page image above, with Hellboy discovering that his buddies aren't what he thought they were: the central panel displaying the RUM label and the final panel (the eighth panel) where he grabs the bottle. The panel to the left of the RUM is a long, narrow image of Hellboy; the three small panels arranged in a grid to the right of the RUM gives us some details of his decayed compadres. No new narrative information is conveyed in any of these panels. There is a mysterious panel below the RUM with a crescent moon and a shadowy figure intoning, "Hellboy." This panel is not part of the rest of the scene, and it's unclear as to both when and where it is situated—is it a foreshadowing? a memory? imagined?

That mysterious image aside, what does the page accomplish? It's atmospheric, most certainly, introducing and emphasizing a weary, bleary scene of death and decay. On a narrative level, it effectively communicates Hellboy's increasing alienation from the world and confusion about his role within it. But what's most striking is the way that Hellboy's ennui is figured for the reader by a sequence that refuses its status as sequence. The forward flow of the comics reading experience is blocked, the only anchor point a bottle of (presumably nicely aged) RUM. The layout of the page is mimetic of Hellboy's experience, an experience the reader, bereft of definite guidance, can share. Stasis thus operates narratively (Hellboy's ennui), formally (the absence of cues of movement), and structurally (the disruption of the forward momentum of the narrative). There is, then, a strange and strangely fascinating stasis operating in Mignola's *Hellboy* comics that extends from the layout of the page, through the use of color and the flat style of drawing, to the depiction of bodies that are in motion but deprived of the codes of movement characteristic of comics.

But the fact remains that *Hellboy* is no sterile exer-

diagrammatic conventions), one can impose arrows and other external cues, but as comics protocols have become codified, the need for such brutish devices has receded. Rare are the comics that are not arranged to determine the proper sequence of reading. Mignola, though, makes 'em all the time.

I will call these inserted panels pillow panels in homage to the similarly inserted static shots of inanimate objects that Noël Burch dubbed "pillow-shots" in the films of Ozu.[17] The question becomes, when are these pillow panels? It's difficult to insert them into the narrative sequence; their placement seems more decorative

17. Noël Burch, *To the Distant Observer: Form and Meaning in the Japanese Cinema* (Berkeley, 1979), p. 160. Burch himself loosely derived his term from the "pillow-word'" of classical Japanese poetry (ibid.). My use of the term should not be taken as an endorsement of Burch's argument regarding the movement away from anthropocentrism in Ozu's work, but *pillow-shot* has become the accepted nomenclature for these shots. David Bordwell reads these shots very differently, finding in them a narrational overtness that owes more to Hollywood than Japanese poetry. While I don't fully buy these shots as constituting as radical a break in the narrative as Burch posits, they do shift the emphasis from a narrative time of ongoing action to a more contemplative experience of time as duration, an experience entirely in keeping with the narrative events and life transitions at the center of Ozu's films; see David Bordwell, *Ozu and the Poetics of Cinema* (Princeton, N.J., 1988), pp. 104–6.

cise in stasis but an action comic featuring a big red demon hunter who pounds the hell out of monster after monster. Full pages of one, two, or three panels are given over to Hellboy in mid-air slugging a cyborg gorilla to an accompanying BOOM! sound effect (sometimes he says "BOOM!" to help things along). Yet, even here, there are none of the cues that commonly connote movement in comics. While there's enough going on for any action junkie, Mignola maintains a dispassionate formal rigor in his approach to the page. The placement of the word balloons and sound effects on the page have a balance and precision that Roy Lichtenstein would envy: a screamed "WAHHHHHH!" occupies the top right of the page, Hellboy's shouted "BOOM!" the center left, and a final BOOM at the bottom right (rendered in white rather than the black of the words above) form an elegant zig-zag that not only moves the eye down the page but is most satisfying to just contemplate in itself (fig. 7). The page also moves from a close-up of Hellboy to a medium full framing to a more distant view as Hellboy finishes off his adversary ("So much for you," he comments on the next page).[18] The page works as narrative; it also works as design. It hums with kinetic energy while also maintaining a formal stasis.[19]

Mignola has been drawing fewer comics of late, but his recent work is, if anything, more stylized and more boldly abstract. One page of the 2012 *Hellboy in Hell* consists of only three panels; the page is divided into two vertical panels: one of Hellboy crashing to the ground at the bottom of a tall red space and the other the solid black pillar of his unconsciousness. Hellboy comes to in a small panel at the bottom right, wondering just where the heck he is. The page resembles nothing so much as a color field painting combining techniques associated with Barnett Newman and Clyfford Still, while the final action—an awakening in the bottom corner—suggests McCay's *Little Nemo in Slumberland*. It's quite the mash-up.

What we find in Mignola, then, is an ostensible classicist—giving us superheroic bodies in action presented in service to a narrative propelled by enigmas, investigations, and slugfests—who's behaving a lot like a modernist. The treatment of page as page, the attention to surface,

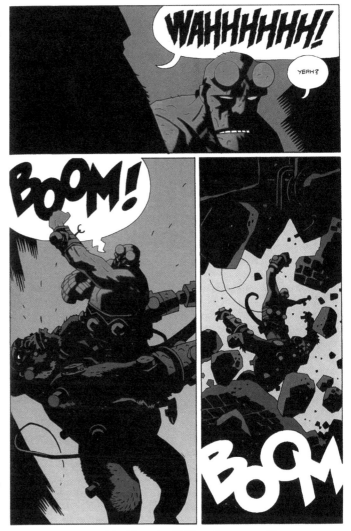

Figure 7. Mike Mignola, *Hellboy: Conqueror Worm*, in *Dark Horse Comics*. Colors by Dave Stewart (2001).

113

the deemphasis on linear sequence, the move towards abstraction—all of this is less traditional than innovative (or we might say that it recovers some of the modernist impulse found in the earlier work of McCay, Herriman, Frank King, and Lionel Feininger).[20] A traditionalist who is actually something of a modernist—in the scholarship on sculpture one finds Auguste Rodin referred to in similar terms. Begging your indulgence, let's see where this comparison can take us.

One is surrounded on the Stanford University campus by the sculptures of Rodin, from representations of

18. Mike Mignola, *Hellboy: Conqueror Worm and Strange Places*, vol. 3 of the *Hellboy Library Edition* (Milwaukie, Ore., 2009), pp. 63–64.

19. Jean Ma, in conversation, detects some rather noir lighting at work here as well, which, given Hellboy's trenchcoat and role as a paranormal investigator, makes a lot of sense.

20. Bill Watterson (creator of *Calvin and Hobbes*) has remarked that the history of newspaper comics seems to run in reverse, from the sumptuous full-page layouts and bold experiments in form that characterized the work of McCay, Feininger, King, and Herriman (to name only the most prominent) in the first decades of this century to the cramped, formulaic, gag-writer strips of our time. "The early cartoonists, with no path before them, produced work of such sophistication, wit and beauty that it increasingly seems to me that cartoon evolution is working backward. Comic strips are moving toward a primordial goo rather than away from it" (Bill Watterson, speech at the Festival of Cartoon Art, Ohio State University, 27 Oct. 1989, web.archive.org/web/20060210115506/http://hobbes.ncsa.uiuc.edu/comics.html).

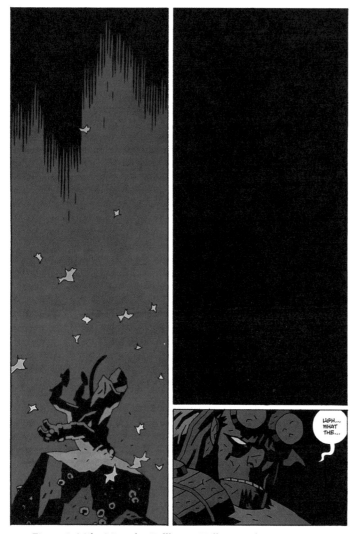

Figure 8. Mike Mignola, *Hellboy in Hell*, in *Dark Horse Comics*.
Colors by Dave Stewart (2012).

114

Rilke, refers to "a still state of absorption at odds with the restless animation of the anxieties and drives rendered by the drama depicted" (*SI*, p. 100). Forgive me, but something similar is at work in *Hellboy*. The rendering of muscled bodies, mid-movement, becomes, when looked at differently, a play of sensuous abstractions of light, color, stillness, and balance. Figures emerge from the negative space of an inky blackness as they emerge from the negative space of Rodin's marble bases and pediments. The sculptural analogy proves surprisingly useful in relation to Mignola's accomplishment.

But Hellboy is not a statue (though there are collectible Hellboy statues), he's a comic book character. Beyond aesthetic accomplishment for its own sake (which I've got nothing against), why should the action adventures of *Hellboy* be rendered in such rich but somewhat counterintuitive terms? My provisional answer is that everything about *Hellboy*, about Mignola's style, speaks to the condition of the comic book. *Hellboy* is not a movie-in-waiting or a future miniseries; it's not seen to best advantage on a laptop screen or an iPad—it's a comic book, which is to say a bound work on paper. Originally a two-part comic book, *The Island* was reprinted as part of the Strange Places trade paperback collection and more recently as part of the third volume of the oversized and sumptuously printed *Hellboy Library* series.[21]

The flatness of the compositions and the flatly applied colors, the adherence to the comics grid (Mignola uses very few bleeds beyond the boundaries of the panel),

hands to the full-size *Gates of Hell* (hmmm. . . .). My colleagues and I tend to give them short shrift. Some have just lived with them for too long, others dismiss Rodin's mimeticism or his return to classical principles. I'll bet they wouldn't warm to Mignola's work, either. But Rainer Maria Rilke's writing on the sculpture of Rodin emphasized the tension between movement and its subsidence; he found in this work something approaching abstraction. "When we cease to envisage" these statues, explains Potts, "as actors caught up in a drama," then we might "find that the represented movement of the figures is absorbed by a 'circulation' of movement in the surfaces that has a certain undisturbed 'calm' and 'stability'" (*SI*, pp. 99–100). For Rilke, in other words, another way of seeing a Rodin was possible in which dynamic movement and change would yield to an experience of soothing balance as one contemplated the play of light and shadow instantiated by the sculpture's contours. Potts, following

the motionless figures given life by the imaginative engagement of a reader, all contribute to the bookishness of *Hellboy*. It might also be worth pointing out that the *Hellboy* comic books are free of advertisements within the span of the story—most superhero comics put ads on nearly every other page, repeatedly interrupting the reading experience. Thus what one encounters in reading *Hellboy* is not just one impeccably composed page but two—and it's quite obvious that Mignola has fully considered the way the two pages work together. In many comics, the page seems like the basic unit of composition; for Mignola, it's the double page. The reader is thus allowed to sink into a *Hellboy* comic, to engage with it and play by its rules across its twenty-or-so pages (and this effect is amplified in the up-scaling to trade paperback or hardcover library edition).

The book is therefore Hellboy's natural habitat, and, if this is so, then we can also connect stasis to a ruminative mode of reading. The pillow panels operate as pauses, blockages to linear flow, encouraging the eye to move

21. This format flatters Mignola's art wonderfully and is highly recommended.

more slowly and less predictably.

There is one branch of what we might call the film theory of stasis that does carry over from film to comics: the irruption of spectacle that brings narrative to a halt. Of course, Mulvey's example of gendered spectacle in Hollywood film is the ur-text here, and there are those writers (such as myself) who have spearheaded the return to the cinema of attractions around issues of special effects, musical numbers, and the like. An earlier essay of mine tracked the deep resonances between Mulvey's and Tom Gunning's germinal essays, finding in both a theorization of spectacle at odds with narrative, as narrative's other, and much of my other writing has celebrated the ways that spectacle has broken with the linearity, causality, and closure of classical narrative models.[22] Comics have the splash page (often an action scene) or—and these are the ones I lived for as an adolescent—those double-page spreads doled out by Kirby and Jim Steranko. Mignola has plenty of such arresting images—the aforementioned full pages of *Hellboy* either whomping or being whomped by some virulent, violent thingie. But it's also interesting to see that the pillow panels—whose function, I've been arguing, is at least in part to push back against the relentless linearity of sequential art—are in every sense the least spectacular elements on the page. They are miniature rather than giant, static rather than kinetic, subdued rather than insistent. The disruption they perform is small and brief. I'm sure that no *Hellboy* reader has scratched his or her head in confusion at encountering a small inset detail. Nevertheless, they do break the flow and wreak some havoc on comics' headlong rush, encouraging the eye to linger, however briefly.

It could be argued that the pillow panels conform to McCloud's "aspect-to-aspect" transition, which "bypasses time for the most part and sets a wandering eye on different aspects of a place, idea or mood."[23] But this still presupposes that the reader processes these panels in a predetermined linear sequence, while I'm proposing that in the page presenting Hellboy's encounter with those deceased drinkers Mignola solicits a gaze that grasps the page as a whole, obviating to some extent the need to move through each panel in its turn. Those three panels on the right, with Hellboy's decayed comrades, work as a cluster rather than a sequence, and things like clusters have no place in McCloud's linear model of reading.[24] Gunning's contention that comics encourage varied practices of reading that do more than simply coexist, but which actively complicate each other, comes closer to what I'm describing here.[25]

Mignola has acknowledged his interest in Japanese comics, and indeed manga is replete with images that break from the action but do something more than simply mark a scenic transition. In Mitsuru Adachi's baseball manga, *Cross Game*, for example, lush realism renders those places of recurring significance to the main characters and also marks the passage of seasons as they and we move through those endless years of high school.[26] These images speak to a different experience of place and time, one that wells up recurrently but inconsistently; it's an experience latent in the landscape, even if not always experienced by the characters themselves. Mignola's images don't offer up an equivalent shift in the aesthetic register, and they tend to be narrower in scope than the scenic long shots of manga. Ultimately, the manga images speak more to an experience of being in the world, while Mignola's connect us more fundamentally to the aesthetics of the work and the act of reading. Narratively and aesthetically, Mignola's pillow panels represent less of an ontological break than the images in manga, but their emplacement on the page does more to complicate sequentiality and the act of reading. Stasis serves more than one function in the world of comics.

If Mignola's pillow panels exist outside of sequence, then they also raise some questions regarding the gutter as McCloud has conceptualized it. For McCloud, the gutter is where a reader's inferential activity occurs

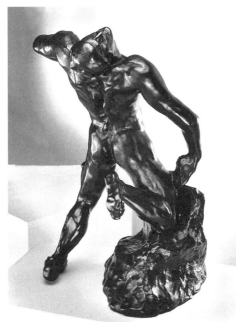

Figure 9. Auguste Rodin, *Falling Man* (1882).

22. See Bukatman, "Spectacle, Attractions, and Visual Pleasure," in *The Cinema of Attractions Reloaded*, ed. Wanda Strauven (Amsterdam, 2006), pp. 71–83 and "The Ultimate Trip: Special Effects and Kaleidoscopic Perception," in *Matters of Gravity: Special Effects and Supermen in the 20th Century* (Durham, N.C., 2003), pp. 111–30.

23. McCloud, *Understanding Comics*, p. 72.

24. Of course, such a reader might exist; but while McCloud seems to assume a single mode of reading a comics page, I'm allowing for the possibility of multiple paths, multiple approaches.

25. See Tom Gunning, "The Art of Succession: Reading, Writing, and Watching Comics," pp. 36–51 in this issue. Gunning also notes that "the power of comics lies in their ability to derive movement from stillness—not to make the reader observe motion but rather participate imaginatively in its genesis," which complements my argument here quite nicely and that also connects to the discussion of reading as playing that I advanced in *The Poetics of Slumberland* (p. 40).

26. See, for example, Mitsuru Adachi, *Cross Game* (San Francisco, 2010).

in order to account for the change from one panel to the next. A reader must determine whether time and space are continuous and, if not, how great the disjunction is and—most importantly—fill in the missing information. This continual act of creating closure defines the act of reading comics for McCloud. The reader, following a set of pictorial, structural, and linguistic cues, constructs the sequence, just as the film viewer stitches together conjoined shots to construct meaningful relations between them. It's surprising, in fact, how indebted to film theory (from Eisensteinian montage theory through suture theory) the gutter actually is. For McCloud, closure in film viewing occurs as the sequence of individual film frames fuse into an experience of continuous motion, but surely the space between one shot and the next is the more relevant comparison. McCloud argues that where "comics panels fracture both time and space, offering a jagged, staccato rhythm of unconnected moments. . . . Closure allows us to connect these moments and mentally construct a continuous, unified reality."[27] Certain transitions demand more closure, more active engagement than others; in both film and comics, cut and gap can demand either a great deal of or scarcely any inferential action. The intercutting of striking workers being gunned down with the slaughter of a steer in Sergei Eisenstein's *Strike* (1925) demands some active participation from the viewer to make it meaningful; conversely, a conventionally edited move from medium shot to close-up with no change of location and perhaps continuous speech carrying from one shot to the next can hardly be misconstrued. The same coexistence of radical disjunction and smooth continuity exists in comics, which present both hugely challenging and engagingly straightforward reading experiences.

But what of the pillow panels in *Hellboy* that exist outside sequence or, at least, outside of a single, linear sequence? Are these assimilated to construct "a continuous, unified reality," or do they preserve something of the "jagged, staccato rhythm"? While they surely contribute to the aesthetic unity of the page, they trouble the linear act of narrative synthesis.

Andrei Molotiu has introduced to comics studies the concept of iconostasis,[28] which derives originally from the arrayed icons on Greek Orthodox choir screens, in which "icons are arranged in a grid, yet they are not intended to be read sequentially." Molotiu finds in the work of numerous comics artists "an impulse toward the iconostasis, yet an impulse which is never fulfilled, or else the narration would stop dead in its tracks." Sequence and stasis exist in tension. Molotiu argues that, "iconostatic perception, rather than conflicting with sequential dynamism, is a prerequisite for it,"[29] and his own interest lies in discovering how artists manage to avoid that stasis that would stop

the narrative dead. The page becomes a dynamic arrangement in which sequence prevents ossification. Molotiu has done us great service in finding in the work of some of the greatest superhero comics artists an attention to the page as a unit, which provides the occasion for iconostatic perception, and a play with form and movement that borders on abstraction. But Mignola does something different than Kirby, Steve Ditko, Neal Adams, and the other artists that Molotiu privileges. He includes elements that are intended to slow down the reading process, to complicate more than complement it.

I'm therefore sympathetic to Thierry Groensteen's account of the experience of comics and its gutters when he writes, "we would be mistaken to want to reduce the 'silences' between two consecutive panels by assimilating the ellipse to a virtual image. On the contrary, this silence often speaks volumes. It has nothing to introduce, no gap to suture." Writing in praise of the void, he argues, "Reading a comic, I am here, then I am there, and this jump from one panel to the next (an optical and mental leap) is the equivalent of an electron that changes orbit. In other words, an intermediate state between the two panels does not exist" (*SC*, p. 113). Uneasily connected to the panels that neither precede nor succeed them, Mignola's pillow panels speak to a void, which is why they are so often evocative of a sense of foreboding or suspense (suspension). Not all gutters demand closure.

McCloud's insistence on the importance of closure has the unintentional consequence of bringing comics closer to film in the way it engages its reader/spectator. Groensteen and Mignola present something different, something that respects the void between the panels, that accepts the "jagged" nature of the medium, and that sees (or prefers) that jaggedness as something incompletely contained. In the context of *Hellboy*, we might say that the reader does perform the inferential work of connecting panels and constructing sequence (and therefore meaning), but that even as this work occurs, the jaggedness lingers on; the experience of these as static panels in an array remains. The first reading, the one that privileges sequence and closure, leads to the production of *Hellboy* movies, but the other, the one that can't be completely sutured—that gives us comics.

By stepping away from the gutter, Groensteen is able to foreground the page as a more pertinent unit than the transition between one panel and the next and to recognize how comics creators create elaborate, nonlinear correspondences upon the page or across a story (or even a series) that speaks more to the condition of networked information—a database aesthetics—than the filmlike sequence of successive shots. "Comics should be apprehended as a networked mode that allows each panel to hold privileged relations with any others and at any dis-

27. McCloud, *Understanding Comics*, p. 67.

28. "Based on the writings and teachings of art historian Werner Hofmann, I will use the term 'iconostasis' for the perception of the layout of a comics page as a unified composition; perception which prompts us not so much to scan the comic from panel to panel in the accepted direction of reading, but to take it in at a glance, the way we take in an abstract painting" (Andrei Molotiu, "Abstract Form: Sequential Dynamism and Iconostasis in Abstract Comics and in Steve Ditko's *Amazing Spider-Man*," in *Critical Approaches to Comics: Theories and Methods*, ed. Matthew J. Smith and Randy Duncan [New York, 2011], p. 91).

29. Ibid., pp. 91, 93.

tance" (*SC*, p. 126). *Hellboy*—with its inclusion of panels that foreshadow or recap, captions that belong to a different temporality than the images that surround them, and elaborate, epic backstory—foregrounds this network of inter- and intratextual reference to a striking degree.[30]

Groensteen valuably reminds us that while comics are not as perceptually immersive as the cinema, they engage in other ways, ways that are pertinent to contemporary culture: "Comics is not a syncretic (total) art such as opera; it does not solicit from the reader the same perceptual deployment that is demanded from the cinematic spectator," he writes. But, "comics, which marries the visual and the verbal, demonstrates a discontinuity, a staggering, and the effects of networks, and finally constitutes a sort of image bank." Comics, he adds, "appear[s] to be situated not far from the turning point between the civilization of the book and that of multimedia" (*SC*, p. 160). Groensteen is correct about comics in general, but despite its multimedial existence as a property (comics, novels, films, cartoons, statues, drink coasters, T-shirts), *Hellboy* the comic leans heavily towards the book. The relevant network to consider is the network of literary and visual references that informs *Hellboy* on all levels.

A full consideration of the bookishness of *Hellboy* must be reserved for another essay, but here is a quick sketch of my argument: narratively, *Hellboy* is steeped in the *Weird Tales* mythos of H. P. Lovecraft and other fantasists including Clark Ashton Smith, Robert E. Howard, and Manly Wade Wellman, and it deploys concepts, language, and structures well known to readers of these tales. And so many of these tales are framed as, or incorporate, documents themselves: journal entries, letters, maps, scrolls. As Hellboy engages with paranormal activities that stem from numerous folkloric traditions and weird fictions, the book—the *Hellboy* comic—becomes an extension and manifestation of those imaginary, those bookish, worlds: a place where they are reanimated through the acts of writing, drawing, and reading and a meeting ground in which these worlds —literary, authorial, readerly—entwine and ensnare. Hellboy becomes the figure whose task it is to weave through other narratives, other books, binding and thereby reanimating them: he is the vehicle of the translation to the animated and animating imaginative space of the comic. So narratives about books meet an aesthetic that speaks to the materiality of the book and the network of weird literature.

Moriarty and Ware use comics to explore the quotidian. The slowing down of the reading process, the elevation of observational detail over action, a sense of deliberateness, an enframing of the moment, and an evenness of pace: all open comics to the exploration of the mundane.[31] Stasis and quietude are appropriate to the material, and Moriarty's turn to painting has its equivalent in Ware's exploitation of elements of graphic design. *Hellboy* is something else, and therein lies its audacity. Within the context of pulp adventure stories, Mignola, too, emphasizes the static and finds some of his vocabulary in textual, painterly, and sculptural imaginations. Moriarty, Ware, and Mignola all emphasize the materiality of the comics object—primarily, the book—but in the pages of *Hellboy* the book becomes both object and network. It is a thing to hold and a complex space for the reader to activate and inhabit.

117

30. Thanks to Mike Metzger for this observation.

31. Much of the proliferation of autobiographical comics deploys at least some of these elements to similar ends.

Public Conversation:
Aline Kominsky-Crumb
and Kristen Schilt

May 19, 2012

ALINE KOMINSKY-CRUMB: I have a gift that she gave me. It is a sleepover Barbie.

KRISTEN SCHILT: I made it.

KOMINSKY-CRUMB: And Barbie has a beauty mask on. She is having her hair done. I have made art out of Barbie beauty products and she picked up on that. She has her little cushion. There.

SCHILT: We have our own commentator here.

So to start off our conversation I wanted to pick up on some of the themes that were raised this morning. You refer to yourself as one of the pioneers of the early autobiographical comics. But in a lot of your early work you show yourself as a child having very early artistic talent and doing reproductions of Picasso and showing them to your parents and grandparents. But your work is also filled with people trying to thwart you from not doing art. There is a theme, your parents don't want to you go to art school and pay for it. People tell you you should abandon this, it is not something you should be doing. How do you persist in the face of all that?

KOMINSKY-CRUMB: I just had no choice; it kept me sane. I had a need to vent my rage against my family and it was a simple way to do it, inexpensive, and immediate. My family encouraged me when I was eight to copy famous paintings because other crass relatives of mine gave me money for the work. They really liked the fact that people gave me money for the work. But, then, you know, they also thought it was totally stupid and useless and they wanted me to marry an orthodontist or something like that. They made me play the violin and take ballet lessons and not read comics and try to make a cultivated product that could be sold to an orthodontist. So I could move into a split-level in Great Neck and make my family proud. When I was eight I realized I was going to have a different destiny. My artistic self started to emerge. Also I think as a reaction to these totally crass and horrible barbarians that I realized I lived with. It was my sanity to have this ar-

tistic secret life and that's what sustained me and that's why I also continued to write stories about them when I could. I don't know what I would have done otherwise.

ROBERT CRUMB [from the audience]: Tell her how your uncle threw money at you.

KOMINSKY-CRUMB: I had this great uncle who had made a lot of money in some really shady business. When I held up one of my fake Picassos, he was so impressed he just threw money at me. I could have been doing a striptease, and it would have been the same matter how my family viewed art. "Aht." [laughter]

SCHILT: Something to make money…?

KOMINSKY-CRUMB: Something crass and materialistic, as everything is.

SCHILT: So you did go on to art school and you were trained as a painter. What happened in art school?

KOMINSKY-CRUMB: It was the 1960s and in art school they were teaching well, DeKooning, abstract painting, really big sloppy paintings. And there were other people into pop art. If you actually were doing any kind of narrative art, they hated it and discouraged you. If you wanted to do anything realistic or with details, they discouraged you. I couldn't see at all how I would find a voice in that world in any way, shape, or form. I continued to keep my own notebooks where I just drew humorous pictures of people I knew, and drew about my life, and kept journals, and glued things in. That was my actual developing voice. I was compelled to get an art degree or get some kind of degree because I thought I had to earn a living and I thought I had to have that. It had nothing to do with my personal expression at all.

CRUMB: What about Cooper Union?

KOMINSKY-CRUMB: I went to Cooper Union briefly also. Thanks, Robert. [laughter] That was like the most sexist, you know, incredibly uninspiring creative environment that I can imagine. It was so hard-ass and it was so scary

119

Figure 1. Aline Kominsky-Crumb, "Hard Work and No Fun," in *Wimmen's Comix*, no. 2 (1973).

and the critiques were so mean and the competition it was so horrible, it made you never want to draw or ever show your work to anybody. It was the total anti-creative. It was horrible. Anyway, I don't know if it is like that now but that's how it was then.

SCHILT: This morning [in the "Comics and Autobiography" panel] you frequently referred to your work as grotesque. I think you said that a million times.

KOMINSKY-CRUMB: You don't think that's grotesque?

SCHILT: No.

KOMINSKY-CRUMB: I always start with the nose, that's all I know.

SCHILT: But I think what is so compelling about your work is that you, particularly in your early work with [your character] the Bunch, you represent a side of women's experiences or particularly girl's experiences that you just don't often see. So you do talk about the feeling of grotesqueness and awkwardness about your body, but also sexual curiosity, sexual pleasure, wanting to be the object of the gaze, wanting to feel in control, but also the complete disappointment with early sexual experiences from a woman's perspective. Which I feel like even now you don't see. It is very rare. When I read your early work—I still don't see anything like that. I can think of a few examples of that. But at the same time you were saying this morning that you got some really negative reactions, particularly from women. What is so challenging about your work?

120

KOMINSKY-CRUMB: I don't really know, because I was just talking about the issues that I was confronting. I don't know why other women don't talk about those things. I can't tell you. Because it seems obvious to me to talk about those things. As I said, the period that I started working was very—it was the early feminist period—and women were being very extreme in their reactions towards men and what they perceived as being oppressed by men. The fact that I was talking about my sexual curiosity and interest in men and wanting to have sexual adventures was in some way threatening. I was considered like an Uncle Tom because I so wanted to have sex with men. I thought that that was an appealing idea. *[laughter]* And then I wanted to make myself as attractive to men as possible. I liked that. And I thought—I didn't see why that wasn't about power. I didn't see why that had to be, you know, a passive situation. I thought that you could be attractive and have men desire you and then do what you want with that. But in the early feminist period everything was overly simplified, very black and white, as it quite often is when people are overly zealous in trying to change things.

To this day there are a few women that still don't like me, even after I have had face lifts and grandchildren; they still remember that they don't like me because of that period of time. It sort of amazes me.

SCHILT: In *Need More Love* you talk about how they called you sexist. You were perceived as not just sort of disempowering women, but you were actually sexist—

KOMINSKY-CRUMB: I was called a camp follower. Prostitutes that followed soldiers from camp to camp. Someone called me a camp follower in a newspaper article in the early 1970s because I was involved with Robert Crumb and he was like the ultimate male chauvinist pig, that made me a camp follower because I was involved with him. I don't know if being together forty-two years has changed that, but, you know. *[laughter]*

SCHILT: What kinds of reactions do you get now? Has your work from the 1970s been re-imagined now?

KOMINSKY-CRUMB: We put out a new book, the book that's called *Drawn Together* [in the U.S.]. It already came out in France as *Parle-moi d'Amour*—they couldn't find a French equivalent of the title. It is talking about love. I looked at some Internet commentary on that book and they called me a talentless parasite, which I thought that would be a good [next] book title for me. *[laughter]* So thank you whoever said that.

SCHILT: This morning's panel when Phoebe was on the panel, she was talking about her reaction to your work and having this really kind of amazing reaction to it and I think I had a similar reaction of thinking, like, this somehow is relating to my life. This is something that someone is talking about that no one is talking about and you just don't see. Do you get the letters from people saying this changed my life?

KOMINSKY-CRUMB: Very rarely. And I usually write back to them. And they are always amazed I write back to them, because I think they think I get a lot of letters like that, but it is very rare. I'm always touched and moved and amazed. I always feel sorry for the person, too, because I figure they are probably a miserable, suffering person like I am. I don't understand why more women don't honestly talk about those things. I never could figure that out. I didn't think I was particularly unique or brave. It just sort of seemed like the obvious thing for me to talk and write about. I wasn't trying to prove anything or trying to be more tough or brave than anybody else. I thought everybody talks about what they know, and this is what I know, these are the issues I'm facing.

SCHILT: I think that's why it is a big deal because you are not trying to do it. Right? You are just doing it. Do you want to talk about how *Need More Love* was conceptualized and how that came out?

KOMINSKY-CRUMB: I thought it was a really great title because I thought everybody needs that. But the reason I worked on this book is because this woman befriended me who kept telling me what a wonderful genius and talented and amazing person I was. First she wanted me to do a fitness book—I teach exercise class. Then she wanted me to do a lifestyle book. She just wanted to do something with me. It was so flattering, it started to stimulate me and got me thinking of all these ideas. My ideas became more and more self-indulgent as she flattered me more and more. That's why *Need More Love* is so long and so totally self-indulgent, uncensored, unedited. Because I had such an overblown opinion of myself based on her flattering. And

Figure 2. Aline Kominsky-Crumb, cover of *Need More Love: A Graphic Memoir* (2007).

122

Figure 3. Aline Kominsky-Crumb and R. Crumb, "Dinner with Slacky," in *Drawn Together* (2012).

the day that the book came out she went out of business. She had also at the same time talked me into convincing Robert to do a book with her, too, which probably was the reason that she was flattering me all along. His book, all of his images were not protected by copyrights because she was so unprofessional. So I had to hire a lawyer and get all of his work—get reversion of copyrights back to him. In doing so I found out that this so-called friend had three different identity changes. She was really like the Bernie Madoff of small publishing.

The first time they printed it they were trying to save money so they printed it in India. When it came out like there was brown shoe polish smeared over every page, so I said, I can't accept this book. They said they would reprint it, so they did. So there are thousands of those books in India somewhere and I was hoping that someone built a house out of them because they were like concrete blocks. That's my fantasy, that somewhere someone is living in a hut made from my books in India. *[laughter]* When I go to India every time I look around to see anywhere if I can see any of them sticking out from anywhere.

SCHILT: It is a beautiful book. It has the pictures and the narration and the comics. In that book you talk about your horror growing up, about your mother's emotional hypocrisies, or her ability to be having this screaming fight with your father and then to answer the phone and say hello and kind of turn that off. It seems like your work is almost the exact opposite. In response, somewhat, to having that kind of bracketing of emotion.

KOMINSKY-CRUMB: I never thought of that. Yeah, in my work in the beginning, it definitely was reaction to the grotesque environment that I grew up in. I remember that age eight was when I became conscious of the fact that I was living with out-of-control adults. It was dangerous. And these were treacherous waters. I was going to have to learn to navigate them. I realized that they were not in control. I had to make everything safe for myself. That's when I started lining up my dolls. At night all my Teddy Bears had to be lined up around my room to make it safe to sleep in. That's when I started becoming very crazy to protect myself. That's why I have millions of protective things on me all the time. I can't take them off. From that time on I realized it was up to me. But that created a certain rage in me that no adults were taking care of me. I had to do all this myself.

SCHILT: This was raised this morning, and as a social scientist and not an artist, I feel like having this [situation] where you have your whole life documented—some retrospectively but now sort of concurrently as you are living it—is it cathartic? I thought maybe it was cathartic. You get to have these images out there and you kind of get it over with. But then on the "Comics and Autobiography" panel this morning, everyone said "No."

KOMINSKY-CRUMB: No, it is not cathartic at all. It barely makes a dent. It is not therapy. It has nothing to do with that. The only thing I can say is that getting all those images out there, those mean images about my mother…Our relationship has improved. Maybe I wouldn't be able to have a decent relationship with her now if I hadn't gotten it out.

SCHILT: One thing I thought was interesting in *Dirty Laundry* is you talk a lot about, once you do have a child, what is going to happen when she grows up and reads your comics? There is a lot of discussion about what is she going to think? What is this going to mean? Should we change what we are doing? What kind of parents is she going to think that she has? I was interested in how you navigated that.

KOMINSKY-CRUMB: Well, we try to hide most of it from her. We live in the country. We try to have our life removed from all that. We maybe succeeded up to a certain age, but obviously later she got curious and found all the stuff we hid from her. She told us that she read all the stuff. And she told us she was really disgusted by all the sex stuff. She still is. I think when she was a kid and she looked at the stuff she just censored it and she'd go, oh, yucky, uch, disgusting. She wouldn't look at it. Even now she kind of still does that. I just made this short film that I'm going to be showing in New York about a Miami[–style] makeover . In the end of it I'm naked or half naked. She says, oh my God. Can't you stop doing this? You are like sixty-four years old, do you still have to do these extremely embarrassing things? She still found it really hard to look at. I don't think it is easy for her. I think it has caused her a lot of anxiety and discomfort. I feel bad about it, but, you know…Robert and I think we probably shouldn't have had a child, but—*[laughter]*. It is too late for that now. We're good grandparents, though.

SCHILT: And she's a main character in a lot of the comics. Growing up, is that something that she liked? That she was in the comics? Or is it now something that is completely mortifying?

KOMINSKY-CRUMB: I don't think she particularly noticed; it was like nothing to her one way or the other. Also you have to keep in mind, everyone around us was an artist; almost everyone we knew were cartoonists at that time. That's what everybody did. And she drew comics, too. That was an extension of normal life for her up to a certain point, until she started going to other people's houses a lot, and she realized their families weren't like that. Up to a certain point in age I think it was normal. I remember one time she asked a babysitter, could you draw a city with a monorail and airplanes and people walking down the street. The babysitter said, I can't draw that. And she said, "What's wrong with you?"

SCHILT: Do you have boundaries about what you think is not an episode [for a comic]? Is there something that is off the table?

KOMINSKY-CRUMB: I don't think about boundaries. I just get inspired by certain things. Hopefully those will turn into usable ideas. I see comics all the time. I see stories all the time. I write down things all the time. There is no shortage of ideas. I don't draw about sex that much anymore because I don't care about it that much anymore. *[laughter]* There are other issues now, as you get older. You know? I talk about aging and loss of beauty a lot now since I'm obsessed with that. I talk about being a grandmother a

123

lot. And moving on. And also the loss in life, getting older. I also stopped drinking a long time ago and that changes your whole vision about things. I'm seeking some kind of lucidity in my old age and I'm concerned with that kind of evolution, too. And I make fun of myself for all my bad habits. I'm way more aware of them now. As you age, the subjects get different.

SCHILT: What about how much you talk about other people?

KOMINSKY-CRUMB: I try not to focus on specific people too much. Because it always gets me in trouble. Always. Every time I've ever done that it has been a bad reaction. When I think about other people, it is not usually very nice.

People even threaten me. I recently I paid someone a debt. I owed him money. He is not speaking to me, but I decided to pay him back anyway because I wanted to keep my word. And instead of saying thank you, he said "You better not turn this into a nasty comic." People are threatening me; they are afraid I'm going to put them in a comic, even though I hardly ever do. We put my brother in a comic though, actually. That's right. In the comic that's coming out, *Drawn Together*, the last story we did has my brother in it. Because it was a dinner that was so unforgettable that it transcended anything I—even if he never talked to me again, it had to be told. His nickname is Akkie. And it is called "Dinner with Slacky." I won't tell you more about it, but it involves a couple that was talking about their experience in the Holocaust. My brother was very high. And he was talking about the quality of the leather of his shoes. And he was holding his foot up like this on the table. "Look at the quality of that leather. Look at that shoe. Is that gorgeous?" That's the most embarrassing dinner I've ever lived through. These people, after years of knowing them, decided to share this really deep and personal story with us. My brother interrupted them to talk about his shoes. It was pretty amazing. So that moved Robert and I so much we had to do it. My brother was really hurt. I said, the only way that I could not harm you and keep living with you is to write that story. So he never said anything about it again.

SCHILT: How do you [and Robert Crumb] work together in terms of drawing the strips?

KOMINSKY-CRUMB: Well, usually we write everything first. We write all the dialogue in pencil. Then Robert lays everything out. Anything that has to do with any kind of order he does. Then after we pencil the dialogue and stuff like that, then we go back and pencil our own drawings, each one. We each take a page or if it is one page, each ink ourselves and we hand it over to the other person. He's always tempted to retouch my drawings because they are so crude and sloppy but I try to keep him from doing it. He always wants to make them look better. Can't help it.

CRUMB: Tell her how we write the dialogue.

KOMINSKY-CRUMB: What do you mean, how we write the dialogue? We just go back and forth and talk. Right?

CRUMB: Yeah.

KOMINSKY-CRUMB: He'll ask a question and I'll talk for fifteen minutes. He says, wait, what did you say? He writes it down a lot. It is like George and Gracie. You know? He's a straight man and I like, you know, go with it. More or less. Is that correct, dear?

CRUMB: Something like that.

SCHILT: You've been doing a series for *The New Yorker*.

KOMINSKY-CRUMB: Well, we had. We had been.

SCHILT: Those are pretty different just because I'm guessing they are much more sanitized than some of the other things you have done together. What was that like to write for *The New Yorker*? To get that kind of audience?

KOMINSKY-CRUMB: Great honor for me. I never imagined I would ever be in *The New Yorker*. They were stories that didn't involve, necessarily, sex or controversial prohibited subjects. But *The New Yorker* was very good in backing us if we had a crazy idea. Like I wanted to do a story about this tape dispenser that I bought for Robert ["Our Beloved Tape Dispenser"]. Which doesn't seem like a very sexy idea.

When I told *The New Yorker* about it, they said, yeah, great idea. I thought it was amazing that they actually could get the story. It was a wonderful adventure. The company did turn out to be exactly like my dream. When I got the package with the tape dispenser in the mail, it was so carefully packed and had all these nice pieces of cardboard and it was so old fashioned. I pictured this nice old fashioned family business in this nice town and I was saying oh, this is wonderful. In fact it was like that. We went there and they had baked chocolate chip cookies for us. They were so proud. They had these old tape machines in a glass cabinet showing the evolution of their tape dispenser. It had been in the family for seven generations or something. It was totally wonderful. It was a really heartwarming story. We were really happy *The New Yorker* backed us on the story because when we were describing it, it sounds like a really weird idea for a story when you talk about it. They were really good that way. They sent us to the Cannes film festival and [New York] Fashion Week. So we got to be sort of like Joe Sacco except instead of being at the war zone we were at Fashion Week and the Cannes film festival. It was dangerous in its own way. We had to deal with Brad Pitt and things like that. [*laughter*] And I had to deal with Harvey Weinstein, that was very scary. It was very fun. It was very stimulating. That had interesting challenges, too. I don't think it was sanitized as much as it was focused on a subject that we could do in a way that would be acceptable. I don't see it as being sanitized.

SCHILT: Did it bring you a different audience?

KOMINSKY-CRUMB: Oh, yeah, absolutely. I think people in my family were proud of that, too, that they could say, oh, she works for *The New Yorker*. Instead of saying, oh, she made some book called *Dirty Laundry*.

SCHILT: I know we have a lot of audience questions.

Q&A

HILLARY CHUTE: Can you explain why you wanted to move to France?

124

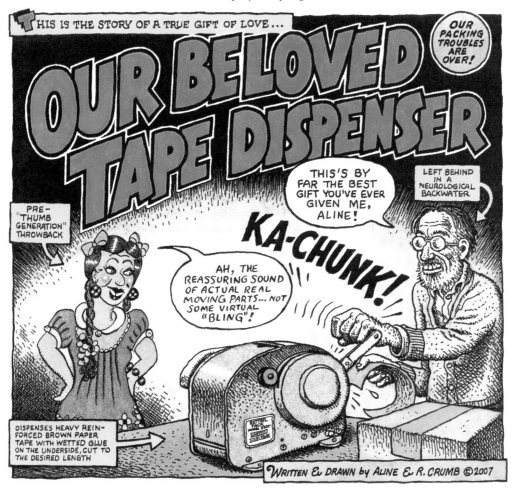

Figure 4. Aline Kominsky-Crumb and R. Crumb, "Our Beloved Tape Dispenser,"
The New Yorker, 26 Nov. 1997.

KOMINSKY-CRUMB: I was having a midlife crisis. I had to have something dramatic in my life. I didn't want to get a divorce. I didn't want to get a face lift. I didn't want to go to law school. But I wanted to do something dramatic. Also Robert is someone who complains really a lot, and when we were in California like for the last ten years he was complaining every day about how real estate developers were destroying California and how horrible it was. I think it finally got to me. I finally said, one day, all right, we're getting out of here. And because we could live anywhere, we didn't have jobs, I figured, well, we have to do this for everybody else that has a job and can't move. We have to be the pioneers and adventurers and try something different. I also wanted to get my daughter out of America for a while just so she would see there was another way to live. I didn't know how long we would stay and what would actually happen. But I like it there.

AUDIENCE MEMBER: Bonjour. Could you talk a little bit about the reception of your work and Robert's work in France as compared to the United States? How have, over the time you've been there, how have the French people taken up your work as opposed to an audience here?

KOMINSKY-CRUMB: It is interesting. Robert's work was known in France through magazine called *Actuel* in the 1970s. So there are a lot of people our age that knew him then but they think he's dead. They think he died. My work was unknown in France until [*Parle-moi d'Amour*] came out last year. That was very risky for the publisher because French comics are much more traditional, and they're very elaborate, quite often historical, they are very beautifully done. So I was not sure at all. We weren't sure how this book would be seen. So I think our publisher took a big chance. But it got a really good reaction. It was really well received by the press and by the public. But that's the first time my work has ever been published in France so that's all they know about me. I have gotten a lot of positive feedback on that. Now we're doing a monthly strip for a magazine called *Causette*, which means to gossip and talk. It's a satire on women's magazines. It is pretty funny. We've been doing it for them for a year. This strip is coming out in French and Portuguese, and it's not yet coming out anywhere in English, although we write it in English first. And that strip also I think is having a pretty positive reaction. We're dealing with all kinds of subjects in there. It is kind of unusual. Also there's no other couple in France, obviously, doing comics together like that. They seem to like it.

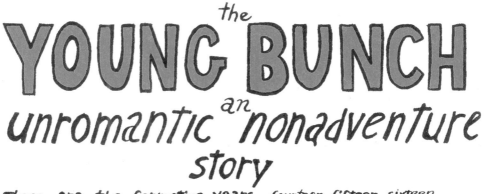

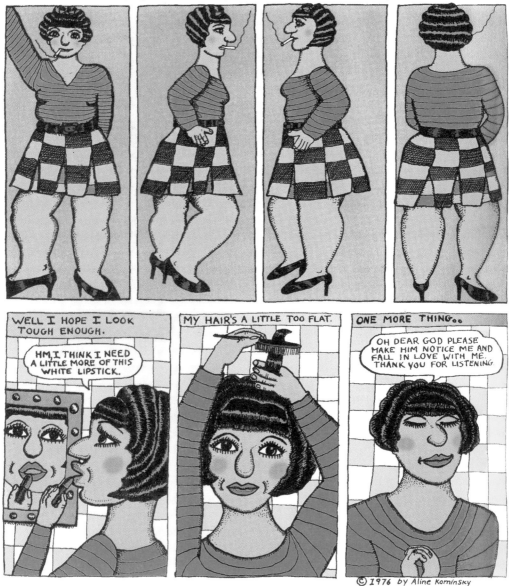

126

Figure 5. Aline Kominsky-Crumb, "The Young Bunch: An Unromantic Nonadventure Story," in *Twisted Sisters* (June 1976).

SETH: If you wanted men to like you, why were you drawing yourself—like why were you trying to show stuff that was so unfeminine and probably would have been really a turn off to a lot of guys?

KOMINSKY-CRUMB: I wasn't trying to show the stuff. That's how I really felt.

SETH: Isn't that kind of unusual? The natural impulse would be to hide stuff. To cover it up and put on a false front to attract people.

KOMINSKY-CRUMB: Well, I dressed in a sexy way to try to attract men in my life. I tried to act in a way that I thought would appeal to men in my life. But in my art I had no control of that, I had to get that stuff out. I felt that ugliness, I felt that grotesqueness, that's what came out of me. It wasn't like I wanted to do that. It wasn't that I was trying to seduce men in my work at all. What came out was just absolutely how I felt, emotionally.

SETH: That seems real unusual.

KOMINSKY-CRUMB: I'm a case, what do you want? You think I'm an ordinary run of the mill well adjusted female? Obviously not. *[laughter]* It's contradictory.

SETH: That's interesting. Because most people would do the exact opposite.

KOMINSKY-CRUMB: If they had control over what they did in their art.

SETH: Did you really feel like you didn't have control? As an artist, I feel like I'm picking and choosing what I'm putting in.

KOMINSKY-CRUMB: Yeah, but your work is very controlled and very beautiful and very well-constructed. My work is just completely out there. It is like vomit.

SETH: It's great, though. That's terrific.

AUDIENCE MEMBER: I want to know your process of choosing to write as an alter ego and why she's named the Bunch.

KOMINSKY-CRUMB: Okay. The Bunch: there was a series of books called *Honey Bunch*, right? The original books. Honey Bunch was a fictional character. And then Robert created a character called Honey Bunch Kaminski. He made that character up before he met me. But it had my name, which was really weird. So at first I thought that was cute, and I kind of liked it. And then I got involved with him and people still kept calling me Honey Bunch. And it got on my nerves a little bit. Gradually it started getting on my nerves a lot. Finally, one day this journalist came up to visit us—a Dutch guy, and I was working on a comic, he said, "Oh ze Honey Bunch, she draws ze comics, too, how sweet!" And it was so irritating to me I decided I had to make the anti–Honey Bunch. So the Bunch was the anti–Honey Bunch. She was like the grotesque side of Honey Bunch. That's how that started, and it just stuck. People even called me the Bunch. It became my total name, nickname completely. That's how that developed.

AUDIENCE MEMBER: Why use an alter ego? Is she supposed to be somebody different than you? Or just a different side?

KOMINSKY-CRUMB: No. No. It is a part of me. That's a part of me I choose to show—not choose to show, that's a part of me that comes out in my comics. So it is a major part of me. I've outgrown that character to a certain degree, over the years. I have a little more confidence now than I did then.

AUDIENCE MEMBER: So you talked about the guilt that you have about what you drew about your mom now twice today. Do you feel that maybe you are going to have to do something in some upcoming work to address that?

KOMINSKY-CRUMB: What am I going to do? Make Mrs. Nicey Nicey? Or what? My mother is still quite grotesque. Let's not go overboard about how nice she is. She's better than she was. *[laughter]* The fact that I take care of my ex-junkie brother and took him off her hands has made her very nice to me.

PHOEBE GLOECKNER: One of my favorite [comic] books is the first *Twisted Sisters*. And one thing that was amazing about it is that it's two artists and it is a big chunk of work by each of you. And even with underground comics, you didn't really see that. It was, like, lots of little stories. It was so rich that way. I guess I never knew, how did you and Diane Noomin come together to make this brilliant pairing of artists?

KOMINSKY-CRUMB: We met at a party. We instantly liked each other. Like love affair at first sight. We were also both alienated from the original group of cartoonists. It was the feminists against the bad girls. And Diane was like me, a bad girl. So she was involved with a male cartoonist. So we were both considered like the two camp followers. So we were kind of thrown together, but we also really liked each other and had a lot in common. Our backgrounds, our point of view, our humor, and everything. We really had a strong affinity. So when we got disgusted with this group of humorless women that wanted to paint themselves as superheroes and stuff like that with, you know, just—we found it really to be alienating, we decided to do our own book. The book happened very naturally and easily. It was like, really a very smooth work of art together.

GLOECKNER: There is nothing like it.

KOMINSKY-CRUMB: Well, *Self-Loathing Comics* that Robert and I did was like that, years later. For one of them, Robert and I each did half of the book. We each did a really long story, and it's a "69" thing, where you could turn it over.

AUDIENCE MEMBER: So you talked a little bit about your collaborative, creative process. And I'm just wondering if that's affected at all how you think about your creative process when you are working on your own. And whether you found there are particular advantages or disadvantages to either the collaborative, or working on your own now.

KOMINSKY-CRUMB: That's a good question. And actually, it's

a lot easier collaborating. You have this feedback. I say something and then Robert comes back and I go back and we go back and we feed on each other and we stimulate each other. These strips write themselves. We're doing something together. We get into a certain role where we each play our role. And the strips write themselves. It is much easier. Working on my own I find harder. More isolating. Pulling things out of deeper—I think it is much more difficult. Working with him, I actually think it is fun. When we're on the road, we write ideas down. They just kind of come to us. Just thinking that way, the ideas just seem to flow.

AUDIENCE MEMBER: I've seen it in *Dirty Laundry*, the role surrounding being a Jewish woman. How have you interacted with Jewish femininity over time? Has changed? How has it influenced your work?

KOMINSKY-CRUMB: You mean being a Jewish woman? I don't understand the question exactly.

AUDIENCE MEMBER: Your attitude towards the representation, has it changed since the 1970s?

KOMINSKY-CRUMB: You mean has my perception of being a Jewish woman changed because of how I've drawn myself?

AUDIENCE MEMBER: Yes.

KOMINSKY-CRUMB: Well now I'm just an old Jewish woman. *[laughter]* An irritating old Jewish woman instead of like an obnoxious, young Jewish woman. I think I point that Jewish thing out to sort of disarm the racial stereotype, whatever. If you say that about yourself, it automatically takes the words out of the other person's mouth. So I think it is important to include that in your self-deprecating self-image. I can't separate that from anything else. I was raised also in the crassest aspect of middle class, materialistic, New York suburban Jewish culture. I still am relating to that and reflecting that and reacting to it because it is a very powerful thing. In fact the show that I'm doing in June in New York called Miami Makeover is really dealing with those issues of, you know, how you are supposed to age as a middle class Jewish woman, people that I grew up with, how they deal with that. And how I'm dealing with it. So I'm still relating to those things because of how powerful an effect it had on me in my childhood. But I don't really know how I've changed in relationship to my Jewishness since I was young. I still have very mixed feelings about it. Never got over it. Yeah, I still feel very Jewish at the same time I hate it.

CHUTE: I was wondering if you could talk about if your work has ever encountered censorship. Was there an issue with the printers not wanting to print your work? Could you talk about that?

KOMINSKY-CRUMB: It wasn't like I was censored by publishers, but by the actual printers which I thought was really unbelievable. And Gary [Groth, of Fantagraphics Books] went through the trouble to find a printer that would print it. Other than that, my work was just condemned by journalists and people for many reasons. For being crude. For being poorly drawn. For being disgusting. All of those things. And they are all true.

CHUTE: Did it ever get back to you what the reason was when the printers didn't want to print it? Do you think it had something to do with what you're talking about, with this disgustingness? Or was it just the sexual, explicit content?

KOMINSKY-CRUMB: Yeah, it was me on the toilet. The one about me, "The Bunch Plays with Herself." Drawing yourself masturbating and doing all these things to yourself. I just think it was too much for men to look at that. I could imagine. I can't blame them either. It is too horrifying. They didn't want to touch it, go near it, thought they would catch something from it. I think it is still pretty unacceptable. I don't think people have changed to think that that's okay. Why would they? It is not okay, probably.

AUDIENCE MEMBER: You've talked about being compelled to do the work. The compulsion—and I've heard that a bunch through the day. I'm also thinking of other ways, when people have studio time and they go in in a very disciplined way. So I just wonder, are there periods where it is compelled and erratic? Is that a different kind of work than some kind of idea: oh, this is the time I start every day, these are my hours. I guess I'm just wondering how it translates into practice, this idea of having to do it.

KOMINSKY-CRUMB: I'm very chaotic and erratic in my artistic expression, always have been. Periods of on and off. I don't go every day in my studio in a controlled and disciplined manner at all. I'm like all over the place. And I disperse my energy too much into a lot of different areas of life. But then when I am working on something, I can work on it very compulsively. And if I have a deadline, I always make my deadline. So I can't give you one answer at all. But I'm not a good example of someone who has structured and disciplined work habits at all. I'm really bad and really all over the place. It's not good. I wish I was more, I wish I could go in my studio at a certain time and work for a certain number of hours, but I'm not like that at all.

AUDIENCE MEMBER: Why do you wish it?

KOMINSKY-CRUMB: I would be more productive and it would be more predictable and controllable. I feel a lot of times that it's out of control. I can't control it. It's more scary. Every I day I think I might never do it again. I never know.

CRUMB: Sometimes you go through periods of despair where you don't think you can do any art work again.

KOMINSKY-CRUMB: Each time it is like I'm starting for the first time. It is scary.

AUDIENCE MEMBER: So in relation to the fact that you became disillusioned with that fine arts background: Do you think that might be part of the reason why you kind of seem to eschew the rules of comics, because you had such a negative experience with those high boundaries of abstract expressionism? Or maybe does the fact that you are a painter also affect the way you kind of create comics?

KOMINSKY-CRUMB: I think the fact that I started as a painter and I still—when I'm not doing comics I'm painting and doing other things—has definitely affected how I see comics. Yeah. The hieroglyphics of comics and the

128

Figure 6. Aline Kominsky-Crumb, cover of *Self-Loathing Comics*, no. 2 (May 1997).

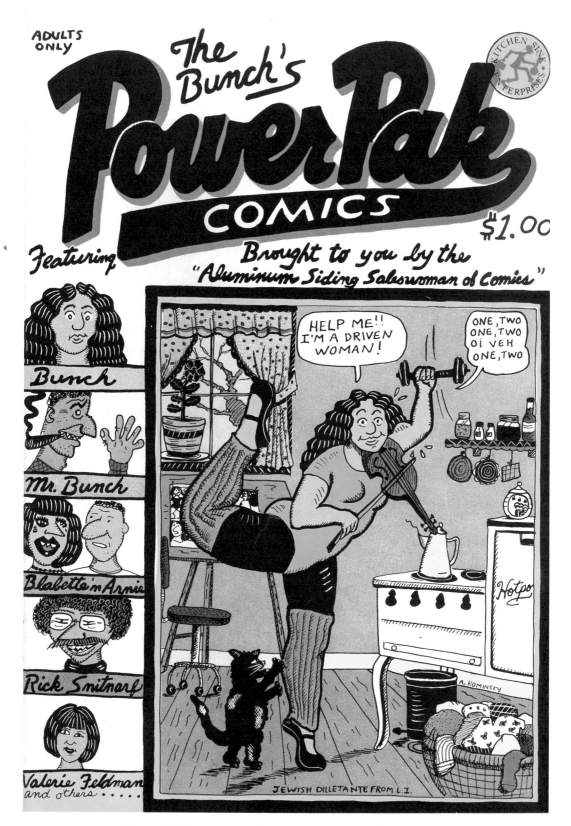

130

Figure 7. Aline Kominsky-Crumb, cover of *Power Pak*, no. 2 (1981).

graphic design aspect of comics aren't too relevant to me. I don't see it any differently than from painting and other work that I do. It is sort of all in the same spectrum. I don't think it is very necessarily graphically strong, or it doesn't incorporate the hieroglyphics of communicating in comic form. So they're hard to read. But I think for me it is all the same. I feel the same way about decorating my house. About dressing. It is all like one thing. I don't really separate anything from the other. It is all just part of the same need to express oneself. It is sort of seamless in a way.

AUDIENCE MEMBER: I came to the underground comics after reading mainstream comics, so I was all about craft and talent. But I have to say, your work stayed with me then, was powerful then. And it is still powerful now. And it has always been powerful. Maybe the most powerful of all the woman cartoonists who worked in the 1970s. *[applause]*

KOMINSKY-CRUMB: Wow. That's amazing.

AUDIENCE MEMBER: I also want to say, your *Weirdo* work was really tremendous. It really was valuable in a large sense for the comics community. Can you tell us a little bit about how you worked and how you picked and chose and were you rejecting things? And exactly how that worked? Thanks.

KOMINSKY-CRUMB: Robert first started editing, then Peter Bagge; I was the last one. Robert accused me of using people because I liked them. Like using my friends more than other people. But I don't think that's completely true. I got tons of stuff in the mail by the time I took over *Weirdo* because it already had a reputation. A lot of artists [who] had never published before [were] published in that magazine. I think that the young artists whose work I got were inspired by the work they saw in *Weirdo*, inspired by my work. I took it very seriously. Very seriously as a forum for presenting new work. When I saw these sincere artists who were really great, it was very exciting to me to publish them. The only thing I regretted was I couldn't use everybody's work that I liked. I made some people really angry. I got, like, threatening letters and people accused me of all kinds of things. It was a horrible position. It was also hard to get the money from the publisher. I had to stand at the publisher's office and stay there all day while he wrote out one check after another and I had to wait for lunch and then come back and everything. It was a really pressured and tense position to be in. It was really time-consuming. We got no money. But there was some great work that had never been published before that came to my hands and I felt really compelled to do something with it. I regretted that I just couldn't do everything. It was a process of elimination and some people couldn't say how many pages they were going to do so I would have to tell someone else, well I'll use your story if this person doesn't use seven pages; if they only use six pages, I can put one page of you in there. Then the person made eight pages so I had to eliminate them and somebody else and those two people would write me threatening and menacing letters. Someone threatened to sue me, I said, but sue me for what? I don't have a cent. It was an uncomfortable position to be in. And then trying to do my own work as well for the magazine. Wearing those two hats was very stressful and it was really a lot of work. Now I can look back with a sort of romantic and nostalgic view of it and think that it was a great magazine. But at the time it was very stressful. There was no budget. Very little reward other than getting this really good work coming through there.

AUDIENCE MEMBER: So I'm curious. You were talking sort of about your relationship to power and how you have been criticized for that. I'm interested to hear you talk about both your visual style and how you kind of deliberately draw things that are gross and not well drawn.

KOMINSKY-CRUMB: I don't deliberately draw things not well drawn. That's how I draw.

AUDIENCE MEMBER: I think of it as very much part of the identity of how your work looks. So the idea that if you, if you can draw something and call it bad, then that takes away the power from someone else to call it bad. And if you portray yourself as a sexual being…if you call yourself a slut first, it doesn't matter if someone else calls you it.

KOMINSKY-CRUMB: Sure.

AUDIENCE MEMBER: I'm curious how you feel that that kind of disempowering of the people who would attack you relates to how you feel about your work. Does that make sense as a question?

KOMINSKY-CRUMB: Yeah, I do think that's a very good point. In the beginning when I first started drawing comics, I didn't think about any of those things. I didn't realize my work was crude and horrible compared to other people's work. I was really excited to get my work published. I couldn't believe that it was going to be in a comic. It was amazing. I didn't realize how bad it was either. But then, in the first women's comics all the work was pretty bad. So it wasn't even outstandingly bad. My drawing kind of stayed crude. It didn't change all that much. It is true that by calling yourselves names, you do kind of disarm your critics. I think that is probably a good defense to keep people off of you. But that's not a major concern when I'm working either. The work comes out of a very deep place. I don't think that, you know, I do it for effect or think of it necessarily about the effect it is going to have or what is going to happen afterwards very much.

AUDIENCE MEMBER: Could I ask a question about collaboration? Because you are working together. That is kind of unusual. What would you say you have taught Robert that is most important as a cartoonist, and what has he taught you?

KOMINSKY-CRUMB: Well, when you say that it is unusual that we work together… we're the only couple in the history of the world that has ever drawn together. That's how unusual it is. Okay? We tried to get other couples that are both cartoonists to work with us at one point and nobody else could do it. So anyway, what did we learn? Well, I think Robert has learned not to worry so much about being perfect. That just, like, get it out there. Express yourself. And I have learned that you have to like at least write clearly enough for people to read it. *[laughter]*

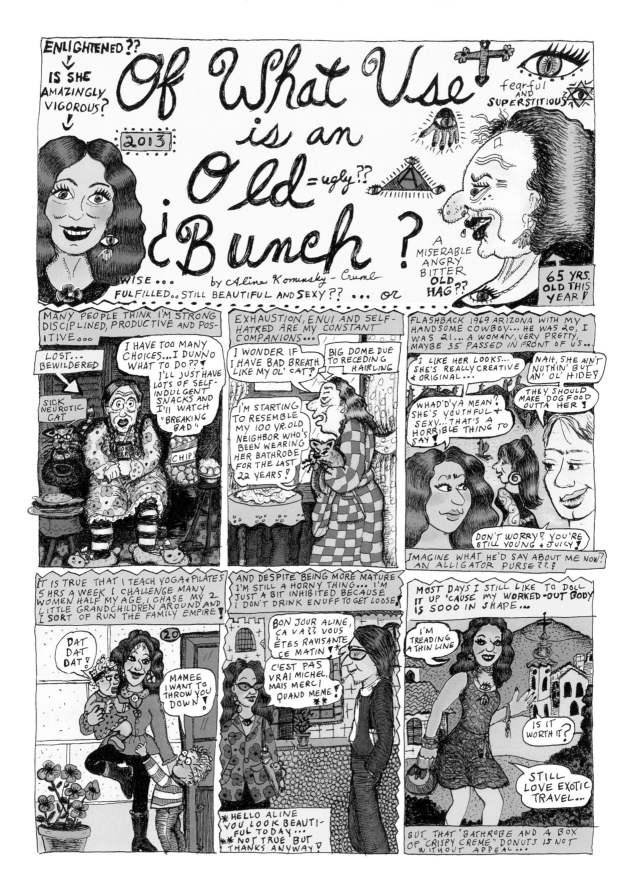

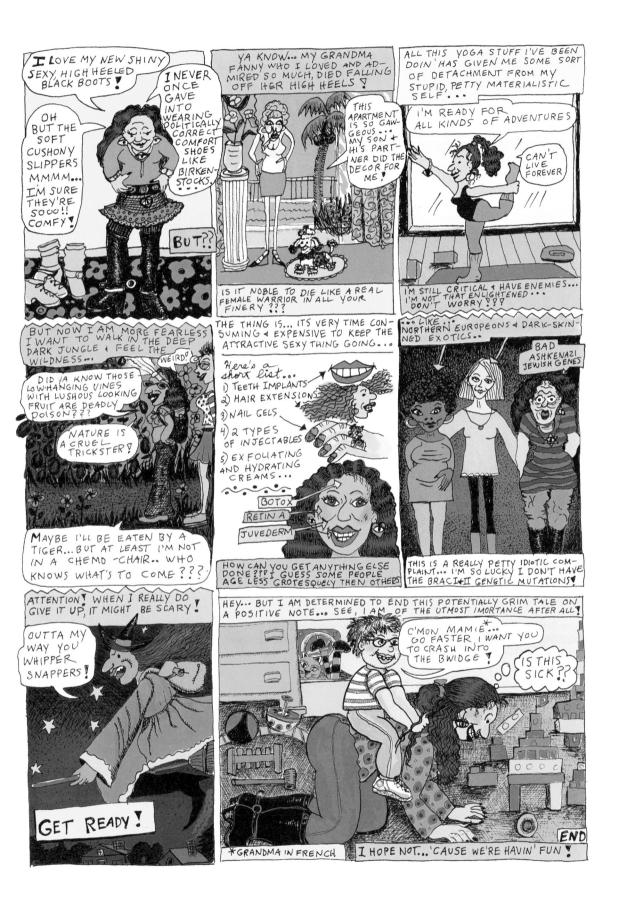

"This Is No Longer Dance": Media Boundaries and the Politics of Choreography in *The Steel Step*

Daria Khitrova

Is it the medium of ballet or the media of ballet? On the one hand, a typical ballet consists of four mediums, not one. The ballet we call classical, for instance, is a combination of orchestral music, classic dance steps, and a fantasy narrative unfolding against eye-pleasing sets. On the other hand, ballet regulars have grown too familiar with the classical idiom to pay much regard to the complex nature of ballet's hieroglyphics. From this all-too-familiar perspective the classical ballet is a medium in its own right.

Defamiliarizing the familiar was a drive behind the collective endeavor this essay is about. Classics and fantasy are familiar ballet-related tags. What happens to the medium of ballet when a composer, a librettist, a set designer, and a choreographer—a crew of four in charge of a ballet production—put heads together and conspire to produce a ballet about class struggle and topical politics? Stripped of familiar tags, will it remain ballet? As a case study, this essay is about a ballet production that defamiliarized ballet as an art form and as a medium.

More generally, the subject of this paper is ballet and revolution. This twin subject has two sides to it, neither of which can be addressed without attending to the other. One side is the effect on ballet of the social revolution in Russia of October 1917. The other side is a revolution in ballet, an upheaval as momentous on the scale of arts as the October revolution was on the scale of history. The politics of choreography—the phrase I use in the title of this essay—points to both. This essay looks at the subject from two angles. One is balletic repercussions of the political revolution; the other, ballet's own choreographic

revolution launched to change from within what was perceived as the courtliest and most conservative of arts.

This essay is also an attempt to look at Russian ballet through the lens of evolutionary poetics as developed in works by literary scholars such as Yuri Tynianov or Yuri Lotman. What makes arts like literature or, in my case, ballet evolve over time? Condensed to three words, the answer is: constantly shifting boundaries. As Tynianov claimed in his essay "On Literary Evolution" (1927), it is hard to pinpoint the borderline between poetry and prose because a dynamic front line, not a fixed border, constantly defies and redefines the existing rapport between the two.[1] Literary boundaries only matter as long as they keep changing.

What counts and what doesn't as a "literary fact" is a key question of literary evolution. Take books and games. The trope we identify as literary today may turn into a form of a parlor game tomorrow and vice versa. As we play charades and logographs with kids do we always remember that today's nursery games were once a productive genre of late eighteenth-century poetry? Tynianov asks in his 1924 essay "The Literary Fact."[2] A similar metamorphosis, but in the opposite direction—from games to arts—is also a subject of Lotman's 1975 study of the *lubok*.[3] Let me outline in brief the main argument of that important study, for what it tells us about literary boundaries turns out to be relevant to the shifting boundaries of ballet.

Named after a special kind of woodwork also used in boat building, *luboks* are popular woodprints believed to reflect the mental horizon of the lower-class populace of eighteenth-to-nineteenth-century Russia. The range of

I am grateful to Alexei Evstratov, Elizabeth Kendall, Irina Klyagin, Maria Kotova, Jindrich Toman, and Yuri Tsivian for their help with and comments on this essay. Special thanks to Ekaterina Shaina, head of the Saint-Petersburg Circus Art Museum. And I am truly indebted to Hillary Chute and Patrick Jagoda for their comments and suggestions on ways to improve a draft version of this. Unless otherwise noted, all translations are my own.

1. See Yuri Tynianov, "O literaturnoi evolutsii" [On Literary Evolution], *Poetika, Istoriia Literatury, Kino* [Poetics, History of Literature, Cinema] (Moscow, 1977), pp. 270–81.

2. See Tynianov, "Literaturnyi Fakt" [The Literary Fact], *Poetika, Istoriia Literatury, Kino*, pp. 255–69.

3. Yuri Lotman, "Khudozhestvennaia priroda russkikh narodnykh kartinok" [On Artistic Nature of Russian Popular Pictures], *Stat'i po semiotike kul'tury i iskusstva* [Essays on Semiotics of Culture and Arts] (Saint Petersburg, 2002), pp. 322–39.

genres these prints cover stretches from pious to playful and from heroic to satiric. A typical *lubok* print includes awkward drawings with occasional captions inscribed above or inbetween the creatures the picture features (figs. 3 and 4). The way *luboks* were used depended on the subject displayed. Heroic plots like Prince Bova's triumph in a combat against the centaur Polkan or biblical stories like the Return of the Prodigal Son would decorate the walls of homes and inns; but when it came to the lower end of the spectrum—scenes from conjugal life or frivolous political allegories furnished with humorous (and often bawdily worded) inscriptions—the *lubok* pictures yielded themselves to less conventional and more game-like uses.

The presence of the *lubok* pictures in the illiterate and semi-literate subculture of Russia's stratified society was too significant to go unnoticed on the part of educated literati. But what the latter failed to notice was the unique way in which these pictures functioned. The prevalent view of the nineteenth century presented *luboks* as crude or at best naïve forms of underliterature and underart. A reversal of fortunes occurred after Dmitrii Rovinsky's annotated catalogue of his *lubok* collection appeared, conveniently, in 1900.[4] Much as with wooden icons or shop signs, the incoming age of futurism and neoprimitivism not only conferred on the *lubok* the status of art but also held it up as a model for the new; significantly, avant-garde painter Mikhail Larionov, later a set designer and (occasionally) a choreographer with Serge Diaghilev's Ballets Russes in Paris, organized an exhibition of *luboks* in 1913 and integrated elements of the *lubok* style into his own paintings.

The problem with both views is that, polarized as they may sound, their frame of reference is one and the same. Both those who looked down on and those who looked up at the *lubok* treated it as a peculiar form of literature and visual art and modeled the original users of the prints on more familiar readers and beholders. The uniqueness of the *lubok*, however, as Lotman's study shows in some detail, was that its prints were made not to be enjoyed as we do paintings or books but to be played with, passed around, rotated (some, indeed, have multilateral orientation), used as visual storyboards and verbal springboards for improvised enactments, more often than not peppered with political and erotic innuendos. Distinct from the serious *luboks* on the wall, the playful *lubok* served as a trigger script for behavior. Lotman calls this "ludic user-response," comparing *lubok*-prints now with the children's cinema, now with a playbill in an imaginary theater; today, we would be tempted to use an analogy with gaming media.

Media are not always what they seem; nor are their boundaries always found where we look. The boundary I explore in this study is between ballet and nonballet. Experimental choreography of the kind this paper looks at may result in balletic audiences looking for this boundary in vain. The phrase "this is no longer dance" used in the title of this paper belongs to a stunned reviewer of *The Steel Step*, the ballet produced by Diaghilev's Ballets Russes, first shown in Paris and London in 1927. What aspects of Diaghilev's production made audiences ponder over the identity of ballet? What means and media did its makers marshal to provoke the identity crisis within the medium of dance? What part did they assign in that mission to mediums such as political posters and *lubok* pictures tirelessly promoted by Diaghilev's stage designer Mikhail Larionov? Such are some of the questions I am going to address in the second half of this paper, which looks at the choreographic revolution in ballet.

The analysis of choreography is prefaced with a more general discussion of ballet and the revolution. What leverage can there be between the rise and fall of governments and classes and the rise and fall of media and arts? Before asking this about the art of ballet and the medium of dance, let me step back for a moment to take in a more panoramic view of what might be called Russian mediascape—a slowly moving landscape of media and arts in nineteenth-century Russia.

Russia's nineteenth-century literature loved to stage encounters and contests between media like painting, poetry, or sculpture. I stress media to prevent a possible confusion; it was not means or skills but the very material of arts that was at stake in those discussions. To evoke the distinction used in modern media aesthetics, the contended area is not about instrumental but rather material causes of art.

Roman Jakobson's milestone book from 1975, *Pushkin and His Sculptural Myth*, is an important study of such causes.[5] Jakobson's book is about statues-in-movement, a recurring motif found in a number of Aleksandr Pushkin's plays and poems. Pushkin's myth is not a version of Pygmalion's; in none of the cases that Jakobson examines does Pushkin treat his statue as a work of art. Whether Pushkin makes a statue descend from a tombstone in *The Stone Guest* (1830) or a monument to the emperor that climbs off the pedestal in *The Bronze Horseman* (1833), the important thing is that (unlike Galatea) neither of Pushkin's moving sculptures become a flesh-and-blood human. When Pushkin's statues are set in motion they are made so not to overcome their native medium but to defamiliarize it; the Stone Guest becomes walking stone, the Bronze Horseman, galloping metal. The material causes of sculpture are thus foregrounded.

Media mythologies like Pushkin's are best explained when set against collective mythologies of art. When the futurist poet Vladimir Mayakovsky included in his 1929 comedy *Bathhouse* a murderous satire of a successful ballet called *The Red Poppy* (which I will further discuss) was it because he hated the production or perhaps because looking down at ballet was considered politically correct?

135

4. See Dmitrii Rovinsky, *Russkiia narodnyia kartinki* [Russian Popular Prints], 2 vols. (Saint Petersburg, 1900). The first, multivolume edition published back in 1881 was meant more for specialists and came out in two hundred and fifty copies only; the 1900 abridged version was the one that reached the public eye.

5. See Roman Jakobson, *Pushkin and His Sculptural Myth* (The Hague, 1975).

A closer look at what may be called media hierarchies should help us figure out these questions.

There is no such thing as equality among arts, at least as far as Russian and Soviet cultures are concerned. An influential current of thought in Pushkin's time, starting from the Moscow followers of German romantic aesthetics and stretching to Nikolai Gogol, preferred to rank media according to the diminishing materiality of their means: the less palpable, less visible, and less figurative the material of art, the more spiritual it is and the closer it stands to heaven. Little wonder if, in this view, audial arts like music and poetry turned out to be at the top of the pyramid and "cruder" ones like painting and sculpture at the very bottom.

It was to challenge the romantic pyramid of arts, for instance, that Pushkin inserted in his 1828 poem a tribute to the Apollo Belvedere whose divine perfection, the poem said, resided in the very material of sculpture. A romantically correct way of extolling a statue would be to say that its beauty emerged as a result of overcoming stone. For 1828, Pushkin's punchline—"but this marble is a god!"—[6] sounded like what Russian futurists from the twentieth century called "a slap in the face of the public taste."

1. A Soviet Ballet?

Arguably, no age in the cultural history of Russia has been as preoccupied with media hierarchies as those first years of Soviet power. In 1921 Lenin pronounced the phrase cited more than once by Commissar of Education Anatoly Lunacharsky: "Of all your arts, cinema is the most important for Russia."[7] At the same time, as Lunacharsky reports, Lenin was "very nervous" about whether or not Soviet Russia needed to spend money on operas and ballets, which he thought were "part and parcel of the land-owners' culture."[8] Lenin did not say much on the subject besides this, but the media pyramid he drafted found eager supporters among critics and artists of the Soviet Left in whose eyes cinema was the medium of real life, while ballet was the natural habitat for various creatures from the past: dying swans, sleeping beauties, and lovely but immaterial Sylphides.

If a parable were needed to describe the rapport between Russian ballet and Bolshevik culture, the French fairy tale *Beauty and the Beast* would do the trick. As the story unfolds, the initial incongruity between the two main characters grows into a healthy relationship.[9] In 1921 Lenin moves that the Bolshoi and Mariinsky theaters be closed; at a public debate held at the Moscow House of Press Vladimir Mayakovsky supports Lenin's motion on behalf of the "Communist-Futurist" (Komfut) group of artists and poets.[10] However, ballet was not abolished and Bolshevism made peace with the Bolshoi. In June 1927, *The Red Poppy*, to be called "the first Soviet ballet," opened at the Bolshoi; in this ballet, bits of romantic choreography, interlaced with the foxtrot and the *Yablochko* folk dance, came framed in a present-day class-conscious libretto.[11] Mayakovsky lived to witness the new deal between the old and the new and to satirize it on the stage of Vsevolod Meyerhold's avant-garde theater in Moscow. Let me quote a speech made by Ivan Ivanovich, a cartoon of a Soviet bureaucrat from Mayakovsky's play *The Bathhouse*:

IVAN IVANOVICH
Please us with beauty! At the Bolshoi Theater they always please us with beauty. Did you see The Red Poppy? Oh, I saw The Red Poppy! Marvelously interesting. Everywhere you looked, they were dancing, and singing, and flitting about—all those different elves and... syphilides.
STAGE DIRECTOR
Sylphides, you mean?
IVAN IVANOVICH
Yes, yes, yes! Sylphides, very observant of you. We must launch a broad campaign. Yes, yes, yes, all kinds of different elves and twelves... are shown flying, marvelously interesting![12]

It so happened that in June 1927, within a week of the opening of *The Red Poppy* in Moscow, Prokofiev's *The Steel Step* premiered with Diaghilev's company in Paris, another dance production that was nicknamed by critics a "Soviet ballet" (fig. 1).[13] We know what a favor a Soviet libretto did to classical ballet in the Soviet Union; it helped it secure a place in the new pantheon of arts. What value could a libretto like this have for a venture like the Ballets Russes in a place like Paris?[14]

6. Alexander Pushkin, *Poet i Tolpa* [The Poet and the Mob], *Polnoe sobranie sochinenii*, 16 vols. (Moscow, 1937–49), 3:141–42.

7. Quoted in Anatoly Lunacharsky, "Teatr i iskusstvo, o hudozhestvennoj politike," *Izvestiia*, 29 Apr. 1923, p. 5. Lunacharsky quoted Lenin's dictum in his speech at *Fourth All-Russian Convention of Art Workers* on 28 April 1923.

8. Anatolii Lunacharskii, "Lenin i iskusstvo" [Lenin and Arts], *Ob iskusstve* ed. I. A. Sats and A. F. Ermakov, 2 vols. (Moscow, 1982), 2:107.

9. On ballet and Soviet politics, see Elizabeth Souritz, *Soviet Choreographers in the 1920s* (Durham, N.C., 1990), pp. 44–48, and Christina Ezrahi, *Swans of the Kremlin: Ballet and Power in Soviet Russia* (Pittsburgh, 2012), pp. 10–29.

10. Newspaper report quoted in Vasilii Katanyan, *Mayakovsky: Khronika zhizni i deiatel'nosti* [Mayakovsky: Chronicle of Mayakovsky's Life and Work] (Moscow, 1985), p. 219.

11. See Souritz, *Soviet Choreographers in the 1920s*, pp. 231–54.

12. Vladimir Mayakovsky, *The Bathhouse*, in *Plays*, trans. Guy Daniels (Evanston, Ill., 1995), p. 229; trans. mod.

13. To specify: that *The Red Poppy* has won the reputation of the first "Soviet" ballet was not because this was the earliest attempt to produce a ballet about the Bolshevist revolution. In 1924, for instance, Fedor Lopukhov's avant-garde *The Red Whirlwind* was shown on the Mariinsky stage, but its choreography proved to be too radical to gain enough critical recognition or earn it a long stage life. One Leningrad critic wrote this about *The Red Whirlwind*: "We were shown anything but ballet" (Gaik Adonts, "Spekuliatsiia na revolutsionnost" [Revolution as a Selling Point], *Zhizn' Iskusstva*, 4 Nov. 1924, p. 15). Ironically, a similar statement would later be made by an English reviewer with regards to Massine's *The Steel Step*, not to condemn, but to extoll an experiment in choreography.

14. See the excellent study of *Le Pas d'Acier* based on more than one hundred and fifty review clippings collected in Prokofiev's archive, in Elisaveta Souritz, *Artist i baletmeister Leonid Miasin* [Léonide Massine, Dancer and Choreographer] (Perm', 2012), pp. 100–11.

LE PAS D'ACIER
1920
(CRÉATION)

Ballet en deux tableaux de Serge PROKOFIEFF et Georges IAKOULOFF
Musique de Serge PROKOFIEFF
Constructions et Costumes d'après les Maquettes de Georges IAKOULOFF
Chorégraphie de L. MASSINE
Les Costumes sont exécutés sous la Direction de Mmes N. IAKOULOFF et A. YOUKINE
Les Constructions exécutées dans l'atelier de M. D. KAMISCHOFF, à Paris

Les deux tableaux de ce ballet présentent une suite de scènes résumant deux aspects de la vie russe :
les légendes du village et le mécanisme de l'usine.

PREMIER TABLEAU

I. Bataille de Baba-Yaga avec le Crocodile

Mlle Vera Petrova,
MM. Tcherkas, Efimow, Domansky, Kochanovsky,
Petrakevitch, Borovsky, Gaubier

II. Le Camelot et les Comtesses

M. Léon Woizikovsky
Mlles Thamar Gevergeva, Dora Vadimova,
Henriette Maikerska, Sophie Orlova
MM. Lissanevitch, Pavlow, Hoyer, Ladré, Ciéplinsky,
Ignatow, Strechnew, Hoyer II, Romow.

III. Le Matelot et les trois Diables

M. Léonide Massine
MM. Jazvinsky, Fedorow, Winter
MM. Tcherkas, Efimow, Domansky Kochanovsky,
Petrakevitch, Borovsky, Gaubier

IV. Le Chat, la Chatte et les Souris

Mlle Vera Petrova M. Thadée Slavinsky
Mlles Savina, Markova, Miklachevska, Kouchetovska,
Evina, Jassevitch.
MM. Lissanevitch, Pavlow, Hoyer, Ladré, Cieplinsky,
Ignatow, Strechnew, Hoyer II, Romow

V. La Légende des Buveurs

M'' LéonWoizikovsky, Nicolas Efimov, ConstantinTcherkas.
MM. Domansky, Kochanovsky, Petrakevitch,
Borovsky, Gaubier.

VI. L'Ouvrière et le Matelot

Mlle Alexandra Danilova M. Léonide Massine

VII. Ensemble

Par tous les Artistes

DEUXIÈME TABLEAU

VIII. Le Béguin

Mme Lubov Tchernicheva M. Serge Lifar

IX. Passage des Ouvriers

M.Lissanevitch, Pavlow, Hoyer, Ignatow, Strechnew, Hoyer II

X, XI, XII. L'Usine

M'''Alexandra Danilova, Lubov Tchernicheva, Vera Petrova.
MM. Léonide Massine, Léon Woizikovsky, Serge Lifar,
Thadée Slavinsky.
Les Ouvrières : Mlles Thamar Gevergeva, Dora Vadimova,
Henriette Maikerska, Sophie Orlova.
Mlles Savina, Soumarokova, Branitska, Chamié, Markova,
Fedorova, Zarina, Klemetska, Miklachevska, Kouchetovska,
Slavinska, Obidennaia, Barash, Evina, Matveeva, Jasevitch.
Les Ouvriers : MM. Tcherkas, Efimov, Domansky,
Kremnew, Jazvinsky, Fedorov, Winter, Lissanevitch,
Pavlow, Kochanovsky, Hoyer, Cieplinsky, Petrakevitch,
Ladré, Borovsky, Hoyer II, Ignatow, Strechnew,
Gaubier, Romow.

Figure 1. Playbill of *The Steel Step* from its opening at Théâtre Sarah Bernhardt in Paris. The credits say: "Ballet in 2 scenes by Sergei Prokofiev and Georgii Yakoulov, music by Sergei Prokofiev, costumes and set constructions by Georgii Yakoulov, choreography by Léonide Massine." The annotation in italics says: "The two scenes of this ballet summarize two aspects of Russian life: the legends of the countryside and the mechanism of the factory."

137

A simple answer might be the value of attention, something that Diaghilev never shied away from. But even such a simple task as winning public attention entailed a complex act of political balancing; in this case anything Soviet, if showcased on a European stage in the 1920s, was bound to become a polarizing issue.[15] How did Diaghilev intend to handle this?

What words and movements did the ballet authors borrow from the political language and body language of Bolshevism, and what props did they use to extend and reforge the vocabulary of dance? What media other than dance, including verbal ones, did they import into Diaghilev's ballet?

By what we learn from some bewildered reviews, *The Steel Step* failed to give a definite answer to what everyone seemed immensely eager to learn: is the ballet for or against the Reds? For want of certainty about this, some critics felt obliged to offer their own version of what the ballet meant. Two opposite views will suffice to give an idea of the range of readings. French readers, having opened *Le Temps* of 15 June 1927, learned that "the authors of *Le Pas d'Acier* devote their art to the character of our epoch. They wish that from now on theater and choreography make use of metallurgy and the proletariat. Aided by modern times, they celebrate events and movements favored by their contemporary compatriots. In a sense, they are history's witnesses."[16]

And here is what the British *Daily News* concluded on 5 July when the ballet opened in London:

Epileptic Dancing. Prokofieff's new ballet, "Le Pas d'Acier," . . . may be translated freely "The Tyranny of Steel". . . . What do all these twitchings and jerkings, these twistings of the human body into ugly

15. In fact, after *Le Pas d'Acier* was shown in London, Diaghilev lost an endowment (which he later regained) from Lord Rothermere, a wealthy aristocrat; see Stephen D. Press, *Prokofiev's Ballets for Diaghilev* (Burlington, Vt., 2006), p. 73. London audiences were especially hard to win with a "Soviet" ballet in 1927, right after the general strike and amidst increasing diplomatic tension between Great Britain and Soviet Union. As the legend has it, after the curtain dropped, the entire hall waited for the reaction of one spectator: the Duke of Connaught, a member of the royal family and the first cousin of Empress Alexandra (executed by the Bolsheviks in 1918). After a pause, the duke clapped his hands, and only then the whole theater burst into applause; see Richard Buckle, *Diaghilev* (London, 1993), p. 492. From the other side of political spectrum, Jean Cocteau reproached Massine "for having turned something as great as the Russian Revolution into a cotillion-like spectacle within the intellectual grasp of ladies who pay six thousands francs for a box" (quoted in Boris Kochno, *Diaghilev and Les Ballets Russes*, trans. Arienne Foulke [New York, 1970], p. 265).

16. Henry Malherbe, "Chronique Musicale," *Le Temps*, 15 June 1927, gallica.bnf.fr/ark:/12148/bpt6k2466619.langFR

and impossible positions signify? It is said by some that they mean to show us how the imagination of the Russia of to-day has distorted the old stories. . . . Perhaps it is a tractate against the Russian Revolution. If so, it is very powerful.[17]

The issue whether *The Steel Step* of 1927 was meant to condemn or glorify the world it showed has resurfaced more recently in debates on the subject of the 2005 reconstruction of Prokofiev's ballet at Princeton University and in the scholarship that preceded and surrounded it. I will explain how this happened in a moment, but, first, a few words about that particular reconstruction and ballet reconstructions in general.

Reconstructions are a recent fad; a more established form of keeping old ballets alive is known as new editions or redactions. New redactions of the old is a widespread, if not the basic, form of choreography's evolution, and this peculiar devotion to the past has to do with the material (or, in this case, immaterial) nature of ballet as a medium. Indeed, that ballet has been the most conservative of arts is, in part, because it is also the most ephemeral of media. Performance arts are ephemeral by definition, yet drama has written plays, opera written arias, and music has notation. Despite the long and elaborate history of trials and failures, no workable or universally recognized alphabet of written signs exists for choreography. In folklore, the tradition lives on from mouth to mouth; in choreography, from feet to feet. The very survival of choreographic forms and movements depends on live memory, sustained performance, or regular revivals of the old. Which art form other than classical ballet can say, tomorrow we are performing *The Sleeping Beauty* choreographed by Marius Petipa? No matter if Petipa staged it in 1890 and died in 1910. Redactions allow for reductions and additions, and skills and drills may change over time; still, *The Sleeping Beauty* remains the Petipa ballet.

Ironically, we are more fortunate with Petipa than we are with regards to many of Diaghilev's ballets, which are closer to us in time but whose steps were perhaps too experimental to be easily taken up and carried on by others. In such cases, archival research is our only hope. In order for a dance company at Princeton University to be able to reconstruct *The Steel Step*, two academic researchers, art historian Lesley-Anne Sayers and musicologist Simon Morrison, embarked on long and scrupulous research that resulted not only in the new *The Steel Step* staged in 2005 but also in a series of scholarly publications.[18]

Excellent as their research was, the findings produced by Morrison and Sayers were not used to reconstruct all the components of the 1927 production. Prokofiev's music survives, as do a photo of the scale model and a number of sketches for the set, plus a short but detailed libretto.

On the other hand, the only sources that could be used to reconstruct the principal component of *The Steel Step*—its choreography—were a handful of posed photographs and a few descriptions scattered in memoirs and critical reviews. A decision was taken to concentrate on the libretto and set design, both of which date back to 1925, hence the title of the new production: *Le Pas d'Acier 1925*. The dance was factored out of the four-media equation. The choreographer in charge of the Princeton University's *Steel Step* no longer saw it as her task to revive even those steps and scenes that we know for sure to have been part of Massine's choreography in 1927.

This creative choice ensued logically from the scholarship that prepared the Princeton reconstruction. We know that audiences and critics in 1927 were confused whether *The Steel Step* was for or against the Red Russia it depicted. Was the confusion intended, and, if so, what political and stylistic strategies may have provoked it? These seem to be logical questions to pose. All confusion is not undesirable noise; confusion can also be a message, a desired effect.

The confusion factor has not been given the benefit of the doubt in recent literature on *The Steel Step*. If the ballet was sending a mixed message to its public, didn't the lack of clarity result from a lack of agreement among those who authored the ballet? Indeed, what kind of agreement, it would seem, could be reached between Georgii Yakoulov and Prokofiev, who cowrote the libretto in 1925, and Massine, who choreographed it in 1927? Yakoulov was a left-wing artist with a Soviet passport; Prokofiev, a resident of France with many Soviet ties and Soviet plans; Diaghilev snubbed socialism as a way of life but was extremely curious about what was going on in Soviet art. As to Massine, who left Russia as early as 1913 and had no stake or interest in what happened in the Soviet Union, it is widely assumed that he was as uneasy as the rest of the Diaghilev troupe about the whole idea of turning the Ballets Russes into a ballet rouge.[19]

According to this somewhat mechanical picture of the genesis of *The Steel Step*, the initial Marxist message ingrained in the libretto and the music was obscured and rendered ambiguous by Massine's intervention with his crocodiles, Baba Yagas, and other irrelevant folklorisms from Diaghilev's time-proven bag of tricks. Too many cooks can spoil the broth; wasn't the mixed authorship of the ballet responsible for its unbalanced ideology?

While it is true that the libretto of *The Steel Step* had been changed and revised more than once on its two-year journey from page to stage, I don't think the many-cooks explanation accounts for its surprising ambiguity. My point is that ideological ambiguity was a tactic, not a miscalculation on Diaghilev's part, and the deliberate suspension of political attitudes was something which he, Pro-

17. A. K., "A Bolshevik Ballet," *Daily News*, 5 July 1927.

18. See Lesley-Anne Sayers, "Sergei Diaghilev's 'Soviet' Ballet: *Le Pas d'Acier* and Its Relationship to Russian Constructivism," *Experiment/Eksperiment* 2 (1996): 101–25 and "Re-Discovering Diaghilev's *Pas d'Acier*," *Dance Research* 18 (Winter 2000): 163–85, and Sayers and Simon Morrison, "Prokofiev's *Le Pas d'Acier* (1925): How the Steel Was Tempered," in *Soviet Music and Society under Lenin and Stalin: The Baton and the Sickle*, ed. Neil Edmunds (New York, 2004), pp. 81–104. The video recording of the 2005 Princeton University production of *Le Pas d'Acier 1925* was released on DVD in 2006 by IDM Ltd. and the Arts and Humanities Research Council.

19. See Serge Lifar, *Serge Diaghilev, His Life, His Work, His Legend: An Intimate Biography* (New York, 1976), p. 320.

kofiev, and Yakoulov had agreed about early on. Evidence of this abounds in correspondence and in Prokofiev's diary. In an entry dated July 1925: "What I like is the ambiguity of the plot: it is impossible to figure out if it is in favor of Bolsheviks or against them, which is exactly what we need. Yakoulov is somewhat fearful of Moscow being offended by such a plot, for he has to return there; but he agrees."[20]

Ambiguity was a concept, a constructive principle, not a slipup. The intended, prearranged ambiguity of *The Steel Step* is an analytical perspective in which to place other things as well: the ballet's steps and jumps, its title, and its story.

2. The Politics of the Libretto

The Steel Step is a story in two acts that relate to one another as before relates to after. In the first typescript of the libretto signed by Yakoulov and Prokofiev, the before is the chaos and anarchy of the civil war: impoverished countesses willing to part with anything for food, a shady street vendor taking advantage of them, a sailor sans ship and his compliant girl, nimble commissars wearing leather jackets, and long-winded orators attacking people with books. As the story unfolds, chaos gives way to order. At the end of the first act (tableau) a fire brigade arrives to clean the seedy railway platform on which the act is set and transform it into a metal factory.[21] Act two, by contrast, is dominated by the collective discipline of labor; as the ballet nears its finale the factory workers' dance grows more and more machinelike. Towards the end, Prokofiev's music becomes, literally, the music of labor; the on-stage mallets and hammers take the role of percussion instruments banging rhythmically against the deck of Yakoulov's stage construction.[22] The curtain falls as the ecstasy of the work reaches its highest point.[23]

As the actual stage work on the 1925 libretto began in 1927, its political trajectory became more elastic than Yakoulov and Prokofiev initially envisaged. The before of the original libretto had been the crucial year of the civil war, that is, 1920. When Massine started turning the libretto into dance, Yakoulov's civil-war before metamorphosed into a larger scale before, the big before of Russia's rural past. What Massine did (with Diaghilev's blessings and Prokofiev's approval) was insert elements of Russian folklore into the framework of Yakoulov's first act. A ferocious forest witch from many Slavic fairy tales named Baba Yaga appears on the stage before it is given over to the street vendor and four countesses. No sooner has the revolutionary sailor left that stage than a tomcat enters to make love to a pussycat—to the delight of a corps-de-ballet of mice.

To make sure the public and critics noticed this newly added past, Diaghilev flagged it, in italics, in the playbill handed out to spectators before the show began: "The two parts [tableaux] of this ballet summarize two aspects of Russian life: the legends of the countryside and the mechanism of the factory" (fig. 1). To stress this point again, the rural dimension added to the first part of the show did not replace or upstage Yakoulov's civil-war characters. The two worlds mixed and merged; Massine's fairy-tale devils, for instance, who harass the tattooed sailor in scene 3, were shown wearing firemen's helmets taken from Yakoulov's libretto. The spectator is free to read the action in three ways: as set in 1920, as Yakoulov first envisaged, or in Russia's rural prerevolutionary past, or else in the mythological once-upon-a-time, the favorite time of action in Russian folk tales and Diaghilev's Ballets Russes.

What made this design even more ambiguous was its self-reflective dimension. Ballet as an art is always concerned about its own frailty as a medium. Whatever its libretto may be about, every ballet is also about ballet, about continuity and change within the balletic tradition. It so happened that the year 1927 marked not only the tenth anniversary of the October revolution but also the twentieth anniversary of Diaghilev's presence on the Paris stage. It was important for *The Steel Step*'s makers that its before and after would provide ballet lovers with an excuse to reflect on the creative evolution of Diaghilev's Russian Seasons.[24]

Indeed, Russia's pagan past was also the past of the Ballets Russes. There were similarities some critics pointed to between Prokofiev's music for *The Steel Step* and Stravinsky's *Le Sacre du Printemps* (The Rite of Spring, 1913.) Even the pounding of peasants' bast shoes

20. Sergei Prokofiev, entry from July 1925, *Dnevnik 1919–1933* [Diaries 1919–1933] (Paris, 2002), p. 347. Prokofiev stressed the same point: "I think, Yakoulov and I had composed the libretto exactly the way we need it: apolitical, personal (love in the factory), . . . and in the end the entire factory, hammers included, is set in motion forming a background for the main characters' dance" (Prokofiev, letter to Diaghilev, 16 Aug. 1925, in Viktor Varunts, "'Stal'noi Skok'—v dokumentakh i pis'makh ego sozdatelei" [*Le Pas d'Acier* in Papers and Letters of Its Authors], *Muzykal'naia Akademiia* 2 [2000]: 196). In fact, as it follows from Prokofiev's diaries, the composer was initially disposed to reject Diaghilev's commission, doubting if an impartial ballet about contemporary Russia was possible at all. Prokofiev requested more than once to see to it that the ballet not become too pro-Soviet even if Diaghilev succeeded in hiring a choreographer from the Soviet Union to stage it. See Prokofiev, *Diaries 1924–33: Prodigal Son*, trans. Anthony Phillips (Ithaca, N.Y., 2013).

21. Yakoulov's constructivist sets included mobile elements: wheels, swinging ladders, blinking lights, signal hands, and so on. Though it is habitual to connect the avant-garde craze for mobile sets with the names of Vsevolod Meyerhold and Liubov Popova, in his memoirs the émigré set designer Yuri Annenkov claimed its priority. According to Annenkov, Yakoulov never denied that his work for *The Steel Step* had been influenced by his 1922 Petrograd production of Georg Kaiser's play *Gas* as well as Annenkov's manifesto "Rhythmic Sets" (1921). Unexpectedly, Annenkov links this craze with Charlie Chaplin's 1935 film *Modern Times*, in which Chaplin is trapped in the industrial machinery of a factory; see Yuri Annenkov, *Dnevnik moikh vstrech* [Diary of My Encounters], 2 vols. (Leningrad, 1991), 1: 217–22.

22. This coup de théâtre—making music directly on the stage, not in the orchestra pit—is highly unusual for the art of ballet. According to his diaries, Prokofiev initially composed a score for mallets and hammers to be performed behind, not on, the stage, but the orchestra being short of time to rehearse, the mallet music was delegated to the dancers. See Prokofiev, entry from 25 June 1927, *Dnevnik 1919–1933*, p. 568.

23. See the English translation of Prokofiev and Yakoulov's 1925 libretto in *Press, Prokofiev's Ballets for Diaghilev*, pp. 212–13.

24. Diaghilev's programming tactics also helped provoke in spectators "evolutionary" observations of this sort. It was a habit with Diaghilev to keep old hits on the bill to go along with novelties. Thus, one of Fokine's picturesque pantomimes from the 1900s was often billed back-to-back with *Le Pas d'Acier*.

Figure 2. Lubov Tchernicheva and Serge Lifar in
The Steel Step

staging of the ballet," an entry from Prokofiev's 1927 diary begins. This is how the meeting went, Prokofiev recounts:

> Massine started off with a complete rejection of the story project invented by Yakoulov and me. I did not protest too much. The main thing for me was to steer Massine and keep his projects from contradicting my music. He had Rovinsky's book in his hands, the study of Russian [*lubok*] prints (by the way, a surprising number of them are indecent); it is from this book that Massine is going to draw themes for his choreography.[27]

It was a sign of the times that a choreographer who came to see a composer about a ballet would bring to the meeting *Russian Popular Pictures* by Dmitrii Rovinsky and not, say, a reproduction of Apollo Belvedere. These *lubok* prints were, we recall, crude eighteenth–nineteenth-century pictures with inscribed doggerels to be read aloud by those who knew how to read in front of those who didn't. Rovinsky's 1900 volume gave *luboks* a cachet of being visual folklore. In 1913 another collector, young neo-primitivist painter Mikhail Larionov, exhibited his selection of ancient *luboks* in Moscow. This, in turn, gave the popular woodcuts an artistic and avant-garde cachet. At the time *The Steel Step* was staged Larionov was Diaghilev's long-time staff scenographer, and it was from him that Diaghilev and Massine contracted their weakness for *luboks*.

Neither was it by chance that among many different genres of the *lubok*—biblical, historic, didactic, and heroic pictures—Prokofiev's diary singles out the indecent set. Low stood high on the ladder of Larionov's neo-primitivist taste, as it did apparently with Massine. "The choreography of 'love' scenes borders at times on pornography," one Russian émigré critic wrote in a Paris newspaper *Le Temps Russe*; another émigré connoisseur condemned Massine of vulgarity and called the ballet an apache dance a la Russe.[28] Some of this, if not all, must have been inspired by the lowly medium of *luboks*.

Not many photographs of Massine's work in *The Steel Step* survive; one of those that does looks like a lead to Rovinsky. In figure 2 the woman dancer (Lubov Tchernicheva) is shown straddling her partner (Serge Lifar) as she might a horse, sidesaddle.

Apparently, the pose has to do with love, since judging from the playbill it comes from, the dance number was called *Le Béguin* (The Crush). Yet even knowing this we would hardly appreciate the full degree of its crudity without opening Dmitrii Rovinsky's collection of *luboks*. In one of these (fig. 3) a woman wearing a foreign dress is shown riding, literally, a barebacked man.

It might take Mikhail Bakhtin with his expertise in Rabelaisian bodily functions to interpret every aspect of this image;

against the ground that had shocked the Paris public in 1913 was echoed in the drumming of workers' mallets at the finale of *The Steel Step*.[25] In the public eye, folksy fancies with their Baba Yagas and *danses sacrales* were associated with the before of the Ballets Russes. And Diaghilev's after, as Yakoulov imagined it, was "the urban industrial classicism of *The Steel Step*."[26]

The intrinsic ambivalence of *The Steel Step* story was that every new step in its making entailed an uneasy trade-off between opposite impulses: to look to the East and stay with the West, conquer the new and keep the old, become something else and stay yourself. If we now change the optics and look at *The Steel Step* from the point of view of choreography we may discover some other tensions and other sources of the ambiguity—between the steps of dance and political steps, the ballet and circus routines, the steel mill and steel toe—that defined the physiognomy of this tour de force of a ballet. The *lubok*, of all media, served as one such source for Massine.

3. The Politics of Choreography

"April 9. This morning I had a meeting with Massine; basking in the sun near the casino he and I discussed the

25. "[Prokofiev's] music makes one think of *The Rite of Spring* (dances of the barbaric and primitive Russia) transposed to the modern Russian milieu, as barbaric as then" (Raoul Brunel, "*Le Pas d'Acier*," *L'Oeuvre*, 10 June 1927).

26. Georgii Yakoulov, "'Stal'noi Skok' Sergeia Prokofieva" [*Le Pas d'Acier* by Sergei Prokofiev], *Rabis*, 19 June 1928, p. 5.

27. Prokofiev, *Dnevnik 1919–1933*, p. 557.

28. Valerian Svetlov, "Premiera v Balete" [Première in Ballet], *Le Temps Russe*, 9 June 1927; see Sergei Volkonsky, "'Stal'noi Shag,' balet Yakulova i Prokofieva" [*Le Pas d'Acier*, ballet by Yakulov and Prokofiev], *Poslednie novosti*, 14 June 1927.

Figure 3. *Foreign Woman Riding an Old Man*. Eighteenth-century *lubok* print from Dmitrii Rovinsky, *Russian Popular Pictures* (1900).

Figure 4. *Baba Yaga Rides to Fight the Crocodile*. Eighteenth-century *lubok* print from Dmitrii Rovinsky, *Russian Popular Pictures* (1900).

the aspect that concerns us here is a time-honored theory according to which this particular *lubok* belongs to political media of its time. As Rovinsky comments in his book, this print is not just a dirty picture but a political caricature of Peter the Great, his Westernizing policy, and his foreign wife.[29] In any case, what the *lubok* (and the spotty doggy on the left) seems skeptical about is similar to what Diaghilev's skeptics could point to: his attempt to arrange in *The Steel Step* a productive encounter between the East and the West.

To get a better sense of Massine's choreography and its political relation to Yakoulov's libretto (and to Rovinsky's collection of *luboks*) a brief digression into ballet's own history will be of help. Classical ballet has always been a medium of storytelling. Dance and storytelling are difficult bedfellows. Dances are modular; storytelling, continuous. In classical ballets, a fairytale (or mythological) libretto, with a love interest in the center, is one of the few factors that could be used to impart a sense of unity to what otherwise would look like a succession of isolated dances. From the era of Petipa, every choreographer has had to face the dilemma inherent in the very medium of ballet: how to balance the diversity of dance numbers cherished by dancers

and dance aficionados with the plot needed to give these numbers a meaning and a sense of development.

As sometimes happens with dilemmas ingrained in the medium of art, the tension between the two principles, diversity and unity, became the matter of stylistic preferences and theoretic debates among leading choreographers.[30] Mikhail Fokine's post-Petipa reforms tipped ballet towards more dramatic and period unity; choreographers like Vaslav Nijinsky or Massine, on the contrary, strove to liberate dance from narrative chains. Nijinsky's *The Rite of Spring*, in which many saw *The Steel Step's* prototype and precursor, was, in fact, not a story at all but rather a sequence of ethnographic tableaux.

A paragon of aesthetic inconsistency, Diaghilev let Fokine do it Fokine's way and Nijinsky Nijinsky's. In 1925, however, when the first draft of what would eventually become *Le Pas d'Acier* was in the making, Diaghilev did request that Yakoulov and Prokofiev's libretto acquire more of a "private intrigue" and even considered hiring a professional novelist, Ilia Ehrenburg, to help with this.[31] In his 1925 letter to Diaghilev, Prokofiev reported: "The main characters have been emphasized as you had wished."[32] In

141

29. Dmitrii Rovinsky, *Russkiia narodnyia kartinki*, no. 106, col. 88. See cols. 273–74 for Rovinsky's interpretation of this and some other prints as anti-Petrine political leaflets. It is worth remembering that Peter the Great's Westernization of Russia in the eighteenth century was seen by many as the forerunner of the post-1917 Sovietization. Modern ballet historian Vadim Gaevsky even insists on the invisible presence of Peter the Great in the metallic music and title of *Le Pas d'Acier*, both via Pushkin's poem *The Bronze Horseman*; see Vadim Gayevsky, "Stal'noi Skok," *Nashe Nasledie* 56 (2001): 196–97.

30. A parallel from the medium of film will help to elucidate this point. Even when we as filmgoers perceive film action as seamless and continuous, we do so despite the fact that most of the films we watch are composed of relatively short shots. A film theorist thus can say (as has been said more than once) that the choice between continuity and discontinuity is ingrained in the very medium of film. In this perspective, it makes sense to say that three grand dimensions of film style explored and exploited by different filmmakers in the last one hundred years of film history had been latently present in the very material cause of cinema: (1) the continuity editing style (dominant in Hollywood, old and modern) wherein many shots are edited so as to look continuous; (2) discontinuous montage (used in the Soviet cinema of the twenties and in certain avant-garde movements in the West) where fast cutting is foregrounded and visible; (3) the tableau style (dominant in Europe in the 1910s and coming back nowadays as the slow-cinema movement) in which long-lasting shots allow action to develop without much editing. See a related discussion in Matthias Stork, "On Cinemetrics, Video Essays, and Digital Scholarship—An Interview with Dr. Yuri Tsivian and Dr. Daria Khitrova," *Mediascape* (Winter 2013): www.tft.ucla.edu/mediascape/Winter2013_Cinemetrics.html

31. Prokofiev, entry from 30 July 1925, *Dnevnik 1919–1933*, p. 347.

32. Prokofiev, letter to Diaghilev, 16 Aug. 1925, *Dnevnik 1919–1933*, p. 196.

the spring of 1927, however, in an interview in a Soviet magazine a propos *The Steel Step*, then still in production, Prokofiev warned: "The ballet does not have a single line of action; rather, it is composed of scenes of ethnographic nature featuring the new social strata which emerged in Russia in 1920."[33] In the process of Massine's reworking, the first panel of Yakoulov's historical diptych broke into a succession of strangely labeled scenes.

Imagine a ballet lover studying the playbill of *Le Pas d'Acier* as the orchestra is tuning up (fig. 1). The first scene on the bill is entitled: "Bataille de Baba-Yaga avec le Crocodile" (Baba Yaga's fight against the Crocodile). Suppose our spectator is French, someone who has been to the zoo and also knows what Baba Yaga stands for from having seen Massine's ballet of 1919 *Les Contes Russes* (Russian Folk Tales). The playbill prepares this spectator for a surrealist encounter between a tropical beast and a mythical monster from the northern woods.

Now, suppose our ballet regular is a well-educated Russian familiar with Rovinsky's book of *luboks* from which Massine borrowed the title for scene one. The expectations the title is likely to arouse in the latter might be a little more accurate but, still, not very helpful for interpreting Massine's choreographic treatment of the said fight.

The android creature with a long beard and fluffy tail (on the left) preparing to repel the attack by an ugly pig-riding woman as depicted on a 1760s *lubok* from Rovinsky's collection (fig. 4) is indeed labeled "crocodile" in the caption sitting above its head, yet, judging by his looks, this crocodile is as much a product of popular imagination as his more famous adversary.[34]

Whether they knew this *lubok* print or not, neither of our two hypothetical spectators was likely to come to grips with Massine's stage enactment of it. No review we know of did; and, one should add, such puzzled bewilderment on the part of the public was exactly what Massine had counted on.

As any Russian kid will tell you, Baba Yaga is an old, a very old woman. In Massine's choreography, however, she is a young, lascivious girl engaged in bizarre interactions with seven male dancers whose movements are mutually coordinated. Reviewers made guesses, none of them lucky. Some read it as a bandit attack on a girl; one even thought this scene was a reference to the Chubarov Alley case, the 1926 gang rape trial in Leningrad.[35] A critic from *La Liberté* suggested that what the chorus line of seven men depicted was "Spartan" soldiers maneuvering in the "testudo" (tortoise) formation;[36] Prince Sergei Volkonsky, a prime expert on stage movement, saw soldiers in the

male dancers as well but was repulsed by the unseemly way Massine's soldiers moved, squatting and hopping like sparrows in single file.[37] It is only when we parse and peruse a number of such descriptions we come to realize that what the squatting men must have impersonated was not a Roman military tortoise but seven vertebrae of a short-legged and long-tailed crocodile.

Massine's choreography in the first act of *Le Pas d'Acier* was a premeditated, cold-blooded experiment in semantics, notably in "making-it-difficult" (*zatrudnenie*), which was Viktor Shklovsky's famous one-word definition of art. Shklovsky's favorite example of *zatrudnenie* was the art of dance that, according to the formalist doctrine, was walking-made-difficult. Meaning-made-difficult was Massine's politics of choreography in *The Steel Step*.

The target of Massine's politics was aesthetics. Ballet's is the aesthetics of sameness. A classical ballet regular frequents ballets to experience the familiar and learn about the known. To a newcomer, classical ballet may look like a form of abstract art; veteran ballet fans read it like a book. They may grudgingly tolerate minor changes in syntax but will revolt if the book is in a language that is not their own. The aesthetics of identity shines through in an unfriendly, but perceptive review of Massine's choreography by Valerian Svetlov:

> The classic dance has its alphabet, its own graphics used to compose plastic syllables, words, sentences and ultimately the poem. Innovative choreographers or those who see themselves as such, often flip these letters, or topple them, or displace syllables to do it differently from classics, as they say, "worse but different." As to Massine, his method is not to turn the classics inside out; he invents his own hieroglyphs and speaks not a tongue-tied version of normal speech, but some kind of language that is his own and which no one else can understand.[38]

One can imagine Massine's sense of triumph as he read Svetlov's verdict.

Massine's transrational choreography did not undermine the politics of Yakoulov's libretto, as Lesley-Ann Sayers suspected, but reinforced it in its unique way.[39] The power of Yakoulov's dramatic idea was that it thematized the basic binary of ballet, its constant tension between diversity and unity. To use Yakoulov's own words, "*The Steel Step* symbolizes [Russia's] powerful jump from the initial chaos of the revolution to the socialist construction."[40] To translate this ideological brief into the language of ballet, one would say that the jump is from the principle

33. Prokofiev, "Beseda s Prokofievym" [Conversation with Prokofiev], *Muzyka i Revolutsiia* 3 (Mar. 1927): 30–31; rpt. in *Prokofiev o Prokofieve* [Prokofiev on Prokofiev], ed. Varunts (Moscow, 1991), p. 73.

34. Rovinsky, *Russkiia narodnyia kartinki*, pp. 273–74 (two print versions of the same picture reproduced under nos. 224 and 225).

35. Valerian Svetlov, "Premiera v Balete."

36. Robert Dézarnaux, "Théâtre de Sarah-Bernhardt," *La Liberté*, 9 Aug. 1927.

37. See Volkonsky, "'Stal'noi Shag,' balet Yakulova i Prokofieva."

38. Svetlov, "Premiera v Balete."

39. See Sayers, "Re-Discovering Diaghilev's *Pas d'Acier*," p. 182.

40. Georgii Yakulov, "'Stal'noi Skok' Sergeia Prokofieva" [*Le Pas d'Acier* by Sergei Prokofiev], *Rabis*, 19 June 1928, p. 5.

of variety dominating the before act of *The Steel Step* to the principle of unity prevalent in the second act. A railway platform swarming with sundry characters absorbed in their private doings gives way to a factory at which each and every movement is part of the well-adjusted and well-oiled ensemble. From confusion to order; from discord to concord; from variety to unity; curtain.

Yakoulov was a painter and set designer; Massine was a man of dance. As one looks at the costume sketches for the first part of *Le Pas d'Acier*, one can point to a number of clever ways in which Yakoulov planned to plant in the spectator the sense of disorder of the civil war. The impoverished countess in fig. 5a offering her leftover belongings for a sack of flour wears a makeshift hat formerly used as a lampshade; and the land-locked sailor sporting a tattooed anchor (fig. 5b) wears a cuffed boot on one leg and a bell-bottomed pants leg on the other.

Figures 5a and 5b. Costume sketches by Yakoulov. Countess (left) and Sailor (right).

If Yakoulov can be said to have described and depicted chaos, Massine provoked it. Aren't cognitive confusion and semantic frustration the mental equivalents of chaos? "There was a great deal of activity accompanied by considerable noise, but it all appeared rather meaningless," the great British ballet critic Cyril Beaumont admitted after the first part of *The Steel Step* in London was over.[41]

"Which was to be demonstrated," Massine could have added and would have been right, for what Beaumont wrote about Massine's choreography in the second, steel-mill act differs diametrically in tone from his lukewarm response to act one. Beaumont's description is the best, most detailed document we have of Massine's celebrated climax and deserves to be adduced in full. "There were isolated movements which gradually built up into one huge machine, now of this type, now of that," the critic writes. There then follows details of how this huge human machine-tool functioned:

Arms weaved, swung, and revolved; feet pounded the floor; even bodies took part in the movement, swinging from the waist in different arcs and at varying angles. The dancers massed, divided, strung out into line, and, with arms outstretched sideways, sharply turned their hands up and down, flat to the audience, which action ingeniously suggested a flashing lamp; this flashing, arranged in changing patterns, was most effective. [*DB*, p. 279]

Towards the apotheosis, two emblematic workers take center stage and, inanimate until now, gyratory elements of Yakoulov's set design join hands with Massine's dancers:

So the rhythmic force ceaselessly grew in intensity until there appeared on a central platform two figures bearing giant hammers, which they swung and wielded more and more strongly until, at the height of the tumult, the climax was reached with the constructivist elements adding their quota—signal discs snapping on and off, and wheels spinning faster and faster. At this point the curtain fell to the accompaniment of a frenzied outburst of applause. [*DB*, p. 279]

Had things been as straightforward as they appear from Beaumont's ecstatic review, *The Steel Step* would have looked like a Soviet agitprop pageant set to music, something we know none of its makers intended. As Diaghilev stated plainly after the ballet opened in 1927, "[*The Steel Step*] is neither a pro- nor anti-Bolshevik ballet; it is out of the pale of propaganda."[42] The neither-nor position spelled ambiguity at all costs, starting from the title (the first thing the ballet connoisseur looks at to see what to expect) and ending with the "two figures bearing giant hammers," which, in Beaumont's words, crown the ballet's apotheosis. "This is a strange work, in all its aspects, from its title to its musical and choreographic realization,"[43] wrote a more

143

41. Cyril Beaumont, *The Diaghilev Ballet in London: A Personal Record* (London, 1951), p. 278; hereafter abbreviated *DB*.

42. Diaghilev, interview, *Vozrozhdenie*, 27 Dec. 1927.

43. Brunel, "*Le Pas d'Acier.*"

Figure 6. Train arrives. Yakoulov's sketch for act one, detail.

reserved expert in dance in *L'Oeuvre*. It is the strangeness and ambiguity of *Le Pas d'Acier* as a string of words rather than of steps that I want to address briefly before we return to movements and visuals.

4. *The Steel Step*: The Politics of the Title

Ambiguity gives birth to monsters. Dogs and pigs were familiar enough to inhabitants of eighteenth-century Russia for the woodcutter to depict them with great accuracy on the two *lubok* prints shown in figures 3 and 4; and even if Baba Yaga's war pig depicted on the latter bares its teeth as if it were a dog, the cloven hooves unmistakably tag it as a pig. Crocodiles are a different matter. For an eighteenth-century Russian, crocodile was an ambiguous, if not transrational name to be filled in with irrational images the likes of which enrages the pig in figure 4.

Several title conferences were held before Yakoulov, Prokofiev, Diaghilev, and Massine eventually settled on *Le Pas d'Acier*. Different participants remember differently who exactly came up with this or that title and when; in cases where pieces of evidence contradict each other I will rely on Prokofiev's diary for information.[44] The earliest was Yakoulov's funny name Ursignol, which, like the crocodile from the world of the *lubok*, brought to mind an imaginary creature—a bird to some, a bear to others. Yakoulov's coinage was an elaborate triple entendre packed with self-referential and zoo-political implications. A neologism only a foreigner would venture, *ursignol* was derived from *rossignol* (nightingale), which, to Yakoulov's ear, chimed with Stravinsky's opera-turned-ballet *Le Rossignol* produced by Diaghilev in 1914 and 1920. Yakoulov's Russian being better

than his French, the word reminded him of his homeland, *Rossiia*, and since Russia in 1927 bore the name of *URSS* (French for the USSR), Yakoulov updated *Rossignol* to *Ursignol*. And even if Diaghilev rejected Yakoulov's coinage as tasteless, Prokofiev wrote he liked *Ursignol* fine, for to him the word evoked an image of *oursonne*, the word for bear cub in French.

It is generally believed that the final title belongs to Diaghilev;[45] Prokofiev's diary says the idea came from Massine. The useful ambiguity arose from the possibility of reading *Le Pas d'Acier* two ways: as an allusion to some specific dance step (like the classical *pas de chat* or *pas de basque*) or as a cliché from the Soviet mass-media vernacular in which step is synonymous with progress and progress synonymous with steel. ("'Pas d'acier' was compared today with 'pas d'argent [no money],'" Prokofiev's diary records somebody's pun).[46]

Stal'noi (made of steel) was a leading political epithet used in 1920s Soviet mass media, one of the top seven, to believe tongue-in-cheek calculations conducted in 1931 by two satirists with experience in working for a number of Moscow daily newspapers.[47] More surprisingly (and importantly for our subject here), the epithet is not foreign to ballet. At the turn of the twentieth century, a trend in dance techniques emerged among female dancers of the Mariinsky ballet associated with such technical feats as thirty-two *fouettés* performed *en pointe*. The athletic training and special hardened footwear this technique involved earned it the label of "steel toe" (*stal'noi nosok*), whose echo, arguably, tipped our titling team to choose *Stal'noi skok*, as a Russian alias of *Le Pas d'Acier*.

The steel-toe technique was not uncontroversial and became a stumbling block for Fokine's idea of dance. "The steel toe is an abominable invention of this decadent era in ballet," Fokine exploded in 1916. "There was nothing of the sort in the best years of ballet. In those years, people used to extol the unearthly lightness of dance. Today, they glorify 'the steel toe,' 'chiseled footwork' and 'turned-out feet.'… I am very concerned about the recent invasion of acrobatics and sports onto the stage of ballet," Fokine complained.[48]

In more than one sense, *The Steel Step* was a polemical answer to Fokine and skeptics like him. Not that Diaghilev or Massine wanted the steel toe back. What was at stake was whether or not circus and sports, *luboks* and hammers and the like should be kept at arm's length from the airy temple of ballet. For choreographers like Fokine, the quality of dance was safeguarded by the purity of ballet as a medium; for art-

44. Prokofiev, *Dnevnik 1919–1933*, pp. 347, 558.

45. Before the publication of Prokofiev's diaries in 2002, Diaghilev was considered the most likely author of both the French and Russian titles of the ballet. Prokofiev, already a Soviet citizen, himself wrote in his brief autobiography, "Diaghilev, for some reason, proposed calling [my ballet] *Le Pas d'Acier*" (Sergei Prokofiev, *Autobiography*, in *Autobiography, Articles, Reminiscences*, trans. Rose Prokofieva [Honolulu, 2000], p. 66). Lifar in his memoirs also ascribed the title solely to Diaghilev; see Lifar, *Serge Diaghilev*, p. 320.

46. Prokofiev, *Dnevnik 1919–1933*, p. 558.

47. See Ilya Ilf and Evgeny Petrov, *The Little Golden Calf*, trans. Konstantin Gurevich and Helen Anderson (Rochester, N.Y., 2009), p. 261.

48. A magazine article originally published in 1916 and reproduced in Mikhail Fokin [Michel Fokine], *Protiv techeniia* [Against the Stream] (Leningrad, 1981), pp. 318, 448. In fact, a critic from Russian émigré *Vozrozhdenie* (Renaissance) touched the same nostalgic chord speaking about *Le Pas d'Acier*: "a lot of numbers, like the one with Danilova and Lifar, were performed very neatly. We automatically use this circus term here. We recall, though, how at the dawn of Diaghilev's triumphs his advocates regarded as his special merit the very freedom from various circus-like tricks of the old technique-based ballet" (Alexandr Bundikov, "Balet Diaghileva" [Diaghilev's Ballets] *Vozrozhdenie*, 10 June 1927).

Figure 7. Lubov Tchernicheva and Serge Lifar in *The Steel Step* (1927).

ists like Yakoulov or choreographers like Massine, mixing media was the whole point about the new ballet.

5. The Mixed Mediascape of *The Steel Step*

To borrow a media studies metaphor (without usurping its specific terminological meanings), the mediascape of *The Steel Step* was not just mixed but mixed to explode. Sylphides or Baba Yagas from fairy tales are indigenous to ballet; and the Russian ballet is a home medium for swans. But when a train engine arrives right at the center of Yakoulov's stage (fig. 6) the mediascape starts changing, reminding us more and more of a place from a silent documentary or a political poster. Fokine would call it an invasion. Politics invaded aesthetics' innermost sanctuary, ballet.[49] "Perhaps this is no longer dance, but whatever you call it, it is a new and powerful form of art," one critic pondered after the curtain fell on *The Steel Step*.[50] Having invaded ballet, alien media changed what the audience was used to perceiving as an autonomous medium with its sovereign boundaries. The intrinsic conventions of ballet could no longer be taken for granted.

The three media foreign to ballet that Yakoulov and Massine let invade *Le Pas d'Acier* at different stages of its making were propaganda visuals, political oratory, and the circus. First, a publicity still presents the two dancers bearing giant hammers, who, according to Beaumont, appeared on a central platform at the high point of Massine's bravura finale (fig. 7). Is it dance any longer? Of course it is, but the question the critic has posed is legitimate. It is dance defamiliarized, based not on balletic conventions but on some borrowed, uncomfortably alien conventions. The grotesque

Figure 8. Land and Will. Leaflet promoting the Socialist Revolutionary party slogan (1914–1917).

oversize mallets (about to turn into gigantic drumsticks) do not look like ballet's props, and the stride Lifar is shown making does not come from the classical vocabulary. The conventions these elements fit in are those of the political poster, like the one reproduced on figure 8. It matters little that the Socialist Revolutionary Party, which stood behind the slogan in figure 8, was the party of peasantry, not workers; political imagery can be bipartisan. The mallet that the red-painted blacksmith carries across his shoulder is a class attribute and a political symbol, the heavier the better; and the long stride the smith makes from the miniature factory at his left foot to the green countryside at his right can only be described in political terms: powerful, resolute, decisive.

Some turns of political phraseology easily melt into dance, as we learn from the 1925 version of *The Steel Step* libretto. Among the many civil war types Yakoulov summons to the stage, there is an irritable character named the Orator, an uncommon occupation to choose for a ballet. Orators may be at home with the medium of radio; what can an orator possibly achieve in the speechless medium of dance? As Yakoulov marks in his libretto, the Orator is supposed to dance out an indignant speech.

Some texts are more danceable than others. Yakoulov's

145

49. Of course, politics and modernity as such were no news for Diaghilev's ballet. They played tennis in *Jeux* (1913), shot a film in *La Pastorale* (1926), and even used *Le Train bleu* as the title for a 1924 production. Born at the court, ballet was never free of political connotations. But neither metal factory nor revolutionary radicalism was ever conceivable on the ballet stage.

50. Quoted in Leslie Norton, *Léonide Massine and the Twentieth-Century Ballet* (Jefferson, N.C., 2004), p. 117.

Figure 9. N. [V.I.] Lenin, *One Step Forward, Two Steps Back* (1924).

Figure 10. Léon Woizikowsky (center), Nikolas Efimov (?), and Constantin Tcherkas (?) on the flanks in *The Steel Step* (1927).

146

proposal was brilliant and unexpected. Why not take a quotation from Lenin and transform it into a sequence of steps? Yakoulov's Orator holds a book in his hand; his other hand pokes at the book with a finger; as he mimes this, the Orator "makes a decisive step forward and two small ones back."[51] *One Step Forward, Two Steps Back* is the title of a political pamphlet against Mensheviks written and published by Lenin in 1904. In 1924 (the year of Lenin's death) the book was republished in Leningrad with Lenin's full-size photograph placed to the left of its title (fig. 9); which ballet librettist could possibly resist a temptation to misread this cover as Lenin's guide to dance?

Buffoonery is the closest match to what Yakoulov wanted to achieve with Lenin's book and, more generally, the second self of *The Steel Step.* Whomever he was meant to impersonate—Lenin or (as likely) those sorry revolutionaries whom Lenin's book blamed for making headway in reverse—Yakoulov's Orator was a buffoon.

By all we know, Massine crossed out the Orator and never used the three-step from Lenin's book. Perhaps, Yakoulov's in-joke was too Soviet to get for the seasoned Parisian that Massine had become by 1927. Yet Massine himself was no stranger to comedy routines. When Massine's choreography does not look like dance any longer, more often than not it looks like circus. A publicity still shown in figure 10 is a good example of this. In the playbill, this scene has a title: "The Legend of Drunkards." The scene looks like a mock version of the classical *pas de trois* (fig. 10). The oilskin costumes the dancers are wearing were

designed by Yakoulov to evoke the legendary *kozhanki* (leather jackets) favored by commissars and chekists. In Yakoulov's libretto, the commissars do what commissars normally do: chase criminals and court young ladies; in Massine's choreography, one of the three gets legendarily drunk while his boon companions are trying to control him. The three fingers raised by the drunken commissar could have meant a number of things, from Russia's proverbial troikas and three judges on the bench of Lenin's revolutionary tribunals, or perhaps the one in the center is gesturing "three more drinks!" while his buddies are showing that their bellies are full up to the chin.

Take a closer look at the central dancer's legs. There is no number among balletic positions to account for the way in which these legs are bent: knees together, heels apart. And it is not the Charleston that he is dancing. Bending one's legs like this was habitual for clowns, as Eisenstein demonstrates in a publicity still released in connection with his circuslike production *The Wiseman* on a Proletkult stage in 1923 or as Nikolai Tsereteli does in a comic dance from *Giroflé-Girofla* (1922) for which Yakoulov had designed the sets (the production was shown in Paris and earned Yakoulov an invitation from Diaghilev) (fig. 11). In *Le Pas d'Acier*, as in the Soviet utopia/dystopia at large, there is only one step between the earnest and the comic.

Circus tricks need circus props. Lenin's book *One Step Forward, Two Steps Back*, which Yakoulov's Orator is described holding in his hand, is what circus professionals call a gimmicked prop. At one point in the libretto the Orator grows so angry that he hurls the book at his listeners; perhaps, Yakoulov planned the book prop to be of a size that would have frightened anyone it was thrown at. However, the book does not hurt anyone; it is attached by a rubber band to the thrower's hand, to which it returns as a boomerang might.

51. Quoted in Press, *Prokofiev's Ballets for Diaghilev*, p. 212; trans. mod.

It is an old clown trick, head of the Saint-Petersburg Circus Art Museum Ekaterina Shaina explains. The Bartens brothers, for instance, who were dumbbell jugglers and clowns, used to employ rubber bands to give the public a scare, throwing at them a weight that turns out to be weightless.[52] A Moscow circus sketch from the 1920s entitled "People vs. Vitaly Lazarenko" includes a trick similar to the one that Yakoulov's Orator performs. The star and darling of the Soviet political circus, acrobatic clown Lazarenko is on trial for battery. As he explains to the judges, "I grabbed volume sixteen of Marx's collected works and gave it to him—just like that, in the kisser."[53] We only know the written text of this sketch (authored, one must add, by Nikolai Erdman, one of the twentieth-century's remarkable playwrights); as happens in performance arts, we do not know how the sketch was physically enacted. Lazarenko must have shown to the public how the book was thrown (the phrase "just like that" suggests this) and, not unlikely, volume sixteen boomeranged, attached to a rubber band.

Figure 11. Sergei Eisenstein on a publicity still for Wiseman (left) and Nikolai Tsereteli in *Giroflé-Girofla* (right).

That every sign is at once a physical thing and an incorporeal allusion is the ABC of semiotics. Apollo is both Apollo and a piece of stone. This inherent ambivalence of signs applies to the print medium as well. Marx can be studied or thrown at someone too stupid to get it. Lazarenko's circus trick is funny because the gimmicked book belongs to two realms at once: to politics with its lofty theory and to comedy with its lowly tricks. Yakoulov's libretto smuggles circus and politics into ballet. Massine's choreography made the mixture detonate.

6. Ballet and Media Boundaries

How far does ballet go and still remain ballet? If by the ultimate, sine-qua-non definition ballet is the medium of moving bodies, Massine's *Steel Step* is a ballet. It is ballet even when it seems to outgrow its own boundaries, with many dancers' bodies melting into a single body of the steel mill. At this moment, dancers are not only workers and their working tools; their writhing bodies also enact strips of red-hot metal wriggling and twisting under the impact of mallets—contortions of inanimate matter that some critics mistook for the depiction of Bolshevik violence and

sadism.[54] Wheels and flashlights, every detail that moves, become part of the dance. Is this work or dance; are these many bodies or one? The finale is ambivalence embodied.

To sum up the experiment that Prokofiev, Yakoulov, and Massine staged with *Le Pas d'Acier*: their aim was to test and question our sense of boundaries that, as tradition has it, define what counts and what doesn't as ballet. Classics and fantasy are familiar ballet-related tags. That these were replaced by class struggle and topical politics did not mean that *Le Pas d'Acier* was extradited from ballet. What it meant was that ballet's boundaries were defamiliarized. The question "is this dance any longer"—a symptom of such defamiliarization—was planted in the minds of the public by *The Steel Step* itself. Such was its politics of choreography.

What are, in theory, the outmost boundaries of ballet as a medium? What traits or properties of a step or movement turn them into a "balletic fact"? A Russian theoretical tradition defines dance against walking. Dance relates to walking as poetry to natural language. Walking, like talking, is a practical, simple and inconspicuous mode of human locomotion. Dancing, like poems, is difficult, uneconomic, and noticeable. "Dancing is constructed of movements not used in ordinary walking," Boris Eikhenbaum wrote in an essay devoted to silent films.[55] "Dance is . . . walking constructed

147

52. See Yuri Dmitriev, *Sovetskii Tsirk* [The Soviet Circus] (Moscow, 1963), p. 166.

53. Nikolai Erdman, "People vs. Vitaly Lazarenko: A Circus Sketch," in Erdman et al., *A Meeting about Laughter*, trans. and ed. John Freedman (New York, 1995), p. 71.

54. See Volkonsky, "'Stal'noi Shag,' balet Yakulova i Prokofieva."

55. Boris Eikhenbaum, "Problems of Film Stylistics," trans. Ronald Levaco, *Screen* 15, no. 3 (1974): 8–9.

to be perceived," wrote Viktor Shklovsky in a book about literature.[56] Dance defamiliarizes the way we humans move.

Both Shklovsky and Eikhenbaum wrote this before *The Steel Step* premiered. Had they seen Massine's choreography they may have added a footnote to what they wrote. If we look again at Serge Lifar and the step he makes in figure 7 we will see that Massine aimed at the reverse. The step Lifar makes is not a *pas*, it is a step. Massine's way of defamiliarizing the overfamiliar vocabulary of ballet was to make dance look like walking. When poetry becomes the norm, prose becomes poetry.

Perhaps the boundary between ballet and nonballet is one between movement and stillness? If ballet is about movements of human bodies (and inanimate objects, Fernand Léger and Georgii Yakoulov might have hastened to add), isn't it plausible to say that still images, bodies, and objects at rest constitute the negative space, the antibody of ballet? To answer these questions, they must be considered in two ways: as ballet history and as a single choreographic movement. In both cases, the answer is no. If not for still images, there would be no choreography as we know it, and ballet as such would be an endangered medium indeed.

Stillness is not the beyond of choreography but an integral part of its dialectics. A crucial skill learned in classical training is how to freeze in a particular pose between movements (called to hold a pose in the rehearsal vernacular) or even in mid-air (an ability known as ballon). Fairytale librettos furnished magic excuses for dancers to freeze and to restore to life. Inanimate things like tapestry or nutcrackers readily come to life on the balletic stage. A statue turns into the White Lady to haunt and guard the house in Petipa's 1898 *Raymonda*; and a beautiful mummy named Aspicia is revived in Petipa's 1862 *Pharaoh's Daughter* to kidnap an English tourist and transport him, topi and all, into the ancient past. In this respect, the famous *The Sleeping Beauty* (Petipa again, now 1890) is a ballet par excellence: not only Princess Aurora but her entire court are petrified in act 1 by the witch Carabosse so that the princess and the group of her courtiers can be revived after the rescue kiss in act 2.

Bodies at rest form tableaux, a telling name. At still moments, ballet pretends to be crossing the boundary that separates it from pictures and statues—much like statues and pictures appear to be doing each time a sculptor or painter attempts to depict movement in the arrested mediums of fine arts.[57] Paradoxically, what dancers look for in the still arts are ideas for movement. Michel Fokine is remembered for championing the relaxed dynamics of contrapposto as an alternative to the tense and straight vertebral column that defined (and still does) the anthropology of the classical ballet. Nijinsky's *L'Après-Midi d'un faune* (1912) famously set in motion figures from ancient Greek vases; and a few years

before that, Russian ballet was afflicted with Egyptomania, the plague of fin-de-siècle Europe.

An anecdote from older times gives us a real insight into the push and pull between ballet and the visual arts. When Petipa choreographed *Pharaoh's Daughter*, period costumes and sets were the only tokens by which spectators could say they were in Egypt. In 1903, at the age of eighty-five, Petipa was forced to retire from his position as chief choreographer of the Imperial ballet. He lived to see a redaction of his own *Pharaoh's Daughter* staged by a younger choreographer, Aleksandr Gorsky, in 1905 and publicly express his disappointment; Gorsky's version of Petipa's choreography sported profiled wall paintings from Egyptian tombs.

"Not that I failed to look up Egyptian paintings when I prepared the original version in 1862," Petipa insists in his book of memoirs published in 1906.

> I did, but found those paintings misleading: real Egyptians could not possibly walk like that. I studied those pictures carefully until I realized that the profiled positions in them were caused by the lack of craftsmanship on the part of [Egyptian] painters, so I never forced those who danced in my *Pharaoh's Daughter* to dance in profile only. Painters used to paint people the way they could, but there is no doubt in my mind that Egyptians used to walk the same way as you and I, that is, straight ahead. Some self-important ignoramus must have lost his mind to force ballet artists to dance and walk in profile all the time.[58]

If for the choreographer of Petipa's generation a dance was an artwork made of walking, choreography after Fokine defined its course against the book. It was to no one's surprise that Massine showed up at a meeting with Prokofiev holding a picture book in his hands; this was how Diaghilev and Larionov trained him. If in former times a dancer would freeze to look like a picture, now it was pictures that were transformed into dance.

Take another look at figures 2 and 3, for instance. Figure 3 is a reproduction of a *lubok* woodcut. This *lubok*, we recall, had ignited Massine's choreographic imagination and was transformed into a dance for scene 1, part 2 of *The Steel Step*, one movement of which we see in figure 2. The illusory movement arrested in the still image is temporarily set free. What Massine did with the *lubok* was equivalent, on a different level and in a different era, to what Lotman claims had been the original, authentic way of using the *lubok*: play with it, enact it, set its still action into motion. It is a game, of course, for isn't it childish to assume that someone can walk the way the seven-league strider walks in the political poster reproduced in figure

148

56. See Viktor Shklovsky, *Theory of Prose*, trans. Benjamin Sher (Elmwood Park, Ill., 1990), p. 15. See Shklovsky, *O teorii prozy* [On Theory of Prose] (Moscow, 1929), pp. 24–25.

57. See E. H. Gombrich, "Moment and Movement in Art," *The Image and the Eye: Further Studies in the Psychology of Pictorial Representation* (1982; London, 1994), pp. 40–62.

58. Marius Petipa, *Memuary Mariusa Petipa* [Marius Petipa's Memoirs] (Saint Petersburg, 1906), p. 57. See Petipa, *Russian Ballet Master: The Memoirs of Marius Petipa*, trans. Helen Whitaker, ed. Lillian Moore (London, 1958), p. 50.

8, or that Baba Yaga wagged her tongue exactly as she does in the *lubok* in figure 4? But if Lotman and Johan Huizinga have a point, much of what media are and do is predicated on ludic responses.

Still images help ballet survive. A dancing couple in figure 2 is, very likely, the *lubok* couple from figure 3 transformed into dance, the medium of motion. That this image does not move is, of course, because the essay you are reading came out in the still medium of print. But this is not the sole reason for its stillness. Distinct from frame enlargements of a movie, dance movements whose photographs we encounter in old books and journals are seldom moments snatched out from the actual performance. The photographer had set up lights and chosen the background (in our case, a neutral curtain to not distract the beholder's gaze) and asked the players to strike a pose. None of the seven photographs that survive from *The Steel Step* are snapshots of the actual movement. These are pieces of mediated evidence, photographic artifacts of dance. The dancers are frozen in positions that, on the real stage, only existed on the fly. Created from stillness, the balletic movement returns to it.

People of ancient Egypt are said to have been so acutely aware of mortality that they made mummies of themselves in order to be revived. Choreographers know how perishable their medium is and are in the habit of making still photographs of their work to make it known to posterity and in case it might be revived by choreographers to come. Two great film theorists, Eisenstein and André Bazin, each writing in the 1940s, theorized Egyptian mummies as forerunners of modern photographs: here, as there, a still effigy outlives its self that once lived and moved; the very reason why mediums of photography and mummification were invented was the mother *(Urtrieb)* of all drives: the drive to survive, both thinkers believed.[59]

If there is a mite of truth to this, the medium of choreography includes the act of self-mummification. Still photos in figures 2, 8, and 10 are mummies still waiting to be revived, for, from its inception, ballet is a medium of reincarnation. Or, to be less metaphorical about this, choreographers are both creators of moving images and archivers of still ones. It is the back and forth, not the either-or, between immobility and movement that defines the dynamics of ballet.

149

59. See Sergei Eisenstein, "Zametki ko 'Vseobshchei istorii kino' [Notes for the General History of Film], *Kinovedcheskie zapiski* [Film Studies Annals] 100–101 (2011–2012): 53–56, and André Bazin, "The Ontology of the Photographic Image," *What Is Cinema?* trans. and ed. Hugh Gray, 2 vols. (Berkeley, 1967), 1:9–16.

"BROADCASTING" JUSTIN GREEN

Panel: Graphic Novel Forms Today
Charles Burns, Daniel Clowes,
Seth, Chris Ware
Moderated by Hillary Chute
May 20, 2012

HILLARY CHUTE: Daniel Clowes is a cartoonist, illustrator and screen writer who grew up in Hyde Park, Chicago. And in honor of this I'm starting us off with the first page of his "Chicago" story. This story is one of the reasons I felt happy to move to Chicago. I had something to visualize.

DANIEL CLOWES: Doesn't seem like it is accurate anymore, somehow. Seems like the Chicago of my youth. There's reference in this story to, you know, "Chicago was filled with bars that played old ragtime music and had peanut shells on the floor." That meant a lot to people of my age and that means nothing to anybody now. It's very different…It is like a sports bar thing has taken over.

CHUTE: I'm sorry.

CLOWES: No, I'm sorry. I don't live here anymore. [laughter]

CHUTE: It strikes me that you four are really at the vanguard of graphic novels. And you all work in diverse formats, not only from each other but also *within* your work. So your work looks different from your other work, often. So to start off, I'm interested in what you all think about comics and the question of the book as an object. Across all of your work there is an intense attention to the materiality of the book, from the design of covers and endpapers and foldouts and frontispieces. I'll run through a few examples. Here is the cover to Seth's *Palookaville* 20. Here is a foldout in the middle of that book. Charles in his book *Black Hole* has endpapers that themselves tell a narrative. So the beginning endpapers are a "before" space and the end endpapers are an "after" space. So here is one example. The woman here is in the front and the woman here is on the back. And here we have covers to two of Dan Clowes's books. This is the cover that he drew and designed for the book *The Anthology of Graphic Fiction* that Ivan Brunetti edited. You can see the intense attention to design here.

CHRIS WARE: I'm the youngest person here. I feel like I've gone through phases in my development as a cartoonist

that I could almost label with the name of every person here, and seeing them talking and being around them has been a very strange experience. It has left me feeling like I don't know where I am anymore. My heart's been racing. But at the same time it makes me so proud to be a cartoonist. [applause]

CHUTE: Thank you for coming. So will you guys talk to me about the book as object? [laughter]

SETH: I must admit, I'm just trying to make a pretty book because I love the book. The book is a beautiful physical object—it's the way I most enjoy taking in information. For example we were talking about *George Sprott*. There is that foldout in the center. It folds out. There are reasons to do that simply because it is an interesting thing to do. You have these options available when making a book but that foldout provided a perfect opportunity to actually use the physicality of the book to enhance the story itself. You see, that foldout was the one point in that whole graphic novel where you enter inside the character. Everything else is presented from the outside—whether it is other people's opinions of George or George speaking to the reader or simply following him around narratively. [Here] is one point where you have his interior point of view. So you open up and go inside the character. That's something you couldn't have done in the old comic books, in the pamphlet format, and possibly not in the digital medium either.

The physical form of the book allows you to lead the reader into the story and out of the story in a leisurely way that is really a very different opportunity than we had back when we were stuck with just the comic book pamphlets. Now you've got like twenty pages (before you even reach the comics themselves) to lead readers into and through the story. You might open with a spread of a landscape drawing, and then you perhaps turn the page and you might have a one-page strip just before the title page, etc.—all these opportunities to use photographs or objects or to use graphic design itself to affect the very telling of the

Figure 1. Daniel Clowes, "Chicago," *Eightball,* no. 7 (Nov. 1991).

story. That is a great exciting tool that the book has added to our storytelling repertoire. The size of the book—all these things can be factored in. So, yes, it is exciting to be able to work with books.

CLOWES: Somebody recently was asking me, "Why aren't you excited to do web comics?" I'm not unexcited by the idea. It is just not my interest. I was thinking, when I'm working on a book, when I start out I'm just drawing a comic and not thinking of how it's going to work. But after a while it starts to crystallize in my mind. I'm picturing the final object. I was thinking it is really like a sculpture in many ways. I'm imagining what this thing is going to look like in 3-D. I'm imagining it sort of sitting on a desk. Then I'm trying to make that happen through what I'm working on. It feels very much like a comic on the web is, you know, a website with pictures of a sculpture instead of the sculpture itself. That's why I'm not that excited about that format, because I want to see that book and feel it. That's the thing that I'm waiting to get, that box from the printer. Which is always the most disappointing day of a cartoonist's life. Because it is never what you thought it was going to be. I have thrown many books out the window.

CHUTE: Literally thrown them out the window? Like on the lawn or the street?

CLOWES: Like on Division Street. I once threw a whole box of *Eightball*s out in the street and then I realized, Oh, I'm not going to get any more of those. I was out in the snow picking them up. *[laughter]*

CHUTE: Since you're talking about the book as a sculpture, I thought of weight, and *Wilson*, your book that came out a few years ago.

CLOWES: That book in particular has a certain bulletproof quality. You just feel, like, this is going to be around when the next ice age hits. This will be like the one remaining book that survived because it's [got] the two-inch-thick cardboard on the cover. It is like you feel protective, and you want it to have, you know, a shell that can allow it to proceed in the world. That book feels very sturdy in that regard.

CHUTE: Is it tied at all to the content? Or is that just how you were feeling about comics in general?

CLOWES: No, it is tied to that character, who is certainly a guy who needs some protection.

CHUTE: I like that idea: the covers of his own book are protecting him.

SETH: Well, the funny thing about cartooning; it's pretty much an ephemeral artform. Cartoonists who just worked in the newspaper must have really felt that as they threw away that newspaper every day. But when you work on a comic it doesn't feel that it truly exists until it is that final physical printed object. It is not the original art. That's not what it is about. I could stack up twenty original art pages of a story and that's an artifact—parts that will lead to the end. When it is the book it is the real thing. Now it

has entered into the world in some real way. Even if it was just one copy and I put it on my shelf, that's the final product. That's what makes it concrete. That's when it turns into the sculpture you were talking about. Before that to me it is just little puffs of smoke or something.

CHARLES BURNS: Did I remember hearing some story about you having a contingency plan with other cartoonists? Like, "Here are my notes in case I have a heart attack. I've got ten chapters." There is that moment where you are in suspended time. Like, I want this thing to exist in the world as this finished piece.

SETH: I read this Borges story on the plane yesterday where the guy is sent to a firing squad and he hasn't finished his novel. He begs God for one more year to finish it, and—sorry to ruin the story—just as the bullet is fired, God stops time for a year and he stands frozen to finish the book in his mind—so it will be done. And then the bullet is released. And I was thinking the whole time, what a rip-off. *[laughter]* I want it published. I want somebody to read the stupid thing.

CHUTE: So I want to keep talking about the book as object and about format. I think both of these things are related to the question of seriality. It strikes me that all of you work in serial contexts.

BURNS: I think we've all worked in various forms to get our work published. But that's changed so much over the years. When I was starting out I would try anything, so it was like what is the little slot that's open in the back of the *Village Voice*? They have some gag cartoon section. I'm not a gag cartoonist, but [I was] trying anything at first to get it out there. But then, I don't know, there have been periods where the floppy comic book, the regular American-style comic book was a viable way of having your work out there on a fairly regular basis. If I had to wait, I don't know, ten years for a book to come out, it would be tough.

CHUTE: But you did wait ten years for a book to come out. Right? So these *[picking up comic books from the table]* are comic books of *Black Hole*. Didn't they come out over a ten-year period?

BURNS: Yes, but it was *something*, it was a physical object again that would help push me forward.

CHUTE: Did you feel when you saw the book version of *Black Hole* like something had been lost?

BURNS: No, not at all. It was just a story. The story was a long story. The book came out around the time that a significant number of other big serious graphic novels came out, around the time when that term was understood by the general public. But it wasn't a conscious decision on my part. It is like I wanted to tell a longer story and it came out in that form.

WARE: I think the idea of making a book that *contains* the story—in a way that is suited to the story—we can credit to Art and Françoise with *RAW*. At least that's where I first saw it done in comics, where design was more than simply wrapping something in a nice cover. Art and Françoise

153

paid attention to what the content of the book was and created something to contain it that reflected the content and tone of the story itself. I've said this before, but to me, books, they are a perfect metaphor for a person: they have a spine and they are bigger on the inside than they are on the outside, just like we are. Plus they can also lie to you.

CHUTE: Tell me about this idea of the book lying to you. I'm not sure I know what you mean.

WARE: You can make a book look inviting, but when you open it and start reading it, it can turn out not to be. It can tell you one thing but when you actually start reading the story, you realize that's…not exactly what you are getting. Frequently you expect a book cover to tell you, "Oh, this is the feel of the book" or "this is what is going to happen" or "this is what you should expect," but it is much more interesting if you controvert that expectation. [The cover] shouldn't just advertise what the book is, it should be a part of the experience itself.

SETH: Yeah, I think that one of the important things in the last twenty years is that cartoonists have started to think of themselves as designers as well. *RAW* deserves a lot of credit for this, I think. That doesn't mean that cartoonists weren't designers before then. Certainly I can look at Robert Crumb's covers—there was an amazing quality of design there that I recognized even when I was twenty years old. I understood the cohesiveness of that design—those Crumb comics—as a fully thought-out physical object. But starting in the 1980s and then moving on I think more cartoonists have started to understand the situation is not simply, "I need to finish this story and have somebody stick it into a book." We've come to the point where you want to control the very form of how it will be presented.

CLOWES: With the comics we used to have deadlines. Somebody would call you up and say, "Oh, by the way, we need the cover on Thursday for the catalog." Back in those days you took that seriously. Now I know, yeah, fine, then ignore that call. [laughter] But I had a couple covers for which I said "Er, oh, yes, it is almost done," and I hung up, oh, my God I got to do this now. Those days are gone. Now we can spend all the time we want.

WARE: Back then, too, comics were stuck in this very specific format that had been set by the superhero publishers. You guys had all been publishing stuff for a while but when I finally got to do something with Fantagraphics, I was stuck with that size, and I'd always hated it. I don't know why…maybe it tied into the embarrassing memories of my own childhood of reading superhero comics and I wanted to somehow change that. The most that Kim Thompson would give me with my first issue was to cut off the top half-inch to make it slightly shorter because he was so afraid the distributors wouldn't carry it otherwise. Then, to make matters worse, I really wanted to make the next issue extremely large, and Kim said, "Oh, God, there's no way we can do that, nobody will sell it." He wanted to fold it in half, and he came up with this complicated way of trying to get it into book stores. But then he just finally called me up one day and said, "Oh, let's just

forget it. We'll make it whatever size you want and we'll see what happens."

BURNS: Chris is one of the first people that I knew that had developed enough skills to have really, really incredible covers and publication. Just beautiful books. There is a learning curve there. I still rely on other people to help me. But just the idea of having a series for which every single issue was a slightly different format—that was an amazing thing. Nobody had ever really done that before. It just didn't even seem like a possibility to me before that. I remember thinking, okay, this is a comic book. It is the comic book size. I'll work within that format. As you were saying, the first issue of *ACME Novelty* was a relatively normal-size comic book. And then the next one was this odd thing that didn't fit on anybody's shelf, and everybody is pissed off because they couldn't line them all up together in order, I guess. There is that whole obsessive fan base that wants to have them all stacked up in the same size.

SETH: Chris really changed the playing field. When Chris's work appeared, I really think a lot of us started to scramble. We were like, holy shit! I've got to try harder. I can remember sitting down and saying, like, it is time to up my game on my lettering. This guy is like—[laughter]

CLOWES: There was also just that notion—we never thought it was possible to do comics of a different size. I tried for years to do different size comics and just was always discouraged. Even that first issue of *ACME*, the half-inch that was cut off, I almost fainted when I saw it. I really imagined like thirty people will buy this because the fans will not accept it. And then when that second one came out and it was in color. "I have been trying to do color for years." [laughter] My *Eightball* comics were always in black and white. My publisher, Fantagraphics, at the time also published pornographic comics, and I noticed they were on glossy paper and the first four pages were in color. I thought, can't I have the same privilege? They said, well, your comics don't sell as well. But they decided to let me do it. So I have comics where the serial story, *Like A Velvet Glove Cast in Iron*, starts out in color and turns black and white at page four.

WARE: Well, to be fair, there were a lot of different sizes of underground comics. *[Pauses, addressing the audience]* This is really dry, isn't it? You guys are like, why are they talking about this stuff? But there was this weird period where everything became standardized in the 1980s. I don't know why. Then *RAW* changed everything.

SETH: We'll be talking about page signatures in a minute.

WARE: We're going to talk about fill tones.

CHUTE: Dan, a lot of your recent work first appeared in *Eightball*, which is pretty interesting. Here is one issue of *Eightball [holding up comic book]*, which became the hard cover book *Ice Haven,* which then became the paperback version of *Ice Haven*. We have three *Ice Havens*.

CLOWES: Soon I'll be able to transmit it into your brain.

Figure 2. Charles Burns, *Black Hole* endpapers.

Figure. 3. Chris Ware, *Building Stories* (2012).

Do you like it? *[laughter]*

CHUTE: When you were working on these stories, did you think of them as books in the way you were talking about? The moment where it crystallizes and you can imagine the sort of sculptural object? Or were you just thinking of them as stories for the serial?

CLOWES: Well, the last two issues of *Eightball* are not serials. They are self-contained stories. They really should have just been books to start with. But I was so caught up in that—I mean, my life-long dream was just to have my underground comic. My own version of *Zap* or something. So the thought that I would not be doing that was just too painful. So I kind of awkwardly formatted them so they would work as comics so I could just stick to that format and then later rethink them as books. When I drew *Ice Haven* as an issue of *Eightball*, I decided to work as big as I possibly could. So the pages are enormous. For me to be able to reach the top panel to letter it I had to actually cut the pages in half and fold them in half. So I was really working on half pages; I was never looking at a full page. I had the vision for this book which seemed—it just seemed right. It is sort of this Midwestern town and it has this sort of flatness that connotes that kind of environment. So this is really what I think of as the ultimate version. Although everybody read it as a comic book first and they all got used to that version and so they like that better.

CHUTE: I want to ask about the serial format of some of your current projects. Charles, I was hoping you could tell me about your current project, which is being published in a serial format. What's the thinking behind publishing these Belgian album-style serialized books?

BURNS: Well, they're based on the size and style of the French Belgian *Tintin* books that I grew up with. For me it was something I internalized. I love that size. I wanted to do my stories that way. So I was used to that existing format. Which is not a great fit over here in the United States. For example, my agent was telling me, when we were trying to sell the book, that the British publisher was saying, well, I don't know, it is a very slim graphic novel, as though I'm trying to pass off—here is my cheap-ass version of a graphic novel. No, that was how I wanted to tell the story. The story is going to be three books. There is a reason: the story is broken down in that manner. But I guess primarily it really does go back to that kind of seeing and experiencing those books as a kid and internalizing that format, really enjoying that. I was somewhere in France and doing a signing and I remember someone came up with a copy of *Black Hole* and he was so used to the normal Franco-Belgium album format, he said, "I just couldn't bring myself to buy this, it just seemed so foreign and strange to me, but I finally bought it." So it works both ways I suppose.

CHUTE: Can you say anything about the third installment?

BURNS: The title of the last book is called *Sugar Skull*, which my German publisher informed me can't be translated. I don't know why. *[laughter]* There is sugar and skull.

CHUTE: So are you writing the story as you go? Or are you still figuring out the whole arc?

BURNS: I've worked everything out. I've broken everything down in notes. But it is still open enough that things are entering into the story as I'm working on it, which for me is the enjoyable part. That discovery, not just filling in the blanks or working on some given script. It is something that's growing as I'm working.

CHUTE: Chris, I was hoping we could talk about your book that's coming out in the fall, *Building Stories*.

WARE: I will not be able to talk about this cogently because I just finished it, but it is about the residents of a Chicago apartment building. The person who lives on the top floor is a woman who lives alone, though she eventually gets married and has a child. There's also an elderly woman on the first floor who owns the building, and a couple on the second floor who are not necessarily too happy together. This [*pointing to slide*] shows a strip I did about how in a relationship sometimes the touch of affection becomes a touch of aggression. I did a stupid e-thing version of this for the iPad, trying to use the touch interface of an iPad to somehow connect with the idea of physical contact in a relationship and how it changes—a very pretentious idea. After I did it, though, I just thought: I really like the paper better.

For a long time I'd been wanting to do a book that didn't have a beginning or end, a book that you didn't know where to start and you didn't necessarily know where it finished, but once it was in your mind it would start to, kind of, coalesce. Design approaches like this have been done before by Dave Eggers and *McSweeney's*. So if one opens [*Building Stories*], there are fourteen books inside of the box itself, ranging in size from a giant newspaper-format-thing that opens up very large to accommodate the larger pages to some very tiny booklets. Also some strips of paper, and a hardcover.

SETH: Man, that makes me feel really shitty. *[laughter]*

BURNS: Can we leave now?

WARE: I really love Joseph Cornell, who I kind of think kept this warmth and humanism alive through the whole twentieth century of—not such warm art, necessarily. And I wanted to try to do something that at least had the feeling of his work, a little bit, in a book format. And amazingly Pantheon agreed to do it. I don't know if they needed a tax shelter need or something…I don't know.

The book itself is about—I don't know how to talk about it, necessarily. It is mostly about one person. The book is actually trying to—it is about empathizing with other people, which I think fundamentally is what all art tries to do in some way. To try to allow for an increased sense of empathy, at least. I find that being a parent, too—that empathy is the one thing I really want to instill in my daughter. Since so much of the popular culture seems to go directly against that.

BURNS: I was talking to Chris on the phone maybe half a

159

Figure. 4. Chris Ware, *Building Stories* box and opened spread (2012).

year ago. And I said, So can you tell me what the format of the book is? Chris said, um, no, I really—I can't talk about it. And now I know why.

CHUTE: Is this the first time that you've talked about the form of the book in public?

WARE: I guess, yeah. I was still kind of figuring it out. You can see I can't really articulate it very well. Maybe—again, maybe it is dumb. I wanted to try to make something that seems like—you know, there is so much stuff coming at us now, with the Internet and TV and movies and everything—I wanted to try to make something that compels the reader in some way, or that offers the same sort of—that's *inviting*, in a way. I think Stanley Kubrick said at some point we consider something "art" by the degree of affection that we feel for it; the things I really love, I come back to…and I wanted to try to get a feeling of that in this.

SETH: I agree. One of the main things I feel about works that I love is a desire to repeat the experience over and over again. I'm really a person who, if for example I like a movie, I'll watch it a thousand times. Literally over and over and over again. I won't submit anyone else to it, but I'll keep doing that. And books too, that's one of the marvelous things about them; I guess that's why I don't respond to the digital format so much, because to me that physical book invites me to actually re-experience it, rather than just click on to it again. Some books that I love I've acquired multiple copies of for some—I don't know, some apocalyptic fear that the book will be lost. It's as if, if the end of the world comes, I'll need two copies. *[laughter]* This same feeling applies to a lot of art forms, I suppose… but the fact that a book is a physical object really encourages me to re-experience it—to reenter it.

CLOWES: Don't you find if you watch a movie over and over again, it loses its power?

SETH: Only for a little bit. I find that if there is a movie I watched one hundred times, okay, I can't watch it again. But left alone for a while the tank will fill up again. In time I'm ready, more than ready, to watch it again.

CLOWES: I watch a movie I love and I try to avoid it like the plague for ten years so I can have the experience again.

SETH: I'm the exact opposite. Perhaps it is from watching television so much as a child. I would watch the same shows over and over and over again. My mother would say, "You've seen that." I would say, "No, I haven't." I knew she would make me turn it off if I admitted I'd already seen it. I like re-experiencing. It is probably a child thing, the idea of repeating experiences. And though the book or movie or whatever is always the same, when you come back to it, it is *not* always the same. Something new is found each time. You get different experiences from it each time around.

WARE: It was the holiday shows that got to me. "It's The Great Pumpkin, Charlie Brown"—I used to kiss the television set when the Charlie Brown Christmas special was almost over because I knew I wouldn't see it again for a

whole year. *[laughter]* I still remember that cold feeling of glass. *[laughter]*

CHUTE: I want to ask right now about some offshoot publishing projects that are related to some of your books. One of the things that's been fascinating to me about Charles's recent work, *X'ed Out*, is that it really strikingly has a fake language that Charles created, which is this kind of unbelievable comics writing. There are publishing offshoots from *X'ed Out*, can you talk a little bit about some of those? Here is a book that's entirely done in the fake language that Charles created.

BURNS: This is published by a French publisher [Le Dernier Cri]. I basically did a cut up version of the first book and part of the second book and created a typeface that would give that sense of—I guess the sense that I had when I was a kid that I was looking at foreign books, books I couldn't read, and maybe even that feeling of looking at books when I was so young I didn't know how to read yet. The kind of mystery. The inability to translate something. Someone advertised it as a pirated version. It is not; I pirated it myself. Unbeknownst to me, there are people out there interested who actually broke the code.

CHUTE: That's amazing.

BURNS: I had this typeface I had made that corresponds to regular typing. But I was just kind of randomly touch-typing. There is probably like really bad rock lyrics in there. Whatever is playing in the background, maybe. And somewhere—I shouldn't even say this, it is not a good idea, someone has transposed it; you can find it on the Internet. It was actually useful for me because I had touch-typed it and hadn't really looked at it since then. Other art I have been working on periodically is doing these kind of fake comic covers with a foreign language or foreign text, I should say, typeface, just for my own pleasure.

WARE: Can you just tell the quick story about when you were a kid and your dad brought home the *Tintin* book?

BURNS: It is kind of embarrassing. I guess it is like kissing the TV. *[laughter]* I had grown up with pretty mainstream comic books. My dad was interested in comics. My memory is *Mickey Mouse*, *Donald Duck*, and probably *Dennis the Menace*, comics that were appropriate for kids. For a brief period, Golden Publishing, I think it was called, did six translations, American translations of the *Tintin* books. My dad went out to book stores all the time so he came back and brought me these books. There was one evening where he came back with a book and it was too late for me to actually look at it. It was time to go to bed. So I just briefly saw the cover. It was just impossible for me to let go. We lived in a very small house. I had to walk through my parents' bedroom to get downstairs, but I walked through the bedroom, downstairs in the dark, and looked at this book cover. Looked at the book in the light of the, I don't know, moon or the street lamp outside. That was the story.

CHUTE: I would also like to ask you about this amazing tiny book that you did that's related to your *X'ed Out* proj-

Figure 5. Charles Burns, cover of *Johnny 23* (2010).

161

ect. And we can see there is a Gary Panter image in this book and this is such a beautiful tiny object.

Burns: Yeah, it is a series that some Swiss publishers [B.U.L.B.] have put out. It is just this oddball format that comes down and gets stuck into a little box. To me it was an opportunity to do something that—I ended up just doing an image with a prose on one side and an image on the other. It is the only thing I have ever done that would be fairly close to autobiographical or straight autobiographical. They are just little snippets, little pieces. It is called "Cut Up, Random Fragments, 1977 through 1979." The series I'm working on right now was really—my intention was to do a series of books, a story about that time period in my life. So this is like some more little pieces out of that, including, as you said, Gary Panter. There was hippie art and punk art and Gary Panter was the first person I recognized as being a punk artist. I immediately wanted to be a punk artist. I tried. I didn't have a mohawk, though. I think Gary had a mohawk.

Chute: Is the title here, "Cut Up," related to the focus on William Burroughs?

Burns: Well, the protagonist in *X'ed Out* is my age during that time period, the late 1970s. I was certainly reading him at that time. So I'm kind of placing my interests into that character. And the character gets up and does kind of spoken word performances where he's reading his cut up narratives. Yeah, it is taken from the William Burroughs writing, the idea of treating writing as a collage, cutting up your writing and reassembling it, which some people found very irritating.

Chute: What about *Free Shit,* which is one of your publications?

Burns: Anybody got any free shit? I was at some comic convention and sitting at a table, and someone asked me for free shit. So the title came from that. So periodically I do something that is just a regular piece of paper printed and folded and stapled. They are usually just kind of

Figure 6. Charles Burns's *Cut Up* booklet at conference. Photo: Karen Green.

crappy notebook drawings. The logo is, "it may be shitty, but it's free." *[laughter]* I hand them out to people I know, or friends, or if I am out somewhere I'll hand them out. I think we're up to # 17 or something.

CHUTE: Keeping with this idea of offshoot projects, Seth, I was hoping you could talk about the cardboard buildings that you make for your fictional city, Dominion.

SETH: Yeah, it is kind of a crazy project. Though it didn't start out to be a project *at all*. Basically some years ago I was trying to come up with—I was beginning this story about these six characters. And as I was working out these six little stories I thought I would set them all in the same place. I came up with this town called Dominion, which was just the town they all lived in. As I was thinking about them, it occurred to me that the town was the unifying element for the book. Simply that they all lived in the same town. I thought it might be interesting to start off this story with a long section that explained the history of the place where they lived and give some sense of place. I thought this might be a bit of a problem because that means you need to fabricate all this civic history and that is kind of a daunting task—to make up a small city and come up with its history beyond something vague. It's a big task if you are going to try to flesh it out in any fair amount of detail. So I wondered how I would go about that. And I figured the simple answer would be to

pick one building or one place at a time and start writing in a notebook a few notes; eventually if I kept doing this, at some point these things would intersect and an organic history would just develop. Somewhere early on, for some peculiar reason I decided to make a little model of the first building that I was writing about. And it was fun. And then I started to make more models. While I was working on the model it gave me time to think about the history of the place, or that particular business or whatever it was. And over time they started to add up. Later, I totally lost interest in the story I was working on. *[laughter]* But I was still interested in the city. So I continued.

And I still work on it. I don't work on it like every day or every week even. But every once in a while I make a new building and I write about it in my notebooks. It has grown into quite a place now. The plan actually did work; the history started to make sense. I now know this place fairly well. Certainly a million details I don't know. But things did start to come together. Places intersected and a history developed in my mind and Dominion has developed into a place where I now know all my stories take place. *George Sprott* takes place in Dominion. If I had started this earlier, *Clyde Fans* would have been more focused there, but the characters do go to Dominion in *Clyde Fans*; it is still connected. This place has taken on some life for me. It is not really a comics project, I suppose. It is more an inner world that I'm interested in. Sadly, this

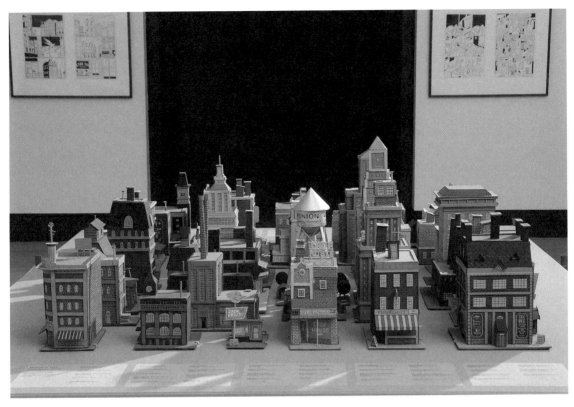

Figure 7. Seth's cardboard city of Dominion. Photo: Seth.

is the thing I felt strongly when I was listening to Joe Sacco earlier—I couldn't help thinking, "Jesus Christ, Joe is out there doing something big and real in the world. So much of my work is terribly small—all about the inside world." I feel envious of other artists when I see the work they do. I see the work Joe does and I know why Joe does that and that's who Joe is. I think my life is about that tiny world inside my mind and body. And that is…you have to just do that work you do. That is the way it is. And that's why I'm building a cardboard city in my basement. *[laughter]*

CLOWES: Is it actually in your basement?

SETH: It is in the attic right now. Because for a couple years it was on exhibition and it would go around to different galleries, and that was great to get it out of the house. I would continue to add buildings, but they would be in the studio. Recently though it all came back home and had to go somewhere. It is going out again in about a year, I think, for a few more places, so it will be nice again to get it out of the attic. But it doesn't have a permanent set-up. It wasn't really built to be displayed. When it was smaller it was displayed. But now it is mostly packed up in boxes.

WARE: This thing is so astonishing—it is not just *this*, either. He's got books filled with, like, histories and drawings and watercolor paintings of all these places. It is unfathomable the amount of work he's put into it. All four of us up here, we're the "fiction writers" up here, in case it wasn't already clear. So that's kind of what we're—that's what we're defending I guess. *[laughter]*

SETH: I see myself after I'm dead and I imagine my wife's foot crushing them down into the dumpster. *[laughter]* I think of that story of Scott Joplin. That suitcase full of his compositions that was carted around for ten years until finally the sister threw it in the garbage.

WARE: It is hard to cart around a cardboard city.

Q&A

CHUTE: On that note, let's open it up for questions.

AUDIENCE MEMBER: You've been talking a lot about the book as an object. And I was wondering if you could talk a little bit about the page as an object. All four of you write lengthy extended narrative pieces, but all four of you also at various times and actually throughout your work seem very committed to the page or the double page as a unit in a way that goes beyond maybe the needs of seriality or serial publication, giving them separate titles, ending with a punch line, having images that reflect back and forth on one another. So I was wondering if you could talk about how thinking in pages is a part of making comics, or if thinking in pages and having starts and stops is a part of making comics, as opposed to just letting the story roll on.

CLOWES: The page is certainly the natural pause. It is like having built-in paragraphs. And it is what you have to take into consideration when you are building a story. I try to do it absolutely by feel. I just have to have an internal sense of that. I'm trying to use a part of my brain that's—like if you are walking upstairs and you're car-

163

164

Figure 8. Daniel Clowes, "I Hate You Deeply," *Eightball*, no. 2 (Feb. 1990).

rying a cup of coffee and a bowl of cereal and you have to open the door. Somehow your brain figures out how to do that. Once you start to think about how do I open that door, oh, I spilled everything. But somehow you like squeeze it against your body and you open the door and you are inside and you don't think about that. That's the way I am trying to design a page is I'm using that. It is like an athlete who has his swing down when he's batting or something. And if he thinks about it too much, he's all of a sudden thinking about his muscles in his elbow and how his feet are and all that. I find that that's when you start to do really bad, self-conscious work.

AUDIENCE MEMBER: So you are naturally thinking in pages?

CLOWES: Yeah, that's just sort of the natural way I break down daily reality. I don't have a conversation with somebody and think, there is the punch line. That was the silent panel before the punch line. *[laughter]*

BURNS: When I started, I think the way that I would break down a page or write a story I guess would be in a much more intuitive way. At some point I very consciously wanted to teach myself how those things—how those elements work. I started working in a much more, I guess you could say, conservative way of breaking down the page. Thinking of a page as a sentence—or as a paragraph and thinking of each tier as a sentence. I'll bring up *Tintin* again or Hergé again. I didn't realize it at the time, but Hergé—the comics when he was putting them out originally were serialized. He would always have some kind of cliffhanger at the end of the page and I remember noticing that early on. I guess that's what you are supposed to do. So I know that that part was part of my learning process that sunk in there early on.

SETH: The vocabulary of the page really depends on what opportunities you've been given in publishing as a cartoonist. For a great deal of the twentieth century newspaper cartoonists had *a* page. A Sunday page. Or comic book artists had six pages. You had to get that story they gave you into six pages so you had a lot of very condensed story telling. We have an opportunity now where people can make their own decisions about page design based on length, although it is not like our generation has been the people who pioneered that or anything. All you have to do is look at *Breakdowns* or anything by Art Spiegelman or look at *Krazy Kat*, and you see that a whole vocabulary was built. But now cartoonists have to make their own decisions about this that weren't always available. I think that's changed a lot of thinking. You can just do a straightforward six-panel grid if you want, or even if you've got one hundred pages, you can make every page quite elaborate.

ROBERT CRUMB: A question about the buildings. Are those based on the real buildings?

SETH: No. They are mostly composites. Sometime they will be composed from pieces of some real building or buildings. Mostly they are just made up.

CRUMB: What are they made up of?

SETH: They are made out of FedEx boxes. I cut them up and glue them together with a glue gun and paint them with house paint. They are about this big *[gesturing about a foot tall]*, each one. Some of the skyscrapers are bigger.

CRUMB: When you have them in the attic, do you arrange them like a city block? Don't you actually ever arrange them like a real street and get down and pretend you are on the street? Like a model train set, that kind of thing?

BURNS: Did you ever play with them?

CLOWES: Do you play with your toys?

SETH: I'll tell you a sad but true story here. Years ago, maybe ten years ago, I bought a bunch of old GI Joes because I had loved them as a kid. I remember getting down on the floor and sitting there with them. And I was like—I can't play anymore. It was sad. As an adult, you just can't play.

WARE: And then your wife came home. *[laughter]*

AUDIENCE MEMBER: It seems to me that a lot of graphic narratives feature characters who are alone and kind of hapless. And there is a lot of solitude—

CLOWES: What? *[laughter]* Look at us!

AUDIENCE MEMBER: Obviously that sounds a little bit like Charlie Brown, but otherwise it contrasts with super heroes. I would be interested in whether you agree that this is true nowadays. And if it is true in your work, why is that so common?

CRUMB: Well, look at them. *[laughter]*

BURNS: Well yeah, as Robert said, *look* at them.

CHUTE: That's not a real answer!

BURNS: I know. But it is a reflection of what we do and how we live our lives. I sit in a room for, you know, twelve hours a day by myself. And that's out of choice. Briefly I worked on an animated movie. Out of choice, too. I wanted to kind of push myself out of my studio for a while to see what it would be like to work in the collaborative medium. And I quickly, immediately realized that it just, you know, it was fine, it was a good experience but it was not for me. I'm not a person who collaborates. I think all of us are trying to be relatively honest about our stories and what they reflect. And they reflect ourselves for the most part. I hope.

CLOWES: I think most artists, their sense of themselves in relation to others is shaped when they're very young. I think all of us have either no siblings or much older siblings. You look at work by the Hernandez brothers, who grew up with a big family, and almost every panel in their work is filled with people. People running around in every panel. In my work, it tends to—*[laughter at Clowes image on screen: "I HATE YOU DEEPLY"].* In this book I would look through my work and notice that, page after page after page, I always draw the same vision of like the back of a guy's head against a cityscape. I thought, well, I grew up, that was my life in Chicago as a kid sort of walking around Chicago in this sort of film noir-ish world that existed back then.

165

SETH: My two heroes when I came in were Robert Crumb and Charles Schulz, who are pretty much at two different ends of a spectrum, but in a strange way they share a lot in common. I think what I responded to most in them was a deep sense of empathy and honesty in the work that, to me, encouraged you to not simply come up with a snappy story, but to try and somehow express real and genuine feeling. I think because of that there tends to be this misconception that graphic novels are all about painful losers or crybabies. However, I think at the heart of it, it is merely that this kind of artform attracts a certain type of person who reflects a certain type of personal experience which can often be, especially because we are cartoonists, isolated situations and stories about isolated individuals.

WARE: A lot of popular culture is about destruction and winning and devastation—or *teamwork. [laughter]* So we just cover different topics.

AUDIENCE MEMBER: I was just really curious from any of you what your process of creating a narrative is and how you go about tackling such a huge feat of making a graphic novel.

SETH: I start with who I want to get back at.

CLOWES: That's a valid…I mean, you have to have some reason to start. It often is something really petty like that. You think, "I'll show them!"

WARE: When I started my *Rusty Brown* story, now, oh my God, twelve years ago, my initial thought was, I'm going to draw my childhood gym teacher getting—I shouldn't say this. But there was definitely a sense of, yeah, I want to…but then of course it had nothing to do with the story afterwards.

BURNS: I almost always have a number of false starts. I have some idea at first and I don't even realize it is not a great idea. It sounds like a good idea to me. For example, the series of books I'm working on now, I wanted to do a story about the punk era in the Bay Area in San Francisco, which I lived through. At first it was kind of a real literal version of that and I realized, here is a good note for yourself. If you are working on something and you absolutely can't stand it, it is a good time to, you know, reevaluate. That almost always happens. I'm working on something just because I want to move forward. I want to get ideas down. And I just—I'm hating it. That's the time to throw it aside and reevaluate.

WARE: That's how I feel all the time.

BURNS: The other thing is you can turn to a story that you don't know exactly what it is at first but then the story develops. And you find out that the story is about something else. And that discovery is the interesting part for me.

WARE: Do you guys feel confident about what you do? Do you sit down to say, oh, boy, I get to work on that great story I'm really proud of and I feel certain about?

SETH: Sometimes. It does happen. There is so much self-doubt involved in things. I think to make art you have to have these two conflicting—

CLOWES: Be very critical of yourself.

SETH: You've got to be filled with both some sort of feeling of high confidence that balances back and forth with a sense of self-loathing. You have to be working on it and say this is the best page I've ever done. You put it down the next morning you come in, oh—

BURNS: What you have to understand is self-loathing is very important.

CLOWES: When I was in high school I was always trying to think of a big grand idea to do a comic about. I remember I was asleep and I woke up in the middle of the night and all of a sudden I had the greatest idea for a comic in the world. And I thought, this is it. I've been looking for it. Here it is. I got up and I went over to my drawing board and I wrote it down and I went back to sleep with the feeling that I was destined for greatness. I woke up the next morning and said, "I've got to go see what I wrote." I looked at the piece of paper—I wrote: "ear phone one one ear phone."

WARE: Can I use that? *[laughter]*

SETH: Actually, if I was going to give any advice to somebody starting out, it would be: try to analyze what it is you are actually attracted to, what kind of art you like. Genuinely try to nail it down—figure that out. Because a lot of times you don't know why you are doing things. Every once in a while a thought will occur to me and I'll realize, "Oh, that's why I like all those movies—because they all have this specific thing in common." Understanding why you are attracted to specific ideas or images will really help you make the art you want, rather than the art you *think* you are supposed to make. It's harder to simply do what you want. It's hard to know yourself.

AUDIENCE MEMBER [Oscar Chavez]: This question is inspired, definitely, by Dominion City and the creation of the cardboard city. I'm interested in why all of you are interested in world creation as well as historiography. All of you, each in a very different way, are interested in rewriting or writing, creating histories, sometimes about fictional places and sometimes about very real places. I'm thinking of the World's Fair and what you did in *Jimmy Corrigan*, Chris. I'm also thinking about *Black Hole* and some of the things you did, Charles. Then *Ice Haven,* of course.

SETH: Dan, I think, made a very good reference in one of his strips where he has depicted himself as God looking down on his little world of characters. There is, I think, a strong impulse for world building in cartooning. This is a private world you've created. It is your world. All fiction is world building, of course. Every story that anybody writes is a fictional world, has been created. But with cartooning the fact that you are drawing it, too, rendering it out, takes it one step further toward a physical reality. I'm not willing to swear that it is really that different from any other kind of visual narrative art. It feels different to me though. The combination of writing and drawing your world seems to set it apart from other kinds of world building.

WARE: There is sort of a pungency to it. There's more of a tactility to something when you draw it. Your buildings and your drawings, Seth…and Dan's *Ice Haven*, too—the way you divided the pages and did them as individual Sunday strips—you can almost feel it within you. Whereas if you were just reading about it, you'd kind of have to assemble it in your brain.

SETH: That's true. The entire art of the cartoon is the art of the miniaturist. You are drawing little people in little boxes. It is very much a doll-house experience. Moving your little dolls around. I think that really does appeal to that same quality of how a miniaturist operates. If you have ever seen those amazing medieval carvings, in which artists have carved whole little worlds inside a sphere, that reminds me tremendously of the cartooning impulse. There is a great sense that you are sculpting out your own tiny little world in these boxes on a page.

WARE: Really what it comes down to is what Seth was saying, when you start working on something it starts making itself. That's the creative process that they try to flog out of us in art school and try to create this overriding self-consciousness that will completely prevent you from ever doing it again. It's that thing that we can all do as kids with a blank sheet of paper: start in one corner and start creating this place. Just going through art school, I had to figure out a way to get back to that. It was seeing comics like Robert Crumb's and the stuff in *RAW* and even the superhero comics I read as a kid—I had to get back to that feeling that I had as a kid and starting from zero and creating something and letting it happen rather than feeling like I had to plan it out and have some overriding stupid idea.

SETH: I think you once said, Chris, something along the lines of, making art is like an opportunity to correct the errors of the past.

CLOWES: I think that was Hitler. *[laughter]*

AUDIENCE MEMBER [Benjamen Walker]: I read all four of you in a serial nature, in the 1990s. So I can remember when particular issues of *Eightball* or *Black Hole* or *ACME Novelty*—all four of you were publishing serial. But as a reader I think the serial nature between issues was very important in why I have such a strong affection for so many of these projects. I'm curious if you could all speak, as creators, is that serial nature as important to you individually?

CLOWES: I think back in the early 1990s there was a real culture built around the comic book. People who were not your typical comic fan were coming into the comic shop for the first time. There was this real kind of excitement of getting a new audience for these comics and everyone was waiting for the new issues of these things, and we were trying to crank them out as quickly as possible. At a certain point I got so slow that I was taking over a year in between issues and it just—that whole serial nature became absurd. Like I had a comic that ended with a cliff hanger, of a bullet going into a guy's head and it finally struck eighteen months later.

WARE: I think we're all inspired by the underground; certainly getting a Crumb comic, whether it was a reprint of something from when we were kids, or the later work.

SETH: Individual comics, too. Generally they weren't serialized. You would buy one and that was the object itself. Nothing else needed. I didn't think there were cliffhanger endings.

But there was something else interesting about that time, as well; it was pre-Internet, and that was important. There was a special quality that if you discovered the comics in the 1980s, the "alternative" comics, or whatever they were called, that discovery was part of the very nature of their appeal. The serialization wasn't so important as the idea that you had chanced into a subculture of some sort—a world that you didn't know about. Something inherent in the Internet would make that completely meaningless today. You'd simply Google, then click, and order your comic. There was something essential about having to make the extra effort to discover and acquire the comics that was part of the experience. It was how you slowly learned about that little world. You would buy an issue of *Weirdo* and you might say, who is this fellow J.D. King? Then you would attempt to find out more—explore that a bit. You had to reach out into the culture in sometimes difficult ways to find out about things. And that made you an active participant in that world. It is not really the same anymore.

WARE: Newsprint was the fiber-optic cable of the nineteenth and twentieth centuries. I'm still drawing a serialized story on an erstwhile basis just because—I kind of like the idea. I do a hard cover maybe every year and a half or two years; serialized chapters, just to say, "I am done" with this or that part.

BURNS: But your books are so self-contained, the ones that you've serialized. They feel like complete things.

SETH: That's the thing about your books, Chris: they feel complete, so you are surprised when you discover how seamlessly they fit together. They are fully integrated with each other. Yet you could pick up one of them and think that what you'd just read was the entire story.

AUDIENCE MEMBER: I was thinking of Ware for this one. Because you experiment so much with different page formats and ways to guide the viewer's eye, I was wondering if it is more common, the impulse to think, "The only way I can tell this narrative is by arranging the panels in a unique way." Or if it is more common that you are really excited about trying a new format and then you make the stories suit that unique format.

WARE: I start in the upper left-hand corner and I draw, and whatever happens, happens. It is not planned at all. I might occasionally do a thumbnail because I know I want one image to be larger than the others, but it is entirely based on not only what I have in mind for what I want to have happen on a page, but, more importantly, what happens when I draw one picture and what occurs to me in my own memory, and then how that keys into the story itself. So it is entirely driven by the story. Sometimes it goes in directions I had no plans towards at all.

167

AUDIENCE MEMBER: You don't figure out a story arc?

WARE: One of the advantages of drawing comics is that, as a cartoonist, you're sitting in this almost hermetic environment, staring at this blank page and everything that you draw, no matter where you think it is coming from—"beyond," whatever—it is not, really. It is still always from within your mind. It is a part of your memory...and it comes out in an amazingly organized way, even if you try to not organize it. All of it is strangely connected in your own mind. I'm not trying to impose a sort of an artsy experimentalism on what I write, or anything; I find that the more I *try* to connect things, the less it works. But if I just kind of let it come out the way that it wants to, it seems to actually be more connected, and make more sense.

UNFOLD➤

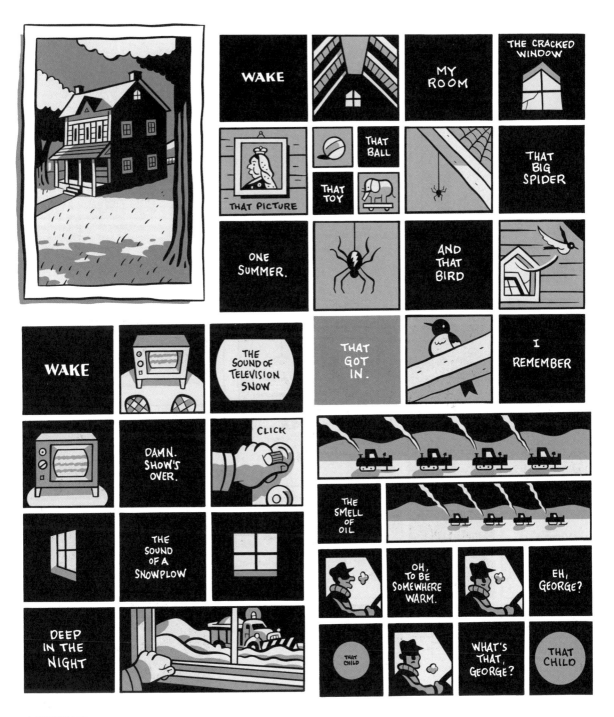

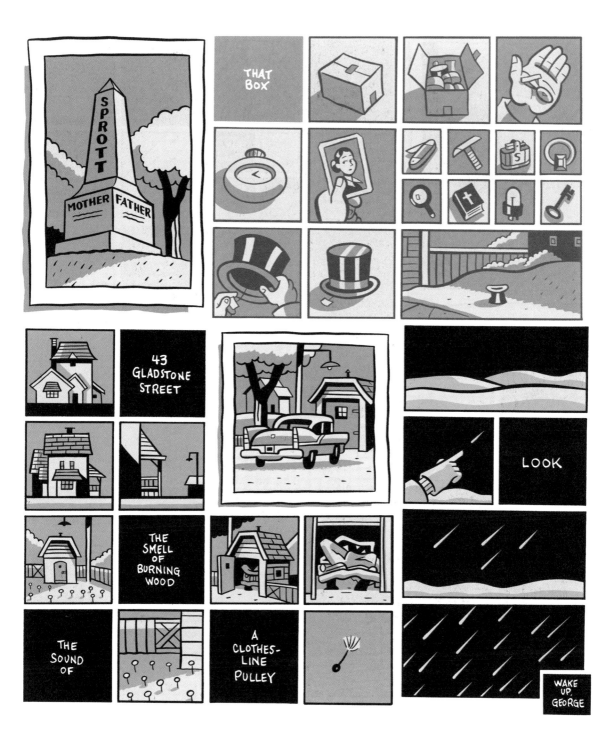

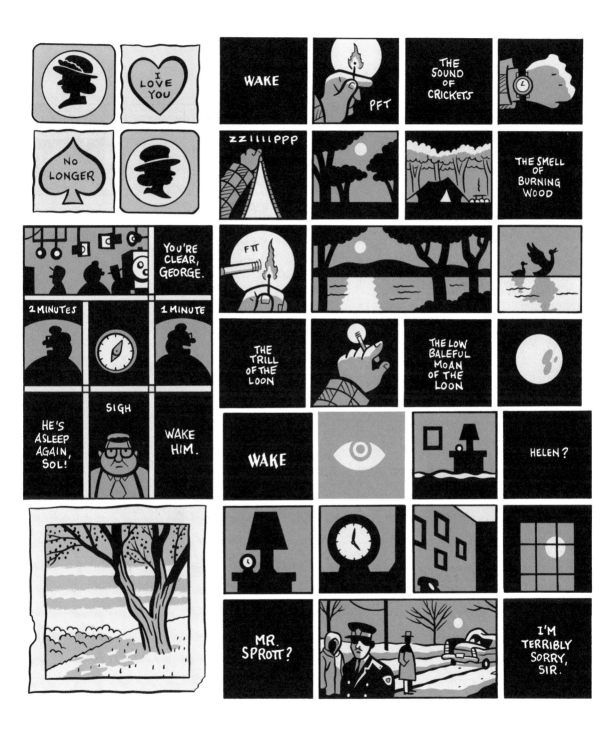

MORE FROM THE MAN HIMSELF

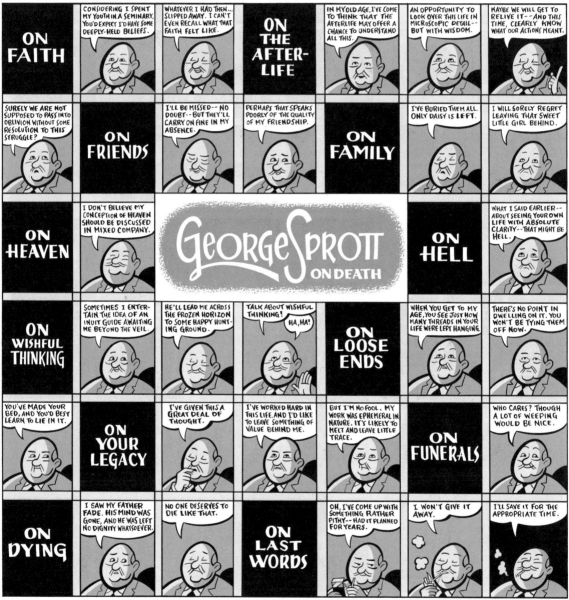

A Language of Scratches and Stitches:
The Graphic Novel between
Hyperreading and Print

Katalin Orbán

p-book, n. A paper book (cf. e-book).[1]

In one of the memorable media historical anecdotes of the electronic Stone Age that was the 1970s, security officials learned about haptic reading the hard way when the classified documents hastily shredded before the takeover of the US embassy in Tehran were painstakingly reassembled by hand. The unshredding was not done by intelligence officers but by specially hired local carpet weavers. As the deputy director of the National Security Archive at George Washington University commented, "for a culture that's been tying 400 knots per inch for centuries, it wasn't that much of a challenge."[2] The different time scales of abstract mathematical possibility and human activity are important elements of the unexpected reconstruction, yet the story reveals more than a case of absurdly patient reading. It is also a demonstration of the curious fact that if you cannot read a document with your eyes like an intelligence analyst, you may still be able to read it with your hands like a carpet weaver—a shift that acknowledges reading as a genuinely multisensory experience. The *New York Times* article mentioning the Tehran unshredding incident (on the occasion of the more recent electronic reassembly of Stasi files) calls the weavers' method "crude," a label both naïve and arrogant in equating predigital slow technologies with a lack of sophistication.[3] In fact, the role of touch in the embodied reading process can vary in subtle, often unconscious ways, although the significant cognitive consequences of this multisensory experience, which normally go unnoticed, may require cultural confrontations as bizarre as analysts versus weavers to appear.

In the following pages, I will present graphic narrative as a site of reading that merits attention precisely because of the cultural contestation and rival practices it dramatizes in its embodied, multisensory reading process, though in this case we will abandon the differ-

ent weaving (and unraveling) methods of text and textile for paper and screen. When viewed in a broad cultural-historical context, the increasing prominence of graphic narrative in mainstream and even canonical culture—particularly through the invention and development of the graphic novel genre—pinpoints the intersection of two often-related processes. One is the increasing prevalence of hyperreading and hyperattention, and the other is a move away from stable material forms to increasingly volatile and adaptable digital, virtual forms. While these two processes often go hand in hand, there seems to be a tension between the hyperreading encouraged by the multimodality of graphic narrative (its use of different systems of signification) and its enduring reliance on the printed book. Although digital comics (born digital or migrated from print) confirm the broader technocultural trend in which nonlinearity, multitasking, and digital environments are seen as mutually conducive, web comics are just as often a stepping stone to print publication, and plenty of graphic narratives call for a print-based hyperreading without moving to screen reading and surfing. After establishing that this is a significant cultural constellation both in the aesthetic and publishing paradigms, I will examine how two works—Art Spiegelman's *In the Shadow of No Towers* and David Small's *Stitches*—utilize this special position to explore a new sense of materiality that belongs neither to a nostalgic dependence on predigital materiality nor to hyperreading in computer environments.[4]

The concept of hyperreading emerged quite recently (1999) in the context of digital literacy and screen-based reading. James Sosnoski links it to the common operations of computer-assisted reading (such as searching and commenting) and emphasizes the constructive aspects of reading from and across texts, singling out behaviors such as

1. Paul McFedries, "P-book," *Word Spy: The Word Lover's Guide to New Words*, www.wordspy.com/words/p-book.asp

2. Quoted in Douglas Heingartner, "Back Together Again," *New York Times*, 17 July 2003, www.nytimes.com/2003/07/17/technology/back-together-again.html

3. Ibid.

4. See Art Spiegelman, *In the Shadow of No Towers* (New York, 2004), hereafter abbreviated *I*, and David Small, *Stitches: A Memoir* (New York, 2009), hereafter abbreviated *S*.

keyword filtering, pecking, trespassing, and fragmenting.[5] Based on subsequent neurological research, Katherine Hayles adds that hyperreading also "stimulates different brain functions than print reading." While she considers hyperreading a healthy response to an information-intensive environment and rejects its criticism as sloppy or dumb reading (basically a deterioration of literacy), she admits that this new kind of literacy impairs the old one (as it "may be involved with changes in brain architecture that makes close reading more difficult to achieve").[6] Armando Petrucci observed this in cultural-historical terms as an effect of nonreading practices as early as 1990, stating that (1) reading is no longer the primary form of acculturation, its role in mass culture having been replaced by that of television, and that (2) these differently acculturated people read books with the kind of jumpy, less progressive reading that used to characterize uncultured readers.[7] The shift is important, however. What Petrucci sees as a contrast between reading and audiovisual environments will appear in Hayles as a split within reading. The set of cultural habits that Petrucci sees (precluding slow, progressive reading for many contemporary readers even in a classically suitable environment for undisturbed individual reading, say a quiet room with a single printed book on the table) become in Hayles's terms "changes in brain function" and "brain architecture." She has some reservations about individual studies that argue for particular ways our brains are being rewired by "a constant state of distraction," pointing to several methodological problems, but she agrees with the larger phenomenon of hyperreading undermining deep attention (*HW*, p. 62).

While I do not want to equate hyperreading with the reading of comics, the affinities are significant enough to warrant this application. To name just a few of the liberties I am taking with the original concept of hyperreading, the dynamism of reading comics is not database driven (its mixed signs are permanently arranged and cannot be pulled and rearranged through searches); the visible areas and details of comics offer a more homogeneous and continuous "information-intensive environment" for browsing and flexible switching than plural "information streams" to be selected or abandoned (*HW*, pp. 61, 69). At the same time, even linear graphic narratives involve a fundamentally divided attention. A linear narrative of uniformly–sized panels in a conventional reading order— a reductive use of the medium's complex possibilities— would still involve different levels of overview, the reader's attention moving sequentially as well as in and out of local details, dealing with images embedded in other images and with visual information connected to words and con-

tained within the graphic lettering itself. The seemingly uniform panels may, in fact, show important variations in their verbal content (dialog-driven or silent panels; words connected to another panel). The identity of discrete components and possible links between them are not trivial either even in such a straightforward panel arrangement, let alone in sophisticated constructions of narrative and page layout; the components' narrative, temporal, spatial, verbal, and visual connections almost never coincide in a single mandatory path and rather compete as alternatives. This does not fully equate the state of distraction associated with hyperattention, as I will show later in the discussion of Spiegelman's and Small's books, but it is a type of dynamic multitasking akin to and supported by browsing habits. Given this, graphic narrative should flourish in the digital "native habitat" of hyperreading, and one might not expect substantial hurdles or major alterations in the transition process. However, the seemingly perverse alliance of hyperreading and paper in graphic narratives is not a random contingency and, for that reason, not so easily jettisoned.

Graphic narrative's potential investment in the medium of print is, of course, inseparable from the embattled cultural prestige of comics, a subject exhaustively covered in comics scholarship.[8] The graphic novel in particular has emerged as a product of the gentrification of comics into a canonizable literary form over the last twenty years, moving selected long-form comics from a literacy discourse to a literary one. In this move the category of literature and the format of the codex book mutually imply and confirm each other, allowing graphic narrative to appear as a book both on the market and in reception, being distributed in book stores and reviewed in nonspecialized publications,[9] while infusing the literary with the kind of multimedial and nonlinear forms and reading habits that are central to the profound contemporary transformation of the book and the "new brains" of its readers. If, as Thierry Groensteen argues, the dominance of multimedial visual culture is reversing the word-image hierarchy rooted in the logocentrism of alphabetic cultures and (see "W," p. 36), as Jay Bolter suggests, we live in an environment of reverse ekphrasis (words described by pictures), graphic narratives can perhaps hook the native inhabitants of that world. A recent collection on "how librarians learned to love the graphic novel" makes several references to this capacity of the genre and always against the backdrop of the dominance of electronic culture: "in a world that is going more and more with digital content, graphic novels are one of

5. See James Sosnoski, "Hyper-readers and Their Reading Engines," in *Passions, Pedagogies, and 21st Century Technologies*, ed. Gail E. Hawisher and Cynthia L. Selfe (Logan, Utah, 1999), pp. 161–77.

6. N. Katherine Hayles, *How We Think: Digital Media and Contemporary Technogenesis* (Chicago, 2012), pp. 61, 62; hereafter abbreviated *HW*.

7. See Armando Petrucci, "Reading to Read: A Future for Reading," in *A History of Reading in the West*, trans. Lydia G. Cochrane, ed. Guglielmo Cavallo and Roger Chartier (Amherst, Mass., 1999), pp. 345–67.

8. See Thierry Groensteen, "Why Are Comics Still in Search of Cultural Legitimization?" in *Comics and Culture: Analytical and Theoretical Approaches to Comics*, ed. Anne Magnussen and Hans-Christian Christiansen (Copenhagen, 2000), pp. 29–41; hereafter abbreviated "W."

9. The Francophone tradition with its substantial institutions and scholarly reception from the 1970s has suffered far less from this ambivalence and mutual suspicion between comics and high culture, and the *bande dessinée* has accordingly survived without any extra emphasis on the book or ties to prestigious literary genre labels.

the last varieties of the printed form that are gaining in popularity as each year goes by";[10] "at a time when most academic libraries are busy responding to the electronic research needs of their patrons, comics and graphic novels are a resilient reminder of print culture."[11] By contrast, in the PR invention of the graphic novel as "the new novel" in the late 1980s and early 1990s, the alleged novelty was often located in postwriting and postprint culture: "heralds of a new era in visual literacy" and "'literature for the post-literate generation.'"[12] For one thing, this prediction seems to have underestimated the time lag between technological advancement and a more conservative transfer of cultural prestige trailing behind it. This lag and the special stakes of elite sanctions for graphic narratives may partly explain why the medium, while thoroughly embedded in a multimodal reading culture, is not less but more attached to paper and print than purely textual books in more pedigreed genres.

Secondly, while the remediation of comics for digital platforms offers numerous benefits of "true" hyperreading, such as interactivity or dynamic animation, it also seems to alter profoundly the alliance of sequential exploration and visuo-haptic processing that has become a specific modality of processing graphic narrative. Roger Sabin gave some early insight into the obstacles to a successful transfer of comics to the web, seen by many as the solution of the—primarily economic—disaster in the comics industry. Writing in 2000, he enumerates several economic, technical, and aesthetic factors: for instance, the limitations of web and computer access may not match the portability and affordability of print comics, and the reading of web comics is less immediate due to downloading and screen size.[13] Many of Sabin's objections are obsolete today (especially the technical ones solved by cheap web payment systems, fast downloads, portable devices, eye-friendly e-paper, and more affordable access to internet services). The concerns in this over-ten-year-old study that seem most intact are the different topographies of page and screen and the tactile, sensual qualities of creating and reading comics predigitally.

[Comics] can be bent, rolled-up, roughly opened or whatever. They can be held in different ways:

cradled in your hand or gripped at the edges. We know how far into a comic we've read because we can feel how many pages are left. There are also smells: of dust, glue and paper. Compared to this very sensual experience, clicking a mouse just isn't the same. This question of tactility is magnified when it comes to actually creating comics.[14]

Interestingly, of the spatial and sensual aspects of comics extolled in these elegiac comments, spatial ones are turning out to be the more robust obstacle to remediating the specific haptic modality of print comics for the screen. Questions of prestige aside, the importance of the haptic modalities of reading graphic narrative in print are confirmed by neuroscience research, where it has been established that visuo-haptic processing is especially suited to sequential spatial exploration. Experiments on children's reading acquisition, for example, have shown the involvement of the haptic modality to have measurable effects on memory and association[15] and to be more analytical and less global than purely visual perception.[16] If this is the case, the reading of the graphic novel suffers more—even at the level of cognitive processing—from a sense of relative haptic deprivation than other kinds of narratives.

It is hard to judge the relative importance of cultural legitimacy and haptic investment in graphic narrative's attachment to print despite its kinship with hyperreading. Still, a significant change in the haptic experience of reading electronically—through a combination of technological development and a naturalization of new interfaces—is most likely a precondition for the continued replacement of printed graphic narratives by digital publication forms. A key area of development in touch screen technology,[17] such advanced haptic interfaces have the capacity to diminish the difference between the print text experienced as permanently integrated with its material base and the digital text experienced as "ontologically intangible and detached from the physical and mechanical dimension of [its] material support"[18] (a rapidly evolving range of fixed and portable devices). Haptic response—a buzzword, if there has ever been one—can thus contribute to a specific materiality of digital graphic narrative that sustains a meaningful tactile connection to

171

10. Robert Weiner, "Introduction," in *Graphic Novels and Comics in Libraries and Archives: Essays on Readers, Research, History and Cataloging*, ed. Weiner (Jefferson, N. C., 2010), pp. 5, 118.

11. Richard Graham, "The Spinner Rack in the Big Red and Ivory Tower: Establishing a Comics and Graphic Novels Collection at the University of Nebraska-Lincoln," in *Graphic Novels and Comics in Libraries and Archives*, p. 118. This may change once affordable digital comics lending programs are launched in libraries (iVerse Media was launched recently, and others will most likely follow).

12. Roger Sabin, *Adult Comics: An Introduction* (New York, 1993), p. 93.

13. See Sabin, "The Crisis in Modern American and British Comics, and the Possibilities of the Internet as a Solution," in *Comics and Culture*, pp. 43–58.

14. Ibid., p. 52.

15. See Benjamin Fredembach, Anne Hillairet de Boisferon, and Edouard Gentaz, "Learning of Arbitrary Association between Visual and Auditory Novel Stimuli in Adults: The 'Bond Effect' of Haptic Exploration," *PLoS one* 4 (Mar. 2009): www.plosone.org/article/info:doi/10.1371/journal.pone.0004844

16. See Florence Bara et al., "The Visuo-Haptic and Haptic Exploration of Letters Increases the Kindergarten-Children's Understanding of the Alphabetic Principle," *Cognitive Development* 19 (July–Sept. 2004): 433–49, lpp.psycho.univ-paris5.fr/pdf/1492.pdf

17. The use of piezoelectric actuators for the output of haptic sensations is the subject of several recent patents and applications; see Louis B. Rosenberg and James R. Riegel, "Haptic Feedback for Touchpads and Other Touch Control," US Patent 8,049,734 B2, filed 15 Nov. 2007, and issued 1 Nov. 2011.

18. Anne Mangen, "Hypertext Fiction Reading: Haptics and Immersion," *Journal of Research in Reading* 31 (Nov. 2008): 405. For a theoretical critique of equating the truth of the digital image with the intangible ideality of pure code, see Johanna Drucker, "Digital Ontologies: The Ideality of Form in/and Code Storage or Can Graphesis Challenge Mathesis?" *Leonardo* 34 (Apr. 2001): 141–45.

the text. Yet, such pulses and vibrations may reach the reader within a very different spatial experience, for the effects of a screen interface on the panel layout of the page can profoundly alter the possibility of spatial exploration itself, for example by removing off-screen elements from physically experienced space.[19] The alternation and parallel processing of verbal and visual components through different levels of overview and detail, which characterize even linear graphic narratives, may be remediated through multiple windows and various magnification tools,[20] but incomplete pages or even panel-by-panel viewing can become the dominant reading mode in the interest of "onscreen legibility" (especially on smaller devices). [21] Besides affecting the digital migration of comics with a preexisting page layout (where legibility vies with the rival priority of archival or aesthetic fidelity),[22] this also informs the remediation of comics topography across multiple platforms.

Therefore graphic narrative is hardly confined to print today, and extensive experimentation with print and digital formats and distribution can be expected to continue along with migration in both directions. Yet, it is the print-based graphic narrative integrated with the form of the codex book that uniquely encapsulates the larger cultural transition dispersed in the platforms, formats, modes of reading, and models of distribution characteristic of convergence culture. (How firmly the medium-specific sense of reading comics is still tied to print is shown when even a digital comics publisher praises the ability of his application to handle page layouts as coming "closest to emulating how we read comics," tout court.)[23] While the combination of multimodality with a renewed emphasis on materiality is relevant to the medium as a whole, I will offer a detailed analysis of two works that reflect on this connection more acutely. Rather than typifying the diverse works within the medium, Spiegelman and Small illustrate what makes graphic narrative a culturally significant medium at this time. *In the Shadow of No Towers* and *Stitches*, both written over the past decade, make distinct use of the material qualities of print media

172

in their multimodal reading space as part of a larger project of reaffirming embodied experience.

Touch Wood—Embodied Perception and the Materiality of Print in *In the Shadow of No Towers* and *Stitches*

In the Shadow of No Towers, Spiegelman's creative response to 11 September and its aftermath, illustrates a strong version of the argument, as the reconstructed diary of the author's personal experiences takes both hyperreading and bookness to extremes. It encloses a topologically fragmented, dynamic—figuratively exploding—reading space in an emphatically material superbook. While the breaking up of the reading space responds to the event, the tactile visuality of the object intervenes in the networked imaging of 9/11 as a televisual spectacle that threatened to supplant physical, local presence as a primary experience of the event.[24] The inescapable materiality of *In the Shadow of No Towers* weighs on the reader from the start (it weighs in at one pound twelve ounces, in fact). Its thick cardboard and large format push the material quality of the book into the sphere of recognition and, to a great extent, materially counteract the structural effects of its original serial publication. The book is, in fact, a complex exercise in salvaging and consolidating fragile and perishable serial formats into a permanent object: a cardboard monument perhaps not more lasting than bronze, but lasting enough. It not only assembles its own immediate antecedents—the prior serial publication in *Die Zeit* and other periodicals—but also incorporates a longer prehistory by other creators in a comic supplement section nearly equal to Spiegelman's own. This move—which reflects both the common life cycle of graphic narrative from comic book to trade paperback and its longer evolution into increasingly prestigious and permanent forms— gives additional emphasis to the historical embeddedness of material objects accumulated and transformed over time and bearing the marks of time's passage, making

19. This disappearance of the unviewed is an important aspect of e-book acceptance more generally. See Jin Gerlach and Peter Buxmann, "Investigating the Acceptance of Electronic Books: The Impact of Haptic Dissonance on Innovation Adoption," *ECIS 2011 Proceedings*, aisel.aisnet.org/ecis2011/141

20. Options include local magnification tools producing enlarged details superimposed on an overview (as in Marvel's online comics reader), zooming in and out (by double-clicking a page on the ComiXology website), or the lack of remediation (the online version of Sarah Ellerton's *The Phoenix Requiem*—since published in print—offers no dedicated solutions against cropping or for viewing details, putting the layout at the mercy of the user's device).

21. Darren Wershler "Digital Comics, Circulation, and the Importance of Being Eric Sluis," *Cinema Journal* 50 (Spring 2011): 131. Wershler compares digital reeditions of Marvel Comics's *The Fantastic Four* on various platforms (DVD and online). Shaped by contingencies of hardware, software, and, most importantly, the screen dimensions relative to the panels and the page, this emerging aesthetic can vary significantly across devices; a comics application for a mobile phone may render the page a mere "organizational concept" to group pictures rather than an image or a space, as Wershel notes (p. 133). On the other hand, an application optimized for a larger tablet computer and long-form graphic narratives may allow us to "see the full page before we see the panels, and the impact of each panel is therefore exactly as its creator intended" (David Brothers, "Digital December: IDW Launches Digital Graphic Novels on the iTunes App Store [Exclusive]," *Comics Alliance*, 20 Dec. 2010, comicsalliance.com/idw-digital-graphic-novels-itunes/)

22. See Wershler, "Digital Comics, Circulation, and the Importance of Being Eric Sluis," pp. 133, 131.

23. Brothers, "Digital December"; emphasis added.

24. For a more detailed analysis of the visuality of 9/11 and the Holocaust, see Katalin Orbán, "Trauma and Visuality: Art Spiegelman's *Maus* and *In the Shadow of No Towers*," *Representations* no. 97 (Winter 2007): 57–89.

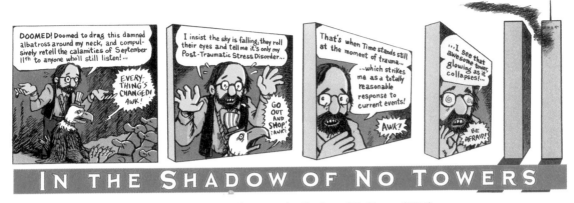

Figure 1. Art Spiegelman, *In the Shadow of No Towers* (2005).

each object (even originally identical copies) unique.[25]

The text as material object is also emphasized through the tactile layering of its surface, achieved through variations of surface that gesture towards the artist's book, yet are more distinct, articulated, and deliberate than the effects of rich physicality and material variation of surface resulting from traditional printmaking technologies. On the covers and spine that frame the book, the alternation of glossy and matte areas calls attention to the physical superimposition of certain images and letters on others. The less detail these glossy shapes contain (the black-on-black towers and cartoon characters), the more striking their reflective quality, which optically highlights the surface (you can literally see yourself in the mirror of these images) yet confirms the materiality of this surface as part of a textured object in a tactile way. Where the physically existing three-dimensional object brushes against its environment, this layering also changes as the history of use gets written on the covers in a language of smudges and scratches. Layering is more illusory inside, where different drawing and painting techniques and tonal scales are juxtaposed and often overlap, and it is only the thickness of the cardboard that materially sustains the illusion of tactile depth. (This diversity of techniques includes computer-generated images, but the book object brings these back to the emphatic material of paper no less than the images drawn or painted with more traditional techniques.)

The sense of materiality is thus established primarily through a tactile relationship, in which hand-book contact and haptic visuality mutually inform each other. Aloïs Riegl described haptic visuality as a seeing from proximity that was literally displaced by the large cultural shift to a privileged optical distant view *(Fernsicht)* due to the parallel rise of figurative space and decreasing physical tactility in visual and decorative art. The book object of *In The Shadow of No Towers* consistently reinforces an interest in the material and tactile—restoring a haptic sense of three-dimensional space to the abstract two-dimensional flat plane through perceptions and "memories of tactile experience,"[26] occasionally bolstering this by identifying panels and pages with three-dimensional architectural objects, particularly the twin towers themselves (in the rotating panels that literally turn into a view of the towers or the stretching of page height to match the tall building represented [fig. 1]). This is part of a broader affirmation of closeness and locality (of the "'rooted' cosmopolitan" Spiegelman discovers himself to be) that relies on and gives access to the close senses of touch, taste, and smell— a richness of the nontelevisual human sensorium that is, in literal physical terms, compressed into the tactile qualities of the book (*I*, p. [i]). This is clearly a reaction to the electronic, networked imaging of 11 September—exemplified in the televisual fascination of infinite replay on CNN (see *I*, pp. 1, 2, 8)—or, more precisely, to the conditions that made 9/11 a disaster crafted for a world of hyperattention. It is not a simple rejection, however, but rather a difficult renegotiation of the status of experience in convergence culture, in which the validation of real materiality through the demystification of unreal images misses the point of the "changing dynamics of embodiment and perception." As Laura Tanner adds in her corrective to dismissive assessments of Ground Zero pilgrimages and the public's allegedly naïve desire for contact: "Caught up in the experiential dynamics of changing

173

25. For an alternative view, emphasizing references to the serial and ephemeral over the integrity of the book object, see Hillary Chute, "Temporality and Seriality in Spiegelman's *In The Shadow of No Towers,*" *American Periodicals* 17 (Autumn 2007): 228–44. In fact, the act of incorporating ephemeral variants and precursors into a single material instantiation is all the more forceful, because it consolidates these elements from sources widely dispersed in space and time (New York, Los Angeles, London, Germany, Italy; between 11 September 2001 and 16 February 2004) rather than from a single regularly published series. While Chute links the effects of traumatic fragmentation in the text to serialized antecedents, I will link them primarily to the multimodality of graphic narrative, the sequences and breaks of which are not identical with those of serialization (the latter arguably not as intact, once incorporated into the book, as she suggests).

26. Aloïs Riegl, *Historical Grammar of the Visual Arts*, trans. Jacqueline E. Jung (1966; New York, 2004), p. 187. Using the term *haptic* in his earlier work, Riegl prefers the term *tactile* sense in this unfinished, posthumously published text. His account of weakening tactility followed the formative period of German research into human haptic perception in the late nineteenth and early twentieth century by Ernst Heinrich Weber, Max von Frey, and Max Dessoir, which attempted to define the tactile sense and renegotiate its position in the hierarchy of senses, a status that had long wavered between extreme denigration and high esteem. See *Human Haptic Perception: Basics and Applications*, ed. Martin Grunwald (Boston, 2008), pp. 15–38.

174

Figure 2. David Small, *Stitches: A Memoir* (2009).

forms of embodiment not yet fully understood or articulated, the public often insisted on seeking the referent of affect at the intersection of the 'natural' body and the stable object world."[27] Given the shock and devastation of the attacks, the scale of this insistence was exceptional, but the difficulty of correctly responding to the experience of the event was rather exemplary of the troubled status of real contact and experience more generally.

The zone of proximity that *In The Shadow of No Towers* valorizes through its haptic visuality is no less important for Small's memoir of a disturbing and terrifying childhood—one plagued by silence, emotional distance, illness, and disability—but *Stitches* inhabits this zone differently. Instead of foregrounding embodied experience through the materiality of the multimodal text engaging our bodies, it foregrounds the vulnerable material body with its epidermal surface and intricate layering as it takes shape in the book object. Whereas Spiegelman invites us to hold his book and close the distance of idealized optical vision by approaching the multimodal text bodily, Small invites us close to the book as an imperfect body; where Spiegelman insists on our embodied experience of reading as an approximation and trace of his effort to reenvision a reality evaporating in a thoroughly mediatized spectacle, Small creates a material form that bears witness to his embodied experience in the body of his book. Spiegelman's is a historical challenge taken personally: to reorient the reader from the "awesome" sublime of 9/11 to

27. Laura E. Tanner, "Holding on to 9/11: The Shifting Grounds of Materiality," *PMLA* 127 (Jan. 2012): 60, 63–64.

a more contingent history that does not transcend material bodies and traces (*I*, p. 1); Small's is a publicly relevant personal challenge: how not to relinquish his loss of voice to a metaphorical interpretation, a set of culturally ascribed meanings based on abstracting truth, subjectivity, and disability from embodied experience.

Stitches is a mostly chronological though lacunar account of Small's childhood and early youth in Detroit from age six to thirty. The main narrative thread follows protagonist David's successive illnesses while also incorporating various episodes of family prehistory. In a difficult, disturbed family of many secrets and as many styles of dysfunctional communication (say, the language of cupboard slamming), David identifies the language of symptoms as his own: "getting sick, that was my language" (*S*, p. 19). The key event in this story of symptoms is the throat cancer David develops as a result of his radiologist father's X-ray treatment of his sinus problems and the nearly complete loss of voice he suffers as a result of his throat operation (possibly because his frugal parents postpone the operation for years).

Both this narrative and its representation revolve around the relationship between the epidermal surface and the interiority inherent in the three-dimensional space of the body, a relationship introduced in the book's opening pages. A three-panel epigraph simultaneously embraces and questions paper as a surface. It shows a child magically diving through a blank sheet of paper laid out for drawing, leaving behind three unused crayons scattered in a corner of the sheet (fig. 2). By rupturing the plane and partially disappearing through it, the character we soon come to identify as David reveals the liberty that depthless graphic media has on the constraints of space that usually rules physical bodies. At this point, the character's and the creative artist's clever trick appears as a self-reflexive visual wordplay or a sight gag, based on a "double sense" of visual language in comics and animation that depends on the material identity of a visual element in its autonomous and referential functions.[28] Each of the three outlined blank sheets (penetrated by the diving boy) is materially identical with the blank sheet of the frontispiece of the physical book. The blank page is simultaneously the surface of representation and its referent, the joke working in the oscillation between the truth of the fantastic reality referenced by the lines and the truth of the surface marks (lines) themselves as the only reality. This involves two degrees of an imaginary flattening of space. The three-dimensional imaginary space of the drawing—emphasized through light and shadow and corresponding to the character's movement—collapses into the flatness of the page; the real space—occupied by the book object held by a corporal reader—collapses into an abstract plane subject to a mute and disembodied act of reading. When first encountered, these panels are simply a playful invitation to dive into the still-unseen world of the book awaiting one behind the title page. Their fuller

meaning only emerges later in a richly detailed narrative context (see *S*, pp. 56–63), when the visual trick turns out to herald the book's engagement with both the page as plane and material object and the body as surface and interiority, both subject to breaks fantastic and real.

The body first appears as an enclosed and embattled space of interiority vulnerable to an intrusive, normative outside that is institutionalized as a care for the body. This negotiation between inside and outside also involves the question of meaning: how is one's subjectivity connected to what can be read from the body (whether directly on the surface or from its depth)? The body's surface is registered in the hostile world of shots and enemas in the narrative, while its depth emerges through speaking wounds, inaudible shouts, and subjective travels into the body's interior. The moment David is born, his body fails to meet a preexisting standard, a failure that propels the entire narrative. "I was born anxious and angry. My sinuses and digestive system didn't work as they should have" (*S*, p. 20). This body is introduced as disabled—diverging from a normative standard understood not as a fantasy but a functioning reality of the complete and self-sustaining human subject. Symptoms indicate interior malfunctions that challenge medicine with the difficulty of direct perception and access, a challenge met with a host of violent intrusions and dislocations of the body (shots, enemas, cracking the neck, and X-rays) to bring it back to normal and to facilitate a better flow between its inside and outside (see *S*, pp. 20–21).

These early panels present the body—both verbally and visually—in terms of its vulnerable, discontinuous surface (its orifices ever anxiously awaiting the next medicine-filled spoon or enema tube), as a negotiation at a permeable epidermal borderline about what is properly inside and outside. (*Stitches* will also build up the materiality of the paper-based multimodal textual object out of this body, but far more gradually than Spiegelman's invitation to haptic visuality.) The litany of low-tech manipulations and violations of the permeable body (including later examples of suicide by drinking Drano, the nails of crucifixion, burning hands with scalding water, and others) are juxtaposed with a more magical, futuristic medical technology of visualization, the x-ray as wonder vision and cure (see *S*, pp. 73, 87, 93). "Piercing the unknown with radiology" proclaims an ad featuring an army of doctors "marching bravely into the bright and shining future" (*S*, p. 27). This mode of visualizing the interior points towards the nascent "'nanopolitics'" of difference, which, as Paul Gilroy explains, "not only departs from the scalar assumptions associated with anatomical difference but accelerates vertiginous, inward movement towards the explanatory power of ever-smaller scopic regimes."[29] Yet, under the spell of the unseen and unseeable, this seemingly less violent, enhanced vision of the invisible interior turns out to be the most aggressive, even lethal of them all. This is implied, well ahead of any

175

28. See María Lorenzo Hernández, "The Double Sense of Animated Images: A View on the Paradoxes of Animation as a Visual Language," *Animation Studies Online Journal* 2 (2007), journal.animationstudies.org/category/volume-2/maria-lorenzo-hernandez-the-double-sense-of-animated-images/

29. Paul Gilroy, "Scales and Eyes: 'Race' Making Difference," in *The Eight Technologies of Otherness*, ed. Sue Golding (New York, 1997), p. 193.

revelation of the actual damage, by the dramatic contrast between David's fragmented, disjointed experience of the X-raying process and the machine's view of him (see *S*, pp. 22–23). Unlike the patient, his X-ray portrait smiles, bringing a better, "cured" David to the surface—if not to his own skin, at least to that of film as a sensitive substitute. The same structure of decomposition will return, as if to finally confirm the initial intimation of destruction, in the scene of the father's confession (though no apology) many years later (see *S*, pp. 289–91). This quietly lethal ambition of a penetrating vision is also echoed in the ubiquitous prosthesis of spectacles. The hostility of these technologies of enhanced visualization—in league with medical efforts to disclose the secrets and mysteries of the body—is visualized in the appearance of spectacles as eyeless blank lenses signaling a cruel or at least impenetrably incomprehensible human being who intentionally, mindlessly, or unwittingly mistreats the child protagonist in his or her care (fig. 3).[30]

When the visual epigraph returns in a full narrative context, it integrates these bodily concerns with questions of the material book as a created world, as the sheet of paper is mapped onto the body's epidermal boundary (see *S*, p. 62). David's flight through this paper/skin is driven by parallel violations of inside and outside in body and on paper. David and his brother like "seeing the x-rays of little kids' stomachs" and the odd objects they swallowed (*S*, p. 28). As a counterpoint to what's improperly inside, David encounters the opposite during a prohibited exploration of the hospital: a lab full of malformed fetuses in jars, improperly outside, especially when one of them even climbs out and chases him down the corridor. This chase in a mysterious cavernous building soon recurs in a dream space and is identified as a body's interior, namely an esophagus leading to a stomach. When David dives through the paper, the hole he falls into is both the space of two-dimensional cartoon creatures (freed from their plight with the help of a pencil or an eraser) and the inside of the human body (while also referencing the rabbit hole of *Alice's Adventures in Wonderland*, part of an Alice theme running through the book). The inside to which he withdraws from a hostile external world (now a mob of neighborhood children instead of the hostile fetus) is populated by cartoon creatures who come alive and scamper off the pages (see *S*, pp. 45, 48–49).

All this attention to the paper-based nature of the printed book object could in principle come across as a withdrawal, a return from new-fangled technological systems mediating the reality of a "true" and "natural" sensory world. Such a return would correspond to the position of Luddite "naïve realists" in Michael Heim's classification of techno-pessimists and optimists:

> Many naïve realists take reality to be that which can be immediately experienced, and they align computer systems with the corporate polluters who dump on the terrain of unmediated experience....

The suppression [of reality] comes through 'the media,' which are seen to function as vast, hegemonic corporate structures that systematically collect, edit, and broadcast packaged experience.[31]

Adopting some version of this naïve (and nostalgic) realist position would not only valorize traditional materiality and embodied experience but would primarily serve to provide a privileged position based on some notion of idealized unmediated experience. (This privilege would be closely associated in our case with the cultural prestige of the traditional book form as the proper repository of literary value.) This, however, is curbed by the hyperreading potential of the graphic narrative, in which the simultaneous break through paper and body boundaries entails a signifying surface of breaks, rips, holes, and stitches—the multimodal construction and reading of the graphic novel.

Hyperreading and the Multimodal Text

Spiegelman's book foregrounds this hyperreading potential excessively and explosively, as if testing the limits of the medium already experimentally stretched by its oversize materiality. Yet, these excesses only accentuate tensions of multimodal print reading that are quietly naturalized in more conventional linearly structured narrative comics. *In the Shadow of No Towers* plays up its multimodality with its verbal-visual signs, emphatically heterogeneous visual codes, and the formal fragmentation within its large frames. The expanded reading space of the large and relatively few pages offer conditions for the reader's attention that are closer to searching and browsing than to a predominantly linear reading/viewing process. The reader's attention is divided not simply between verbal and visual information but between the competing mininarratives of the page, each with its own form, space, and style (panel size, border type, color palette, and more). *In the Shadow of No Towers* privileges an intense multisequentiality, combining both the sequential character of comics and the nonsequential or multilinear character of hypertext. In most pages, there is no obvious order in which the narrative develops. Rather, the differences in style and technique invite one to read hypertextually, alternating immersion in a subset of closely connected elements with following links between them.

The first page consists of seven such subunits—the single-panel title and six multipanel strips (with two to twelve panels)—floating between homogenous white gutters. The variation of horizontal and vertical orientation between the multipanel strips precludes the perception of an imaginary narrative ribbon segmented into strips and panels from the start. Groensteen suggests that the strip can be a contingent entity somewhat randomly determined by the publishing format or an aesthetic-narrative unit with its own role in the "apparatus of enunciation."[32] In the former case, the cartoonist proceeds in a predeter-

30. The blankness, however symbolic, always allows for the realistic interpretation of a reflection of strong light. The single exception to spectacle wearing is the mother unbespectacled when she is exposed as a closeted lesbian.

31. Michael Heim, "The Cyberspace Dialectic," in *The Digital Dialectic: New Essays on New Media*, ed. Peter Lunenfeld (Cambridge, Mass., 1999), p. 32.

32. Groensteen, *The System of Comics*, trans. Bart Beaty and Nick Nguyen (Jackson, Miss., 2007), pp. 60–61.

Figure 3. David Small, *Stitches: A Memoir* (2009).

177

mined (mostly conventional) direction of reading, bumps into the edge of the page, and moves to the next line. This resembles the line-by-line presentation of any linear text, which is commonly considered an external visual accident attributed a low (or zero) level of significance in narrative prose. Groensteen argues, however, that the pause is longer and more significant in comics because the eye dropping and returning to the beginning of the next line typically travels longer relative to the page size. In the latter case, the reading process relies less on the "regularity of a rhythmic reading," and the strip appears a less neutral and transparent integrated element of the layout. Groensteen discusses both of these alternatives as different ways to manipulate progression, acceleration, and duration in narrative development proceeding along a route.

Spiegelman's use of self-contained and linked strips and panels has a different logic, however. The centrifugal and centripetal forces within each strip and between the strips are more immediately and powerfully present in representation than any segmented route. In fact, this centrifugal-centripetal force field on the level of the strip is the primary structuring principle of the page. The multipanel strips are cohesive reading/viewing units because of their immediately apparent internal visual uniformity within a space of juxtaposed differences, which is confirmed by the internal narrative cohesion of their miniplots upon immersion into the strip. Yet each of these self-contained strips has at least one element on the verge of detaching itself as if expelled or trying to escape. The American flag in the fourth panel of the strip showing a family watching television, the ad for Jihad footwear, the shoe dropping in the corner of the "Etymological Vaudeville" strip, and the lettering of the title panel all display this centripetal force of uncoupling, at times minimally by just a subtle change of border style responding to the impact of colliding objects in the panel (a tiny airplane hitting Art's television set) and at times more dynamically rotating and moving away (a partial image of the glowing tower about to collapse [fig. 4]). The juxtaposition and partial overlap of the strips within the page create implicit links between them, which can be actualized by numerous reading sequences in a nonhierarchical space open to repeated recentering. It is the moving parts of each strip that add more explicit links to these, propelling the viewer's gaze outward to the gutter or to a neighboring node or lexia (to borrow a term from hypertext theory).

Of course, this multicentered, multilinear, linked dynamic space corresponds to the reality of explosion,

Figure 4. Art Spiegelman, *In the Shadow of No Towers* (2005).

178

terror.) The contemplative effects of this self-contained commotion may recall the decorative principle of the kind of tableau that overwhelms narrative sequence insofar as they invite a lingering perusal of the pages as a kind of tapestry,[33] but the resemblance ends with the dominance of the tableau as a self-sufficient space with its own contemplative time. Spiegelman's subpanels demand primarily rhetorical reading, and it is the reduction of narrative development and the multiplicity of competing narrative kernels that allow these rhetorically structured parts to take on a more contemplative character by exploration through browsing and return (rereading, reviewing, and rerouting). So the possibility of contemplation is based on a negative principle of arrested development and relative containment in the tableau rather than a positive decorative principle overriding the rhetorical logic in reading comics. Still, the element of return in such an exploratory browsing within the topography of the page is an alternative to repetition as instant replay.

fragmentation, and dissolution entailed in the terrorist attack, which extends beyond its literal representation into a topology of disaster. (This is also a topology of the aftermath; the reading paths correspond to traversing the transformed landscape of the neighborhood, the text's privileged level of public space in the face of the national discourse of the war on terror.) At the same time, the comic sustains a peculiar temporality on the level of the page that is both fragmented (into interrupted narrative kernels) and contemplative (a contemplative reflection on interruption and fragmentation). In the page in question, these contradictory aspects of time and attention are literalized in the instant (the attack conceived as instantaneous rather than processual) and in the interminable duration between instants (the new time defined by the possibility and therefore a possible repetition of the attack—a comics-style literalization of waiting for the other shoe to drop).

In the double-page tableau as a whole, the self-enclosed terrain encourages prolonged browsing rather than a narrative impetus that would drive a turn to the next page. (This is, in fact, key to the often-disappointing limits of historical interpretation in the book, as the counternarrative element of Spiegelman's authorial strategy precludes situating 11 September in a historical narrative interpretation deemed more valid than the rejected spectacle of instant history and the official discourse of the war on

Within the visual style of Small's book, the most characteristic device in the signifying multimodal surface of breaks and stitches is the consistent mismatch between outline and fill in the grey-toned world of pen-and-ink drawings combined with watercolor. Since the fill is often erratically incomplete (rather than overflowing), the images are constructed out of visual gaps and overlays within the panels with an effect varying between sketchy tentativeness and expressive emphasis on detail. In the multimodal graphic novel, this gap-ridden display of near correspondence can occur on various levels: in the elevated importance of the gutter and in between verbal and visual signs (often out of sync for long pages of withheld verbal information). If the visual epigraph of the diving boy signaled the surface/interiority and body/paper concerns of the book, the paratextual detail of white lettering on solid black chapter title pages signals the need to read the blanks together with the positively marked surface and to locate meaning in the interdependence of gaps and the surface they break up. This is especially prominent in the frequent representation of experience through juxtaposed discontinuous details from a child's uncomprehending perspective, above all the confused, disintegrated experience of medical procedures (see *S*, pp. 180–82, 192) (fig. 5).

On the level of word and image, the discrepancy of outline and fill that creates gaps in the self-identity of

33. See Benoît Peeters, *Case, planche, récit: Lire la bande dessinée* (Paris, 1998).

Figure 5. David Small, *Stitches: A Memoir* (2009).

anything represented corresponds to the insufficiency of verbal knowledge for comprehending and articulating experience. The lack of (verbal) knowledge about the body haunts the memoir—both in a range of childhood terrors and in the concealment of the illness and its consequences from David. The secret is brought to light by yet another transgressive act of visualization—David opening his mother's writing desk with a forgotten key and finding (instead of a fetus in a jar) an unfinished letter: "Of course the boy does not know it was cancer" (*S*, pp. 202–6). When he utters the word in a scene of confrontation in the "rasping whisper" that is his literally and materially impaired voice (rendered in the visual notation of dotted speech balloons), his father responds: "Well, the fact is, you did have cancer . . . But you didn't need to know anything then . . . And you don't need to know about it now. That's final!" (*S*, p. 238). This violent separation of fact from knowing through the denial of words locks David in his

experience and in his body represented in his sensation of "living inside [his] own mouth," a closed echo chamber for his own words, as he sits with mouth closed, eyes shut, and ears covered. A four-panel double page shows him sitting on the couch in the living room, while also sitting on his own tongue in the "hot, moist cavern" of his mouth surrounded by a double line of his giant teeth—an internal living room (*S*, pp. 216, 217).

David's recovery (both from his illness and his family) is therefore a struggle for self-possession through the comprehension and articulation of embodied experience. In this struggle, experience and its articulation are on a continuum; experience is not posited as something naturally unmediated and fully possessed unlike verbal knowledge withheld by the adult world. In a number of scenes, such as David undergoing and waking from anesthesia, smudges and blurry outlines indicate an unclear sense of experience (see *S*, pp. 180–82, 192). The struggle

Figure 6. David Small, *Stitches: A Memoir* (2009).

does not lead to a restoration of a single, unique, continuous, and self-identical body (such has never been presumed to exist) but rather a stitching together of the wound between subjective interiority and the world outside the sheltering-confining asylum of the self, connecting the tissues of body and world.

This is where the embodied interaction between book and reader and—through the proxy of interior architectures of the body intimated within the flat surface of paper—between author and reader come into play (fig. 6). Embodied subjectivity is frequently figured in the book as an interior space, often represented as a body cavity or as an architectural interior and less frequently as an interior landscape (see *S*, pp. 257–68). Given the reality of pain and damage in the narrative, such interiors could be spaces of withdrawal negatively defined as a lack of interchange with the outside world, yet they are also narrated as uncharted interiorities to be positively discovered. These spaces are at times small and thunderously loud (as in the echo chamber for the words in David's brain, when he is "living inside [his] own mouth"). At other times, they are grand and

monumentally silent as in David's recurring dream that takes him through secret narrow passageways to the "temple whose guts had been bombed," the abandoned, ruined temple that is his embodied self (*S*, p. 242 and see pp. 216, 217–23, 240–42). In either version, however, they are spaces that figure the body as a chamber of internal experience without outward expression (that results in amplification or silence inside). This raises the stakes for the book as communication between author and reader.

Through a variety of connections between body and paper surface and between body and book depth, *Stitches* succeeds in building a complex relationship between the book and the site of embodied experience, whereby the material object encountered by the reader comes to stand for the body without reducing that body to metaphor (for example, pushing for a metaphorical understanding of voicelessness). Following David Mitchell and Sharon Snyder's critical analysis of disability as a frequent "opportunistic metaphorical device" in literature that serves to embody textual abstractions (the materiality of metaphor manifested in the representation of the disabled body),[34] a

34. David T. Mitchell and Sharon L. Snyder, *Narrative Prosthesis: Disability and the Dependencies of Discourse* (Ann Arbor, Mich., 2000), p. 48.

review of *Stitches* raises questions about the invitation to read David's silence in such a metaphorical way.[35] On such a reading his voicelessness (along with the chain of physical interventions that have led to it) literalizes a preexisting metaphorical silence, and metaphor attains materiality in the protagonist's physical impairment. Since both the metaphorical and literal senses of disability operate in the book simultaneously, the reviewer acknowledges that its metaphors do not prevent the book from engaging with disability as, what Mitchell and Snyder call, a lived "experience of social or political dimensions."[36]

I would like to suggest a different kind of figuration at work here. The articulated, structured flat surface of the printed page is construed not as an abstraction of embodiment (subsuming and textualizing the reality of experience) but rather as an access point through which the interiority of the ruined temple can (and must) be reached. The book materially held by the embodied reader is thus a crucial element in a chain of mediated materialities. This chain is one of multiple mediated reembodiments of experience that has a metonymic rather than metaphorical logic. From drawing as a kind of handwriting to the reader's holding of the book, a chain of contiguities both discursive and physical connect the two. Rather than abstracting both the writing and reading subject into disembodied functions of the text (the corresponding muteness of the acculturated reader of literature permitted to access the textual world through her or his eyes alone), the metonymic chain adds a material dimension to the autobiographical pact by embracing the world of sensory experience and obligating the reader to imaginatively enter that realm on the far side—the authorial side—of its textual representation.

Although I suggested earlier that Spiegelman insists on our embodied experience of reading as an approximation and trace of his effort to reenvision a reality evaporating in a mediatized spectacle, and Small creates a material form that bears witness to his embodied experience in the body of his book, the two cases are ultimately not as different as they seem. When our haptic seeing is encouraged by the intensification of the material object quality of the big book, this mirrors Spiegelman's (and protagonist Art's) own effort to protect and reclaim his embodied experience both from the shattering power of a personally witnessed catastrophic event and from the audiovisual spectacle that supplants it as a primary form of witnessing 9/11. And in *Stitches*, where the main narrative and representational focus is Small's (and protagonist David's) embodied experience, transmission depends on the reader's acknowledgement of a relationship through the book—the book operating not as a symbolic site but a discursive-material node for their (partly literal) interconnectedness. Instead of Roland Barthes's metaphorical "umbilical cord" of light connecting body to gaze under a sign of inevitable death, this one connects artist and reader nonphotographically through the multimodal graphic interface of print,[37] through their joint traces and investments in each other, under the sign of fragile and transient life. This precarious life depends both on the materiality and multimodality of graphic narrative, the distinct way in which it brings together the space of reading and the artist's and reader's embodied experiences.

Graphic narrative opens reading to a different kind of attention. Although the potential deepening of hyperattention is first a function of the pace of the alternating rhythm of immersion and travel, it is sustained by the materiality of the narrative object's finitude and tactile weight. In this sense, graphic narrative is a transitional medium equally attuned to the conditions of contemporary convergence culture and to the senses of embodiment, locality, and materiality. As such, graphic narrative fosters a developing sense of the new materiality of the altered spaces of reading and viewing by integrating hyperreading with familiar forms of materiality and, at the same time, demanding deep attention and the refashioning of habits and expectations tied to print and digital textuality. Inhabiting this cultural gutter space, comics have once again—as they have in so many ways before—found a way to flourish in the in-between.

181

35. See Scott St. Pierre, review of *Stitches: A Memoir*, by Small, *Disability Studies Quarterly* 31, no. 3 (2011): dsq-sds.org/article/view/1664/1614%5D

36. Mitchell and Snyder, *Narrative Prosthesis*, p. 48.

37. Roland Barthes, *Camera Lucida: Reflections on Photography*, trans. Richard Howard (New York, 1981), p. 81.

FOR EXCEPTIONAL MEN LIVING ON THE MORAL HIGHGROUND

BECAUSE RULES WERE MADE FOR OTHER PEOPLE

VALIENTE

ZÁŘÍ 2010 NO. 1

5¢

SEX IN THE ACADEMY

A PROFESSOR'S MORAL TURPITUDE? OR PRUDISH INSTITUTIONAL ETHICS?

IN HER OWN WORDS:
STUDENTS TELL US WHY THEY'RE

HOT FOR TEACHER!

HE'S 60. SHE'S 26!

THIS STUDENT-TEACHER RELATIONSHIP IS HOTTER THAN A BUNSON BURNER!

LUST IN THE LAB!

PLUS: SHE'S REALLY SWEET & THINKS HE'S THE GREATEST!

EX-WIVES...

WHY IS SHE STILL DWELLING ON THE PAST?
Studies show: *men know how to get a life!*

ESCAPE THE BITCH-WIFE OF YOUR MIDDLE YEARS
without compromising future wealth!

MODERN CHEMIST

MARCH 8, 2014

WALTER WHITE & THE CHEMIST'S MID-LIFE CRISIS GONE BAD:

*The AMC series that inspired a decade of
clandestine garage labs*

Experimental Psychoses

When the drug called HOPE is administered to human subjects, it produces the symptoms of psychosis. The phenomenon provides a remarkable new tool for the investigation of psychotic states.

by Six Staff Members at Boston Psychopathic Hospital, with an introduction by Faïence Le Merisier

The last 20 years of my life might have been erasable were it not for two things: my children. Other than them, the grand experiment of my marriage to a scientist was a farce and a draining investment of time and emotion. Indeed, I was in love at first, but soon, "love" became an exercise in the suspension of disbelief as I found myself entangled in a web of lies and maudlin pledges of penitence.

He isn't anything. He is Delusion and to love him was nothing. He would tumble into abysmal 6-months states of secret Vicodin numbness, and when discovered, respond viciously as if he were the oppressed victim, wallowing in self-pity. He played the role of the rigidly straight, aging chemist with convincing impatient, judgmental dullness. Every now and then, he tried to snag a bit of "cool" by listening to marginally slightly edgy modern jazz, writing a never-published novel about a tantalizing, yet dangerous, futuristic psychoactive drug, and, while on a bender, trying to make methamphetamine in his own garage in order to prove he was as smart as the very smartest television character (but, as he'll no doubt tell you, he was very sad when he was doing that because people were being mean to him, so that's why...)

Physically, we are not the same. The first time we went on a hike together (Yosemite), we had to stop every quarter mile because his legs hurt. I was shocked, but I chose to ignore it. I knew in my heart that we were somehow not suited to each other, since my legs are always dying to run.

Even the first time I saw him naked, I couldn't help but notice that his hips were wider than his shoulders. This is unusual for a man. Again, it seemed like a sign, but I chose to ignore it. Now, his ass is soft, white, and dimpled like a woman's. His legs are thick and shapeless, finely etched with blue varicosities. His feet are flat and he has no ankles to speak of.

I thought, "I'm not ever going to be a good wife because I'm not happy. Our home feels like a closed system and no air enters. I don't think this bothers him much, since his habits tend towards the sedentary."

In the first year of our relationship, he told me that he didn't want to introduce me to his mother because my artwork was "unseemly."

Anyone who cares would not have liked to have seen me last night as I was walking across the pedestrian bridge from Juárez to El Paso around 10 or 11, it was pitch black, and of course they have some stupid detour so I don't know which way to go the streets are desolate, broad, run-down avenues and I'm walking fast but totally disoriented finally I see a Kentucky Fried Chicken and the young woman who was cleaning wouldn't open the door she seemed startled but she yelled directions through the window. She was beautiful, I thought she was a gringa from afar but she was not she had bleached hair tightly pulled back and slicked down and hardly any eyebrows and maybe even light contacts but olive-ish skin, kind of a roundish face and she was quite tall and large-ish, just pushing a broom around wearing a white uniform trapped in a picture-window box all lit up with darkness and wanderers, some unseen all around her.

And then on the phone my ex-husband tells me that my daughter was driving home in the dark on her bike no headlamps no helmet and I know she's upset and wants all the shit in her life to disappear or else she wants to disappear herself, but it can't be like that, not for her. I know the feeling you want to just go go go in the dark but I don't want her to be in danger.

His brother said, "Many of us were concerned about your husband a few months ago when he was involved in this ridiculous stuff (in addition to liquid use) that was clearly altering his personality. I told him then that it was insane and people would surely recognize the long lasting effects of different personalities. I had thought he was doing better because when I talked to him he sounded clean and he seemed focused on work, but clearly, he's still the expert prevaricator."

The distance vertical increases vertigo and things may be seen for as small as they are and time is no longer, no shorter, no time at all.

My mother stares at me coldly as I enter the room. She is sitting at the dining table with other family members, who either ignore me as they talk and eat,

or they say hello... but she simply stares coldly at me.

It's snowing sideways. My husband screams that I hate him, so I consider, naturally, whether this is true. He was the first and only man I remember trusting. It's important to make it clear that I remember being aware that I felt I trusted him, but I can no longer remember how it felt to trust.

He was angry when a female acquaintance told me that he had been trying to make methamphetamine, and he punished her in an email, "In between your petulant sarcastic emails you have managed to betray me twice, now at a level that gives my wife a button she can push at any moment to take my daughter away. And why? To assuage your jealousy over my new girlfiend (who is half your age)? Or for an amusing tale over a drink? My wife, you may not realize, is vindictive and violent and *capable of anything*."

I've been feeling entirely detached, as if my life is not my own. I forget how it felt when I thought it was mine.

Once, I wrote a letter to my father. I told him, "I used to believe that you could hear me even though you are dead. Now I know you can't hear me, and that makes me sad, because I hardly ever saw you, only 3 or 4 times in my whole entire life and I really enjoyed talking to you those 3 or 4 times even though my mom says you didn't love me."

A personal note to *El Moyote*, son of the desert: I am so sorry if I caused your death. You were gunned down while walking your dogs. *El "pitbull" no le saltó.* I wish I had actually killed you myself- or talked with you, or at the very least fucked you. Because that's the way I am. I like to touch people, make them angry, disappoint them, and kill them. I can't really help the way I am, neither could you.

I want to scream and sing loud and feel like I'm alive. May I live now? Please? I really, really want to live.

—*Faïence Le Merisier*

FURTHER COMMENTS

I'm working on a long story about Maria Elena, who was murdered by Neo, and about her family, her neighbors, her colonia in Ciudad Juárez, and the people who live on either side of the US-MX border, sparkling like multi-colored sprinkles on a cupcake. I intend this project to ultimately be published in two forms: a printed book and an electronic, animated book. I've devoted much of my time to this project for many years, and I can only pray that I will see it to completion.

I would have made a normal comic about this girl, but it got me too upset to draw the story, because it felt like bad things were in my head too long. So I taught myself how to sew, and build things. I built Maria Elena's house at 1/4 scale, and I made a doll meant to be her, and other dolls of myself, and her mother, and the neighbors, and Neo, and my ex-husband, and lots of other people. Miniature worlds are easier to navigate than the big one we live in. I've traveled to Juárez many times over the last 8 years, and some friends got a death threat and stayed with me 9 months in Michigan until they got political asylum, then two of my nephews died, and I suffered through a terrible divorce, and so did my kids, and I got tenure but fuck.

BELOW: The author destroys a scale model (built by her ex-husband) of the family home. Standing by to observe are the ex-husband himself, protectively embracing his sweet new bride. He's older than her parents, and richer, too.

185

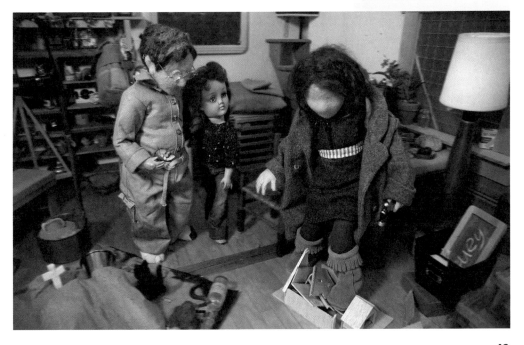

ARPÍA

SEPTIEMBRE 2010 NO. 1

ONE WOMAN'S QUESTION:
WILL I EVER BE HAPPY AGAIN?

MY HEART FEELS BROKEN IT PHYSICALLY HURTS

WHAT ABOUT MY KIDS?

BITTER DIVORCE

CAN'T THE WORLD SEE WHAT AN INTERESTING CARING PERSON I AM?

DOES AGE REALLY MATTER?

TRANSITIONS!
- DOWN-SIZING YOUR DREAMS
- WHAT TO WEAR WHEN YOUR BLOOM HAS FADED

I WAS SURPRISED WHEN HE ASKED FOR A DIVORCE...
AM I STUPID?

ANGST & THE ARTIST: WHEN PAIN GETS IN THE WAY OF CREATIVITY

PLUS: HOW TO SAY FUCK YOU IN 10 LANGUAGES!

Talk on *Blown Covers*
Françoise Mouly

with Daniel Clowes, R. Crumb, Chris Ware
May 19, 2012
Introduced by Eric Slauter

ERIC SLAUTER (from his introduction): My name is Eric Slauter and I am the Director of the Karla Scherer Center for The Study of American Culture here at the University of Chicago, one of the principal co-sponsors of this conference. It is my great pleasure to introduce a figure who has profoundly shaped American culture in our own time. In her book *Blown Covers:* New Yorker *Covers You Were Never Meant to See*, Françoise Mouly says she has the best job in the world and she must believe it because she says it twice. She has been the Art Editor at the *New Yorker* for almost twenty years, from the spring of 1993. She is only the fourth Art Editor of this nearly ninety-year-old magazine, and she is the one who has transformed the visual and culture impact of what a cover of a magazine can be and do. She was brought to *The New Yorker* in 1993 by Tina Brown to do precisely that because of the success of *RAW*, both the magazine of that name that she and Art Spiegelman co-founded and published beginning in 1980, and the publishing house that she began in 1977 when she and Art hoisted a small offset press into their fourth floor loft in Soho. *RAW* served as a platform for the careers of several of the artists here today—Charles Burns, Gary Panter, Ben Katchor, Art Spiegelman himself, and Chris Ware. If one half of Françoise's career has been making comics safe for adults, the other half has been devoted in the opposite direction. Through ventures such as the *RAW* Junior division. which she founded in 2000, and most recently, TOON Books in 2008, she has brought smart comics to children. The books in this marvelous new series ask questions of who stole Benny and Penny's pail, what will Jack's new toy do today, can Stinky share his swamp? These are not rhetorical questions by the way. They help people form the complicated relationships between words and pictures. They capitalize on the epistemological issues in this conference. Adults and children owe her a lot. At the end of her talk she will be joined by three giants of the comics world, Daniel Clowes, Robert Crumb, and Chris Ware.

FRANÇOISE MOULY: Thank you very much, Eric. As Eric mentioned, I have been the Art Editor of *The New Yorker*

for the past nineteen years, but for me it started an even longer time ago. When I first came to New York, I was studying architecture. I didn't know English that well, so I wanted to find something to help me learn the language. When I asked around for comics, I was shown *Arcade* and discovered the work of Art Spiegelman, and fell in love. Fell in love with his work. Then I met him and I fell in love with him—and I fell in love with the medium. All of a sudden, I discovered all that Art was a passionate advocate of: what comics could do—but also graphic arts and objects that could get printed. This was an answer to something that had been frustrating to me as an architectural student, when I was asked to dream up buildings and cities, but nothing would ever actually get built. Hearing Art talk about the possibilities of comics and how great it could be, I got tired of seeing him trying to convince editors at various magazines, including at the *New York Times*, that they should run comics. I discovered the American prejudice against comics, which was totally new to me, since I grew up in France. I read comics as a kid and I loved *Pilote*, which was a French weekly inspired by *Mad*, since the editor had worked for Kurtzman in New York.

Language was not easy for me and I wasn't as articulate as Art was, but still I wanted to make something that showed what comics could be. And I thought, let's make this object that will demonstrate all our ideas, because we can. So on the first issue of *RAW*, I printed a little color insert, and this is the cover (fig. 1).

For the second issue of *RAW*, I printed some bubble gum cards by Mark Beyer. Art was working at Topps at the time so we put a small piece of gum he got from Topps together with the cards. For the third issue, we gathered work by Gary Panter who was, at the time, living in Los Angeles. In our fourth issue of *RAW,* we worked with Charles Burns—he had come to the door and rung our bell. I loved that we could make physical objects—combining commercial printing with what we could do by hand. It was similar to art objects, like Fluxus boxes and it

VOLUME 1 NUMBER 1 $3.50

IN THIS ISSUE

ALFRED JARRY : HOMMAGES POSTHUMES

ART SPIEGELMAN : TWO-FISTED PAINTERS

JACQUES TARDI : MANHATTAN

THE GRAPHIX MAGAZINE OF POSTPONED SUICIDES

Figure 1. Art Spiegelman, cover of *Raw*, no. 1 (July 1980).

much about *The New Yorker*, just that it had predictably typical covers by Gretchen Dow Simpson.

Actually Chris Ware wrote something interesting for *The New Yorker* blog about her work—I would like him later to talk about the virtues of Gretchen Dow Simpson because he loved it when he was growing up.[1] But I didn't especially understand what I could contribute until I realized that part of the reason Tina was asking me is because she knew she wanted a change: after Art's cover, she wanted images that people would discuss, that would bring attention to the magazine, but she didn't know which images by which artists.

So I went to the library and I started looking at the old *New Yorker* covers, and what I found especially is that the covers of the 1930s and 1940s up until the 1960s are storytelling and narrative covers, which I found fascinating. I saw a lot of what the urban sophisticates were paying attention to at the time. I love the way the artists used color and composition, and lots of details for their storytelling. I love the way [Constantin] Alajalov [in his January 17, 1942 cover] uses an angled row of dancing girls: look at his use of repetition. They are coming from right to left onto the stage, and they have a beaming smile. But you the reader can see them when they are right behind the curtain; you see they have this gloomy look on their faces and as they are entering the limelight, all of a sudden they transform, putting on a radiant smile.

The New Yorker had many women artists in its early years, which I find interesting. In one Helen Hokinson cover [from May 29, 1937], you see crowds looking at the artist, who is herself drawing a "Hokinson lady." There's freedom for the artist to choose her topic and develop her own character over several covers.

It was highly unusual at the time, but it did happen that instead of pictures of butlers and maids, the old covers show what is going on: here's a telling image of the Depression, with people out in the street selling apples, or matches, or gum [March 11, 1939]. This really gives you a very nuanced sense of what people's attitudes were, what they lived through, during those years. In this Peter Arno image, we see a car: look at the straight diagonals and the sweep of the car and the very slouchy hobo who is using the car lighter to light up his stump of a cigar. In another Arno, a very sophisticated young woman has come to hug her baby before giving it back to the very concerned baby nurse, who's not used to seeing the baby held by the mom. In another Alajalov cover [from 1942], the young just-married woman is looking outside the window of a car and seeing Italians in the village, a mother with lots of children—and she is getting a little concerned. Sometimes the artists are even ahead of anyone else, captur-

is also in the same spirit as what Chris Ware was showing [earlier today], his upcoming *Building Stories*. But ours were not like the art books that were at Printed Matter at the time, which were unique or signed editions that cost a lot of money. I thought there was something absolutely magical about the fact that there could be a mass-produced object printed on a printing press and it could still have the feel of one's hands. So for the "Torn Again" issue of *RAW*, we tore off the upper right-hand corner and I designed a contents page where we would get to paste the corners in—but we made sure to mix them up, pasting the corner from another issue.

In *RAW*, we *were* putting a lot of different things together, including what Art had started to work on, which was *Maus*. *Maus*, which was done same size [ratio of drawing to printing], had to be done as an insert in a magazine we had chosen to do in a large format specifically to make people take the measure of what could be done in comics. *Maus* took on a life of its own when it got published as a book. And at that point, once it was published—the first volume in 1986 and the next one in 1991—*The New Yorker* came calling. Art published an explosive cover, his Valentine Day's Hasidic kiss, and Tina Brown asked me to come and be the Art Editor. I confess my first reaction was: why would I want to do that? I didn't know

1. Chris Ware, "Cover Story: Haunted by Gretchen Dow Simpson," *The New Yorker*, 30 Apr. 2012, www.newyorker.com/online/blogs/culture/2012/04/mothers-day-the-women-cover-artists-of-the-new-yorker.html#slide_ss_0=1

Figure 2. Gretchen Dow Simpson,
cover of *The New Yorker*, 16 Mar. 1981.

Figure 3. Helen Hokinson,
cover of *The New Yorker*, 29 May 1937.

189

ing what was happening before it's articulated in words. George Lois, the art director for *Esquire* in the 1960s and 1970s, wasn't using drawings, he was using photographs, but he was using them as cartoons. In this [March, 1965] cover he captures the beginning of the feminist rhetoric before it is actually spelled out in speeches and discourses. You get a lot of information about what people are going through, a portrait of the time. But it's a great magazine cover that captures trends in an image even before they're actually spelled out in discourses or in books.

In the covers of *The New Yorker*, you see a shift over the years, from Harold Ross as an editor in the early years, where it's a humor magazine, to William Shawn who's more inclined to serious journalism. Under Ross for example, we get this is really complex image by Alajalov [March 26, 1949]: it's a view of a darkened theatre, with a whole scene taking place onstage, while members of the audience are getting up to leave in the middle of the show; the strap on the left, made of a train time table, tells you they have a train to catch. It's a good gag but it's also a reflection of what happened: the artists left the city, moved to the suburbs. A lot of contributors moved out, had barbecues, and *The New Yorker* became a magazine that took a much more distanced view of the city. After the fifties, when the city appears, it is more of a postcard to show you a snapshot of what the city folk go through. This cover [August 31, 1946] is a typical fifties summer cover, a scene of New England by Charles E. Martin. Inside, the whole issue is devoted to something far less sedate and bucolic,

John Hersey's *Hiroshima*. That's what William Shawn, when he became editor, really wanted—he wanted incendiary journalism. But he never flagged it on the cover, never gave an indication it was there. He wanted to have images on the cover that would just be a quiet moment, a respite from what he saw as the attention-grabbing noise of other magazine covers.

Now, by spending time in *The New Yorker's* library, I found something that was meaningful to me: the portrayal of American culture in images in ways that communicate effectively. So I wanted to take that job. Now I knew what to say to the artists. For these covers, first, there's a first-person point of view—that's what we had in *RAW*. The Art Editor doesn't tell the artist what to draw, but encourages the artist to come up with his or her own content. That's the tradition of *The New Yorker*, and it worked for me. Nobody would structure a magazine like that if they started now, but fortunately we are continuing a tradition that started in 1925 in the heyday of great magazines.

One of my privileges as Art Editor of *The New Yorker* has been to be Saul Steinberg's editor. His most famous cover is "View of the World from 9th Avenue" [March 29, 1976].

When I met him, he was in his late seventies, early eighties, but he was interested in the other artists around him, and in what could be done. Looking at his work, I could see how he had been paying attention to underground comics, looking at Kim Deitch and Robert Crumb; it seeps into his work in the mid 1970s. Steinberg always

Figure 4. George Lois,
cover of *Esquire* (Mar. 1965).

Figure 5. Saul Steinberg, cover of
The New Yorker, 29 Mar. 1976.

190

wanted to do things with colored pencils, wanted to use simple means. He had grown up around printing presses and box making. He was fascinated by the new artists I wanted to bring to the magazine. Now this (fig. 6) is what Charles Burns proposed in 1993 as a cover for the anniversary issue, an issue that had reprinted the original Eustace Tilley first cover every year since 1925. Everyone at *The New Yorker* was horrified that that's what Tina Brown was bringing to the magazine. That's actually the only reason why Art Spiegelman's image of the Hasidic Jew kissing a black woman [February 15, 1993] was allowed, because everyone at the magazine was focused on fighting the Charles Burns image. *[laughter]*

The year after, I asked Robert [Crumb] to do a cover and he sent us a drawing [the February 21, 1994 cover]. I remember bringing it to Tina and saying, oh it is really nice, and I comped it out as a cover. I put it on my wall—I like working out sequences on the wall. So a week or two after I had gotten it, I realized, oh, my God, it is Eustace Tilley. I didn't see it at first, but it is. Look, this is Forty-Second Street. This is a dandy that used to have a top hat, now he has a baseball cap backwards. Instead of looking at a butterfly, he is looking at a the kind of fliers they were giving out on Forty-Second Street, "Adult XXX." It was really fascinating for me to see contemporary artists interpret the world around them, and making a record of our trends and attitudes. I also encouraged the artists to take advantage of the fact that the magazine is a physical object. One cover by Richard McGuire [in 1994] was a double issue date; if you look at it with the December

date on top, it's the old man with a scythe, but if you turn it upside-down, with the January date on top, now it is a baby new year. A classic upside-down.

This is the seventy-fifth anniversary cover of *The New Yorker* (fig. 7), and it is the only time when I actually wanted to run a photo. The artist is William Wegman. This would take two minutes in Photoshop. But for Wegman it took two weeks to make the photo. He knew of course it could be done in Photoshop, but because he's a cartoonist at heart he *insisted* he had to photograph a dog in costume. He tried to dress a dog with a custom-made outfit, then he painted a cutout. And he had an assistant holding a gloved hand, hiding behind the dog and the cutout. All of this was shot on a Polaroid as big as a room, a machine made of wood and bellows. It was just a thrill to see how complicated it was to do a simple photo of this.

We had another big anniversary in 2010, the eighty-fifth anniversary. We needed to mark that moment, so I got the permission to do a split run. We did actually four covers [February 15 & 22]: Chris Ware shows you Rea Irvin in his studio holding his thumb up to judge the scale of the drawing that he's working on; the second image is a comic strip by Adrian Tomine. The price is the first thing you read in this strip, where an actor is hired to stand in for the dandy with the top hat; the second balloon starts with "February 15th," which is both the date of the issue and when the actor's rent is due. The third cover is a comic strip by Dan Clowes, seeing the same scene from the point of view of the butterfly. The butterfly arrives and takes a look at Eustace Tilley. We managed to get the phrase

Figure 6. Charles Burns, proposed cover of *The New Yorker*. This image appeared inside *The New Yorker*, 22 Feb. 1993, in Charles McGrath, "Hey, Eu! HEY, EU!"

Figure 7. William Wegman, cover of *The New Yorker*, 21 Feb. 2000.

191

"they erect priapic monuments to their own dominion" cleared—Dan was very happy to get that on the cover of *The New Yorker*. And the fourth cover was by Ivan Brunetti: it showed various people capturing butterflies over the decades, either on their iPhone or on their Etch a Sketch or on easels. But what was really extraordinary about the four artists I had chosen for this is that they were willing to take on an additional challenge: the four covers put together make an outline of Eustace, a sort of meta-Eustace. In Adrian's, you see the top hat. In Chris's you see the monocle and the butterfly in the right place. In Ivan's you see the coloring of Eustace Tilley's coat. And in Dan's, you see the hand—the swoop of the hand and also of Tilley's coat. It's of course a somewhat private joke—not too many people got all four covers and put them together in just the right way, but there is something immensely pleasurable about having private jokes on the cover of a magazine that publishes over a million copies.

This is an image for gay marriage, that ran back in 1994 [June 3], so it is nearly twenty years ago. At the time, just the image of two men getting married was enough to be utterly shocking. We ran another gay wedding cover last week, so the change is reflected in the covers. You see how gay weddings have become commonplace. We did a cover back in 1993 [July 26] at the time of the first bombing of the World Trade Center, for which we were denounced. David Mazzucchelli did the drawing (the idea was from Art). And we were denounced by a Muslim anti-discrimination group for using any kind of representation of Mus-

lims, and for labeling the terrorist attack as being done by Muslim extremists. There were death threats and we had to get extra security at the magazine, and I had to give Tina Brown a statement. But attitudes, what can be said and what can't, all that changes over the years. This (fig. 9) is a cover that made people laugh back in 1936 because the idea was: oh, look, a Jew wins a race! *[laughter]* The idea of a hairy Jew with a big nose that would win over Aryans— the Olympics in 1936 were in Berlin—New Yorkers of the time thought that was really funny.

When it works well, the artist will take a chance and bring out a touchy topic that will force you to examine your assumptions and prejudices. The ideas are proposed by the artist, but the editor has to be able to stand behind any cover and feel fully comfortable when the image is published. This is what happened at the time of Obama's bid for the Democratic nomination—I was encouraging artists to come up with images that addressed the calumnies and innuendoes that were constantly percolating in the face of a black candidate. In a phone conversation with Barry Blitt, he said something about "They say Obama is a Muslim—wouldn't it be funny to draw their worst nightmare…Obama in the White House, dressed as a Muslim?" So I asked him for a sketch ["The Politics of Fear," July 21, 2008; fig. 10]. In this first sketch, Blitt showed Rush Limbaugh, Ann Coulter, the various pundits, outside the window. We refined it in such a way that, first of all, it would be an accurate caricature of what the innuendoes against Michelle Obama were. Not so much that she was

192

Figure 8. Chris Ware, Adrian Tomine, Daniel Clowes, and Ivan Brunetti, split cover of *The New Yorker*, 15 and 22 Feb. 2010.

Muslim, but that she was a terrorist. And I asked Barry to remove the pundits because the fears about the hidden side of Obama, the rumors that he was born in Kenya, weren't limited to just Fox News. It was also ABC, CBS, it was all of us. It was a much more interesting comment if it just brought the calumnies to light so we would talk about it. The cover was widely denounced, but I'm very proud of it because I think it actually worked to inoculate the body politic. I do believe that prejudices are not as vicious once they are brought out into the open.

Issues of PC-ness, of acceptable representation come up all the time, especially when you have a black president, the first black president—how to represent him? One of the ways artists are trying to show the new president is by using precedents. So we ran a picture by Drew Friedman of Obama as George Washington, and Blitt shows him as Roosevelt, and also as Nixon, Taft and George Bush. There was a sketch in which Bush was handing the keys of a wrecked car to Obama. The image made a lot of sense—it was approved and went to finish. Then we realized, oh, wait a minute, this could be read like Obama is a valet, with Bush handing him the keys. So we had to worry about a different interpretation of the idea. Then there was an image by Anita Kunz about an elephant having left a pile of crap in the White House for Obama to clean up—a sentiment with which I totally agreed. But it also showed Obama in the position of a janitor, which simply wasn't the right thing for our new president.

I love what I do and I also love the creative process when all of the artists come up with images. But there are many sketches that don't run. It is very hard to get the right thing at the right time so I have to over-solicit. Rejection is the hardest part of my job, by far, for me and for the artist. Part of doing the book *Blown Covers* was putting together a lot of the images that had not been publishable, and now I asked my daughter, Nadja Spiegelman, to do a blog to publicize the book. She's set up something that has also taken on a life of its own where she asks artists, anybody—totally open submission—to tackle those topics.

But if we can have Chris Ware and Dan Clowes and Robert Crumb come in, then we can actually talk about covers and rejected covers. Let them talk. This image is by Robert and it is a rejected *New Yorker* cover. *[applause]* Can we actually start with that, Robert? This is an instance where I feel I did my job very badly—didn't communicate the rejection well. Robert sent this as a finish; it was accepted when it came in.

R. Crumb: I don't deal well with rejection myself.

Aline Kominsky-Crumb *[from the audience]*: You are a big brat.

Mouly: Actually I had asked Robert, back in 2009; we knew we wanted to run an excerpt from his upcoming *Book of Genesis*, which we timed for June—so I talked to Robert about doing a cover around that time. We all agreed, David Remnick, Robert and I, that there was no reason to do a cover on the topic of *Genesis*. In June, on my calendar of topics, there is "June weddings"—for which

Robert sends this image. I believed that we were going to run it. I did ask Robert to remove the words "gender inspection" because I thought the idea was simpler if he just showed a couple in front of a marriage license window. And then it sat and sat and sat, and it didn't run. It kept being put off. Obviously there was something about it that was making my editor, David Remnick, uncomfortable. At some point I just realized I had to ask David, what is going on? Turns out he was uncomfortable with Robert's portrayal of gays and he felt that, oh, it's out of date with the times. It's true that a lot of the fight for gay marriage is one for normalization—today's gay advocates are not presenting themselves as freaks. I remember my argument was, but it is a Robert Crumb! By which I meant two things: One is, I don't want to have to talk to Robert about not running this. *[laughter]* The other argument was, but this is "on artist." "On artist" is a concept you use as an editor—you get feedback from your copyeditor and fact checker, but sometimes you say, I understand this may not be accurate, but I'll keep it because it's "on artist." That's what the artist wanted. You can override a correction by saying that's the intent of the artist. But that didn't work in this case for David Remnick. Because he's always backed up everything he has published, and it's also part of the deal that he won't have to publish something that he doesn't believe in. And I agreed that "Well, it's an R. Crumb" was a weak argument. So I sent it back to Robert after a few months and I did not explain all my back-and-forth with Remnick, but I simply said we can't run it. If I do a book of rejected images, we can always publish it then. But that's a small consolation. I'm curious to hear your side of it, Robert. *[laughter]*

Crumb: I don't know. Well, what do you think, Clowes?

Daniel Clowes: What do I think? I have nothing do with this. Don't involve me.

Chris Ware: Don't look at me.

Clowes: This is between you two.

Ware: Did you have fun drawing the legs?

Crumb: Nah, not really.

Mouly: Well you've said, Robert, that you don't start out wanting to offend, but on the other hand you don't want to have to worry when you are formulating your idea, you don't want to have to look over your own shoulder to worry about whether you will offend or not.

Crumb: Well, yeah.

Mouly: Is that fair to say?

Crumb: Yeah. That's fine. I don't know what to say about it. Certainly you are free to accept it or reject it. If you have some reason, it's too lurid or whatever—you know, it was kind of unclear to me why it was rejected, so I kind of felt a little bit insulted because I didn't receive any clear explanations. That's all. Just got it back in the mail one day, nothing said about it. *[laughter]*

Mouly: Now it is as published as it gets [in *Blown Covers*].

193

Figure 9. Constantin Alajalov, cover of *The New Yorker*,
1 Aug. 1936.

Figure 10. Barry Blitt, cover of *The New Yorker*,
21 July 2008.

194

CRUMB: So come on, Clowes, what do you think? Chris, do you have any opinion? What are you guys doing up here? *[laughter]*

WARE: We're company. We have come to tell you something very important.

CLOWES: That's right. This is an intervention.

CRUMB: I tried, God knows.

MOULY: Chris, is there something about doing images for *The New Yorker* that you approach differently from the other work that you do?

WARE: Growing up my mom subscribed to *The New Yorker* and it was around the house. So it was—I like the magazine. I especially like the cartoonist George Booth. I remember my mom hanging [covers] up on the refrigerator. Gretchen Dow Simpson, like you mentioned. When I look at them I think of my own childhood. To me they hearken back to the time where I imagine *The New Yorkers* kind of stuffed in faded wicker furniture in some sort of vacation house or something. Stayed there for years. Seemed kind of nice and—they make me think of John Updike. *[laughter]* There is a possibility—why are you laughing? Complex sexual subtext to this.

CRUMB: Very kind of New England vacation house for guys in gray flannel suits.

CLOWES: I was shocked [some of those earlier covers you showed] are from 1993. I thought those were from 1953.

MOULY: It lasted for decades. It felt like decades. It was a long period.

CLOWES: To think that the magazine now has this sort of—that you've brought in this sensibility from our comics. And to think of what we were doing in 1993 that was so far afield of those images. That that's now on [the cover of] *The New Yorker*. That just shows the general decline of our civilization. *[laughter]*

WARE: Didn't *National Lampoon* do a parody of *The New Yorker* where they used one of Robert's drawings? Who could imagine this?

MOULY: There was this great, great thing in the *Lampoon* of fake *New Yorker* covers.

CLOWES: There was a great *New Yorker* parody in the *National Lampoon* where all the little spot illustrations between the fiction pieces were like broken windows and stolen hub caps. Like this 1970s *New Yorker*. It was like the real New York.

CRUMB: When I did that Eustace Tilley cover in 1994, Françoise sent me those letters, like schoolteachers in Iowa and lawyers who lived in midtown Manhattan, they were so offended. I just realized that you have this loyal readership there that is pretty fucking square. You know? *[laughter]* They are liberal. And they are on the liberal side of things generally, but they just…so when you work for

The New Yorker you kind of have that audience in mind to some degree. You have to kind of bend whatever lurid qualities your work might have to fit that sort of lite, L-I-T-E, it's lite.

MOULY: But on the other hand, I remember at some point seeing a photo of your brother's bedroom wall and he had covers of *Mad Magazine* and covers of *The New Yorker* as well.

CRUMB: Yeah, yeah. Sure, sure. There is good stuff on the covers. And in the magazine.

MOULY: Did you see the magazine when you were growing up?

CRUMB: Sure. But often it was—in the 1950s it was real thick and it was very literary. I was just a comic book reader. It was too literary for me. I would look at the covers which were often very bland. But once in a while there would be a good one.

MOULY: Well, the 1950s still has Charles Addams and Steig, and a number—

CRUMB: Yeah. But you know, I was much more interested in *Humbug* and *Mad*. That was the real stuff.

CLOWES: Some of those Charles Addams [images], though, are really sick. If you tried to submit that now, they would be all in the *Blown Covers* book.

CRUMB: Like the cartoon where the guy next door is sharpening the spikes on top of his iron rail fence.

CLOWES: This gleeful, evil misanthropy going on. I loved that stuff as a kid, of course.

MOULY: Is there some connection for you when you were a kid? With *The New Yorker*?

CLOWES: Oh, yeah, my family always had *The New Yorker*. I think my mom had all the covers on her wall and stuff. It seemed like a very big deal in my world.

CRUMB: You came from sophisticated people.

CLOWES: Well, yes, we come from the finest stock. [*laughter*] It felt like when I was a young artist trying to be an illustrator, I felt like that's the holy grail of illustration assignments. Now when I get other illustration assignments it feels like, oh, I don't want to do that, I already did *The New Yorker* cover. You get very spoiled.

WARE: The one thing that magazine designers and editors just don't get now is that one of the real powers of a *New Yorker* cover in and of itself is that there is no type on it. It is an image. And it has a power to itself that allows the artist to make the image. Every other magazine, they have to put every single story there [on the cover]—they put titles on it. It obscures everything. It is the only magazine left—almost every magazine in the 1920s and 1930s only used an image. There was no type on it at all. But now this is the single magazine left—unless maybe there is some obscure architecture periodical or something that does that. [*laughter*]

MOULY: I think to some extent it has an influence now and *The New Yorker* gets other magazines to understand the value of the artist in the cultural dialogue. When ASME [American Society of Magazine Editors] does a lineup of the best magazine covers of the past decades, you get George Lois and a couple of *Rolling Stone* covers, but they also choose many *New Yorker* covers, because they are more long lasting and they are more interesting—in part because they don't have headlines on it. When I started at the magazine, twenty years ago, one of the innovations was to add cover lines. What Tina did at the time was to put them on a velum, a sheet of tracing paper. Now it's on a separate sheet of paper, to make sure that the headlines won't be embedded in the image.

CRUMB: They compromise with the flap that covers half the cover and has all the headlines on it.

MOULY: Exactly.

CRUMB: Is that only on the newsstand copy? It is not on the subscription copy.

MOULY: It's only on the newsstand copies. I loved to see how it got imitated by other magazines. *Harper's,* for example, which has an all-type cover, now has a flap with more type on it. [*laughter*] At *The New Yorker*, the lack of headlines forces the image to communicate on its own. When I asked Dan to do a cover for the innovators issue, it doesn't say "innovators" anywhere—all of the content and the fact that it's a special issue has to be communicated. You don't get the words; the image must demonstrate its idea.

WARE: If it was another magazine, it would say "The Innovators Issue!" "Moving America Forward" and then a list of all the stories that you are supposed to read. [*laughter*] It telegraphs to the reader that the magazine thinks they are not intelligent or something. This allows the images to breathe.

MOULY: It is also the only magazine that gives the artist his signed image on the cover. Even the conversations that we had about Robert's image, it's legitimate for *The New Yorker* to say, but, wait, it's a Steinberg or it's a Robert Crumb, or it's a Chris Ware, because it doesn't condescend to its audience. It allows the audience to recognize that it's a signed statement and part of an artist's body of work. That's important, and also the fact that the rest of the magazine has to stand behind it.

CRUMB: What is the circulation of *The New Yorker* now?

MOULY: I think a million-two or a million-three.

CRUMB: One million point two, wow. That's scary.

CLOWES: It is too many to even comprehend. Anything over like five thousand just may as well be five.

CRUMB: I'm used to thinking about twenty thousand the most. So when you work for an audience that size, it is very particular and special. And you know they are out there. One here, one there, but it adds up to about twenty thousand people. That's the audience generally for my stuff. And I know they will accept pretty much anything.

Figure 11. R. Crumb, rejected cover of *The New Yorker* (2009).

No matter how crazy and lurid I do. But when you work for this magazine that has 1.2 million people, that's mainstream even if it is on the upper end. It is on the upper middlebrow end of things.

CLOWES: That's like the population of San Francisco and Oakland put together.

CRUMB: Wow. That's a whole different story. It's a different ball game. A lot of power. You are a powerful gatekeeper.

MOULY: Thank you.

CRUMB: That's no joke. You are. There is a lot of shit that won't get past you—because of your position.

MOULY: But the way I see it, it allows something I think that's really fitting—putting artists like all of you at the center of cultural dialogue. Because I think that artists have a unique ability to cut through—

CRUMB: Price to pay.

MOULY: It is the only place for an individual to get an image out that is read by millions—because it is not just the number of subscribers, but now there is also a million people on the website, a million that doesn't necessarily overlap.

CRUMB: That's like the Faustian deal, again, the allure of the bigger audience. You're going to reach 1 million people and you get paid well. Okay, I'll pull back a little bit. I know you can't push this lurid grotesqueness too much. It is not going to be acceptable to those schoolteachers in Iowa and those lawyers in the skyscrapers. So, all right, I'll compromise a little bit. Oh, they loved it. Okay. Great. I'll do another one. Oh, that one is not acceptable. Oh, gee, I went too far that time. Okay, I'll pull back again. Eventually you just might as well go get your dick cut off. *[laughter]* I don't know. I'm not completely uncompromising. But okay, when that cover was rejected I had a lot of time to think about it.

CLOWES: To stew over it.

CRUMB: Yeah, gnash my teeth about it.

197

Out of Jest:
The Art of Henry Jackson Lewis

Garland Martin Taylor

> He who can accurately represent the form of an object . . . has unquestionably
> a power of notation and description greater in most instances than that of words.
> —John Ruskin, *Education in Art* (1858)

In 1968 Chester Arthur Lewis, the son of Henry Jackson Lewis, bequeathed forty-seven of his father's original ink-on-paper drawings, mostly unpublished editorial cartoons, to the DuSable Museum of African American History in Chicago. Lewis was a late-nineteenth-century artist, engraver, and illustrator regarded today as the first African American editorial cartoonist.[1] What Lewis left us is more than mere elegant works of art or vintage propaganda. His work recalls an age when images of blacks by blacks served blacks in strategies of resistance and uplift. Lewis gives us a rare glimpse of Gilded Age African American life—an age when blacks migrated from the South to urban centers like New York, Cleveland, Chicago, and Indianapolis; an age that bore witness to increased lynchings and domestic terrorism; and an age that gave rise to the NAACP, the civil rights movement, and the Harlem Renaissance. Many of the illustrations, cartoons, caricatures, and column headings in this collection were conceived, carved into woodcuts and chalk plates, then printed and published during Lewis's tenure as an artist at the Indianapolis-based illustrated weekly newspaper, *The Freeman*. Other works in this collection, however, were neither printed nor published in the artist's lifetime.

Though it is common for cartoons and illustrations published in newspapers and magazines to rely on captions to help viewers interpret an artist's visual narrative, Lewis's debut self-portrait spoke for itself on page two of the 13 July 1889 issue of *The Freeman*, a black-owned-and-operated illustrated newspaper. For reasons unknown, the paper's editor published Lewis's portrait without an accompanying biography (fig. 1). Lewis seems to have borrowed heavily from the formal structure of medieval heraldic achievements, or coats-of-arms, to pledge allegiance to Victorian values, civic responsibility, black journalism, and a brand of pictorial reporting aimed at (re)building a national identity. The

key elements of heraldic achievements that Lewis co-opted were the crest, helmet, shield, supporters, compartment, order, and motto (fig. 2). At the crest the eagle perched above Lewis's head screams American identity. Its outstretched wings protect the two supporters below (Lewis's oldest son and daughter), one of whom bears upon his shoulder a flagless pole based on a copy of *The Freeman*—foreshadowing the nation-building and uplift yet to come from the black press. Lewis carefully arranged his drafting tools and artist's instruments directly on top of a book open to the "Science of Fine Art" on one page and the "Science of Engraving" on the other. This was Lewis's way of earning the trust of *Freeman* readers—assuring them that his depictions of the race were based on a sort of empirical confirmation. Lewis was a self-made man beholden to African American uplift like many of *The Freeman*'s subscribers and readers. The signs and symbols he employed tell us that he was acutely aware of the role art played in the struggle toward progress. Essentially, Lewis was an early incarnation of twentieth-century social realists: "agent[s] of democratic consciousness raising and social change," who use art, especially images of blacks, "to leverage transformations in the social and political sphere."[2] Lewis's statement of purpose can be found inscribed on his palette. It is a motto in Latin that translates to Not Born for Ourselves Alone, but for the Whole World.

Born into slavery near Water Valley, Mississippi, around 1845, Henry Jackson Moore found freedom in 1863, abandoned his slave surname for Lewis, and then volunteered to fight in the Civil War with the Fourth United States Colored Heavy Artillery.[3] Three years later, Corporal Henry Jackson Lewis emerged. Little is known about Lewis's war years, but in 1866 he mustered out of the military a free man at Pine Bluff, Arkansas. Despite a blinded left eye and a disabled left arm, Lewis educated himself and then learned to draw and sketch. By 1874 Lewis worked as a carpenter, bought a house in Pine

1. See Marvin D. Jeter and Mark Cervenka. "H. J. Lewis, Free Man and Freeman Artist," *Common-Place* 7 (Apr. 2007): www.common-place.org/vol-07/no-03/jeter-cervenka/

2. Stacy I. Morgan, *Rethinking Social Realism: African American Art and Literature, 1930–1953* (Athens, Ga., 2004), p. 2.

3. See the National Archives and Records Administration United States Colored Troops (USCT) enlistment papers, www.fold3.com/category_268/

Figure 1. Henry Jackson Lewis, self-portrait (1889).

Figure 2.

Bluff, and married Lavinia Dixon. He also sold sketches to newspapers such as *Frank Leslie's Illustrated*, *Harper's Weekly*, and the *Arkansas Gazette* (along with other Arkansas newspapers) in the late 1870s.

And, remarkably, white newspapers that published drawings based on his sketches credited Lewis as the artist. This resulted in word of Lewis's artistic ability spreading up and down the Mississippi River and across the country. Black newspapers also spread the word. An 1879 editorial in the *Weekly Louisianan* reported that Lewis had "produced fine crayon portraits of several prominent citizens" of Arkansas.[4] This kind of exposure was probably what captured the attention of Edward Palmer, a Smithsonian archeologist for whom from 1882 to 1883 Lewis sketched prehistoric burial mounds built by American Indians throughout Arkansas.[5] Lewis continued to freelance his talent in Arkansas for most of the decade. A blurb in the 27 July 1887 *Arkansas Gazette* reported (via the *Pine Bluff Press-Eagle*) on several "exceedingly credible" illustrations of "residences and public buildings" by "H. J. Lewis, a local colored artist of fine talent," published in four consecutive Sunday issues of the *Gazette* from 10 July through 31 July 1887.[6]

Then in January 1889 Lewis relocated his family to Indianapolis, Indiana where he secured work as a pictorial reporter, designer, cartoonist, and engraver on staff at *The Freeman*.[7] In the twenty-seven months that Lewis lived and worked in Indianapolis he published in *The Freeman* close to one hundred and seventy-five editorial and political cartoons, caricatures, and illustrations. Lewis died in Indianapolis on 10 April 1891, after a ten-

day bout of pneumonia.[8] He was survived by his wife and seven children.

He was also survived by the forty-seven original drawings at the DuSable Museum, one of which is a *Freeman* advertisement featuring a caricature of Edward Elder Cooper, the owner and editor of the newspaper. Cooper stands on an ocean shore holding a very large unrolled scroll announcing *The Freeman* and its subscription rates (fig. 3). When Cooper bought *The Freeman* in 1888, it was mostly a text-based newspaper in which the only images were product advertisements for items like guns, horses, soaps, stoves, and a plethora of remedies promising cures for baldness, coughs, cancer, and consumption. After the November 1888 election of Republican President Benjamin Harrison, and two months before Lewis's arrival in Indianapolis, Cooper transformed *The Freeman* into "the only pictorial colored newspaper published in America," information to which he proudly points in Lewis's unpublished broadside, created around 1890.[9] This broadside reminds us that *The Freeman* was a site of resistance where blacks controlled, for the first time in American history, the mass dissemination of pictorial representations of the race.

Cooper devoted the content of his eight-page paper to general news, politics, theater (and minstrel show) reviews, and other happenings in the black community—as did the one hundred or so other black newspapers in the US from the *New York Age* to the *San Francisco Elevator*. *The Freeman*'s competitive edge, however, was what Cooper called the "beautifully illustrated . . . portraits and sketches of representative colored men and women."[10] The black press lauded Cooper's illustrated weekly. *The Advo-*

199

4. "A Colored Artist," *Weekly Louisianian*, 1 Feb. 1879, p.1.

5. See Jeter and Cervenka, "H. J. Lewis, Free Man and Freeman Artist."

6. "Pine Bluff: Good Words From the *Press-Eagle*, Personals and Notes," *Arkansas Gazette*, 27 July 1887, p. 3.

7. See "Relied on Himself: A Colored Man Who Acquired an Art without the Assistance of an Instructor," *Indianapolis Journal*, 24 Nov. 1889, p.16.

8. Death Certificate, Henry Jackson Lewis, Board of Health, Indianapolis, Indiana, 28 Apr. 1891.

9. Henry Jackson Lewis, unpublished advertisement for *The Freeman* (1890). Courtesy of the DuSable Museum.

10. Advertisement, *New York Age*, 11 Oct, 1890, p. 6.

Figure 4. Henry Jackson Lewis, unpublished editorial cartoon (1889–1891). Lewis visualized the phenomenon often referred to as the "Black bolt"; a period when African Americans began to shift political affiliation from the Republican to the Democratic party. T. McCants Stewart is flanked on the left by T. Thomas Fortune and on the right by Grover Cleveland.

Figure 3. Henry Jackson Lewis, unpublished advertisement for *The Freeman* (1890). The reason a number of the Lewis drawings were not published in *The Freeman* or elsewhere was because they contained spelling errors. Notice Lewis's version of the word *invariably*. Lewis also made a mistake with the subscription rates, as it was a three-month subscription, not a one-month, that cost subscribers seventy-five cents.

200

cate, out of Leavenworth, Kansas, claimed that Cooper's paper was "to the colored people what *Frank Leslie['s Illustrated Newspaper* was] to the whites."[11] The Washington DC-based newspaper *The National Leader* considered *The Freeman* "the *Harper's Weekly* of the colored race" (*AA*, p. 337). In an advertisement in the 16 March 1889 *Leavenworth Advocate*, Cooper publicized his mission: "The colored people have long needed just such a champion—a pictorial newspaper—one which will 'paint them as they are' and not caricature them as is too often done by the white press. *The Freeman* portrays the Negro as he is—giving each week the portraits and sketches of the representative men and women of the race."[12]

At the core of Cooper's pictorial strategy was the "representative" "Negro," William S. Scarborough, a black leader and scholar of Greek classics, who defined "representative man" as one "in whom the people have implicit confidence; a man of much learning and wide experience whose character is above reproach" (*AA*, pp. 432–34). One such representative man was T. McCants Stewart. Stewart was a New York-based lawyer, clergyman, civil rights leader, as well as a "Negro newspaperman, corresponding editor of

the *New York Freeman*, [who] was conscious of his role as a spokesman and radical champion of race."[13] Stewart was also a black Democrat and staunch supporter of Grover Cleveland's second run for the White House in 1892.[14]

Lewis prepared a cartoon that illustrated Stewart and T. Thomas Fortune's support of Cleveland and the Democrats (fig. 4). Although the drawing was never published in *The Freeman*, it's possible that Lewis created it around the time that Cooper republished an opinion editorial in the 5 October 1889 issue of *The Freeman* in which Stewart boldly called on blacks in the South to "organize . . . but if he is forced to fight, he must do so with the same pluck, energy and spirit which he displayed at Fort Fisher and Battery Wagner; and if he must die . . . let him make his death so costly to the whites in blood and fire as to force the conservative and moral white elements of the South to stand up for peace, and to insist upon equal and exact justice to all men alike."[15] Lewis most likely considered his work as a *The Freeman* artist every bit as anthropological as the work he performed for Edward Palmer and the Smithsonian. As an example of the representative "molder of public opinion" and "spokesman of the race," Lewis was the ideal agent to carry out Cooper's pictorial strategy (*AA*, p. 432).

As the only black-owned illustrated newspaper, Cooper's *The Freeman* was the sole site of resistance to the American visual war on the image of its black citizens—the plethora of abject caricatures of African Americans printed, published, and widely disseminated by publishers like Currier and Ives, *Harper's Weekly*, *Frank Leslie's Illustrated*, *Judge*, *Puck*, *Life*, and others. These kinds of

11. I. Garland Penn, *The Afro-American Press, and Its Editors* (Springfield, Mass., 1891), p. 337; hereafter abbreviated *AA*.

12. Advertisement, *Leavenworth Advocate*, 16 March 1889, p. 2.

13. C. Vann Woodward, *The Strange Career of Jim Crow* (New York, 2002), p. 38.

14. See Charles E. Wynes, "T. McCants Stewart: Peripatetic Black South Carolinian," *South Carolina Historical Magazine* 80 (Oct. 1979): 311–17.

15. T. McCants Stewart, "How to Achieve Freedom: The Remedy For Southern Outrages," *The Freeman*, 5 Oct. 1889, p. 2.

images appeared in popular media so routinely that "no proper saloon, poolroom, barbershop or firehouse was without one or more" Negro grotesque.[16] White artists such as Sol Eytinge Jr., Thomas Nast, Eugene Zimmerman, Frederick Opper, and others put forth pictures of exaggerated black physiognomy and portrayed the race as childish, mindless, and shiftless.

This is not to suggest that every image in the white press depicting African Americans was visual calumny. Thomas Nast famously led a campaign of caricatures against the New York politician and business executive William "Boss" Tweed (the political machinist behind an infamous ring of corruption that embezzled millions of taxpayer dollars). Nast's visual representations are said to have played a major role in exposing Tweed's ring of corruption and bringing him to justice. Nast is known as the patriarch of American political cartooning and the artist who helped make *Harper's Weekly* "the greatest political power in postbellum publishing."[17]

Occasionally, Nast drew (and *Harper's Weekly* published) cartoons that called attention to the crimes, disfranchisement, and atrocities committed against his fellow African American citizens. In an 1868 piece published in *Harper's Weekly* titled "This is a White Man's Government," Nast shows us how white immigrants, white Southerners, and white Northerners set aside their differences in order to collaborate against the Negro's vehement struggle for well-being, manhood, citizenship, and suffrage (fig. 5).[18] It is important to note that Nast was careful not to maliciously magnify the physiognomy of the black Civil War veteran. This and several other similar instances indicate that the artist's work was ostensibly well intended.

Lewis is considered "an indirect disciple of Thomas Nast."[19] "This Is a White Man's Government" is a likely source of inspiration for one of Lewis's untitled, undated, and unpublished cartoons from the DuSable collection. Lewis drew four Lilliputian-like white Southern democrats in the concerted act of turning down the screw of an industrial sized copying press that compresses a larger-than-life black man (a recurring character), who has been manacled to the floor below (fig. 6). Although the press forcibly flattens the man, he gazes indefatigably toward the viewer. In this display of Lewis's sheer command of gesture and metaphor we are reminded that if *The Freeman* was the black *Harper's Weekly*, then Lewis was the black Thomas Nast.

To pepper the pages of his progressive pictorial with images of black folk proper, Edward Cooper issued a call-to-arms of sorts, to the nation's colored artists in late 1888. Shortly thereafter Cooper had three master artists to carry out his mission: Lewis, Edward H. Lee, and Moses L. Tucker. To date, very little information is available on the

Figure 5. Thomas Nast, "This Is a White Man's Government" (1868).

201

lives of Lee and Tucker. What we do know is that Lee was a portraitist with a seemingly successful practice in Chicago. He contributed numerous portraits of prominent blacks for publication in *The Freeman* and for Irving Garland Penn's *The Afro American Press and its Editors* (1890).

Caricature was Tucker's forte. Cooper plucked Tucker from an Atlanta-based paper called *The Georgia Cracker*. He contributed to *The Freeman* much more by way of caricatured cartoons and column headings than Lee and Lewis. Tucker also created one of *The Freeman* mastheads. In the 8 June 1889 issue Cooper also penned a biography that accompanied Tucker's self portrait in which he explained how Tucker's "special work on the *Georgia Cracker* was the caricaturing of colored people, and his ability in this line has been thoroughly demonstrated. While we are averse to 'poking fun' at the Negro, still there are many traits and characteristics which will bear criticism, and which should be eliminated. This phase of the race problem will receive more attention hereafter and Mr. Tucker's gifted pen will do a share of it."[20] Tucker had a reputation as a "lightning" artist who, with either hand, produced remarkably fast and accurate crayon sketches.[21]

16. John J. Appel, "Ethnicity in Cartoon Art," in *Cartoons and Ethnicity* (Columbus, Ohio, 1992), p. 29.

17. Stephen Hess and Sandy Northrop, *American Political Cartoons: The Evolution of a National Identity, 1754–2010* (New Brunswick, Maine, 2011), p. 52.

18. See Fiona Deans Halloran, *Thomas Nast: The Father of Modern Political Cartoons* (Chapel Hill, N.C., 2012), pp. 107–10.

19. Paul P. Somers, Jr., *Editorial Cartooning and Caricature: A Reference Guide* (Westport, Conn., 1998), p. 8.

20. "News and Opinion," *The Freeman*, 8 June 1889, p. 4.

21. "An Evening In Fun Land," *The Freeman*, 12 July 1890, p. 5. And see "Our City People," *The Freeman*, 21 June 1890, p. 8.

Figure 6. Henry Jackson Lewis, unpublished cartoon (1889–1891). Courtesy of the DuSable Museum of African American History.

Shortly after Tucker arrived at *The Freeman* Cooper seemed to embrace the very same style of black caricatures that the editor had harshly condemned in his mission statement. More than likely Cooper used the more minstrelized cartoons and the subsequent subscriber outcry in a strategy to increase sales of his struggling newspaper. The U-turn in Cooper's pictorial strategy to "build up" the race probably dismayed Lewis. Moreover, he would have felt betrayed by Cooper's decision to stop the pictorial attacks on the Harrison administration's do-nothing stance on the increase in lynching and racial terrorism in the South. Instead, after the 19 October 1889 *Freeman* in which three Lewis cartoons confronted Harrison, Cooper moved forward publishing politically impotent cartoons. By 18 October 1890 Cooper editorialized a castigation of *Freeman* readers who complained about the stereotyped cartoons and caricatures that virtually replaced Lewis's sharp political cartoons aimed at the Harrison administration's shortcomings. "Our cartoons are not made to offend the most sensitive person," Cooper wrote, "nor have we any intention to make caricatures of the race without having in view some object beneficial to the race." He went on to tell readers that the "mass of our readers enjoy [stereotyped images of blacks] and find in them some salient features from which lessons may be drawn."[22]

Lewis would have been conflicted about making grossly exaggerated caricatures of the race. From 1879 until the end of 1889 Lewis's published illustrations of African Americans were, well, "representative" according to the Scarborough scale. Lewis's first cartoon in which black physiognomy was exaggerated for the sake of comic effect appeared in *The Freeman* on 21 December 1889. It is worth pointing out that this was a time when Lewis no longer worked on staff at *The Freeman*. Instead, Lewis worked out of his own studio on Washington Street in Indianapolis.

Figure 7. Henry Jackson Lewis, self portrait (1890–1891). Courtesy of the DuSable Museum of African American History.

This parting of ways was confirmed in the 9 November 1889 *Cleveland Gazette* by a report that Lewis "severed his connection" with *The Freeman*.[23] Lewis himself alluded to this split in a 24 November 1889 interview by telling the journalist the engravings and published cartoons in *The Freeman* "until recently, were made by me."[24]

If Lewis left *The Freeman* in protest of Cooper's new pictorial policy this would explain why we find a dispirited Lewis in his unpublished self-portrait most likely created around 1891 (fig. 7). Set in his Washington Street studio this portrait of the artist is vastly different from his *The Freeman* debut on 13 July 1889. Whereas Lewis's published portrait is presented like valorous poetry, Lewis's unpublished piece reads like a requiem. The once larger-than-life, optimistic artist, supported by a full array of signs and symbols of progress, gave way to a gangling, secluded, and weary laborer propped up on a slanted work stand. Lewis ignores the viewer; but the caricatured baseball player beneath his brush locks eyes with us—deliberately. For when our eyes follow the single guide attached to the right side of the slanted stand, we find a wood block carved with the image of one man sizing up another. On the floor at Lewis's feet we find a book, possibly the same book Lewis drew, opened to the sciences of fine art and engraving in his *The Freeman* debut; only now the book is closed and stowed away.

202

22. "The Editor's Talk," *The Freeman*, 18 Oct. 1890, p.4.

23. "Of Race Interest," *Cleveland Gazette*, 9 Nov. 1889, p. 1.

24. Quoted in "Relied on Himself," p. 16.

Public Conversation: Alison Bechdel and Hillary Chute

May 19, 2012

Introduced by Lisa Ruddick

LISA RUDDICK (from her introduction): I am Lisa Ruddick from the University of Chicago. It is an honor to be introducing Alison Bechdel and Hillary Chute, people who have done groundbreaking work in the medium of graphic narrative. There was some talk at last night's panel about the danger that comics in time will be academicized, as the medium responds to the scholarly community that now has more and more to say about it in analytical terms. Considering what has happened in other media, that's not an unrealistic concern, although it is really hard to imagine that happening with comics. If it ever were to happen, we might look back at this conference as marking a wonderful moment when the academic and artistic communities are acknowledging each other and engaging with each other with a sense of authentic discovery. The panel last night was called what the bleep-ti-bleep happened to comics? A joke happened that what the bleep-ti-bleep has happened to the University of Chicago?

ALISON BECHDEL: Hi. Thank you.

HILLARY CHUTE: I'll start by making reference to the class that Alison and I are teaching, which is called "Lines of Transmission: Comics and Autobiography." We had the pleasure—it was a pleasure for me—of teaching Alison's book *Are You My Mother?* which just came out, in class last week. Alison, one of the things you said in class that I was so interested in is that the seed of the story was conceptual. So it's an autobiography, it's about events that happened to you that you've been thinking about for years, but you said, and I'm quoting you here, "I wanted the book to be about ideas I was excited about." As opposed to about *events* in your life you were excited about. Can you talk about that?

BECHDEL: Well, this is what my book looked like when I began it [*pointing to slide of Excel spreadsheet breakdown of* Are You My Mother?].

CHUTE: This is one of Alison's charts.

BECHDEL: I wanted to write about the problem of the self and the relationship with the other. Which is a crazy ab-

stract thing to try and write a book about. Unless you are writing an academic book, which I wasn't doing. I wanted to write a book that would entertain people. [I thought that] in all of these little ideas I would somehow find a narrative path. And I realized things were starting to cohere into strands. It wasn't all just a million random ideas, but I had different lines of ideas that would run through the book.

CHUTE: Can you explain what some of the colors signify?

BECHDEL: Each little cell is like everything that ever happened to me or anything I ever thought. A lot of them are quotations or references to ideas. But that's not a story. Like there is a story of me, there is a story of my mother's life and the way that my mother's life and my life reflect each other or don't, there is a strand of ideas by the psychoanalyst Donald Winnicott, there is a strand of my own experiences in therapy. And all that started to cohere into these bands of color which eventually became a story.

CHUTE: So can you talk a little bit more about some of the conceptual strands? Like at the bottom I see number five is "Psychoanalytic Material." And number six is "Language." And then you have a parenthetical: "Lacan addresses it, Winnicott doesn't."

BECHDEL: A lot of this stuff got dropped out, thank God.

CHUTE: Let's look at a page that I think shows pretty clearly how this is a book about ideas in the way you were talking about—can you tell me about this page?

BECHDEL: I got really obsessed with Donald Winnicott and in each of my chapters of the book I tried to explain one of his really pretty abstract psychoanalytic ideas. Chapter 2, which we are looking at here, it is the idea of the transitional object. I use these images from *Winnie the Pooh* which I felt explained it all really, really clearly without having to use too many words. This image by E.H. Shepard pretty much sums it all up. And I just kind of zoom in on the key concept.

Figure 1. Excel spreadsheet from conference. Photo: Karen Green.

204 CHUTE: Why were you interested in the concept of the transitional object?

BECHDEL: This book is a memoir about my mother. I was trying to figure out my mother. That's what that whole chart was. Trying to figure out my relationship with my mother. I feel like, in a way, this book is using ideas to get at feelings. Another of the ideas of Winnicott is the idea of the "mind object." The mind that just takes over and separates a person from their body or from their everyday life. I definitely suffer from that. So the book is kind of a symptom of this because it is coming at feelings from a very cerebral intellectual way. But what I was hoping as I went along using this technique is that I would get to the feelings through the ideas.

CHUTE: Did that happen?

BECHDEL: I don't know. Because I haven't really had a chance to read the book yet. *[laughter]* I'm hearing from readers who seem to be responding in that way, but it is kind of an experiment.

CHUTE: Okay, well, another thing that I wanted to talk about that I think your work calls our attention to is this idea of words *as* images. I'm wondering why in your work there is so much drawing of typeset text?

BECHDEL: It's crazy. It feels really crazy when you look at the vibrant stuff that Aline [Kominsky-Crumb] and Robert [Crumb] are drawing. But I'm making words into pictures. I just have a sensual delight in letter forms. I love

words and I love their physical manifestations, and I find it very soothing to do this kind of lettering. It is just fun. But I guess I could make a theory about it, which is I want people to enter into my experience as a reader. My intimate reading experience in these books.

With this page I was working on, it is a newspaper clipping on the bottom half and the top half is a letter that my mother typed to me once. I want you guys to read these archival images the way I read them. Like through my eyes. Through my hand.

CHUTE: Are saying that the typeset text becomes an image by virtue of you drawing it for us on the comics page?

BECHDEL: Yes, I think so.

CHUTE: So let's look at this a little more closely. Can you describe what was going on when you made this page? What you were trying to get at?

BECHDEL: I think newspapers are really cool. I like the randomness of it. I like that these other stories are running off the margins. I guess I like that my story is just one of many millions of possible stories.

CHUTE: One of the things that I'm really keen to talk to you about is this idea of inhabitation. I heard Joe Sacco use the word inhabitation a couple times this morning, this idea of what happens when you draw someone. And is it a kind of inhabitation of their gesture, for example. What does it mean to draw someone and to draw someone with a certain degree of attention, where you are pay-

Figure 2. Alison Bechdel, *Are You My Mother?* (2012).

THE KIND SHE DESCRIBED IN THIS LETTER SHE SENT TO ME WHEN I WAS IN COLLEGE.

Congeniality as far as …

I am reading another Margaret Drabble book - The Garrick Year - about the theatre. Good! What she says about actors! And also what she says about herself - how mean she is, etc. Here is how she describes an actress: "-her face pale and tremulous. Nobody would look at her twice, and yet she is the genuine thing, and one of the few actresses that I admire, one might almost say a great, a classical actress. On stage she always looks enchanting. She is a doctor's daughter, and has never been known to say anything of interest to anyone." Of course I am confusing narrator and author, but since Drabble has been in the theatre, I feel the observations are hers.

The house undergoes another inspection today. One of Sam's friends. I blew a little dust off the artifacts, but Bruce will soon begin dumping apples around in casual disarray, arranging funeral flowers in art glass vases, and displaying the more prominent of his recent correspondences.

… roast beef sand-

MOM NEVER PLAYED A TYPICAL INGÉNUE. SHE SAYS PROUDLY THAT SHE DID CHARACTER ROLES EVEN AT NINETEEN.

James' Story Is 'Heiress' Theme

Helen Fontana Plays Catherine Sloper Role

A Henry James novel "Washington Square" has been adapted into a play, "The Heiress," to be given on Thursday and Friday of this week at Price auditorium by the combination of Lock Haven Playmakers and the College Players.

Briefly, the story concerns Catherine Sloper, a role to be portrayed here by Miss Helen Fontana. An heiress, she has been dominated by a father who would have her grow into his idealized likeness of her dead mother.

Complications of a fortune-hunting young man, and Catherine's romance, inject subtleties and twists into this plot.

Miss Fontana, a graduate of the Immaculate Conception High School and a sophomore at the college, has now twice been placed in dramatic jeopardy in her short career on the college stage. Last year she appeared in the role of the second Mrs. De

Helen Fontana

She will play the central role of Catherine Sloper in "The Heiress," to be given this week at Price auditorium by the Lock Haven Playmakers and the College Players.

Personals

Mrs. Viola Sterner of Blooms-

Hospitals

It could be one of two that made Robert Jacobs, the Teachers College, jumping meters last evening he was making plans to t with Coach Jack's track or maybe he was entertair group of friends with his ' jumping.

HER FIRST PART IN COLLEGE WAS THE NAMELESS "SECOND MRS. DE WINTER" IN *REBECCA*. NEXT, THE LEAD IN *THE HEIRESS*.

Albert E. Eyer, a nati Mill Hall, who became a h visiting in Daytona Beach was brought home yester train to Philadelphia an ambulance to Lock Haver was admitted last evening Lock Haven Hospital. Hi dition today is reported "

Saturday Surgical pati were Edward Jacobs, five old son of Mr. and Mrs. Jacobs, Howard, who h tonsils removed: Stanley son, RD 1, who had tee tracted, and Harry Ham

Figure 3. Alison Bechdel, *Are You My Mother?* (2012).

Figure 4. Bechdel as Winnicott rolling on the floor. Photo courtesy of Alison Bechdel.

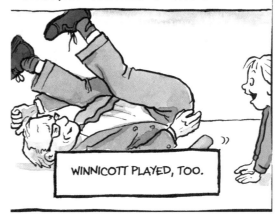

Figure 5. Alison Bechdel, *Are You My Mother?* (2012).

ing attention to their body and their movement and their psyche? I know that you, among cartoonists, have a pretty interesting procedure, in which you set up photographs that you pose in. Could you tell me about that?

BECHDEL: Yeah, I just—*[laughter]*. It's almost an aerobic activity sometimes—

CHUTE: So this is Alison posing as Donald Winnicott, rolling on the floor.

BECHDEL: I do this for almost all the figures I draw. I pose. Sometimes I put on costumes if I feel like I need to. Like it was hard to draw a suit. But I do this primarily as a drawing aid to have a quick reference to draw from. As Joe said, it gives you this weird insight into the character. Joe was talking about looking at himself holding a club, and he enters the subjectivity of that club-wielder. As I am doing these poses which are really just quick drawing aids, there is a kind of interesting emotional thing that happens as I have to impersonate these characters. I would like to think it gives me an emotional intimacy that filters into my drawing. I don't know if that happens but it is just like I *have* to do it.

CHUTE: I love the pictures of you as Winnicott. But I'm particularly interested in the pictures of you posing as your parents, who are the subjects of your work. Does that feel different for you? I remember you saying once, about the reference shot: the funny thing is when I have to act out my parents having a fight with each other, and I have to be both of them.

BECHDEL: Yeah. I'm sort of thinking of Seth right now when he said he was comparing his models in the basement to Joe Sacco out in the world writing about things that are really happening. I am literally in my basement recreating my childhood. *[laughter]* But I feel like this is my way to the outside world. And that when I'm writing about my family, my family is like a little country. It is like a little state and I'm trying to like overthrow it. *[laughter]*

So it is a kind of political act even though it is also very intimate.

CHUTE: Aren't you working on a new project about family systems theory?

BECHDEL: Oh, Jesus, Hillary, I haven't told you this yet. My mother read about that in some article about me. I've been going around talking about how I want to keep writing more family memoirs. I've already written two, much to my mother's chagrin. She read this article saying, oh, Bechdel is going to write another book with her family. And she said, no, I really don't want you to do that. I'm going to cut you off. I don't know if she meant financially or emotionally or if she was going to come slice my head off. *[laughter]*

CHUTE: Or archivally, right?

BECHDEL: She means archivally. But it has unmistakable overtones.

CHUTE: Keeping on the subject of photographs in your work, it is really interesting to me that for both of your graphic memoirs you've told me that the seed for the book comes from a photograph—or the initial idea, the inspiration, comes from a photograph.

BECHDEL: Yes.

CHUTE: This is a double spread from *Fun Home* which is literally at the center of the book, and photographs play a big role in *Are You My Mother?*, too. This is another double spread with these images of you and your mother interacting when you were a baby. That was the genesis for the second book.

BECHDEL: I kind of lied when I said the beginning of this book was an idea. It was really these photographs. I had seen one or twos of these photographs growing up. We had an album. But later I found more of them and realized there was a whole little sequence of photos. I don't have the negatives so I don't know what order they happened in

207

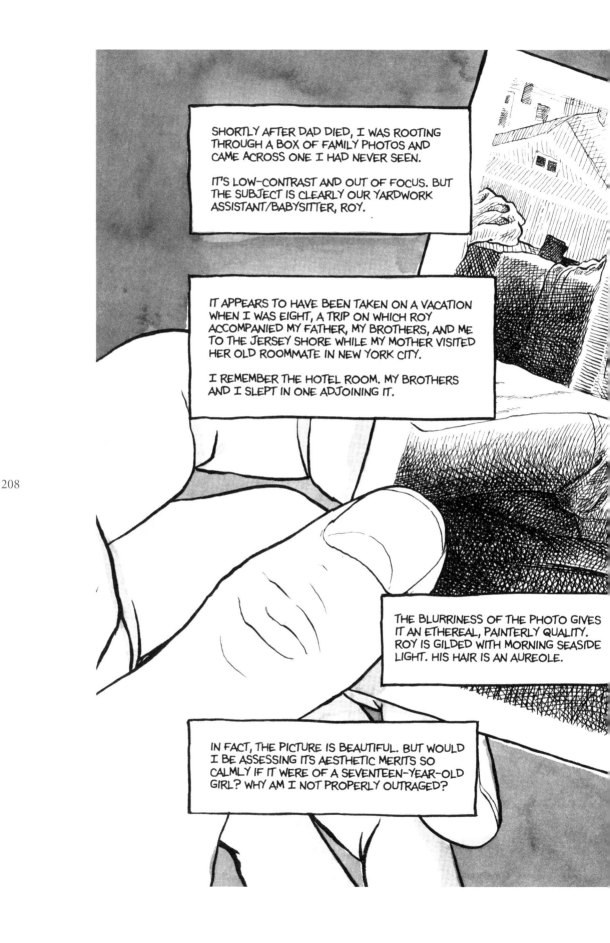

SHORTLY AFTER DAD DIED, I WAS ROOTING THROUGH A BOX OF FAMILY PHOTOS AND CAME ACROSS ONE I HAD NEVER SEEN.

IT'S LOW-CONTRAST AND OUT OF FOCUS. BUT THE SUBJECT IS CLEARLY OUR YARDWORK ASSISTANT/BABYSITTER, ROY.

IT APPEARS TO HAVE BEEN TAKEN ON A VACATION WHEN I WAS EIGHT, A TRIP ON WHICH ROY ACCOMPANIED MY FATHER, MY BROTHERS, AND ME TO THE JERSEY SHORE WHILE MY MOTHER VISITED HER OLD ROOMMATE IN NEW YORK CITY.

I REMEMBER THE HOTEL ROOM. MY BROTHERS AND I SLEPT IN ONE ADJOINING IT.

THE BLURRINESS OF THE PHOTO GIVES IT AN ETHEREAL, PAINTERLY QUALITY. ROY IS GILDED WITH MORNING SEASIDE LIGHT. HIS HAIR IS AN AUREOLE.

IN FACT, THE PICTURE IS BEAUTIFUL. BUT WOULD I BE ASSESSING ITS AESTHETIC MERITS SO CALMLY IF IT WERE OF A SEVENTEEN-YEAR-OLD GIRL? WHY AM I NOT PROPERLY OUTRAGED?

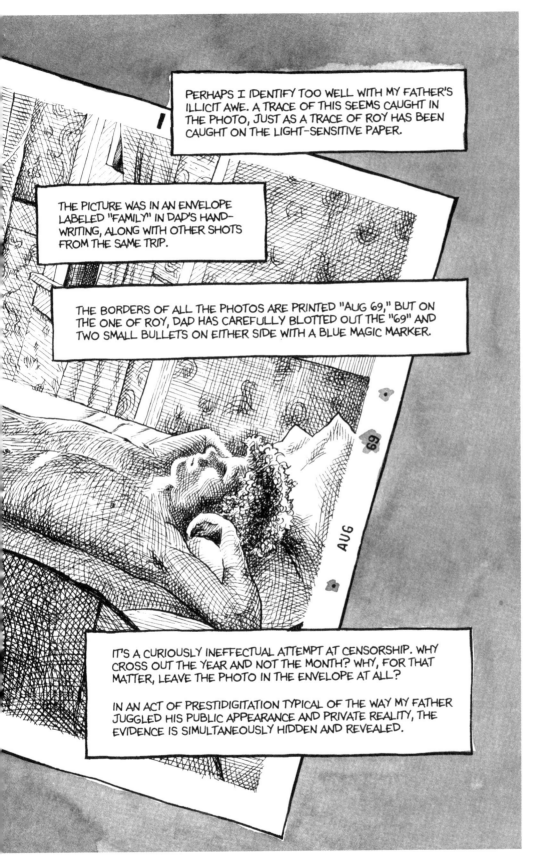

Figure 6. Alison Bechdel, *Fun Home* (2006).

actually, but I took great pleasure in arranging them in a narrative. I was fascinated by how closely my mother and I are mirroring each other. She's making these gestures and noises at me and I'm totally, totally mirroring what she's doing. Which is kind of what the book is about. Mirroring is another Winnicottian idea.

CHUTE: You found this series of pictures and you put them in a kind of comics form for the book, figuring out which came first.

BECHDEL: Yes.

CHUTE: How did you come to this version?

BECHDEL: It is just increasing delight on the baby's part. Until the moment is shattered and the baby sees the photographer. Who I think was my father, but might not have been.

CHUTE: And what about this picture here from *Fun Home* [of Roy posing in his underwear]?

BECHDEL: My father died when I was nineteen. This is a picture I found when I was about twenty. I found this when I was looking through some old family archives. This was in an envelope of photographs of me and my brothers at the beach. This young man in his underwear. And I knew this guy. It was our babysitter. And I remembered this trip to the beach when I was eight. And it was like this sudden amazing and disturbing window into my father's secret life. And when I saw this picture, I knew that I wanted to write about it. It is so complicated. But my father—we don't need to go into all that…? *[laughter]*

CHUTE: I don't know what you are about to say, so I don't know if everybody else does.

BECHDEL: I get confused by all the chronology. When I found the picture, my father had recently died. And my father died soon after I came out to my family as a lesbian. It freaked everyone out. My mother [had] told me that my father was gay. Soon after that he was hit by a truck. So the book is all about this sorting out what happened in that strange little knot of sexual coming of age and death and trauma.

CHUTE: Why in drawing the photographs in both of your works do you render them differently than you render other parts of the book?

BECHDEL: I wanted them to look like photographs. In the one of the boy on the bed, I really wanted to capture the tonality of a photograph by using line, which is really difficult. I want people to know it is a real photograph of something that actually happened.

CHUTE: In *Fun Home*, you have drawings of photographs that are chapter title pages for all of the chapters in the book, and they have photo corners on them. Some of them are missing photo corners and some of them are creased. So I feel like you are not just trying to give us a transparent window, but rather you are calling our attention to the photograph as a kind of archive.

BECHDEL: Yes, yes.

CHUTE: Another thing that relates to archives in your book has to do with handwriting. And there is such an interesting emphasis on handwriting in this book. Sort of tacitly, formally, but also as an explicit subject. You have panels in *Are You My Mother?* that are your own recreated journal entries. And also panels in which you are recreating your father's handwriting in a letter to your mother. Here is a scene in which we see your mother taking dictation from you.

BECHDEL: This is my primal scene.

CHUTE: Why don't you describe it?

BECHDEL: This is this pivotal moment in my life where I think I became a memoirist. I had this obsessive compulsive phase as a kid and my diary entries got really, really elaborate and took forever, so my mother said, "let me take dictation for you for a while." So for six weeks in my childhood she did that. And it was like this way of getting attention from her that was very important.

Both of my parents kind of found their way into my diary in an interesting way. I got started writing a diary by my father showing me how do it. He explained to me, just write down what's happening. So the very first words of my diary are in my father's handwriting, "Dad is reading The Trumpet of the Swan." Then I took over from there.

I feel like there is something really intense [that] got transmitted to me through my parents and each of their handwriting in my diary during this period of time when I was ten or eleven. My therapist has a theory that my parents encouraged me to keep a diary because it was a way to—they were making me into the person who was carrying the emotional weight of the family. My diary was a repository for all these emotions that weren't being expressed. And I think that's probably true. But I also feel like it was keeping these records that really helped me to survive my childhood. And to become someone who could write about it.

CHUTE: But not only write about it, but also *draw* about it. What is so striking to me is how you're redrawing your own childhood handwriting for the purposes of the book. So nothing is scanned; you're redoing it. And you are redoing your dad's handwriting [that opens your childhood diary]. So there is all of this focus on drawing and redrawing your own handwriting.

BECHDEL: It's repetition compulsion.

CHUTE: I know that this has been a preoccupation for a while for you.

BECHDEL: Oh, yeah.

CHUTE: Even since college. Even before you became a cartoonist. Can you tell me about that?

BECHDEL: Hillary was at my house last summer and I showed her this crazy college art project that I had done.[1]

1. This piece was included in the show "Fevered Archives: 30 Years from the Not-So Mixed Up Files of Alison Bechdel" at the Center for the Study of Gender and Sexuality at the University of Chicago.

It was for a drawing class. We had to do a self-portrait. I was surprised to look back at it because it was like a proto-comic. It is a sequence of these big panel outlines and each of them has words and pictures in it. But one of them in particular seems to me to be totally the germ of the memoir about my mother and the memoir about my father that I have just written.

I made this little chart. There's a photo of my mother and a sample of her handwriting. A photo of my father and a sample of his handwriting, and they're laid out like a sum, like I'm adding them together and the result is me and my handwriting. Like, if you could average out the vectors of my parents' handwritings, you would get my handwriting. So there is this way I've clearly for a long time been preoccupied with how my parents are operating through me creatively.

CHUTE: What is so interesting about this, too, you said "proto-comics," but it is all about words and images and it is all about the hand. So it is not just the frames as a kind of proto-comics, but actually what's in the frames.

BECHDEL: Yes.

CHUTE: You were such a cartoonist even before you knew it, right?

BECHDEL: I guess so, yeah. I mean when I was little I wanted to be a cartoonist but that got all drilled out of me. "Nobody gets to become a cartoonist." *[laughter]*

CHUTE: Another thing about handwriting in *Are You My Mother?* that's so interesting is your focus, in addition to your own childhood handwriting and the handwriting of your parents, on Winnicott's handwriting and Virginia Woolf's handwriting. I guess there is a question here about the potential fetishization, which is another thing we are talking about today, of the hand or the hand as an index of the body. Here is [an image of] you drawing one of Winnicott's hand-drawn diagrams.

BECHDEL: I wanted to connect with him through his own hand-drawn images.

CHUTE: So you did research about his handwriting.

BECHDEL: I went to an archive that had a lot of his papers and spent a lot of time going through them just to be exposed to his line.

CHUTE: Why was that important to you?

BECHDEL: I don't know. I felt that was how I would transmit him in the story. Like if I were going to be drawing a visual story about these ideas and about his life, I wanted to have some physical contact with him. That was important somehow.

CHUTE: That's so interesting. Can you talk about drawing as a form of contact or touch?

BECHDEL: You know, I do think drawing is a form of touch for me. When you are drawing a figure, you are touching them. You are creating this person's body. You are outlining their face. Their limbs. Their clothes. It is very

intimate. And I hadn't ever thought about this until you and I were discussing it the other day, but—you know, my mother kind of cut me off from touch at an early age, so I wonder—I guess I can psychoanalyze myself on stage since I'm doing it in the book. *[laughter]* I think maybe I'm trying to compensate in some way with this very tactile physical medium. And I ultimately am trying to touch the people who are reading it, or wanting them to—wanting them to touch me. While they are holding this story about me. It's sort of pathetic.

CHUTE: No. It is fascinating. So you also did research into Virginia Woolf's handwriting, too?

BECHDEL: I forgot to mention, she was one of the other strands of this really dense narrative. I got really interested in her, in how the stuff of Virginia Woolf's life made it into her fiction. I looked into her handwriting. This is her diagram for how *To the Lighthouse* was structured, with two big sections on either end and a little bridge between them.

CHUTE: Here you redraw her diagram for *To the Lighthouse*, and you also went and you looked at her manuscripts. Here is an image of an actual Woolf manuscript. And here is the way you recreated it in your book. Pretty interesting. I am going to do this very simple A to B again. Here is the manuscript page and here is your page. Why was that important to you, to reproduce it?

BECHDEL: I know, it is a kind of fetishization.

CHUTE: Fetishization is not a bad thing. I didn't mean that as a pejorative.

BECHDEL: If you are focusing on the artist's pen and not what the artist is writing, that's probably not so good.

CHUTE: Well it's *both* in this book.

BECHDEL: I guess it is. It was really interesting tracing and recreating her handwriting, and her editing process. I was sort of inside of her head. Like seeing what she crosses out, what she decided not to use. I had to use a kind of pen that she would have used to get the line right.

CHUTE: So the next question is related. It is about this thing that we see in your work which is you putting your own words over another person's words on the page. You put your own text boxes over Woolf's recreated manuscript page, for instance. And here in *Fun Home* for example you recreate a page from Joyce's *Ulysses*.

BECHDEL: It is the last page of *Ulysses*.

CHUTE: You layer your own text boxes over it. Tell me why you do this.

BECHDEL: I don't know. I thought this edition of *Ulysses* was beautiful. I loved the book. I wanted to recreate it because I liked how it looked. And I also wanted to write over it because it also annoyed me. I wanted to have my own commentary. That's something you can do in comics that I really love. I can show the book and I can talk

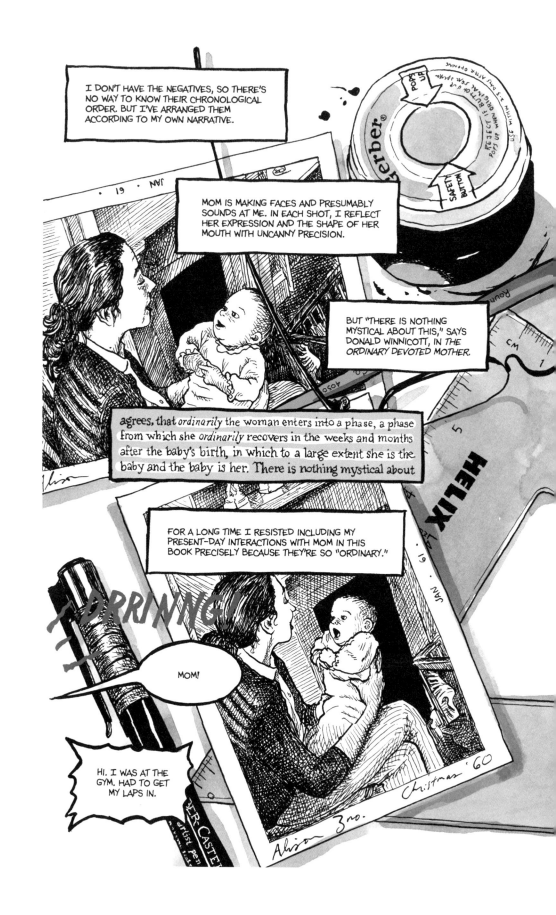

I DON'T HAVE THE NEGATIVES, SO THERE'S NO WAY TO KNOW THEIR CHRONOLOGICAL ORDER. BUT I'VE ARRANGED THEM ACCORDING TO MY OWN NARRATIVE.

MOM IS MAKING FACES AND PRESUMABLY SOUNDS AT ME. IN EACH SHOT, I REFLECT HER EXPRESSION AND THE SHAPE OF HER MOUTH WITH UNCANNY PRECISION.

BUT "THERE IS NOTHING MYSTICAL ABOUT THIS," SAYS DONALD WINNICOTT, IN *THE ORDINARY DEVOTED MOTHER.*

agrees, that *ordinarily* the woman enters into a phase, a phase from which she *ordinarily* recovers in the weeks and months after the baby's birth, in which to a large extent she is the baby and the baby is her. There is nothing mystical about

FOR A LONG TIME I RESISTED INCLUDING MY PRESENT–DAY INTERACTIONS WITH MOM IN THIS BOOK PRECISELY BECAUSE THEY'RE SO "ORDINARY."

DRRINNG!

MOM!

HI. I WAS AT THE GYM. HAD TO GET MY LAPS IN.

212

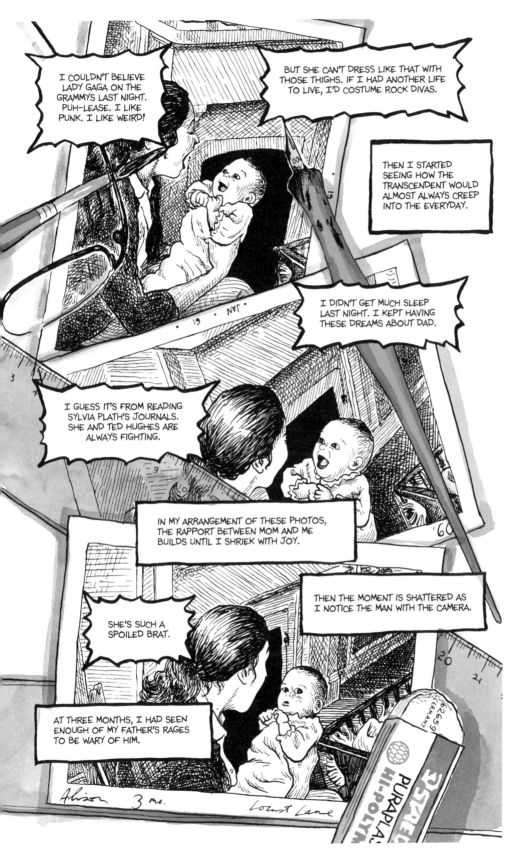

Figure 7. Alison Bechdel, *Are You My Mother?* (2012).

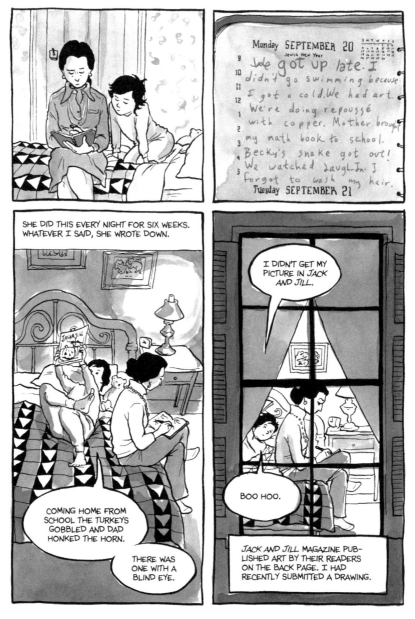

Figure 8. Alison Bechdel, *Are You My Mother?* (2012).

about the book. And I can highlight a certain section of the book. It was fun to do that. To sort of violate *Ulysses*. *[laughter]*

Chute: But recreate it in comics form, too. You didn't just scan it, you actually sort of painstakingly drew this page from *Ulysses*. To then violate it.

Bechdel: Yes.

Chute: Okay. *[laughter]* So my last question—and then we'll open it up for questions from the audience—is about time and space. I'm always trying to think about what comics do with time and space. And I want to show the very last page of *Fun Home* which I think is so fascinating. Something I am always trying to think about is the past and the

present and how they are imbricated or intertwined on the comics page. Here we start with a panel in the 1980s, and then the book ends with this panel in the 1960s.

Bechdel: Yes.

Chute: I guess I'll just ask you, what do you think comics can do with expressing the past and the present? There are similar interesting juxtapositions in *Are You My Mother?*

Bechdel: I feel like this might be another case where you can't explain it. You just have to look at the thing. Explaining it sort of kills it. I'm juxtaposing two moments that are emotionally similar, but they are temporally far apart. Which is another thing comics can do. And the other participants here do really brilliantly.

214

Figure 9. Alison Bechdel, *Self Portrait*. Close-up of panel on handwriting. Photo courtesy of Alison Bechdel.

Q&A

AUDIENCE MEMBER: *Are You My Mother?* got a huge reception and obviously *Fun Home* did, too. As you read more and more essays and academic work, I'm sure there must be academic papers at this point about *Dykes to Watch Out For* and so on, and people are reading these in courses. Is this providing you with more insight? Do you find it helps or hinders you in your thinking about your life and your comics? Do you read that stuff? Do you find it enlightening?

BECHDEL: I read some of it. I don't read all of it. It is kind of enlightening. I enjoy being analyzed, so I feel like it is free analysis to read an academic article about my family. *[laughter]*

AUDIENCE MEMBER: So I'm curious, I haven't yet read the new book, but considering the importance you guys are talking about of handwriting, I was wondering if you could speak a little bit about your choice to use a font of your own handwriting for the text.

BECHDEL: This is my great moral failing. I use a digital font. I don't hand-letter my work. And it is just easier. It is total convenience.

CHUTE: That exists in such a weird tension with this really painstaking re-drawing that you do of all of these paper archives.

BECHDEL: I know. But I guess I just only have so much patience.

But [it's also about] changing my writing up to the last minute. I like being able to edit it—to go in and manually change words. I like having freedom to edit up to the last minute.

AUDIENCE MEMBER: We've been talking a lot about the way you synthesize your own experience and the research you do on these primary sources by drawing them yourself and re-drawing them to make a memoir. Can you ever imagine making memoir or nonfiction of any kind by using real excerpts, or producing a piece of nonfiction as an editor instead of recreating each detail?

BECHDEL: I'm not sure what you mean.

AUDIENCE MEMBER: Can you imagine yourself making a similar story, whether it is about your life or not, using the actual documents, using the real photos and not re-drawing them?

BECHDEL: Oh, and not redrawing them. I could make a documentary film I guess.

AUDIENCE MEMBER: That's what I mean. Or a book even. Why not? Like why all the redrawing?

BECHDEL: Because filmmaking doesn't interest me and re-drawing tiny little newspaper articles does. *[laughter]* I don't really have a justification for it. It is just what I like to do.

AUDIENCE MEMBER: I spend a lot of time myself thinking about my past, digging through old papers and ephemera

Figure 10. Alison Bechdel, Winnicott diagram panel, *Are You My Mother?* (2012).

Figure 11. Alison Bechdel, *To the Lighthouse* diagram panel, *Are You My Mother?* (2012).

I have from my childhood and my parents' childhood and remembering things. But I've never done anything like you've done where you put it on paper and you share it with everybody. And you go through a very long process to create your memoir. When you think back on those memories that you have illustrated and shared with us, do you experience those memories differently now that you've gone through this whole process than when you first thought of them?

BECHDEL: Oh, yeah. I've kind of corrupted my own memories hopelessly. And that's a loss. Writing these things down and committing them to a physical form, it is kind of like I've almost removed them from my hard drive. Which is very freeing in some way. I feel like I have room to think about other things. But I do feel like I've lost some authentic connection to my own past. But that's okay because I've hoisted it off on everyone else.

AUDIENCE MEMBER: In *Are You My Mother?* you have a number of biographical threads that are going on, with Donald Winnicott, Adrienne Rich, Virginia Woolf, in addition to the ongoing autobiographical narrative you have about yourself and your mother. And I think that you handled those biographical threads really well, in that they, at the very least with me, had the effect of making me write notes along with "must go read Adrienne Rich." Which I have. And she's good. I'm curious, how would you feel about writing just a straight biography of someone without having yourself as an element in the text?

BECHDEL: I'm actually considering maybe doing a graphic biography of someone. Like to take the heat off my family for a while. *[laughter]* I think that would be fun. I love reading biographies, and I think to do a graphic one would be a good challenge. A really dense, long one.

AUDIENCE MEMBER: I want to know if maybe you would talk for a little bit about what kinds of things came together to create a shift from the kind of serialized exciting soap opera stories that totally pulled me into *Dykes to Watch Out For* into this much longer form? A lot of other speakers [at the conference] have been talking about

changes in publishing, changes in the book as format. And changes in what an artist or an author can go ahead and do or ask for. What are some of the things that pushed you into this? Because [your graphic memoirs are] significantly different from *Dykes To Watch Out For*.

BECHDEL: It is a number of things. One big one was economic. It was getting more and more difficult to earn my living from a comic strip that was running in newspapers. Newspapers are folding and, you know, conglomerating. There were fewer and fewer people paying me for it. I was working on *Fun Home* while I was still doing *Dykes to Watch Out For*. And I got a lot more money to do a book. It just made economic sense to try to do another book. But it wasn't only economic. I also feel like the culture changed so much I didn't feel the same impetus and passion to create my comic strip as I originally had. It just felt like time to let it go. There was the whole Internet explosion of everything…plus the fortuitous popularity of the graphic novel as a form, without which I wouldn't be able to keep doing it.

CHUTE: Martha?

AUDIENCE MEMBER [MARTHA KUHLMAN]: One of the things I really enjoyed about *Fun Home* were all of the literary references. As a teacher of literature, I really got a lot out of that. I wondered if you could talk about the intersection between your personal life and the literature. Because I see those references as very multilayered and profound. They are not gratuitous. They have a lot to do with your relationship with your parents and how you understood yourself relating to them.

BECHDEL: I think it is just what I was saying before, trying to get at feelings through ideas. In the book about my dad it was literature. I used books that he loved to figure more out about my father and my relationship to him. And in the book about my mother, it was analysis. Because I grew up in a distant detached family I have to get at my feelings in this detached way.

AUDIENCE MEMBER [RIVA LEHRER]: I was thinking about

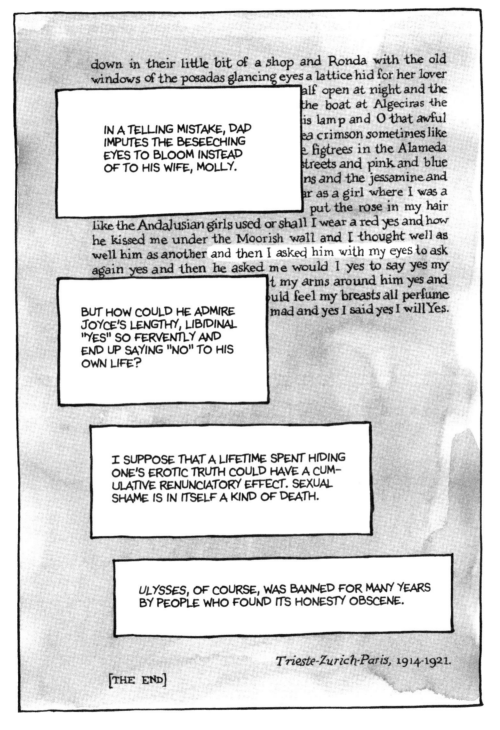

Figure 12. Alison Bechdel, *Fun Home* (2006).

Figure 13. Alison Bechdel, final page of *Fun Home* (2006).

the part in *Are You My Mother* where you talk about your mother's relationship—or reaction to your coming out where she says, "You have a mind. Can't the rest of it wait?" I was thinking about this reproduction of the handwriting and you acting out the characters in the book. That the other theme, the other impulse that you have I think towards survival is an embodiment of all things that are engaging. That in reproducing the newspaper articles and reproducing the handwriting, you are embodying these passions. And then you are also stepping into the bodies of all these other people. In the same way that you are interested in having one level of reality going on at the top of the panel and then a contrapuntal thing going on in the panel. It is the tension between, the relationship between the intellectualism and then the embodiment, that I see being played out in these choices.

BECHDEL: That's good. I like that. *[laughter]*

AUDIENCE MEMBER: I haven't read your newest book, but your work is pretty text heavy, and there is a strong narrative voice. And I feel often that the text sometimes even overpowers the images. And I think it is not a bad thing. I think it is why your work has become more acclaimed in the mainstream maybe because people are used to—

BECHDEL: They like more words.

AUDIENCE MEMBER: Right. But I was wondering about your process. I was wondering how if you ever play with taking out the words and things like that.

BECHDEL: I certainly try to prune them down. It is a constant battle between the words and images on the page. Toward the end of the process often I realize a lot of the words can just go. But I'm not interested in just telling stories with pictures. If I am looking at a story that's purely visual, I have to actually translate it into words in my head. I narrate it silently to myself because I just can't follow it [only] visually.

AUDIENCE MEMBER: The ending of *Fun Home* is beautiful, and I was wondering, how did you reach the ending? Did you have to look for it? Or you knew it before you started?

BECHDEL: No, I certainly did not know it before I started. I cannot tell you how I got the ending. It just came to me. After sitting in my chair for many years.

AUDIENCE MEMBER: You mentioned at one point taking the heat off your family. The thing that I like best about your work is how intensely personal it is. I find that to be a strength. But I'm wondering if you can talk about how you navigate all the pressures that come with writing about things that are intensely personal to you.

BECHDEL: I try to talk to my family about what I'm doing, but they are not that interested, really. So that's good. I don't really handle it that well. We are kind of not that close, so it gives me a certain amount of freedom to do things like this. If I were living near my family and involved in their daily lives, I would go crazy and not have time to write. *[laughter]* But I wouldn't be able to do what I do. I kind of maintain a distance, an isolation, which is, I

don't know, maybe a bad thing, maybe a good thing.

AUDIENCE MEMBER: Alison, I really appreciated your recreation of the photos of you and your mother making faces at each other. I saw a lot of symbolism in that, too, with the work that you do, drawing comics. I guess I can say I consider myself an armchair psychoanalyst. It seems like one could see your process of drawing comics as making more and more elaborate faces to get a response. But of course at the end you see the baby is disappointed. You are disappointed to notice the cameraman photographing it. *Dykes to Watch Out For* reached such a selective audience. I wonder if the sheer power and force and effort that you put into these books has made the cameraman any safer.

BECHDEL: The cameraman being my father here?

AUDIENCE MEMBER: The audience.

BECHDEL: I don't really think about the audience when I'm writing these books. Somehow I'm writing what I need to write. I know you are supposed to think about the audience, but I don't. And I know I'm reaching a much wider audience and it is unnerving and I guess I don't like to think about it. *[laughter]* Because I'm reaching a wider audience with much more intimate material, and that would freak me out if I really thought about it.

AUDIENCE MEMBER: I'm wondering when in the process of your writing you are forced to impose the narrative on it. In other words, I can see how passionate you are about collage and juxtaposing different times together and different imagery together and different times. I'm wondering when in this long process from beginning a book to ending it you have to create the beginning, middle, and end. I noticed in the beginning of *Are You My Mother?* for example that there was a very interesting, well-developed struggle about where to begin telling the story, what point in time.

BECHDEL: Yes. I worked for four years on this story and I showed it to my agent and she said, this doesn't make any sense. And it was at that point that I realized I was avoiding the real story which is a story of me and my mother. And that's when the narrative strands started falling into place. It was just a sudden transformation when I knew the story was about my mother; the structure started to cohere, even when I saw that Winnicott and Woolf would become characters. But that took four years of work at what was—what seemed to be the wrong direction. But then it was necessary in the end.

CHUTE: And you totally dropped that chapter. Right?

BECHDEL: Yes.

CHUTE: Four years and you put it away.

BECHDEL: Yes. Thank you very much, you guys.

Speculation: Financial Games and Derivative Worlding in a Transmedia Era

N. Katherine Hayles, Patrick Jagoda, and Patrick LeMieux

Fqp'v vgnn og aqw'xg hqtiqvvgp jqy vq rnca.
—NEX[1]

1. Alternate Realities: Playing within the Transmedia Present

While games have a long social history, computer and video games have only recently developed into a significant cultural form. From the labs and arcades of the 1960s and 1970s to the personal computers and home consoles of the 1980s and 1990s to the digitally distributed and networked video games available on nearly every electronic device today, digital games have grown steadily in popularity over the past fifty years, especially throughout the Americas, Europe, and East Asia.[2] Alongside the proliferation of popular screen-based gaming genres such as first-person shooter, real-time strategy, and massively multiplayer-online-role-playing games, a more peripheral and experimental form of gaming emerged in the early years of the twenty-first century. This new form, whose boundaries are still in flux, goes by several names, each of which stresses different features of the broader category. These designations include *pervasive games, immersive games, transmedia games, search operas, unfiction, and chaotic fiction.*[3] The most popular examples—including *The Beast* (2001), *I Love Bees* (2004), and *Year Zero* (2007)—have most commonly been called alternate reality games or ARGs.[4]

Unlike screen-bound video games, ARGs are not constrained to any single medium, hardware system, or interface. ARGs use the real world as both a platform and a medium, even as they complicate the concept of realism in a digital era. As transmedia writer Sean Stewart explains, ARGs incorporate a range of media—"text, video, audio, flash, print ads, billboards, phone calls, and email to deliver parts of the plot" ("ARG"). The stories that organize most of these games are nonlinear and broken into discrete pieces that players actively rediscover and reconfigure. Thus, ARGs encourage players to form

1. This message, which requires decryption, was published in the original *Speculation* alternate reality game introductory hub. The epigraph's encryption method, known as a Caesar shift, substitutes each character with another at a fixed interval (in a Caesar set to the order of two, as in this epigraph, A becomes C, B becomes D, and C becomes E, and so on). For more, see criticalinquiry.uchicago.edu/nexus_x

2. Most video game publishers and console manufacturers are not required to report global software and hardware sales publicly. Nevertheless, consumer market research agencies such as Media Create and the NPD Group audit, analyze, and publish sales figures, primarily in East Asia, Europe, and North America. An increasing number of video games are also making their way to Australia, Russia, South America, and even the Middle East and Africa via digital distribution and mobile platforms. For example, the Valve Corporation, a company responsible for one of gaming's most successful online marketplaces, Steam, has recently opened content servers in Brazil and the Ukraine and has reported that "outside of Germany [Russia] is our largest continental European market" (Todd Bishop, "How Valve Experiments with the Economics of Video Games," *Geek Wire*, www.geekwire.com/2011/experiments-video-game-economics-valves-gabe-newell). Beyond sales, global video game distribution is evident in terms of diverse and multilingual online communities and the countries represented in global gaming events like the World Cyber Games.

3. For the term *pervasive games*, see Markus Montola, Jaakko Stenros, and Annika Waern, *Pervasive Games: Theory and Design* (New York, 2009). For *immersive games*, see Jane McGonigal, "'This Is Not a Game': Immersive Aesthetics and Collective Play" (2003), Melbourne DAC 2003 Streamingworlds Conference proceedings, seanstewart.org/beast/mcgonigal/notagame. The term *transmedia games* comes up in many contexts. For an early discussion of transmedia storytelling, see Marsha Kinder, *Playing with Power in Movies, Television, and Video Games: From Muppet Babies to Teenage Mutant Ninja Turtles* (Berkeley, 1991). For a more recent elaboration on *transmedia storytelling* that includes games such as *The Beast*, see Henry Jenkins, "Searching for the Origami Unicorn: The Matrix and Transmedia Storytelling," *Convergence Culture: Where Old and New Media Collide* (New York, 2006), pp. 93–130; hereafter abbreviated *CC*. For *search operas*, see Sean Stewart, "Alternate Reality Games," www.seanstewart.org/interactive/args; hereafter abbreviated "ARG." For the terms *unfiction* and *chaotic fiction*, see Sean Stacey, "Undefining ARG," www.unfiction.com/compendium/2006/11/10/undefining-arg.

4. While not wholly satisfying as a designation, *alternate reality game* provides a stable marker. Indeed, a similar case arises with the genre name *science fiction*, which, though in some senses less descriptive and inclusive than alternatives such as *speculative fiction*, remains dominant and conventional because of a long history of usage. We will use primarily *ARG* throughout this essay.

networks which are largely participatory, collective, and sometimes transnational in scope. Unlike challenges in standard video games, which are designed for individuals to solve given enough time and persistence, most ARG puzzles mobilize a range of specialized knowledge across disciplines and a pooling of effort. ARGs are never single-player games.[5]

ARGs borrow from earlier artistic, literary, and social forms. Their genealogical roots stretch back to diverse gaming practices such as nineteenth-century English letterboxing, the Polish tradition of *podchody*, the practice of invisible theater, the situationist art practice of *dérive*, scavenger hunts, assassination games, and live action role-playing games (LARP).[6] However, a major difference between these older genres and recent ARGs has to do with the way they reflect and complicate two key concepts—gamification and convergence culture—that characterize the historical present.

First, gamification is a design strategy that uses motivation-oriented game components, including leaderboards, achievement systems, and other metrics to motivate various forms of consumption, education, employment, and industry.[7] Whereas older forms of social play often functioned in contrast or even outright resistance to industrialized labor, work and play blur in the postindustrial period of information economies and cognitive capital.[8] Corporations recode workplaces as campuses, playgrounds, and homes-away-from-home. At the same time, new forms of affective labor have become commodified through the statistical analysis of social media networks, the offloading of product testing to early adopting customers, and off-site customer service call centers.[9] Aside from the corporatization of leisure and the invisible labor that often structures consumption, websites such as *Chore Wars* (2007), apps such as *Foursquare* (2009), and products such as *Nike+* (2010) gamify daily routines like taking out the trash, going out to dinner, and running. Such software motivates users through extrinsic goals, automated scoring, and virtual prizes that are digitally tracked and shared over social networks. Gamification has also played a major role in ARGs, which convert daily media interactions into games and obscure the distinction between everyday lived experience and alternate realities. Following Bernard Suits's utopian philosophy,

Jane McGonigal, the designer of ARGs such as *Superstruct* (2008) and *Evoke* (2010), has gone as far as to suggest that "reality is broken" and can only be saved through games that turn "a real problem into a voluntary obstacle" and activate "genuine interest, curiosity, motivation, effort, and optimism" among their players.[10]

A second distinguishing feature of ARGs relies on the aesthetic experiences made possible by digital computers, distributed networks, and (in some cases) locative technologies. The appearance of the form of Alternate Reality Games has had much to do with a process of total subsumption characterized by a spread of nearly ubiquitous digital media and network access across the First World and the rise of what Henry Jenkins calls "convergence culture." Jenkins describes "convergence" as "the flow of content across multiple media platforms, the cooperation between multiple media industries, and the migratory behavior of media audiences who will go almost anywhere in search of the kinds of entertainment experiences they want" (*CC*, p. 2). If "convergence represents a cultural shift as consumers are encouraged to seek out new information and make connections among dispersed media content," then ARGs adopt the techniques of a participation-oriented, collaboration-savvy, and information-based culture to tell stories across numerous media (*CC*, p. 3). Instead of operating as combinatory multimedia, ARGs tap into a more continuous transmedia flow that complicates discrete media objects in favor of mediation as an active process.[11] Transmedia describes a relationship between media that is proliferating rather than additive. ARGs, in particular, tell a single story that passes through and alternates between media—even those "new" media that have already been absorbed into the fabric of everyday life—to make their differences and intersections sensible. Unlike the products of convergence culture, especially multimedia franchises that often erase media distinctions in favor of the diegetic totality of a seamless world, the transmedia aesthetic of ARGs depends on narrative fragmentation and transitions between multiple interfaces. In sum, ARGs address the ways in which media mirror capital through the logic of gamification and relate to the contemporary media ecology through transmedia design.

Like contemporary entertainment industries, finance capital depends on the convergence of multiple media

221

5. The 2008 game *Free Fall* is a single-player transmedia experience that lasts for only about ten minutes. Jeffrey Kim, Elan Lee, Timothy Thomas, and Caroline Dombrowski call *Free Fall* an ARG; see Jeffrey Kim, et al., "Storytelling in New Media: The Case of Alternate Reality Games, 2001–2009," *First Monday* 14 (1 June 2009), journals.uic.edu/ojs/index.php/fm/article/view/2484/2199. Though it makes for an interesting limit case, we do not include it within our definition because of its lack of social and networked interplay.

6. See Montola, Stenros, and Waern, *Pervasive Games*, pp. 32–38.

7. For a critical discussion of gamification, see Patrick Jagoda, "Gamification and Other Forms of Play," *Boundary 2* 40, no. 2 (2013): 113–44. For applications of gamification to areas such as business, marketing, psychology, and design, see Robert Jr. Hunter, *The Gamification Handbook: Everything You Need to Know about Gamification* (Brisbane, 2011). Also see Byron Reeves and J. Leighton Read, *Total Engagement: Using Games and Virtual Worlds to Change the Way People Work and Businesses Compete* (Boston, 2009); Gabe Zichermann and Joselin Linder, *Game-Based Marketing: Inspire Customer Loyalty Through Rewards, Challenges, and Contests* (Hoboken, N.J., 2010); and Gabe Zichermann and Christopher Cunningham, *Gamification by Design: Implementing Game Mechanics in Web and Mobile Apps* (Sebastopol, Calif., 2011).

8. For more on the blurring of work and play that happens in many game environments, see David Golumbia, "Games without Play," *New Literary History* 40 (Winter 2009): 179–204.

9. On affective labor, see Michael Hardt, "Affective Labor," *Boundary 2* 26, no. 2 (1999): 89–100.

10. McGonigal, *Reality Is Broken: Why Games Make Us Better and How They Can Change the World* (New York, 2011), p. 311.

11. For an extended discussion of media objects versus processes of mediation, see Alexander R. Galloway, *The Interface Effect* (Malden, Mass., 2012).

into exchangeable and abstract equivalents that can be transmitted through electronic devices or platforms. A similar process is, then, visible in video game systems and day traders' consoles alike. As Friedrich Kittler observes, "once optical fiber networks turn formerly distinct data flows into a standardized series of digitized numbers, any medium can be translated into any other. With numbers, everything goes."[12] McKenzie Wark observes this same problematic in the context of games, writing, "it doesn't matter whether you think you are playing the bond market or *Grand Theft Auto*. It is all just an algorithm with enough unknowns to make a game of it."[13] As an emerging genre of digital games, ARGs navigate a number of contradictions that characterize convergence culture. On the one hand, these games encourage open, participatory, and collective modes of play. On the other, the ARG form would not be possible without techniques such as gamification and viral marketing, as well as the convergence of media industries around specific reception platforms. A number of ARGs, for instance, have attracted audiences by subordinating their content to that of an established intellectual property, including the story-world of films (*A.I. Artificial Intelligence*, dir. Steven Spielberg, 2001), television shows *(Lost)*, video games *(Halo 2)*, and even top-selling albums *(Year Zero)*.[14] The tendency of such games to commodify player contributions has not merely resulted in anomalous assimilation of ARGs by major corporations, such as Microsoft and Google. The corporate development of this experimental gaming practice constitutes, from the very start, an inherent context and historical possibility of the ARG form.[15]

This essay explores ARGs in relation to media and capital through the case study of *Speculation*, a game we directed and cocreated with students at the University of Chicago and Duke University throughout 2012. A key motivation for producing *Speculation* was the question: Is it possible to create a critical game in a twenty-first century world in which gamification and convergence culture are already core components of contemporary capitalism? Through the ARG form—one saturated with the paradoxes of control, corporatism, and capital—*Speculation* attempts to mobilize a passionate community of players and produce a platform for thinking within and through our contemporary information economy. It is precisely because of the form's complex capacities and dependencies that ARGs offer a rich environment from which to engage with digital media culture and its relationship to the pervasive game of finance capital. *Specu-*

lation—an experiment that emerged from our thought about the culture of Wall Street investment banks since the 1980s, the 2008 global economic downturn, and the 2011 Occupy movement—appropriates the strategies and logics of finance capital in a medium already caught up in the contradictions of neoliberalism and what Gilles Deleuze calls societies of control.[16] Though gamification often puts play in the service of labor and convergence culture carries inherent complicities with multinational capitalism, *Speculation* entails a range of play forms and transmedial practices that are not all reducible to the strategies of finance capital.

Methodologically, *Speculation* builds on the techniques of practice-based research that have recently been explored under the rubric of comparative media studies.[17] In particular, the game sought to complicate the longstanding opposition between practice and theory. As an ongoing, year-long development characterized by challenges, failures, readjustments, and active interplay, *Speculation* was a process of thinking through digital media.[18] Moreover, the game attempted, at every step, to blur conventional divisions between creators and consumers, designers and players, artists and researchers. Rather than understanding digital games primarily as preprogrammed products to be developed, tested, then finally played, we consider the process of designing and producing *Speculation* to be synonymous with playing the game. From brainstorming to development to execution to performance, *Speculation* functioned as an open laboratory for designing play as well as playing with design. Designers and players cocreated the game while exploring concepts related to social networks, spatial and temporal storytelling practices, contemporary finance culture, and transmedia ecologies.

2. Speculation: From Rabbit Hole to Alternate World

"Game. Name. Future. World. Play. Love. Founder. Network."[19] Eight red words flicker and flash across the screen, interrupting a digital video found at Vimeo.com. The video depicts Occupy Wall Street protesters clashing with local police, the New York Stock Exchange devoid of traders, Alan Greenspan testifying at a congressional hearing, and Greg Smith's resignation letter from Goldman Sachs. Part political propaganda, part corporate advertising, this anonymous and enigmatic video predicts a future of greed branded by a monolithic logo: MetaCorp. In contrast to this white, gradated, sans-serif

222

12. Friedrich A. Kittler, *Gramophone, Film, Typewriter*, trans. Geoffrey Winthrop-Young and Michael Wutz (Stanford, Calif., 1999), pp. 1–2.

13. McKenzie Wark, *Gamer Theory* (Cambridge, Mass., 2007), p. [7].

14. *The Beast* served as a promotion for *A.I. Artificial Intelligence* (2001); *The Lost Experience* accompanied ABC's *Lost* (2004–2010); *I Love Bees* was a tie-in with Microsoft's *Halo 2*; and *Year Zero* accompanied the *Nine Inch Nails* concept album of the same title.

15. We are thinking here of the Microsoft-commissioned *I Love Bees* (2004) and Google's *Ingress* (closed beta beginning in 2012).

16. See Gilles Deleuze. "Postscript on Control Societies," *Negotiations: 1972–1990*, trans. Martin Joughin (New York, 1990), pp. 177–82.

17. For an elaboration of comparative media studies, see N. Katherine Hayles, *How We Think: Digital Media and Contemporary Technogenesis* (Chicago, 2012), and *Comparative Textual Media: Transforming the Humanities in the Postprint Era*, ed. Hayles and Jessica Pressman (Minneapolis, 2013).

18. As Hayles has observed, following media scholars such as Kittler and Bernard Stiegler, "we think through, with, and alongside media" (Hayles, *How We Think*, p. 1).

19. *Speculation*, "Speculat1on.net," vimeo.com/39947942. This trailer for *Speculation* has received 1,848 views (Mar. 2013).

speculat1on.net
10.11.12

> NEX IS COMING

We need your trust. We need your belief.
We will reward you in time.

> NEX IS COMING

We are not MetaCorp. We are emergence.
We come from B.R. 12.

> NEX IS COMING

You must learn about MetaCorp.
And James Powell. And the Reticle.

> NEX IS COMING

You call this an alternate reality game.
This is a reality game. This is an economic
stimulation. This is a corporate brain drain.
This is a histrionic transmission. This is an
electronic exploit. This is a realist fiction.
This is speculat1on.

NEX IS COMING

http://speculat1on.net. Make ends meet on 10.11.12

Figure 1. The *Möbius Timeline* postcard (Fall 2012) was distributed to advertise the second run of *Speculation*. 223

stamp, the video ends with a splash of red graffiti that announces "NEX is Coming" alongside a single, enigmatic web address: Speculat1on.net.

This is how *Speculation* began. Two communities of players experienced the game in 2012. The first engaged the game from 1 April to 11 August before a second group participated in a more streamlined play-through from 11 October to 2 December.[20] Each period of play was initiated with a similar rabbit hole: a common term used to describe the entry points by which players discover and begin to play an ARG. The *Speculation* video was distributed widely to communities of gamers, electronic literature enthusiasts, new media students, and other prospective players. This brief video introduction revealed the game's themes, hinted at the possibility of a secret code hidden between its frames, and ended with a URL that led to *Speculation*'s primary hub or nexus. Alongside this digital rabbit hole, the designers also distributed business cards belonging to the game manager and protagonist (NEX), modified actual Zimbabwe currency into

a fictional currency called MetaBux, and disseminated postcards featuring the game's twisting timeline (fig. 1).

These rabbit holes were each designed to lead players back to *Speculation*'s primary home page at speculat1on. net. This website featured an assemblage of textual and social media tools necessary for players to engage the digital labyrinth of the game as a community. Upon exploring the first nexus, players confronted a large, red numeral offset by eight smaller icons and eight long, blank password fields (fig. 2). When clicked, each pixilated icon led to a short puzzle or ludic challenge. These modules operated according to different genres of digital games, from cryptograms and quizzes to financial simulations and interactive fictions. Rather than simulate the processes of finance capital, *Speculation*'s mechanics engaged, in an aesthetic and ludic fashion, with the logics of complex derivatives, international currency evaluation, high speed algorithmic trading, and even the psychology of investment bankers. Completing these games produced documents related to important moments in the history

20. The complexity of *Speculation* and the necessary time investment by players led to a reduced number of participants over the course of each run. Nevertheless, combining Google analytics for the game's two runs—from the first rabbit hole on 1 April 2012 to the final post about the second version of the game on 16 December 2012—the homepage accumulated 3,489 unique hits (and 35,902 page views). The primary player discussion forum generated 1,883 posts during the two rounds of gameplay (speculat1on.net/WE/index.php). Though the anonymous nature of participation limited the demographic data we could gather, 77.4 percent of the player visits originated from the United States, including all fifty states, with the most traffic coming from Illinois, North Carolina, New York, California, and Virginia. An additional 9.2 percent of the visits originated in Canada. All of our site-specific challenges happened within the United States and Canada, but participants could play the majority of the game online. Other significant sources of visits, making up approximately the final 13 percent, included Australia, the United Kingdom, the Netherlands, and Germany.

Figure 2. The homepage of http://speculation.net, *Nexus 00*, functions as a tutorial to introduce players to the themes and mechanics of the game (2012).

of finance or the fictional world of *Speculation*. Nestled within each document, whether via encryption or as part of the file structure, were eight passwords.[21] These passwords operated as keys to unlock each *Speculation* nexus. Once typed into the original interface, the large, red icon would change, revealing a hint that would lead players, collectively, to the next level of the game. The complete ARG featured eight such levels that included approximately sixty-four ludic challenges, sixty-four financial documents, and sixty-four unique passwords.

Though games and challenges were central to the *Speculation* experience, the ARG took the structure of a novelistic piece of electronic literature about a near-future world by including both a lengthy Q&A dialogue titled "The Document" alongside each level and an evocative narrative hidden within the source code of the game itself. In *Speculation*'s diegesis, a group of the world's eight most powerful corporations and eight wealthiest investment banks form a transnational conglomerate called MetaCorp in 2024. MetaCorp offers to bail out the recently collapsed Eurozone and, in the process, effectively seizes control of the world's economic systems. The conglomerate accelerates global capital through the production of unregulated forms of complex derivatives, which can be traded at a scale and speed far exceeding human perception. The primary narrative concerns a series of near-future characters who are communicating with present-day players using a form of transhistorical communication technology called the Histrion. These characters are all related and, in different ways, are resisting MetaCorp. In particular, the 2036 emergence of NEX, an artificial intelligence, poses a substantial challenge to MetaCorp. Players are enlisted in the resistance organized by NEX and learn about the characters through a number

of narrative forms, including interviews, journal fragments, short prose stories, corporate documents, audio files, short videos, and ASCII art (fig. 3).

The challenges that comprised *Speculation* also conveyed information about the game world alongside the passwords needed for progress. Throughout its run, the transmedia experience included stock trading simulations, matching games exploring naturalization of credit, and various cryptograms designed by Nicholas Gessler. There were live "brain training" sessions programmed by Luke Caldwell and performed at the University of Chicago, Duke University, and Vassar College using EEG interfaces to measure and modulate players' attention. Ainsley Sutherland produced text-based adventure games that were set in abandoned investment bank offices and narrated from the perspective of a MetaCorp employee, a rat, and even a sentient heating, ventilation, and air conditioning system. Alongside these substantial contributions were a plethora of other activities we designed with the help of students, including interactive meditations on microtemporal trading algorithms in the form of side-scrolling shooters; a mininarrative distributed across Craigslist's "missed connections" and "for sale" indexes; double-encoded slow-scan television transmissions distributed aurally; swarms of cryptographic puzzles from Morse codes to Vigenère ciphers; an epic poem fragment cowritten by dozens of players; a GPS hunt for flash drive dead drops in three different cities; a community-building challenge on social networks like Facebook; an extended brainstorm about alternatives to Wall Street "brain drain"; information and ASCII art buried in speculat1on. net's source code; collaborative speculations about the future of finance; a two-hour internet relay chat with the game's main characters; and more. Each of these elements expanded the world of *Speculation* but also served as a self-contained artistic experiment with textual and ludic forms. *Speculation*'s transmedia impulse, however, was not merely additive. The gameplay participated, actively, in the assimilative nature of multinational capitalism. Rather than settling for the distance of allegorical fiction or satire, this ARG recuperated multiple genres, forms, and media. This process of absorption took place during the months of production, prior to the game's launch, as well as in response to player suggestions during the execution of the game's two runs.

As an ARG, *Speculation* may be described as a digital game, but it nonetheless departed, in a number of significant ways, from conventional video games. A key difference had to do with the quality of player engagement, which relied on collective (rather than merely single- or multiplayer) gameplay. Throughout the entire run, participants had to discover fragments of the story by locating various artifacts and deciphering codes. Their task was to identify the story's major characters and reconstruct some version of the key events. Many of the puzzles were extremely difficult, requiring, for instance, knowledge of website architecture, social media, formal logic, code

21. For example, one set of passwords that you can enter at the *Critical Inquiry* hub for *Speculation* is RabbitHole123, TrailHead456, Paranoia789, Apophenia987, PuppetMaster654, Jazz321, AlternateReality000, and FinalEvent111. You can test these at criticalinquiry.uchicago.edu/nexus_x

breaking, literary analysis, and text adventure game conventions. Therefore, in order to compile anything resembling a complete narrative, players had to merge puzzle solutions and acquired artifacts. In this way, the narrative involved an irreducibly collaborative dimension that unfolded across forums, wikis, live chats, and social media.

In this ARG, the title and core concept of speculation took on valences of financial risk and risky thought that, while appearing at times politically and ethically opposed to one another, could not be entirely disentangled. The term *speculation*, in one sense, suggests a contemplative distance. Early in the game's development, the creators understood the *Speculation* ARG to be a cultural intervention into Wall Street practices, producing critique through game form. Deeper into the development and execution process, we found the game to be a speculation about the nonhuman (and often inhuman) practices of financial modeling and algorithmic processing that are central to the trading of stocks and commodity futures.[22] At another level, *Speculation* addressed the worlding ethic common in speculative literature and game worlds. Our ARG's generative (rather than merely representational) practice of worlding, which was derived in many ways from science fiction, also shared the world-making qualities of the financial speculation and derivative contracts. The players of *Speculation*, as much as the designers, elaborated the tensions and contradictions proper to this sense of speculation through processes of self-reflexive contemplation, networked collaboration, and playful metagaming. We will later return to this conflated form of financial, philosophical, literary, and ludic speculation through our elaboration of the concept of derivative worlding. But, first, it is important to explain how this concept was derived through the ways in which *Speculation* both borrowed and departed from earlier ARGs.

3. Speculative Derivations: The Beast and Superstruct

Two previous games, *The Beast* (2001) and *Superstruct* (2008), are particularly clarifying to *Speculation*'s project. These games sought to use ARG structure in ways that were formally innovative (in the case of *The Beast*) and sociopolitically ambitious (in the case of *Superstruct*). Both games, however, failed to think through the foundational interconnection of form and politics that enabled ARGs to emerge as a key form of contemporary convergence culture in the early twenty-first century. In departing from these games in *Speculation*, we sought to make a formally multifaceted sociopolitical intervention while actively engaging convergence culture and the politics of gamification. Through both its design and gameplay, our

Figure 3. Sixty-four *Eva Emissions* (2012) form a large ASCII poem that players pieced together from secret source codes and cryptic emails sent by NEX.

225

game acknowledged the complicities of ARG form with finance culture and digital media industries while seeking to subvert their techniques and conventions.

To date, *The Beast* has been perhaps the most visible and, among both game enthusiasts and scholars, the most discussed ARG. This science fiction murder mystery, developed by 42 Entertainment and released by Microsoft in 2001, ran for three months and included three million visitors to the main site. *The Beast* was designed as a promotional tie-in to Spielberg's film *AI*.[23] Most of the game's

22. The term *speculation*, in this sense, put the game in dialogue with contemporary discussions within the philosophical movement of speculative realism. For more on speculative realism, see for instance, Quentin Meillassoux, *After Finitude: An Essay on the Necessity of Contingency* (New York, 2008); Graham Harman, *Guerrilla Metaphysics: Phenomenology and the Carpentry of Things* (Peru, Ill., 2005); and Ian Bogost, *Alien Phenomenology, or What It's Like to Be a Thing* (Minneapolis, 2012). While this point would require additional development, it is worth noting that the game was filled with myriad cyborg, animal, and machinic actors that complicated the notion of human agency and stressed the ways in which processes like the rapid pace and enormous scale of financial trading fail to correlate with our expectations and experiences.

23. See Kim, et al., "Storytelling in New Media."

clues and story segments were released online through websites created specifically for the game. A significant internet community developed around this game, including a self-organized group called the Cloudmakers.[24] *The Beast* introduced several distinctive features of ARGs. First, the game was a transmedia design. Especially by 2001 web standards, it included a significant network of websites, emails sent from characters, voicemail messages, and faxes. Negotiating this decentralized assemblage of sites and locating puzzles was oftentimes as difficult as solving them.[25] Along with the puzzles, the core story was neither linear nor unified in its delivery. It required active effort on the part of players to piece together. Second, unlike standard video games, the puzzles that made up *The Beast* called for collective interactions among thousands of players with specialized skill sets. In fact, the Cloudmakers alone exchanged 43,000 messages by the end of the game. The capacity of the game community to collaborate as effectively as it did caught the game designers off guard. Initially, the creators constructed what they thought would be three months worth of game content, but the community of millions banded together to solve all of those puzzles in a single day, requiring the team to go immediately back to the drawing board. Third, *The Beast* was what McGonigal calls an "immersive game." That is, instead of investing in a virtual environment that promises immersion through graphic realism and mimetic detail, *The Beast* co-opted "real environments to enable a virtual engagement with reality," thereby integrating play "fully into the online and offline lives of its players." It announced, at every turn, "This Is Not a Game."[26] This dimension of the ARG created a paranoid aesthetic and provided players with experiences of apophenia—of seeing meaningful patterns and connections everywhere.[27]

Speculation expanded on many of the innovations of *The Beast*, but it also departed from it in a critical way. *The Beast*, like many ARGs, served as a promotional tool for a commercial product. That game was conceived, as McGonigal notes, as an alternative marketing campaign. Unlike these campaigns, *Speculation* was a stand-alone experience, an aspect of the game that was so unusual that it led some players to wonder whether the game would, at its finale, reveal a connection to some mainstream creative property. While drawing on the methods of viral marketing to attract players, *Speculation* sought to foreground intersections between the ARG form and its dominant economic motivations in order to invite critical interrogations of finance capital. Importantly, these critiques were not mounted through scholarly print media but through the game itself. The ARG form, with strong historical connections to commercial gamification and viral marketing, offered an opportunity for subver-

sive strategies to operate in the belly of the beast rather than through a more distanced critical form.

A second ARG that served as both an inspiration and point of departure for *Speculation* was *Superstruct*. In 2008, *Superstruct*, produced by McGonigal at the Institute for the Future, employed gaming to "forecast" and confront real-world problems.[28] The premise of the game is that a near-future supercomputer called the Global Extinction Awareness System has run a series of environmental, economic, and demographic simulations and discovered that human extinction will take place in approximately twenty-three years. The computer subsequently identifies five specific superthreats that could wipe out humanity. The roughly eight thousand players who reportedly participated in *Superstruct* had to brainstorm solutions to large-scale global crises. Players joined the *Superstruct* community, filled out fictional profiles that would enable extended role-play, and learned about so-called superthreats by viewing news reports from the future. As the experience began, Superstruct players cooperated to form "innovative ecologies." For example, some participants responded to economic threats by imagining what they called the "natural currency ecology." This organizational system reenvisioned "capital systems as tied, not to gold or GDP or other commodities, but to environmental measures, linking sociability to sustainability." Other players responded to mounting food shortages by envisioning what they called the "Appleseed ecology."[29] These participants imagined a gaming platform that would help farmers share information about urban farming, including rooftop and vertical gardening.

The *Superstruct* design departed in a number of ways from *The Beast*, but it still produced an alternate reality that unfolded, through play, in physical and virtual environments. Self-identifying primarily as a serious game rather than an entertainment product, *Superstruct* grappled with social, political, and environmental problems through game form. Instead of accruing individual points, *Superstruct* innovated by assigning a single cumulative score to the entire game community at the conclusion of the experience. Success, here, was understood in collective terms. Not merely through its scoring mechanism but also through its mechanics, *Superstruct* crowdsourced the creation of original content from the players. Through digital media tools and social media networks, the experience transformed participants from passive consumers into active producers who themselves generated "innovative ecologies."

Speculation borrowed many of these features while also departing from *Superstruct* in some important ways. For all of its ludic properties, *Superstruct* was more of a collective brainstorming or forecasting exercise than it

24. See McGonigal, "'This Is Not a Game.'"

25. See Montola, Stenros, and Waern, *Pervasive Games*, p. 34.

26. McGonigal, "'This Is Not a Game.'"

27. For an elaboration of this concept in William Gibson's *Pattern Recognition*, see Lauren Berlant, "Intuitionists: History and the Affective Event," *American Literary History* 20 (Winter 2008). A number of other postmodern literary texts rely on some form of apophenia, including Thomas Pynchon's novels *V.* and *The Crying of Lot 49* and Alan Moore's graphic novel *Watchmen*.

28. McGonigal has called *Superstruct* a "forecasting" game in *Reality Is Broken*, p. 317–33.

29. *The Superstruct Game Archive*, archive.superstructgame.net.

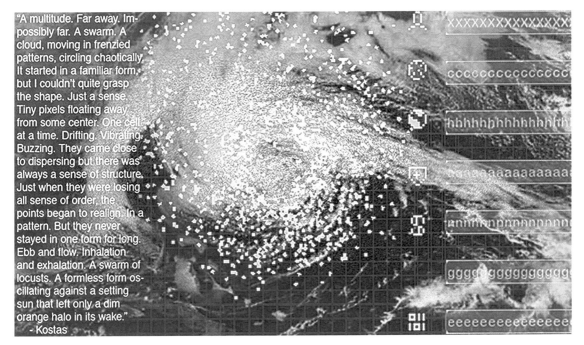

"A multitude. Far away. Impossibly far. A swarm. A cloud, moving in frenzied patterns, circling chaotically. It started in a familiar form, but I couldn't quite grasp the shape. Just a sense. Tiny pixels floating away from some center. One cell at a time. Drifting. Vibrating. Buzzing. They came close to dispersing but there was always a sense of structure. Just when they were losing all sense of order, the points began to realign. In a pattern. But they never stayed in one form for long. Ebb and flow. Inhalation and exhalation. A swarm of locusts. A formless form oscillating against a setting sun that left only a dim orange halo in its wake."
- Kostas

Figure 4. *Strange Attractors* (2012) was one product of a collaborative challenge in which players visualized the world of *Speculation*.

was a game. McGonigal's project required participants to create content by role-playing twenty-three-year older projections of themselves, a narrative constraint that resulted in a critical distance at once playfully liberating and politically debilitating. *Speculation*, as we will see, embedded numerous game genres into its overall design that players approached as themselves: twenty-first-century subjects encountering transmissions from the future. The metaphor and structure of games was a core component of the participatory reflection about the deadly serious game of American finance and the culture of Wall Street in 2012. Instead of divorcing form from content, we imagined *Speculation* as an emergent process or an interactive forum that would transform with the ever-changing player collective, embodying possibilities for political change within the players as they worked through the game. While not always fun, the game form interpellated participants as players and invited an active play with the emerging diegesis set as much in the present moment of play as in a speculative future.

4. Puppet Masters and Jazz Players

A swarm of particulate agents, flocking and spiraling around some strange attractor, is overlaid on top of satellite imagery of Hurricane Sandy (fig. 4). Embedded next to this collage, a heavily edited photograph of Google's server hardware melts into whorled corkscrew alongside a crashing red stock graph. These images were created by *Speculation*'s players to mark the cultural valences

produced by two very different storms. On 2 November 2012, in the sixth level of *Speculation*, players discovered an entry posted on the game's forum by the protagonist, NEX, which read, "What does it take to transform the normal into the queer? The commonplace into the bizarre? How do you world without words?" Below these questions, players found a hint that read "[img]URL[/img]" along with a series of eight prompts that alluded, suggestively, to narrative and character details that made up the ongoing game world.[30] This challenge had been designed to guide players to create eight images in order to earn one of the eight passwords that they needed to progress to the next level. With this basic framework, however, the designers had little sense of what range of responses they would receive or how they might play back as the scenario progressed. This challenge, meant to motivate players to create game content, was a risky departure from the manner in which the game had unfolded up to that point. The first five levels of *Speculation* had, after all, given players access to digital mini games and code-breaking activities that required them to solve puzzles rather than to cocreate the game.[31]

The day after the *Speculation* designers posted the image-creation challenge, players began to wonder about the nature of the task and post images in response to the eight prompts. In order to promote participation and collaborative creation, the designers (role-playing the character of NEX) engaged in an active exchange in which

227

30. Forum post, speculat1on.net/WE/viewtopic.php?id=184

31. One previous eco-activist ARG, *Tomorrow Calling* (2007), came to a premature end during precisely this type of crowdsourced task: one that required players to take photographs and upload them to Flickr. Though that game had maintained a base of approximately one hundred players up to that moment, this creative task never reached the participation quota that the designers, Jim Wolff and Andrew Sides, had established for player advancement. At that point, players abandoned the game. The fate of *Tomorrow Calling* did not befall *Speculation*.

Figure 5. Another collaborative collage, visualizations of *JP's Gender* (2012) were built by players to challenge normative assumptions about the protagonist.

they began to combine the players' images into collaborative collages (fig. 5). Designers modeled the remixing process for the players without knowing what kind of response each contribution might yield. The resulting assemblage of cocreated images included interpretations of textual passages from the game narrative, art pieces by key game characters, visual representations of characters that had previously only been described in prose, blueprints of science fiction technologies, parodies of advertisements from the game world, and a logo for a central antagonist, MetaCorp.

This moment from the middle of the *Speculation* experience demonstrates the ongoing collaboration between players and designers. The interplay represents a significant departure of ARGs from many video games in which players reverse engineer processes that have been encoded by designers.[32] Admittedly, many ARGs incorporate traditional puzzles with single correct solutions and (following the dungeon-master language of *Dungeons and Dragons*) dub their designers puppet masters. However, in practice, ARG players are rarely puppets, and, given the unpredictable behavior of player networks, designers cannot hope to be masters of much. The image-creation challenge of *Speculation* privileged a mode of interactivity available to ARG designers that Stewart calls "jazz" ("ARG").[33] Like improvisational musical forms, *Speculation* left "blank spaces" in the narrative so that players could contribute, and these contributions became in turn material for further inventions by the designers, facilitating the emergence of the play community as a space of cocreation ("ARG"). At many moments, players took the role of codesigners of the game. Similarly, designers took the role of players both in the sense of actors in a theatrical performance and of ludic participants.

32. As Wark quotes Alexander Galloway, "'to play the game means to play the code of the game. To win means to know the system. And thus to interpret a game means to interpret its algorithm (to discover its parallel allegorithm)'" (Wark, *Gamer Theory*, p. [21]).

33. For Stewart, jazz exists alongside other modes of "power without control" and "voodoo." Each of these modes were employed in *Speculation* to differing degrees. Through power without control, the designers encouraged players to contribute to the narrative in a defined way (through a collage challenge) without giving them overwhelming control over the game's development. In posting the initial prompt, for example, the designers left open the possibility of selecting certain player contributions and rejecting others. Similarly, a dimension of voodoo (allowing players to offer "raw materials" from which the designers would compose the story) played a role in this challenge and the broader game, as player-created designs and characters were admitted into the game's core world. However, it was jazz that best defined *Speculation*'s core interactive method ("ARG").

Figure 6. The *Environmental Text Adventure* (2012) game module, designed by Ainsley Sutherland, embedded interactive fiction within dystopic office spaces.

It was the jazzlike interplay and coconstruction of a shared space that ultimately defined *Speculation*'s core strategy of derivative worlding, which we elaborate in the next section. For the remainder of this section, we focus on the transformation of *Speculation* from a pre-programmed interactive criticism of Wall Street to an improvisational cocreation between designers and players.[34] During its run, *Speculation* featured a number of experiments with representation, narrative, temporality, technology, and other concepts. Here, we focus on three examples organized around the idea of space that demonstrates the transformation of the game's design philosophy from the logic of puzzles and video games toward the improvisational play of jazz. The game modules that experimented with space included a series of text adventure games, a GPS-based dead drop challenge, and, finally, the game's player-led discussion forum.

An early module developed for the *Speculation* world was a series of text adventure games that, alongside a text-based console complete with an input field, offered visualizations of the narrative world in the form of navigable, panoramic photographs that allowed scanning and zooming in a three-dimensional space.[35] Instead of interacting with this visual space through mechanical means, however, players could only progress by inputting text instructions (fig. 6). For example, in the first level, players enter an empty MetaCorp office. When they type "Exam-ine window" into the console, the program responds, "Buildings block the view. They are all the same model as this one. . . . On the window is a plant."[36] Following this discovery, players must examine the plant, dig through its dirt, find a keycard, use that keycard to unlock the door to the next office, and so on until they uncover a secret memo about the financial consequences of global warming that contains a password necessary for progress to the next level. This minigame privileges spatial exploration to linear plot development. In Jenkins's sense, it allows players to enact a prescribed narrative by exploring a series of empty MetaCorp offices and unlocking doors between them ("GD").

The spatialized text adventure module served as an interactive commentary about the way that many Wall Street investment banks themselves conceptualize and use space. As Karen Ho argues in her ethnography of Wall Street, investment banks rely heavily on the concept of the global in order to construct a top-down version of the market in which money is "governed by universal logics which naturalize and predetermine its workings and effects."[37] On the contrary, Ho (much like *Speculation*) approaches the "Market" as a bottom-up and emergent assemblage of "a set of daily, embodied practices and models" (*L*, p. 31). One way that Wall Street constructs and promotes abstract concepts such as the market is through a strategy of "global presence" (*L*, p. 311). As Ho explains, invest-

229

34. The practice-based research of *Speculation* investigated the affordances and effectivities of spatial storytelling. As Jenkins contends, games, whether analog or digital, tend to be nonlinear and spatially organized. For this reason Jenkins argues that game designers might best be understood not as "story-tellers" but as "narrative architects." As he puts it, "Game designers don't simply tell stories; they design worlds and sculpt spaces" (Jenkins, "Game Design as Narrative Architecture," www.electronicbookreview.com/thread/firstperson/lazzi-fair; hereafter abbreviated "GD").

35. These games were developed by a group led by Ainsley Sutherland.

36. See criticalinquiry.uchicago.edu/nexus_x

37. Karen Ho, *Liquidated: An Ethnography of Wall Street* (Durham, N.C., 2009), p. 187; hereafter abbreviated *L*.

Figure 7. The "WE" discussion forum (2012) functioned as the game's main platform for communication, collaboration, and play alongside player-made wikis and subreddits.

ment banks such as J. P. Morgan often claim a "global" extension by virtue of having offices in countries outside of the United States, even if, in most cases, those offices are completely empty.[38] Through *Speculation*'s navigable text adventure minigames, set primarily in empty MetaCorp offices around the world, players engaged procedurally and spatially with the narrative of global presence produced by investment banks. This critical statement, however, was essentially built into the digital environment by the game designers and consumed by the players. While this text-based game, as a discrete piece of software, was clearly produced in advance of its play, examining detailed logs of player interactions changed the design of later iterations. *Speculation*'s players, like many early adopters of contemporary video games, became covert beta testers, tracking bugs, glitches, and other inconsistencies on the community forum as they explored this alternate reality.

A second spatial experiment in *Speculation* was a module that required players to move from their computer screens out into the physical environment. This challenge included a prescribed task but allowed considerably more latitude than the text adventure game in terms of group organization and play style. In the fourth level, players found a secret message encrypted using a Vigenère cipher, with a corresponding key. After struggling to break the code, they discovered a secret message containing a series of three GPS coordinates that led to locations in and around Vassar College, Duke University, and the University of Chicago. By inputting these lengthy longitude and latitude figures into mapping software, players found a series of physical locations that had to be explored in person. After visiting each point, players found dead drops—flash drives with narrative fragments as well as copies of the infamous Citigroup Plutonomy memos.[39] Additionally, the flash drive in each location (Poughkeepsie, Durham, and Chicago) contained

one-third of the password that players needed to move to the next level. This challenge employed a spatial storytelling approach that Jenkins calls "embedded narrative." The narrative, here, was imagined less as "a temporal structure than a body of information" or a "narratively-impregnated mise-en-scene" ("GD"). The experience thus bore less similarity to linear texts such as novels and films than to nonlinear works such as spatially oriented graphic narratives (Chris Ware's *Building Stories*, for example) and open world, role-playing video games (such as *Fallout 3*).

Speculation's game design privileged the discovery, comprehension, and rearrangement of narrative documents to linear narration. The dead drop challenge began with set codes and places, but quickly transformed these stable maps into movements by leading players from their laptops out into the local world around them where their trajectories were no longer fully under the direction of the designers. The challenge reintroduced play into the conditions of everyday life and produced a novel experience from familiar environments by requiring players to travel to nearby locations without knowing what they would find.[40] Through its participatory and embedded narrative, *Speculation* thus turned a fixed place into a dynamic atmosphere infused with curiosity, paranoia, apophenia, and attentiveness. The paranoia, in particular, crept into the game design process, as designers snuck out at all hours of the night to leave signs, spray-paint messages, and dig holes to drop their flash drives. Though still asymmetric, the game took on the character of hide-and-seek and overlapped with quotidian academic life as classes and meetings continued even as developers attempted to avoid players.

A third experiment of *Speculation*, the one that most substantially altered the flow of the game from designer-created spaces to cocreated spatiality generative of improvisational jazz, was the space of the discussion forum that organized the game's player network.[41] Players used the

230

38. As a result, "the requirement of being 'global' is not simply about how widespread a bank's business is but rather how it 'leverages' its presence and capability" (L, p. 312) To achieve a sense of global presence, without overextending themselves,

 Wall Street investment banks maintain empty offices in many places throughout the world, and correspondingly, they focus their material infrastructure, people, and energies on even fewer places such as New York, London, and Tokyo. Such an approach allows investment banks to target their resources and be exclusionary in their sites of capital investment while the empty office secures an entry point, a slight foothold, and a particular global image. [L, p. 313]

39. These are the memos from which the Occupy movement drew the language of the 99 percent and the 1 percent.

40. For more on subversive transformations of space in conditions of everyday life, see Michel de Certeau, *The Practice of Everyday Life*, trans. Steven Rendall (Berkeley, 1984).

41. An archive of the original forum is located at speculat1on.net/WE/index.php

forum space for numerous purposes that included sharing requests for help, posting strategies and possible solutions to puzzles, coordinating play to complete multiplayer challenges, announcing the appearance of new narrative documents, summarizing the narrative, debating details of the story and its characters, analyzing the game, playing metagames that the designers had not anticipated, creating illustrations of the game, and engaging in off-topic exchanges (fig. 7). Though some participants may have encountered the game on an individual basis, the forum demonstrated the predominantly social character of the *Speculation* ARG and organized its gameplay. This forum also served as a storytelling space for the production of what Jenkins calls "emergent narratives" that are "not prestructured or preprogrammed, taking shape through the game play, yet they are not as unstructured, chaotic, and frustrating as life itself" ("GD").

The space of the ARG forum complicates the older metaphor of cyberspace, a term coined by William Gibson in his breakthrough 1984 science fiction novel *Neuromancer*. The prefix *cyber* finds its origin in Norbert Wiener's coinage of the term *cybernetics* in 1948.[42] Etymologically, *cybernetics* derives from the Greek word for "steersman" and metaphorically describes a "guide" or "governor."[43] The name thus carries a connotation of control. Though the term *cyberspace* is still often deployed to describe online spaces, the *Speculation* forum represented a space that complicates control. Given the social networks that governed this forum, the space proved difficult for our game administrators to govern or manage. For example, though we created the initial forum, the discussion quickly spilled out into other spaces, including an unofficial forum on the *Unfiction* gaming website, several Reddit threads, an extensive wiki that was created and updated regularly by players, and even face-to-face exchanges among players.[44] The emergent aspects of *Speculation* suggest that the earlier fantasy of a controlled cyberspace, one patrolled, for instance, by the ICE (Intrusion Countermeasures Electronics) of Gibson's "Burning Chrome" and *Neuromancer*, has ceded to a more diffuse, dynamic, and distributed network space of the early twenty-first century. Though networks rely on communications protocols, the precise way in which information moves across them is not under the control of any

designer.[45] The network space of *Speculation* became less a cyberspace to hack into than a shared hub from which to proliferate out.[46] In place of the self-contained virtual world of cyberspace, players engaged in a more active type of worlding to which we now turn.

5. Derivative Worlding

Hidden away in the source code of *Speculation*'s homepage is a short poem:

It was a bright cold day in April, and the clocks were striking eight.

Next, noumenon of my nightmares, fire of my wall.

I am an invisible thing.

eXchange was spiteful.

The sky above the north tower was the color of a reticle, projected onto a dead world.

I am a sick man . . . I am a derivative man.

It will be like so, but won't be.

Call me JP.[47]

As *Speculation*'s players almost immediately discovered given their apophenic reading style, each line of this poem is derived from a classic work of literary fiction. Alluding to *1984*, *Lolita*, *Invisible Man*, *Beloved*, *Notes from the Underground*, *Galatea 2.2*, and *Moby-Dick* respectively, JP's poetry reads like a ransom note, a patchwork of sources deployed to camouflage the identity of the writer. But, in *Speculation*'s transmedia reality, who is being held hostage? JP, as both players and designers discovered together over the course of *Speculation*'s playthroughs, turned out to be exactly what he claimed in this opening statement: "a derivative man."

The financial derivative and transmedia derivation came to be closely related in the *Speculation* gameplay. First of all, the game explored the financial derivative. This type of derivative is essentially a contract—an agreement among parties. More specifically, as Richard Godden explains, a derivative "is an instrument for translating volatility into security insofar as it assesses the cost of risk, for a price."[48] These financial tools do not take as the object of their trade either goods or labor but instead risk itself.[49] In the form

231

42. See Norbert Wiener, *Cybernetics: or Control and Communication in the Animal and the Machine* (Cambridge, Mass., 1961). For an extensive discussion of the early history of cybernetics, see Hayles, *How We Became Posthuman: Virtual Bodies in Cybernetics, Literature, and Informatics* (Chicago, 1999).

43. *Oxford English Dictionary*, online edition, s.v. "cybernetics."

44. For the *Unfiction* thread (from the first run of the game), see forums.unfiction.com/forums/viewtopic.php?t=34405&sid=fb8035b6960ab9b0320a6e3a4fbb8a5a. For the Reddit discussions (from the second run of the game), see www.reddit.com/r/speculat1on. Unfortunately, the player wiki (from the second run of the game) is no longer avaliable at speculat1on-wiki.us.to

45. For an elaboration on this critique of cyberspace and discussion of network space, see Jagoda, "Speculative Security," in *Cyberspace and National Security: Threats, Opportunities, and Power in a Virtual World*, ed. Derek S. Reveron (Washington D.C., 2012), pp. 21–35.

46. Though hacking was not the game's key mode, it is worth noting that one player attempted to hack a stock-trading simulation game in an early hub of *Speculation* to gain the password without having to play the game. This player exploit prompted the game designers to play back and foil subsequent attempts at circumventing the game.

47. Criticalinquiry.uchicago.edu/nexus_x

48. Richard Godden, "Labor, Language, and Finance Capital," *PMLA* 126 (Mar. 2011): 414.

49. Derivatives can now be created on anything, for instance the risk of whether a tornado will pass through northern Illinois next week. Moreover, one kind of derivative, the VIX, is calculated from the amount of volatility of a selected group of stocks (also called the fear index). This derivative has no underlying asset but is an abstraction from a certain set of relationships, thus taking on an even greater degree of abstraction.

of a "future," for instance, a derivative is essentially "a bet on an anticipated price" and also a form of insurance that protects a buyer against the risk of market fluctuation.[50] Derivatives as such are nothing new—these instruments, for instance, already played a key part in the tulip mania that precipitated the Dutch crash of 1637.[51] However, beginning in the 1980s, a number of developments transformed the volume and nature of derivatives trading. In these years, investment banks developed over-the-counter (OTC) derivatives to further engorge their profits.[52] By the late 1990s, speculative practices, facilitated by derivatives such as forwards, futures, and options took on an expanded scale. This change took place with the passing of the Gramm-Leach-Bliley Act that repealed the provisions of the Glass-Steagall Act of 1933—a major piece of legislation that prevented commercial banks from speculating in financial markets (see *L*, p. 7). Moreover, shortly after this act, in 2000, David X. Li developed a groundbreaking formula (a Gaussian copula function) that allowed investment banks to calculate complex risk on mixtures of derivatives. This series of financial, legal, and technical innovations, among others, raised the annual value of financial derivatives from a hundred million dollars in 1980 to nearly a hundred trillion in 2000.[53]

Financial derivatives, as Edward LiPuma and Benjamin Lee have argued, can be described as "strategies of representation."[54] We also view them as processes of worlding. Following Rob Wilson, we understand worlding to be a sustained process of imagination rather than a static worldview. As Wilson notes, "'Worlding,' as an active-force gerund, would turn nouns (world) to verbs (worlding), thus shifting the taken-for-granted and normal life-forms of the market and war into the to-be-generated and remade."[55] Worlding is thus an effect of interrelated strategies—aesthetic, cultural, and political—that generates new forms of life. In this sense, the market itself is not merely a natural or "normal" phenomenon reflected by derivatives. Rather it is a concept that is actively produced by investment banks and other financial actors. On an economic level, Wall Street has been instrumental in generating the hype and developing the financial instruments (most centrally derivatives) that have produced a cyclical atmosphere of crisis characterized by perpetual bubbles and crashes, booms and busts.[56] Derivatives, as a critical instrument of neoliberal finance, generate economic relations and a world of high-risk, high-reward transactions. However, they also produce a

world by making possible new social configurations. As Max Haiven notes, "finance digests the world, transforms social processes into metrics of risk, volatility, and profitability based on the market adjudication of price, splits them apart, and bundles them back together. In this way, finance governs and disciplines multiple levels of social actors, transforming social life into a matrix of risk and response."[57] This form of worlding and social production is achieved as much through the culture of Wall Street as through the technologies that have enabled high-frequency trading.

Speculation sought to foreground the ways in which Wall Street constructs the very concepts (for example, the market and global presence) that produce a vision of a volatile world defined fundamentally by risk.[58] The game did so through interactive aesthetic renderings of processes that covered a spectrum from human practices (for example, the racist and sexist Wall Street hiring practices) to nonhuman processes (for example, black boxing or the algorithmic trading that takes place at temporal scales outside the range of human perception). Additionally, the game explored the temporal dimensions of finance. Derivatives monetize the future, intensifying and accelerating capital's imperative of continual expansion by converting the future into a market to be exploited. *Speculation* both mirrored and sought to complicate this temporal logic with the imagined technology of the Histrion, through which communications are sent from the future back to our present and from our present into a possible future. This central narrative logic complicated the linearity of cause-and-effect and posited a Möbius strip continuum. Temporal complexity was enacted in another way through the unfolding of *Speculation*'s gameplay, as players became cocreators who both responded to and directed how the future unfolded.

The logic of the financial derivative bears greater similarity to the logic of transmedia derivation than the surface-level wordplay suggests. This connection becomes most evident through the proliferation and bundling of the game's user-generated content. The core product—the game of *Speculation*—often derived its value from something else: namely, the risks taken by designers and the community of players while cocreating the game's world. Indeed, in this instance, the game adopted the very logic of the "affective economics" on which, according to Jenkins, convergence culture relies. In this economic model, "the ideal consumer is active, emotionally engaged, and

50. Godden, "Labor, Language, and Finance Capital," p. 414.

51. See John Lanchester, "Cityphilia," *London Review of Books*, 3 Jan. 2008, pp. 9–12.

52. OTC derivatives are private contracts between two parties that specify the conditions under which payoffs will be made to the parties (without an intermediary) based on the performance of specified variables of the underlying assets.

53. See Godden, "Labor, Language, and Finance Capital," p. 415.

54. Edward LiPuma and Benjamin Lee, *Financial Derivatives and the Globalization of Risk* (Durham, N.C., 2004), p. 57.

55. Rob Wilson, "Afterword: Worlding as Future Tactic," in *The Worlding Project: Doing Cultural Studies in the Era of Globalization*, ed. Wilson and Christopher Leigh Connery (Berkeley, 2007), p. 212.

56. See Robert Brenner, *The Boom and the Bubble: The US in the World Economy* (New York, 2002).

57. Max Haiven, "Finance as Capital's Imagination? Reimagining Value and Culture in an Age of Fictitious Capital and Crisis," *Social Text* 29 (Fall 2011): 114.

58. These concepts are explored in *L*. See also Ulrich Beck, *Risk Society: Towards a New Modernity*, trans. Mark Ritter (London, 1992).

Figure 8. In Nick Gessler's *Stock Trading Simulation* game module (2012), redesigned by Mark Govea, players buy and sell blue chip stocks over a four-year period.

socially networked." As Jenkins clarifies, "Watching the advert or consuming the product is no longer enough; the company invites the audience inside the brand community" (*CC*, p. 20). The model that Jenkins describes, accelerated by Web 2.0 social media technologies, is not merely a part of the transient new economy witnessed during the dot-com boom of the late 1990s (itself a key symptom of the proliferating financialization of the same period). Instead it belongs to a broader and longer lasting infrastructure that Tiziana Terranova has called the "digital economy."[59]

The digital economy relies on free labor and posits a gift economy that it seeks to make unproblematic and untether from broader forces of multinational capitalism. As Terranova notes, "Simultaneously voluntarily given and unwaged, enjoyed and exploited, free labour on the Net includes the activity of building web sites, modifying software packages, reading and participating in mailing lists and building virtual spaces." The complication of free online labor is that it is "pleasurably embraced and at the same time often shamelessly exploited."[60] Terranova's larger point, which has been elaborated by other new media critics, is that the internet has never been a fully democratic public sphere but rather an infrastruc-

tural form of contemporary capitalism that depends on the primacy of both financial techniques and digital technology. Of course, free labor, as Terranova observes, is not always a form of exploited or involuntary labor.[61] At the same time, it is important to note that so many internet applications, sites, and social media platforms derive their value from the uncompensated contributions of the very people who buy into them.

Speculation explores the relationship between contemporary finance, on the one hand, and the cultural values that underlie convergence culture on the other through a process that we call derivative worlding. This term captures the worlding that is already proper to financial derivatives as well as *Speculation*'s own transmedia game and narrative aesthetics. *Speculation*'s derivative worlding operated simultaneously through participation in and complication of a process of deriving value from free labor and social relations. *Speculation* did not claim an outside position to the finance capital that was its object, nor did the game promise players a total demystification of financial abstraction. In its design, the game acknowledged that finance does not merely posit fictions that obscure an underlying reality but instead produces a reality—a world—through its unique logic.[62] Many of

233

59. Tiziana Terranova, *Network Culture: Politics for the Information Age* (Ann Arbor, Mich., 2004), pp. 76.

60. Ibid., pp. 74, 78, and see p. 75.

61. See ibid., p. 91.

62. For the worlding power of derivatives, see Michael Pryke and John Allen, "Monetized Time-Space: Derivatives—Money's 'New Imaginary'?" *Economy and Society* 29 (May 2000): 264–84.

Figure 9. The *International Currency Trading* game module (2012) simulated the risk management and gambling mechanics that drive global speculation.

the game mechanics simulated derivative bets and reproduced financial logics, as in games that explored stock trading (fig. 8) and international currency trading (fig. 9). If players wanted to discover passwords that would allow them to progress in the game, they were forced into complicity with the very system that the game-generating protagonist, NEX, claimed to oppose.

Other game procedures and processes relied, by virtue of their design and platform selection, on the related structural ideologies of software. For instance, in certain levels, players had to investigate the source code of websites in order to find passwords and hidden narrative excerpts. In these moments, far from shifting its focus away from financial processes, *Speculation* emphasized the fetishistic parallels between finance and digital media. As Gooden notes, Karl Marx's reading of the fetish form of capital (the misrecognition of social relations as object relations) takes a more extreme form in finance capital. Here, "a higher order of misrecognition occurs, since relations between commodities are misconceived as relations between monetary entities."[63] Through derivatives, commodities, already a reification of social relations, are further abstracted and reified into financial instruments. As Alexander Galloway and Wendy Chun have both observed, a similar fetish (what Chun playfully calls "sourcery") is evident in discussions of software.[64] As Chun points out, discussions about software frequently conflate written human-readable code with the event of program execution. The concept of "source code," in particular, is imbued with an alleged power that belongs to more complex social and machinic relations.[65] Thus, *Speculation* sought not merely to expand the digital literacy of players by calling their attention to the layers of code that made up the game, and the limits of their interpretability, but also drew additional links between that code and the social, financial, and technological processes it so often distorts.

Speculation participated in financial (and technological) logics, but it also complicated the type of risk inherent in contemporary financial derivatives, which remain

63. Godden, "Labor, Language, and Finance Capital," p. 417.

64. See Wendy Hui Kyong Chun, "On 'Sourcery,' or Code as Fetish," *Configurations* 16 (Fall 2008): 299–324. Galloway observes, "software requires both reflection and obfuscation" (Galloway, *The Interface Effect*, p. 64). Admittedly, software requires exacting symbolic descriptions that leave little room for ambiguity but, at the same time, through the use of layers (a user interface, assembler, machine code, all the way down to voltage levels), software conceals. To return to the example of websites that were a common element of *Speculation*, the HyperText Markup Language (HTML) used to create these sites was not visible to users unless they chose to view the source code.

65. Chun, "On 'Sourcery,' or Code as Fetish," p. 303.

largely unregulated despite the 2008 financial crisis. Derivative worlding, as we understand it, emerges from an interactive process in which the narrative and gameplay construction of a world both mirrors and departs from the world of financial derivatives, recognizing our complicity with finance capital while at the same time striving for a different future. *Speculation*'s derivative worlding shared with financial derivatives a series of bets on player participation and a final date on which the bet (the promise of the game and the completion of the narrative) would come due. Through the risk of losing control of the story because of player participation, the game also channeled the escalation of risk that characterizes many financial deals. In its deliberate and ongoing absorption of multiple genres, forms, and media (performed in response to player comments and objections), *Speculation* adopted the strategy of reducing risk through bundling that is a regular attribute of complex derivatives. Unlike derivatives, however, the benefits of cooperative and distributed gameplay were available to all, and the many were not penalized for the excesses of the few. Moreover, the future was not so much commodified as rendered malleable to those who dared to imagine a different kind of world.

One final example of this process will suffice: JP, the derivative man, was first created in Marcel O'Gorman's Critical Media Lab at the University of Waterloo months before *Speculation* was launched. At an ARG workshop that we organized, students designed personal emails, business memos, resumes with cover letters, financial reports, and even social-networking information for newly generated *Speculation* characters, including a then-minor James Powell. Powell was initially intended as a granular asset within *Speculation*'s larger derivative world. However, once the game was launched players became curious about this particular character's relation to the larger story and convinced of his centrality. Responding to this interest, we added Powell as a parallel player of a parallel game on a parallel forum. During gameplay, we performed his character as that of a twenty-first-century cyberbully turned MetaCorp investment banker: a comic relief villain whose online mischief was overshadowed by MetaCorp's dehumanizing corporate culture. But, in the process, we discovered that our collaboratively imagined character was full of holes. Why would MetaCorp hire someone with Powell's track record? Why would Powell skip work, as MetaCorp surveillance logs suggested, to care for a nonexistent daughter? And, crucially, why would MetaCorp fire someone after only employing that person for three months? What began as simple, numerical oversight in a shared design process was reabsorbed into the alternate reality of *Speculation*. Given the dates on the documents, Powell could not be who he said he was. In the coming weeks, we deployed even more elaborate and convoluted stories of identity theft, corporate conspiracy, and international espionage. There were many Powells: the fratboy forum dweller, the successful invest-

Figure 10. *MetaBux* (2012), an early rabbit hole, repurposed actual Zimbabwe currency that was available for purchase on eBay because of hyperinflation generated by global financial markets.

ment banker, the phony salary man, and, finally—and most substantively by the second playthrough—JP, the politically driven hacker and identity thief.[66] In a careful push and pull with players over the course of a year, we cocreated a distinctive and deeply flawed character who tarried in real time with the ongoing speculations of our players. The original white, male, upper-class fall guy transformed, consistently within the rules of the world that we had produced, into a transient, transgendered, and transmediated child who was ultimately responsible for the emergence of NEX: the character with whom the game began.

This form of worlding, the production of a new subjectivity, was made possible by the transmedial and productive capacities of contemporary capitalism, but it would be a mistake to reduce the process of play that yielded JP to a mere symptom of gamification, convergence culture, or finance. Evolving JP in the midst of gameplay was a risk, but the risk taken through the game's ongoing collective speculation was not identical to the risk inherent in financial speculation. In the months leading up to the subprime mortgage crisis, investment bankers used financial derivatives to reduce risk by disseminating it among multiple investors only to spread toxic assets and push, in the process, the global financial system to the edge of systemic collapse. Whereas the speculation leading to the 2008 financial crisis enriched the very few at the expense of the vast majority, *Speculation* employed the willing few to establish critical positions not outside but inside the metaphors, mechanics, and game strategies of finance capital. The forms of play that the game

235

66. In many ways, JP became an avatar of our own designer experience of playing *Speculation*.

inspired were both procedurally and conceptually difficult. They were rarely, in a conventional sense, fun. These processes did not yield new products, consumers, or markets. The game's play did, however, self-reflexively bring into sharper view the capacities of the creative collective that shaped the transmedial world of *Speculation* and differentiated it from the world of finance.

6. Conclusion: The Matter of Finance

In finance, leverage means going into debt to increase the power of available capital. For the last four decades, the US government has implemented monetary policies through the Federal Reserve and fiscal legislation to facilitate free market exchange, leading to a huge national debt that will ultimately have to be paid by future taxpayers. Leverage here means privileging the rich, those who can afford to invest, at the expense of those who cannot. The resulting massive shift of wealth has impoverished the middle class and pushed the working class to the brink of disaster. *Speculation* enacts a different kind of leverage, using the current appetite for computer games and the relatively new ARG form to enact a form of worlding that critically interrogates the systemically risk-laden world generated by financial derivatives and other practices of investment banks. It strives to contribute to a different kind of cultural imaginary, one that can see the lurking catastrophe of finance capital and imagine possibilities for change.

Speculation posed a modest challenge to this presumed totality of finance in a number of ways, demonstrating that while financial derivatives may achieve a world-making power in our historical moment, they are not equivalent to the world. Finance is not the neutral abstraction of market forces and global networks that its advocates make it out to be. Even financial transactions have concrete foundations and consequences—a materiality that *Speculation* attempted to foreground at every turn. At the start of the game, we did so through the distribution of repurposed and massively devalued Zimbabwe currency purchased on eBay—a consequence of hyperinflation generated by global financial markets that had its most devastating impact on the poor (fig. 10).[67] At a similar moment, we distributed business cards for the game's protagonist with the GPS coordinates of an enormous server warehouse in New Jersey (a facility the size of three football fields) that serves as the grounding infrastructure for those allegedly immaterial and hyper rapid algorithmic trades that have enabled Wall Street's success. Later in the game, we emphasized the material reality of the global presence of investment banks of J. P. Morgan through text adventure games set in the empty offices that these banks purchase to produce an illusion of totality. Perhaps most pointedly, the second run of *Speculation* told the story of Eva: an impoverished laborer who works for MetaCorp through virtual telecommuting from outside of the US. Eva's story gradually made players aware of circuits of capital that connect coltan mines in the Congo and the violent conflicts surrounding this precious substance to the electronic and mobile devices that contain tantalum capacitors and fuel the games of the overdeveloped world.

Speculation comments on all of these material contexts and undercuts the fantasy of infinite exchangeability maintained by finance. After months of intense and daily gameplay, in each of its two runs, *Speculation* itself reached its material limits. But through this process of engaged speculation, the game mobilized players as cocreators of something that sometimes seems impossible in this present: a future not already used up in advance by debt and derivative contracts but rather one that encompasses the possibility of a more open, sustainable, and just world.

236

67. The Zimbabwe dollar failed because the government printed out absurd quantities of the currency with nothing to secure it. The hardest hit, of course, were the poor and those who saved as opposed to investing in the market. A fifty trillion dollar note now sells on eBay for under two US dollars. One *Speculation* document that explored this situation was a memo revealing a plot by MetaCorp to stimulate the failure of cash through similar hyperinflation, forcing everyone to convert to electronic currency, which is easier to track and surveil.

Panel: Lines on Paper
Lynda Barry, Ivan Brunetti,
R. Crumb, Gary Panter
Moderated by Hamza Walker
May 20, 2012

HAMZA WALKER: I'm Associate Curator and Director of Education at the Renaissance Society at the University of Chicago. I'm deeply honored by the chance to moderate today's discussion. It was a year ago that I accidentally confessed to Hillary that I actually got into art by way of comics, and it is still amazing. Had someone asked me not so long ago which of these two scenarios is more likely to happen—there will be a black president in the White House within your lifetime or there will be a panel at the University of Chicago featuring you four? *[laughter]* I would have balked. The likelihood of either proposition being comic book-slim—not graphic novel-slim, because those get kind of fat these days. I will let Ivan be my witness, since we share the same years as undergraduates [at the University of Chicago]. Could you imagine this happening?

IVAN BRUNETTI: No, never. Surreal. We need the first black cartoonist up here, though. That's kind of what's missing. *[laughter]*

WALKER: I was eleven when *Star Wars* was released. This was followed by the rise of video games. My college years were marked by the wholesale advent of the digital revolution, ending with the rise of a shiny thing called the CD, for those of you who remember those. At the same time, comic books not only underwent a Hulk-like metamorphosis, the underground came above ground. What is the imagination if not a reservoir of alternatives? Superheroes became less super and more dinosaur-like as the charms of Lynda Barry took root. Week in and week out, you pen what I took as open missives, addressed personally to me. *[laughter]* You came on strong. You came on strong, cool like Thor. But you were also vicious in a Lou Reed sense. *[singing]* "Hit me with a flower." *[laughter]*"Do it every hour. 'Cause you're so vicious." Thank you for indulging me while I serenade Lynda. I'm not going to serenade R. Crumb. That's a different Lou Reed song. And I don't have my backup singers.

R. CRUMB: Unless you can do Charlie Patton.

WALKER: We can get down into some down and dirty.

[laughter] But when all is said and done, that one question, that eternal question which can be put before any artist remains: Where does all of the stuff come from? There is an inner place, a conscious and an unconscious, where the gears are grinding, the wheels are turning, but then there is the moment when the rubber hits the road. The "do" of it. That's what I would like to talk about this morning. Drawing is a very conspicuous site of activity. And I'm going to start with a page from one of your sketchbooks, dated December 1982. This is from one of Gary's sketchbooks, and it is an amazing list of influences.

CRUMB: What are all those crossed-out ones? *[laughter]* A revisionist list there.

GARY PANTER: Second thoughts.

WALKER: Jack Kirby, Chester Gould, Ed Ruscha, Frank Stella, Phillip K. Dick, H.C. Westerman. It was beautiful for me to see Jim Nutt, Karl Wirsum. Getting into a Chicago funk school. You have quite the pantheon.

CRUMB: Jack Webb? You mean from *Dragnet*? Dum da dum dum—that guy?

PANTER: Yeah. Jack Webb.

WALKER: And at another moment, in an interview, [Gary] said, "Yeah, well my band, we were just like Destroy All Monsters." And I thought, "No, he didn't just drop another one." But you hail from that era.

PANTER: Yes.

WALKER: But it is the last name on this list, actually, Jefferson Machamer, that was the more telling one.

LYNDA BARRY: Who is that?

WALKER: There he is. *[laughter]* This is Jefferson Machamer. He did syndicated strips in the 1920s and 1930s. All the way up into the 1960s. Right? And *Laugh and Draw with Jefferson Machamer*.

PANTER: I had two copies.

238

Figure 1. Gary Panter, list of influences sketchbook page, *Gary Panter* (2008).

Figure 2. Jeffrey Machamer, title page of
Laugh and Draw with Jefferson Machamer (1946).

Figure 3. Jeffrey Machamer, frontispiece of
Laugh and Draw with Jefferson Machamer (1946).

239

WALKER: I think of this as really, really telling. It is not just how you guys decided to become artists and the role that drawing would play in the decision to become an artist—the extent to which drawing would define artisanal skill, what it means as work and labor. There would be that, but—and this is key—I think the democratic nature of it is what really runs through all of you.

BARRY: Of drawing?

WALKER: Of drawing. It isn't a question you *learned* how to draw. It is a skill. But at the same time you all acknowledge it is a skill open to all. So it is a means to an end—and I think that that is really the ethos that defines the type of artists that you are. Bob, you continuously return to the self-deprecating parody of what you do, but you want to encourage others. Ivan puts out *Cartooning: Philosophy & Practice.*

BARRY: That's the best book ever written on cartooning ever. *[applause]* You don't need any other book but that one.

PANTER: Except the Machamer.

WALKER: This issue about the labor of it. Right? Mr. Sketchum. Here is what I do for a living, kids, and you can, too! Your list of influences, which is great. Everything about you, Bob, is just out there.

CRUMB: Thank you.

WALKER: And available in a way that—you are probably

one of the hardest people to interview because of that.

CRUMB: Yeah, right. *[laughter]*

WALKER: I'm going to start with you, Lynda. *Picture This: the Near-Sighted Monkey Book* is a deeply metaphysical meditation on drawing. Where does it come from as an activity? Is it in you? Or is it the ability to want to see a face in a water stain? You start to ruminate on those kinds of questions.

BARRY: Well, I can talk about where it comes from, but I want to say where it lands you. I've never been with this many cartoonists before. *[laughter]* And the whole reason that I'm here is because I drew a picture. That's why we're here. We drew a fucking picture. "Now you are here with R. Crumb and Ivan Brunetti and Gary Panter!" It is a means of transportation. My guess is the reason that you all are here is because you drew a picture, or you want to, or you are the people who say, I can't draw but I like to watch others. *[laughter]* But you can. You just take your hand and then you trace it, and then you draw a little beak, little feet. Cigarette. *[laughter]* A sentence about someone you hate. *[laughter]*

CRUMB: Et voila.

BARRY: I think it has an absolute biological function. I think these are the original digital devices *[wiggling fingers]*. Check them out. Wireless. Bio-fueled. Self-healing. So where drawing comes from, that's actually a question

Figure 4. R. Crumb, *R. Crumb's Universe of Art!*
In *The R. Crumb Handbook* (2005).

she continues to do this one drawing, of a 1940s teenage girl. Always the same 1940s teenage girl. Over and over.

BARRY: People who quit drawing, they say "I can't draw." Can you doodle? Yeah. What is your doodle? Eyeballs. Everybody has their doodle. Paramecium. I draw stars. So what are we doing when we're doing that? And why do we doodle when we're in a bad situation like at a very boring meeting? I think it is because it actually transforms time. It doesn't transform time in a magical way. It makes a meeting less of a cheese grater and more like Brillo. At least your skin will last that much longer if you doodle. *[laughter]*

BRUNETTI: You can see where my drawing stopped, too. Drawing myself over and over again.

WALKER [to Brunetti]: We can talk about the self-deprecating nature of this activity, right? But I think that's in the wings, in the margins. More, I want to out you as a modernist.

BRUNETTI: It's not true.

WALKER: It is! It's true!

BRUNETTI: Those Barbra Streisand albums mean nothing. *[laughter]*

WALKER: Here is a beautiful cartoon you did on Mondrian. The reduced nature of your style, but [also] just the idea of writing a philosophy and practice book that would—and I don't know how conscious you were of it—greatly resemble Paul Klee's pedagogical sketchbook.

BRUNETTI: Oh yeah, that's a great book, but I didn't have that high a name for it. You know, the title [of my book], *Philosophy and Practice*, is meant to be a joke. It is kind of a parody of the whole University of Chicago thing. *[laughter]* That's supposed to sound overly dry.

WALKER: Unfortunately you are speaking to the same—it cancelled itself out.

BRUNETTI: That's fine. It is a multilayered joke. *[laughter]*

WALKER: It is a beautifully written book. Gropius wanted to do those series of books, believing that modernist practices were quite accessible in their simplicity. I was wondering if you would talk a little bit about the irony-free nature of the endeavor.

BRUNETTI: I mean, the book by Klee is great. And then

240

I'm very interested in, and when I was teaching this semester at the University of Wisconsin, I wanted to see what would happen if I could get very smart people who were committed to deadlines but had given up on drawing when they were like twelve or younger. I wanted to see if I could get them to draw again.[1]

WALKER: That comes through in the book repeatedly, why do we start drawing? Equally, why do we stop drawing? And what age do we stop drawing?

BARRY: What was amazing to me is if you have stopped drawing your drawing style is intact from that time. You know how children's drawings, they are always satisfying and kind of gorgeous? If you quit drawing back then, your drawing is that still. But you won't know it until you can stand what's coming out of your pen.

CRUMB: Aline [Kominsky-Crumb]'s mother, you know, she stopped drawing when she was about fourteen. But

1. See Barry's *Car and Batman* in this issue, inspired by her students' work at the University of Wisconsin.

Figure 5. Lynda Barry, *Picture This* (2010).

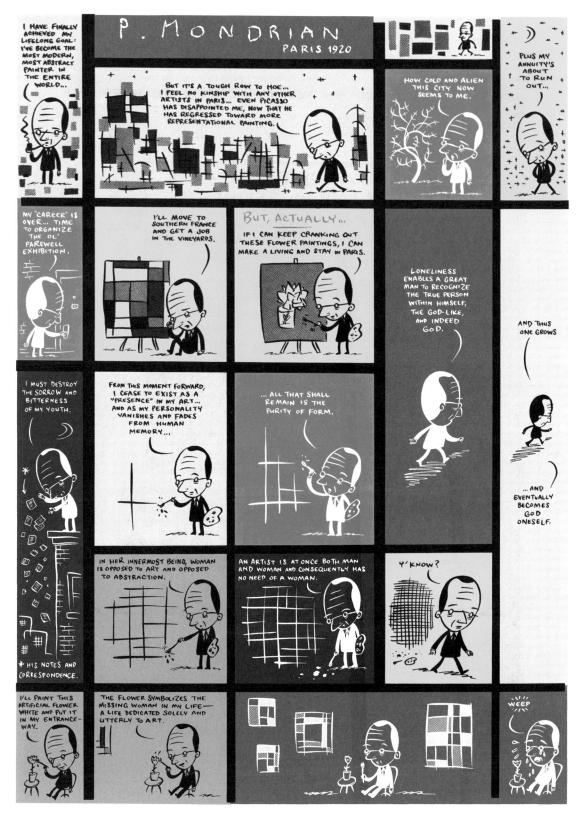

242

Figure 6. Ivan Brunetti, "P. Mondrian, Paris 1920," *Whither Shermy?* (2006).

Kandinsky wrote one about—

WALKER: *Point, Line, Plane*?

BRUNETTI: Yes. Those are important for me. I still think I'm stealing Kandinsky's line. If you look at his paintings, there's a certain spiky line—

CRUMB: Steal from the best.

BRUNETTI: Maybe before that it was Steinberg who took both of them, I think, and turned it into cartooning. But here is the thing: I can't draw. My perspective is dyslexic. I can't see very well so trying to draw things realistically is just horrible. But what I figured out from those artists is there is a power to the calligraphic nature of drawing. You can take that aspect and since cartooning is kind of a mental map of the whole world, everyone has this map in their head of objects, people, and the way spaces look. But emotions can be captured with calligraphy, too.

Forgetting about my limitations and trying to find some other aspect that I could communicate with—that's what I'm trying to impart to people. It is just making people less afraid to try to put stuff on paper. This is a really simplified kind of drawing that people are looking at up there [in my work]. That's easier to do than stick people. Stick people are really hard to draw because you are always going to get the legs wrong and it looks like there is like a dong hanging down. People look at that as the simplest way of drawing. It really isn't. Using circles, squares, triangles—and just these little spiky lines—is actually easier to get started.

I'm still trying to find a way to tell something that's closer to a serious story and get away from trying to be funny, because that's sort of my curse. I think it is possible even with a really simplified or almost abstract style. On some level it must reflect the way I experience things, that I turn everything into verbal concepts, or translating the universe. To me, that's more like writing than drawing up there. It has almost nothing to do withdrawing. It is writing in the sense—calligraphy is both writing and drawing.

CRUMB: You can draw. I saw some really good illustrations and drawings by you.

BRUNETTI: Yeah. *[laughter]* I don't know. I have a lot of crutches. It is embarrassing.

CRUMB: Oh, come on.

BARRY: Wait until you hit menopause, honey. *[laughter]* All of a sudden all that estrogen will go away and you'll feel confident again. *[laughter]*

WALKER: When I was asking about the lack of irony, it is almost evangelical in some sense, in spirit. The Bauhaus did have this, I would say, about modernism and its principles. That really attracted me to *Cartooning: Philosophy and Practice*. If you could talk a little bit more about that spirit some, the democratic nature. Do you think everybody has it in them? Was that something that you were thinking about when you undertook writing the book?

Figure 7. Ivan Brunetti, cover of
Cartooning: Philosophy and Practice (2011).

243

BRUNETTI: I just wanted to say all the things I wish somebody had said to me at some point. I was actively discouraged most of my life from pursuing anything artistic. And I know there are a lot of people who go through the same thing. Or there are circumstances in their life that have prevented them from pursuing this. It is a rarified pursuit. It is a privilege. Most people are stuck washing dishes or shoveling shit or whatever. Most people's lives are horrible and they don't even have the chance to do this stuff. But you want to read stories from people that actually have to live those lives. So I think over the years I've come to see maybe there is some purpose I wasn't even aware of. And I overwrote the book in that sense. I should have made it simpler. I don't know. I mean with college students, a lot of them are just confused, scared kids. Most of their teachers are telling them stupid stuff. *[laughter]* It's just wrong, frankly.

PANTER: Really stupid stuff.

CRUMB: They liked that. They resonated to that remark.

BRUNETTI: Yeah, you know what I'm talking about. I'm just trying to kind of break down a lot of barriers and get people to just start making something. Just to start getting something like real life on paper, because I think there is too much escapism in general in the culture and among students. I mean I'm guilty of it, too. Give me a roast beef sandwich. I'll watch *Hot Tub Time Machine* and kill some brain cells. I understand the impulse. Life is short. *[laughter]*

When I was growing up we lived in a Chicago bungalow and I thought, that's a great form of architecture. It is beautiful but it was made for working people. There is something humble and simple about it. I guess that's kind of the aspect of cartooning that interests me, the humility of it. There is something almost practical about it. It is unassuming, but it does take skill, and you have to respect learning that skill and the craft of it. Just like a bricklayer, or whoever, has to.

WALKER: If I can ask one more. Because this would dovetail nicely with the very obvious question when you are talking about skill. You also use the computer. And what role does that play in your drawing?

BRUNETTI: With printing, I mean, everything is digitized and that's how they make printing plates. If you want any control over the process, you have to learn how to prepare stuff for the printer using the computer. If I didn't have to do that, I probably would have never bothered learning it because I don't like using it. Actually lately I've been telling myself to just try to do things as wrong as possible on the computer and just treat it like a stick on the ground or if you found an instrument or something you have no idea what to do with it and maybe something interesting would come out of it. I'm trying to rewire my brain to just forget all the stuff I know about it. And find some other way to use it like a cave man or something. I'd prefer that. Just the reality is that if you want control over how your stuff is printed, you kind of have to learn how to use it.

CRUMB: Wow.

BRUNETTI: It is a necessary evil, like a car or whatever. *[laughter]*

CRUMB: I don't use it at all. I'm scared now.

ALINE KOMINSKY-CRUMB [from the audience]: You don't drive a car either. I have to drive you because you don't drive. Somebody would have to use the computer for you.

WALKER: All you have to do is just get him to the drawing table. For Bob and Gary, I would actually like to—

BARRY: Did you really just call him Bob?

WALKER: Yeah, I did. Did that scare him? Should I call him Robert? R.? Robby?

BARRY [to Crumb]: I've never heard you called Bob before.

CRUMB: I don't care.

WALKER: I mean, if I call him R., they're going to get him confused with R. Kelly. I just don't want that to happen. There are a lot of similarities.

CRUMB: You can call me Mr. Crumb. If you want.

WALKER: I think of this panel as intergenerational in a very interesting sense and of all the places to locate it, to locate it between you, Monsieur Crumb, and you, Monsieur Panter. Going back to this list of influences. For you, Robert, you encountered obviously, just generationally, probably the greatest barrier entry—like defining this,

like what did it mean in terms of becoming an artist to choose to become a cartoonist as the art form. And that distinction between high and low. It is interesting that those same years would also be the ones where pop art would be in vogue.

CRUMB: Yes.

WALKER: I was wondering if we could revisit this, just a little bit, as it relates to drawing, skill, and the decision to go the route that you did.

CRUMB: Well, it wasn't really a decision. I never decided anything. When I was a little kid I was raised Catholic, I wanted to be a priest, because I figured that was the best guarantee of getting into heaven. But then my older brother got me into the comics thing. I just drew all the time. A lot of kids draw a lot, but if you are a well-adjusted kid, you lose interest in drawing in teen years. But if you are a maladjusted weirdo geek nerd, then you just keep drawing. That's the only reason anybody really keeps drawing after they reach fourteen is because you are maladjusted somehow. *[laughter]* It is the only reason to really stay home and draw. Why would you do that if you could go out and, you know, kick a football around or, you know, learn to drive a car or something. *[laughter]*

WALKER: So it wasn't *against* anything, in terms of making a decision.

CRUMB: There was no decision at all. I was just this out-of-it spastic nerd and my brother just kind of made me draw these comics or I was a worthless piece of shit if I didn't. Very passive. Could barely see with my thick glasses. And I was a child of popular culture, comic books and TV. So I just drifted into that, drawing comics. Then somehow, miraculously, I was able to turn it into a living. When you talk about the practical thing about cartooning or drawing, that's really for me what it is about. Then I took LSD and the hippie thing came along. I was in the right place at the right time with, you know, Mr. Natural, Keep on Truckin', all that stuff. Somehow things worked out. *[laughter]*

WALKER: I guess if I could contrast your list of influences with Gary's list of influences. By the 1970s, the fact that Frank Stella is mentioned on the list—

PANTER: I love Frank Stella.

WALKER: Were you in a similar situation to Robert? You went in several different directions at once, it would seem. But how did you come to drawing? Because drawing is at the core of what it is that you do.

PANTER: Yes. It is.

WALKER: In looking at the sketchbooks, I mean, you already had me. You are dating [your sketches] by the day. And you broke out the stamp on them, living up to that rumor that you only sleep for five or four hours a day.

PANTER: Maybe I should've been asleep. My dad [was] an amateur painter my whole life. So I got interested in drawing, from him. Then I discovered modern art when I was

Figure 8. Gary Panter, *Super Tape Value* and *Doctor Uniforms* (2008).

Figure 9. Karl Wirsum, *Screamin' Jay Hawkins* (1968). Mr. and Mrs. Frank G. Logan Purchase Prize Fund, 1969.248, The Art Institute of Chicago.

about ten through *Newsweek* magazine or something. I'm from a little town in Texas, or several little towns. I got obsessed with modern art. Frank Stella, Claes Oldenberg, British pop—I love all that stuff. The Hairy Who I would like to mention maybe off-topic for one eighth of a second.

WALKER: Make it two eighths.

PANTER: The Hairy Who was the only thing in the 1960s that could not be co-opted. You could not bring The Hairy Who to the JC Penney. This was an amazing thing, because the 1960s was a series of more and more fantastic things day by day and week by week and I saw Karl Wirsum's Screamin' Jay Hawkins cover and it blew the roof off the top of my head. I expected to see it at JC Penney's and it never showed up. I'm not sure it is ever going to show up.

WALKER: And this is to return to a 1970s punk set of years for you—how did that play out in terms of your work ethic?

PANTER: I was kind of waiting for punk rock. I was waiting for someplace that I could plug in. Because in about '72 or so I started doing these weird kind of scratchy drawings because my Rapidographs were jamming up. So I was waiting around for years for someplace. I was in Texas. I drove all over Texas. I worked as a janitor. Couldn't really get work in Texas. I went to New York and it was too scary, so I went to LA and they had palm trees. I saw, you know, *Slash* magazine. I went, oh, they sell Rauschenberg and Kline and all that stuff, too. So my stuff would fit in here. I went in 1976, in the bicentennial year.

CRUMB: That was the flowering of the whole punk era, right? Around that time?

PANTER: I went to LA and was looking for records. You could find Todd Rundgren's *Utopia* albums. I was looking for Eno, that kind of stuff. Then punk rock happened. It was sped up rock and roll. I like the weirder stuff, Pere Ubu, The Residents, Frank Zappa, Captain Beefheart…

CRUMB: Did you like the Dead Kennedys and that kind of stuff?

PANTER: Not so much. I like punk rock fine. I'm friends with a lot of bands. But sped up rock and roll is not my favorite thing. I like weird records.

BARRY: You like the punk slow jams. *[laughter]*

CRUMB: How is your hearing?

PANTER: It destroyed my hearing. I'm in a band now and working on destroying the rest of my hearing.

CRUMB: I thought you were telling me last night that it was a criterion of the quality of the band if blood came out of your ears?

PANTER: Yeah. We went to this show with Boyd Rice as "NON," and he had an electric fan strapped to a guitar in this place downtown LA. Everyone was screaming and running away. That was a good time in those days. *[laughter]*

CRUMB: You think punk is a thing for younger people?

Can you really comfortably move into like older age or middle age with that kind of punk ethic thing? The intensity of it?

PANTER: Yeah. There are punks that get together and they are all like white-haired and have grandkids and tattoos.

CRUMB: Can you still be a punk then and be old?

PANTER: Yeah, punk rest homes. *[laughter]* Punk funerals.

WALKER: The explosion of zines and alternative culture, the DIY movement, it seems would have been a real outlet. Given how prolific you are, I just think of those years as presenting themselves as *surf is up*. You are just like, let's do this. Wholeheartedly with the band. It wasn't a question of where does this go, or what do I do with it.

PANTER: It is like, "Start." That was the cool thing about punk rock. It was just, get up there and do something. Start. And I like cruddy stuff. I always liked bad drawing. I grew up in the 1950s, a lot of it was in Brownsville, Texas, on the border of Mexico and bad Mexican print shops had a lot to do with off-register print shops.

BARRY: Remember we would get Xeroxes for five cents and it was, "Shit, we could make our own books!" You just say it to yourself and you hold it in the mirror: "I published!"

CRUMB: You like off register? I struggled mightily to try to get everything to register correctly and those fucking color separations. Get those hippie printers to do it right. *[laughter]* And get the goddamn registration. *[laughter]*

WALKER: This is the generational divide that I'm trying to draw out. *[laughter]* And you were going for it even though you were a hippie, you were still going for it.

PANTER: If everyone else is on register, you better do it some other way, like print it backwards or something else. Robert, you had good registration covered. And sex. I didn't have to deal with sex at all.

WALKER: With the coming of the Xerox machine, that would indicate also drawing for reproduction versus a drawing as an end in itself.

PANTER: I want both of those things.

WALKER: Lynda, somebody at Printed Matter, and you never found out who it was, kept ordering your zines.

BARRY: Yeah, my little fifty-cent books. But you know the other thing that was interesting back then before computers was headshops. The way that we saw each other's work was headshops. Bob, I can remember exactly where I was and many people tell this story, the first time they saw your work. I was in the eighth grade. I was in math class. And there was this dude I wasn't very interested in except for he had this comic book that I just snatched. It was such a big deal to see that. And then your work, Gary, I saw because of Matt Groening. Matt is somebody who is overlooked in terms of his influence on alternative comics because he did *The Simpsons*, so we're all like fuck you, you are too rich, we're not talking to you anymore. But he worked at a copy shop. He would copy your stuff and send

247

it to me. It was all done through the mail, because phone calls were really expensive. Remember that? It is just wild to think that this whole thing was either done through the mail or walking to the headshop.

And your work, Bob, had such a huge impact. There is a wonderful writer Dan Chaon, he is a brilliant fiction writer. He told me a story: he grew up in a little town in Nebraska and got his first *Zap* and he didn't know what to do with it. He buried it. That's how badass it was. This has to be underground. *[laughter]* It really fucking has to be under the ground. I mean, that's strong! He had had to bury your stuff.

WALKER: Shit was radioactive! Like Fukushima Daiichi! Put it down! So at this point I would like to open it up for questions.

BARRY: Can I just butt in and tell a story? If any of you hold my work in any kind of esteem, I'd like to change that immediately. *[laughter]* By telling you who my other most influential cartoonist person is. My favorite comic strip in the world is *Family Circus*. It is my absolute favorite.

CRUMB: *Family Circus*? *[laughter]*

BARRY: I'll tell you why. You and *Family Circus*, big, big things. *[laughter]*

Bil Keane used to draw the strip. You know how you would hear that thing about how when you see beautiful art you would burst into tears? Remember hearing that when you were a kid? And I always wanted to see beautiful art and burst into tears, and I wanted to do it with a cute guy nearby. Because then he would see, she is so sensitive, I must kiss her. So I would try. I'd be in museums and there'd be, like, cute dudes, and I'd be looking at a thing and trying to bust out a tear, but it would be on the wrong side. So the closest I've come to anything like this is when the alternative cartoonists finally got invited to the conventions where the real cartoonists were. Like the guy who drew like the wizard—

PANTER: *Lockhorns*?

BARRY: Yes. *Lockhorns, Wizard of Id*. I was seeing everybody go by. I saw Cathy. I wanted to just trip her and knock her down. Because she is really skinny. And really pretty. And I thought, you hag. You've been making money off of women with asses like mine. For way too long. For real! What a liar. *[laughter]* So people know this about me with *Family Circus*. And part of the reason I love *Family Circus* is we didn't have any books in the house. We had the newspaper. And my house was a really violent, difficult house. Alcoholics, blood and hair on the walls. It was just very, very difficult. But I would open the paper and I'd look through this circle and I would see, this is happy shit! Jeffy and Dolly. The dog's name was Barfy so you knew something hip was happening. I would just look in there, and while this hell was going on behind me I would look at this. Through the circle.

I go to this convention, and somebody says, "Oh, Lyn-da, you like *Family Circus*, right?" I said "Yeah!" Now, Bil doesn't draw it anymore. He is dead. But Jeffy draws it—this is Jeff Keane. And I went: *[bawling noises]*. And it wasn't cute. Nobody would want to kiss me. I was shaking. Snot. And I was coming toward him. And he's backing up like mother fuck, this has never happened. And then I actually hid behind a potted plant to get myself together: "I'll be right back." Every time I saw him I couldn't stop crying. And it became the joke of the convention to just try to get him in my line of sight. Part of the reason I burst into tears is I realized that when I shook his hand, I was on the other side of the circle. And I did it by drawing a picture. That's the thing I want to talk to you about drawing. I did it by drawing a picture. And I know that it seems crazy to say that it is as big of a deal to meet Jeff Keane as it is to meet Bob. But it is by drawing a picture. And when you think of this stuff as a means of transportation, it gets very interesting. It is much bigger than, "Ooh, I drew a picture and everybody thinks I'm groovy." So that's the story I wanted to tell you.

CRUMB: That's pathetic!

BARRY *[gesturing to Crumb]*: Have you ever seen him say the words "family circus"?

PANTER: Never again, probably.

Q&A

AUDIENCE MEMBER: I was wondering, what is the most disgusting, depraved thing you've ever drawn that hasn't appeared in your work, from a sketchbook or just any very disturbing ideas that have never seen the light of day.

PANTER: I don't know if it was in a sketchbook, but I did take LSD for two weeks and work on a porno comic with a friend of mine. A chicken farmer bought it and buried it in the desert. *[laughter]*

WALKER: What is this theme of burial and drawing?

PANTER: It is just true. I asked him what he wanted with the stuff, and he just sent me a bunch of bloody feathers in the mail. But he gave us money. It was called "P Dog, the Final Captain's Log." *[laughter]*

BRUNETTI: I have to say that the stuff I publish is way worse than what is in my sketchbook. I'm ashamed of most of it.

CRUMB: I have no secrets. Every disgusting thing that I've drawn that is out there has been published. I never kept any of it secret.

AUDIENCE MEMBER: Thank you, Lynda, for bringing up the daily comic strips. I heard you tell that story at the Chicago Humanities Festival with Matt Groening. After that I tried to read *Family Circus*. I'm sorry, I still can't. But I loved it that you brought it up. Sometimes I feel like I'm the last person in the world who loves the daily comics in the paper.

CRUMB: Last person, you say?

248

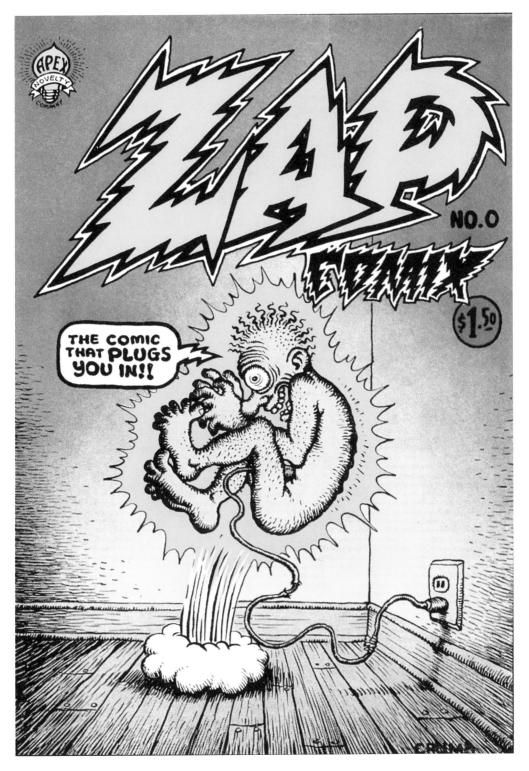

249

Figure 10. R. Crumb, cover of *Zap*, no. 0 (1968).

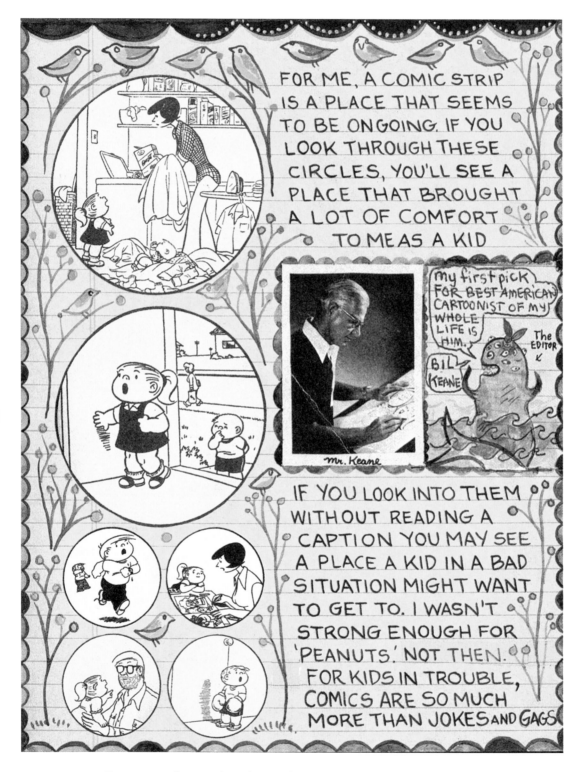

Figure 11. Lynda Barry, from the introduction to *Best American Comics* (2008).

AUDIENCE MEMBER: Sometimes I feel like that because nobody reads the paper anymore and you need a magnifying glass to read it. But I wondered if any of you read the dailies and are there any that you like now? Because I think there is still some good stuff coming out.

CRUMB: Like what?

AUDIENCE MEMBER: *Pearls Before Swine.*

CRUMB: Don't know it.

PANTER: It is a destroyed form.

CRUMB: The only one that I know of at all that's any good is *Zippy*. It is bleak out there.

AUDIENCE MEMBER: There is some creative stuff. You have to look really hard. In France are there daily strips?

CRUMB: No. It is not a French tradition.

AUDIENCE MEMBER: I wondered. Anybody else read any dailies?

CRUMB: *Rex Morgan, MD*, does that still exist?

BARRY: *Mark Trail.*

CRUMB: *Mary Worth?*

PANTER: It used to be a magic carpet. You used to lie on your stomach and fly around on that thing. But no more. You have to fly around on a Kindle now. *[laughter]*

CRUMB: Bill Griffith said he thinks they just put them in there to reassure people that life goes on and things don't change that much. They just want to see them in there. They don't want to read them, necessarily. Oh, the comics, it goes along. It is comforting.

BRUNETTI: Actually, I was going to say the computer—all that stuff could revitalize that form because you could get it on your iPad and [it would] actually be bigger on your iPad than in the newspaper and you could do something interesting as a daily strip.

CRUMB: Yeah, it is a good form, the four-panel strip.

BRUNETTI: But the newspaper is not where it is going to happen.

AUDIENCE MEMBER: This is somewhat specifically for Crumb. I know that most of what you did you wrote yourself. But I was curious if you would talk about working with Harvey Pekar, him writing for you, maybe talk about your friendship with him?

CRUMB: I also collaborate with my wife, Aline. We do comics together, that works out really well. With Pekar, he was a comic reader so even though he didn't draw he understood how to write comics. The pacing and all that. He was good at that. I drew a couple strips for him in the beginning and he got really jazzed about becoming a comic writer. Then for the next fifteen years he just would call me up and browbeat me to draw these comics. *[laughter]* "Crumb, when are you going to draw those strip ideas I sent you?" He would send these layouts with the

dialogue and everything and then these little stick men. He couldn't draw. They were good. Good stories he wrote.

BRUNETTI: Did you feel you got something out of those collaborations that changed the way you cartoon?

CRUMB: I don't think it changed the way I cartooned, but once I got into them they were enjoyable to draw because the stories were good. They were about real life. Little Yiddish vignettes in real life. They weren't in Yiddish but he was kind of in that tradition.

AUDIENCE MEMBER: You guys talked a lot about, as one gets older, drawing is something that happens less. I was just wondering from all of you, what advice would you give people to not get distracted by the discouragement of the world to draw?

BRUNETTI: Well, drawing slows down time, I think we talked about that. You'll remember a lot more things than even writing. If you stop and draw, you'll remember all the stuff that you wouldn't otherwise.

CRUMB: Yeah, it is like a diary.

BARRY: And there is something about doing stuff with your hands.

PANTER: Being a producer rather than a consumer is a good thing, I think. Because we're just passively being bombarded with bullshit every second of our lives now. People forget who they are. Drawing—I would just encourage people to understand that everyone who draws suffers a bit. Everyone doesn't go, I am incredible! You are there, you're living and you are suffering and so everyone suffers and has their pain. So kind of, like, get on with it.

CRUMB: Or you can take up the banjo.

PANTER: Yeah, a musical instrument is a comforting thing to hold.

BARRY: There is a lot of similarity, though, in that. Drawing and using a banjo.

AUDIENCE MEMBER: I'm curious if you guys can talk about drawing from life. I've seen a lot of your sketchbooks. I'm interested where it fits in with the cartooning. Talking about calligraphy and everything—

CRUMB: Salvador Dali said drawing from life is the essence of art.

BRUNETTI: For me, it's all blind contour drawing. I'm trying to get back into drawing, because, like I said, I have kind of stopped looking at things, and it is all this very internal world.

CRUMB: Kandinsky stuff, yeah.

BRUNETTI: It is all like geometry [for me]. I get worried with the cartooning book that people think I am trying to tell them to draw like that. I never say that. Everyone should find their own way of getting things on paper. But I think if you don't start with drawing from life—I mean, at some point you've got to do that. Even if it comes out terrible. Actually those are usually really interesting draw-

251

ings when people are trying really hard.

CRUMB: Yeah, absolutely.

BRUNETTI: That's where people's style is, if they would just see it and embrace it. That's also part of what I try to teach people.

To cartoon you do need to make a mental map of everything. You are not going to have that unless at some point you started to look at things closely and, I mean, you can try to use your memory, but if you can get things on paper it is going to help you remember them. Like the texture of this tablecloth or the folds.

PANTER: One good trick from me if I'm drawing from life, drawing in a sketchbook, is to imagine a cross on everything. Not with Jesus on it. But—*[laughter]*. Divide the room in quadrants, and you start in the center and you kind of figure out where the edges are, and you can have some—then you've kind of positioned your point of view.

CRUMB: Wow. Amazing. Incredible.

PANTER: Or you could start in the corner and keep going.

CRUMB: You start with a cross?

PANTER: Yeah, if I was trying to draw this audience I would.

BRUNETTI: That's composing and designing at the same time that you're drawing.

PANTER: It takes a little insecurity out of it for me.

BARRY: But speaking of drawing, during 9/11 when the buildings were hit, you were in Brooklyn on the roof, and you drew. You drew them. You can see these sketches, you can watch the whole thing happen. I saw lots of images [of 9/11], but this idea, it was of real time…

PANTER: It was the shakiest drawing I ever drew.

CRUMB: Holy shit!

BARRY: He didn't even know what was happening. He said, "I must draw this."

PANTER: It is like, "Okay you are going to die in a minute, what do you want to do?" I'm going to draw.

CRUMB: Go out drawing.

PANTER: Draw for a minute, and scream for a minute. *[laughter]*

WALKER: But you did a suite of drawings of Waco, Texas, the Branch Davidians. It looked like around ten drawings, but you seem to follow the events as they were unfolding.[2]

PANTER: Art and Françoise were involved in *The New Yorker*, so they were involved in sending me to Waco, where I could function, 'cause I was in Texas—if I was anywhere but Texas, I wouldn't have been able to do it. So I did about fifty or sixty drawings in my sketchbook.

252

2. See Gary Panter, "Waiting for Waco," *New Yorker* April 19, 1993.

They were edited down. I took slides and went home and projected them on the wall and sat and drew them as if I was there drawing. That was another way. Talk to drunks on hills. "Well, they could have arrested him at the bar every night. He goes to the same bar, they could have arrested Koresh there." That's what the guy said. They didn't understand why it was happening, really. It was a longish story. It was very interesting.

WALKER: But is it interesting as a form of reportage?

PANTER: You have to be brave to go some places. Joe Sacco—I would never go to places like he goes to. I can go to Oklahoma and Texas. Those are frightening places, but I know how to function there.

CRUMB: Go like ten blocks from here—

PANTER: The world is out there. The world is horrifying. And wonderful.

CRUMB: You have to be pretty brave.

AUDIENCE MEMBER: Has doing comics impacted your relationships to your families at all?

PANTER: My father was very disturbed by my drawings. He told me to go get a job and he secretly arranged for my Wednesday night Bible teacher to offer me a job at the funeral home. To try to scare me straight.

CRUMB: Oh, boy.

PANTER: That didn't really work.

CRUMB: That didn't work out?

PANTER: No. Dressing corpses doesn't make life seem nicer.

CRUMB: That's sort of punk rock.

PANTER: I threw my shovel down one day and walked off the set. *[laughter]*

CRUMB: My father stopped speaking to me when he first saw *Big Ass Comics*. Somebody he worked for showed it to him and said, did your son draw this? He didn't speak to me for ten years after that.

BRUNETTI: I got disowned after my first issue, which I would have never shown my father. But my ex-wife—I don't know what happened. Somehow he insisted on seeing it. And then a week later, disowned for quite a while. But I have learned to just not ever mention anything that I do. That works out better.

PANTER: Our families aren't our target audience, probably.

WALKER: But it's interesting, the relationship with the drawing and immediacy and that inner world and drawing and disclosure.

CRUMB: Full disclosure.

BARRY: I have never had the problem of dealing with family issues because they never look at anything I do. I haven't talked to my mom in a really long time. She can't

find me and she's not looking. And I know people are like, oh, that's so sad. It's like if you met her you would know I'm free! So I'm really free and it is wonderful. But I remember, at one point, I think my brother had one of my comic books and it was on the kitchen table and she looked at it, and she's from the Philippines, and she said *[in accent]* "My God, Lynda, doesn't your hand ever get tired?" That is the entire comment that she's ever had about my work. It is not my hand that's getting tired, mom. I'm getting very tired of you.

CRUMB: You don't look Filipina.

BARRY: It's 'cause I'm a quarter Norwegian. Norwegian blood can suck the color out of anything. *[laughter]* My grandma is from the Philippines. My grandma, she actually was a big influence on me, because Filipinos, their idea of child discipline is stuff like: "You know, Lynda, there is a vampire in the Philippines called the aswang. It's a beautiful lady, but at night she takes off her legs—she comes flying in the air! She comes flying to our house. You know when you see the TV jumping, she's on the antenna. She comes in the house. She comes in the window. She's crawling on the ceiling. She comes to your room. She is above your bed. She has a long tongue which is sharp like a needle comes down to suck your blood. Because you don't pick up your clothes!" *[applause]*

CRUMB: Obviously a big influence on you.

BARRY: It was an influence. That was my kind of child discipline. Instead of, just pick up your clothes. Why should I wash the dishes? You know, God has made a castle for you in heaven. Of bricks. Every time you are bad, he takes one away. Your castle is getting very small. Do the dishes.

CRUMB: What religion were they?

BARRY: Catholic. Catholic. Catholic with vampires.

SETH: I have a question for Gary. Your list of influences is all over the place, kind of like high art, low art, you are talking about how you like bad printing. But a minute ago you also said the world is full of all kinds of terrible shit. What is your filter? What are you deciding what is good and bad? Is everything okay? Or is there an actual grading system?

PANTER: I don't know, gee whiz! There are some things I'm instinctively drawn to—it's like okay, you are on earth. You are going to die quickly. You look around and you try to find something to react to. I am interested in the peculiar ends of things. Those are striking things. Somehow I'm trying to make a hieroglyph of humanity. And what we're leaving behind us. And how we define ourselves. Show girls and muscle men. And so on. It is all absurd and crazy.

SETH: Does it all equal out, though? Is The Hairy Who better than Jack Kirby? Or is it all on the same scale?

PANTER: Oh no, it is all fodder, really. I think as an artist, if you are trying to have a style you can be very frustrated. But a style will catch up with you. But the more influences,

and the more things you absorb, the more likely there is going to be some output from it. I'm really interested in hybridizing, like what if we took Jack Kirby and mixed him with David Hockney, what would you get? Or if you took Jefferson Machamer and mixed it with Karl Wirsum what would you get?

CRUMB: Gary Panter.

PANTER: Gary Panter. That's exactly right. Then people think I brought something into the world, but I didn't.

AUDIENCE MEMBER: I would like to go back to the daily strip, newspaper strip, and just give a shout out for Kaz's *Underworld*. He's the Bushmiller of today. The other thing I wanted to say there is a new hot thing right now going on with artists editions. Mr. Crumb, I don't know if anybody has asked you if you would do an artist edition where your original art is photographed instead of just printed—

CRUMB: I don't go that way. *[laughter]* That's pretentious. I don't want them to see all my whiteout and shit. I really love that about printing, conventional printing where you don't see all that. All that kind of corrections and all that stuff. It is all cleaned up and everything. I like that. I'm very traditional that way. I like nice registration. *[laughter]* I always strove for as professional-looking as I possibly could. That's the way I am. That's the way I grew up on the whole thing.

AUDIENCE MEMBER: I really enjoy your early blues influence poster, and now you have the jazz influence poster, Mr. Crumb. I was wondering if you were going to make an early rock and roll influence-type poster?

CRUMB: I don't go that way. *[laughter]*

AUDIENCE MEMBER: I didn't think so. Thank you just the same.

CRUMB: I hate rock and roll.

KOMINSKY-CRUMB *[from the audience]*: You like early rock and roll.

CRUMB: Some of the 1950s stuff I like, yeah. When it was still proletarian I kind of liked it. Once the middle class got into it, it was the kiss of death to rock and roll. The late 1960s and all that. The last great rock and roll band to me was Tommy James and the Shondells. "My baby does the hanky panky."

BARRY *[singing]*: Crimson and clover over and over.

CRUMB: The only really good psychedelic song. All those guys with those noodling endless psychedelic guitar solos, God, just put me to sleep. I don't want my ears to bleed, I really don't.

AUDIENCE MEMBER: This question is for Lynda and Ivan. I know both of you have taught. I wonder if you can explain the role of encouragement and maybe also discouragement.

CRUMB: That's a good question.

BRUNETTI: I've never discouraged anyone. Whatever they are doing, I just want them to do it better. Even if it is stuff

253

I don't like, I say, you should look at this artist. You need to start looking at the better artist in that genre. And I'll try to suggest something. There is a lot of resistance to that. I think people mostly just want to have somebody pat them on the head and tell them they are okay.

CRUMB: That's pathetic! Could you ask them, what are you doing here? Why are you in this class?

BRUNETTI: That one I ask all the time. If you are going to school to study art, that's pretty lucky. People complaining about having to draw in their sketchbook—they are going to art school. When you get to my age you will *pray* that you have time to draw in a sketchbook.

PANTER: What do you do when you say, draw that, try that again, and they say, "I'll tweak it in Photoshop later"?

BRUNETTI: Don't get me started. This is the danger of the computer. The thing that people think is great with it is that you can erase every line and make it perfect. I think that's the worst thing. You need to see your mistakes. You need to see how your drawing is forming. If you can endlessly erase something, the bad thing is that that just makes you put something on paper that's already in your head and there is never a risk. You are just illustrating what's already there. You are never open to where else it can go. So you need to make mistakes. And you need to lose control of the tool. Then try to learn how to regain it in some way. I can't figure out how to make people do that on the computer, other than, like, take out the Apple-Z keys, or whatever. Don't do that. Just leave it.

CRUMB: That's good. That was interesting.

BARRY: When I went to college I had a teacher who was very influential, who is still actually a friend of mine. She started out by asking this one question which is: what is an image? I've been following that—that question has kind of guided my life. Where it has guided me to now is neuroscience. And also I am convinced that this drawing and the thing we call the arts has an absolute biological function. We wouldn't have hauled it with us through all our evolutionary stages if it didn't. And what is interesting is how right now it is treated as an elective or some kind of side thing. And I think it is like saying your kidneys are an elective. They are not so cute. And I would be thinner without them. Let's just ditch them. I can't figure out... Remember there was that term "junk DNA" for a while? What a pompous thing to say, "junk DNA."

So for my students, I reframe it as, if this thing has a biological function, what is it? When I was teaching I did some things that I learned from my teacher. She said that

everything we call the arts contains an image. Toys that kids get attached to also contain this thing called an image. The easiest way to explain it is—the blankie is the first artwork. It is just like a piece of canvas. But there is a person in there. A personality that somebody made.

I believe that stories, even though they are different forms, are hard wired. Alison Bechdel was talking about Winnicott. He is also a big guy for me. I started to get interested in these objects people carry around. Like I saw a kid walking through the airport; he had an Incredible Hulk doll but all he had left was the leg. "The leg is all I need, man!" So D.W. Winnicott, this British psychoanalyst, amazing guy, he invented this thing—well he didn't invent it, we all do it—called the Squiggle Game. You all did it. Where you are bored and you draw a scribble and you pass it to your friend and they turn it into something and they draw a scribble and pass it back. If do you this with a kid, you'll get a story pretty quick.

AUDIENCE MEMBER: My question is for Lynda Barry. I've been a longtime fan and really loved the *Picture This* book. I'm curious as why you decided to use a monkey to talk about the drawing process?

BARRY: Kind of look like a monkey. *[laughter]* Everybody loves a fucking monkey. Especially a smoking monkey. Everybody is happy—when you see a smoking monkey, your mood—it is the biological function actually. So, yeah, monkey, that's my little avatar. And it is really fun to draw. You know what? I had a friend who died really suddenly. Especially as you get older this happens, people die. I'm not going to. You guys for sure are. *[laughter]*

But there was this period where I couldn't draw after she died. And the first thing that I was able to draw was a monkey. Now I'm going to get all—it was the first thing I could stand to draw. I said I have to draw one hundred of them. And one hundred wasn't enough. Oh, I'll do a thousand. So I did: I drew one thousand monkeys. It got me through it. So the monkey has this—I guess it is my transitional object. My little Hulk's leg. And then I fucking look like a monkey, which is awesome. It works out.

CRUMB *[singing Clarence Williams's 1930 song]*: You're gonna look like a monkey when you get old. You're like a monkey when you get old. I can tell by your face you didn't come from the human race. You're gonna look like a monkey when you get old.

BARRY: Yes! *[applause]*

Comics as Media:
Afterword

W. J. T. Mitchell

When the idea first emerged to combine the proceedings of the 2012 Chicago "Comics: Philosophy and Practice" conference with a group of essays on questions of media, old and new, I admit that I was a bit skeptical. The comics artists are perfectly capable of speaking for themselves, even though they tend to speak in a language relatively unadorned by academic jargon: that is, the modest language of practitioners who like to practice their art more than they like to talk about it. So this collection of texts and comics is a kind of arranged marriage at two levels: first, the conference itself compelled an ongoing conversation between academics and artists, a conversation that was occasionally interrupted by muttering from the artists in the audience (most notably Robert Crumb) about "academic bullshit." Second, the proceedings have now been led into a marriage with the history and theory of media. What has emerged from this double marriage is the text before you. Will it have numerous offspring in the disciplines of media studies and comics studies? Will it be a happy marriage? Consider these remarks nothing but a kind of postceremonial blessing on one of the most adventurous and exciting projects that *Critical Inquiry* has undertaken in my thirty-six years as editor.

The big question, of course, is what precisely is the relation of comics and media? If this is an arranged marriage, who is the husband and who is the wife? Who is the top and who is the bottom? Crumb's cover, with its image of an odd couple applying for their marriage license, strikes me as the perfect picture of our situation. Should we think of comics as personified by the muscular drag queen or the slender youth? Who is the academic theorist and who is the comic artist? Crumb provides a wonderfully carnivalesque framework for thinking beyond our stereotypes, for opening a new world in which we no longer know the answers to all the predictable questions. Where do comics fit among the media, and what can the study of media tell us about comics? Is comics simply one medium among others, a minor medium to be placed well below painting, sculpture, photography, architecture, cin-

ema, and television—not to mention the new media associated with the invention of the computer? If so, what is its specific role and status among the media? Is there some kind of medium specificity to be identified, some essential character of the comics medium (for instance, its inevitable rootedness in the extremely old media of drawing and writing, or its technical pedigree in the very modern invention of the printing press and the rise of newspapers and magazines, or its contemporary articulation as a kind of bookish and materialist alternative to the dominance of virtuality and screen-based media)? Finally, what is the meaning of the historical coincidence between the rise of the new digital media and the emergence of comics as a newly "serious" medium of art, collected and exhibited by major museums, capable of taking on subjects such as the Holocaust or the genocide in Bosnia while engaging in vanguard experiments that reflect on the nature of comics themselves? When one looks at the work of the artists gathered for the Chicago symposium none of whom have ever bothered to depict superheroes), one feels that the medium and its practitioners have themselves entered a heroic phase. Comics and comics artists are now able to leap tall buildings at a single bound, especially all the old boundaries between art and mass culture, juvenile and adult forms of expression, generic distinctions between satire and autobiography, fiction and nonfiction, poetry and philosophy and history. Is there some sense in which contemporary comics are themselves a new medium, in the grip of radical innovations in form and content, technologies and genres?

We could put all this in simpler and more comics-appropriate form simply by inserting here the question that Art Spiegelman posed in his "keynote conversation" with me to open the comics conference:

WHAT THE @#&!* HAPPENED TO COMICS?

Of course Spiegelman's question is a historical one, interrogating the recent transformations in the status of comics. But there is also a more philosophical question, namely the question of ontology, or the being of comics, the essential specificity of comics as a medium:

255

WHAT THE @#&!* ARE COMICS?

One thing the philosophical question reveals immediately is a peculiar grammatical glitch in the word *comics*: is it or are they a singular or plural phenomenon?

WHAT THE @#&!* IS COMICS?

Like the concepts of medium and media, more generally, comic and comics seem to want it all. That is, we speak of a comic book (a singular totality composed of multiple pages, frames, panels, and images) but of a comics page (plural name for a singular element of a book). In writing about this curious singular/plurality in the case of media, Mark Hansen and I came to the following conclusion: "What is to be understood is not media in the plural" (that is, the empirical listing of the many different types of media) "but media in the singular . . . which is to say, by reconceptualizing understanding from the perspective of media."[1] If we substitute the word *comics* for *media* in this statement, we come up with the aim of this volume, and this afterword: to reconceptualize understanding, not just of comics or of media, but of the world as such, from the perspective of comics understood as a singular plurality (or should we say a plural singularity?).[2]

But what is the perspective of comics? Is it the point of view of comics artists? Or is it something impersonal, built into the very structure of comics as a medium? How can an impersonal system have a perspective? Is there a comic view of the world? Put this way, the question makes a kind of sense and resonates well with the abundance of humor that flowed through this conference and that characterizes so much of the work of the artists who participated. If the cartoon as visual joke, as graphic one-liner, is a kind of molecular unit of comics, then it seems that satire, parody, caricature, and clowning, along with the merry (and sometimes savage) playing with stereotypes, the reduction of individuals to abstract, general formulas, must be central to the perspective of comics. But we know that this isn't all there is to it; not all comics are comical. They range over the infinite variety of genres: romance to tragedy, history to biography, autobiography to apocalyp-

tic and epic stories. If stereotyping is indeed fundamental to comics, it need not be funny; it can be vicious, heroic, pornographic, allegorical, or statistical, ranging from animal caricature to the isotypes of Otto Neurath and the logical positivists (fig. 1).

And this leads us to notice a certain confusion of genre and medium in the word *comics* itself.[3] On the one hand, it suggests a certain plot type and particular sorts of characters. Comedy classically involves low, ridiculous characters, stereotypes, caricatures, or, at best, low mimetic realism—characters who are no better than us.[4] On the other hand, comics are graphic discourses, combining words and images, writing and drawing to communicate meaning. As a medium, as graphic discourse, comics can be applied to any genre of narrative or discourse; one can write a letter, philosophize, describe a procedure, or tell a story. Does comics name the content? Or the form?

The divided identity of comics as genre and/or medium came up recently in the comic

Figure 1. Otto Neurath, *Isotypes.*

adaptation by Ryan Alexander-Tanner of Bill Ayers's autobiographical account of his career in education, *To Teach* (fig. 2). Ayers is expressing concern that comics are "not a genre that a lot of folks are familiar with," whereupon the comic artist leaps out of his chair exclaiming "*ROMANCE IS A GENRE. COMICS ARE A MEDIUM,* LIKE MOVIES OR NOVELS." Ayers accepts that he is being schooled in a subject to which he had given little thought. He and Alexander-Tanner quickly begin levitating, reflecting on the "dazzling dance of the dialectic" between words and pictures, constructing a palace of imaginary bricks that begin to float, along with Ayers himself, in an airborne chair. In the midst of their enthusiasm they are interrupted by Bill's spouse, Bernardine Dohrn, who looks at a sample page of the comic-in-progress, and pays a compliment: "Wow, this is great. You guys are going to introduce a whole new audience to this genre." Bill and Ryan promptly set her straight: "*IT'S NOT A GENRE!*" The unimpressed Bernardine replies: "Oh, please. Get over yourselves" (fig. 3).[5]

So is this the last word? Who cares if "comics" is sin-

1. W. J. T. Mitchell and Mark B. N. Hansen, introduction to *Critical Terms for Media Studies*, ed. Mitchell and Hansen (Chicago, 2010), p. xxii.

2. Compare Jean-Luc Nancy's concept of the self as a singular plurality in *Being Singular Plural*, trans. Robert D. Richardson and Anne E. O'Byrne (Stanford, Calif., 2000).

3. The *OED* tells us that "comic" singular is "of, proper, or belonging to comedy . . . as distinguished from tragedy." In the plural, it denotes "the comic strips in a newspaper" (*Oxford English Dictionary*, s. v. "comic"). See Robert C. Harvey, "Describing and Discarding 'Comics' as an Impotent Act of Philosophical Rigor," in *Comics as Philosophy*, ed Jeff McLaughlin (Jackson, Miss., 2007), pp. 14–26.

4. I am following here Northrop Frye's classic theory of narrative modes from *Anatomy of Criticism: Four Essays* (Princeton, N.J., 1957).

5. Ryan Alexander-Tanner and Ayers, *To Teach: The Journey, in Comics* (New York, 2011), p. 15. This is a "translation" into comics of Ayers, *To Teach: The Journey of a Teacher* (New York, 2010).

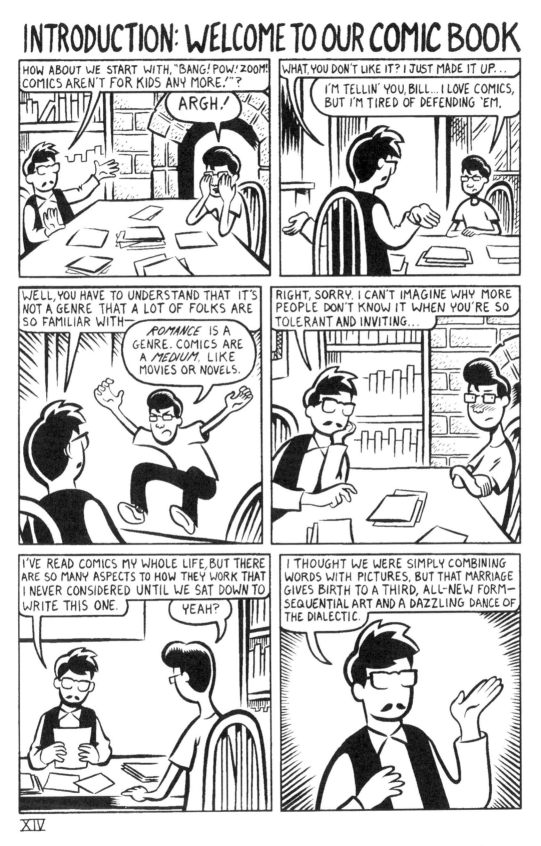

Figure 2. William Ayers and Ryan Alexander-Tanner, *To Teach: The Journey, in Comics* (2011).

258

Figure 3. William Ayers and Ryan Alexander-Tanner, *To Teach: The Journey, in Comics* (2011).

IN LATE MIDDLE-AGE SPIEGELMAN STILL TRIES TO LEARN HOW TO WALK THE LINE....

3/24/07

259

Figure 4. Art Spiegelman, . . . *Spiegelman Still Tries to Learn to Walk the Line.*

gular or plural, a medium or a genre? What is at stake? Well, in some straightforward sense, nothing much. Bernardine is right. The important thing is the "whole new audience" that may come to comics (whoever they are), not what they are called. I am not much interested in drawing boundaries around comics and defining their medium specificity (which in any case would be highly subject to historical variation). From the standpoint of comics as philosophy, in the framework of media theory, and of the being or ontology of comics, comics is a transmedium, moving across all boundaries of performance, representation, reproduction, and inscription to find new audiences, new subjects, and new forms of expression. Comics is transmediatic because it is translatable and transitional, mutating before our eyes into unexpected new forms. The comics artist draws and walks a line of style that is grounded in his or her predecessors, but ventures out over an abyss of possibility like Spiegelman the tightrope walker (fig. 4). Here the pillars of style are the turdlike masses of Crumb on the verso and the typographic abstractions of Steinberg on the recto. Spiegelman teeters, trying to maintain his balance at the fold

between verso and recto, sinister physicality and cerebral rectitude. The tightrope is, appropriately enough, not tethered to the right-hand support, but floats free in a vortex or spiral line—the signature of the artist since Apelles and Hogarth, the sign of transformation and empathetic doodling (fig. 5).[6]

Comics is also transmediatic because it opens audiences onto a deep history that goes back before mass media, perhaps even before writing and drawing, to the fundamental moment of the mark, the graphic sign. Comics is transmediatic in its openness to multiple alternative frameworks in terms of style, form, structure, material support and technical platform. Any audiovisual medium involving language, speech, writing, music, photography, cinema, architecture, painting, dance, and theater is fair game for representation, remediation, and incorporation in comics. Any represented content, from voice to thought to feeling to bodily motion to figure/ground relations, may be seen and read on the comics page. And the page itself is only one, albeit central, material support for graphic discourse: stone and sand, paint and plaster, woven fabrics, wax tablets, wood panels, story boards,

6. See my conversation above with Spiegelman on the line of beauty in Hogarth. See also my essay, "Metamorphoses of the Vortex: Hogarth, Turner and, Blake," in *Articulate Images: The Sister Arts from Hogarth to Tennyson*, ed. Richard Wendorf (Minneapolis, 1983), pp. 125–68, for a discussion of the spiral form in the graphic arts.

Figure 5. William Hogarth, *Line of Grace.*

shadows and screens, actual and virtual images, tactile and projected images. This is why Ayers and Alexander-Tanner, despite their pedantry about comics as medium and not genre, are right to begin floating in the air as they contemplate the dizzying dialectics of comics as transmedia, a form of transport to the possible and the impossible. What will happen when the optical/tactile, eye/hand character of comics comes full circle to the touch screen as a place for both drawing/writing and reading/looking?

Trans- is only one among the many prefixes that must be attached to media in order to do justice to comics. They are also, as everyone knows, *multi-*, *inter-*, and *meta-*, which can reflect on their own conventions,[7] paramedia that parody other media (think of *Mad Magazine*'s wonderful riffs on movies). McLuhan declared them to be cool media because of their typically low resolution and insistence on readerly participation, but they can be just as hot as you please when they incorporate hi-res images, when Joe Sacco faithfully records every stitch in the frayed sweater of a Palestinian, or Alison Bechdel scrupulously transcribes the journals and letters of her father. And no matter how rigorously they try to purify themselves as, for instance, in Lynd Ward's novels without words, they fall back into some sort of impure mixture.[8]

Which is why Spiegelman's term *co-mix* is an attractive alternative to comics. It is a hybrid term for the mixture of media and genre named by comics. And if one looks at the word from the perspective of comics, one can imagine all the *co*'s that might go into the mix: coordination, cooptation, coincidence, collision, cooperation, comingling of words and images, sound and sight. And then there are the *coms* and *cons* that might be linked to *-ics* and the whole icky character of comics as vulgar confections of schematic abstract forms and fleshy chicken fat—comparable, compatible, comfortable, companionable forms, on the one hand, and convergence, conflict, contradiction, and con games, on the other. Co-mix foregrounds the comics' tendency to treat words as visual elements, the look of letters as graphic signs, trading in an eye for an ear, as McLuhan put it. It applies to both the generic and mediatic sides of the question and shows the place where genres and media become confused, defying any singular identity confined to their specific history in mass print media, while simultaneously remembering that history, keeping it alive in the homonym, the sound-pun of comics/co-mix.

So (no big surprise) the worldview of comics/comix is defiantly resistant to medium specificity, much less the "purity" of media imagined in the modernist aesthetics of Clement Greenberg. As media, comics are more like cinema and the computer, capable of remediating every other medium. They are a transmedium that, in contrast to the modern media, maintain a direct link to the most primitive forms of mark-making, from cave-painting to hieroglyphics. When the electrical generators are stilled and all the lights go out, comics will still be possible—and necessary.

People have often asked me why I haven't written very much about comics, given my long-standing interest in the relation of words and images, verbal and visual culture, and composite image-text forms like William Blake's illuminated books, photographic essays, ekphrasis, ut pictura poesis, the sister arts tradition, comparative arts and emblem books, and (best of all) *Mad Magazine*. Perhaps the answer is now obvious. I simply had nothing new to say on the subject. Compared to comics scholars who have spent their lives studying the medium, my knowledge of their history is very patchy. So until the University of Chicago conference on comics in May 2012, I had successfully avoided a direct encounter with comics. I had always read comics in a casual, rather unfocussed way, routinely using cartoons to illustrate philosophical points or (better) to show how pictures theorize themselves in a genre I call metapictures.[9] The closest I have come to engaging comics directly was in *The Last Dinosaur Book*, where my aim was to track down a fabulous modern animal from its birth in the nineteenth century through its 150-year career as a superstar in a number of media, including, but not exclusively, comics. So Gary Larson, Bill Watterson, and a variety of cartoonists in *The New Yorker* and other venues provided a backdrop to the main story of the dinosaur's history on the movie screen, from Winsor McCay to Steven Spielberg.

But there was another reason that I had never wanted to look directly or systematically at comics as a medium. I did not want to defile the sources of my own inspiration as a critic and theorist. Comics have been for me a kind of secret garden, a slightly guilty pleasure, something to be protected from my own professional commitments as a philosopher of the image, an iconologist, and a (not-too) serious art historian. But Hillary Chute and Patrick Jagoda, the editors of the present volume, have now forced me to come out of the closet, Hillary by convening this historic conference on comics at the University of Chicago and Patrick by joining with her to consider the relation of comics to the larger sphere of media, both old and new.

And there was, finally, a much more personal reason that the comics medium forced itself on my attention at this time. Among the persons attending the conference was my son, Gabriel Mitchell, and his friend the talented young comic artist Nate McClennen, who came from New York to stay with us. (Here is a photograph I took of them

260

7. See Scott McCloud, *Understanding Comics* (Northhampton, Mass., 1993).

8. Ward produced a magnificent series of graphic "wordless novels" between 1929 and 1937.

9. See Mitchell, "Metapictures," *Picture Theory: Essays on Verbal and Visual Representation* (Chicago, 1994), pp. 35–82.

Figure 6. Nathaniel McClennen and Gabriel Mitchell.
Photo: W. J. T. Mitchell.

Figure 7. Nathaniel McClennen, untitled drawing.

Figure 8. Gabriel Mitchell. Photo: W. J. T. Mitchell.

261

on the bus that carried all the artists to the conference at the Logan Center) (fig. 6).

The star-struck young men hung out with the artists, devoured their conversations and slide shows, and pored over the fabulous collections of comics and illustrated books mounted by the Regenstein library's rare book collection. Nate filled his notebooks with drawings, and Gabriel schmoozed with the artists and scholars in attendance.

Little did I know at the time I took this photo that Gabriel only had one month to live. His twenty-year struggle with schizophrenia ended on 24 June 2012, when he died in a fall from his sixtieth-floor apartment in Marina City, Chicago. Gabe's death at age thirty-eight was the deepest trauma of my life. I have written about him elsewhere,[10] about his heroic struggle with this terrible mental illness, but I had not been quite prepared for the outpouring of love and creativity that his short life provoked. Poems, long letters, gifts, even sculptural works poured in from his many friends and relatives. And then came two works from the hand of Nate McClennen: a drawing (fig. 7) of him and Gabe playing a cosmic game of checkers, based on my photo of them riding the bus and the memorial card made for Gabriel's wake (fig. 8), a glamorous shot of him at the New Jersey shore in the summer of 2011; and a comic thank-you note to me for hosting him during the conference (fig. 9).

The drawing shows Nate and Gabe side by side, as a checkers team, playing against an opponent with a crescent moon for a head. But rather than gesture toward the board, the lunar man is gesturing toward a ladder that would take us to another space, beneath the frame, perhaps to another kind of game. Nate and Gabe have their respective totem figures riding on the backs of their heads: a schematic rabbit and a solar deity. But hovering next to them are the traces of a spectral face, a portrait sketch of the departed Gabe, based on the photograph that appeared on his funeral card. His totem figure, sitting on the edge of his hat, is Saturn gesturing toward a serpentine trail of ascending smoke, linking the traditional personification of melancholia with Gabe's departing spirit.

Nate's comic letter was an amazing gift to me at a time when, on every side, people were uttering the tru-

10. See Mitchell, "An Artist's Struggle," *Chicago Tribune*, 17 July 2012; see also Gabriel's website, Philmworx.com, philmworx.com/philmworx.com/Post-lude__Chicago_Tribune.html

Figure 9. Nathaniel McClennen, *Thank-you Note to W. J. T. Mitchell.*

ism: words are meaningless at a time like this. Actually the truth is that words are all we have at a time like this, and they are why we have poetry. And art. And comics. Even clichés—including the trope of *occupatio* (for example, words are useless)—are just fine when spoken at the right moment with the right tone. The meaninglessness of words in a time of unimaginable, unspeakable sorrow is also what demands the production of words and images, especially words and images of and about the departed.

Nate's thank-you note to me for hosting him at the comics conference takes the form of a comics page, a labyrinthine composition that begins by saying "I thought this was going to be a normal type . . . of thank you type note for all of your hospitality" and ends with a call to the dead Gabriel's spirit, sketched from his funerary photo. In between is a maze of reflections on the experience of a young artist immersed in the "World of Cartoons," listening to the "talk talk talk" endemic to conferences, basking in the glory of Spiegelman, Chris Ware, Seth, and Sacco, and preparing to pitch his idea that Mesoamerican images are the next phase of comics. What was going to be a conventional thank-you note has turned into a wailing call to a fallen artist, a fellow player of the game of life. And it has turned into a comic.

What can we learn about the present state of comics from McClennen's thank-you note? Certainly it exemplifies the highly personal and expressive character of much contemporary comics artistry; Spiegelman, Phoebe Gloeckner, Justin Green, Lynda Barry, Aline Kominsky-Crumb, and Alison Bechdel all deal with personal trauma, and (as Chute argues) autobiography rather than mythic exploits of superheroes has become central to the most innovative, experimental work in comics (the comic superheros, it seems to me, have now found their primary home in movies). Even relatively cold and impersonal genres like journalism and history are inflected, as in the work of Sacco, by the highly visible engagement of the artist as witness and narrator.

The second point is the permeability of the comics page to all other forms of media, old and new, the transmedia dimension of comics. Nate's composition is built upon my photographs, translated and transformed into surprising new images. A great deal of ink has been spilled trying to provide a firm definition of the comics medium, most of it coming down to what Robert Harvey rightly calls "an impotent act of philosophical rigor" in his article by that title.[11] Again, I have no wish to add to the rigor mortis of definition. In fact, my aim has been precisely the opposite, namely to open comics to the world of transmedia, and to ponder comics as a media platform that, like the computer, can host every form of mediation. The main difference between these two platforms is that computers provide a mechanical-electronic platform via a screen interface whereas comics offer a manual-neurological platform via the page interface.

Figure 10.

Nate's thank-you note also disrupts one of the favorite truisms of comics scholarship about the nature of the medium, namely, that it is inherently defined by a narrative, sequential logic. The emergence of a strong tradition of nonfiction autobiographical comics has displaced the formerly fashionable graphic novel as the respectable moniker for comics with the more general term *graphic narrative*. But if we are to accommodate McClennen (and many others) we will need to expand the term even further, as I have been suggesting, to include graphic discourse. Nate's comic is a letter, a thank-you note, and not (despite the numbers that provide a key to its sequential reading) a narrative. Could it be the harbinger of a whole new genre of graphic epistles? Is there an epistolary novel waiting in the wings of comics? And what about philosophy? What would it mean to do philosophy, to theorize in comics, not just about them?

The only way I know to grasp the intricacy of Nate's thank-you note is to perform a "too-close" reading of it, tracing and retracing it as a garden of forking paths adorned with nested patches of graphic foliage.[12] A verbal-visual reading, as Spiegelman puts it, "to the sound of a dripping faucet."[13] So we begin at the beginning, with the number 1, and the eye of a schematic bunny (Nate's self-portrait) looking at the "I thought" he has just written (fig. 10).

The overlapping panels on which the note has been inscribed are framed by figures drawn from Mayan iconography, who seem to "hand deliver" the note with their outstretched, hieroglyphically tattooed arms. Inside the third nested panel another Mayan figure utters the crucial words of a conventional thank-you note, the direct object of gratitude, namely, "your hospitality!" But as we have skated over the panels in which this first sentence appears, we notice that the words "this was going to be a normal type thank you type note for all of" have appeared in voice balloons whose speakers have been concealed by the panels themselves. Moreover, the first panel's voice bal-

263

11. See Harvey, "Describing and Discarding 'Comics' as an Impotent Act of Philosophical Rigor."

12. The concept of too-close reading is indebted to D. A. Miller, *Jane Austen, or The Secret of Style* (Princeton, N.J., 2003); see also the critical appreciation of its methods by Frances Ferguson, forthcoming in *Critical Inquiry*.

13. Art Spiegelman, "Don't Get Around Much Anymore," www.slate.com/blogs/browbeat/2011/10/05/art_spiegelman_before_maus.html

Figure 11.

Figure 12.

Figure 13.

loon contains some words that do not fit with the straight-forward message: "off" and "err" appear as a kind of visual stuttering that might be fragments of longer words (a mis-spelled "offerring" that signals its own error?). The over-lapping frames, moreover, suggest a reaching out to the medium of the touch screen, which would permit us to peel back the frames, treating what we used to call the gutters of comic narration as something like live, flex-ible wires, sensitive to the brushing touch of the reader/viewer's finger.

What path do we take next? Do we jump directly to number 2, where the hospitality is spelled out? A thank you "for thinking of inspiring and offering me this unique awe-some glimpse into this → world of cartoons"? Or do we go back to the beginning, to the "thought" that trails off into another visual stutter of "T, T, T, T, t, t" in a graphic dimin-uendo of plus signs (+++) that comes to rest in the brain of a schematic fisherman, with the bait of love suspended from his line (fig. 11)? This fisherman is, we notice, himself nested inside the brain of a waiter,[14] whose arm supports a bloody napkin and the image of the rabbit-artist with a Mayan diagram tattooed on his tummy.

And from here it is smooth sailing. We plunge into the "talk talk talk" of the comics conference, with adoring Mayans clustered around the chain-smoking ART who (unsurprisingly) personifies the ART that everyone has come to celebrate (fig. 12). We are then led into number 3, a sidebar in which Nate thinks about pitching his idea for Mesoamerican comics employing Mayan writing and iconography, only to hear Sacco talking about building on this influence in his "next comic." Which leads Nate to think—not say out loud—"Hey, that's my idea! LOL" (fig. 13). How does one "LOL" in thought? Is thought just inter-nal text-messaging? Free indirect discourse tells us what

the thought was, but comics shows and tells us at the same time, diagramming the plural singularity of the human subject thinking, hearing, and speaking in multiple direc-tions and modes.

Meanwhile Nate is thinking ahead to number 4, where he will confess his love for Ware and Seth and discover a "new kind of mark," a hieroglyph that combines the tri-angle, circle, and fork. This mark provides an abstract reduction of the spiritual body displayed in number 4, the final panel with its chakras linked in a "connected soul" portrayed by a painter whose hands twirl the signature spiraling empathetic doodle of the cartoon artist and whose eye has turned into a third arm/hand, wielding the paintbrush "artwise." Nate then promises to keep me, the addressee of this thank-you note, "updated" on what he does "f

Nate's thank you began with a thought, and ends with a promise. He heads off down the dark corridor that leads to an unknown future. His head seems to leave a zig-zag trace on the wall, like a trace of a heartbeat, or brain waves.

So far my analysis of Nate's comic has emphasized its multiple temporalities and alternative pathways through sequences of images and words. But there is another way of looking at this work that is specific, if not unique, to com-ics, and that is the possibility of seeing the whole thing as a unified, synchronic structure. Despite its lack of a salu-tation (there is no "Dear Tom"), the epistolary template of the page is evident from its opening announcement that it is a thank-you note to its closing "Love Nate" at the bottom. A quick scan of the numbers reveals that the

264

14. What looks like an 8 on the waiter's chest is, I am informed, supposed to be an infinity sign.

Figure 14.

entire composition is structured as a reversed S-curve, the formal cousin of the spiraling line that seems so endemic to the comics medium, the line of beauty and signage. Meanwhile, the panel structure defies the usual notion of frames and gutters as fixed elements in a determinate sequence. Panels overlap one another, reminding us of the cascade arrangement of windows in computers and touch-screen devices. Panels shift their orientation, tilting up/down coordinates by 90 degrees, as Nate maneuvers to make his Mesoamerican pitch. The boundaries of the human figures are similarly flexible, sometimes reaching across gutters from one frame to the next and sometimes turning into frames themselves, opening doorways into bodies (the puking baby with the aperture in his stomach) or the fisherman inside the head of the waiter. And throughout Nate makes generous use of chicken fat, piling on detail to slow down the sequential progress so that the dripping faucet may slow its tempo to nearly zero and we find ourselves pondering the meaning of "a new kind of mark." Narration comes to a full stop when Nate turns comic philosopher in panel 5, informing us that "though life and love are impermanent as the wind, the connected soul flows through all." The transitory and the eternal are emblazoned on his body in the cycle of chakras, a kind of schematic emblem of the way comics themselves are organized as a unified, yet internally differentiated body, playing upon temporal sequence and spatial synchronicity. Comics, in other words, are portrayed here as an expression of the "connected soul" and its immersion in "life and love"—here connected to others through the social medium of letter-writing, and internally connected by way of the synchronic array of panels suturing words and images, speech and bodies, selves and masks.

Finally, outside all the frames and panels is a tableau that summarizes the dialectic of the transitory and permanent, the sequential and the synchronic in this composition. A graphic postscript appears in which Nate has dropped the Mayan mask and shifted his address from me to the ghostly image of Gabe. Nate's naked, moony self is calling out to the spirit mask of his friend and fellow artist, "Gabeeeeeee." Is this a silent "e" or a wailing crescendo (fig. 14)?

Only in the singular plurality of comics can one see and dwell on this merging of silence and sound in quite this way. The true addressee of Nate's letter, absent from the opening salutation, is finally revealed. This letter has been addressed to the dead all along, revealed in the postscript to a letter that can never be delivered and that therefore stands as the afterimage of this afterword.

265

Contributors

Lynda Barry is a cartoonist, novelist, playwright, painter, and teacher. Her comics started appearing in the *Chicago Reader* in 1979. Barry is the author of eighteen books, including the "autobifictionalography" *One Hundred Demons* (2002) and the experimental comics-and-collage how-to book *What It Is* (2008), which won the Eisner Award for Best Reality Based Graphic Novel, as well as its companion *Picture This: The Near-Sighted Monkey Book* (2010). The latter two are based on her traveling workshop "Writing the Unthinkable," which is about innate and latent creativity and the relationship between images and memory. Previous works include the comics collections *Girls and Boys* (1981), *Down the Street* (1988), *Come Over, Come Over* (1990), and *It's So Magic* (1994); and the novels *Cruddy* (2000) and *The Good Times Are Killing Me* (1999), which was adapted as an off-Broadway play. Drawn & Quarterly is currently reissuing Barry's older backlist in new editions; the first of these is *Blabber Blabber Blabber-*Volume 1 of *Everything*, the series that will compile works from across her thirty-plus year career in American comics, beginning with her long-running syndicated weekly comic strip *Ernie Pook's Comeek*. In 2013, they republished *The Freddie Stories*. Barry is the editor of *The Best American Comics 2008* and is assistant professor of Interdisciplinary Creativity at the University of Wisconsin-Madison through the Wisconsin Institute for Discovery (WID) and the UW-Madison Department of Art.

On "Car and Batman":

> This is a collage/comic piece about how adults who quit drawing a very long time ago have this kind of line that I find beautiful. It's kind of about how we confuse things when we say it looks like a kid drew it. What if what we are seeing is what a drawing naturally looks like when an artistically untrained human being is getting an idea and drawing it at the same time? I've been interested in this for a while.

Alison Bechdel is the author of the graphic memoir *Fun Home: A Family Tragicomic*, a *New York Times* bestseller that was named the Best Book of 2006 by *Time* magazine and was a National Book Critics Circle Award finalist. *Fun Home* was adapted as an Off-Broadway musical by Lisa Kron (writer) and Jeanine Tesori (composer) in 2013. Bechdel's comic strip *Dykes to Watch out For*, which ran for twenty-five years, has been syndicated in over fifty newspapers and translated into many languages. In 2008 Houghton Mifflin published the compilation volume *The Essential Dykes to Watch out For*. Bechdel's second graphic memoir, *Are You My Mother? A Comic Drama*, appeared in 2012. She is the editor of *Best American Comics 2011*. Her work has appeared in *Granta, Slate, New York Times Book Review*, and *McSweeney's*, among other venues. Bechdel was a Mellon Residential Fellow for Arts and Practice at the Richard and Mary L. Gray Center at the University of Chicago in spring 2012 and is the recipient of a 2012 Guggenheim Fellowship. She is currently James Marsh Professor-at-Large at the University of Vermont.

On "Bartheses" with Hillary Chute:

> We cotaught a theory and practice course called "Lines of Transmission: Comics and Autobiography." One of the books we both love and knew from the outset we would teach is *Roland Barthes by Roland Barthes*—it is a text about proliferating I's that sets up a suggestive and unresolved tension between word and image in the elusive task of locating/articulating the first person. Another book we both love is the cartoonist Kate Beaton's 2011 *Hark! A Vagrant*. Beaton has a brilliant comics series she names "Goreys." She redraws covers that Edward Gorey designed and drew in the 1950s for Anchor Books as her first panel, and she then draws projected interpretations of the content based on the covers—all in a classic gag strip format. *Bartheses* is our response to Goreys, and— perhaps especially because our course focused on how I is always grounded in a we, an addressee— we imagined our *Bartheses* as conversations RB has with himself and images of himself.

Ivan Brunetti lives and works in Chicago as a teacher, editor, illustrator, and cartoonist, usually in that order. His drawings appear in *The New Yorker,* among other publications. He is the author of *Cartooning: Philosophy & Practice* (2011) and *Aesthetics: A Memoir* (2013), among

other titles. He edited the two volumes of *An Anthology of Graphic Fiction, Cartoons, and True Stories* (2006 and 2008). Brunetti is also the creator of the comics series *Schizo*, compiled with other material in his book *Misery Loves Comedy* (2007). He is an assistant professor in the Art + Design Department at Columbia College Chicago.

Scott Bukatman is a cultural theorist and professor of film and media studies at Stanford University. His research explores how such popular media as film, comics, and animation mediate between new technologies and human perceptual and bodily experience. His books include *Matters of Gravity: Special Effects and Supermen in the Twentieth Century* (2003) and *The Poetics of Slumberland: Animated Spirits and the Animating Spirit* (2012).

Charles Burns is a Philadelphia-based cartoonist and illustrator whose work became famous in *RAW* magazine. He is the creator of the graphic novel *Black Hole* (2005), which won Harvey and Ignatz Awards, among many other honors. His most recent work is a three-part series inspired by William S. Burroughs and Hergé's *Tintin*; the first two volumes are *X'ed Out* (2010) and *The Hive* (2012); the final installment, *Sugar Skull*, will appear in 2014. Burns's numerous book collections include *Big Baby in Curse of the Molemen* (1986); *Hard-Boiled Defective Stories* (1988); *Skin Deep: Tales of Doomed Romance* (1992); *Modern Horror Sketchbook* (1994); *Facetasm*, with Gary Panter (1998); *Big Baby* (2000); *Close Your Eyes* (2001); and *One Eye*, a book of photography (2007). Past projects include a set design for *The Hard Nut*, Mark Morris's adaptation of *The Nutcracker*, and an animated film for *Peur(s) du Noir (Fear[s] of the Dark)*. In 2012 he had a solo retrospective at the Museum Leuven in Belgium. In addition to contributing covers to *Time*, *The New Yorker*, and *New York Times Magazine*, Burns is the cover artist for *The Believer* magazine.

Hillary Chute is Neubauer Family Assistant Professor in the Department of English at the University of Chicago. She is the author of *Graphic Women: Life Narrative and Contemporary Comics* (2010) and *Outside the Box: Interviews with Contemporary Cartoonists* (2014) as well as associate editor of Art Spiegelman's *MetaMaus* (2011). In 2006, with Marianne DeKoven, she coedited the special issue of *Modern Fiction Studies* on "Graphic Narrative."

Daniel Clowes is a cartoonist, illustrator, and screenwriter. His influential comic book series *Eightball* ran from 1989 until 2004 and earned numerous awards. In 2001, his graphic novel *Ghost World* was adapted into a film by Terry Zwigoff, for which he wrote the screenplay and was nominated for an Academy Award. They also collaborated in 2006 on the film *Art School Confidential*. Clowes's books include *#$@&!: The Official Lloyd Lewellyn Collection* (1989); *Lout Rampage!* (1991); *Like a Velvet Glove Cast in Iron* (1993); *Pussey!* (1995); *Ghost World* (1997); *Caricature* (1998); *David Boring* (2000); *Twentieth-Century Eightball* (2002); *Ice Haven* (2005); *Wilson* (2010); *The*

Death Ray (2011); and *Mister Wonderful* (2011), which collects his comic strip that was serialized in the *New York Times Magazine*. In 2011, Clowes won the PEN Award for Graphic Literature. The first major solo exhibition of Clowes's work opened at the Oakland Museum of California in 2012; it traveled to Chicago's Museum of Contemporary Art in 2013. A full color monograph of Clowes's work, *The Art of Daniel Clowes: Modern Cartoonist*, was published in conjuction with the show.

R. Crumb is the founder of the underground comics movement. He created *Zap Comix* in San Francisco in 1967, which featured some of his most famous strips and characters, including the oft-cited "Keep On Truckin'" strip. His enduring characters include Mr. Natural, Flakey Foont, Angelfood McSpade, Shuman the Human, and Fritz the Cat. Crumb founded and edited *Weirdo* magazine (1981–1993), a venue in which many alternative cartoonists began their careers. He is the subject of the acclaimed documentary *Crumb* (1994) directed by Terry Zwigoff. Crumb has published numerous comic books (including *Dirty Laundry Comics* and *Self-Loathing Comics*, with Aline Kominsky-Crumb), books (including *R. Crumb's Kafka* and *The Book of Genesis*), and book collections (including *The Book of Mr. Natural* and *R. Crumb's America*). Seventeen volumes of *The Complete Crumb Comics* have been published. Crumb's illustration and comics work has been shown in art exhibits all over the world, including in a 2012 retrospective at the Musée d'Art Moderne in Paris. His most recent book, *Drawn Together* (released in France as *Parle-Moi d'Amour*), is a collaboration with his wife, Kominsky-Crumb, and includes past work from *Dirty Laundry, Self-Loathing, Weirdo,* and *The New Yorker*.

Phoebe Gloeckner is a cartoonist, writer, trained medical illustrator, and associate professor at the University of Michigan School of Art and Design. Her best-known works are the comics collection *A Child's Life and Other Stories* (1998), and the genre-defying illustrated novel *Diary of a Teenage Girl: An Account in Words and Pictures* (2002). Gloeckner is also known for her illustrations of J. G. Ballard's reissue of *The Atrocity Exhibition* (1991) and for her covers to the classic books *Angry Women* and *Angry Women in Rock*. Gloeckner's piece on the serial murders of young women in Ciudad Juárez, Mexico, *La Tristeza*, appeared in the 2008 volume *I Live Here*. Gloeckner's current project, a long-form, multimedia work of experimental reportage, extends her focus on Juárez. In 2008, Gloeckner received a Guggenheim fellowship for this project.

On "Arpía and Valiente":

> These two magazine covers begin to describe the unrelenting darkness that has enveloped the protagonist for the past three years. The stories inside these covers will return the protagonist back to Ciudad Juárez, to 2010, at the height of the Mexican plague of violence, where she had been working on a project about the family of a murdered girl and the neighborhood she lived in.

Justin Green, after graduating from the Rhode Island School of Design in 1969 as a BFA/Painting major, migrated to San Francisco and became one of the founders of the underground cartooning movement. His 1972 *Binky Brown Meets The Holy Virgin Mary* was the first autobiographical comic and the precursor to the graphic novel genre. After other solo productions and work in anthology titles, he started his lifelong pursuit of traditional sign painting. This is charted in "The Sign Game," which appeared as a cartoon column in *Signs of the Times* magazine from 1986 to 2006. He is one of the artists featured in the recent *Sign Painter* book and movie. From 1990–2002, his biographical "Musical Legends" ran monthly in Tower Records' *PULSE!* magazine. Green's work has also appeared in magazines including *The New Yorker*, *Print*, and the *Sacramento Bee*.

In 2011, an updated edition of *Binky Brown* was published that includes his afterword covering the cultural context of the work, which was the first secular treatment of Obsessive Compulsive Disorder in any medium. Original pages from *Binky* have been exhibited in Canada, France, and Portugal. Green is currently working on a historical narrative set in the late sixteenth century. His collected works will be released in 2015. Though far less frequently, he still paints signs.

On *"Broadcasting"*:

> Broadcasting" started as a visual concept playing with the humble word balloon, which is a unique cartooning device. In the course of doing the work, I came across the term broadcasting used in its original agricultural context. It meant sowing seeds with wide arm gestures instead of delicately planting them in rows. Since local radio stations still have spatial purviews, I thought of the wide distribution of political sound bites saturating the air over all states, both red and blue. I also tried to channel the great Carey Orr, whose cartoons adorned the front page of the *Chicago Tribune* for decades.

Tom Gunning is the Edwin A. and Betty L. Bergman Distinguished Service Professor, Department of Art History, Department of Cinema and Media Studies, and the College at the University of Chicago. He is the author of *The Films of Fritz Lang: Allegories of Vision and Modernity* (2008). He is currently writing a book on the poetics of the moving image.

N. Katherine Hayles is professor of literature at Duke University. She is the author of ten books, including *How We Became Posthuman: Virtual Bodies in Cybernetics, Literature and Informatics*, and more recently, *How We Think: Digital Media and Contemporary Technogenesis*.

Patrick Jagoda is assistant professor of English and an affiliate of Cinema and Media Studies at the University of Chicago. Jagoda specializes in new media studies, twentieth-century American literature, and digital game theory and design. He is a coeditor of *Critical Inquiry*, and his current book project is titled *Network Aesthetics*. Jagoda

has also worked on several projects related to digital storytelling, transmedia game design, and new media learning. He is the cofounder of the Game Changer Chicago Design Lab where he has led the design of projects, including card games, interactive narratives, and alternate reality games related to various social justice topics.

Daria Khitrova is currently a Visiting Senior Research Associate at the Neubauer Collegium for Culture and Society at the University of Chicago. Along with research on nineteenth-century Russian poetry, she is writing on the history of ballet and other forms of dance, specifically on ballet in other arts, from literature to film.

Aline Kominsky-Crumb, a cartoonist, painter, and a pioneer of comics autobiography, resides in southern France. Her *Goldie: A Neurotic Woman*, the first female-authored narrative autobiographical comic, appeared in the inaugural issue of the underground *Wimmen's Comix* in 1972. She has published her work in a number of underground comics anthologies, including *Twisted Sisters*, which she cofounded, and *Arcade*, and she created her own comics solo title, *Power Pak*. She was the editor of *Weirdo* magazine for seven years. Kominsky-Crumb's books include *Love That Bunch* (1990), *The Complete Dirty Laundry Comics* (with R. Crumb, 1993), and *Need More Love: A Graphic Memoir* (2007). In 2007, the Adam Baumgold Gallery in New York City mounted a solo retrospective spanning thirty-three years of work. Her show "Miami Makeover: Almost Anything for Beauty," a collaboration with the artist Dominique Sapel, premiered at the Museum of Comics and Cartoon Art in 2012. In 2012, Kominsky-Crumb and Crumb released *Drawn Together* (it first appeared in France as *Parle-Moi d'Amour*). The book contains their collaborative comics from 1972 to the present, including from *Dirty Laundry*, *Self-Loathing*, *Weirdo*, and *The New Yorker*. Kominsky-Crumb's comics story "Of What Use Is a Bunch?"— to which her original contribution to *Critical Inquiry*, "Of What Use Is an Old Bunch?" refers—first appeared in *Power Pak* in 1981 and has been collected in several volumes.

Patrick LeMieux is an artist, game designer, and PhD student in the Department of Art, Art History, and Visual Studies at Duke University. His recent projects include *Speculation* (speculat1on.net), an alternate reality game that explores the culture of Wall Street investment banks in the context of the 2008 global economic crisis, and *Open House* (no-place.org), a telematic installation that allows visitors to virtually squat in a Florida home undergoing foreclosure after the US housing collapse. Patrick has exhibited artworks at the Centre Pompidou, the Bibliothèque Nationale de France, the High Museum of Art, and SIGGRAPH. For more information visit patrick-lemieux.com.

W. J. T. Mitchell is is editor of *Critical Inquiry*. His most recent books are *Cloning Terror: The War of Images, 9/11 to Abu Ghraib* (2011) and *Seeing through Race* (2012).

269

Françoise Mouly has been art editor of *The New Yorker* since 1993 and is the publisher and editorial director of TOON Books. Since 1980 she has founded and coedited (with collaborator and husband Art Spiegelman) the groundbreaking comics anthology *RAW*; the *New York Times*-bestselling Little Lit series; and the *TOON Treasury of Classic Children's Comics*. TOON Books, which she launched in 2008, is an imprint of comics for early readers and has garnered awards including the Theodor Seuss Award for "the most distinguished American book for beginning readers." Mouly is the editor of *Best American Comics 2012*. In 2012 she also released Blown Covers, about the creative process behind New Yorker covers and Postcards from "The New Yorker," A Hundred Postcards from Ten Decades. Jeet Heer's In Love with Art, the first biography of Mouly, appeared in 2013. Mouly has curated exhibits internationally and lectured extensively on the art of New Yorker covers. In 2001, she was named Chevalier in the order of Arts and Letters by the French Ministry of Culture and Communication. In 2011, she received the Richard Gangel Art Director Award from the Society of Illustrators and was also awarded France's highest honor, the Legion of Honneur.

On "My Life as a Cartoon":

> My life as a cartoon is much fuller than my life as a cartoonist. When I met Mirror Man back in 1975, I stepped on the other side of the Looking Glass. I have lived ever since in a land of Cheshire Cats, where the food whispers "Eat Me," and the bottles compel "Drink Me!" I haven't stopped—and I don't think I'll ever stop—marveling at all that's possible in that bizarro MAD world, where the logic is Art, and the moral core is Literature.

Katalin Orbán is assistant professor at the Institute for Art Theory and Media Studies, Eötvös Loránd University, Budapest, Hungary. Her work on narrative and social memory can be found in Representations, Comparative American Studies, African American Review, and her book Ethical Diversions: The Post-Holocaust Narratives of Pynchon, Abish, DeLillo, and Spiegelman (2005). She is currently writing about visual narrative and technologies of reading.

Gary Panter is a cartoonist and painter who works in many media and is credited with defining the 1970s California punk aesthetic. In 1980, he published "The Rozz Tox Manifesto," which encouraged underground artists to infiltrate the mainstream. Within underground comics, Panter is known for his "ratty line" aesthetic and character Jimbo. His strips have been published in such publications as *RAW* and Matt Groening's *Zongo Comics*. Panter's book publications include the graphic novels *Jimbo in Purgatory*; *Jimbo's Inferno*; *Cola Madnes*; and *Jimbo: Adventures in Paradise*. The monograph *Gary Panter* appeared in 2008. Panter designed sets and puppets for *Pee-Wee's Playhouse*, for which he won three Emmy awards, as well as posters and album covers for bands from The

270

Germs to Yo La Tengo. He has staged psychedelic light shows at the Hirschorn Museum in Washington, DC and The Anthology Film Archives in New York City. Panter's painting and other artwork are exhibited widely; in 2008, he had a one-man show at the Aldrich Museum of Contemporary Art. Panter plays in the band Devin Gary & Ross.

Joe Sacco is a cartoonist who has done a number of journalistic books, notably *Palestine* (2001), which won an American Book Award; *Safe Area Gorazde* (2000); *The Fixer: A Story from Sarajevo* (2003); and *Footnotes in Gaza* (2009). He has contributed pieces to venues such as *Harper's*, *Details*, *The New York Times Magazine*, *VQR: The Virginia Quarterly Review*, and the *Guardian*. Sacco's shorter pieces of reportage are collected in his anthology *Journalism* (2012). In 2012, he published *Days of Destruction, Days of Revolt*, a collaboration with the journalist Chris Hedges. Sacco's book *The Great War*, depicting the first day of the Battle of the Somme in 1916, was published by W.W. Norton in 2013. Sacco won the Ridenhour Book Prize in 2010; he has also received a Guggenheim Fellowship and an Eisner Award. He lives in Portland, Oregon.

Seth is the cartoonist behind the long running comic book series *Palookaville*. His books include *Wimbledon Green*, *George Sprott*, *Clyde Fans*, and *It's a Good Life If You Don't Weaken*. He is the designer for *The Complete Peanuts*, *The John Stanley Library*, *The Portable Dorothy Parker* and *The Collected Doug Wright*. A deluxe edition, designed and illustrated by Seth, of Stephen Leacock's *Sunshine Sketches of a Little Town* has just been published. He was recently awarded the 2011 Harbourfront Festival Prize.

On his sketches:

> These are sketches of the participants from sketchbook 12.

Art Spiegelman is one of the world's most famous cartoonists and is the recipient of many awards and honors. In 1992 he received a Pulitzer Prize for the two-volume *Maus: A Survivor's Tale* (1986; 1991). In 1980, after founding and editing *Arcade* (1975–1976) with Bill Griffith, Spiegelman cofounded *RAW*, the avant-garde "comix and graphix" magazine, with Françoise Mouly. His numerous books include *Breakdowns*, a 1978 anthology republished in 2008 along with the new work *Portrait of the Artist as a Young %@&*!*; *In the Shadow of No Towers* (2004); *MetaMaus* (2011), for which he collaborated with associate editor Hillary Chute; and *Co-Mix* (2013). From 1993–2003, Spiegelman was a staff artist and writer at *The New Yorker*, where he has contributed many covers, including the famous black-on-black 9/11 cover. In 2005, Spiegelman was named one of *Time Magazine*'s 100 Most Influential People in the World, and in 2006 he was named to the Art Director's Club Hall of Fame. In 2011, he won the Grand Prix at the Angoulême International Comics Festival. Among other projects, he collaborated with the experimental dance company Pilobolus for *Hapless Hooligan in*

"*Still Moving*"; designed a stained-glass window installation for the High School of Art and Design in New York City, his alma mater; and collaborated with jazz composer Phillip Johnston on the live multimedia performance *Wordless!* which premiered at the Sydney Opera House in 2013. "Art Spiegelman's Co-Mix: A Retrospective," opened at the Jewish Museum in November 2013.

Garland Martin Taylor is an artist with a practice divided between sculpting and independent scholarship. He studied sculpture under Preston Jackson and interned for Virginio Ferrari in Verona. Garland also worked in several of Chicago's museums handling, cataloging, and caring for art and objects. In addition to developing large-scale public and private sculptures in his studio on the South Side of Chicago, Garland is collaborating with the DuSable Museum of African American History on a research project concerned with the life and art of the nineteenth-century artist, engraver, and editorial cartoonist Henry Jackson Lewis.

Yuri Tsivian is the William Colvin Professor of Film at the University of Chicago. He is the author of *Early Cinema in Russia and Its Cultural Reception* (1994), *Ivan the Terrible* (2002), and *Lines of Resistance: Dziga Vertov and the Twenties* (2004). His newest interest is in digital methods of film studies; see www.cinemetrics.lv

Carol Tyler (blog: "*My Screened-in Porch*"; website: Bloomerland) is an award-winning cartoonist, educator, painter, and comedian known for her autobiographical stories. Her comics first began appearing in R. Crumb's *Weirdo* in 1987 and also in the foundational *Wimmen's Comix* as well as numerous other publications, including the *Twisted Sisters* book anthologies. She is the creator of the acclaimed comics collections *The Job Thing* (1993) and *Late Bloomer* (2005). Tyler recently completed *You'll Never Know*, a three-volume graphic memoir. This work details the artist's search for the truth about her father's World War II service while examining the damage his life-long, untreated post-traumatic stress has had on her family and relationships. The three highly praised installments, *A Good and Decent Man* (2009), *Collateral Damage* (2010), and *Soldier's Heart* (2012) have garnered the Ohio Arts Council Award for Individual Excellence, among many other awards and nominations, including a 2013 Eisner Award nomination for Best Writer/Artist.

Every month the inside back cover of *Cincinnati Magazine* features Tyler's comics narrative *Tomatoes*. Tyler teaches at the University of Cincinnati.

On "What's Newsworthy?":

> The page you see here is my attempt to represent all the participants in the conference as well as capture the two elements that happily brought us together: Hillary Chute and that bus! Let me explain.
>
> Most of the comics people who participated in the conference have friendships that go wa-a-a-y back—back to our beginnings. So this was a reunion of old friends and a few new ones, but it had this vibe. Over the years, we may see this one or that one, but to have us all together was a real treat. One thing we don't often get to do is just *be* together, as in just hanging out without any pressure. So, couple the distance from the hotel and the venues with the road closures due to the NATO summit/President Barack Obama being in Chicago at the same time, and you get very long shuttle bus rides. However, in a weird kind of way, all that time on the bus together released this great energy and set the tone for a meaningful, memorable, fun conference. It was our behind-the-scenes place to cut loose and be our true smart-assed selves. Kind of a magical mystery tour for cartoonists.
>
> As for the title, *Newsworthy*: it's because to get all these people together, it truly was. Why the circles with short "Nancy" spikes? Because we are cartoonists, and these are our roots. And finally, what's with that chair? It's my symbol of plush and awesome, and purple = royalty, which seems to sum-up the whole experience.

Chris Ware is a Chicago-based cartoonist whose early work appeared in *RAW* magazine and was serialized in Chicago newspapers *Newcity* and *The Chicago Reader*. He is the creator of the *ACME Novelty Library* series; the American Book Award-winning graphic novel *Jimmy Corrigan: The Smartest Boy on Earth* (2000), which also won the Guardian First Book Award; and *Building Stories* (2012), which won four Eisner Awards, among other honors. Ware's work has been included in many national and international exhibitions, including the Whitney Biennial in 2002. He is a contributor to *The New Yorker* and the *New York Times Magazine*, among other venues. He is the editor of *The Best American Comics* 2007 and *McSweeney's* volume 13.

271

Books of Critical Interest

Abbott, H. Porter. *Real Mysteries: Narrative and the Unknowable*. Columbus: The Ohio State University Press, 2013. $57.95. 178 pp.

Abu-Lughod, Lila. *Do Muslim Women Need Saving?* Cambridge, Mass.: Harvard University Press, 2013. $35.00. 325 pp.

Adkins, G. Matthew. *The Idea of the Sciences in the French Enlightenment*. Newark, Del.: University of Delaware Press, 2014. $70.00. 165 pp.

Agamben, Giorgio. *Nymphs*. Trans. Amanda Minervini. London: Seagull Books, 2013. $20.00. 72 pp.

Aizenberg, Salo. *Hatemail: Anti-Semitism on Picture Postcards*. Lincoln: University of Nebraska Press, 2013. $31.95. 248 pp.

Aleksić, Tatjana. *The Sacrificed Body: Balkan Community Building and the Fear of Freedom*. Pittsburgh: University of Pittsburgh Press, 2013. $27.95. 288 pp.

Allison, Anne. *Precarious Japan*. Durham, N.C.: Duke University Press, 2013. $23.95 (paper); $84.95 (cloth). 248 pp.

Althusser, Louis. *On the Reproduction of Capitalism: Ideology and Ideological State Apparatuses*. London: Verso, 2014. $29.95. 288 pp.

Amar, Paul and Vijay Prashad, eds. *Dispatches from the Arab Spring: Understanding the New Middle East*. Minneapolis: University of Minnesota Press, 2013. $22.95 (paper); $69.00 (cloth). 384 pp.

Amoore, Louise. *The Politics of Possibility: Risk and Security Beyond Probability*. Durham, N.C.: Duke University Press, 2013. $23.95 (paper); $84.95 (cloth). 232 pp.

Amster, Ellen J. *Science, Islam, and the Colonial Encounter in Morocco, 1877-1965*. Austin: University of Texas Press, 2013. $60.00. 350 pp.

Amster, Randall, and Elavie Ndura, eds. *Exploring the Power of Nonviolence: Peace, Politics, and Practice*. Syracuse, N.Y.: Syracuse University Press, 2013. $29.95 (paper); $55.00 (cloth). 320 pp.

Aso, Noriko. *Public Properties: Museums in Imperial Japan*. Durham, N.C.: Duke University Press, 2013. $27.95 (paper); $99.95 (cloth). 320 pp.

Auerbach, Erich. *Mimesis: The Representation of Reality in Western Literature*. Trans. Willard R. Trask. Princeton, N.J.: Princeton University Press, 2013.

Auerbach, Erich. *Selected Essays of Erich Auerbach: Time, History, and Literature*. Ed. James I. Porter. Trans. Jane O. Newman. Princeton, N.J.: Princeton University Press, 2014. $39.50. 336 pp.

Bakrania, Falu. *Bhangra and Asian Underground: South Asian Music and the Politics of Belonging in Britain*. Durham, N.C.: Duke University Press, 2013. $23.95 (paper); $84.95 (cloth).

Baler, Pablo, ed. *The Next Thing: Art in the Twenty-First Century*. Madison, N.J.: Fairleigh Dickinson University Press, 2013. $65.00. 164 pp.

Balibar, Étienne. *Equaliberty: Political Essays*. Trans. James Ingram. Durham, N.C.: Duke University Press, 2014. $25.95 (paper); $94.95 (cloth). 376 pp.

Balibar, Étienne. *Identity and Difference: John Locke and the Invention of Consciousness*. New York: Verso, 2013. $23.95 (paper); $95.00 (cloth). 208 pp.

Barrett, Lindon. *Racial Blackness and the Discontinuity of Western Modernity*. Ed. Justin A. Joyce, Dwight A. McBride, and John Carlos Rowe. Urbana: University of Illinois Press, 2014. $30.00 (paper); $95.00

(cloth). 264 pp.

Barthes, Roland. *Travels in China.* Ed. Anne Herschberg Pierrot. Trans. Andrew Brown. Cambridge: Polity Press, 2013. $14.95 (paper); $19.95 (cloth). 225 pp.

Bauman, Zygmunt. *What Use Is Sociology? Conversations with Michael-Hviid Jacobsen and Keith Tester.* Cambridge: Polity Press, 2014. $22.95. 134 pp.

Baxter, Jeannette, Valerie Henitiuk, and Ben Hutchinson, eds. *A Literature of Restitution: Critical Essays on W. G. Sebald.* Manchester: Manchester University Press, 2013. $100.00. 336 pp.

Benjamin, Andrew. *Working with Walter Benjamin: Recovering a Political Philosophy.* Edinburgh: Edinburgh University Press, 2013. $50.00. 256 pp.

Berlant, Lauren, and Lee Edelman. *Sex, or the Unbearable.* Durham, N.C.: Duke University Press, 2014. $21.95 (paper); $74.95 (cloth). 168 pp.

Biers, Katherine. *Virtual Modernism: Writing and Technology in the Progressive Era.* Minneapolis: University of Minnesota Press, 2013. $25.00 (paper); $75.00 (cloth). 288 pp.

Bigsby, Christopher. *Viewing America: Twenty-First-Century Television Drama.* Cambridge: Cambridge University Press, 2013. $29.99. 500 pp.

Biltekoff, Charlotte. *Eating Right in America: The Cultural Politics of Food & Health.* Durham, N.C.: Duke University Press, 2013. $22.95 (paper); $79.95 (cloth). 224 pp.

Blanchot, Maurice. *Into Disaster: Chronicles of Intellectual Life, 1941.* Trans. Michael Holland. New York: Fordham University Press, 2014. $24.00 (paper); $95.00 (cloth). 160 pp.

Blanton, Ward, and Hent de Vries, eds. *Paul and the Philosophers.* New York: Fordham University Press, 2013. $40.00 (paper); $125.00 (cloth). 650 pp.

Blatman, Daniel. *The Death Marches: The Final Phase of Nazi Genocide.* Trans. Chaya Galai. Cambridge, Mass.: Harvard University Press, 2011.

Bloemendal, Jan and Howard B. Norland, eds. *Neo-Latin Drama and Theatre in Early Modern Europe.* Leiden: Brill, 2013. $228.00. 808 pp.

Blyn, Robin. *The Freak-Garde: Extraordinary Bodies and Revolutionary Art in America.* Minneapolis: University of Minnesota Press, 2013. $27.50 (paper); $82.50 (cloth). 320 pp.

Borchgrevink, Aage. *A Norwegian Tragedy: Anders Behring Breivik and the Massacre on Utoya.* Trans. Guy Puzey. Cambridge: Polity Press, 2013. $25.00. 300 pp.

Bordieu, Pierre. *Algerian Sketches.* Ed. Tassadit Yacine. Trans. David Fernbach. Cambridge: Polity Press, 2013. $28.95 (paper); $69.95 (cloth). 400 pp.

Bowie, Andrew. *Adorno and the Ends of Philosophy.* Cambridge: Polity, 2013. $24.95 (paper); 69.95 (cloth). 210 pp.

Bracher, Mark. *Literature and Social Justice: Protest Novels, Cognitive Politics, and Schema Criticism.* Austin: University of Texas Press, 2013. $60.00. 338 pp.

Brandt, Bettina, and Valentina Glajar, eds. *Herta Müller: Politics and Aesthetics.* Lincoln: University of Nebraska Press, 2014. $40.00. 312 pp.

Britton, John A. *Cables, Crises, and the Press: The Geopolitics of the New International Information System in the Americas, 1866-1903.* Albuquerque: University of New Mexico Press, 2013. $60.00. 488 pp.

Brombert, Victor. *Musings on Mortality from Tolstoy to Levi.* Chicago: University of Chicago Press, 2013. $24.00. 188 pp.

Brozgal, Lia Nicole. *Against Autobiography: Albert Memmi and the Production of Theory.* Lincoln: University of Nebraska Press, 2013. $50.00. 256 pp.

Bruckner, Pascal. *Has Marriage for Love Failed?* Trans. Steven Rendall and Lisa Neal. Cambridge: Polity, 2013. $19.95. 90 pp.

Bryan, Jimmy L., ed. *The Martial Imagination: Cultural Aspects of American Warfare.* College Station: Texas A&M University Press, 2013. $29.95 (paper); $55.00 (cloth). 288 pp.

Buechsel, Mark. *Sacred Land: Sherwood Anderson, American Modernism, and the Sacramental Vision of Nature.* Kent, Ohio: Kent State University Press, 2014. $65.00. 384 pp.

Burch, Noël, and Geneviève Sellier. *The Battle of the Sexes in French Cinema, 1930-1956.* Durham, N.C.: Duke University Press, 2013. $28.95 (paper); $99.95 (cloth). 384 pp.

Cady, Linnell E. and Tracy Fessenden, eds. *Religion, the Secular, and the Politics of Sexual Difference.* New York, Columbia University Press, 2013. $30.00. 330 pp.

Calderon, Ruth. *A Bride for One Night: Talmud Tales.* Lincoln: University of Nebraska Press, 2014. $21.95. 184 pp.

Cammaerts, Bart, Alice Mattoni, Patrick McCurdy, eds. *Mediation and Protest Movements.* Bristol, U.K.: Intellect, 2013. $40.00. 275 pp.

Campbell, Timothy, and Adam Sitze, eds. *Biopolitics: A Reader.* Durham, N.C.: Duke University Press, 2013. $27.95 (paper); $99.95 (cloth). 456 pp.

Caruth, Cathy. *Literature in the Ashes of History.* Baltimore, Md.: The Johns Hopkins University Press, 2013. $22.95. 130 pp.

Caudill, Edward. *Creationists' Tactics in the Culture Wars, from the Scopes Trial to Today.* New Brunswick, N.J.: Rutgers University Press, 2013. $25.00 (paper); $85.00 (cloth). 216 pp.

Ceccarelli, Leah. *On the Frontier of Science: An American Exploration and Exploitation.* East Lansing: Michigan State University Press, 2013. $59.95. 210 pp.

Chartier, Roger. *The Author's Hand and the Printer's Mind.* Trans. Lydia G. Cochrane. Cambridge: Polity Press, 2014. $24.94 (paper); $69.95 (cloth). 224 pp.

Cixous, Hélène. *Twists and Turns in the Heart's Antarctic.* Trans. Beverley Bie Brahic. Cambridge: Polity Press, 2014. $19.95 (paper); $59.95 (cloth). 224 pp.

Cohen, Jeffrey Jerome, ed. *Prismatic Ecology: Ecotheory beyond Green.* Minneapolis: University of Minnesota Press, 2014. $25.00 (paper); $75.00 (cloth). 392 pp.

Confino, Alon. *A World Without Jews: The Nazi Imagination from Persecution to Genocide.* New Haven, Conn.: Yale University Press, 2014. $30.00. 296 pp.

Coon, David R. *Look Closer: Suburban Narratives and American Values in Film and Television.* New Brunswick, N.J.: Rutgers University Press, 2013. $26.95 (paper); $80.00 (cloth). 256 pp.

Cooper, Davina. *Everyday Utopias: The Conceptual Life of Promising Spaces.* Durham, N.C.: Duke University Press, 2014. $24.95 (paper); $89.95 (cloth). 296 pp.

Cooper, Melinda, and Catherine Waldby. *Clinical Labor: Tissue Donors and Research Subjects in the Global Bioeconomy.* Durham, N.C.: Duke University Press, 2014. $24.94 (paper); $89.95 (cloth). 296 pp.

Craig, Layne Parish. *When Sex Changed: Birth Control Politics and Literature Between the World Wars.* New Brunswick, N.J.: Rutgers University Press, 2013. $24.95 (paper); $80.00 (cloth). 210 pp.

Crépon, Marc. *The Thought of Death and the Memory of War.* Trans. Michael Loriaux. Minneapolis: University of Minnesota Press, 2013. $22.50. 184 pp.

Crocker, Stephen. *Bergson and the Metaphysics of Media.* New York: Palgrave Macmillan. $85.00. 185 pp.

Davies, Carole Boyce. *Caribbean Spaces: Escapes from Twilight Zones.* Urbana: University of Illinois Press, 2013. $28.00 (paper); $85.00 (cloth). 264 pp.

Davis, Oliver, ed. *Rancière Now: Current Perspectives on Jacques Rancière.* Cambridge: Polity Press, 2013. $22.95. 250 pp.

Dawes, James. *Evil Men.* Cambridge, Mass.: Harvard University Press, 2013. $25.95. 280 pp.

DeArmitt, Pleshette. *The Right to Narcissism: A Case for an Im-Possible Self-Love.* New York: Fordham University Press, 2013. $24.00 (paper); $85.00 (cloth). 200 pp.

Deuchar, Ross. *Policing Youth Violence: Transatlantic Connections.* London: Institute of Education Press, 2013. $39.95. 215 pp.

Dewhurst, Richard J. *The Ancient Giants Who Ruled America: The Missing Skeletons and the Great Smithsonian Cover-Up.* Rochester, Vt.: Bear and Company, 2014. $20.00. 360 pp.

De Bolla, Peter. *The Architecture of Concepts: The Historical Formation of Human Rights.* New York: Fordham University Press, 2013. $35.00 (paper); $125.00 (cloth). 300 pp.

De Leon, Cedric. *Party and Society.* Cambridge: Polity Press, 2014. $22.95 (paper); $64.95 (cloth). 208 pp.

De Vos, Jan. *Psychologization and the Subject of Late Modernity.* New York: Palgrave MacMillan, 2013. $90.00. 208 pp.

Dijck, José van. *The Culture of Connectivity: A Critical History of Social Media.* Oxford: Oxford University Press, 2013. $24.95 (paper); $99.00 (cloth). 240 pp.

Douglas, Andrew J. *In the Spirit of Critique: Thinking Politically in the Dialectical Tradition.* Albany: State University of New York Press, 2013. $80.00. 192 pp.

Dueck, Byron. *Musical Intimacies and Indigenous Imaginaries: Aboriginal Music and Dance in Public Performance.* Oxford: Oxford University Press, 2013. $29.95. 260 pp.

Duggan, Anne E. *Queer Enchantments: Gender, Sexuality, and Class in the Fairy-Tale Cinema of Jacques Demy.* Detroit: Wayne State University Press, 2013. $29.95. 195 pp.

Eiland, Howard and Michael W. Jennings. *Walter Benjamin: A Critical Life.* Cambridge: Harvard University Press, 2014. $39.95. 768 pp.

Elkins, James and Harper Montgomery, eds. *Beyond the Aesthetic and the Anti-Aesthetic.* University Park: Pennsylvania State University Press, 2013. $74.95. 224 pp.

Erdinast-Vulcan, Daphna. *Between Philosophy and Literature: Bakhtin and the Question of the Subject.* Stanford, Calif.: Stanford University Press , 2013. $24.95 (paper); $85.00 (cloth). 272 pp.

Evers, Kai. *Violent Modernists: The Aesthetics of Destruction in Twentieth-Century German Literature.* Evanston, Ill.: Northwestern University Press, 2013. $39.95. 265 pp.

Ferrari, Chiara. *The Rhetoric of Violence and Sacrifice in Fascist Italy: Mussolini, Gadda, Vittorini.* Toronto: University of Toronto Press, 2013. $29.95. 230 pp.

Fletcher, John. *Freud and the Scene of Trauma.* New York: Fordham University Press, 2013. $35.00 (paper); $110.00 (cloth). 365 pp.

Florczyk, Steven. *Hemingway, the Red Cross, and the Great War.* Kent, Ohio: Kent State University Press, 2014. $45.00. 216 pp.

Floyd-Wilson, Mary. *Occult Knowledge, Science, and Gender on the Shakespearean Stage.* Cambridge: Cambridge University Press, 2013. $99.00. 236 pp.

Flusser, Vilém. *Natural:Mind.* Minneapolis, Minn.: Univocal, 2013. $24.95. 143 pp.

Foertsch, Jacqueline. *Reckoning Day: Race, Place, and the Atom Bomb in Postwar America.* Nashville, Tenn.: Vanderbilt University Press, 2013. $24.95 (paper); $59.95 (cloth). 264 pp.

Forecki, Piotr. *Reconstructing Memory: The Holocaust in Polish Public Debates.* Frankfurt: Peter Lang, 2013. $66.95. 288 pp.

Forkert, Kirsten. *Artistic Lives: A Study of Creativity in Two European Cities.* Surrey, England: Ashgate, 2013. $99.95. 158 pp.

Fornari, Giuseppe. *A God Torn to Pieces: The Nietzsche Case.* Trans. Keith Buck. East Lansing: Michigan State University Press, 2013. $24.95. 150 pp.

Forst, Rainer. *Justification and Critique: Towards a Critical Theory of Politics.* Trans. Ciaran Cronin. Cambridge: Polity Press, 2014. $24.95 (paper); $69.95 (cloth). 240 pp.

Fortini, Franco. *The Dogs of Sinai.* Trans. Alberto Toscano. London: Seagull Books, 2014. $27.50. 116 pp.

Foster, Thomas A. *Sex and the Founding Fathers: The American Quest for a Relatable Past.* Philadelphia, Pa.: Temple University Press, 2014. $28.50. 232 pp.

Fraenkel, Carlos. *Philosophical Religions from Plato to Spinoza: Reason, Religion, and Autonomy.* Cambridge: Cambridge University Press, 2012. $99.00. 330 pp.

Franklin, Sarah. *Biological Relatives: IVF, Stem Cells, and the Future of Kinship.* Durham, N.C.: Duke University Press, 2013. $26.95 (paper); $94.95 (cloth). 376 pp.

Garfield, Seth. *In Search of the Amazon: Brazil, the United States, and the Nature of a Region.* Durham, N.C.: Duke University Press, 2014. $26.95 (paper); $94.95 (cloth). 368 pp.

Gaugh, Harry F. *Franz Kline.* New York: Abbeville, 2014. $60.00. 192 pp.

Gee, Emily, and Jeremy Myerson. *Time and Motion: Redefining Working Life.* Liverpool, UK: Liverpool University Press, 2013. $19.95. 160 pp.

Gellner, David N., ed. *Borderland Lives in Northern South Asia.* Durham, N.C.: Duke University Press, 2014. $24.95 (paper); $89.95 (cloth). 320 pp.

Gershwin, Lisa-ann. *Stung! On Jellyfish Blooms and the Future of the Ocean.* Chicago, Ill.: University of Chicago Press, 2013. $27.50 (cloth). 424 pp.

Ginsberg, Benjamin. *The Value of Violence.* Amherst, N.Y.: Prometheus, 2013. $12.99 (e-book); $24.95 (cloth). 222 pp.

Goggin, Maureen Daly, and Beth Fowkes Tobin, eds. *Women and the Material Culture of Death.* Surrey, England: Ashgate, 2013. $124.95. 384 pp.

Gordon, Peter E. and John P. McCormick, eds. *Weimar Thought: A Contested Legacy.* Princeton, N.J.: Princeton University Press, 2013. $35.00. 450 pp.

Greco, Anthony F. *Chomsky's Challenge to American Power.* Nashville, Tenn.: Vanderbilt University Press, 2014. $29.95. 272 pp.

275

Grimes, Larry, and Bickford Sylvester, eds. *Hemingway, Cuba, and the Cuban Works*. Kent, Ohio: Kent State University Press, 2014. $65.00. 408 pp.

Grinberg, Lev Luis. *Mo(ve)ments of Resistance: Politics, Economy, and Society in Israel/Palestine 1931-2013*. Boston, Mass.: Academic Studies Press, 2014. $34.00 (paper); $85.00 (cloth). 346 pp.

Groom, Amelia, ed. *Time: Documents of Contemporary Art*. Cambridge, Mass.: MIT Press, 2013. $24.95. 240 pp.

Grygienc, Janusz. *General Will in Political Philosophy*. Trans. Dominika Gajewska. Exeter, UK: Imprint Academic, 2013. $39.90. 197 pp.

Guterl, Matthew Pratt. *Seeing Race in Modern America*. Chapel Hill, N.C.: University of North Carolina Press, 2013. $34.95. 248 pp.

Haines, Simon. *Redemption in Poetry and Philosophy: Wordsworth, Kant, and the Making of the Post-Christian Imagination*. Waco, Tex.: Baylor University Press, 2013. 250 pp.

Hanhardt, Christina B. *Safe Space: Gay Neighborhood History and the Politics of Violence*. Durham, N.C.: Duke University Press, 2013. $25.95 (paper); $94.95 (cloth). 376 pp.

Harman, Graham. *Weird Realism: Lovecraft and Philosophy*. Ashford, UK: Zero Books, 2012. $24.95 (paper). 277 pp.

Harrell, D. Fox. *Phantasmal Media: An Approach to Imagination, Computation, and Expression*. Cambridge, Mass.: MIT Press, 2013. $40.00. 440 pp.

Hashemi, Nadar, and Danny Postel, eds. *The Syria Dilemma*. Cambridge, Mass.: MIT Press, 2013. $14.95. 285 pp.

Hassing, Arne. *Church Resistance to Nazism in Sweden, 1940-1945*. Seattle: University of Washington Press, 2014. $50.00. 424 pp.

Hayles, Katherine N. and Jessica Pressman, eds. *Comparative Textual Media: Transforming the Humanities in the Postprint Era*. Minneapolis: University of Minnesota Press, 2013. $27.50 (paper); $82.50 (cloth). 368 pp.

Heins, Laura. *Nazi Film Melodrama*. Urbana: University of Illinois Press, 2013. $30.00 (paper); $80.00 (cloth). 256 pp.

276 Hejinian, Lyn and Barrett Watten, eds. *A Guide to* Poetics Journal: *Writing in the Expanded Field 1982-1998*. Middletown, Conn.: Wesleyan University Press, 2013. $23.99 (paper); $85.00 (cloth). 476 pp.

Herman, Luc, and Steven Weisenburger. Gravity's Rainbow, *Domination, and Freedom*. Athens, Ga.: The University of Georgia Press, 2013. $24.95 (paper); $79.95 (cloth). 258 pp.

Holloway, Jonathan Scott. *Jim Crow Wisdom: Memory & Identity in Black America since 1940*. Chapel Hill: University of North Carolina Press, 2013. $39.95. 288 pp.

Holloway, Karla F.C. *Legal Fictions: Constituting Race, Composing Literature*. Durham, N.C.: Duke University Press, 2014. $21.95 (paper); $74.95 (cloth). 176 pp.

Horwitz, Noah. *Divine Name Verification: An Essay on Anti-Darwinism, Intelligent Design, and the Computational Nature of Reality*. Brooklyn, N.Y.: Punctum Books, 2013. $17.00. 414 pp.

Huhtamo, Erkki. *Illusions in Motion: Media Archaeology of the Moving Panorama and Related Spectacles*. Cambridge, Mass.: MIT Press, 2013. $45.00. 440 pp.

Huffer, Lynne. *Are the Lips a Grave? A Queer Feminist on the Ethics of Sex*. New York: Columbia University Press, 2013. $30.00 (paper); 90.00 (cloth). 264 pp.

Illouz, Eva. *Why Love Hurts*. Cambridge: Polity Press, 2012. $16.95. 300 pp.

Inglis, Fred. *Richard Hoggart: Virtue and Reward*. Cambridge: Polity Press, 2014. $35.00. 280 pp.

Jamal, Amina. *Jamaat-e-Islami Women in Pakistan: Vanguard of a New Modernity?* Syracuse, N.Y.: Syracuse University Press, 2013. $39.95. 296 pp.

Johnson, Erica L., and Patricia Moran. *The Female Face of Shame*. Bloomington: Indiana University Press, 2013. $26.00 (paper); $80.00 (cloth). 268 pp.

Jonsson, Stefan. *Crowds and Democracy: The Idea and Image of the Masses from Revolution to Fascism*. New York: Columbia University Press, 2013. $50.00. 312 pp.

Joy, Morny, ed. *Women and the Gift: Beyond the Given and All-Giving*. Bloomington: Indiana University Press, 2013. $25.00 (paper); $75.00 (cloth). 244 pp.

Kahan, Benjamin. *Celibacies: American Modernism & Sexual Life*. Durham, N.C.: Duke University Press, 2013. $23.95 (paper); $84.95 (cloth). 232 pp.

Kahn, Victoria. *The Future of Illusion: Political Theology and Early Modern Texts.* Chicago: University of Chicago Press, 2014. $45.00. 250 pp.

Keating, Ana Louise. *Transformation Now! Toward a Post-Oppositional Politics of Change.* Urbana: University of Illinois Press, 2013. $30.00 (paper); $90.00 (cloth). 280 pp.

Kim, Kyung Hyun, and Youngmin Choe, eds. *The Korean Popular Culture Reader.* Durham, N.C.: Duke University Press, 2014. $28.95 (paper); $99.95 (cloth). 464 pp.

Klaus, Carl H. *A Self Made of Words: Crafting a Distinctive Persona in Nonfiction Writing.* Iowa City: University of Iowa Press, 2013. $18.00. 86 pp.

Kraus, Chris. *Aliens & Anorexia.* Cambridge, Mass.: MIT Press, 2013. $15.95. 264 pp.

Kruger, Loren. *Imagining the Edge City: Writing, Performing, and Building Johannesburg.* Oxford: Oxford University Press, 2013. $74.00. 274 pp.

Kukkonen, Karin. *Contemporary Comics Storytelling.* Lincoln: University of Nebraska Press, 2013. $55.00. 248 pp.

Lacan, Jacques. *On the Names-of-the-Father.* Trans. Bruce Fink. Cambridge: Polity, 2013. $16.95. 105 pp.

Lacan, Jacques. *The Triumph of Religion*, preceded by *Discourse to Catholics.* Trans. Bruce Fink. Cambridge: Polity, 2013. $16.95. 100 pp.

Lacoste, Jean-Yves. *From Theology to Theological Thinking.* Trans. W. Chris Hackett. Charlottesville: University of Virginia Press, 2014. $29.50 pp. 135 pp.

Lal, Ruby. *Coming of Age in Nineteenth-Century India: The Girl-Child and the Art of Playfulness.* Cambridge: Cambridge University Press, 2013. $95.00. 230 pp.

Lamp, Kathleen S. *A City of Marble: The Rhetoric of Augustan Rome.* Columbia, S.C.: The University of South Carolina Press, 2013. $49.95. 208 pp.

Lang, Berel. *Primo Levi: The Matter of a Life.* New Haven, Conn.: Yale University Press, 2013. $25.00. 175 pp.

Lara, María Pía. *The Disclosure of Politics: Struggles over the Semantics of Secularization.* New York: Columbia University Press, 2013. $40.00. 256 pp.

Larrimore, Mark. *The Book of* Job: *A Biography.* Princeton, N.J.: Princeton University Press, 2013. $24.95. 286 pp.

Larson, Doran. *Fourth City: Essays from the Prison in America.* East Lansing: Michigan State University Press, 2013. $34.95. 352 pp.

Lawtoo, Nidesh. *The Phantom of the Ego: Modernism and the Mimetic Unconscious.* East Lansing: Michigan State University Press, 2013. $29.95. 366 pp.

LeMahieu, Michael. *Fictions of Fact and Value.* Oxford: Oxford University Press, 2013. $49.95. 250 pp.

Levi, Neil. *Modernist Form and the Myth of Jewification.* New York, N.Y.: Fordham University Press, 2014. $55.00. 262 pp.

Levine, Emily J. *Dreamland of Humanists: Warburg, Cassirer, Panofsky, and the Hamburg School.* Chicago: University of Chicago Press, 2013. $45.00. 464 pp.

Levine, Michael G. *A Weak Messianic Power: Figures of Time to Come in Benjamin, Derrida, and Celan.* New York: Fordham University Press, 2014. $26.00 (paper); $95.00 (cloth). 224 pp.

Lewis, C.S. *The Allegory of Love.* Cambridge: Cambridge University Press, 2013. $19.99. 476 pp.

Lilley, James D. *Common Things: Romance and the Aesthetics of Belonging in Atlantic Modernity.* New York: Fordham University Press, 2013. $45.00. 240 pp.

Lim, Eng-Beng. *Brown Boys and Rice Queens: Spellbinding Performance in the Asias.* New York: New York University Press, 2013. $25.00 (paper); $75.00 (cloth). 256 pp.

Louden, Sharon. *Living and Sustaining a Creative Life: Essays by 40 Working Artists.* Bristol, UK: Intellect, 2013. $40.00. 224 pp.

Lyotard, Jean-François. *Why Philosophize?* Trans. Andrew Brown. Cambridge: Polity Press, 2013. $12.95 (paper); $45.00 (cloth). 100 pp.

Marder, Michael. *Groundless Existence: The Political Ontology of Carl Schmitt.* New York: Continuum, 2012. $29.95. 208 pp.

Marovitz, Sanford E. *Melville as Poet: The Art of "Pulsed Life".* Kent, Ohio: Kent State University Press, 2013. $60.00. 256 pp.

Marshall, Kate. *Corridor: Media Architectures in American Fiction.* Minneapolis: University of Minnesota Press, 2013. $25.00 (paper); $75.00 (cloth). 256 pp.

McAllister, Carlota and Diana M. Nelson, eds. *War by Other Means: Aftermath in Post-Genocide Guatemala.* Durham, N.C.: Duke University Press, 2013. $27.95 (paper); $99.95 (cloth).

McCann, Bryan. *Hard Times in the Marvelous City: From Dictatorship to Democracy in the Favelas of Rio de Janeiro.* Durham, N.C.: Duke University Press, 2014. $24.95 (paper); $89.95 (cloth). 256 pp.

McCumber, John. *Understanding Hegel's Mature Critique of Kant.* Stanford, Calif.: Stanford University Press, 2014. $60.00. 232 pp.

McDonald, David A. *My Voice Is My Weapon: Music, Nationalism, and the Poetics of Palestinian Resistance.* Durham, N.C.: Duke University Press, 2013. $24.95 (paper); $94.95 (cloth). 352 pp.

McGowan, Todd. *Spike Lee.* Urbana: University of Illinois Press, 2014. $22.00 (paper); $70.00 (cloth). 184 pp.

Migraine-George, Thérèse. *From Francophonie to World Literature in French: Ethics, Poetics, and Politics.* Lincoln: University of Nebraska Press, 2013.

Milton, Cynthia E., ed. *Art from a Fractured Past: Memory and Truth Telling in Post-Shining Path Peru.* Durham, N.C.: Duke University Press, 2014. $24.95 (paper); $89.95 (cloth). 320 pp.

Minh-ha, Trinh T. *D-Passage: The Digital Way.* Durham, N.C.: Duke University Press, 2013. $24.95 (paper); $89.95 (cloth). 224 pp.

Morgan, Michael L. *Fackenheim's Jewish Philosophy: An Introduction.* Toronto: University of Toronto Press, 2013. $34.95. 400 pp.

Morra, Irene. *Britishness, Popular Music, and National Identity: The Making of Modern Britain.* New York: Routledge, 2014. $125.00. 266 pp.

Morris, Theresa. *Hans Jonas's Ethic of Responsibility: From Ontology to Ethics.* Albany: State University of New York Press, 2013. $80.00. 246 pp.

Morton, Timothy. *Hyperobjects: Philosophy and Ecology after the End of the World.* Minneapolis: University of Minnesota Press, 2013. $24.95. 230 pp.

Moscowitz, Leigh. *The Battle over Marriage: Gay Rights Activism through the Media.* Urbana: University of Illinois Press, 2013. $25.00 (paper); $85.00 (cloth). 184 pp.

Mukherjee, Ankhi. *What Is a Classic? Postcolonial Rewriting and Invention of the Canon.* Stanford, Calif.: Stanford University Press, 2014. 280 pp. $65.00.

Murray, Laura J., S. Tina Piper, and Kirsty Robertson. *Putting Intellectual Property in Its Place: Rights Discourses, Creative Labor, and The Everyday.* Oxford: Oxford University Press, 2014. $95.00. 240 pp.

Najmabadi, Afsaneh. *Transsexuality and Same-Sex Desire in Contemporary Iran.* Durham, N.C.: Duke University Press, 2014. $27.95 (paper); $99.95 (cloth). 432 pp.

Nayar, Pramod K. *Posthumanism.* Cambridge: Polity Press, 2014. $24.95 (paper); $69.95 (cloth). 208 pp.

Negri, Antonio. *Spinoza for Our Time: Politics and Postmodernity.* Trans. William McCuaig. New York: Columbia University Press, 2013. $24.00. 152 pp.

Nietzsche, Friedrich. *The Dionysian Vision of the World.* Trans. Ira J. Allen. Minneapolis, Minn.: Univocal, 2014. $15.95. 66 pp.

Norich, Anita. *Writing in Tongues: Translating Yiddish in the Twentieth Century.* Seattle: University of Washington Press, 2014. $30.00 (paper); $70.00 (cloth). 160 pp.

Osgood, Kenneth, and Derrick E. White, eds. *Winning While Losing: Civil Rights, the Conservative Movement, and the Presidency from Nixon to Obama.* Gainesville: University Press of Florida, 2014. 304 pp. $79.95.

Paul, Steve, Gail Sinclair, and Steven Trout, eds. *War and Ink: New Perspectives on Ernest Hemingway's Early Life and Writings.* Kent, Ohio: Kent State University Press, 2014. $65.00. 384 pp.

Pénichon, Sylvie. *Twentieth-Century Color Photographs: Identification and Care.* Los Angeles: The Getty, 2013. $65.00. 360 pp.

Perry, Lewis. *Civil Disobedience: An American Tradition.* New Haven, Conn.: Yale University Press, 2013. $35.00. 424 pp.

Peters, Rik. *History as Thought and Action: The Philosophies of Croce, Gentile, de Ruggiero, and Collingwood.* Exeter, UK: Imprint Academic, 2013. $35.99. 426 pp.

Petty, Audrey, ed. *High Rise Stories: Voices from Chicago Public Housing.* San Francisco, Calif: McSweeney's Books, 2013. $16.00. 280 pp.

Pippin, Robert B. *After The Beautiful: Hegel and the Philosophy of Pictorial Modernism.* Chicago: University of Chicago Press, 2014. $30.00. 176 pp.

Powell, Richard J., ed. *Archibald Motley, Jazz Age Modernist.* Durham, N.C.: Duke University Press, 2014. $39.95. 176 pp.

Presser, Lois. *Why We Harm.* New Brunswick, N.J.: Rutgers University Press, 2013. $24.95 (paper); $80.00 (cloth). 170 pp.

Price, Leah. *How to do Things with Books in Victorian Britain.* Princeton, N.J.: Princeton University Press, 2012. $24.95 (paper); $29.95 (cloth). 350 pp.

Pyle, Forest. *Art's Undoing: In the Wake of a Radical Aestheticism.* New York: Fordham University Press, 2013. $28.00 (paper); $95.00 (cloth). 312 pp.

Quayson, Ato and Girish Daswani. *A Companion to Diaspora and Transnationalism.* Malden, Mass.: Wiley-Blackwell, 2013. $195.00. 600 pp.

Rabaté, Jean-Michel, ed. *A Handbook of Modernism Studies.* Malden, Mass.: Wiley-Blackwell, 2013. $149.95. 474 pp.

Ramazini, Jahan. *Poetry and Its Others: News, Prayer, Song, and the Dialogue of Genres.* Chicago: University of Chicago Press, 2013. $25.00. 290 pp.

Rancière, Jacques. *Aiesthesis: Scenes from the Aesthetic.* New York: Verso, 2013. $29.95 (cloth); $29.95. 304 pp.

Rand, Steven, and Heather Felty, eds. *Life Between Borders: The Nomadic Life of Curators and Artists.* New York: Apexart, 2013. $14.50. 112 pp.

Randall, Margaret. *Che on My Mind.* Durham, N.C.: Duke University Press, 2013. $19.95 (paper); $69.95 (cloth). 160 pp.

Reitter, Paul. *On the Origins of Jewish Self-Hatred.* Princeton, N.J.: Princeton University Press, 2012. $26.95. 166 pp.

Richards, Robert J. *Was Hitler a Darwinian? Disputed Questions in the History of Evolutionary Theory.* Chicago: University of Chicago Press, 2013. $27.50. 270 pp.

Richardson, Margaret. *Between Reality and Dream: The Aesthetic Vision of K. G. Subramanyan.* London: Seagull Books. $35.00. 188 pp.

Ricoeur, Paul. *Being, Essence, and Substance in Plato and Aristotle.* Cambridge: Polity, 2013. $24.95 (paper); $69.95 (cloth). 266 pp.

Rodowick, D. N. *Elegy for Theory.* Cambridge, Mass.: Harvard University Press, 2014. $39.95. 304 pp.

Roitman, Janet. *Anti-Crisis.* Durham, N.C.: Duke University Press, 2013. $21.95 (paper); $74.95 (cloth). 176 pp.

Romano, Claude. *Event and Time.* Trans. Stephen E. Lewis. New York: Fordham University Press, 2014. $32.00 (paper); $125.00 (cloth). 280 pp.

Rosaldo, Renato. *The Day of Shelly's Death: The Poetry and Ethnography of Grief.* Durham, N.C.: Duke University Press, 2014. $19.95 (paper); $69.95 (cloth). 160 pp.

Rose, Gillian. *The Melancholy Science: An Introduction to the Thought of Theodor W. Adorno.* London: Verso, 2014. $17.95. 224 pp.

Ross, Sarah, Gabriel Levy, and Soham Al-Suadi, eds. *Judaism and Emotion: Texts, Performance, Experience.* New York: Peter Lang, 2013. $77.95. 178 pp.

Rovane, Carol. *The Metaphysics and Ethics of Relativism.* Cambridge, Mass.: Harvard University Press, 2013. $39.95. 304 pp.

Rudrum, David. *Stanley Cavell and the Claim of Literature.* Baltimore: The Johns Hopkins University Press, 2013. $45.00. 285 pp.

Sakakeeny, Matt. *Roll with It: Brass Bands in the Streets of New Orleans.* Durham, N.C.: Duke University Press, 2013. $23.95 (paper); $84.95 (cloth). 248 pp.

Sandy, Mark. *Romanticism, Memory, and Mourning.* Surrey, England: Ashgate, 2013. $99.95. 188 pp.

Sanjinés C., Javier. *Embers of the Past: Essays in Times of Decolonization.* Durham, N.C.: Duke University Press, 2013. $22.95 (paper); $79.95 (cloth). 240 pp.

279

Sartorius, David. *Ever Faithful: Race, Loyalty, and the Ends of Empire in Spanish Cuba*. Durham, N.C.: Duke University Press, 2014. $24.95 (paper); $89.95 (cloth). 328 pp.

Schlabach, Elizabeth Schroeder. *Along the Streets of Bronzeville: Black Chicago's Literary Landscape*. Urbana, Ill.: University of Illinois Press, 2013. $45.00. 170 pp.

Scott, David. *Omens of Adversity: Tragedy, Time, Memory, Justice*. Durham, N.C.: Duke University Press, 2014. $23.95 (cloth); $84.95 (cloth). 232 pp.

Sealey, Kris. *Moments of Disruption: Levinas, Sartre, and the Question of Transcendence*. Albany: State University of New York Press, 2013. $75.00. 224 pp.

Segall, Kimberly Wedeven. *Performing Democracy in Iraq and South Africa: Gender, Media, and Resistance*. Syracuse, N.Y.: Syracuse University Press, 2013. $39.95. 288 pp.

Seider, Aaron M. *Memory in Virgil's* Aeneid: *Creating the Past*. Cambridge: Cambridge University Press, 2013. $95.00. 230 pp.

Sharma, Sarah. *In the Meantime: Temporality and Cultural Politics*. Durham, N.C.: Duke University Press, 2014. $23.95 (paper); $84.95 (cloth). 208 pp.

Sieg, Ulrich. *Germany's Prophet: Paul de Lagarde & the Origins of Modern Antisemitism*. Waltham, Mass.: Brandeis University Press, 2013. $45.00. 330 pp.

Skiena, Steven and Charles B. Ward. *Who's Bigger? Where Historical Figures Really Rank*. Cambridge: Cambridge University Press, 2014. $27.99. 380 pp.

Smith, Shawn Michelle. *At the Edge of Sight: Photography and the Unseen*. Durham, N.C.: Duke University Press, 2013. $28.95 (paper); $99.95 (cloth). 312 pp.

Sohn, Stephen Hong. *Racial Asymmetries: Asian American Fictional Worlds*. New York: New York University Press, 2014. $25.00 (paper); $79.00 (cloth). 297 pp.

Sommer, Doris. *The Work of Art in the World: Civic Agency and Public Humanities*. Durham, N.C.: Duke University Press, 2014. $22.95 (paper); $79.95 (cloth). 232 pp.

Spectrum, Phil. *Color: Orange, Brown, Magenta*. Blue River, Wyo.: Rainbow Press, 2007. $4.95 (e-book); $129.95 (cloth). 472 pp.

Starr, G. Gabrielle. *Feeling Beauty: The Neuroscience of Aesthetic Experience*. Cambridge, Mass.: MIT Press, 2013. $25.00. 272 pp.

Stekelenburg, Jacquelien van. *Dynamics, Mechanisms, and Processes: The Future of Social Movement Research*. Minneapolis: University of Minnesota Press, 2013. $30.00 (paper); $90.00 (cloth). 496 pp.

Stephen, Lynn. *We Are the Face of the Oaxaca: Testimony and Social Movements*. Durham, N.C.: Duke University Press, 2013. $24.95 (paper); $94.95 (cloth). 368 pp.\

Stratton, Matthew. *The Politics of Irony in American Modernism*. New York: Fordham University Press, 2014. $55.00. 280 pp.

Suderland, Maja. *Inside Concentration Camps: Social Life at the Extremes*. Trans. Jessica Spengler. Cambridge: Polity Press, 2013. $24.95. 300 pp.

Swirski, Peter. *From Literature to Biliterature: Lem, Turing, Darwin, and Explorations in Computer Literature, Philosophy of Mind, and Cultural Evolution*. Montreal: McGill-Queen's University Press, 2013. $29.95. 250 pp.

Szendy, Peter. *Kant in the Land of Extraterrestrials: Cosmopolitical Philosofictions*. Trans. Will Bishop. New York: Fordham University Press, 2013. $25.00 (paper); $90.00 (cloth). 185 pp.

Tauber, Alfred I. *Requiem for the Ego: Freud and the Origins of Postmodernism*. Stanford, Calif.: Stanford University Press, 2013. $24.95 (e-book and paper); $80.00 (cloth). 328 pp.

Taylor, Matthew A. *Universes without Us: Posthuman Cosmologies in American Literature*. Minneapolis: University of Minnesota Press, 2014. $25.00 (paper); $75.00 (cloth). 280 pp.

Thacker, Eugene. *In the Dust of this Planet*. Volume 1 of *Horror of Philosophy*. Ashford, UK: Zero Books, 2011. $19.95 (paper). 179 pp.

Thompson, Peter, and Slavoj Zizek, eds. *The Privatization of Hope: Ernst Bloch and the Future of Utopia, SIC 8*. Durham, N.C.: Duke University Press, 2014. $24.95 (paper); $94.95 (cloth). 336 pp.

Trezise, Thomas. *Witnessing Witnessing: On the Reception of Holocaust Survivor Testimony*. New York: Fordham University Press, 2013. $26.00 (paper); $85.00 (cloth). 315 pp.

Tromp, Marlene, Maria K. Bachman, and Heidi Kaufman. *Fear, Loathing, and Victorian Xenophobia.* Columbus: The Ohio State University Press, 2012. $69.95. 440 pp.

Turner, Lynn, ed. *The Animal Question in Deconstruction.* Edinburgh: Edinburgh University Press, 2013. $68.80. 208 pp.

Tweedy, Roderick. *Blake, Bolte Taylor, and the Myth of Creation.* London: Karnac, 2012. $43.95. 356 pp.

Underwood, Lori J, ed. *The Root of All Evil? Religious Perspectives on Terrorism.* New York: Peter Lang, 2013. $72.95. 160 pp.

Vanel, Hervé. *Triple Entendre: Furniture Music, Muzak, Muzak-Plus.* Urbana: University of Illinois Press, 2013. $50.00. $216 pp.

Villarejo, Amy. *Ethereal Queer: Television, Historicity, Desire.* Durham, N.C.: Duke University Press, 2014. $23.95 (paper); $84.95 (cloth). 216 pp.

Von Germeten, Nicole. *Violent Delights, Violent Ends.* Albuquerque: University of New Mexico Press, 2013. $29.95. 320 pp.

Voss, Daniela. *Conditions of Thought: Deleuze and Transcendental Ideas.* Edinburgh: Edinburgh University Press, 2013. $110.00 (cloth). 286 pp.

Wang, Dorothy J. *Thinking Its Presence: Form, Race, and Subjectivity in Contemporary Asian American Poetry.* Stanford, Calif.: Stanford University Press, 2014. $50.00. 416 pp.

Wang, Xiaojue. *Modernity with a Cold War Face: Reimagining the Nation in Chinese Literature across the 1949 Divide.* Cambridge, Mass.: Harvard University Press, 2013. $39.95. 376 pp.

Wehrs, Donald R. *Levinas and Twentieth-Century Literature.* Newark, Del.: University of Delaware Press, 2013. $90.00. 360 pp.

Weinstein, Jack Russell. *Adam Smith's Pluralism: Rationality, Education, and the Moral Sentiments.* New Haven, Conn.: Yale University Press, 2013. $65.00. 360 pp.

Whitehead, Amy. *Religious Statues and Personhood: Testing the Role of Materiality.* London: Bloomsbury, 2013. $120.00. 200 pp.

Whyte, Jessica. *Catastrophe and Redemption: The Political Thought of Giorgio Agamben.* Albany: State University of New York Press, 2013. $80.00. 224 pp.

Witt, Michael. *Jean-Luc Godard, Cinema Historian.* Bloomington: Indiana University Press, 2013. $35.00 (cloth); $85.00 (cloth). 288 pp.

Wolfe, Judith and Brendan. *C. S. Lewis's Perelandra: Reshaping the Image of the Cosmos.* Kent, Ohio: Kent State University Press, 2013. $45.00. 184 pp.

Wood, Paul. *Western Art and the Wider World.* Oxford: Wiley Blackwell, 2014. $34.95. 314 pp.

Woodard, Ben. *Slime Dynamics.* Ashford, UK: Zero Books, 2012. $14.95 (paper). 84 pp.

Wortham, Erica Cusi. *Indigenous Media in Mexico: Culture, Community, and the State.* Durham, N.C.: Duke University Press, 2013. $24.95 (paper); $89.95 (cloth). 288 pp.

Wright, Christopher. *The Echo of Things: The Lives of Photographs in the Solomon Islands.* Durham, N.C.: Duke University Press, 2013. $27.95 (paper); $99.95 (cloth). 240 pp.

Yousef, Nancy. *Romantic Intimacy.* Stanford, Calif.: Stanford University Press, 2013. $55.00 (e-book); $55.00 (cloth). 192 pp.

Zaretsky, Robert. *A Life Worth Living: Albert Camus and the Quest for Meaning.* Cambridge: Harvard University Press, 2013. $22.95. 240 pp.

Ziarek, Krzysztof. *Language After Heidegger.* Bloomington: Indiana University Press, 2013. $45.00. 264 pp.

Zielinski, Siegfried. *Thinking after the Media.* Trans. Gloria Custance. Minneapolis: Univocal, 2013. $26.95. 275 pp.

Žižek, Slavoj. *Demanding the Impossible.* Cambridge: Polity Press, 2013. $14.95 (paper). 160 pp.

Notice to Contributors

The editors invite submissions of manuscripts appropriate to the aims of *Critical Inquiry*. Manuscripts should not exceed 7,500 words. The journal does not pay contributors. Authors will receive a complimentary one-year subscription to the journal and ten copies of the issue in which their articles appear.

Preparation of Copy
1. Type all copy—including footnotes—double-spaced, allowing two-inch margins at the top and bottom of page and generous margins on the sides. Please be sure to number your pages.
2. Footnotes should be numbered consecutively throughout the manuscript.
3. A glossy print or clear photo-copy of each illustration should accompany the manuscript.
4. All quotations, titles, names, and dates should be double-checked for accuracy.
5. Please submit via email to the following address: cisubmissions@gmail.com
6. Do not embed images in your document.

Format of Footnotes:
All footnotes should be typed double-space on a separate page (or pages) following the last page of the text. They should be numbered consecutively and should correspond with the numbers in the text. Footnote style follows *The Chicago Manual of Style,* 15th ed.
Some examples:
1. Ludwig Wittgenstein, *Philosophical Investigations*, trans. G.E.M. Anscombe (New York, 1958).
2. Stanley Cavell, "Leopards in Connecticut," *Georgia Review* 30 (Summer 1976): 233–62.
3. C.D. Jones, "The Dance," in *The Arts in the Twentieth Century*, ed. E. F. White (New York, 1972).
4. Thomas Jefferson, *Papers of Thomas Jefferson*, ed. Julian P. Boyd et al., 17 vols. (Princeton, N.J., 1950), 10:34–35.
5. James Williams, "A Critical Edition of Jack London's *The Star Rover*" (PhD diss., Columbia University, 1989).

Second and later references to a previously cited work should be referred to by the author's last name and the title of the work. Do not use op. cit.

Permissions